DIABOLICAL DESIGNS

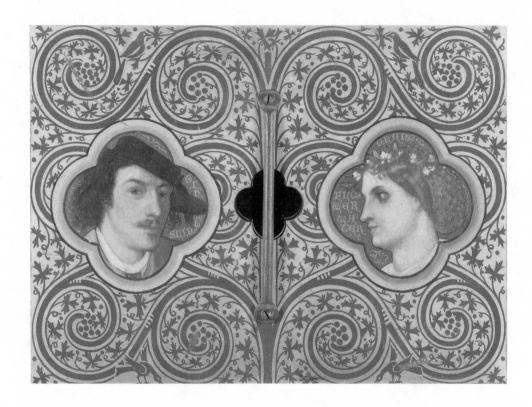

DIAF

Deanna Marohn Bendix

OLICAL DESIGNS

Paintings, Interiors, and Exhibitions
of James McNeill Whistler

Smithsonian Institution Press • Washington and London

©1995 by the Smithsonian Institution
All rights reserved
Manuscript editor: Catherine McKenzie
Production editor: Jack Kirshbaum
Designer: Linda McKnight

Library of Congress Cataloging-in-Publication Data
Bendix, Deanna Marohn.
 Diabolical designs : paintings, interiors, and exhibitions of
James McNeill Whistler / Deanna Marohn Bendix.
 p. cm.
 Includes bibliographical references (p.) and index.
 ISBN 1-56098-415-5 (alk. paper)
 1. Whistler, James McNeill, 1834–1903—Criticism and
interpretation. 2. Aesthetic movement (British art)—
Influence.
 I. Title.
 N6537.W4B46 1995
 709'.2—dc20 94-24957

British Library Cataloging-in-Publication Data available

Manufactured in the United States of America
99 98 97 96 95 5 4 3 2 1

⊗The paper used in this publication meets the minimum require-
ments of the American National Standard for Permanence of Pa-
per for Printed Library materials Z39.48-1984.

Jacket illustration: James McNeill Whistler, *The Artist in His
Studio*, 1865–66, oil on paper mounted on mahogany panel,
28¾ × 18¾ in. (62.9 × 47.6 cm). Photograph © 1994 The Art
Institute of Chicago.

Frontispiece: Portrait of Whistler as a Young Man, by Edward J.
Poynter. Oil, 1858–59. Detail from William Burges's *Battle between
Wines and Beers Sideboard* (the Yatman Cabinet). Victoria and Al-
bert Museum, London. By courtesy of the Board of Trustees.

For my husband, John, and my children, Kate and John

Contents

Foreword: The Whistler Phenomenon

Recent examination of the design reform movement on a worldwide basis and as a phenomenon of the closing decades of the nineteenth century has increasingly led to a cogent reassessment of certain personalities. Whether designers or theoreticians, these individuals were committed to design issues before they became prevalent or had found a popular support. Among these figures was the cosmopolitan James McNeill Whistler, whose work as a painter and printmaker is well known. However, his passionate involvement with redesigning his private and public spaces has been concealed by conflicting viewpoints considering the value and lasting contribution that Whistler has made to modern art.

Deanna Bendix's current study of Whistler and the design movement demonstrates that it is apparent that this artist believed in unification of the arts. He was committed to designing everything himself, from the clothes he wore to the preview of an exhibition, to the invitations he sent to potential attendees, to

the catalogue that was published for a particular show, to the final "look" of the entire installation. Whistler designed according to his own personal standards and taste. He continually challenged authoritarian views and called into question what was generally believed by other artists and critics, supporting innovative stances that pushed toward new areas of assimilation and beauty. Whistler tried to cleanse design of previous historicism by finding significance in simplification.

During his lifetime (and after his death), Whistler was seen as both brilliant and unnerving. He did everything to remain in the spotlight even though he knew that people were unable to recognize his contribution—they were blinded by his overbearing persona. Few saw that Whistler was in the vanguard, as his showmanship prevented an adequate assessment of his work in all media. Painting could no longer remain the sole preoccupation of an active creator. Art had to become part of life, and in order for this

relationship to blossom, the creator had to take charge of the spaces in which he lived, the manner in which they were decorated, and the dress that he wore as he moved through them. New colors, modern materials, the harmonizing of effects, and the purification of environments went toward improving the way in which people lived. The contemporary artist working in this vein tried to draw on new stimuli to maintain the creative edge. In Whistler's terms this meant the artist had to understand (almost intuitively) the Oriental world—then a new craze—so that subtle principles of design could be applied to Western interiors and surfaces. In recognizing the value of the two-dimensional surface, the importance of planes of flat, delicately modulated color and the uncluttered impact of spaces with these qualities, Whistler was, in all of his creative work, capable of redirecting the energies of the artistic world. He continually provided the glittering impression that in rearranging the universe according to his personal intentions, the surface was primary. Whistler had rediscovered the look of the Momoyama period of the Japanese golden age; the geometric screen returned with a passion.

Although Whistler was not a designer of furniture, nor a craftsman who worked with rare gems for elaborate pieces of jewelry, he did have the mentality of the intuitive artisan who was trying to sever the applied arts from the domination of the historical past. What Whistler aptly demonstrated, and what was so difficult for his contemporaries to grasp, was that simplification of form and harmony of color and shape should be primary concerns of the modern artist. He understood that to be contemporary an artist had to pay attention to these overriding aesthetic concerns. Whistler remained a phenomenon during his lifetime, a comet bursting over his peers, a figure who was well ahead of his time. It is to Deanna Bendix's credit that she has reformulated Whistler's position in his time by seeing how his creativity went beyond well-trodden paths. With her book, *Diabolical Designs: Paintings, Interiors, and Exhibitions of James McNeill Whistler*, Dr. Bendix shows how Whistler's contribution continues to provoke controversy, amazement, and contemplation in our century. We are still debating the significance of good design and the imperative of recognizing universal creators from the vanguard of earlier design reform periods.

Gabriel P. Weisberg
University of Minnesota

Acknowledgments

Although I did not know it at the time, my odyssey to discover Whistler as a designer actually began about fifteen years ago. It was then that I began periodically to visit the Freer Gallery of Art, where, together with my small red-haired daughter Kate, I would stand in the Peacock Room and absorb its magical atmosphere. I had no idea that Whistler had designed other rooms or that his fight to make pure, decorative beauty a legitimate basis for his work—against the prevailing Victorian demand for morality in art—had turned him into a kind of "diabolical provocateur." In any case, Whistler's alchemy began to work on me back then as I viewed his marvelous blue-and-gold room. Eventually, it would lead to the intriguing experience of unearthing and reconstructing his other interiors, which seem to have been lost and buried in the history of art.

My "archaeological dig" began in earnest when I returned to the University of Minnesota with the intention of entering doctoral studies. It was a stroke of luck that in January 1986, I landed in Professor Gabriel P. Weisberg's class in *japonisme*; he, too, had just arrived at the university. Within days it occurred to me to inquire whether I might write a paper on the *japonisme* in the Peacock Room. Dr. Weisberg's enthusiastic response—that indeed this would be a germane research topic—unwittingly set me off on a journey that would monopolize much of my life for the next seven years. Without Dr. Weisberg's pioneering scholarship on the decorative art movements in the nineteenth century, which gave me the foundation for this study, along with his constant support, this book would never have moved so successfully from inception to completion. My heartfelt thanks to him for helping to make an exhausting and lengthy research project possible and always fascinating.

My research trips involved the gracious assistance of staffs from the following institutions, which I would like to thank. In Glasgow: the Hunterian Art Gallery, the Special Collections Department of the Library,

and the Centre for Whistler Studies, all at the University of Glasgow; Glasgow Art Gallery and Museum; the Fine Art Society; and Glasgow School of Art. In Oxford: the Ashmolean Museum, Department of Western Art, and the Oxford University Union. In London: the Tate Gallery and Archive; Trustees of the British Museum, Department of Prints and Drawings; the Fine Art Society; the Witt Library of the Courtauld Institute; the National Gallery; the Victoria and Albert Museum, Department of Designs, Prints and Drawings; P. & D. Colnaghi & Co., Ltd.; and the Royal Academy of Arts. In Paris: the Musée d'Orsay and the Louvre. In Hamburg: the Kunst und Gewerbe Museum. In New York: the New York Public Library; the Frick Collection; and the Metropolitan Museum of Art. In Washington, D.C.: the Freer Gallery of Art and the Charles Lang Freer Papers, Freer Gallery of Art/Arthur M. Sackler Gallery Archives, Smithsonian Institution; the Manuscript Division, Joseph and Elizabeth Pennell Papers; the Lessing J. Rosenwald Collection, Rare Book and Special Collections Division, and the Prints and Photographs Division, all at the Library of Congress; the Archives of American Art; and the National Gallery of Art.

To the following individuals who contributed to the completion of this project, I extend sincere thanks: Roger Billcliffe, Jennifer Booth, David Park Curry, Martin Durrant, Phillip Escreet, Maja Felaco, Donald Garstang, Adrian Glew, Paul Goldman, Anita Gostomczik, Judy Hanks, Colleen Hennessey, Timothy Hobbs, Teresa Hoehn, Martin Hopkinson, Charles Kelly, Lionel Lambourne, Katharine Lochnan, Margaret MacDonald, Andrew MacIntosh Patrick, Linda Merrill, Bernadette Nelson, Pamela Parker, Nicholas Penny, Sarah Fox Pit, Phyllis Poehler, George Rogers, Kathryn Rynders, Peyton Skipwith, Lawrence Smith, Lindsay Stainton, Joyce Stoner, Petra ten-Doesschate Chu, Nigel Thorp, Judy Throm, Moira Thunder, Clive Wainwright, Elizabeth

Watson, Yvonne Weisberg, David Weston, Catherine Whistler, Peter Van Wingen, Edwin Wallace, and Irene Weller. Several of these individuals assisted me beyond the call of duty, and I am most thankful.

I appreciate the assistance from the staff and faculty at the Department of Art History, University of Minnesota. I also want to thank Professor Marion Nelson, Professor Chester Anderson, Professor Marjorie Durham, and Dr. Lyndel King for reading and commenting on the original manuscript. A number of staff members at the University of Minnesota Library also deserve credit for aiding my research.

In the final stages of this project I have had the pleasure of working with Amy Pastan, Cheryl Anderson, and Jack Kirshbaum, editors at the Smithsonian Institution Press, and Catherine McKenzie, manuscript editor. To them I extend my sincere gratitude for their superb guidance and expertise. To Caryn Wendt, who prepared the electronic manuscript, I wish to express my grateful acknowledgment of her skillful handling of this difficult and exacting job.

Personal thanks to my parents Theresa and Herbert Marohn for their example of strength and determination. Their love and interest in my endeavors have helped to sustain and fortify me. I also wish to honor the memory of Dr. L. H. and Molly Bendix, my scintillating parents-in-law, who remain a continuing source of inspiration. Special thanks are given to Dr. Karel and Mary Absolon, who were wonderful hosts during my research trips to Washington, D.C.

Finally, thanks to my family for their tolerance and support over the long period of time in which this project was in progress. My greatest appreciation goes to my husband, John D. Bendix, for his calm, intelligent, and positive presence. To my children Katherine and John, who kept the faith and their good humor while their mother researched and wrote and they grew up, I also offer my appreciation.

DIABOLICAL DESIGNS

Introduction

When carefully examined, the record of James Abbott McNeill Whistler's life and achievement in his own time proves to be amazingly detailed and closely reported. Because he was in the limelight so much, virtually every comment he made seems to have been recorded somewhere. Once, when someone threatened him with an exposé of his private life, he responded with his famous cackle, and declared, "I have no private life!"[1] Even so, a true understanding of the significance of his work and his career is exceedingly rare. For many, Whistler is remembered simply for the portrait of his mother—perhaps the best-known American painting. For scholars of French and English nineteenth-century art, Whistler is perceived primarily as a consummate etcher, a painter of misty nocturnes and distinguished portraits, and an agitator for modernist aesthetic thought.

What is missing from these perceptions, and seldom realized, is that Whistler was, above all, a master

designer. Indeed, Whistler's portrait of his mother provides a convenient microcosm to help elucidate the real nature of his fundamental approach to art [pl. 1]. The 1871 painting reveals the highly evolved refinement of an impeccable designer—in Whistler's words, his "theory in art," the "science of color and 'picture pattern.'"[2] What gives the painting its indelible quality, beyond the dignified visage of his elderly mother, is the strong silhouette and the tranquil and solemn effect of the exquisitely balanced pictorial design in monochromatic tones of black, white, and grey. Whistler deliberately entitled this work *Arrangement in Grey and Black: Portrait of the Painter's Mother.* "By the names of the pictures also," he stated, "I point out something of what I mean in my theory of painting."[3]

The meticulously calibrated, flat, arranged-surface aspect of Whistler's canvases is well understood, as is his incorporation of the frame as part of

that designed surface. "My frames," he noted, "I have designed as carefully as my pictures—and thus they form as important a part as any of the rest of the work—carrying on the particular harmony throughout. This is of course entirely original with me and has never been done."[4] What has not been fully acknowledged, however, is that Whistler's focus on design did not stop at the edge of his green-gold, red-gold, or white-glazed picture frames. Indeed, he was incapable of conceiving of his paintings and prints apart from the ambience in which they would ultimately be hung. His flat, simplified nocturnes, particularly, seem designed to become part of the unified color and composition of the wall [see figs. 38, 46; pl. 2]. Given this perspective, it comes as no surprise that as Whistler's career as a printmaker and painter advanced, so did his desire to decorate not only the paper or the canvas but the entire setting in which the work would be seen. He felt a need to invent a new abstract, tonal environment to achieve an ideal context consistent with his subtly colored works.

Whistler's studio assistant, Mortimer Menpes, remarked, "He never hung a picture on his walls unless it was his own. Occasionally he would hang a few of his etchings on a lemon yellow wall, just because he liked the harmony of the old Dutch paper against the yellow. To hang them merely because of their intrinsic interest he considered inartistic."[5] This point of view caused Whistler to "visit" his paintings and prints after they were purchased, in order to assess their proper decorative effect in their new settings. "You will perhaps pardon my curiosity to see them hanging on your walls," he wrote to one unnerved collector who quaked at the prospect of meeting the notorious aesthete.[6]

Since Whistler conceived of a picture as an integrated part of an interior world, he particularly sought to revolutionize the design of this world, which in the Victorian period was, more often than not, antagonistic to painted works of art. Specifically, then, Whistler designed domestic interiors, artists' studios, and tem-

porary exhibition spaces—and he did it with considerable style and wit.

Whistler's fastidiousness and fanatic perfectionism, which led him to destroy a large part of his life's work, were traits that seem to have served him better as an interior decorator. Indeed, it was as a designer of interior spaces that he appears to have found his metier. He was supremely confident in this role. There are numerous reports of his troubled struggle to satisfy his own criteria for his pictures, but no such tales of doubt survive in regard to his designs for galleries and domestic interiors. More common are the stories of Whistler's frenzied ecstasy as he orchestrated symphonies of color for interior spaces. His friend, lithographer Thomas Way, stated: "There remains one side of the master's art in which his pre-eminence has never been questioned, namely interior decoration. Here, no doubt, he learnt much from the Japanese, but he brought his own sense of colour into his schemes, and the results were always strikingly original as well as beautiful."[7]

Whistler's avant-garde experiments in the field of interior design received a great deal of critical attention in his day, eliciting both praise and ridicule. Beyond the abundant contemporary newspaper and art journal reviews, however, his contributions as a decorator to nineteenth-century design reform have seldom been acknowledged or examined. This is no doubt because the subtle, slyly comical exhibitions, which he meticulously arranged to the last detail, were shortly dismantled.

The houses for which he designed startlingly stark interiors in the midst of an era of elaborate wallpaper and overstuffed plush have long ago been razed, or the interiors have been subjected to repeated redecoration. Only the Peacock Room [pls. 12, 14] remains intact. To his chagrin, even the rooms of his minimalistic residence in Chelsea, Whistler's beloved White House, were redecorated while he stood helplessly by, writing furious letters to the editor of the *World* about the desecration.[8] As Thomas Way

remarked, "Those who were privileged to visit him carried away the memory of rooms as entirely simple in decoration as they were refined and reposeful in effect. It is to be feared, however, that few if any of these rooms remain, and Mr. Whistler's reputation as a designer will rest on the masterpiece which he designed and carried out for Mr. Leyland [the Peacock Room]."[9] The importance of Whistler's role as an interior designer began to be forgotten as soon as his interiors were redone.[10]

The British decorator, William Morris, on the other hand, is generally acknowledged as the principal fulcrum on which the design revolution turned. Together with John Ruskin, Morris has achieved legendary status as a proselytizer for upgrading the decorative arts in England in the latter half of the nineteenth century. His designs for interiors continue to be internationally recognized and admired. It is perhaps not a coincidence that Morris's flat, complex floral wallpaper and textile designs have lent themselves *ad nauseam* to reproduction to this day. Morris and Company itself actually survived until 1940, continually repeating Morris's designs and adding a few new ones in the Morris style in different color schemes. William Morris's own daughter May remained with the company until about 1922. Morris designs became an unending vogue and a status symbol like a designer label. The use of Morris textiles and wallpapers in a home signified the owners' refined aesthetic sensibilities.[11]

By contrast, any discussion of Whistler as a decorator invariably involves a disturbing lack of photographic or illustrative material. The true nature of Whistler's color-based interior schemes may have seemed unreproducible in an era before color photography. It is conceivable that a yellow-and-white, or flesh color-and-grey, or brown-and-gold watercolor sketch of one of his interiors may yet be discovered. The chances, though, are remote. However, written records exist of at least twenty-five Whistlerian interiors. And, even without images, if we can imagine entering one of these interiors, with their plain walls,

light colors, and empty spaces, we will feel we have left behind the fussy, old-fashioned Victorian world of Ruskin and Morris and stepped into the first decade of the new century.[12]

Despite the modernist character of Whistler's work in interior decoration, little progress has been made in understanding or exploring his contribution as a designer in this crucial period in the history of design in England. Even though interest in Whistler's legacy as a designer has continued to attract the attention of several Whistler scholars, no extended or concentrated study has been completed.[13]

Although research thus far has been slight, it is clear that Whistler focused on many of the main aspects of the design revolution of his time. He was "in the swim of things," picking up influences in Paris and London and forging his own style. His strongly personal ideas for decorating are interesting in themselves. They are, as well, seminal for twentieth-century trends in interior design, which have continued to evolve. In other words, Whistler was an original and yet participated fully in the general thrust of design reform. And he was one of the major links, transmitting ideas particularly between England, France, Belgium, and America. His design activities were central not only to his own artistic enterprise but to the entire course of late-nineteenth-century design in England.

Tracing and assessing the origins of the evolution of Whistler's modernist theory of decoration and setting his concepts against theories espoused by other major figures such as William Morris and Edward W. Godwin will shed considerable light on the British design reform movement. More than any other designer of this period in England, Whistler resolutely turned away from the Victorian taste for rampant eclecticism and heavy historicism. His initiative in interior design toward purified, harmonious, and unified ensembles dominated by beautiful color schemes, particularly as represented by the Peacock Room, prepared the way for sophisticated art nouveau and art deco interiors.

Manipulating the Press
The Artist as Celebrity

Agitator for Reform: Revolution via the Daily News

Writers on James Abbott McNeill Whistler (1834–1903) [fig. 1] often lament the fact that the artist left Paris just at the point that it was fermenting with avant-garde painting movements such as realism, naturalism, and impressionism. Frequently, his move to London in 1859 is cited as a whimsical error made by an artist who initially showed promise as a potential leader in the modern movement in French painting.[1] In 1892 Whistler resettled in Paris, where he became recognized as a major progenitor of French symbolist art. But during the intervening years, though he often worked in Paris, his primary base of operation was London. Pictorial artists in Victorian London at the beginning of the 1860s seemed to be caught up in academic, retrograde styles, heavy with sentiment and novelistic meanings, and turgid with moral lessons for the viewer. The days of the great English landscape painters, John Constable and J. M. W. Turner were

past, and the rebellious Pre-Raphaelite Brotherhood had lost its initial fervor and cohesiveness. Why, one could wonder, would a cosmopolitan figure like Whistler choose to make his mark in parochial Victorian London when Paris offered such a sophisticated aesthetic environment?

What is overlooked in this view of art history, which envisions the advance of the modern movement largely in terms of "high art," is that England was at that very moment in the vanguard of launching a renewal of the decorative arts. As British art historian Denys Sutton has stated, "Towards the end of the nineteenth century, artists, craftsmen and theorists were haunted by the need to renew the decorative arts and to create the 'house beautiful.'"[2] Spurred by the alarming state of design fostered by early industrialization in England and clearly demonstrated by the phantasmagoria of distinctly vulgar and decadent

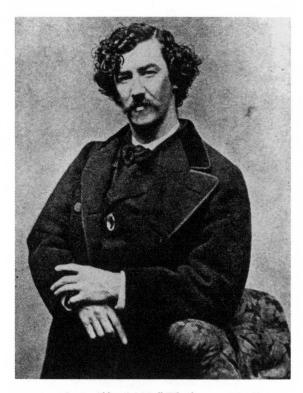

FIG. I. *James Abbott McNeill Whistler, ca. 1864, Etienne Carjat photograph, Paris. Joseph and Elizabeth Pennell Papers, Library of Congress.*

decorative arts displayed at the 1851 London Great Exhibition, many of Britain's talented artists turned their attention to the decorative arts.[3]

Attempts to improve low design standards had begun to emerge as early as the 1830s. The effect of this concentrated effort by the best creative minds in England was to bring about an eventual transformation of British arts and crafts. Several Pre-Raphaelite painters, such as Dante Gabriel Rossetti, Ford Madox Brown, and Edward Burne-Jones, began to direct some of their creative energy into design projects by the end of the 1850s. William Morris, usually considered the leader of the design reform movement, stopped painting altogether and became an all-round

craftsman and poet. It was at this moment, when the role of the artist was being expanded and redefined in England, that the young Whistler arrived in London.

Undoubtedly, Whistler had several reasons for settling in England. He had experienced somewhat better acceptance at the London Royal Academy than at the Paris Salon. He had social entrée through his brother-in-law Francis Seymour Haden, a distinguished physician. And very early on he had the patronage of certain wealthy members of the Greek community and may have felt riches awaited him. Whatever his reasons, his relocation in London brought him in touch with the British revival of the applied arts.[4] By 1862, Whistler was already in direct contact with several leading artist-designers who were attempting to elevate the decorative arts, and he was meanwhile enthusiastically collecting and studying Japanese arts and crafts. Whistler was certainly not immune to the rising design mania in Britain, and he became involved in decorative art projects such as the design of exhibitions, a logical development in this exciting era of design and exhibition.

In Paris, Whistler had quickly demonstrated an uncanny ability to ingratiate himself in bohemian circles and make himself into an avant-garde French realist. In the design-conscious environment of London, his focus moved away from realism to questions of design, both for his canvases and for his private interiors, which he decorated with the arts of Japan he was then collecting. It is doubtful Whistler's pictorial work would have so resolutely progressed toward abstraction had he not been in an artistic atmosphere that encouraged artists to concentrate on design.

Eventually, Whistler went on to become an active designer, but recognition of his designing capabilities today is usually limited to a discussion of the Peacock Room. As important as this project may be, there is much more than a single room to consider when studying Whistler's contribution as a decorator. It is quite clear his importance in this field has been

significantly underestimated in the study of the British design reform movement.[5] If Whistler's position as a key figure in the revival of English design is generally ignored today, during his own day he could hardly be missed as a public agitator for escaping the dull and fusty in Victorian domestic and exhibition design.

It may be helpful, in clarifying Whistler's unique role in the world of English arts and crafts, to consider some of his predecessors. Earlier British reformers such as Augustus Welby Pugin, John Ruskin, and Henry Cole had pursued more readily recognized methods of drawing attention to the need to upgrade the applied arts. They published serious books and articles on the problem, cooperated with the efforts of public agencies in this direction, and aligned themselves with prestigious art schools and universities.[6] As a result, their reforming efforts took on the sober character of officially sanctioned pronouncements.

Whistler's famous contemporary, William Morris (1834–1896), while following closely the neo-Gothic thrust of decorative renewal charted by Pugin and Ruskin, made his mark in improving the applied arts in a somewhat different way. After acquiring an elite Oxford University education, he dedicated himself to creating an art "of the people for the people."[7] Dressed as a hardworking artisan in blue workers' clothing, he set out to embody the moral and social values that he attached to a craftsman, devoting his life to creating domestic interiors based on historical medieval models. Morris also gathered around himself several of the most gifted artists in England, including Burne-Jones, Rossetti, Philip Webb, and Brown, and set up a decorative workshop named Morris, Marshall, Faulkner and Company, Fine Art Workmen in Painting, Carving, Furniture and the Metals (later Morris and Company) in 1861. As his social conscience grew more acute, Morris expressed his growing concern for bringing beauty into the daily lives of the people by publishing twenty-four volumes of his collected writings and repeatedly delivering, from 1877 to 1894, a series of thirty-five lectures on art, architecture, and design, with titles such as "The Decorative Arts and Their Relation to Modern Life and Progress."[8]

But whatever their individual differences may have been, Morris, Ruskin, Cole, and Pugin, in conducting campaigns to renew the applied arts in England, shared the comfortable status of insiders. They were admired by their fellow Britons for their reforming efforts. Whistler was a different case entirely. Not only was he an expatriate American, he had also acquired a French orientation by spending the formative years of his career, from 1855 to 1859, in Paris. He was, therefore, the quintessential outsider, and he had adopted a radical approach for disseminating his theories of decorative art—using newspapers, journals, pamphlets, exhibition catalogues, and even popular comic magazines—perhaps in part borne of his difficulties in receiving acceptance in the British art world through other established channels.

Once settled in England ("settled" is an oxymoronic term for this peripatetic artist), Whistler did not join the incipient British applied art movement in a predictable way. For example, he evinced no interest in designing prototype furnishings for multiple production in industry as did his fellow aesthete and friend Edward William Godwin (1833–1886), and he did not attempt to establish a craft workshop of any kind in the mode of Cole or Morris.[9] As an unapologetic elitist, it was not his style to lecture in the provinces about art for the people; nor did he ever write a straightforward tome on the problem of improving Victorian interiors. In fact, he was utterly opposed to the appearance of belabored seriousness of any kind. Instead, true to his personality, Whistler assumed the role of aesthetic gadfly. He thrived on stirring up controversy and indulging in deviltry, and he gleefully brought these elements into play in the stolid world of British arts and crafts, thereby energizing the entire movement.[10]

Early in his career, Whistler perceived the press as the enemy; it became a major objective of his life to reverse that situation and put journalists and art critics in his service. As a natural wit and propagandist, he took the media as his personal vehicle of expression. It would become increasingly important to him as his career progressed. He had no inclination to behave or conform to the status quo. He was a revolutionary determined to change not only the way pictures looked but also the way they were displayed and the way people dressed and lived in their homes. He spoke out fearlessly for change in the arts through the press more than any other design reformer.

Oscar Wilde (1854–1900) [fig. 2] would subsequently follow Whistler's example and adopt a similar pose as a celebrity promoting the elevation of the decorative arts, and he would likewise court the press. As Wilde's character, Basil Hallward, in his novel *The Picture of Dorian Gray*, states, "I believe some pictures of mine had made a great success at the time, at least had been chattered about in the penny newspapers, which is the nineteenth-century standard of immortality."[11] Wilde was parodying Whistler's obsession with press reviews, not that he himself was above a need to capture immortality through the daily news. For Whistler, his exploitation of the media was a way of maintaining the high visibility he needed to be a leader in fomenting a revolution in the arts.

Although his primary motive was to turn the spotlight on himself, in so doing he drew enormous attention to the entire British renaissance in design, which began as the "aesthetic movement" in the 1860s and took second wind and new direction as the "arts and crafts movement" in the 1880s. Whistler became a leading figure in the aesthetic movement by the late 1870s. The fundamental motives of the movement were to unify the arts and bring beauty into daily life. With this new, all-encompassing objective directing their thoughts, many artists poured heightened levels of creative energy into artistically

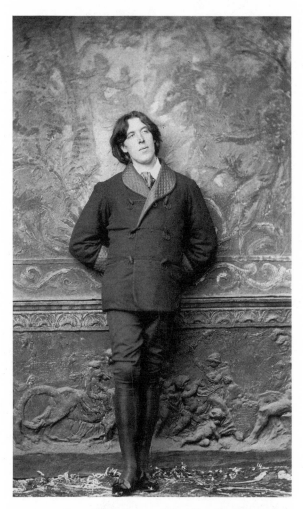

FIG. 2. *Oscar Wilde, January 1882, Napoleon Sarony photograph, New York. Wilde was photographed as he began his lecture tour devoted to teaching Americans how to bring art into their daily lives. By courtesy of the National Portrait Gallery, London.*

upgrading the design of Victorian interiors. But who, other than James McNeill Whistler, could have taken the usually tame topic of interior design and transformed it into a controversial subject? Through his astonishing originality, and by injecting exoticism, theatre, and scandal, he made interior design newsworthy.

Whistler's Press Clipping Albums

That Whistler did indeed do this becomes abundantly clear when one reviews the extensive series of albums of press clippings, now in Special Collections at the University of Glasgow, that the artist compiled from the early days of his career until the end of his life. When Whistler's future great collector, Charles Lang Freer, the Detroit industrialist, visited the artist at Tower House, his studio flat in Chelsea, in March 1890, he reported: "[Whistler] showed me some of the most remarkable scrapbooks I have ever seen. In those scrapbooks, elaborately classified and indexed, he had hundreds upon hundreds of clippings."[12]

In an effort to methodically chart the progress of his press campaign, Whistler subscribed to clipping services such as Durrant's Press Cuttings and Romeike and Curtice Press Cutting Agency [fig. 3]. In an 1890 letter to *Truth*, he referred to the latter as "the indefatigable and tardy Romeike, who sends me newspaper cuttings."[13] He thereby accumulated a phenomenal personal historical record of the course of his own career as artist and provocateur. The vast majority of newspaper clippings Whistler saved concern his exhibitions, interior designs, lectures, and court cases. For example, his press clipping albums contain more than two hundred articles, caricatures, and poems reviewing, explaining, or advertising his 1885 "Ten O'Clock" lecture, in which he promoted his theory of decorative art.

This coverage was not atypical. But while such highlights in Whistler's career as his "Ten O'Clock" lecture attracted blanket coverage in the news, he had devised another method for evoking a steady stream of press releases. By designing provocative exhibition spaces for his own work and, later, for group exhibitions, he was able to elicit extensive media coverage for years. His private views (exhibition openings) became the major means by which he kept his name and ideas alive in the press—that is—in history.

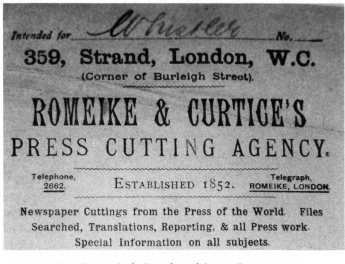

FIG. 3. *Press Cutting Stub, Romeike and Curtice Press Cutting Agency. Whistler press clipping album, Birnie Philip Bequest, Glasgow University Library.*

Whistler was not content with attracting a few stray comments from uncomprehending reporters in general reviews. Once he started designing his own shows, he began to step up his news impact dramatically, and he could also demand a higher level of critical evaluation. The opening few paragraphs of these articles invariably focused on Whistler's design for the gallery space itself. A review of his first solo exhibition at the Flemish Gallery in Pall Mall in 1874, is typical.

> The decoration and furnishings of this room, which have been executed under Mr. Whistler's immediate superintendence, are in admirable harmony of tone and colour with the pictures on the walls, and the *tout ensemble* of the gallery is itself a triumph of art. On the floor is spread a glaring yellow matting striped in two shades; the finely-formed couches and chairs dispersed about the room are covered with rich light maroon cloth, the walls above the skirting board are delicately tinted with maroon, and below it are painted

creamy white and on steps and ledges stand blue pots with growing flowers and plants; while the light from the roof is subdued and mellowed by passing through thin white blinds.[14]

Hundreds of similar reviews appear in Whistler's press clipping albums, covering his one-man exhibitions as well as other exhibitions he arranged at the Grosvenor Gallery, the Royal Society of British Artists, and the International Society of Sculptors, Painters and Gravers. The press coverage was thorough and seldom failed to give top billing to the gallery as designed by Whistler. In view of this coverage, it would seem that by the late 1880s the art public would have been as familiar with Whistler's unorthodox ideas for the design of interior spaces as with the pictorial concepts in his paintings and etchings.

In 1884, ten years after his first 1874 one-man exhibition, Whistler was still hard at work capturing news coverage and public attention by designing an enticing exhibition at Dowdeswell's Gallery. The reporter for the *Yorkshire Post* started his review with the sentence, "A 'harmony' in shell pink and smoke colour—a 'noctourne' [sic] in grey and flesh colour—this is the setting in which Mr. Whistler shows us his pictures this season."[15] By this time the press had learned the Whistlerian language to describe his color-keyed exhibition installations.

Mortimer Menpes (1855–1938), Whistler's friend and pupil at this time, recorded the artist's handling of a reporter from *Funny Folks* at his 1884 flesh color-and-grey exhibition.

It was amusing to watch Whistler when the journalists began to arrive. Unless a critic was sympathetic, the Master treated him with scorn. An antagonistic man was torn to ribbons before he left the gallery; scarcely a shred of him was left to show to the world that he had once been a writer with views. Whistler had held the poor fellow up to ridicule before everyone, and the Dowdeswell

gallery had rung again to many a roar of laughter. To be sure, Whistler was irresistibly funny. He would take a reporter by the arm, and lead him up to a very small and dainty picture of a shop in a fantastic Whistlerian frame. Then, anticipating all criticisms and complaints, he would din them into the man's ears, repeating them one by one, until the wretch had not a leg to stand upon. He would examine the reporter's face. . . . The first Press man, a very insignificant-looking person, arrived at about half-past ten or eleven. Whistler was standing in the middle of the room surrounded by his marvellous exhibition of flesh colour and grey. The little man drifted into the gallery. . . . The critic looked as though he wished the earth might swallow him.[16]

Obviously, Whistler's unwavering confidence in the superiority of his skills in arranging art installations was matched by his belief in his powers of manipulating the press in connection with these exhibitions. In 1886, when Whistler was again devising a show for Dowdeswell's, he wrote a letter to his dealer about the details of the exhibition which contained these swaggering comments:

I have thought of something for you—It is folly your not always consulting me!—for you have no idea of what I can do in all matters. Now notwithstanding your rashness in attempting to do without me, to show you that I am "bon prince," I will still bring success upon your new show from all quarters of the Globe.

Write out at once a short resume of the kind of notice (in its shortest form,) you would like of your Salon, and it shall be flashed accross [sic] the Seas and appear in New York papers *before* they have it in London.[17]

Whistler may have had much to do with initiating the practice of thorough press coverage for exhibitions as we know it today. We now consider an

exhibition a logical and worthy subject of evaluative review, regarding not only the individual works on display, but the exhibition as a whole—its theme, artistry of installation, and theoretical underpinnings. This critical viewpoint came into play when Whistler introduced his holistic concept for art exhibitions, when the show acquired focus and became all of a piece.

But Whistler carried the idea of making the media an integral part of his aesthetic program further. He also believed that his interior designs for private residences warranted critical press reviews. When Whistler decorated his first major interior, *Harmony in Blue and Gold: The Peacock Room* (1876–1877), he went to great lengths to involve the press and attract public attention. He made his decoration of the room a society event by holding a series of informal teas and receptions for influential people while he was working on the project. He even went so far as to stage a private view in the evening for the press. In a letter to his mother, in which he enclosed a press clipping about "this famous dining room," Whistler wrote: "Willie [Whistler's brother] has told you of the visit of Princess Louise to the 'Peacock Palace' in Princes Gate, and her delight in the 'gorgeous liveliness' of the work—also the Marquis of Westminster and the Prince—and all, and everybody. . . . they are *charming* people and show real delight in the *beautiful* room. Keep up the buzz of publicity pleasantly in London society and this is well."[18]

Whistler's obsession with press coverage and his full realization that interior design could make a splash in the news may date to his outstanding success in attracting press attention with his Peacock Room. His interest in interior design became keener from that point forward.

Understandably, Frederick Richards Leyland (1831–1892), owner of the mansion, resented the notices in the papers and the way in which Whistler was making his house into a public exhibition.[19] Sir Henry

Cole's son Alan, a friend of Whistler's, said that Leyland "lost his temper outright" when he learned of the "unjustifiable use" of his house and "the publicity given to his dining room."[20] Leyland, a very insular man, was subjected to a barrage of press coverage and a large dose of scandal while Whistler was executing the room.[21] Whistler had virtually stolen the commission from the architect and designer Thomas Jeckyll (1827–1881), who would subsequently go mad. He complained vociferously about the payment, and furthermore, he tried to seduce Leyland's wife. Finally, Leyland, in exasperation, locked Whistler out of the mansion and an acrimonious exchange of letters ensued.[22]

Whistler, who was keeping a file of their correspondence, threatened his patron with further public exposure in a July 1877 letter.[23] Leyland did not even give the artist the satisfaction of knowing that he kept this letter, which was insulting throughout. He sent it back on July 22, 1877, with the following note scrawled on the reverse: "I return your letter.—It is an ingenious puff of the work you have done in my house and it will be useful for you to keep with newspaper cuttings you are in the habit of carrying about with you. An advertisement of this kind is of such importance in the absence of/or in the incapacity to produce any serious work that I feel it would be an unkindness to deprive you of the advantage of it."[24]

Whistler's hoarding of press clippings was apparently well known among his associates, several of whom remarked upon his pockets bulging with newspaper articles. Though he had accumulated pocketsful of clippings on the Peacock Room, he was not content to let the matter drop. Determined to escalate the private battle to the level of public theatre, he willfully misinterpreted Leyland's letter and fired back a telegram the following day: "A thousand thanks. It is really too kind and nice of you to give me your permission to publish the correspondence."[25] Leyland responded immediately, calling Whistler "an unbearable nuisance" and "a man who had degenerated into

nothing but an artistic Barnum." He also wrote that "so many newspaper puffs" on the Peacock Room had appeared that he felt humiliated.[26]

Written correspondence, both public and private, was an extremely important mode of communication for Whistler. For forty years, his letters to the press—the words polished to perfection—were a major method by which he maintained his command of the media and established a public dialogue. They were his letters to the world, so to speak. Mortimer Menpes said: "The writing of these letters was a great joy to him. . . . the first and foremost duty to be attended to was Whistler's correspondence."[27] Whistler was one of the few nineteenth-century artists who talked back sharply and directly to critics, officials, and the public. Through his letters to the editor he was able to explain his aesthetic goals and simultaneously expose the vacuity of the critics who arbitrarily set themselves up as judges of his work. He was determined to set the record straight and chastise the philistines. Whistler answered his critics and kept the published correspondence in his press clipping albums. In 1890 he published a representative sampling in his book, *The Gentle Art of Making Enemies*.[28]

Whistler's first published letter [fig. 4] appeared in the pages of the *Athenaeum* in the summer of 1862 in connection with an exhibition in the recently opened Morgan's Gallery in Berners Street. A critic made derogatory comments about his painting *Symphony in White No. 1: The White Girl* [fig. 5]. The gallery director had labeled it "The Woman in White," and the critic compared it unfavorably to Wilkie Collins's popular mystery novel of the same name. The bland assumption that his subtle tonal portrait was a mere literary illustration prompted Whistler to write a reply to the newspaper in which he denied any connection to the novel. "It so happens, indeed, that I have never read it." Thus began an avalanche of increasingly sharp letters to the press.[29]

Like his paintings, which he slaved over—

A new Exhibition of pictures has been opened in Berners Street, with the avowed purpose of placing before the public the works of young artists who may not have access to the ordinary galleries. Although containing some amazingly ugly pictures, by untrained clever men, and a few very foolish ones, it must be admitted that the ability shown in the first consoles us for the pain of seeing the second class. The most prominent is a striking but incomplete picture, by Mr. J. Whistler, *The Woman in White* (No. 42), which, the Catalogue states, was rejected at the Royal Academy. Able as this bizarre production shows Mr. Whistler to be, we are certain that in a very few years he will recognize the reasonableness of its rejection. It is one of the most incomplete paintings we ever met with. A woman, in a quaint morning dress of white, with her hair about her shoulders, stands alone, in a background of nothing in particular. But for the rich vigour of the textures, one might conceive this to be some old portrait by Zucchero, or a pupil of his practising in a provincial town. The face is well done, but it is not that of Mr. Wilkie Collins's 'Woman in White.' Those who remember the promise of this artist's *Lady at the Piano*, seen at the Academy, will gladly see it again here.—

We insert this explanation as desired :—
"62, Sloane Street, July 1, 1862.
"May I beg to correct an erroneous impression likely to be confirmed by a paragraph in your last number? The Proprietors of the Berners Street Gallery have, without my sanction, called my picture 'The Woman in White.' I had no intention whatsoever of illustrating Mr. Wilkie Collins's novel; it so happens, indeed, that I have never read it. My painting simply represents a girl dressed in white standing in front of a white curtain. I am, &c, JAMES WHISTLER."

FIG. 4. *Whistler's first letter to the editor,* Athenaeum, *published July 5, 1862, in response to a June 28 critique. With this letter, concerning* Symphony in White No. 1: The White Girl, *Whistler began a lifelong practice of writing public declarations to clarify his aesthetic position. Whistler's press clipping album 16:3, Birnie Philip Bequest, Glasgow University Library, Scotland.*

though determined to have them appear spontaneous and deft—Whistler labored obsessively over subsequent public letters. His butterfly signature became an integral part of these "designed letters." When he was exiled in Venice, he demonstrated his desire to make them pungent and literate by soliciting comments from one of the literary giants of the age, Robert Browning, on a projected "Jimmy letter" to the *World*.[30] He often quoted sections of the original critiques verbatim in these letters, to expose the idiocy of the critic's assertions or, if he agreed with the critic, to reaffirm worthwhile points. An 1874 letter to the editor of the *Hour*, about his first one-man show, illustrates Whistler's method. He said that he wished to "correct misconceptions" and explained why he had taken the trouble to meticulously design his own exhibition. "It was from no feeling that 'my works were not seen to advantage when placed in juxtaposition with those of an essentially different kind.' . . . My wish has been, though, to prove that the place in which works of art are shown may be made free from 'discordant elements which distract the spectators' attention' as the works themselves."[31] Eventually, critics of Whistler's work learned to comment on it gingerly rather than risk having their loose statements thrown back in their faces.

Along with writing letters to the editor, Whistler publicized his reformist views by carefully cultivating journalists. He cooperated in their interviews, no matter how seemingly insignificant the paper, as long as they gave him the forum to express his ideas as he wished to have them known. A follower, Harper Pennington, remarked, "*All* his talk was 'fit for

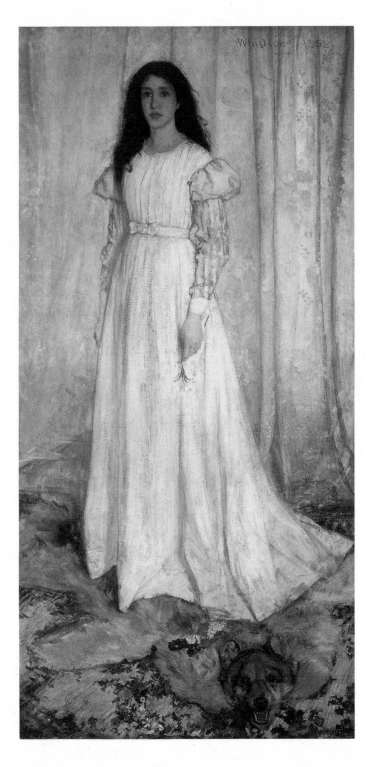

FIG. 5. Symphony in White No. 1: The White Girl, *1862, oil on canvas, 84½ x 42½ in. (214.6 x 108 cm). Whistler's mistress, Joanna Hiffernan, is depicted in a white-on-white harmony, a color scheme favored by Whistler, whether for walls or canvas. Harris Whittemore Collection, National Gallery of Art, Washington, D.C.*

publication.'"[32] He attempted to achieve this by virtually dictating the copy to reporters. Various documents in Whistler's papers suggest that he also had associates write up articles and feed them to the press. Menpes described Whistler's manipulative tactics with reporters. "'Now, I will tell you exactly what you are to say in this article that you propose writing.' He would then proceed to give the man word for word the whole gist of his article. . . . When the criticisms appeared in the papers next day, Whistler read them with relish, never missing one. It was the attacks that interested him. . . . The reading of notices involved a series of long letters to be written, and a rush on my part to the various newspaper offices."[33] Apparently Whistler's pupil was not only charged with stretching canvases, printing etchings, and hanging exhibitions; he was also expected to serve as press agent.

Friends and Followers Get into the Act: Advertising and Satirizing Whistlerian Aestheticism

Whistler's passion for self-advertisement may have been effective in advancing his career, but it often did not wear well with friends and acquaintances. In 1879 English artist Henry Woods, who met Whistler in Venice, wrote to his brother-in-law, Luke Fildes, also an artist: "I could do with Whistler very well, but for his confounded conceit and ever-lasting seeking for notoriety. I cannot stand it." In a later letter he commented: "I believe if the papers were to take no notice of him, he would collapse altogether. There is no mistake that he is the cheekiest scoundrel out."[34]

If Whistler's sensation-seeking propensities had the effect of turning away some of his friends, it did not keep him from attracting youthful followers, who were of course expected to assist him in publicly amplifying his aesthetic program. Walter Sickert (1860–1942) came under Whistler's spell in 1882 when he was an art student with Professor Alphonse Legros at Slade School. Sickert was soon reporting daily to Whistler's studio at 13 Tite Street to prepare the master's canvases and print his etchings.[35]

Sickert was also willing to do battle for Whistler in the press. By June 7, 1882, he had submitted his first letter to the editor of the *Pall Mall Gazette*, taking to task the newspaper's critic for his misunderstanding of Whistler's work at the Grosvenor Gallery. He carried on an obstinate defense of Whistler in whatever papers would put up with it. One day the subeditor of the *New York Herald* ran into Sickert on Regent Street and remarked, "See here, Mr. Sickert, people are asking whether the *New York Herald* is a Whistler organ."[36]

Later in their relationship, Sickert became convinced the impressionists and others were stealing some of Whistler's ideas for provocative independent exhibitions and making a "burlesque" of his cabinet-sized pictures in coordinated frames. In an 1889 article in the *Pall Mall Gazette*, he complained that Whistler's "advertisement" of his new ideas for painting and for exhibition had backfired in the form of a "plague of 'Whistler for the million,'" that is, cheap copies made for a public primed to accept anything enveloped in the context of a chic antiestablishment exhibition with press coverage—à la Whistler. He sensed the pitfall in the kind of exhibition magic wrought by Whistler. Using his method, copyists could create an aura of excitement to intoxicate the philistines so that they would lose whatever little discernment they might have had and accept inferior work.

> He has allowed his work . . . to be presented in certain quaint garbs, and accompanied by certain external flourishes that could easily be imitated, and he has invited rather than discouraged the familiarity with it of a joyous five o'clock tea throng, whom the carpet and the crush of the exhibition room "passioned," and who would hardly notice the substitution on the walls of

something cheaper, in queerer frames for his "Notes, Harmonies, Nocturnes." . . . the public that he had called in with the big drum forgot before "a hint in apple-green," . . . the painter of Carlyle and Sarasate.[37]

Sickert's incisive articles in the press on Whistler's behalf continued for years. He even went so far as to draw an invidious comparison between Edouard Manet and Whistler. Obviously, Sickert was on Whistler's wavelength, which meant viewing the artist as a universal designer rather than as someone limited to pictorial concerns. He declared, "Manet had none of Whistler's decorative science, and above all he had not Whistler's infinite variety." Later, his ideas about impressionists changed markedly. It was through Whistler that Sickert met Edgar Degas. Eventually he developed a more critical attitude toward Whistler's elegant decorative approach to the arts. In 1897, after Whistler had lost the first round in a suit against Sir William Eden, he learned Sickert had visited a gallery with Eden, and the friendship was instantly terminated.[38]

Earlier, in 1888, a breach of loyalty by Whistler's other major pupil, Mortimer Menpes, was even more egregious. Like Sickert, he was expected to act as a champion of Whistler's unpopular views. Menpes stepped into a minefield when, in a lengthy newspaper interview about the decoration of his Fulham Road home in the Whistlerian style, he allowed himself to take credit for some of Whistler's most cherished ideas for interior design. In the article, entitled "The Home of Taste," published in the *Philadelphia Daily News* and the *Pall Mall Gazette*, he failed to mention Whistler. This interview subsequently led to similar articles in other papers such as the *Daily Telegraph*. Even worse, Menpes, an Australian by birth, had made a trip in 1887 to Japan—mecca for a *japoniste* like Whistler—and afterward attempted to take on Whistler's long-cultivated role as "the Japanese artist in Chelsea." Whistler was staggered by Menpes' dundering move

into his territory. In retaliation he fired off a series of letters to editors.[39]

Sheridan Ford, a wily American journalist who evidently was well acquainted with Whistler's interior decorating theories, helped to perpetrate a typical Whistlerian hoax. He concocted a takeoff on the original article that consisted of a follow-up interview with the "unconscious Menpes" on house decoration. Ford syndicated it for international distribution. The article appeared in such newspapers as the *Philadelphia Daily News*, the *Kansas City Journal*, the *Weekly Mail and Express*, and the *Pall Mall Gazette* for the benefit of British and American philistines. Ford pointed out that Menpes was a *disciple* of Whistler's who had decorated his house in accordance with Whistler's "well-known ideas on colour and the use of distemper."[40] The interview began: "Mr. Menpes received me in a lemon-yellow room, the colour-scheme of which was Whistlerian pure and simple. . . . He seemed in a chatty mood, and at once confided to me that the newspapers were all talking about him. Were there any agencies in the States for supplying press clippings? . . . Had I seen his exhibition of Japanese pictures?" Ford's interview revealed that not only had Menpes surrounded himself with Whistler's signature color of yellow and claimed it as his own idea, he had gone so far as to steal Whistler's very persona as a celebrity decorator and "Japanese" exhibitor. Also, he was bragging about managing the press—heart and soul of Whistler's innovative design reform campaign. Ford asked Menpes:

"Is this massing of simple colour, and the ordered harmony of the whole entirely original with you? . . . Is it the dream of a night?" I brought the conversation back to the walls about us by saying: "In writing of you in the press, you authorize me then, do you, to state that the basic idea of this scheme of yellow distemper originated with yourself . . . ?"

"I do," he answered. "I am the sole origina-

tor . . . of it, and this is the only house in London decorated in this manner. I suppose in a year or two there will be one thousand London houses decorated as this is now."[41]

Menpes claimed this interview was "purely imaginary." Whistler's Byzantine machinations make it difficult to know whether the interview was real or largely a hoax. In any event, it delighted Whistler, who proceeded to order three thousand copies of it. Just in case Menpes had missed this well-distributed exposé, Whistler sent him his copy with a note attached saying, "You will blow your brains out, of course."[42]

It was through this interview that Whistler met Ford. Ford included the humorous article in his edition of *The Gentle Art of Making Enemies*, a compilation of Whistler's published letters and press releases. Whistler blocked Ford's publication, though he had initially authorized it, and published his own aesthetically designed book in 1890 using Ford's title.[43] The rare surviving copies of Ford's edition are of considerable value in getting a clearer understanding of the great importance Whistler attached to his theories for interior decoration. Ford's comments on the Menpes fiasco in his edition reveal his perception of Whistler as a master decorator. "Imagine an artist posing as the creator of a scheme of decoration perfected nearly twenty years ago by his master—a scheme of decoration in use not only in England, but also in other countries. . . . We are told on all sides in recurring paragraphs of misstatement and adulation that Mr. Menpes is the father of a decorative revolution."[44]

In a letter to the *World*, Whistler railed against the "false colours" of Menpes, whose "lemon yellow" and "beautiful tone . . . on the 'face' of the 'Fulham Palazzo'" were his own, "*for I mixed it myself!*"[45] In Whistler's version of *The Gentle Art of Making Enemies*, Ford's farcical interview is reprinted as "The Ideas of Mr. Blankety Blank on House Decoration."

The article touches upon several of Whistler's key concepts for house decoration.

The other day I happened to call on Mr. Blank, Japanese Blank, you know, whose house is in far Fulham. The garden door flew open at my summons, and my eye was at once confronted with a house, the hue of whose face reminded me of a Venetian palazzo, for it was a subdued pink . . . however, the interior was a compound of Blank and Japan. . . . I begged the artist to explain this—the newest style of house decoration. I need not say that Blank, being a man of an *original* turn of mind . . . holds what are at present peculiar views upon wall papers, room tones, and so on. The day is dark and gloomy, yet once within the halls of Blank there is sweetness and light. You must look through the open door into a luminous little chamber covered with a soft wash of lemon yellow. . . . The blinds were down, the fog reigned without, and yet you would have thought that the sun was in the room. . . . "Now, Mr. Blank, would you tell me how you came to prefer tones to papers?" "Here the walls used to be covered with a paper of sombre green, which oppressed me and made me sad," said Blank. "'Why cannot I bring the sun into the house,' I said to myself, 'even in this land of fog and clouds? . . .' I assure you the effect of a room full of people in evening dress seen against the yellow ground is extraordinary, and, . . . perhaps flattering." . . . "But you propose to inaugurate a revolution." "I don't go so far as that, but I am glad to be able to introduce my ideas of house furnishings and house decoration to the public."[46]

These seemingly flip parodies of interviews with Menpes (recorded in both Ford's and Whistler's books) provide an important matrix for identifying a number of Whistler's most prized ideas for design reform for the Victorian English home. These include:

lemon yellow as a sunny wall color, his signature color inspired by Japanese art; "massing of some simple colour," his foremost concern in interior designing; "ordered harmony of the whole," his insistence on a complete ensemble; "the dream of a night," rooms with evocative mystery, for example, the Peacock Room; the use of hues such as "subdued pink," for Whistler a reminiscence of Venetian palaces; the conflation of his original decorative ideas with Japanese concepts; Matthew Arnold's Hellenic ideal of "sweetness and light" as a source; attaining a "luminous little chamber," or "sun . . . in the room"; preference for "room tones" rather than papers—no "sombre green" Morris wallpaper; using blinds to filter and control light, escaping "fog and clouds"; and walls used as a "yellow ground" to form an "extraordinary and . . . flattering" theatrical backdrop for fashionable people and events.

Menpes and Sickert had entered Whistler's life in the 1880s when his media-blitz life-style was in full swing, but George Du Maurier was a friend from his less spotlighted youth. They met in Paris in Charles-Gabriel Gleyre's studio in the late fifties and Du Maurier subsequently roomed in Whistler's studio at 70 Newman Street in London for a few months in 1860. To his mother he wrote, "I must tell you that I am now in Jemmy's studio which he has left, and for which I pay 10 [shillings] a week, unfurnished—but Jemmy has left me his bed, his sister's sheets and towels, 2 chairs, a table and lots of wonderful etchings to adorn the walls, besides the use of a dress coat and waistcoat, quite new (when he doesn't happen to want it himself.)" In a later letter Du Maurier observed, "This room of Jemmy's is so beastly uncomfortable." This was to remain a common complaint leveled at Whistler-decorated rooms.[47]

The friendship may have faded early, but a rivalry continued and the two artists remained of considerable long-term importance to each other in maintaining influential public positions in the aesthetic movement. Du Maurier cast Whistler as a central pro-

tagonist in his extremely well known caricatures mocking the aesthetes and their indulgence in a cult of beautiful living. These cartoons appeared in *Punch* from 1873 to 1882. Du Maurier also featured Whistler as a character in his immensely popular 1894 novel, *Trilby*, which was initially serialized in *Harper's New Monthly Magazine*. Du Maurier only narrowly missed a court battle with the enraged Whistler over his characterization of Whistler as Joe Sibley, "the Idle Apprentice" in the novel.[48] It seems to have been overlooked that Du Maurier's far more fascinating creation, the figure of Svengali, who cast destructive spells over people, also appears to have been based on Whistler.

In an era just preceding newspaper and magazine photography, Du Maurier's *Punch* illustrations provided an elegant and witty pictorial counterpoint to Whistler's media wordplay [see figs. 6, 7, 8]. *Punch* was a widely distributed magazine with considerable influence in this period, and Du Maurier cartoons reveal that he was as fascinated as Whistler with the society that attended the theatre, lived in aesthetic-style interiors, and came out for the private views at the Fine Art Society and the Grosvenor Gallery.[49] Given the absence of extant photographs of Whistler's aesthetically elegant exhibitions and interior settings, Du Maurier's caricatures, though broad and satirical, provide some of the most authentic documentary images of artistic society in Whistlerian environments. Though these caricatured interiors were actually a conflation of several aesthetic interior designers' work—they often include William Morris wallpapers, for example—they are nevertheless as near as one can now come to recapturing the character of the interiors Whistler helped to invent.[50]

Both Whistler and Du Maurier were entirely capable of being charming and witty additions to this aesthetically self-conscious society scene. Cultivated and wealthy Anglo-Greek families, such as the Spartali and the Ionides families, who collected Whistler's

work, were among the first to welcome the young artists to their homes. "Last Sunday I went with Jimmie to the Greeks', such a charming house and such charming people," wrote Du Maurier, who also raved about how popular he and his friend were. "[I] intend to rival Whistler who is the pet of the set."[51]

The frequent amateur theatricals at the Alexander Ionides home at Tulse Hill captivated both Whistler and Du Maurier. They joined Luke and Alecco Ionides and Aglaia Coronio for a production acted in Greek costumes. "The theatricals went off splendidly. . . . Such splendid embroidered costumes the Greeks had," the enraptured Du Maurier wrote to his mother. "I did my part stunningly. . . . Jimmy was magnificent, but unfortunately got awfully drunk at supper and misbehaved. . . . What splendid people these Greeks are." Whistler was attracted to the Greek costumes. They made him and Du Maurier feel like Alma-Tadema figures in togas and eyeglasses, crowned with flowers. Whistler himself was responsible for "getting up some private theatricals at the Greeks'."[52]

For both young artists their early romp in amateur theatricals and artistic society would prove to be anything but incidental to their future careers. Whistler, particularly, would parlay his talent for sparkling society gatherings and theatrical events directly into his role as the dramatic host at the center of his originally designed house interiors and exhibition installations. Whistler contrived his interior spaces primarily as simplified theatrical stage sets for scintillating opening night dramas. The various domestic interiors he designed for himself supplied settings for his famous Sunday breakfasts and dinner parties.

Whistler's continuous round of social engagements was part of his bid to remain perpetually in the spotlight. Du Maurier's 1880 cartoon, "Distinguished Amateurs—2: The Art-Critic" [fig. 6], features a close portrait of Whistler and seems to catch the artist much as he might have appeared in a starring moment at one of his private art openings, such as his exhibition of Venice etchings at the Fine Art Society, which opened not long afterward with Du Maurier in attendance. Clearly, Whistler conceived of an exhibition as "performance art," and he was prepared to go to any length to bring in an audience and give it a show. The critic Frederick Wedmore caught this character of Whistler's 1884 exhibition, "Arrangement in Flesh Color and Grey."

> We could not say, truthfully, that our spirits would be dashed not a jot if Mr. Whistler, in opening a new exhibition of his work, deprived it of the element of comedy. He has taught us to look for temporary entertainment. . . . A gallery does not suffice for Mr. Whistler. He needs a stage. . . . Nor, so long as we enjoy his performance, can we grumble at his method. We are rejoiced . . . to note that the properties have been got together, the scenery refurbished, some of the furniture repainted, the stage itself—or Mr. Whistler's matting—brought safely from a few doors down the street where the tent was last pitched [from the Fine Art Society at 148 New Bond Street to Messrs. Dowdeswell's at 133 New Bond Street].[53]

Du Maurier's cartoons for *Punch*, featuring attenuated fashionable people at art exhibitions and parties in private homes (similar to those Whistler staged), captured the artificial quality of British aestheticism, of life lived as if it were theatre.

In a February 14, 1880, cartoon, "Nincompoopiana—The Mutual Admiration Society," for example, Du Maurier introduced a Whistlerian character, Jellaby Postelthwaite—a particularly limp-wristed, effete, and unhealthy looking dandy—arriving in the midst of an aesthetic drawing room [fig. 7]. The room is furnished with the requisite Japanese screen, spindly ebonized furniture, and striped floor matting. Jellaby is surrounded by tall, wearily gaunt women in high-waisted, flowing, artistic garments. Postelthwaite and Maudle, London aesthetes who closely resemble

FIG. 6. *George Du Maurier. "Distinguished Amateurs — 2:*
The Art-Critic," cartoon in Punch *78 (March 13, 1880):*
114.

Whistler and Wilde, are entering the salon of
Mrs. Cimabue Brown, the aesthetic hostess.[54] These
aesthetic cartoons, despite their evident ridicule, must
have had considerable impact on readers and further
reinforced Whistler's media presence and advanced
his position as a central figure in the British aesthetic
movement.

It is difficult to realize today that a comic maga-
zine like *Punch* could have had such a strong influ-
ence, but the periodical was a national institution
at the time and perhaps the most successful of all
nineteenth-century magazines.[55] That Whistler's in-
terest in *Punch*'s parodies was particularly keen cannot
be doubted. At the time of his 1881 Venice pastels
show, *Punch* ran a long article on the exhibition, call-
ing Whistler "Pastelthwaite" instead of Postelthwaite
and featuring caricatures of several of his pastels.
Whistler was utterly delighted. He added his butterfly
signature to one of these large press clippings in his
scrapbook and had another copy framed and hung in
the gallery for his exhibition "Arrangement in White
and Yellow" at the Fine Art Society in 1883.[56] It was

FIG. 7. *George Du Maurier. "Nincompoopiana — The Mutual Admiration Society," cartoon in* Punch, *78 (February 14, 1880): 66.*

a testament to the central role the press played in his career.

It almost seemed inevitable that the level of risibility evoked by Du Maurier's aesthetic cartoons for *Punch* and Whistler's unrelenting press releases and publicity stunts would reach the point that some parodist playwright would seize the opportunity to lampoon Whistler and other aesthetes like Oscar Wilde while the aesthetic vogue was still hot.

The first attempt to put Whistler on stage was made by John Hollingshead on December 9, 1877, at the Gaiety Theatre. He based his character, Pygmalion Flippit, an "Artist of the Future," vain with "Hyp-

erion curls," on Whistler. The play was called *The Grasshopper*, and Flippit, a "Harmonist in colours," was working on a "Harmony in Grey" in a scene in his studio. It was a farce that humorously dramatized Whistler's penchant for elusive color harmonies and abstract design. The great cartoonist Carlo Pellegrini designed a scene incorporating a caricature of Whistler and using a painting entitled *Dual Harmony in Red and Blue* as a comic prop. The painting appeared to be an ocean with a sunset, but when viewed upside down, it became a desert scene beneath the sky.[57] Whistler attended the rehearsals for the burlesque and approved of the production.[58]

The next theatrical venture based on mocking

the aesthetic affectation was *Where's the Cat?*, staged at the Criterion Theatre on November 20, 1880. Such lines as "I feel like—like a room without a dado" satirized the new rage for "artistic" interior design.[59] Then came *The Colonel*, featuring an Oscar Wilde-like Lambert Stryke in a nonmusical satire for which Du Maurier advised the producer, F. C. Burnand, editor of *Punch*, on ingredients for an appropriately muddled aesthetic interior for the set.

> Try and have a room papered with Morris' green daisy, with a dado six feet high of green-blue serge in folds and a matting with rugs for the floor (Indian red matting if possible)—spider legged black tables and side board—black rush bottom chairs and armchairs: blue china plates on the wall with plenty of space between—here and there a blue china vase with an enormous hawthorn or almond blossom sprig—also on the mantelpiece pots with lilies and peacock feathers—plain dull yellow curtains . . . with dull blue for windows if wanted, large sixpenny fans now and then on the walls in this picturesque unexpectedness.[60]

Although Du Maurier's ideas for an aesthetic room for the stage included William Morris wallpaper and Sussex chairs as well as E. W. Godwin ebonized furniture, there was, nevertheless, a distinctly Whistlerian flavor of *japonisme* in peacock feathers and hues of blue, blue-green, and yellow. The play's sets, which were supposed to be snidely humorous, were actually excellent advertisements for Whistler's elegant brand of aestheticism.

But the epitome of all of the satirical aesthetic plays was Gilbert and Sullivan's comic operetta *Patience, or Bunthorne's Bride: An Aesthetic Opera*, which ran concurrently in New York. It opened at the Opera Comique in London on April 23, 1881, and in October moved to the new Savoy Theatre, artistically designed with Venetian red wallpaper, peacock blue seats, pale yellow accents, and a gold satin curtain. The owner, Richard D'Oyly Carte, sounded Whistlerian when describing it: "The main colour tones are white, pale yellow and gold." The programs were printed in a Japanese asymmetrical style reminiscent of Whistler's designs for publications. Aesthetically decorated sets and fashionable costumes in coordinated hues, utilizing Liberty textiles, made the operetta a spectacle and satirized the excruciating color sensitivity popularly identified with Whistler. "Cold gravy" and "cobwebby grey" were the fashionably desirable hues of the hour according to the dialogue.[61] The play also was a parody of the "greenery yallery Grosvenor Gallery" and featured Archibald Grosvenor, a composite of Rossetti and Swinburne, and Bunthorne, who was "fleshly" like Oscar Wilde but essentially like Whistler, with black curls, white lock of hair, single eyeglass, and famous "Ha ha!" Bunthorne was "such a judge of blue-and-white—A Japanese young man, A blue and white young man." *Patience* ran for 578 performances in London.[62]

Undoubtedly, what caused the intensely theatrical Whistler to overcome any doubts he might have had about being satirized as an aesthete dandy and decorator was his love of being center stage. He frequently appeared at opening nights and, throughout the sixties and seventies, performed in amateur theatricals.[63] The staging of exaggerated aesthetic interiors in comic plays, even more than Du Maurier's *Punch* cartoons, kept the spotlight on him as a devilishly chic design guru. Dramatized aesthetic interiors were, after all, true reflections of his concept of the interior: the room as a stage set.

It was just at this time, when the aesthetic movement was on the verge of being popularized to the point of kitsch, that Whistler became friendly with Oscar Wilde, perhaps hoping for an ally among the critics. Wilde was very much a major player in the heady theatrical mix of art, wit, society, exhibition magic, voguish interiors, aesthetic dress, and the attendant

publicity hype that Whistler was so instrumental in fomenting. He would become a popular disciple of Whistler's aestheticism, promoting many of his ideals for design reform, including the use of color as an organizing principle for domestic interiors.

Evidently Wilde had become acquainted with Whistler's decorative approach to art while still a student at Trinity College, Dublin, in the early seventies. Once, after Wilde set up an easel in his room with an unfinished landscape of his own in oil, he joked, "I have just put in the butterfly." (The butterfly was Whistler's famous signature, the design of which evolved throughout his life, eventually becoming stencil-like.)[64] Subsequently, at Oxford, within a student's limited means, Wilde managed to create an aesthetic effect in his quarters and make it into a showplace. It was evidence of his incipient interest in interior design, which would later blossom under Whistler's tutelage. In December 1876, Wilde moved into the best apartment in the college, with windows overlooking the River Cherwell. All three rooms were paneled, and he had the dados and ceilings decorated with painted ornament. He hung old engravings mostly of pale, sleepy nude women and photographs of the Pre-Raphaelite paintings of Burne-Jones. There was a piano and grey carpet on the floor. He arranged his collection of blue-and-white porcelain on shelves, and two large vases of blue china on his mantelpiece always seemed to be filled with lilies.[65]

Once, when entertaining his fellow Magdalen College students, who were much amused by his peculiar decor, Wilde remarked, "Oh, would that I could live up to my blue china!"[66] The phrase lived to be embodied in Du Maurier's 1880 *Punch* cartoon, "The Six-Mark Tea-pot" [fig. 8]. The languorously posing man featured in the drawing is essentially the young Wilde, and the attenuated woman with horsy profile, curled bangs, and puff-sleeved dress appears to be a conflation of figures from Whistler's painting *Purple and Rose: The Lange Leizen of the Six Marks* (1864) [fig. 9] and *Symphony in White No. 3* (1867) [see fig. 20].

FIG. 8. *George Du Maurier. "The Six-Mark Tea-pot,"* cartoon in Punch 79 *(October 30, 1880): 194. Caption: Aesthetic Bridegroom, "It is quite consummate is it not?" Intense Bride, "It is indeed! Oh, Algernon, let us live up to it!"*

The aesthetic decor is strongly Whistlerian with Japanese accents, an Oriental screen, a blue china vase, and an impossibly fragile Godwinesque table with a sticklike chair ready to snap under the weight of Wilde's hand.[67]

When the "Six-Mark Tea-pot" cartoon was published on October 30, 1880, Wilde and Whistler were just acquaintances. After taking his degree from Oxford, Wilde went to London at the end of 1878. Whistler was embroiled in legal problems, which led to his exile in Venice in September 1879. Their friendship

began after Whistler returned from Venice and moved near Wilde's residence on Tite Street. At Oxford, Wilde had attended Ruskin's lectures on Florentine art and studied under Walter Pater, the chief British theoretician of aestheticism, to whom he became an enthusiastic friend. He followed the aesthetic beliefs of the leading Oxford Pre-Raphaelites before him— Morris and Burne-Jones, as well as their master, Rossetti.[68] All these influences had turned him into a crusader for the decorative arts.

None of these famous figures, however, would be as crucial to Wilde's growing dedication to the cult of living beautifully as Whistler. The reverse was also true. Wilde, as a worshiper of Pater and his 1873 *Studies in the History of the Renaissance*, which he characterized as "the holy writ of beauty," must have been a chief transmitter of Pater's hedonistic theories to Whistler. Pater's belief that life was but a series of ephemeral moments that could best be lived with the greatest intensity through the arts seemed to provide the *raison d'être* for Whistler's desire to turn all of life into art. His drive to reach perfection in the form of temporary exhibitions fits Pater's theory that "art comes to you proposing frankly to give nothing but the highest quality to your moments as they pass, and simply for those moments' sake."[69]

By the early eighties Wilde seems to have been an important part of the heightened aesthetic moments that Whistler staged at his private views. In November 1887, he presided at a Royal Society of British Artists' exhibition arranged by Whistler. The reviewer for *Bat* reported:

> Mr. Whistler stood, or rather leaned, in solitary state, but withal gracefully, against the entry to the cloak room, and watched, his white plume [Whistler's white lock of hair] waving for the celebrities and millionaires he expected to admire and purchase his collection of artistic eccentricities. At length Mr. Oscar Wilde arrived, and, with easy smile and depreciating manner, relieved him

FIG. 9. Purple and Rose: The Lange Leizen of the Six Marks (*or*, Lady of the Lang Lijsen), *1864, oil on canvas, 36 x 24½ in. (91.5 x 61.6 cm). Joanna Hiffernan poses at Whistler's home at No. 7 Lindsey Row amid objects from his Oriental collections. This painting predicts the tendency during the British aesthetic movement to transform women into exotic objects of art. John G. Johnson Collection, Philadelphia Museum of Art.*

of his sentry duties. Mr. Oscar Wilde constituted himself at once master for ceremonies and centre of attraction. . . . Nobody looked at the pictures on the walls, which perhaps contributed to the universal good humor.[70]

It is understandable that the aesthetic actors, Wilde and Whistler—"Maudle" and "Postelthwaite"—performing in concert together at one of Whistler's openings, would distract the attention from the pictures. They offered not only a source of piquant delight for the gallery crowd but great newspaper copy and instantly recognizable figures for the illustrated magazines.

The persiflage between Wilde and Whistler as they whisked telegrams back and forth via the pages of the *World*, trying to outwit each other with caustic remarks, was part of the aesthetic artifice of the London milieu in the 1880s. A typical exchange, published on November 14, 1883, read:

> From Oscar Wilde, Exeter, to J. McNeill Whistler, Tite Street. *Punch* too ridiculous—when you and I are together we never talk of anything but ourselves.

> From Whistler, Tite Street, to Oscar Wilde, Exeter.—No, no Oscar, you forget—when you and I are together, we never talk about anything except me.[71]

Illustrators consistently depicted Whistler and Wilde as the dual epitomes of aesthetic foppery.

Before the bitterness and acrimony set in and Whistler accused the poet of plagiarism, Wilde was a welcome guest at Whistler's studio and exhibition openings for many years. Thus he had ample opportunity to absorb the fundamentals of Whistlerian design theory firsthand. In society together, the two aesthetes were a London spectacle. Actress Ellen Terry remarked: "The most remarkable men I have ever known were Whistler and Wilde. . . . There was something about both of them more instantaneously individual and audacious than it is possible to describe."[72]

Wilde was of the greatest use to Whistler as a media draw at his exhibitions, as a critical ally, as a conduit for the philosophy of Walter Pater, and as an international promoter of his theories of interior design. Furthermore, Wilde was game to engage in lively day-to-day news releases of "private letters." "Now Oscar," "No, no Oscar," "Oscarino," wrote Whistler. And Wilde replied, "My dearest Jimmy," "My dear good-for-nothing old Dry-point!," "Dear Butterfly."[73] Whistler's public letter exchange with Wilde helped fill the gaps between reviews and *Punch* cartoons, keeping him alive in the press from moment to moment.

No artist before or since Whistler, with the possible exception of Andy Warhol, has so captured the popular press and made it an integral part of his lifelong aesthetic program. "The Press have ye always with you," said Whistler, "feed my lambs."[74] He wished to reign in London as a master artist and celebrity. He seems to have been thinking of ways in which to manipulate the press to this end every waking hour.

It was a manifestation of Whistler's fundamental theory, as well as his egomania, that he was not content to confine his creative efforts to the surface of the canvas or the printmaking paper. Designing complete interior spaces like the Peacock Room had the enormous advantage of being far more attention getting, as were his series of theatrically dramatic one-man exhibitions, highlighted by elaborate private views. An entire gallery decorated to his specifications had a greater total impact than he could ever hope to attain by exhibiting individual works of art in group exhibitions, especially in his case, since his works were often small to tiny in size and muted in character.

Whistler's letters to the editor and interviews, the reviews of his exhibitions, and his consistent appearance at center stage in the guise of satirical cartoons and theatrical characters also helped to keep him and

his decorative ideals in the spotlight.[75] Furthermore, he had an uncanny ability to exploit his friendships with notable figures like Leyland, Du Maurier, Menpes, Sickert, Ford, and Wilde to further advance himself as a master decorator, through either their patronage, their emulative hero worship, or their willingness to be mouthpieces for his ideas.

Whistler's aims as a designer are sometimes hard to discern. It is necessary to pierce the smoke screen of his unorthodox razzle-dazzle courting of the limelight. But make no mistake about it, Whistler was much more than a printmaker or a painter of portraits and nocturnes. He was, as well, a key figure in the ongoing British design reform movement.

2

The Dandy Dresses for Battle

Haute Couture Aestheticism

Whistler's interest in making life into art extended to the precise cut of his coat and to the demeanor of sparkling evanescence that he assumed. A small-boned, slight figure with refined mannerisms and appearance suggesting effeminacy, he had transformed himself into a flamboyant walking caricature. Glossy raven-black hair in tangled curls with a single white forelock, eyeglass screwed into place, hand on hip, black wasp-waisted suit, silk hat cocked over one eye, pointed patent leather shoes, canary gloves, gardenia in his buttonhole, needle-like walking stick poised ready to sting—it was all a part of his painstakingly contrived image [fig. 10]. When set off by the brilliantly keen look on his face, he became a scintillating arrangement in black and white.[1]

The dandified pose struck by Whistler seemed expressly devised to catch the imagination of cartoonists and comedic playwrights. Mortimer Menpes said,

"[The] fit of the Master's coat was far more important to me . . . than my own artistic work." He recalled one of many torturous visits to the tailor in Bond Street with Whistler. The fastidious artist gave elaborate directions on how a coat was to be made. Strutting up and down before a mirror to see "whether the tails fell in graceful lines toward his heels, he screamed, 'This is all wrong.'" His delight in clothes included an attraction to uniforms, especially those of the Russian military and his own West Point cadet uniform—an attraction he was able to work into his one-man exhibitions by designing gallery attendant costumes.[2]

On the occasion of his "Ten O'Clock" lecture, Whistler was dressed for public battle in his usual sartorial splendor. He assumed his position at the podium with one eyebrow lifted, mustache curled upward, and an elfishly diabolical expression on his face. Observing his rival, Oscar Wilde remarked, "a miniature

FIG. 10. *"Jimmy and His Wand," 1882, newspaper caricature. Whistler press clipping album, 4:69, Birnie Philip Bequest, Glasgow University Library.*

Mephistopheles mocking the majority!"[3] Whistler and Wilde were in a stiff competition to attract news coverage and become the center of attention in London, and audacious attire was an important part of the game. Wilde said, "The first duty in life is to assume a pose"; and when he wrote *Dorian Gray*, the aesthetic novel par excellence, he said, "To become a work of art is the object of living."[4]

When Wilde returned from his 1882 lecture tour dedicated to instructing America in a more gracious mode of life, he went, ostentatiously dressed in a red suit, to see Whistler. Whistler's irreverent response to his flashy get-up caused Wilde to say, as he frequently did, "Jimmy, you're a devil." This was an image entirely to Whistler's liking. About this same time, Wilde also remarked to Whistler: "Jimmy, this time last year, when I was in New York, all we men were carrying fans. It should be done here." Whistler had already tried this. He had arrived at a dinner carrying a Japanese fan that Mme Desoye, owner of an Oriental shop in Paris, was supposed to have set aside for the artist, poet, and critic Zacharie Astruc. A fight nearly broke out when Astruc spied Whistler with the fan.[5] Whistler also often carried a Japanese bamboo cane, and his passion for Oriental art and theatre had led him to wear kimonos. His friend Henri Fantin-Latour painted him dressed in a kimono at his insistence. He may well have had Oriental robes made for himself in emulation of the costumes depicted in the Japanese prints he collected. On one occasion, Degas, seeing his friend dandified and strutting, remarked, "Whistler, you have forgotten your muff!"[6]

Whistler was playing the Victorian dandy not only to captivate the press but to make a design statement with his very appearance. The artist Valentine Prinsep met him one evening on his way to dinner. He was carrying his long white wand and had his overcoat thrown back to reveal an expanse of white shirt and a salmon-colored silk handkerchief hanging out of his waistcoat pocket. Thinking he might lose the handkerchief, Prinsep tucked it into his pocket. "Good

God!" cried Whistler, "what are you doing? You've destroyed my precious note of color."[7] Whistler expressed his concept of the artist as a designer in his canvases, his interior decorations, and the gestalt of his own person. He became a symbolic configuration circulating in London, a living, breathing embodiment of haute couture aestheticism, a designed object himself.

Whistler's equally aesthetic friend, the architect and designer Edward William Godwin, also cultivated a superior and jaunty air; he was tall and alluring to women, and was flawlessly attired. Both Whistler and Godwin designed artistic clothing. Godwin primarily designed costumes to coordinate with the theatrical sets he was creating. In the corseted Victorian age, the health-conscious Godwin designed dresses that were loose and freely flowing. During his alliance with the actress Ellen Terry, one ethereal, flowing aesthetic gown he created for her was a crinkled and clinging dress made by the Oriental "tie and dry" process. He also dressed her in Japanese garments such as a memorable blue kimono that complemented her golden hair. In 1883 Godwin accepted a post as the first supervisor of the new couture department at Liberty and Company's East India House at 218A Regent Street, a shop that Whistler patronized. The establishment, managed by Arthur Lasenby Liberty, was famous for its soft textiles, especially its imported Oriental silks, exotic kimonos, and various fabrics made with Eastern dyeing and weaving techniques. Liberty's later created machine-made textiles in unusual, delicate "art colors" of Persian pink, Venetian red, terra-cotta, ochre yellow, sapphire, peacock blue, sage, olive, willow green, and drab that were also subtly beautiful and attractive to aesthetes.[8]

Whistler and Wilde followed Godwin's lead in creating fashionable and dramatic clothing conceived as an integral part of theatrical interior settings. Whistler designed ensembles for the rarefied creatures who appeared on the stage of his canvas. His Pre-Raphaelite friends had long followed the practice of designing costumes and props for their paintings. Whistler could be counted upon to make his subjects look coolly chic with an air of dignified superiority. His fashion-conscious paintings were aligned with those of his friend Albert Moore, who depicted elegant women swathed in flowing muslin fabrics like Grecian statues [pl. 3]. Liberty recalled that Moore used Liberty of London's filmy gauzes and lustrous silks from the East—India, China, and Japan—for his models, because he found nothing of European make that draped so beautifully or was so satisfying in color. Whistler was equally enthralled with Liberty's textiles [see fig. 20]. For his portraits of red-haired Frances Dawson Leyland, flamboyant Lady Archibald Campbell, and pouty Cicely Alexander, Whistler designed softly elegant dresses down to the last frill and ribbon.[9] Though he held himself aloof from any overt portrayal of the character or personality of his sitters, he took immense interest in the smallest decorative aspects of their costumes. The directions he issued in a letter to Cicely's mother in preparation for *Harmony in Grey and Green: Miss Cicely Alexander* [pl. 11] give an idea of his meticulous attention to details of dress. Anna Whistler, the artist's mother, began the August 26, 1872, letter:

> The Artist is very sorry to put you to any additional trouble, but his fancy is for a rather clearer muslin than the pattern enclosed in your note. I think Swiss Book Muslin will be right, that the arms may be seen thru it, as in the *Little White Girl*, you may remember. It should be without blue, as purely white as it can be. He likes the narrow frilling. . . . [Whistler then took the pen and wrote] If possible it would be better to get fine Indian muslin—which is beautiful in color—It would be well to try at a sort of second-hand shop called Aked's in a little street running out of Leicester Square on the right hand corner of the Alhambra as you face it and on the same side of the square like this: [he draws a map] or perhaps Farmer and Rogers [which Liberty

managed] may have it[;] they often keep it—But try Aked first. The dress must have frills on the skirts and about it—and a fine little ruffle for the neck—or else lace.—Also it might be looped up from time to time with bows of pale yellow ribbon—. In case the Indian muslin is not to be had—then the usual fine muslin of which ladies evening dresses are made will do—the blue well taken out—and the little dress afterwards done up by the laundress with a little starch to make the frills and skirts etc. stand out—of course not an atom of blue!—[he scribbled a fast sketch].[10]

Cicely survived her endless sittings, and Whistler then began the meticulous design process all over again for her older sister May's portrait.

> I think I may promise . . . to not give to [sic] much trouble to my new sitter as I did to poor Cissie. How is Cissie and am I forgiven yet? . . . Well then Mrs. Alexander it occurs to me that if you like I will paint May in your own house [Aubrey House]—I think I should like this if you do not fear that I should be in the way—The new drawing room with its white and black wainscot is what I think of—it would be to [sic] delightful to be able to hang the picture up every now and then and see how it would look in its own proper place.

Whistler proceeded to give long, exacting details of fashionable attire that May would need for her portrait.[11]

The key point revealed in this letter is that Whistler conceived of his portrait as a decorative component in a larger scheme. He was unusually sensitive to what the total effect would be within the room in which it would hang. Thus it was necessary to move into the Alexanders' new home on Campden Hill and actually paint the picture in the environment. The design of the costume, the design of the canvas, and the design of the interior were all to be of a piece—a true ensemble. Whistler's first influence for his ideal of total ensemble probably derived from the example of eighteenth-century French rococo interiors, but his keen interest in theatre reinforced his penchant for achieving harmony between setting and attire. *Age* reported that the play *The School for Scandal*, starring Lillie Langtry, was a "ten o'clock symphony," with one character "as a nocturne in peacock blue and old gold," an indicator that Whistler's design theories influenced theatrical productions. Conversely, Whistler sometimes had theatrical costumiers make dresses for his portrait subjects to his designs.[12]

Wilde, as a playwright of popular farces, also devised clothing keyed to interior settings and enjoyed wearing theatrical costumes in his day-to-day life. Once, "upon seeing the Poet in Polish cap and green overcoat, befrogged, and wonderfully befurred," Whistler, who was appalled by Wilde's ostentatious taste, wrote a public letter: "Oscar—How dare you! What means the disguise? Restore those things to Nathan's, and never again let me find you masquerading the streets of my Chelsea in the combined costumes of Kossuth and Mr. Mantalini!"[13]

A Rocket or a Bomb? Confronting Ruskin's Aesthetics

Cutting a stylish figure in London and grabbing the spotlight for his exhibitions and interior designs was not enough to satisfy Whistler's need for publicity. He was on the lookout for more-prominent stages. Two major "aesthetic dramas" stand out above the steady stream of other publicity stunts by which Whistler catapulted himself onto center stage: the *Whistler v. Ruskin* trial and his "Ten O'Clock" lecture. In both cases he took on the role of devil's advocate, an antagonist fighting against the established aesthetic order and the accepted moral code in art. Whistler cast himself as a central hero in these dramas in which he endeavored to turn the British art world upside down

and move it in the direction of art as abstract, evocative design. This he attempted in an era when highly finished, quasi-religious, realistic art was equated with moral rectitude. The first of these dramas—the famous *Whistler v. Ruskin* case—occurred in 1878.

John Ruskin was the epitome of a sacred cow in the British art world in 1877, when he decided to lambaste Whistler's painting *Nocturne in Black and Gold: The Falling Rocket* in print [fig. 11]. Ruskin was reviewing the inaugural show at the Grosvenor Gallery.[14] Whistler "was in great excitement over Sir Coutts Lindsay's gallery for pictures," and he contributed eight major works to the show including several foggy, moonlit waterscapes called "nocturnes."[15]

Ruskin had already denounced Whistler's nocturnes as "absolute rubbish" in an October 1873 lecture at Oxford. The Grosvenor exhibition gave him an opportunity to target for flagrant public ridicule a nocturne that was unusually abstract even for Whistler.[16] What the extremely influential critic wrote in his own periodical, *Fors Clavigera*, on July 2, 1877, was this: "For Mr. Whistler's own sake, no less than for the protection of the purchaser, Sir Coutts Lindsay ought not to have admitted works into the gallery in which the ill-educated conceit of the artist so nearly approached the aspect of wilful imposture. I have seen, and heard, much of Cockney impudence before now; but never expected to hear a coxcomb ask two hundred guineas for flinging a pot of paint in the public's face."[17]

It was not until a couple of weeks later, when Whistler met his friend George Boughton at the Arts Club, that he learned about the insulting review. The two men were quietly reading in the smoking room when Boughton found Ruskin's comment in a London journal and hesitantly called Whistler's attention to it.[18]

In later years, Whistler, whose sense of humor seldom failed him, would himself blithely refer to his *Falling Rocket* painting as the "Pot of Paint."[19] But initially, Whistler was stunned by Ruskin's clever, but

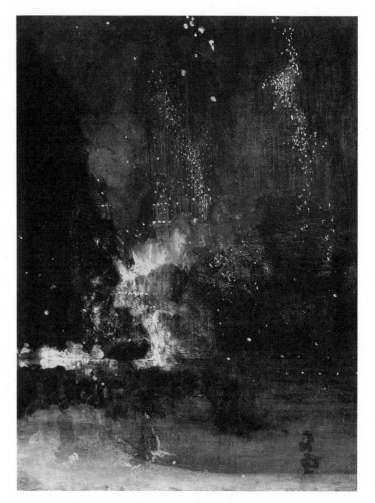

FIG. 11. Nocturne in Black and Gold: The Falling Rocket, *ca. 1875, oil on oak panel, 23¾ x 18⅜ in. (60.3 x 46.7 cm). It was this painting that led John Ruskin to accuse Whistler of "flinging a pot of paint in the public's face." Gift of Dexter M. Ferry, Jr., Detroit Institute of Arts.*

libelous, statement. He determined that it was time to contact his solicitor, J. Anderson Rose, to initiate a libel suit against Ruskin; his combative nature allowed nothing less. As his friend Rossetti had aptly written in an 1869 limerick:

There's a combative artist named Whistler
Who is, like his hog-hairs, a bristler:

A tube of white lead

And a punch on the head

Come equally handy to Whistler.[20]

In the memorandum to his defense counsel before the trial, Ruskin tried to explain his criticism of Whistler's work. He said that it was his "first duty" as a critic to "distinguish the artist's work from the upholsterer's" and to offer "resistance" to those who "conceive the object of art to be ornament rather than edification."[21]

That was the rub. To many, Whistler was mixing it all up, confusing everybody about what one should expect in high art, as distinct from applied art, and obfuscating where one started and the other left off. Where was the "finish" in Whistler's evanescent nocturnes [see figs. 11, 38; pl. 2]? What was the point? The story? The moral? And why all of this ungodly emphasis on the design of a canvas or a room or a costume? What had any of this to do with high art? Finally, the evangelical priest of Victorian criticism had found it necessary to alert the common man to be on guard against this joker who was threatening to reduce painting to a meaningless decorative art. Ruskin explained that the critic must "recommend the spectator to value order in ideas above arrangement in tints."[22]

The trouble was, Ruskin, who had been appointed Slade Professor of Fine Art at Oxford University in 1870 and who was, besides, the self-appointed arbiter of British taste, had anything but impeccable aesthetic judgment. Ruskin's real talent lay in his evangelical enthusiasm for art, as expressed in moving writings and lectures. Through them he had helped to stir new interest in the arts in Britain and then elevated that interest to a height of moralistic fervor generally reserved for religious worship. Through an outpouring of books such as *The Seven Lamps of Architecture* (1849), *The Stones of Venice* (3 vols., 1851–1853), *Modern Painters* (6 vols., 1843–1857), and *The Two Paths, Being Lectures on Art and Its Application to*

Decoration and Manufacture (1859), and in his periodical, *Fors Clavigera*, Ruskin had proclaimed his doctrine that art should have a moral basis. He promoted this ideal for decorative arts as well as for fine arts. The violence of Ruskin's reaction to Whistler's vague, deconstructive "arrangements" epitomized the Victorian belief that there was something disturbingly immoral about pictures that did not teach a lesson, tell a story, or demonstrate proper diligence in achieving meticulous fidelity to nature.[23] Even the American novelist and critic Henry James warned in 1878: "Mr. Whistler's productions are pleasant things to have about, so long as one regards them as simple objects— as incidents of furniture or decoration. The spectator's quarrel with them begins when he feels it to be expected of him to regard them as pictures."[24]

Whistler was far from alone in his abstract, design-conscious approach to the arts in the late 1870s in Britain. London by this date was a lodestone for advanced designers. Morris, Rossetti, Godwin, Brown, Burne-Jones, Owen Jones, Christopher Dresser, Charles Lock Eastlake, Bruce J. Talbert, Lewis F. Day, William Burges, and Philip Webb were among several who worked with varying degrees of abstraction in the applied arts. But Whistler's place in this roll call of design reformers was quite different in that he was actively blurring the traditional Western lines of demarcation between the minor arts and the fine arts. He brought the same kind of attention to color relationships within an entire room, for instance, that most artists devoted strictly to the confines of the canvas. Conversely, he transferred the two-dimensional abstraction commonly deemed acceptable in the applied arts to the hallowed realm of the easel picture. It was disconcerting to Victorians, to say the least, to contemplate evocative color harmonies arranged on a canvas claiming to be nothing more than that.

Six months before the Whistler-Ruskin trial actually took place, Whistler made a clear and direct effort to

explain his abstract decorative theory of painting to the public, though, he said, "the vast majority of English folk cannot and will not consider a picture as a picture, apart from any story which it may be supposed to tell." Whistler's attempt to communicate his philosophy of art to Victorian picture readers took the form of a newspaper interview, actually a prepared statement, in the May 22, 1878, issue of the *World*. He discussed his objection to telling stories in paint, using a particularly blurred, faintly executed picture, *Nocturne in Grey and Gold: Chelsea Snow* (ca. 1876), to demonstrate his point. He said that although it was a snow scene with a lighted tavern and single black figure, he disdained sentimental literary interpretations being attached to the painting.[25]

Whistler declared his concern had been pictorial design; he cared nothing for the past, present, or future of the figure. He had simply needed a black spot to offset his combination of grey and gold; it was the arrangement of this color harmony that was the real "basis of the picture," not any imagined genre scene.[26] Even for the portrait of his mother, a subject for which a viewer might be forgiven the contemplation of possible emotional and sentimental content, Whistler disclaimed any such comfortable notions, insisting that it was simply an "Arrangement in Grey and Black!" Whistler's stoic New England Puritan background, manifest in this portrait, reinforced his anti-sentimental approach.[27]

Whistler was taking his concept of art as pure design to its logical extreme by stressing form over narrative content. Art for Whistler was about manipulating forms and colors—the abstract elements—into pleasing formal harmonies. That manipulation constituted his "theory in art," or "science of color and 'picture pattern' as I have worked it out for myself during these years."[28] Pattern, harmony, and repetition were his recurrent themes. This focus on design was difficult for Victorians to grasp. Paintings, he declared, should not be concerned with "legendary or local interest." Rather, "Art should be independent of all claptrap—

should stand alone, and appeal to the artistic sense of eye or ear, without confounding this with emotions entirely foreign to it, as devotion, pity, love, patriotism, and the like. All of these have no kind of concern with art; and that is why I insist on calling my works 'arrangements' and 'harmonies.'"[29] He adamantly rejected referential or associative values being attached to his paintings. To the New York collector Samuel P. Avery he wrote that even his titles were "not meant to have any literary twang of poetry about them . . . but are meant to indicate scientifically the kind of work upon which I am engaged."[30]

Whistler may have taken the art for art's sake theory to its radical extreme partly because he felt the need for a strong antidote to the Victorian fondness for sentimental, often maudlin, stories in paint [see pl. 6]. He never retreated from this position of intense aversion to British subject painting.[31] When he was ill in 1900, he said, "Lowered in tone, the doctor says I am—well, you know, the result, no doubt, of living so long in the midst of English pictures."[32] Whistler was determined to release painting from its job of didactic illustration and to make purely decorative objectives legitimate.

Art historian and psychologist E. H. Gombrich has observed, in analyzing the complex roots of modernism in painting, "There is nothing the abstract painter used to dislike more than the term 'decorative,' an epithet which reminded him of the familiar sneer that what he had produced was at best pleasant curtain material."[33] Whistler's work was subject to this sort of accusation. His paintings were frequently compared to delicately tinted fabric or wallpaper. Indeed, critic Tom Taylor made this comparison during the 1878 trial, and shortly afterward, the periodical *Judy* featured a cartoon entitled "The Newest Thing in Wall-Papers," which depicted a couple viewing a roll of unfurled Whistlerian nocturne wallpaper replete with moons. The American art historian James Jackson Jarves, who, like Whistler, collected Far Eastern art, agreed that Whistler's productions were close to

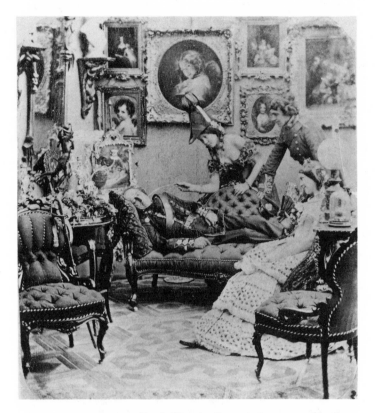

FIG. 12. *Comic Victorian Domestic Scene, ca. 1860, from the stereoscopic photograph "The Disturber of the Peace." An exaggerated Victorian room, replete with gewgaws, suggests the gaudy excesses of interior design in this period. PL 3958-1953, Victoria and Albert Museum, London. By courtesy of the Board of Trustees.*

"a superior kind of wall-paper." Another critic suggested Whistler was merely a house painter.[34]

Nevertheless, in late-nineteenth-century Britain, the decorative arts were rapidly gaining on the fine arts in status. Of the artist-designers in England, Whistler seems to have been the one figure poised squarely on the line between the pictorial and applied arts and possessed of the protean ability to let his talents flow in either direction. His long-term study of the arts and crafts of Japan had a profound influence

on his development of an abstract pictorial art. It also led to his realization that applied arts, long considered inferior to fine arts, had potentially equal value, and that applied and fine arts might share similar decorative objectives.

Ruskin, on the other hand, had spent years of his pedagogical life teaching Britons that they had a right to expect paintings—and whole buildings for that matter—to be reverent transcriptions of nature amounting to sermons in paint and stone. His puritanical propensities took a distinctly different slant from Whistler's. Ruskin's influential chapter, "The Nature of Gothic," from *The Stones of Venice* seemed the final word in Victorian England on the necessity of moral feeling being inextricably wedded to art.

In view of this dominant attitude, Whistler's cool, restrained, improvisatory portraits and serene, Zen-like nocturnes, deftly brushed on the canvas with light films of thin paint, like Japanese water-based paintings on silk, were considered slight indeed [see figs. 11, 38; pls. 2, 4]. To his contemporaries they looked empty, not only of subject matter but also of meaning—so much "curtain material."[35] These same ideals of spare, elegant, coloristic design, which Whistler proceeded to carry into his interior schemes [pls. 9, 10] and promote via his various homes—most conspicuously through his controversial new White House—were equally upsetting to the status quo for house decoration. Nonplussed Victorians, recently become prosperous, were not inclined to opt for Whistlerian restraint and simplicity in their homes. Typically, the well-off Briton wanted comfortable, overstuffed furniture and abundant bric-a-brac—more, not less—in their rooms and in their pictures [fig. 12].[36]

Thus, the historical moment at which Whistler's trial concerning a less-is-more picture commenced was hardly favorable to his cause. The style of the painting in question was so out of keeping with the dominant values in art of that period as to be laughable; and, indeed, that was the common response.[37]

Whistler v. Ruskin

The trial of Whistler's libel suit against Ruskin, charging one thousand pounds in damages for the injury done to his reputation, took place on November 25 and 26, 1878, in the Exchequer Chamber at Westminster. Whistler's friend Godwin appeared to lend moral support. He jotted down notes and made a sketch from his vantage point behind Whistler in the courtroom [fig. 13]. The trial must have seemed to offer comic relief from more serious artistic concerns—a mere tempest in an aesthetic teapot.[38] Though the general attitude toward Whistler during the trial was certainly derisive, and though Whistler, ever the performer, phrased his answers specifically to draw laughter, the views he was propounding were historically significant for the future of modern art.

Whistler was battling against suffocating systems of aesthetic thought in England, as represented by the people's prophet, Ruskin.[39] The celebrated trial promoted Whistler's idea that art devoid of subject matter, story, or moral lesson of any kind, purporting to be nothing more than evocatively subtle pictorial design based on color and form—and only inspirationally linked to nature—could have intrinsic value and possess validity as serious easel painting.

On the first day of the trial, the cross-examination concerning the offending painting, *Nocturne in Black and Gold: The Falling Rocket* [fig. 11], was directed at Whistler. He described the painting as a night piece that represented the fireworks at Cremorne. He assured the jury members that if they were looking for a *view* of Cremorne (an amusement park and garden), they would be disappointed. Rather, he stated, "It is an artistic arrangement." In regard to another painting, *Nocturne in Blue and Gold: Old Battersea Bridge*, he explained, "My whole scheme was only to bring about a certain harmony of colour" [pl. 2].[40] Following some discussion, the court adjourned to Westminster Palace Hotel to view some of Whistler's pictures that had been put on display for the jury.

FIG. 13. *Edward W. Godwin. "Whistler in Court," November 25, 1878, pencil, 5 x 2¾ in. (12.7 x 7 cm). Godwin made this sketch at the* Whistler v. Ruskin *trial. Sketchbook A123b, E 248.71–1963, Victoria and Albert Museum, London. By courtesy of the Board of Trustees.*

After the interval, *Nocturne in Black and Gold* was again produced and passed around the courtroom. Apparently, Whistler had not been able to prevent this handling of his work, though he had written to his lawyer Anderson Rose: "Your client most determinedly objects to whatever pictures there may be of his shown in any accidental and promiscuous

manner.... Pictures may not be handed about like samples of butter to be inspected ... [as if] in the market places." He demanded they be hung in proper light and as they had originally been seen by Ruskin. Yet, here was his nocturne getting short shrift. Whistler tried to salvage the moment. He pointed to the frame, which he had signed and decorated with a Japanese wave pattern, and explained to the assembled crowd, "The black monogram on the frame was placed in its position with reference to the proper decorative balance of the whole."[41] His butterfly monogram, based on Japanese seals and his initials, was a basic ingredient of his designed canvases, and he always placed the cartouche with the greatest care in reference to the balance of the entire composition.

Throughout the proceedings, Whistler hammered away at his purist, designed-canvas approach to painting, making no concessions to insistent questions about his subject matter. He repeatedly made the point that art was a search for beauty in the harmonious relationships of tonalities arranged into coherent picture patterns, not a search for didactic subjects to illustrate. Whistler rejected any suggestion of specific narrative content or mere anecdotal interest in his pictures. He had probably painted *Nocturne in Black and Gold* on the floor, as he had other nocturnes, to keep his diluted washes, or "sauces," of oil paint from running off the canvas. (Later he hung them up in his garden to dry.) Whistler succinctly explained that his intention was only to manipulate the elements of design into a balanced abstract arrangement. "I have perhaps meant rather to indicate an artistic interest alone in the work, divesting the picture from any outside sort of interest which might have been otherwise attached to it. It is an arrangement of line, form and colour first, and I make use of any incident which shall bring about a symmetrical result."[42]

Although by this date Japanese art was extremely popular, there was no allusion to Eastern art during the trial. Apparently no one in the courtroom was informed enough to perceive the link between Whistler's deftly blurred, fleeting, moonlit nocturnal scenes and the transitory, floating, designed world of Japanese *ukiyo-e* prints.

In several instances in his testimony, Whistler stressed the dimension of subtle evocation in his elusive paintings of the night, so deftly poised between purely decorative arrangement and suggestive waterscape. Like the British aesthetic theoretician Walter Pater, Whistler was drawn to flickering, shadowy images, to a world—as Pater described it in his famous "Conclusion" in *Studies in the History of the Renaissance*—"not of objects in the solidity—but of impressions, unstable, flickering, inconsistent, which burn and are extinguished with our consciousness of them." When cross-examined about *Nocturne in Blue and Gold: Old Battersea Bridge*, Whistler expressed his delight in such fugitive effects, noting the figures on the Hiroshige-like, T-shaped bridge that cuts boldly across the picture plane "are just what you like" [pl. 2]. He said he had completed the picture in a day "after having arranged the idea in my mind." For Whistler, memory, imagination, and inner vision were vital aspects of the creative process, superseding mere illustrative objectives.[43]

Ultimately, Whistler won the case, ludicrous though the proceedings may have been. Ruskin, who was suffering from repeated episodes of mental illness, had not appeared. Whistler had performed brilliantly and extracted a farcical farthing in damages. Immediately after the trial, Burne-Jones wrote Ruskin that he and Morris were determined he would "not pay one penny." A subscription organized through the Fine Art Society paid for Ruskin's court costs.[44] Nonetheless, Whistler had substantially diminished Ruskin's credibility as a dictator of modern British art.

The trial dramatically changed Whistler's position as well and encouraged him to become more polemical. One newspaper stated: "You hear the trial discussed wherever you go. It has kept dinner-tables supplied with animated conversation for a fortnight."[45] Whistler was quite aware of his heightened

public profile and basked in the glow. To his sister-in-law Nellie he wrote: "As to the court business, my dear Sis, it was, now that I come to look back upon it, simply amazing. Really, you know the whole thing would seem to amount to a sort of involuntary public recognition of the position of your brother! . . . You can see from the papers how wonderfully it was reported . . . I send you one of the most appreciative accounts."[46]

The trial, to Whistler's complete satisfaction, was a major media event. He had achieved a new level of international notoriety, but the public was not amused enough to pay for the entertainment.[47] Friends of Whistler's started a subscription to pay for his court costs, but it failed to gain popular support. His financial situation became desperate. He had greatly underestimated the cost of building and decorating his new White House. Arthur Lasenby Liberty, from whom he had bought porcelains, Japanese objets d'art, silk, and other aesthetically desirable goods, forwarded his bills and then, in view of Whistler's financial straits, agreed to wait for payment. Whistler wrote gratefully to Liberty:

> You are really more than considerate and it is not easy to thank you. Of course I have been . . . tremendously absorbed in the trial matter—and you will be pleased to know how greatly delighted I am with the fight as far as it has gone. I came home to find my place covered with letters of congratulations and sympathy. . . . Of course "costs" would have been more satisfactory . . . but to the world really it has been a great victory morally—and the first shot at the "Critic" has at last been fired—You know I always win in the end![48]

Whistler's initial euphoria about his moral victory did not last long. (Despite his claims to the contrary, apparently Whistler did not eradicate morality from his thoughts about art.) He began to realize that he had won a Pyrrhic victory. His conviction that the reporting of the trial was superficial, that his aesthetic aims were still wholly misunderstood, and that Ruskin's influence was far from quashed, combined with the threat of imminent bankruptcy hastened by court costs, prompted him to take further polemic action.

Reformer in Print: Brown Paper No. 1

Within a month, Whistler had published his first literary effort, a pamphlet [fig. 14]. This was a different tack for the artist and the beginning of a series of pamphlets, bound in brown paper, in which he attempted to maintain the public dialogue he had begun in the courtroom. It was entitled *Whistler v. Ruskin: Art & Art Critics* and was dedicated to Albert Moore, his colleague in the crime of decorative art, who had testified in his behalf at the trial.[49]

Whistler's singular design was duly noted by several reviewers. Creative book design was pursued with new vigor during the aesthetic period, and Whistler followed the example of his literary friends by exhibiting a concern with devising a new look for his publication. The reporter for the *Chelsea News and Kensington Post* compared the impression it made to "one of his clever etchings, [an] incisive little *jeu d'esprit* with broad '*luxe*' margins, slightly asymmetrically arranged title in small, reticent italics lettering, with butterfly monogram and the curious use of the cheapest, seemingly most inelegant material of common brown paper for the cover."[50]

The radical typography and layout of Whistler's pamphlets were carefully conceived. The slightly asymmetrical cover designs reflected his cultivation of the art of Japan. The pamphlets were the antithesis of William Morris's limited edition "Arts and Crafts beautiful books," which were prized by collectors. Morris's aesthetic, launched more than ten years later at Kelmscott Press, resulted in books designed to look like copies of old medieval manuscripts [fig. 15]. Laboriously handcrafted pages, dense with Gothic print,

FIG. 14. *Brown Paper No. 1: Whistler v. Ruskin: Art & Art Critics, December 24, 1878, 7⅞ x 5¾ in. (20 x 14.6 cm). Whistler designed and wrote the pamphlet as a follow-up publication after the trial. Joseph and Elizabeth Pennell Papers, Library of Congress.*

conceived publications, which later included insouciant little butterflies fluttering about the pages, became as much a part of his total public image as the careful contrivance of his dandified appearance. He also designed book covers, including two designs for feminist novelist Elizabeth Robins. But it was his own meticulously designed pamphlets that became prototypes of refined aesthetic design. Whistler's restraint, which gave to the pages lightness and readability, represented a protest against popular bourgeois taste for cluttered book design.

Both the medium and the message of Whistler's first publications showed his consistency in demonstrating concern with design in all aspects of his art. His seventeen-page, six-by-eight-inch pamphlet, published by Chatto and Windus in Piccadilly and printed by Thomas Way, sold for the modest sum of one shilling. It went into at least seven printings and, according to Henry James, was featured in most of the shop windows in London.[52]

In this publication, which was mainly a diatribe against ignorant critics, Whistler mocked Ruskin's dictum that high art must speak to the masses. "The whole scheme is simple: the galleries are to be thrown open on Sundays, and the public, dragged from their beer to the British Museum."[53] It was anathema to Whistler to pander to the public taste, and he would continue to defy the Ruskinian forces that attempted to put art in the service of social causes or bourgeois taste. He insisted that artists be considered professionals who need not be told what is acceptable by platoons of amateur critics.

Following the 1878 trial and apologia, the pivotal events in Whistler's career, he consciously assumed the role of reformer. He was in the process of developing and clarifying his ideas through a kind of self-generated cultural debate that was more radical and far more dynamically combative than the campaigns carried forward by most of the other late-nineteenth-century design reformers in Britain.

decorative borders, and illustrations, made Morris books expensive and tended to obfuscate the author's meaning.

Whistler's designs for his aesthetic publications, by contrast, are characterized by delicate spacing and a great deal of white. They have a look of modernity, with wide margins, light mechanical print, and half-empty pages. The pamphlets were consciously designed to be small, understated, and inexpensive. Though they looked like throwaways, people nevertheless collected them for their entertainment value and fresh appeal.[51] The character of these scrupulously

A Battle for Pure Art: The "Ten O'Clock"

In 1885 Whistler decided to make a formal declaration, or manifesto, of his reformist views that would exceed what he could hope to accomplish through the newspapers and magazines, or even in a courtroom. Thus he prepared to stage his second major aesthetic drama—his "Ten O'Clock" lecture—which was intended to be a summation of his thoughts on the state of the arts.

The gestation of the ideas behind his "Ten O'Clock" lecture started when, as a young man, he began to absorb current art philosophies in France. The concepts of the French aesthetes Théophile Gautier and Charles Baudelaire were among the first that nourished his thinking while he was a student in Paris in the late 1850s. Indeed, it was Gautier who expressed this philosophy in the phrase *l'art pour l'art,* "art for art's sake."[54] Baudelaire built upon Gautier's ideas and promoted a cult of beauty and imagination and a science of the harmony of color, correlating it with poetry, music, and the darkness of the night. As early as April 2, 1862, in the *Revue Anecdotique,* Baudelaire had favorably reviewed Whistler's etchings of the Thames, finding in them the spontaneous, poetic, and abstract modernity that fit his own philosophy of art.[55] A few months later at the 1863 Salon des Refusés, he expressed his admiration for Whistler's controversial tonal painting, *Symphony in White No. 1: The White Girl* [see fig. 5]. His aesthetic interests, however, went beyond the pictorial arts. Like Gautier, Baudelaire displayed the dandy's depth of concern for the details of dress and evinced a high regard for the art of interior design.[56] His belief in the concordant aspects of all the arts and his concept of correspondences, which involved synaesthesia, were fundamental to Whistler's thinking.

Whistler endeavored to maintain ties with the French circle of artists who took up Baudelaire's challenge to become imaginative painters of modern life.

FIG. 15. *William Morris. A Page from Chaucer,* Works *(London: Kelmscott, 1896), 129. The illustration includes Pre-Raphaelite maidens and a wide, decorative floral border. FE 2113 95E, Victoria and Albert Museum, London. By courtesy of the Board of Trustees.*

In 1864 he joined the critic and other avant-garde artists and theorists such as Félix Bracquemond, Edouard Manet, Jules Champfleury, and Edmond Duranty for an engaging group portrait, *Homage to Delacroix*, painted by Henri Fantin-Latour [fig. 16]. In the painting Whistler is the epitome of the lithe young dandy, a peacocklike poseur. Fantin had put his friend where he liked to be—at the center of attention. He captured Whistler's chic presence, and the painting enhanced the artist's fashionable reputation.

British aesthetes who contributed most significantly to the formulation of Whistler's philosophy included his best friends, the poet Algernon Swinburne and the painter Albert Moore. At the beginning of the sixties Swinburne had begun to develop his theory of purely decorative art divorced from narrative content or moral concerns. He was an early admirer of Baudelaire's poetry and wrote the first English review of his controversial collection of poems *Les Fleurs du Mal* (1857). The review appeared on September 6, 1862, in the *Spectator* and introduced the art for art's sake concept in Britain.[57]

Swinburne was instrumental in publicly defending and interpreting the puzzling new decorative figure paintings that Whistler and Moore had begun to create after their meeting in 1865 [see pl. 3, fig. 41]. In an 1868 review, Swinburne called attention to the link between the direction the two men's work was taking toward nonnarrative, abstract arrangement and the concepts of the seminal French thinkers Gautier and Baudelaire. He recognized the work as "the worship of beauty . . . simple and absolute."[58]

It was during this same period, the late 1860s and early 1870s, that the British theorist Walter Pater was formulating his theory of hedonism through art. Whistler could not have helped being influenced by Pater's philosophy, with its strong relationship to the cult of beauty of Gautier and Baudelaire. Pater's beliefs that "all art constantly aspires to the condition of music" and that the purpose of art is to offer sensuous

delight with the primary emphasis on color were aligned with Whistler's ideas.[59]

By the 1870s Pater's theories and incantatory words were so popularly recognized as to offer prime material for a caricature by W. H. Mallock in his witty novel *The New Republic* (1877), which parodied aestheticism. Mallock casts Pater as "Mr. Rose," who typifies the aesthete and speaks in the softly lulling manner for which the Oxford professor was known. His name also suggests a glance at Rossetti and other Pre-Raphaelites. Mr. Rose's words dreamily "float down the table in languid monotone." Though Rose could be Pater himself speaking, he also sounds like Whistler explaining the theoretical and psychological basis of his interior designs.

> "I rather look upon life as a chamber, which we decorate as we would decorate the chamber of the woman or the youth that we love, tinting the walls of it with symphonies of subdued colour, and filling it with works of fair form, and with flowers, and with strange scents, and with instruments of music. . . . what does successful life consist in? Simply," said Mr. Rose, speaking very slowly, and with a soft solemnity, "in the consciousness of exquisite living—in the making our own each highest thrill of joy that the moment offers us."[60]

Is this Paterian or Whistlerian? It seems a mix of the two, and the conflation seems to suggest that Whistler's ideas for hypnotically color-drenched interior spaces had infiltrated both the ideas of a popular comedic novelist and the theory of an Oxford professor.

Mr. Rose's perfectly decorated Whistlerian chamber, with walls tinted in "symphonies of subdued colour," epitomized the exclusivity and sweetness of the aesthetic life Pater envisioned for certain elect and peculiar people. Pater reminded his readers that they

FIG. 16. *Henri Fantin-Latour.* Homage to Delacroix, *1864, oil on canvas, 63 x 98⅜ in. (160 x 237 cm). Back row, left to right, Louis Cordier, Alphonse Legros, Edouard Manet, Félix Bracquemond, Albert de Balleroy; front row, left to right, Edmond Duranty, Fantin-Latour, Whistler, Jules Champfleury, Charles Baudelaire. Musée d'Orsay, Musées Nationaux de France, Paris.*

were only a momentary concurrence of "phosphorous and lime and delicate fibers," all "under sentence of death." Since they had only this "interval," this "short day of frost and sun," they must escape the ordinary and dull, and experience the "flamelike." Salvation lay in the "love of art for its own sake," which offered the greatest chance of increasing the "number of pulsations," thereby "expanding the interval" with a "quickened, multiplied consciousness."[61] But Pater's philosophy had dangerous implications. Whereas Ruskin had linked art to Christian morality, Pater's concept of an epicurean life—life lived as art—virtually replaced Christianity and embraced decadence.[62]

Pater's theories thoroughly informed Whistler's

thoughts in his 1885 "Ten O'Clock" manifesto. But the immediate impetus for delivering a formal lecture on art—beyond his long-term desire to take on leaders like Morris and Ruskin—probably grew out of his rivalry with Wilde and his brother-in-law, Francis Seymour Haden. Both Haden and Wilde had assumed positions of leadership in the art world and both had conducted lecture tours to America.

Wilde had developed into a most effective apostle of aestheticism. In January 1882, the poet decided to carry the gospel to America in a ten-month series of eloquent lectures on what he called the "English renaissance of art." He delivered his message to large audiences in more than seventy-five cities. Dressed in a purple coat, knee breeches, black silk stockings, lace frills, and lavender silk, wearing his long hair parted in the middle, and holding a talismanic calla lily, Wilde made a distinct impact when he arrived, as he said, in the midst of coyotes and yellow-bearded miners. Though the American press maligned him, his popularity inspired songs like "Quite Too Utterly Utter, a New Aesthetic Roundelay," and his name created a sensation throughout the United States and Canada. After his triumphant return (despite the mixed reviews), he delivered two lectures at Prince's Hall, Piccadilly. Whistler attended the second lecture on July 11, 1883, and the *World* reported that Jimmy was seen "jumping about like a cricket." Whistler "crammed" Wilde for a lecture to students at the Royal Academy, and from October 1884 through March 1885, Wilde took his lectures on dress and home decoration, with titles like "The House Beautiful" and "The Value of Art in Modern Life," to England, Ireland, and Scotland. In his addresses he acknowledged Godwin, Ruskin, and Morris, but he declared the supremacy of Whistler as the most important artist not only in England but in all of Europe.[63]

In his "House Beautiful" lecture, Wilde took his American audiences on imaginary tours of their hideous houses, pointing out their decorating mistakes.

He complained to them about modern wallpaper so ugly that a boy who grew up in a room thus decorated could justifiably point to the experience as a reason for turning to crime. In his standard, oft-repeated lecture, "House Decoration," Wilde urged Americans to consider bringing Whistlerian color into their homes instead.

> You have too many white walls. More colour is wanted. You should have such men as Whistler among you to teach you the beauty and joy of colour. I regard Mr. Whistler's famous Peacock Room as the finest thing in colour and art decoration which the world has known since Correggio painted that wonderful room in Italy . . . Mr. Whistler finished another room just before I came away—a breakfast room in blue and yellow [13 Tite St.]. The ceiling was a light blue, the cabinet-work and the furniture were of yellow wood, the curtains at the windows were white and worked in yellow, and when the table was set for breakfast with dainty blue china nothing can be conceived at once so simple and joyous. The fault which I have observed in most of your rooms is that there is apparently no definite scheme of colour. Everything is not attuned to a keynote as it should be. The apartments are crowded with pretty things which have no relation to one another. . . . All beautiful colours are graduated colours, the colours that seem about to pass into one another's realm . . . one tone answering another like . . . a symphony.[64]

Despite the genuine homage Wilde paid to Whistler in his lectures, Whistler, twenty years older than the poet, became increasingly jealous of Wilde's success as a professional lecturer. Whistler may have at first thought of Wilde as a personal publicity agent, but now he believed he was being plagiarized by Wilde. He was convinced the poet was taking credit for his theories and making a farce out of some of his personal ideas by confounding them with the precepts of Ruskin and Morris.[65]

Whistler, no doubt, wanted to reaffirm his seminal role in the English design reform movement with his "Ten O'Clock" lecture. He was still working to strengthen his position in England following the Ruskin trial, and though he himself had been a prime mover in the aesthetic movement, he now wanted to pull away from what that movement had become. Whistler thought Wilde had vulgarized the beautiful by taking the aesthetic movement on tour, lecturing indiscriminately in halls and parlors, foisting art on the middle classes. What had started as a renaissance was beginning to take on the taint of decadence. Satirizing of the aesthetic movement had nearly reached the saturation point on the stage and in the comic magazines. And just then, in 1885, Gilbert and Sullivan were mounting a glittering production of *The Mikado*, highlighting the Japanese vogue—now commonplace and nearly synonymous with the movement—which Whistler had been so instrumental in introducing to England twenty years earlier. The repugnant situation of finding himself identified with the hordes and upstaged by Wilde sent Whistler to the lecture hall. With his "Ten O'Clock," Whistler attempted to bring the aesthetic movement to a close and claim a higher plane for himself beyond popular taste.[66]

In preparation for his public lecture, Whistler took out advertisements in all the daily papers and issued fifteen hundred invitations (five hundred people showed up; every seat was occupied). As with his exhibitions and publications, he designed the form of the entire event as carefully as the content. A writer for the *World* reported, "Mr. James McNeill Whistler, who is nothing if not eccentric has lately issued huge cards couched in most dubious terms, inviting people to be present at what he terms his 'Ten O'Clock.'"[67] Whistler designed the invitation, had it enlarged into a poster, and chose the offices and galleries to sell tickets. The *Country Gentleman* reporter announced that "Mr. MacWhistler's" tickets were on sale and

"everyone is expected to bring his own mug"—probably a reference to Whistler's line about dragging the public from their beer to the British Museum.[68]

Alan Cole received letters from Whistler about his upcoming performance and in his diary recorded a series of visits from the artist in which he helped him with his notes for the lecture.[69] Menpes said Whistler repeated the lecture to him hundreds of times while pacing up and down at night on the Chelsea embankment. Mrs. D'Oyly Carte coached him in a dress rehearsal, by which time he had polished and memorized the text. She recalled, "The idea was absolutely his, and all I did was to see to the business arrangements. Knowing him, you can imagine how enthusiastic he was over it all, and how he made one enthusiastic too."[70]

Whistler devised an elaborate seating plan arranged according to status and friendship and scheduled the lecture for the attention-getting hour of ten o'clock. On the night of the lecture, the hall was crowded and many prominent, fashionably dressed people appeared, fully expecting to be amused by one of the most brilliant wits in London society. The writer for the *Sheffield Independent* reported, "People are convinced of two things, that whatever it is, it will be funny . . . and secondly, that 'everybody' will be there."[71]

On the evening of the lecture, February 20, 1885, Whistler arrived at Prince's Hall, Piccadilly, appearing to be "jaunty, unabashed, composed" [fig. 17]. He was soberly dressed in faultless evening clothes: a white shirt with no tie, eyeglass, cane, "crush" opera hat, and white gloves. People thought there would be jokes and quips. The newspapers predicted a "burlesque or a breakdown or a comic song." *Punch* thought "the McNeil" [sic] would "stand upon his head." However, though the lecture evoked laughter, Whistler spoke seriously and with conviction.[72]

He began, "Ladies and Gentlemen: It is with great hesitation and much misgiving that I appear before you in the character of the Preacher."[73] With

LADY'S PICTORIAL.

FIG. 17. *"J. A. McN. Whistler's 'Ten o'Clock' Whistle,"* caricature in Lady's Pictorial, *February, 1885. Whistler delivered his manifesto on February 20, 1885, looking smartly dandified. Whistler press clipping album 5:43, Birnie Philip Bequest, Glasgow University Library.*

proclaiming art as abstract, arcane, and the province of the rare genius and chosen few.

Adopting a mocking tone in his introduction, he expressed his disgust at the attitude of society toward the arts, the cheapening of art as a "sort of common topic for the tea table." He echoed Flaubert and Gautier's disdain for the people when he lamented: "Art is upon the Town!—to be chucked under the chin by the passing gallant—to be enticed within the gates of the householder—to be coaxed into the company, as a proof of culture and refinement." Whistler objected to the leveling of taste and the loss of aristocratic exclusiveness of art.

Whistler had by this time designed several interiors as well as a series of stunning exhibitions, and throughout the lecture he revealed his heightened concern for art conceived in terms of a decorated interior world. "Art . . . has been brought to its lowest stage of intimacy. . . . [The people] have been told how they shall love Art, and live with it. Their homes have been invaded, their walls covered with paper, their very dress taken to task . . . bewildered and filled with the doubts and discomforts of senseless suggestion, they . . . cast forth the false prophets, who have brought the very name of the beautiful into disrepute." In this passage Whistler scoffed at such "false prophets" as Ruskin, Morris, and Wilde, as well as the "senseless suggestion" of a host of lesser artmongers— "the Amateur," the "dilettante"—who had set themselves up as saviors of the people in domestic aesthetic matters. Choosing to ignore the fact that he himself was assuming the role of a reformer, even if a different sort, Whistler poured out his scorn upon those individuals who, following the principles of the arts and crafts movement, proposed to improve people morally through bringing "art" into their homes. He objected to the idea that it is the duty of the painter to be an improver of "mental or moral state" and abhorred the derision heaped upon "the panel that merely decorates."

tongue in cheek, Whistler announced he was taking on the popular nineteenth-century persona of an evangelical Ruskinian reformer. The difference, as soon became clear, was that he was a diabolical preacher, an iconoclast, not preaching the orthodoxy of Ruskin's gospel of art for Everyman, but rather

Whistler romantically envisioned the artist as a transcendent being, a "designer of quaint patterns," a "deviser of the beautiful," a person able to perceive "curious curvings" about him in nature "as faces are seen in the fire," one who is a "dreamer apart." He conceived of the archetypal creator as a master designer. In the biblical cadences of the King James Bible, Whistler intoned: "And it became well that men should dwell in large houses and rest upon couches, and eat at tables, whereupon the artist, with his artificers built palaces, and filled them with furniture, beautiful in proportion and lovely to look upon. And the people lived in marvels of art—and ate and drank out of masterpieces . . . handed down from the design of the master, and made by his workmen . . . and the people . . . had nothing to say in the matter . . . and there was no meddling from the outsider." The true artist, as described by Whistler, is a visionary godlike creature who creates palatial environments, "marvels of art" in which people can live a cultured life, and who "brings forth from the chaos of nature glorious harmony."

In a famous symbolist passage, which critic and caricaturist Max Beerbohm declared "as perfect . . . as any of his painted nocturnes," Whistler proceeded to sketch in words an impression of his abstracted fog-shrouded nocturnal waterscapes [see figs. 11, 38; pl. 2]. In a manner similar to Gautier's and Baudelaire's earlier musical descriptions of poetic scenes, the artist identified the soft haze of a London evening as inspirational for his symbolistic painted nocturnes.

> And when the evening mist clothes the riverside with poetry, as with a veil, and the poor buildings lose themselves in the dim sky, and the tall chimneys become campanili, and the warehouses are palaces in the night, and the whole city hangs in the heavens, and the fairy-land is before us. . . . and Nature . . . sings her exquisite song to

the artist alone . . . her secrets are unfolded . . . with the light of the one who sees in her choice selection of brilliant tones and delicate tints, suggestions of future harmonies.[74]

Whistler lyrically restated this concept of nature as a source of mystical inspiration for the design of his interiors as well. Specifically, he called up an actual incident from his 1883 "Arrangement in White and Yellow" exhibition. In the elegant lemon yellow room inspired by the wings of a butterfly, he had actually traced a large butterfly high on the wall above the dado. "In the long curve of the narrow leaf, corrected by the straight tall stem, he [the artist] learns how grace is wedded to dignity, how strength enhances sweetness, that elegance shall be the result. In the citron wing of the pale butterfly, with its dainty spots of orange, he sees before him the stately halls of fair gold, with their slender saffron pillars, and is taught how the delicate drawing high upon the walls shall be traced in tender tones of orpiment, and repeated by the base in notes of graver hue." Whistler's poetic image of a golden room as an artistic inner sanctum evokes his ideal of the interior as an Oriental fantasy. It also provides a prophetic picture of future interiors in the art nouveau mode, a graceful decorative style based on the curve of the leaf and the line of the stem.[75]

In one of several abrupt shifts in the lecture, Whistler returned to his vendetta against Ruskin, blasting him as "the Preacher 'appointed'!" the "Sage of the Universities," the "Gentle priest of the Philistine." The whole manifesto was devoted to a final repudiation of the Ruskinian aesthetic.[76]

Whistler concluded the lecture with an equation of Greek and Japanese art as equally representing the epitome of beauty. Years later a reporter for the *London Times* summed up the Whistlerian philosophy as expressed in his "Ten O'Clock" with a certain wry insight. "The lecture had a little of Heine in it, a little

of the book of Ecclesiastes, a good deal of Walt Whitman, and the residue pure Whistler."[77]

The possible influence of Whistler's manifesto was very great, since he continued to present it in private and public circumstances through 1891. During those years hundreds of newspaper reports were published on the lectures. At least fifteen of the presentations have been recorded, beginning with the first at Prince's Hall. This was followed by performances at the Society of British Artists; the University Art Society of Cambridge; Oxford University; and later at the Royal Academy Students' Club; the London Fine Art Society; the Grosvenor Gallery; the homes of Lady Maidstone and Lady Jeune; Kensington Palace, for Princess Louise and a party of friends; Dieppe, where Paul Gauguin quite likely heard it in 1886; and finally the Chelsea Arts Club. D'Oyly Carte negotiated with Whistler to give the lecture in the principal cities of the United States and Canada. No doubt Whistler dreamed of captivating America well beyond Wilde's achievement. As he remarked in a letter that appeared in the *World*, "This is no time for hesitation—one cannot continually disappoint a Continent!"[78] However, the plans did not materialize, though they were widely reported in the press. Whistler was short on the tolerance required for an extended lecture tour. When he gave the "Ten O'Clock" at Oxford University, Sidney Starr recalled, it "was delivered impressively, but lacking the original emphasis and sparkle. Whistler hated to do anything twice over and this was the fourth time; but it was on the record."[79]

Whistler had his lecture printed privately in brown paper covers in 1885. Three years after its first delivery, in the spring of 1888, it was published by Chatto and Windus with the "rivers of wide margins, the latest eccentricity in type," and "of course the immortal butterfly." Just prior to its publication, Monet introduced Whistler to the French symbolist poet Stéphane Mallarmé. The poet became intrigued with

Whistler's "Ten O'Clock" and offered to translate it in January 1888. He made a superb French translation, with Whistler's assistance, that first appeared in the *Revue indépendante* in May and caused a great furor in Parisian literary and artistic circles.[80]

Mallarmé, later a dear friend, correspondent, and fellow interior decorating enthusiast, arranged a special evening at one of his *mardis* (Tuesdays), to which Paris intellectuals were invited to hear Mallarmé read the translation. Thus, Whistler's manifesto, as promoted by Mallarmé, became an influential document of modern art theory in French avant-garde circles, more so than among British artists, who had received it coolly. For French and Belgian symbolist and art nouveau artists, the impact of Whistler's carefully worked out ideas and poetically evocative visions of misty near-empty nocturnes and ethereal golden chambers was germane to the mysterious, decorative, and suggestive art they were then beginning to create.[81]

In England, though the reviews of the "Ten O'Clock" during the six-year period in which he gave the lecture were prodigious in number, they lacked seriousness. Whistler was dismissed with an imperious tone. One reviewer wrote, "Mr. Whistler is not generally accepted either as a representative artist or as an exponent of any principles of art."[82]

Wilde's famous review of Whistler's lecture in the *Pall Mall Gazette* appeared the day after the lecture at Prince's Hall. He was typically preoccupied with being witty. "Remembering, no doubt, many charming invitations to wonderful private views, this fashionable assemblage seemed somewhat aghast, and not a little amused, at being told that the slightest appearance among a civilized people of any joy in beautiful things is a grave impertinence. . . . The scene was in every way delightful; he stood there, a miniature Mephistopheles mocking the majority! He was like a brilliant surgeon lecturing to a class composed of subjects destined ultimately for dissection." Wilde chided the

devilish artist for telling the audience "how vulgar their dresses were" and "how hideous their surroundings at home." He said, "I strongly deny that charming people should be condemned to live with magenta ottomans and Albert blue curtains in their rooms."[83]

Algernon Swinburne's review did not occur until more than three years later in the *Fortnightly Review*, but it caught Whistler off guard, nevertheless. The artist asked his old friend, the most important poet of his generation—who twenty years earlier had written so lyrically of the early evidences of Whistler's decorative style—to write a critical analysis of his "Ten O'Clock." Whistler was not prepared for Swinburne's vitriolic attack, in which he refuted Whistler on nearly every point of his lecture.

Swinburne scoffed at Whistler's assertion of purely decorative intent in the portraits Whistler described as abstract arrangements in color; and he made a particularly scathing characterization of Whistler's Japanese-inspired interior decorating style, which the artist had called an Oriental fantasy of fair gold in his lecture.[84] Swinburne taunted, "They [Whistler's audience] were not in a serious world; . . . they were in the fairyland of fans, in the paradise of pipkins, in the limbo of blue china, screens, pots, plates, jars, joss-houses, and all the fortuitous frippery of Fusi-yama [*sic*]."[85] Swinburne's cruel downgrading

of Whistler's cultivation of the decorative art of Japan revealed a *volte-face* from his position of twenty years earlier, when he had praised the artist's experiments in achieving pure formal beauty based on Japanese and Greek art. The devastating review cut Whistler to the quick.

He could now be satisfied that he was completely misunderstood on every level in Britain. No one seemed capable of fathoming or accepting his abstract theory of art. His estrangement was quite complete. Perhaps Whistler should have heeded Wilde's letter of advice to him after he had first delivered his "Ten O'Clock." Wilde had said, "Be warned in time, James; and remain, as I do, incomprehensible. To be great is to be misunderstood.—*Tout à vous*."[86]

The "Ten O'Clock," however, was indeed on the record, as Sidney Starr had remarked. Thus it had left its mark and would continue to do so, if not profoundly in England, then more strongly on the Continent. Whistler had once again used a public platform to work through his singular aesthetic beliefs. He had caught the missionary fervor of English reformers like Ruskin and Morris, but he refused to give his paintings, prints, and interior designs a moral-social cast. The importance and impact of Whistler's paintings and interiors can be understood only in the broader context of his vigorous public efforts to proclaim his abstract, color-sensitive aesthetic.

3

The "Japanese Decorator" in Chelsea

The Drawing Room as High Art

In his "Ten O'Clock" lecture Whistler clarified that he sought not to popularize art and make it the business of the people; rather, he wanted to aristocratize art and keep it exclusively the province of the true artist.[1] While other artists veered off, driven by social reform in the name of art, Whistler held the line on pure aesthetics, determined to reform art, not society. His polemicizing was combined with his personal example of total commitment to design renewal, as expressed in his dress, homes, canvases, prints, exhibitions, and publications. Despite his elitist pose, Whistler played a vital role in awakening public consciousness to the possibility of demanding higher standards of design in several facets of life.

But it was especially in regard to the design of their homes that Britons, during the aesthetic movement of the 1860s, 1870s, and 1880s, acquired new sensibilities and began to agonize about how to decorate their interiors. Whistler was chief among the late-nineteenth-century tastemakers who caused them to seriously doubt their judgment and call in a designer. He told them unequivocally in his "Ten O'Clock" that interior design was not the province of dilettantes. They should stay out of it, since only a true artist had the creative ability to devise beautiful interiors, "stately halls of fair gold, with . . . slender saffron pillars."[2]

Whistler's interest in designing fine schemes of decoration was keen, and he answered the call to decorate an interior whenever given a chance. He had the ability to make the designing of exquisitely colored spaces seem exciting and avant-garde—a form of high art. The interiors that he devised were closely related to his personal world. Dining rooms, drawing rooms, studios, and exhibition galleries—such rooms furnished a backdrop for his art and for the high

society in which he loved to participate, often as a kind of a society favorite. Thus he sought to revolutionize domestic interior design and exhibition design, which were sorely in need of fresh, creative attention during the Victorian period.

Through his decorating "demonstrations," staged in London, Whistler created heightened interest in interior decoration and provided conceptual models to illustrate that excellence in design could be potentially life enhancing. He was an active presence in leading the public back to the idea of the interior as a work of art.

The point of departure for Whistler as an interior designer of archetypal significance arrived with Commodore Matthew C. Perry's opening of the ports of Japan at mid-century. Within the next few years a virtual tidal wave of exports entered the West.[3] Japanese arts and crafts began to penetrate the Parisian art world at the very moment Whistler arrived in France, and his exposure was probably immediate, though the exact date of his encounter is often debated and is yet to be absolutely established. However, what is most impressive about Whistler's exposure to Japanese art is not the exact date of his encounter but the facility with which he began to assimilate the new aesthetic. Certainly, by the early 1860s, the guiding principles behind his mode of decorating interiors emanated from Oriental art.[4]

Whistler's desire to create Oriental-inspired interiors may be explained in part by the illusion of an alternative world such exotic decor suggests. Pater and Baudelaire had both sketched word pictures of dream environments that offered imaginative release from mundane reality. But it was the Goncourt brothers who most vividly captured the heavily romantic, escapist aura of Japanese art in their 1867 novel, *Manette Salomon*. The book's hero, a painter, enjoys an Oriental daydream as he pages through Japanese woodcut albums.

Coriolis, after several faint-hearted attempts to work, a few brush strokes, took from a credenza a handful of albums with covers of various colors, embossed, dotted or woven with gold . . . [the pages were] loaded with colors from the Orient, spotted and speckled, sparkling with purple, ultramarine, with emerald green. And a day in the land of fairy-tales rose for him from these Japanese albums. . . . The winter, the grayness of the day, the poor shivering sky of Paris, he escaped them. . . . Before him unfolded a country of red houses . . . with dazzling interiors, bespattered, begilded by all the reflections made from polished wood, the enamel of porcelain, the golds of lacquer, the wild glimmer of Tonking bronzes. . . . a yellow door, a trellis of bamboo, some fences of bluebells lets one guess that it is the garden of a teahouse. . . . before him passed women, some of them winding cherry-colored silk, others painting fans; women drinking with small sips from red lacquer cups. . . . They had dazzling and soft robes, whose colors seem to fade away at the bottom, robes sea-green as shells or flowing like the shadow of a drowned monster . . . dresses which open and sprawl in back, [like] the wings of a butterfly.[5]

The inherent romance of the remote land of Japan, so poetically revealed in this passage, was central to Whistler's interior design aesthetic. The Orient represented an idyllic place, an Eastern Eden, removed from the vulgarity and pollution of industrial London.[6] As an individual who seemed to live his life with nerve endings exposed, Whistler may have needed interiors that offered the illusion of retreat into an exotic world of serene beauty.

In 1875, the French art critic Philippe Burty, who coined the term *japonisme* for Western artists' adaptation of fundamental aspects of Japanese art, referred to the influence of albums of Japanese woodcut prints on Whistler in particular, and on interior design in general. These small picture books featured depictions

of plants, animals, human figures, interiors. "The influence of the Japanese albums on artists such as Mr. Whistler. . . . [and their] action upon our artists who apply their talent to manufacture . . . [is] apparent. For some years past our carpets, our hangings, our wallpapers, our furniture, our table service have been designed and executed in a lighter and more harmonious scale of colour. I think it very important for Western nations to make bright homes for themselves."[7]

Whistler's Puritan New England roots reinforced his inclination toward Japanese restraint in interior design. He was born in Massachusetts in 1834, and when he was nine, his family moved to Russia, where the czar had commissioned his father, an engineer, to construct a railway from Moscow to St. Petersburg. There they lived in a large luxurious house from 1843 to 1849 until his father, Major George Washington Whistler, died at forty-seven as the result of a cholera epidemic. Whistler lived nearly a year in London, in 1848 and 1849, with his half-sister and her husband, Dr. and Mrs. Seymour Haden. The family spent the subsequent years in America, from 1849 to 1855, living in plain New England houses. Finances were extremely strained, and frugality marked Whistler's teenage years. Although he received an appointment to West Point, he failed to graduate. Just prior to his arrival in Paris in 1855, he lived in Washington, D.C., where he worked briefly at the United States Coast Survey and learned the basics of etching. He boarded with the Gautier family in an old two-story brick house on the northwest corner of E and Twelfth Streets near Pennsylvania Avenue. While waiting impatiently to turn twenty-one, when he would come into a small inheritance, he amused himself by memorizing Henri Murger's contemporary novel about artists in the Latin Quarter of Paris, *Scènes de la vie de bohème*, which he would continue to quote all his life.[8]

As a handsome, slender young man, Whistler affected the style of dress he imagined to be that of such bohemian artists, wearing a loose black frock coat with tails pinned back to show his waistcoat. He also had a circular cloak in dark blue-and-green plaid and wore a large tam-o'-shanter over his blue-black curly hair, which was long and bushy. His carefully contrived appearance was an early indicator of a design-conscious dandy in the making, as were the decorated walls of his attic room. Having found bare painted walls in his apartment, Whistler proceeded to draw spontaneous sketches all over them. When the landlord objected, he said, "Now, now, never mind, I'll not charge you anything for the decoration!"[9]

Whistler's interiors in Paris, according to various reports, were characterized by simplicity and austerity. This was in direct opposition to the overwrought, complex interiors then being displayed in universal exhibitions. Great international fairs, which featured extensive displays of Japanese art, were just beginning to be held in Paris and London when Whistler arrived in November 1855. Especially in Paris, the Japanese craze was about to explode, and Whistler, as an art student living in the city, was among the first Western artists who discovered Japanese crafts.

Initially, he learned about Japanese art through Auguste Delâtre, a printer. Delâtre discovered an album of Hokusai's woodcuts, the *Manga*, in a shipment of porcelain in 1856; he also displayed Japanese porcelains in his studio. In November 1858 Whistler arrived in this studio to watch Delâtre print a series of Whistler's etchings called the "French Set." Whistler was also acquainted with Félix Bracquemond, an etcher, designer, and ceramist, whose imagination was fired by Delâtre's find. Bracquemond acquired an *ukiyo-e* album about two years after Delâtre's discovery. He became a champion of *japonisme*, carrying his album with him and enthusiastically showing it to everybody in order to enjoy the astonished reactions.[10]

Whistler had joined a progressive art circle in Paris by the fall of 1858 that included artists who were among the first to study Japanese art. In this group

were original *japonistes* such as Fantin-Latour, Bracquemond, Manet, Alfred Stevens, James Tissot, Baudelaire, Burty, Zacharie Astruc, Frédéric Villot, and Ernest Chesneau. His prominent position within this group was such that Chesneau advanced the name of Whistler, together with that of Stevens, as the chief initiators of the Japanese movement.[11] As *japonisme* scholar Gabriel P. Weisberg has pointed out, Whistler was, by the early 1860s, a regular visitor to shops selling Japanese wares, such as the fabled La Porte Chinoise at 36 rue Vivienne, which opened prior to the middle 1850s and served as a meeting place for *japonistes*.[12] The Oriental shop of E. Desoye and his wife under the arcades at 220 rue de Rivoli is thought to have opened in 1862, and Decelle's l'Empire Chinoise at 55 rue Vivienne had sold Japanese objects since the 1850s. The fad for Japanese art spread like wildfire, and by the 1870s print albums, kimonos, screens, lacquers, porcelains, bronzes, fans, and *kakemonos* became widely available in a variety of shops and department stores.[13]

Little is known of the details of Whistler's various flats in Paris. Certainly he was not settled enough to become seriously involved in interior design projects. In his excursions about the city he met Murger himself, and he began to live the bohemian artistic life the author had depicted in his novel. He at first cultivated the friendship of French and British students who attended the *académie* of the Swiss artist Charles-Gabriel Gleyre, where he occasionally turned up. His rooms were similar to those of other penniless young artists in Paris, as his earliest depictions reveal. Whistler and his English friends, Edward Poynter, L. M. Lamont, Frederic Leighton, Thomas Armstrong, and George Du Maurier, lived in empty rooms. One of Whistler's friends skillfully drew beautiful furniture on the walls with charcoal, in lieu of real furnishings. Whistler's growing dandy propensities can be surmised from a meticulous pencil drawing Poynter made at this time of Whistler in a jaunty hat [fig. 18]. His chaotic bohemian period did not last long; he already

betrayed a puritanical streak, not in his social behavior, but in his decor. He could not tolerate uncleanliness and was unusually fastidious. In 1857 he kept in spartan order, as if it were a palace, one tiny room that was ten flights up, with a brick floor, cot, chair, basin, and pitcher ("and that was *all*").[14]

By student standards Whistler's interiors were, nevertheless, luxurious, and they were filled with beautiful china, according to Joseph and Elizabeth Pennell, Whistler's biographers. Presumably, Whistler was their source for this statement, though there is no record of how he arranged or displayed his china in his rented quarters; nor do the Pennells definitively clarify whether these decorative art objects were Chinese or Japanese. Whistler never stayed anywhere long. He is known to have lived at nine different addresses in the Latin Quarter, including the rue St. Sulpice, No. 1 rue Bourbon-le-Château, and No. 3 rue Campagne-Premiere.[15]

It was no problem for Whistler to change residences, since he had no furniture—a state of affairs that continued and that drew commentary in later years. A scene from Murger's novel of bohemian life seems to suggest an early model for the austerity of Whistler's decorating schemes. In the book the protagonist, Marcel, who wears a white hat and has a suit that fits him like a glove, attempts to rent a sixth-floor room. The landlord is highly suspicious of him, since he appears to have no belongings beyond an easel and a large folding screen.

Monsieur Bernard looked around him and could see only the great screen. . . . [and he said], "but I

FIG. 18. *Edward J. Poynter.* Portrait of Whistler, *December, 1858, pencil, 7 1/16 x 5 1/16 in. (18.1 x 13 cm). The sketch catches Whistler at age twenty-four, when he was a bon vivant living in Paris. Freer Gallery of Art, Smithsonian Institution, Washington, D.C.*

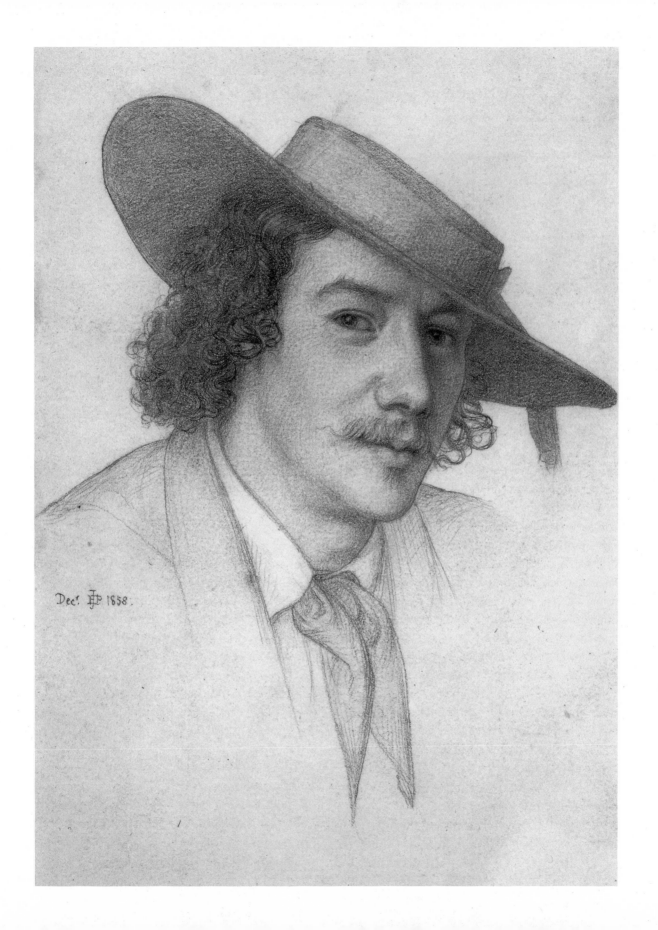

Dec. ℍℙ 1858.

see nothing." "There they are," the young man replied in turning the leaves of the frame thereby giving the now agitated proprietor a view of a magnificent interior of a palace with jasper columns, reliefs and pictures by the great masters. "But your furniture?" demanded Bernard. "There it is," the young man answered pointing to the [screen]. . . . "Sir," resumed the proprietor, "I prefer to think that you have more serious furniture than that. . . . I want some furniture . . . some real furniture in mahogany!" . . . "[No] I cannot endure it. The wood is too ugly—everybody has it." "But you must have some furnishings whatever they are, my dear sir?" "No, it takes too much room in apartments. When there are chairs one never knows where to be seated." "Surely you have a bed."[16]

But the artist, who proves to have art for art's sake pretenses, fails to produce even a bed. However, on that same evening he is set up in his new lodgings, now transformed into a palace by means of a single screen. His friend Rudolph finally rents a room with "serious" furniture, including an imitation red velvet couch, two porcelain vases with flowers, and an elaborately ugly alabaster clock. Rudolph finds himself disturbed by his new setting, and experiences "that secret anxiety which almost always one experiences on entering a new apartment. 'I have noticed,' he thought, 'the places where we dwell exercise a mysterious influence over our thoughts.'"[17]

Screens, porcelains, empty spaces uncluttered with chairs, an abhorrence of mahogany (which "everybody has"), a delight in contriving palaces with an economy of means, and a penchant for creating interiors that "exercise a mysterious influence"—all would become intriguing aspects of the future interior design aesthetic of James Whistler.

When Whistler moved to London in 1859, he brought the French craze for Japanese prints and Oriental porcelains with him. Exactly what he had collected at this point is not clear, but over the next few years he transported screens, blue-and-white china, sketchbooks, kimonos, fans, prints, *kakemonos*, *tatami*, embroideries, lacquers, and other decorative arts to London from Paris and also began to make purchases in England [see pl. 8; figs. 30, 71]. He became a leading *japoniste* in Victorian London, promoting a fashion for Japanese arts and crafts and creating a sense of rivalry and excitement about studying and collecting art from the Far East. He publicized the Japanese taste at the same moment that the aesthetic movement was being launched in Britain, and the art of Japan became inextricably interwoven with the movement. Furthermore, he continued to shuttle back and forth between London and Paris, thereby becoming a dynamic force for the dissemination of *japonisme*. Author James Laver declared, "It was from Whistler that the whole tide of Japanese influence flowed to modify interior decoration and to color the Aesthetic Movement."[18]

When *japonisme* came in, *chinoiserie* tended to be pushed out, though collectors like Whistler often did not differentiate between Japanese and Chinese art in any exacting way. As early as 1854 a certain interest was expressed in the work of Japanese craftsmen. By that date the South Kensington Museum (today's Victoria and Albert Museum) had made substantial purchases for its Science and Art Department from a large exhibition of Japanese arts and crafts held at the Old Society of Water Color in Pall Mall. The Japanese decorative arts were recognized as being fashionable, exotic, inexpensive, and well made, and they would become the single most potent outside influence on British style in the last half of the nineteenth century.[19]

Whistler had no difficulty in continuing his private acquisitions. He sent various orders from London to Paris via Fantin-Latour, writing him to stop at 220 rue de Rivoli on his way from the Louvre to obtain such items as a Japanese costume or a lacquered box from Mme Desoye, whom he referred to as *la japonaise*.

Madame laughed at Whistler's consternation over the china collection of his friend and rival Dante Gabriel Rossetti. On one of his visits, in November 1864, Rossetti, who was equally involved in *japonisme*, purchased four Japanese albums. In London, Whistler patronized a shop in the Strand and a tea shop near London Bridge where Japanese prints were given away with every pound of tea. By 1863 the Farmer and Rogers Great Shawl and Cloak Emporium had the Oriental Warehouse, managed by Arthur Lasenby Liberty. In 1875, Liberty, a key entrepreneur in the design reform movement, set up his own shop, East India House, specializing in Oriental objects, across the street at 218A Regent Street. The shop became a major force in weaving the spell that Far Eastern art cast over Britain; Godwin called it "an enchanting cave." Whistler befriended Liberty and also Charles Augustus Howell and Murray Marks, who imported blue and white to sell at his shop, Fine Arts, at 395 Oxford Street. After the 1868 Meiji Restoration, and the subsequent unrestricted Japanese export trade, a rash of Oriental shops quickly appeared, and big department stores carried Far Eastern commodities. Auction houses such as Christie's were soon selling Japanese wares. By the early 1870s the South Kensington Museum had a large collection of Oriental arts and crafts. The scholarly *japoniste* Christopher Dresser set up the Art Furniture Alliance in 1890 and opened a showroom and shop in New Bond Street where clerks, dressed in aesthetic costumes, sold his modernist wares and Japanese accessories.[20] Eventually, the commercialized fad for Japanese art would lead to vulgarization. This trend would undermine the seriousness and exclusivity of Whistler's *japonisme*.

The English fascination with the arts of Japan was also expressed through a profusion of colorfully illustrated books and magazine articles. Sir Rutherford Alcock, the first British ambassador to Japan, was among the earliest to publish a general book on Japan, in 1863; entitled *Capital of the Tycoon*, it featured reproductions of Japanese woodcuts. Later he offered a guide to Japanese applied arts, *Art and Art Industries in Japan* (1878), which was serialized in *Art Journal*. Alcock discussed the current British taste for painting walls and backgrounds in neutral colors as a hint taken from the Japanese, but he identified this clearly Whistlerian decorating hallmark with Morris.[21] Owen Jones, though best known for his influential book *The Grammar of Ornament* (1856), featuring colored lithographs of decorative patterns from all over the world, also published *Examples of Chinese Ornament* (1867), which included Japanese designs. Charles Lock Eastlake's immensely popular guide for the amateur decorator, *Hints on Household Taste* (1868), drew heavily on Japanese examples.

Whistler utilized George Ashdown Audsley and James Lord Bowes's *Keramic Art of Japan* (1874, 1881), which featured illustrations such as peacocks and wave and cloud motifs, as a direct source when he decorated the Peacock Room. Bowes served as Japanese consul, and it is likely that Whistler became acquainted with his remarkable collection of Far Eastern art in the late 1860s and 1870s when he stayed at Speke Hall near Liverpool, an important center for the cultivation of Oriental art. Christopher Dresser's writing, lecturing, and designing activities made him one of the most important *japonistes* in Europe. He traveled to Japan in 1877 to study its industrial and fine arts and as a result wrote a comprehensive book entitled *Japan: Its Architecture, Art, and Art Manufactures* (1882). Like William Morris, Dresser believed the decorative arts could have moral power, but like Whistler, he incorporated the clean, simplified lines of Japanese art into his decorative art designs, resulting in an astonishing modernity.[22]

One would expect Whistler's inspiration from Japanese art to emanate chiefly from the artifacts themselves, but he was enthusiastic about Japanese books and literature as well. He read Japanese poetry in translation in the 1870s. His feeling for mood and atmosphere in his nocturnes and in his interiors was doubtless enhanced by this reading. He evidently

placed real importance on the Japanese books he owned. At the time of his bankruptcy in 1879, Messrs. Sotheby, Wilkinson, and Hodge sold eighteen of Whistler's Japanese picture books. In an 1864 letter, Whistler's mother mentioned that not only was her son fascinated by his "very rare collection of Japanese and Chinese" but "he has also a Japanese book of painting unique in [his artist friends'] estimation."[23] An amusing undated letter from Whistler to Samuel Putnam Avery, an avid New York collector of the artist's etchings, leaves no doubt whatever about Whistler's excitement at the prospect of leafing through a book of Japanese art.

> By this time it is doubtless quite clear to you that writing is "not my forte" or I would have answered your very pleasant letter long ago—especially as it involves matters of such interest to me as the Japanese book which I am to be presented with—But do you know I want it at once!— When a gift is made to me I like it to be in my possession immediately! and to my horror . . . after the Monday's post brought it not, I found at the [?]ted Hotel that you had come without leaving my book! You can fancy my long face when the Porter assured me there really was no parcel with Mr. Avery's kindest regards for me!—Now when am I to have it?

Who could resist such a charmingly childlike demand for a promised present? Apparently Avery came across with the gift, and Whistler sent him "a couple of photographs as mementos of your visit to the Studio this time."[24]

Whistler's involvement with the earliest stirrings of interest in Japanese art in England went beyond books and curio shops, however. Evidence suggests he was in immediate contact with several important pioneer English *japonistes*. The single creative figure in England known to have been actively interested in Japanese art in the late 1850s, when Whistler moved to

London, was the High Victorian Gothic architect and designer William Burges. The scholarly Burges was a thirty-five-year-old medievalist design reformer with an insatiable passion for collecting odd and exotic things. Whistler very likely knew about Burges's collecting activities soon after his move. Burges, Morris, Rossetti, and Whistler were all members of the group who frequented the Hogarth Club, a private exhibiting society of the Pre-Raphaelites that was in full operation by 1859. The changing attitude toward the decorative arts within the Pre-Raphaelite circle is suggested by the rejection of Ford Madox Brown's furniture designs for exhibition that year because they were judged not legitimately within the domain of art. By 1860, however, the club accepted a "wedding wardrobe" by Morris and a Rossetti painting depicting Dante meeting Beatrice that decorated a settle. All four artists would become key players in reviving the decorative arts in England.[25]

The instructive aspect of Burges's *japonisme*, for Whistler, was that he used it (though in combination with an almost fantastic mix of objects such as medieval armors and Siamese paintings) to create a mysterious atmosphere in his art and life. Burges was deeply influential to Rossetti in this respect. Burges's personal interiors had a symbolist quality, and the same would be increasingly true of Whistler's interiors, though they were much more austere. After Whistler became friendly with Burges, he invited him to dine amid his blue-and-white china at Lindsey Row, and Burges in return invited Whistler to the quaint tea parties that he staged in his overcrowded and exquisite bachelor quarters at 14 Buckingham Street.[26]

Whistler's full awareness of Burges's cultivation of Japanese art probably coincided with the London International Exhibition. This international exhibition, which opened on May 1, 1862, had a profound impact on the development of taste and design. Two major themes of late-nineteenth-century British decorative arts were showcased at the fair: *japonisme* and medievalism. The display of one thousand Japanese items

was the largest exhibition of the art of Japan ever seen in the West and represented Japan's first participation in an international exhibition. Burges showed his medievalist furniture and wrote an enthusiastic review in *Gentleman's Magazine and Historical Review* about the Japanese Court, which had been assembled by Sir Rutherford Alcock and others. From Burges's point of view, the crafts of Japan helped prove the point that high-quality handcraftsmanship was the answer to the decorative problems in England, which were exacerbated by machine production.[27]

The displays at the 1851 Great Exhibition had provided an overview of the world's manufactured and handcrafted goods and revealed the wretchedness of the situation in Britain—that taste had somehow gone badly awry. The 1851 exhibition became a catalyst in England, and by the time of the 1862 International Exhibition, it became clear, especially to the French, their formerly superior competitors, that the English had made real strides in the decorative arts. William Morris's original ideas for interior design, though based on Gothic sources, were the most striking, pointing toward a renewal in British design.[28]

Whistler himself made a strange "decorative appearance" at the exposition, not as a designer, but as a subject in a panel painting on the main piece of medieval furniture exhibited by Burges, the *Battle between Wines and Beers Sideboard* [fig. 19].[29] This curious furniture portrait of Whistler as a young man suggests an early relationship with Burges and constitutes an unlikely harbinger of the direction Whistler's career would take toward the decorative arts.

The sideboard, which Burges sold to the South Kensington Museum during the fair, was painted by Edward Poynter.[30] Poynter, who had roomed with Whistler in Paris, based his furniture portrait of Whistler directly on his 1858 pencil sketch of the twenty-four-year-old Whistler [fig. 18]. (The portrait on the left resembles Fantin-Latour, who visited Whistler in London in 1859 [see fig. 16, left of Whistler]). The word "gin-sling" is included under the portrait.

FIG. 19. *William Burges.* Battle between Wines and Beers Sideboard (*the Yatman Cabinet*), *1858–59, 85¹⁄₁₆ x 55⅛ in. (216 x 140 cm). The oil portrait of Whistler on the right is by Edward Poynter; it is based on his pencil drawing [see fig. 18]. HA 658042-1862, Victoria and Albert Museum, London. By courtesy of the Board of Trustees.*

Sparkling champagne and gin sling cocktails were favorite drinks for the effervescent Whistler. More than forty years later, Whistler was still drinking gin slings. In a 1902 letter, Charles Freer, his American patron, wrote: "Last night was the first evening of jubilation. . . . Whistler invited himself to dine with me— He cracked anti English jokes mixed up with good Burgundy and gin slings till the lights went out."[31]

Whistler had several months to inspect the Japanese Court, which included lacquer ware, wood objects, rattan, porcelain, papers, and textiles, especially silk. Once the exhibition closed, Alcock's assemblage of Japanese arts and crafts was auctioned off by Christie's between December 1 and 4. The rest was brought to Farmer and Rogers emporium and placed next door in its annex, the Oriental Warehouse, at 179 Regent Street. These wares were probably purchased directly by Dresser, Godwin, Whistler, Burges, and other collectors who became personally responsible for the evolution of *japonisme* in England.[32]

Whereas Burges's fascination with Japanese art was expressed primarily through his personal collections, Poynter, then an up-and-coming young artist (later Sir Edward Poynter, president of the Royal Academy from 1896 to 1918), became one of the first artist-designers to incorporate Japanese motifs directly into the design of an interior. His 1866 Grill Room for the South Kensington Museum is, according to Clive Wainwright, assistant keeper in the Department of Furniture and Interior Design at the Victoria and Albert Museum, "arguably the first fully realized Anglo-Japanese room—in a very high-profile public place."[33]

The room, which is no longer in use as a grill though still on display in the museum, was the talk of London. Its flavor of early *japonisme* is expressed in the blue-and-white ceramic sunflower wall tiles inserted into a plain rectangular wooden framework, in the Japanese motifs of sunburst and sunflower discs and undulating wave patterns on the huge brass and cast iron ebonized grill, and in the use of a peacock motif in the white plaster frieze that encircles the room.[34] Poynter's use of the favored Japanese motif of a peacock in a dining room furnished a popular precedent for Whistler's far more flamboyant Peacock Room, which he and Thomas Jeckyll created ten years later, just down the block from the South Kensington Museum.

Whistler's fondness for Oriental folding screens, and his eventual painting of one, probably owes something to one of the most remarkable early Anglo-Japanese artifacts. (*Anglo-Japanese* is the nineteenth-century term for English art inspired by Japanese art.) A brilliant, exotic ebonized screen, created by the architect and designer William Eden Nesfield in 1867, is a compendium of angular Oriental decorative motifs. While its irregularly arranged "pie" patterns and fretwork are of Japanese derivation, the central panels are authentic Chinese paintings of birds and flowers on silk. Nesfield also incorporated Japanese motifs into the interior decor of Cloverley Hall, and he collected Japanese art along with other exotica. Whistler was friendly with Nesfield in the mid-1860s; they were boxing partners. So presumably he would have known of the architect's design for this tall, sixfold screen and his cultivation of Japanese art.[35]

Whistler's contact with, and probable influence from, three members of a distinguished coterie of English decorative artists, all of whom were doing Japanese things, is generally overlooked. This may be because Whistler's evolution as a designer has not been traced and because these artists are more commonly thought of as medievalists or establishment figures. Therefore their early contributions to *japonisme* have been underplayed. But there is no reason to suppose their impressive decorative *japonisme* escaped the sharp eye of their American friend, who, several years earlier in Paris, had begun to assimilate the aesthetic lessons of the Far East.

The *japonisme* of Nesfield, Poynter, and Burges also highlights the essential difference between the initial approaches to Japanese art in Paris and in London. In Paris the discovery of Japanese art profoundly affected the pictorial arts, whereas in London, aside from the work of Whistler and Moore, pictorial arts revealed little influence. In England, where realistic academic painting predominated, Japanese paintings were viewed as defective because they lacked shading and an understanding of perspective. In the

decorative arts, on the other hand, the revitalizing influence of Japanese art was welcomed.[36]

For Whistler, as an artist thoroughly captivated by the arts of Japan, this state of affairs in England may have directly contributed to his expanding his career beyond etching and painting to become a decorator. In the decorative arts, specifically interior design, Whistler could find a much higher degree of acceptance for his adaptations of Far Eastern concepts.

Just at the point when Burges, Nesfield, and Poynter were designing furniture and interiors that revealed their study of Japanese art, Whistler was himself growing increasingly sensitive to questions of design. In August 1865, he wrote to Fantin-Latour and enclosed a sketch of a carefully positioned and composed decorative figurative painting entitled *Symphony in White No. 3* [fig. 20]. "Things become simpler from day to day," he noted, "and now I pay most attention to the composition." Significantly, it was with this picture that Whistler adopted the practice of calling his works "symphonies," "arrangements," "harmonies," "nocturnes." He also retroactively gave his earlier works similar decorative titles in an effort to emphasize design and discourage narrative interpretations.[37] Whistler was preoccupied with mastering color, composition, and arrangement, as well as creating a more allusive art of nuance and evocation, as he struggled to move away from Courbet's earthy realism. Two years later he expressed his frustrations about this difficult transition in a famous letter to his French friend. "Ah my dear Fantin what a frightful education I have given myself. . . . You see I am at an unfortunate moment. Courbet and his influence were odious. The regret, the rage, even the hatred I feel for all that now would perhaps astonish you. . . . That damned Realism made such a direct appeal to my vanity as a painter! and, flouting all traditions, shouted with the assurance of ignorance, 'vive la Nature!'"[38]

Part of the education Whistler was giving himself was to expand the depth of his understanding of Japanese art. He was also studying stylized classical figurative art, especially Roman terra-cotta Tanagra statuettes (ca. 300 B.C.).[39] Although a blend of classical and Japanese art ultimately proved too difficult a synthesis for his pictorial designs, Whistler began to conflate these influences successfully in the design of his interiors.

Whereas Oriental, neoclassical, and French rococo decorative art appealed to Whistler, the mix of Japanese art with medievalism never captivated him as it did most of the other major English designers of this period. Nor did Whistler, as was often the case for other artists, treat Japanese art as a passing fancy; rather, it became a lifelong affair.[40] His continuing fascination was observed by Otto Bacher, an artist friend of Whistler's. In 1883 Bacher recalled: "We dined together every night. Among many pleasant experiences, I remember that he took me to see a remarkable collection of Japanese embroideries. As I knew his inspiration was from the Japanese, his enjoyment of these things was interesting to remark." And in 1885 Bacher noted: "At his request I visited Dr. Whistler [James's brother] in order to see a remarkable Japanese lacquered tray representing a fish at various depths. This was the only thing saved from the sheriff's sale of his effects in the White House on Tite Street."[41]

Whistler's sustained cultivation of Japanese art can also be gauged by his extended contact with Siegfried Bing, the Parisian entrepreneur and dealer extraordinaire of Japanese arts and crafts, to whom he sold a nocturne in the 1890s. Whistler was well aware of Bing as a prominent figure in the dissemination of Japanese art and, by 1878, as the proprietor of a shop at 19 rue Chauchat in Paris. Whistler probably purchased Japanese arts and crafts from the shop, and he may have been among the famous artists who searched through the Japanese prints in Bing's attic looking for fresh sources of inspiration. Whistler and Bing not only shared an international outlook, they were also among the first who began to think in terms

FIG. 20. Symphony in White No. 3, 1867, *oil on canvas, 20½ x 30⅛ in. (52 x 76.5 cm), Whistler frame. With this design-conscious painting, Whistler first used a musical title. The Barber Institute of Fine Arts, University of Birmingham, England.*

of perfectly integrated interior spaces patterned substantially on Japanese principles of organic unity.[42] When Bing made his 1894 trip to the United States to evaluate American applied arts, Whistler wrote a letter of introduction to Isabella Stewart Gardner, his Boston friend and collector: "Dear Mrs. Gardner— This line is to present you to my friend Monsieur

Bing—whom you of course know as the distinguished authority upon all that is Japanese and beautiful— and whose visit to America, we *all* know, would be a foolish crossing of waters without this introduction!"[43]

Bing evidently recognized Whistler as an artist with a design orientation, since in 1895 he invited

Whistler to exhibit at his gallery's first salon, which highlighted the decorative art nouveau movement. In 1896, Bing also included Whistler's book *The Gentle Art of Making Enemies*, the design of which was based on Japanese principles, in his international exhibition on modern book design at his gallery, L'Art Nouveau, at 22 rue de Provence.[44]

Whistler did not have an opportunity to become a designer of Japanese-inspired interiors immediately upon his arrival in London. However, in his pictorial work from the late fifties and early sixties he often depicted interiors, suggesting his incipient development in that direction. When he first settled in the city, on May 6, 1859, he lived with his half-sister, Deborah, and her husband, Francis Seymour Haden, a doctor and amateur etcher who had inherited a large house at 62 Sloane Street. It was a four-story, cream brick house, deep, narrow, and tall. The place had an air of austere comfort as well as a touch of severe style. Several of the etchings and paintings Whistler produced at this time reveal his sensitivity to the design of the rooms in which he found himself.

Whistler's paintings *At the Piano* [fig. 21] and *Harmony in Green and Rose: The Music Room* [fig. 22] allow us to enter this placid upper-middle-class home. In interior scenes reminiscent of seventeenth-century Dutch domestic settings such as those Vermeer and de Hooch painted, Whistler catches Deborah, Seymour, and Annie Haden in calm activities of reading and of playing and listening to music. The prevailing luxury of the fine old house, with its polished paneling, bright brass fixtures, and sparkling silver, all perfectly kept under the meticulous guidance of Deborah, is mentioned in letters of Whistler's French bohemian friends who visited him in London. The quietly tasteful decor suggested in Whistler's paintings presumably reflects his sister's preference in interior design. Apparently she shared her brother's flair for arranging interiors. Moreover, the taste and cultivation of the

Hadens may well have influenced Whistler. Deborah would later consider James's decoration of the Peacock Room "beautiful beyond her language to describe."[45]

Both of Whistler's paintings capture an atmosphere of repose. His acute sense of design and pattern was beginning to assert itself, as reflected in the light and limpid tones and in the balanced geometry of the setting, which contained gilt-framed pictures carefully arranged in horizontal lines on pale yellow walls above a mint green dado accented in gilt. In *The Music Room*, the poufed chintz curtains with pink and rose flowers, which echo the deeper red of the carpeting, together with the plain neutral walls, are decorative touches in accord with Whistler's concepts. Because of the color tones in the room, the figures dressed in white and black (one resembling a geisha figure) are bathed in a pale green light, a factor that evidently intrigued Whistler. This is not a typical, overdone, stuffy Victorian interior, but is very much what one imagines a conservative version of a Whistlerian interior might look like. Whistler's eventual title for this interior scene, *Harmony in Green and Rose: The Music Room*, indicates his growing sensitivity to the color schemes within rooms as well as in paintings.

Clementina Hawarden, a High Victorian photographer, may also have influenced Whistler's newfound interest in creating decorative compositions featuring aesthetically posed figures in striking domestic interiors. Lady Hawarden, who was friendly with the Hadens and exhibited at the South Kensington Museum and elsewhere, contrived similar scenes. Her photographs of figures in light-flooded, empty chambers appear to be models for several of Whistler's paintings and etchings [fig. 23]. They also represent potent examples of stark, strangely evocative, even haunted, interior spaces, which conceivably may have been among the sources that inspired Whistler's inexplicably austere, symbolist decorating style.[46]

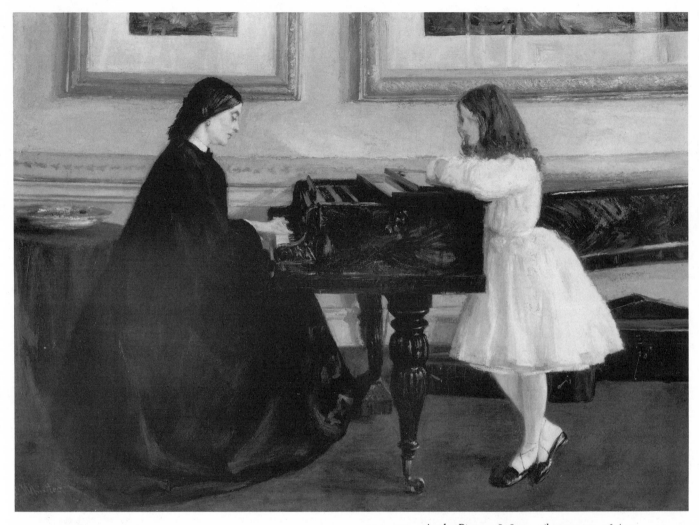

FIG. 21. At the Piano, 1858–59, oil on canvas, 26⅜ x
35⅝ in. (67 x 90.5 cm). Whistler employed the tasteful inte-
rior in Deborah and Francis Seymour Haden's home in London
as a backdrop for this depiction of Deborah and Annie Haden.
Louise Taft Semple Bequest, The Taft Museum, Cincinnati,
Ohio.

One cannot help thinking that by the early sixties Whistler must have needed his own place to hold his burgeoning collections. In May 1862, Du Maurier noted that Whistler was "in his furnitures somewhere with Jo [his mistress]." According to the critic William Michael Rossetti, brother of Dante Gabriel, in 1862 and 1863 Whistler lived for a while in a house at 7A Queen's Road West (now Royal Hospital Road) in Chelsea. The houses were rather old-fashioned, two-story houses of a cozy, homely character with forecourts. He thought Whistler might have lived at No. 12. In his diary, the artist George P. Boyce mentions visiting Whistler on August 8, 1862, at this address. While living at Queen's Road, Whistler traveled with Haden and Legros to Amsterdam to view his etchings in an exhibition at The Hague and to hunt for blue-and-white porcelain to add to his collection.[47]

When he returned from Holland, he began looking for a house. It was time for the *bon vivant* to come to rest and arrange a private, more permanent interior to showcase his exotic objects. Aided by patronage from the Greek colony, he was able to lease a house in March 1863.[48] He temporarily left behind his experiments in etching as well as the limitations represented by the household of the Hadens when he moved to a narrow row house facing the Thames River.

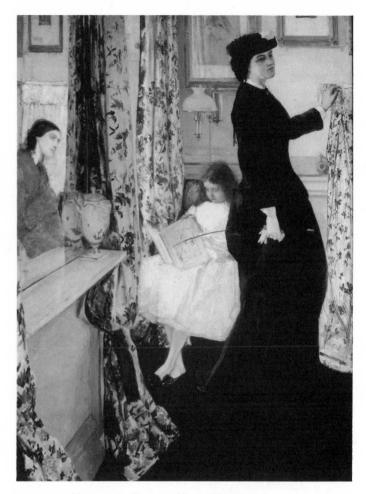

FIG. 22. Harmony in Green and Rose: The Music Room, *1860–61, oil on canvas, 37⅝ x 27⅞ in. (95.6 x 70.8 cm). Whistler staged this painting in a corner of a room in the Deborah and Francis Seymour Haden home in London. Freer Gallery of Art, Smithsonian Institution, Washington, D.C.*

Whistler's First Aesthetic House: No. 7 Lindsey Row, 1863–1867

Whistler's first real chance to exercise his innate ability for original interior decoration began with his rental of No. 7 Lindsey Row (now 101 Cheyne Walk). Located on the waterfront near Battersea Bridge across from an industrial area of factories with smokestacks and coal piles, it was within view of the lights of Cremorne (the amusement park that provided the basis for his *Falling Rocket* painting).[49] For the next four years, Whistler was able to experiment with arranging his collections of Japanese arts and crafts within rooms that he distempered in light, harmonious tones of color. It was the first of some eight different addresses he would have in Chelsea, and eventually this artists' district would become identified with him as "Whistler's Chelsea," not only for his paintings

FIG. 23. *Clementina Hawarden. Woman by Window, mid 1800s, photograph. The interior is typical of the stark spaces featured in Hawarden's photographs. GA 3463 PL. 250-1947, Victoria and Albert Museum, London. By courtesy of the Board of Trustees.*

inspired by the riverside environment, but also for the style he set in his homes there. Whistler made Lindsey Row famous and later also Cheyne Walk and Tite Street.

Lindsey Row had originally adjoined Lord Lindsey's palace, and a number of notable artists had resided there, including William Dyce and John Martin. J. M. W. Turner had once lived nearby, and Dante Gabriel Rossetti was a neighbor within easy walking distance. Rossetti had just moved, in October 1862, to a big, brick Queen Anne house called "Tudor House" at No. 16 Cheyne Walk.[50]

The Lindsey Row building, having been stuccoed, modernized, and divided into several residences, had lost much of its former aristocratic charm and was on the verge of seediness. It may very well have appealed to Whistler's taste for working-class dockside environments, as his "Thames Set" etchings specifically demonstrate, as well as to his offbeat sense of modernity. No. 7 is a humble three-story house that in the artist's era still retained some of its original paneling and had a spacious stairway and a garden in front.[51]

Photographs of the dining room of Whistler's first home reinforce this image of an unpretentious house, inexpensively decorated. Plain distempered walls in two medium tones separated by a chair rail are accented with a white cornice [fig. 24]. The woodwork is painted, and the geometry of the doors has been highlighted in white. A set of Hepplewhite-style side chairs are arranged around the edge of the room, and a cloth in a small print covers the table. The sparse furnishings include a Regency overmantel mirror and a Dutch display cabinet [fig. 25]. Whistler's pictures, matted in white, repeat the geometry in the room. A flavor of Puritan New England or Holland is evoked by the decor, which also has a cleanness of line and austerity that is suggestive of Japan.

Whistler's collection of Dutch and Oriental blue-and-white porcelain dominates the room and is arranged on the mantel, in the cabinet, and in a shallow alcove [see fig. 71 for samples of his later collection]. In October 1863, Du Maurier described a dinner party given in this simple room at which the meal was served on Whistler's exquisite plates. "I dined with Jimmy and Legros; Poynter and Willie O'Connor were there. . . . Jimmy doesn't seem to be doing much. He bought some very fine china; has about 60 pounds worth, and his anxiety about it during dinner was great fun." On another occasion Rossetti became so excited about the blue-and-white plate he was dining on, that he immediately turned it over to inspect the mark, thereby spilling his fish on the table. Whistler

FIG. 24. *Whistler's Dining Room, No. 7 Lindsey Row, Chelsea, 1863–67. The photograph shows a porcelain installation and plain distempered walls. From Pennell and Pennell,* Whistler Journal, *following 152.*

consistently used his porcelain treasures, causing a Miss Chapman to ask, "Suppose one of these plates was smashed?" Whistler answered, "Why, then—you know, we might as well all take hands and go throw ourselves in the Thames!"[52]

A photograph of Whistler's drawing room shows a somewhat grander and more fashionably sophisticated room and, more apparently than the dining

room, indicates that Whistler's interest in Japanese art was at its height [fig. 26]. The main furnishing in the room is a miniature five-section Oriental screen with a flower-and-bird motif. This interior environment helped influence Whistler to compose his first Japanese picture in 1863. The screen appears in the background of his painting, *Rose and Silver: The Princess from the Land of Porcelain*, the earliest

FIG. 25. *Whistler's Dining Room, No. 7 Lindsey Row, Chelsea, 1863–67. From Pennell and Pennell,* Whistler Journal, *following 152.*

Japanese-inspired painting in England—though the title actually refers to China [pl. 8]. In the painting, the Greek beauty Christine Spartali is dressed in a grey, red, and salmon-colored robe from Whistler's valuable collection of kimonos. She holds an exquisite flowered fan and stands on a blue-and-white Chinese rug in the mode of a Japanese woodcut figure such as Utamaro or Eishi depicted. Maria Spartali, who accompanied her sister to portrait sittings,

recalled that in his studio Whistler's mother served them elegant lunches of roast pheasant, tomato salad, apricots with cream, and champagne, placed on low Japanese tables. They sat on stools, though, rather than on mats in the Japanese style.[53]

The dark-stained floor of Whistler's drawing room is covered by a large Persian rug; other rugs are Chinese or Japanese. Later, he would design matting for his floors with patterns of rosettes, daisies,

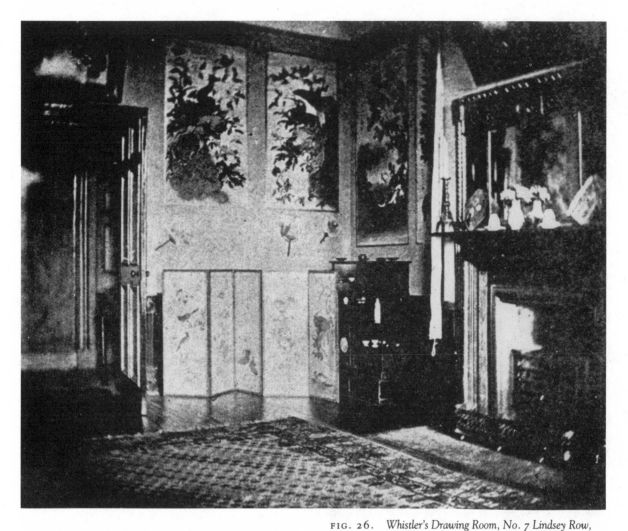

FIG. 26. *Whistler's Drawing Room, No. 7 Lindsey Row, Chelsea, ca. 1865. The photograph shows the artist's first aesthetic house, decorated with* kakemonos, fans, *and a* byōbu. *From Pennell and Pennell,* Whistler Journal, *1921, opposite 152.*

sunflowers, and stripes, or geometric patterns like checkerboards, to harmonize with the color schemes [see fig. 62]. Walls in the room are distempered in flat washes, with a dark dado, light upper wall, and white cornice. The woodwork is lacquered in a deep glossy color—probably black to match Japanese lacquered objects in the room.

This neutral shell is enlivened by Oriental accessories. A lacquered cabinet displays curios, and three large *kakemonos* (probably Chinese) painted in ink with abstracted birds and flowers are placed high on the wall; Japanese fans are also tacked on the wall. Whistler's 1864 painting *Symphony in White No. 2: The Little White Girl* includes some details found in the

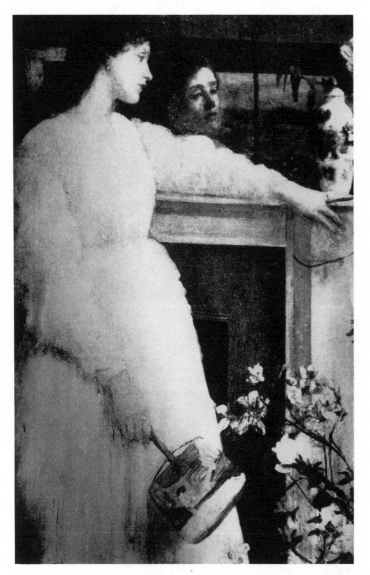

FIG. 27. Symphony in White No. 2: The Little White Girl, 1864, oil on canvas, 30 x 20 in. (76 x 51 cm). Joanna Hiffernan poses by the mantel in Whistler's No. 7 Lindsey Row drawing room, holding a Japanese fan. Tate Gallery, London.

photograph of the room [fig. 27].[54] Joanna Hiffernan, his stunning Irish mistress and mannequin, poses pensively in a white dress, standing before a mirror above the mantel and holding one of the Japanese fans from Whistler's collection. Next to her is a cinnabar-colored pot and a tall blue-and-white vase.

The notable number of prints, fans, kimonos, screens, and porcelains that appear as studio props in Whistler's early "Japanese" portrait paintings suggest that he had been collecting for some time. Although these photographs show none of his Japanese dolls, his house was full of them. Whistler's desire to acquire and display his objects was typical of this period, since so much decorative art was being either produced or imported and since so many more people had the money to buy it. Japanese art collecting in particular, because of its reasonable price, high quality, and the example set by prominent collectors like Whistler, soon turned into a craze in England.[55] The Pennells wrote:

> In his own house in Chelsea, Mr. [Arthur] Severn [a painter and acquaintance of Whistler's] writes, "[Whistler] had lovely blue and white, Chinese and Japanese. The only decorations, except the simple harmony of colour everywhere, were the prints on the walls, a flight of Japanese fans in one place, in another, shelves of blue and white." People, afterwards, copying him unintelligently, stuck up fans anywhere, and hung plates from wire as ornaments. Whistler's fans were arranged for a beautiful effect of colour and line. His decorations bewildered people even more than the then new firm of Morris, Marshall, Faulkner and Company.[56]

Whistler's richly colored early series of Japanese-inspired portraits, painted during the winter of 1863–1864, capture the "Oriental daydream" atmosphere of Whistler's first aesthetic house more accurately than do the black-and-white photographs. In Caprice in Purple and Gold No. 2: The Golden Screen [fig. 28], for

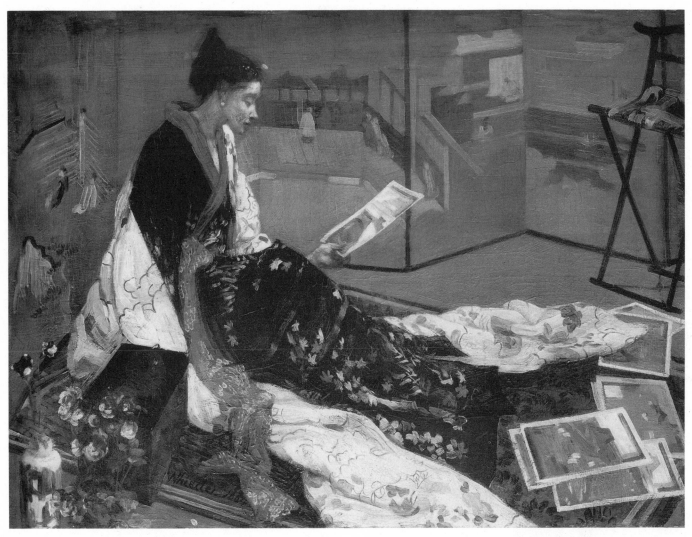

FIG. 28. Caprice in Purple and Gold No. 2: The Golden Screen, *1864, oil on wood panel, 19¾ x 27 in. (50.2 x 68.6 cm). Joanna Hiffernan is shown immersed in artifacts from Whistler's Far Eastern art collections, including a silk kimono that forms a kind of textile still life. Freer Gallery of Art, Smithsonian Institution, Washington, D.C.*

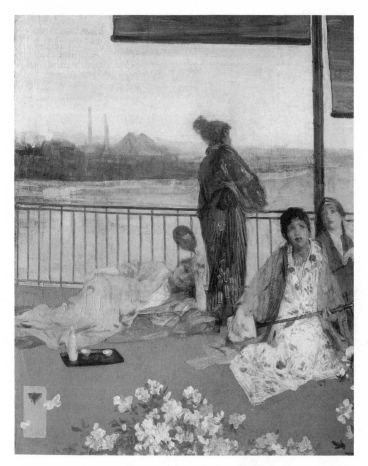

FIG. 29. Variations in Flesh Color and Green: The Balcony, 1865, oil on wood panel, 24¼ x 19¼ in. (61.6 x 48.9 cm). Models in kimonos recline on the balcony at No. 7 Lindsey Row. The grille motif common to ukiyo-e prints, formed by the balcony railing, was a pattern Whistler carried also into his interior designs. Acc. no. 92.23, Freer Gallery of Art, Smithsonian Institution, Washington, D.C.

example, Whistler depicted Joanna, her long red tresses twisted into a Japanese-style hairdo, wearing a richly embroidered black, red, and white kimono. Seated on a cinnamon brown rug, she examines a series of prints from Whistler's collection of Hiroshige woodcuts, Sixty-Odd Famous Places of Japan. She is surrounded by a decor that includes a golden screen of

the Tosa school, a porcelain vase, a lacquered box, and an Oriental folding camp chair—all items drawn from the immediate environment.[57]

Apparently, Whistler felt a need to arrange his Japanese artifacts into interior designs—even in his paintings—just at the moment that he was arranging the interiors at 7 Lindsey Row. For a while, the interior decorator facet of Whistler's artistic persona nearly overwhelmed that of the pictorial artist. His exuberant Japanese mania briefly expressed itself in the somewhat exaggerated, if delightful, manner of japonaiserie both in his paintings and in his interiors. More subtle forms of japonisme would come later.[58]

In one of Whistler's most peculiar early paintings, Variations in Flesh Color and Green: The Balcony [fig. 29], the artist invites the spectator out on his Lindsey Row balcony, where a foggy view across the Thames of industrial London imposes itself on the Oriental fantasy. In this case, the daydream includes geisha girls based on Japanese dolls that Whistler had purchased at a London shop.[59] Whistler appears to have been inspired by Kiyonaga and Eishi woodcuts when he composed this painting [fig. 30].

Japanese prints Whistler acquired at a later date are now in the Hunterian Art Gallery collection at Glasgow University in Scotland and in the Print Room at the British Museum. They include late-eighteenth- and nineteenth-century prints by Hiroshige, Utamaro, Hokusai, Kiyonaga, Shūnchō, Toyokuni, Kunisada, and Eishi. A friend of the artist commented that Whistler "grafted on to the tired stump of Europe, the vital shoots of Oriental art." The decorative patterning of the pictorial plane in ukiyo-e prints was no doubt as instructive to him for his designs of interior arrangements as for his designs for canvases.[60]

Whistler had an etching room at the top of his house and, in the back, a second-story atelier that can be glimpsed in his unfinished painting The Artist in His Studio (1865–1866) [pl. 4]. He wrote to Fantin-Latour and mentioned this painting, which "represents the

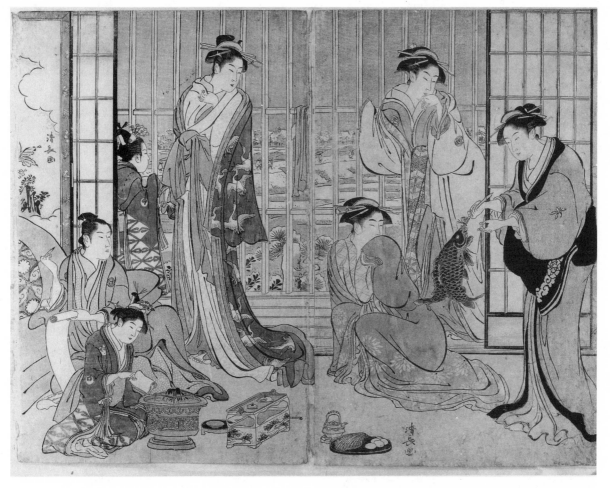

FIG. 30. *Kiyonaga*. Gentleman and Ladies at a Window
Overlooking a Snowy Landscape, *ca. 1790, Japanese* ukiyo-
e *color woodcut, 14⅛ x 20⅛ (36 x 50 cm). Formerly
in Whistler's collection, this print or a similar Kiyonaga print
was a source of inspiration for his painting* Variations in
Flesh Color and Green: The Balcony *[fig. 29]. Hunterian
Art Gallery, Birnie Philip Bequest, Glasgow University.*

interior of my studio, the porcelains and everything else . . . the White Girl seated on the sofa, and the Japanese walking around." He described the compositional colors of white, flesh color, and black against the soft grey walls of the studio.[61] Whistler was attracted to the Japanese use of subtle films of grey and would continue to use them on walls for more than thirty years. Other effects in the studio included a large mirror, a tiny print placed asymmetrically next to it, three Oriental scrolls on the back wall, and an impressively tall shelf filled with glistening blue porcelains.[62] Whistler had sketched Fantin in his studio during one of his visits. In July 1864 the French artist had written home to Paris from Chelsea: "We are leading an impossible life, all three of us, in Whistler's studio. We might be at Nagasaki, or in the Summer Palace."[63]

The Japanese-Chinese costume picture that provides the most vivid documentation of what was being accumulated at Whistler's "Artistic abode" is *Purple and Rose: The Lange Leizen of the Six Marks* [see fig. 9]. In a letter, Anna Whistler provides considerable information about this work and the exotic ambience Whistler was creating in his home.

Are you an admirer of old China? this Artistic abode of my Son is ornamented by a very rare collection of Japanese & Chinese, he considers the paintings upon them the finest specimens of Art & his companions (Artists) who resort here for an evening relaxation occasionally get enthusiastic as the[y] handle and examine the curious subjects pourtrayed [*sic*], some of the pieces more than two centuries old. [H]e has also a Japanese book of painting unique in their estimation. You will not wonder that Jemies inspiration should be (under such influences), of the same cast. (. . . he has for the last fortnight had a fair damsel sitting as a Japanese study) a very beautiful picture for which he is to be pd one hundred guineas without the frame that is always separate. I'll try to describe this inspiration to you. A girl seated as if

intent upon painting a beautiful Jar which she rests on her lap, a quiet & easy attitude, she sits beside a shelf which is covered with Chinese matting a buff colour, upon which several pieces of China & a pretty fan are arranged as if for purchasers. [A] Scind Rug carpets the floor (Jemie has several in his rooms & *none others*) upon it by her side is a large Jar & all those are fac-similies of those around me in this room—there is a table covd with a crimson cloth, on which there is a cup (Japanese) scarlet in hue, a sofa covd with buff matting, too.[64]

Whistler at first lived at No. 7 with Joanna. Though uneducated, she was intelligent, good-natured, and devoted to Whistler [see figs. 5, 9, 20, 27, 28]. But in late 1863, in the middle of the Civil War, his mother, then fifty-six, came from America to London to set up housekeeping with him. Whistler wrote to Fantin-Latour: "All of a sudden in the middle of the affair, my mother arrived! . . . General upheaval!!" Whistler quickly had to "purify" his house "from cellar to attic" and look for an apartment for Jo and Alphonse Legros, his friend from Paris. "If you could only see the state of affairs! Affairs! Up to my neck in affairs!"[65] Anna would continue to live with him until August 1875, and her influence on him was considerable, as she herself remarked. Her household economies helped him to indulge his taste for collecting, and her New England puritanism encouraged his inclination to maintain an austerity in his surroundings despite the exotic artifacts he was acquiring. To her sister Kate, Anna wrote that the simple house had an "excellent kitchen, laundry, pantries" and "delightful parlors and bedrooms."[66]

At this time, Du Maurier began to notice a change in Whistler and wrote to Tom Armstrong, a "Paris Gang" friend, in October 1863 that he had gotten the cold shoulder. "Jimmy and the Rossetti lot, i. e. Swinburne, George Meredith and Sandys, are as thick as thieves . . . their noble contempt for everybody but themselves envelopes me I know. Je ne dis

pas qu'ils ont tort, but I think they are best left to themselves like all societies for mutual admiration of which one is not a member."[67]

Rossetti: Whistler's Link to the Decorative Phase of Pre-Raphaelitism

The mutual admiration society revolved around the magnetic Dante Gabriel Rossetti, a poet and painter whom, according to George Boyce's diary, Whistler had met by July 28, 1862 [fig. 31]. This meeting no doubt figured largely in Whistler's move to Chelsea, an apparently ordinary district that in the latter 1800s became an exclusive quarter for the avant-garde. For the better part of ten years Whistler was on intimate terms with his Pre-Raphaelite neighbor and the bohemian circle of painters, poets, and designers that Rossetti attracted, including George Meredith, Frederick Sandys, William Rossetti, William Bell Scott, Algernon Swinburne, Edward Burne-Jones, William Morris, Philip Webb, Ford Madox Brown, Val Prinsep, and Charles Augustus Howell. Whistler would become particularly close to Swinburne, who had a strong influence on him and with whom he shared an interest in French literature and theory. In 1865 Swinburne tried to talk Ruskin into visiting Whistler's studio. "Whistler (as any artist worthy of his rank must be) is . . . desirous to meet you, and let you see his immediate work. As . . . he has never met you, you will see that his desire to have it out with you face to face must spring simply from knowledge and appreciation of your own works." The visit fell through; there were already signs of friction.[68]

As for Rossetti, Whistler joined him in, among other things, his ardent connoisseurship of beautiful women like the Spartali sisters, "stunners" whom they both painted. With these paintings, they paralleled the cult of Japanese artists preoccupied with depicting elegant geisha figures, and they provided a primer for a new sort of British female beauty and aesthetic fashion. The interior ensembles the two artists were creating required a beautiful woman as a central element. Particularly in Whistler's canvases of this period, the woman is treated as an objet d'art, much as the screens, fans, and porcelains with which she is surrounded. Above all, what brought Whistler and Rossetti together in their pursuit of beauty was their shared enthusiasm for Japanese design. Gabriel's brother, William, stated: "It was through Whistler that my brother and I became acquainted with Japanese woodcuts and colour-prints. This may have been early in 1863. He had seen and purchased some specimens of those works in Paris, and he heartily delighted in them, and showed them to us; and we then set about procuring other works of the same class. I hardly know that anyone in London had paid any attention to Japanese designs prior to this."[69]

Whistler's main contribution to the Rossetti set, besides the Japanese taste, was his sparkling wit. It was a strange and wonderful group. Max Beerbohm, who caricatured them, said his caricatures revealed the "silver thread of lunacy [which ran so delightfully through] the rich golden fabric of 16 Cheyne Walk." Tudor House also had a wild, neglected garden, "Eden," and a menagerie of animals almost as peculiar as Rossetti's housemates. It included a Brahmin bull, a wombat, screeching peacocks, owls, hedgehogs, dormice, wallabies, kangaroos, monkeys, salamanders, armadillos, and gazelles. Whistler certainly had a taste for the bizarre parties and fantastic goings-on at No. 16, including the seances and spiritualism that the group practiced, but he did not share Rossetti's latterday Pre-Raphaelitism in the form of a revived medievalism in the decorative arts.[70]

Nonetheless, Whistler's friendship with Rossetti provided a direct link to this major emphasis of the design reform movement in England. Unlike in Paris, where Whistler's understanding of avant-garde theory was acquired chiefly through writings, in London he

FIG. 31. *Henry Treffry Dunn. Dante Gabriel Rossetti in his*
Sitting Room at Tudor House, 16 Cheyne Walk, 1882, water-
color. Rossetti is seen reading from proofs of his Ballads and
Sonnets to Theodore Watts-Duncan. The Sheraton settee is
now in the Fitzwilliam Museum. From Henry Treffry Dunn,
Recollections of Dante Gabriel Rossetti and His Circle
(Cheyne Walk Life), *ed. Gale Pedrick (1904; reprint, New*
York: AMS Press, 1971). Private collection.

was rubbing shoulders with men such as Swinburne and Rossetti, who were at that moment formulating the fundamental concepts for the nascent aesthetic movement. Whistler was drawn into this heightened consciousness of the need to renew the decorative arts.

Rossetti, whose decorative, fairy-tale-like "medieval watercolors" were seminal images for the movement, had become involved in a venture to improve the applied arts through the decorating firm of Morris, Marshall, Faulkner and Company. The younger generation of Pre-Raphaelites, particularly Morris and Burne-Jones, looked to Rossetti as the master who represented the daring reforming spirit of the original Pre-Raphaelite Brotherhood of ten years earlier. William Holman Hunt, one of the original Pre-Raphaelites, had already taken a deep interest in the decorative arts [pl. 6]. Writing in his 1855–1856 memoirs, he said: "I had done as much as I could to prove my theory that the designing of furniture is the legitimate world of the artist. When I showed my group of household joys to my P.R.B. friends, the contagion spread. . . . After this, the rage of designing furniture was taken up by others of our circle until the fashion grew to importance." He also recalled discussions with Rossetti. "We spoke of the improvement of design in household objects—furniture, curtains, and interior decorations—and dress; of how we would exercise our skill as the early painters had done, not in one branch of art only, but in all."[71]

The decorating firm that the younger Pre-Raphaelites cooperatively launched took up the newly legitimatized decorative arts with enthusiasm. Morris, Marshall, Faulkner and Company acquired early fame partly because of the larger-than-life personality of the Oxford graduate William Morris, who was a poet, pamphleteer, reformer, architect, and, ultimately, inspired designer, practical manufacturer, and shopkeeper. As a young man Morris had been horrified by the decadent decorative arts exhibited at the 1851 Great Exhibition. He resolved to do something about the situation, and in April 1861 he stated in the company prospectus, "The Growth of Decorative Art in this Country . . . has now reached a point at which it seems desirable that Artists of reputations should devote their time to it."[72]

Rossetti's alliance with Morris and Burne-Jones, and his involvement with the design firm, continued through the 1860s, during the same period in which he was seeing Whistler daily and forming a close friendship with him. (The frequency of their contact dropped considerably after 1870.) No doubt Rossetti's potent example, and the depth of interest demonstrated by this painter of legendary mystical appeal in joining the campaign to transform the decoration and furnishings of the country, had the effect of validating such a pursuit for the younger Whistler.

In January 1861, Rossetti had written to a friend, "We are organizing a company for the production of furniture and decoration of all kinds for the sale of which we are going to open an actual shop!" Rossetti executed plans for wallpaper, stained glass (thirty known designs), and furniture. Although his designs for the firm were not numerous, he was an important catalyst. In another letter Rossetti stated: "Our endeavors here have been to make all our work more truly artistic than such work has been hitherto. We have an admirable colourist—William Morris—who gives his whole time to the work of the firm, and all that is needed in . . . design."[73] The Pennells noted: "In the arrangement of a house, still more than in the painting of a picture, before Whistler had a house to decorate, the Preraphaelites had set the fashion in England. . . . The firm with which Morris was associated, the one vital outcome of Preraphaelitism, was the authority."[74]

During this early period of design reform in Britain, Whistler's and Rossetti's interests followed similar paths. They painted spiritualized Pre-Raphaelite maidens bathed in exotic symbolist ambiences such as

they were then contriving in their own homes, and designed the frames for these paintings as carefully as the pictures themselves. Rossetti also designed illustrations, book covers, linings, and title pages, and Whistler followed his example. Unlike Morris, Rossetti was not concerned with the social implications of improving design; the same was true for Whistler. They both acquired rare collections of Oriental pots and displayed them in their homes—the main decorative enterprise that captured their imagination.[75]

Whistler, who had brought porcelains from France, had a head start on Rossetti and other collectors. Murray Marks, a young dealer in Chinese and European antiques who in 1862 had a shop in nearby Sloane Street, Chelsea, declared, "It was Whistler who invented blue and white in London." Marks helped to fan the flames of rivalry and jealousy between the two artists in their severely competitive drive to collect pots and contrive exotic settings for fashionable living. Most of their pots were Chinese porcelains of the K'ang Hsi (1662–1722), Yung Cheng (1723–1735), and Ch'ien Lung (1736–1795) periods. They bid against each other in Paris and London, acquiring vases called by the Dutch name "Lange Lysen" and ginger jars with hawthorne and blossom designs—amazing items, because they were first to discover blue and white and could obtain the best. It was Rossetti who introduced Whistler to Liberty, the energetic, progressive manager of Farmer and Rogers Oriental Warehouse and one of the first importers of porcelain. This warehouse became one of the main sources for high-quality Japanese goods. The entrepreneur's later establishment, Liberty's of London, offered interior design services, following Morris's example, and was a key porcelain importer. It became, like La Porte Chinoise in Paris, a meeting place for the apostles of art for art's sake. Liberty, a design trendsetter, was the retailer most closely associated with the aesthetic movement, and his influence would continue into the art nouveau period.[76]

Despite their shared interest in the arts of Japan,

Rossetti's idiosyncratic taste for the odd and ancient, and the picturesque disorder of his house [fig. 31], were quite unlike Whistler's preferences for light modernity and classical restraint. For example, in 1861, Rossetti designed wallpaper for his drawing room to be printed on either brown packing paper (later a favorite decorating material for Whistler) or blue grocer's paper with a pattern of trees standing above the dado the whole height of the room. His museumlike, medievalist interiors had a gloomy symbolist atmosphere replete with mirrors and paneling in somber green and were littered with a rich medley of exotic accessories. Even before Whistler's personal interiors began to attract press attention, public curiosity about the unusual setting Rossetti created had been aroused. Philip Hamerton, the English art critic in Paris, reported, "He lives in a magnificent house, furnished with very great taste, but in the most extraordinary manner."[77]

Although there was a world of difference between their personal tastes in interior decoration, together Whistler and Rossetti turned their attention to infusing beauty into the everyday framework of life. In so doing, they launched a movement with the craze for blue and white as the keynote. Rossetti was Whistler's guiding star in the sixties, and in the seventies Whistler would emerge as a decorator of original interiors. Both artists were rebelling against established forms of Victorian interior design, and their life-styles stood out with clarity from conventional patterns. As Susan Lasdun has noted, "A new ethic [was introduced] into the public sensibility, the ethic of aestheticism. The temple of this new religion in a family-dominated society was of course the home."[78] The personal interiors of Whistler and Rossetti in the 1860s epitomized the two major competing themes for fashionable avant-garde living in the early years of the British aesthetic movement: Whistler's interiors were dominated by an austerely modern *japonisme*, and Rossetti's richer ambience exemplified the taste for eclectic medievalism.

Whistler and Morris: Opposing Modes of Decor

The strong strain of romantic medieval revivalism in English interior design and architecture had evolved since the first half of the nineteenth century. Ruskin's books—*Modern Painters, Seven Lamps,* and *Stones of Venice,* especially the chapter "The Nature of Gothic," in which he stated that Gothic architecture reflected the joy of the individual workman—were considered sacred texts. They profoundly influenced the direction of the design reform movement in England. Morris and Burne-Jones, future leaders of the movement, regarded them as revelations; they were thunderstruck when they discovered them while students at Oxford University in the mid 1850s. They also read the Pre-Raphaelite journal, *Germ;* Ruskin's *Edinburgh Lectures* (1854); and Carlyle's *Past and Present* (1843). These writings espoused the ennobling ideal of diligent work as salvation and convinced them of the sanctity of a return to handcraftsmanship. They launched the *Oxford and Cambridge Magazine* on January 1, 1856, and began to cultivate Pre-Raphaelite painting. Morris continued his direct examination of plants in the countryside surrounding Oxford and perused illuminated medieval manuscripts (as had Rossetti) in the Bodleian Library. During vacations, they studied the beauty of the early Gothic cathedrals in northern France and the Low Countries. In the arts of the Middle Ages they found evidence of art meaningfully blended with life and decided to set aside their plans to become Anglo-Catholic clergymen and pursue careers in art instead. Morris started architectural training with G. E. Street, whose work showed adherence to the Gothic style. And Burne-Jones went down to London, where he sought Rossetti, the founder of the Pre-Raphaelite Brotherhood, for guidance. Rossetti was then teaching at the Working Men's College, where the revered Ruskin also taught. Morris soon followed, and in November 1856, Rossetti decided that Topsy and Ned, as the two were

known, should take over his rooms at 17 Red Lion Square.[79]

The first inklings of Morris's and Burne-Jones's design reformer personas emerged at this point. Faced with their first interior to decorate, they found they were unable to buy anything satisfactory in ready-made furniture and decided to design their own and have it fabricated by a neighborhood carpenter. In a December 1856 letter, Rossetti wrote, "Morris is doing rather the magnificent there, and is having some intensely medieval furniture made—tables and chairs like incubi and succubi [pl. 5]. He and I have painted the back of chairs with figures and inscriptions in gules and vert and azure, and we are all three going to cover a cabinet with pictures."[80] This prototypical medieval furniture of distinctly simple plank construction was decorated by the three artists with colorful paintings of knights and ladies based on characters in poems and tales by Morris, Chaucer, and Dante. It preceded by two years the similar, medieval-styled furniture by Burges [see fig. 19]. Ruskin, who became a friend and patron, was a frequent visitor to Red Lion Square and seems to have been influenced by the craft experiments going on there. In 1857, when he delivered his first lecture on socialism, "The Political Economy of Art," at the Manchester Art Treasures Exhibition, he emphasized mastering a craft before producing designs for it. This principle of practical involvement was to guide all of Morris's work. He became the leading socially conscious craftsman in the applied arts, advocating a return to preindustrial handcraftsmanship in the second half of the century in England.[81]

At the exact time that Whistler had settled in England, a historic Morris design project was taking shape. By 1860 Morris and his new wife, Jane Burden (whose strange beauty personified the Pre-Raphaelite woman), had moved into Red House at Bexleyheath, Kent. Designed by the architect Philip Webb, the picturesque house was cooperatively furnished and decorated by Morris's friends, who were mainly painters

instead of designers or architects. Red House, together with an 1857 mural based on Sir Thomas Malory's *Morte d'Arthur*, which was painted for the Oxford Union Debating Hall by Rossetti, Morris, Burne-Jones, and others, became the first two major manifestations of the second decorative phase of Pre-Raphaelitism. Morris's house—an intensely romantic, medieval red brick "Palace of Art" more affectionately known as "Hog's Hole" or "Towers of Topsy"—provided a landmark domestic interior for the aesthetic movement and the arts and crafts movement, the two decorative art reform movements that consumed the remainder of the century in Britain.[82]

Although it was a collective enterprise, the house was an expression of Morris: immensely solid, sensible, and medieval but unpretentious, if somewhat naïve and novel in execution. Morris, Burden, and Burne-Jones painted the walls with frescoes from ancient Greek tales, Arthurian legends, and Teutonic sagas. Scenes from the legend of Troy covered the staircase; Burne-Jones painted a large space in the hall with a great ship carrying the Greek heroes; on one of the doors Rossetti painted Dante meeting Beatrice. For various rooms wall hangings in coarse, dark blue serge were embroidered by Burden with daisy patterns designed by Morris. Persian carpets were laid on the bare floors, and the walls were distempered with patterns, since Morris had not yet designed wallpapers. The ceilings had exposed beams, and plain red brick fireplaces had painted tiles designed by Burne-Jones, who also designed several stained glass windows for the house. Ford Madox Brown and Philip Webb produced simple furniture such as tables and settles, with flat surfaces to be painted by Rossetti, Burne-Jones, and Morris. The elaborately furnished rooms were quite dark, not a severe departure from High Victorian decor, though handcrafted and more carefully coordinated.[83]

As a direct result of this collaborative enterprise, dedicated to creating a total work of art, Morris conceived of the idea of a return to the handcrafted methods of medieval craftsmanship guilds. "We found," he wrote, "that all the minor arts were in a state of complete degradation especially in England and accordingly in 1861 started sort of a firm for the production of decorative articles." United as an artistic community, Morris, Marshall, Faulkner and Company launched a decorative arts movement of reaction against commercial, mass-produced mediocrity in interior decorative arts, and produced handcrafted stained glass, murals, furniture, embroidery, metalwork, ceramic tiles, textiles, wallpapers, and, later, rugs and books—all based on nature and medieval or vernacular prototypes. The charismatic Morris had convinced his friends that decorating houses was a worthy pursuit for painters. The group took up Ruskin's fight against dehumanized factory production. As Burne-Jones declared, they decided to wage a "crusade and Holy Warfare against the age."[84]

Whistler never became part of such a group of socially conscious craftsmen nor formally went into the decorating business. He was, however, involved in a curious attempt by Alexander Ionides and Murray Marks to form the Fine Art Company in 1868 and 1869, together with Rossetti, Burne-Jones, and Morris as shareholders. Ionides had purchased Whistler's copper plates for his etchings, and the plan was that the company would have exclusive rights to the sale of Whistler's etchings and possibly paintings and would deal in the decorative arts and blue-and-white china.[85] Although the company was apparently short-lived, the fact that it existed points to the close connecting link between these particular figures in the design reform movement.

The artists working for the Morris company first showed their wares—stained glass, embroideries, and painted Gothic furniture—at the International Exhibition of 1862, where they won two gold medals. They continued to show at international exhibitions, reaching a wide audience. Established decorating firms, designers, and architects resented the company's intrusion, and its designers received criticism

for pseudomedievalism and amateurish technique. But sympathetic High Church architects gave commissions to the company, enhancing its reputation. The quality and originality of the company's handcrafted designs and use of rich color attracted patronage. Its first jobs were for ecclesiastical embroideries and stained glass. Through the years, the company designed interiors such as the Armory and Tapestry Rooms at St. James's Palace. Its 1866 Green Dining Room for Henry Cole's South Kensington Museum became a public exemplar of medievalist interior design in the 1860s and 1870s [pl. 5].

Whistler could not have failed to notice the impact that the Red House, the Green Dining Room, and various Morris company wares on display in its shop and at fairs had in the world of art. Nor could he have ignored the prestigious and lucrative commissions that accrued to the painters who worked for the company. They executed medievalized domestic interiors for some of Britain's wealthiest families. The middle-class aesthetic suburban homes of the utopian Bedford Park project (1875–1881) were also decorated with their products. The spirit of Gothic reform of the Morris company was bolstered in popularity by home decorating manuals, especially Eastlake's *Hints on Household Taste in Furniture, Upholstery, and Other Details* (1868), which favored simple furniture of rugged medieval character. Designer Bruce Talbert's *Gothic Forms Applied to Furniture, Metal Work, and Decoration for Domestic Purposes* (1867) likewise promoted colorful designs evocative of the Middle Ages. Later a handbook by architect Robert W. Edis, *Decoration and Furniture of Town Houses* (1881), featured Morris wallpapers, Eastlake furnishings, and bric-a-brac for an intricate, eclectic blend in the spirit of the Queen Anne style [fig. 32].[86]

From the mid-seventies, the Morris company began to be recognized as an influence in the world of design, and by the early 1880s Morris products were a household word; their reputation reached the Continent and the United States. The idea of craft

FIG. 32. *Robert W. Edis. Aesthetic-Style Drawing Room, ca. 1870. The drawing by Edis of his own densely patterned Victorian room includes a deep frieze with peacock by Stacy Marks, William Morris's Pomegranates wallpaper, and an ebonized cabinet. From Edis's* Decoration and Furniture of Town Houses, *1881.*

workshops with an underlying humanist philosophy flourished in the decorative arts, leading to the formation of a series of handicraft guilds in England in the 1880s that fueled the design reform movement. These included Arthur Mackmurdo's Century Guild (1882), the Art Workers Guild (1884), the Home Arts and Industries Association (1884), C. R. Ashbee's School and Guild of Handicraft (1888), and the Arts and Crafts Exhibition Society (1888). All of these organizations sought Morris's help and evinced his missionary spirit.

Nearly all the distinguished artists in London—

except Whistler—belonged to the Art Workers Guild. Lectures were given at the guild about his work (and it honored him with an exhibition after his death), but Whistler stayed out of it because of his theoretical conflict and probably because of the identification with Morris as the unchallenged leader.[87]

Morris's conviction, expressed in an early lecture entitled "The Decorative Arts," was that art should be a part of everyday life for ordinary people rather than something esoteric or rarefied; and interior decorative arts should have equal status with fine arts. "What business have we with art at all," he asked, "unless all can share?" He promoted a democracy of art and said that it was the "duty of those serious about the arts to save the world from the loss of art." In his "Lesser Arts" lecture of 1878, he stated his golden rule: "Have nothing in your houses which you do not know to be useful or believe to be beautiful."[88]

In an 1889 article, Sheridan Ford observed, "There are in England to-day two new and in their origin distinct methods of interior decoration. Gradually they have coalesced to a degree, though they will always retain their individual traits and differences. These two methods may be termed the *Whistlerian*, and the *English* or *Pre-Raphaelite*; the one spontaneous, fresh, simple—the other, a revival, complex, reformatory." Morris rejected Whistler's philosophy of art for art's sake. His humanist arts and crafts ideal focused on morality, on materials—wool, silk, linen, and wood—and on patterns closely based on nature's forms and medieval models. Whistler, meanwhile, favored an evocatively spare, modernist, coloristic approach flavored with exotic *japonisme*. The opposing decorative ideals of Morris and Whistler epitomized the contradictions inherent in the British aesthetic movement. Ford summed up Whistler's theory:

> [A]n outside influence, a personality, has been making itself felt in London in strange and subtle

ways. In [1863] Mr. Whistler came to live in Lindsey Row, Old Chelsea. . . . The house [was] quaint and spacious. . . . he conceived among other conceptions three simple rules for decoration, which, interpreted in words might read in this wise:—First—that a house should be a complete and dainty thing in itself—from door knocker to ridge tile. Second—that each room should be restful, with ceiling, walls and floor so treated to a sense of shelter—freedom—and completeness, terminating in the floor as the base. Third—that pure tender colours scientifically used give ease and infinite suggestion, and that color should be allowed to play about a room. . . . [He] determined to put his ideas into execution in his own house. And the memorable dinner given a few weeks later marked the date when he revealed the House Beautiful in its completeness—from the delicate turquoise blue door to the slender flower in the vase of Japan. From that day Mr Whistler has been the acknowledged leader of decoration, and the refinement of his influence can be traced in the details of daily life.[89]

Despite differences, Whistler and Morris were both examples of a unique phenomenon characteristic of the latter half of the nineteenth century in Victorian England. They were artists of the highest intellect and creative powers who felt compelled to devote serious attention to improving interior design. Professional interior decorators had not yet made their appearance, and so serious artists applied their aesthetic sensibilities to the home. Morris's call for simplicity as the "very foundation of refinement" also has a curious similarity to Whistler's ideal. However, for Whistler this meant an elegant, urban art house, whereas Morris envisioned a yeoman's cottage in rustic, storybook style enhanced with homespun fabrics.[90]

Although in his lectures Morris preached against dirt and clutter and in favor of humble practical surroundings with no-nonsense, plain white walls, the

They contained stained glass windows, hand-painted figurative medieval furnishings, handwoven patterned carpets, sumptuous hand-embroidered, patterned hangings, and hand-printed wallpapers that could require as many as thirty wood blocks for complicated designs [fig 33; pl. 5]. A later disciple, C. R. Ashbee, recognized the fallacy in Morris's socialistic theory of interior decoration, and wrote in his memoirs, "We have made of a great social movement, a narrow and tiresome little aristocracy working with great skill for the very rich." Morris himself expressed concern about "ministering to the swinish luxury of the rich." During just the ten years following the establishment of the company in 1875, Morris created over six hundred flat and usually complex designs for wallpapers, chintzes, damasks, carpets, tapestries, rugs, stained glass, and embroideries.[91]

Morris's medieval escapist dreams expressed in these slavishly handcrafted interiors were as intense as Whistler's equally romantic Oriental fantasies. Morris, who was better known as a poet than as an upholsterer, wrote in his enormously popular 1868 poem *The Earthly Paradise* about his desire to forget ugly reality and escape to a better world.

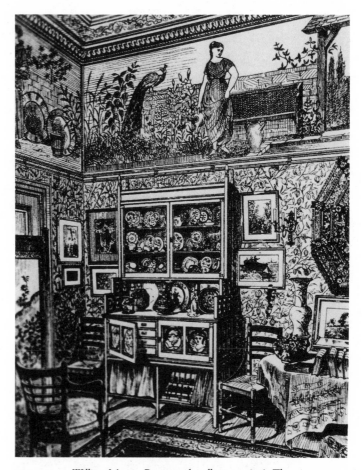

FIG. 33. *William Morris. Pimpernel wallpaper, 1876. The dining room at Morris's Kelmscott House was covered with this paper. 56526 E. 497-1919, Victoria and Albert Museum, London. By courtesy of the Board of Trustees.*

> So with this Earthly Paradise it is,
> If ye will read aright, and pardon me,
> Who strive to build a shadowy isle of bliss. . . .
>
> Forget six counties overhung with smoke,
> Forget the snorting steam and piston smoke,
> Forget the spreading of the hideous town;
> Think rather of the pack-horse on the down,
> And dream of London, small and white and clean,
> The clear Thames bordered by its gardens green; . . .
>
> Pass now between them, push the brazen door,
> And standing on the polished marble floor
> Leave all the noises of the square behind;
> Most calm that reverent chamber shall ye find,

> Silent at first, but for the noise you made
> When on the brazen door your hand you laid
> To shut it after you—[92]

Morris's desire for a reverent chamber to shut out grimy nineteenth-century industrial London paralleled Whistler's dream of stately halls of fair gold.

In "Impressions du Matin," Oscar Wilde imagined one of Whistler's foggy grey nocturnes transformed into shadowy walls.

The Thames Nocturne in blue and gold

Changed to a harmony in gray:

A barge with ochre-coloured hay

Dropt from the wharf; and chill and cold

The yellow fog came creeping down

The bridges, till the houses' walls

Seem changed to shadows . . .[93]

Whistler's vaporous nocturnal paintings [see figs. 11, 38; pl. 2] and also the walls of his interiors were fugitive, dematerialized, seemingly composed of shadowy yellow-grey fog. In fact, his yellow walls were underpainted with tones of grey—a well-known interior design trait of the artist's. Chrome yellow was his distinctive, Japanese-inspired signature color, but it was tempered by the shades of dun used as a base coat.

Not surprisingly, Morris seems to have scrupulously avoided making specific comments on the peculiar interior design practices of the litigious representative of the opposition. Nevertheless, he specifically criticized the use of "dull grey" and "dirty no-colour shades." Grey was identified with Whistler, as was yellowish green. In an 1882 lecture, "Making the Best of It," Morris stated his "special and personal hatred" for "a dingy bilious looking yellow-green," assuring his audience he had not "brought it into vogue" and telling them not to use it.[94] And in the "Lesser Arts" lecture, when talking about proper wall color, Morris also expressed his doubts about pure colors (though he himself had used primary colors in his early schemes). He seemed to imply that bright colors were immoral. He particularly went out of his way to condemn the use of yellow, stating, "Yellow is not a colour that can be used in masses. The light bright yellows, like jonquil and primrose, are scarcely usable in art, save in silk. . . . In dead matts, such as distemper colour, a positive yellow can only be used sparingly in combination with other tints."[95] Such pronouncements probably were enough for Whistler to distemper many rooms with flat yellow, grey, and yellow green. These were

the unlikely schemes, usually based on secondary and tertiary colors, that Whistler managed to make seem bizarre, scandalous, and outrageously modern all at the same time.

For his part, Whistler certainly disdained quaint Morris pseudomedieval interiors decorated with fabrics and wallpapers in busy conventionalized botanical motifs repeated endlessly. The English public disagreed with Whistler. Morris is known as the father of modern wallpaper, and his beautiful floral designs, coordinated with textiles, became widely known and remain part of the cherished heritage of the English people. Morris designed more than fifty patterns, including *Daisy, Trellis, Pomegranates, Jasmine, Willow, Pimpernel* [see fig. 33], *Sunflower, Honeysuckle,* and *Bachelor Button.* As charming and appealing as these patterns might be, they effectively killed any paintings or prints placed on them. Whistler's penchant for luminous chambers was a logical antidote to London's dark and dreary skies as well as a reaction to the gloomy complexity of Morris's wallpapers, produced in somber colors.[96]

It seems quite likely that Whistler studied the *bijinga* prints of artists from the Kansei period (1789–1801) such as Utamaro and Eishi, which would have made him aware of the effectiveness of the Kitsubushi technique of using an undifferentiated yellow ground.[97] Whistler adopted this characteristic device to use as a stunning interior backdrop in a period when people commonly wore black and furnishings were often ebonized or japanned black.

The distemper Whistler used was a flat paint composed of lime pigment, water, and a glue binder. It lent itself to a wide variety of delicate powdery pastels, whereas oil-base paints had a very limited range of colors. The matte-finish washes of subtle colors in Japanese prints no doubt led him to consider more-nuanced possibilities for wall colors. Distemper did not distract from the pictures, and it cost very little, which made a Whistlerian interior inexpensive, whereas Morris's elaborate, labor-intensive

decorations required wealthy clients able to invest thousands. This is an irony in view of Whistler's proclaimed elitism, as expressed in his "Ten O'Clock," and Morris's desire to democratize the arts, as propounded in his "Lesser Arts" lecture. The Pennells noted Whistler could arrange a beautiful room for "about five dollars." Also, Morris's cozy, patterned interiors remained rather Victorian looking, whereas Whistler's purified rooms suggested a new sort of interior world.[98]

In 1885, when both Oscar Wilde and Morris were lecturing throughout the country on interior decoration, Wilde borrowed ideas from Morris as well as from Whistler. But his Whistlerian indoctrination held on the point of wall treatment. In a May 16, 1885, letter to the arts and crafts designer W. A. S. Benson, Wilde wrote:

> I don't agree with you at all about the decorative value of Morris's wallpapers. They seem to me often deficient in real beauty. . . . Then as regards design, he is far more successful with those designs which are meant for textures which hang in folds than for those which have to be seen flat. . . . I am surprised to find we are at variance on the question of the value of pure colour on the walls of a room. . . . I have seen far more rooms spoiled by wallpaper than anything else: when everything is covered with a design the room is restless and the eye disturbed. . . . My eye requires a resting-place of pure colour, and I prefer to keep design for more delicate materials than paper . . . and the only paper I use now are Japanese gold ones . . . with these and with colour in oil and a lovely house can be made. . . . Anybody with a real artistic sense must see the value and repose of pure colors.[99]

Wilde hoped wallpaper would be used much less frequently and that Morris would put his talents to dyeing and designing textile fabrics. Whistler's mode of decoration was achieved through spacing, balance, proportion, and tonal harmony—the total arrangement and disposition of colors within an entire room—rather than through highly patterned individual surfaces. He repeatedly referred to his color arrangements as "scientific" and sought to control the whole environment through color. Whistler's experiments helped to bring about a new attitude toward the role of color in interior design as an agent to generate mood, promote unity, and achieve beauty.

Whistler's ideas for harmoniously colored distempered walls eventually filtered down to affect popular taste. Mrs. H. R. Haweis, an occasional guest of Whistler's and a writer of self-help decorating manuals, seemed to be parroting Whistler, in *The Art of Decoration* (1889), when she declared: "The walls are a background not only to furniture, not only to faces, but to dresses, and they ought to harmonize with the main pieces of furniture. . . . Distemper is so cheap . . . that people really might indulge oftener in the luxury of a clean coat for their room."[100]

In 1904, Richard Norman Shaw, by then the dean of domestic architecture, expressed his regret that good design was thought of as "pattern repeated *ad nauseam*." He reflected the influence of Whistler when he said, "The art teaching of today follows in the steps of William Morris, a great man who somehow delighted in glaring wallpapers. The kind of paper-hanging that we need most of all is . . . 'tone' wall-paper." The repose achieved by broad unarticulated expanses of plain walls, usually in neutral tones, was fundamental to Whistler's decorating style. As the Pennells observed, "Whistler was simple, Morris was complex." They reported that in Whistlerian rooms pattern never disturbed the simple wall spaces that were delicately flushed with color [pls. 9, 10] and that after his second Chelsea house Whistler had effectively eliminated pattern from his decor.[101] He may well have taken this position in conscious opposition to excessively patterned English interiors. The flat distempers used on his walls were reminiscent of the whitewashed walls of quiet, simple old New England

and American Shaker houses. He had lived in such austere houses during his youth, the memory of which his mother's constant presence must have helped to perpetuate. Whistler's study of Dutch and Spanish paintings, which featured rooms with whitewashed walls, provided another source for this natural preference.

Mortimer Menpes wrote that Whistler had very strong views on house decoration and could not abide crass Victorian decor, and he recalled the artist's ideas about covering walls with distemper.

> It was clean and easily renewed, and with it one procured a finer quality of colour. If Whistler were distempering a small house, his first thought would be to create a oneness of colour throughout. For example, he would never dream of introducing into an old-rose room lemon yellows, apple greens, and Antwerp blues: such a room in his opinion must be of one simple, broad color. . . . The tones that appealed to him most for distempering rooms were lemon yellow, Antwerp blue and apple green. But there was nothing that Whistler loved more than a plain white room. White appealed to him. He loved the silvery greys that one sees in the interior of large white rooms. I have often heard him say that the apartment which attracted him most of all in people's houses was the pantry, which had "nice whitewashed walls." The woodwork of a room he generally liked to have all white: a true white—no subtleties, no cream or ivory tones, but—a clean flake white nothing added.[102]

Morris, who became increasingly renowned for richly patterned wallpapers as his career progressed, had actually introduced crisp whitewashed walls in Red House. The pale distempered walls were considered radical at the time. In 1883 Morris was still promoting white walls as "a perfect foil to most colours." Whistler shared Morris's sensitivity to color. It led

him away from the harsh, dark jewel-toned palette of purple, sage green, maroon, Prussian blue, and mahogany of High Victorian interiors toward more subtle tertiary and secondary hues.[103] And his view that walls should serve as backdrops for collections of art and people precluded the use of richly patterned wallpapers. Walter Crane, a contemporary and a key figure in the design reform movement, recognized the essential difference between Morris and Whistler as decorators.

> In many ways Whistler, though distinctly a decorative artist, was the complete antithesis of William Morris. Mr. Pennell makes a true remark in his book in speaking of Whistler's ideas in decoration when he says . . . "Colour for [Whistler] was as much decoration as pattern was for William Morris." One would be inclined however to qualify this by saying that Whistler's main principle in decoration, in which he showed a fine taste, was by *tones* of colour; especially was he successful in the choice of pale delicate tones. Whistler appeals to one as a great craftsman in *tone*, rather than as colorist. . . . Whistler by the way, who must be numbered with the decorators, showed unmistakably in his work, the results of a close study of Japanese art. His methods of composition, his arrangements of colour declared how he had absorbed it.[104]

If Whistler was the master of tonal wall color for interior schemes, Morris was the greatest pattern designer England ever produced.

Ascetic Japonisme *or Medieval Moralism?*

An equally striking difference between the two decorators was the socialist-moralist cast that Morris insisted upon placing on the crafts—an approach that Whistler eschewed entirely. (Indeed, this was an era

in which an 1875 article in the *Furniture Gazette* was actually entitled "The Moral Influence of Decoration.")

Even in his two-dimensional designs, which he created mainly for textiles and wallpapers, Morris found morality to be a crucial ingredient. "No pattern," he stated, "should be without some sort of meaning." He unwaveringly followed Ruskin, who had promoted a taste for rich handmade surface ornament as evidence of man's labor, which he considered sacred. The creation of decorative interiors with highly patterned surface designs based on the direct observation of nature was thought of as an act of homage to God's natural world.[105] He believed a well-designed, more artful environment would be morally uplifting to the occupants of the home; it was not only beautiful but good for them. Meretricious decor, then, might be linked to immoral behavior, as Pre-Raphaelite William Holman Hunt's painting *Awakening Conscience* (1853) suggests [pl. 6]. This "white girl" seems sullied by the vulgar Victorian interior, with its blatant, philistine veneers and strident, sexual reds, as much as by her rude suitor.

Whistler, of course, required no ethical cast or meaning in his interior designs beyond pure aesthetic beauty. He made no attempt to invest the decorative arts with high-minded morality or political associations in the mode of Morris. Anna Whistler's unrelenting religiosity possibly contributed to Whistler's refusal to mix art with morals. Yet the ascetic propensities in his interiors betrayed moral qualities of honesty and integrity; and his white-and-gold, blue-and-yellow, and flesh color-and-grey arrangements resulted in spiritualized, serene settings.

Whistler voiced his opinion of Morris's "artist as preacher" philosophy in an early 1890s letter. While living in Paris, when anarchists were daily setting off bombs, Whistler wrote to a friend, "For my part a little healthy American lynching would be the proper thing for these scoundrels—But I should begin by seizing

the preachers and philosophers who do the mischief and keep out of danger. I think our friend William Morris in London is more or less one of these!"[106]

Though his biographers, the Pennells, characterized Whistler as a "master decorator," much of his effort was directed toward making decorative schemes for his own pleasure. Few could accept his ideas of pure beauty in an era dominated by a Ruskinian ideology that demanded literary, moralistic, and medievalist overtones even in the walls, fabrics, and furnishings of ordinary rooms. As a disciple of Ruskin, Morris found Whistler's amoral approach to the arts unconscionable. He revealed his conviction that such work was without value when he commented on Whistler's nocturnes, stating that there were "clever and gifted men of the present day who are prepared to sustain as a theory that art has no function but the display of clever executive qualities." Such pictures, Morris said, seem "intended to convey the impression of a very short-sighted person of divers ugly incidents seen through the medium of a London fog."[107]

While Morris reveled in the medievalist romanticism [see pl. 7] of his interior designs and poems, apparently he was not inclined to allow Whistler the romanticism of mist-laden nocturnes and Japanese-inspired interiors [see figs. 11, 38; pls. 2, 12]. In an 1889 essay, "Textiles," which appeared in the catalogue for the first exhibition of the Arts and Crafts Exhibition Society, Morris took a stand against the rage for Japanese arts. "It may be well to warn against . . . the feeble imitation of Japanese art which are so disastrously amongst . . . us.[108]

Morris seems not to have been fundamentally influenced by Japanese art. Nevertheless, in addition to his preference for distempered walls in his personal rooms, he had a keen desire to simplify crowded Victorian houses.[109] In his "Lesser Arts" lecture he said, "As for movable furniture . . . don't have too much of it; have none for mere finery's sake, or to satisfy the claims of custom. . . . But . . . it is almost the universal

custom to stuff up some rooms so you can barely move in them" [see figs. 12, 32]. With this idea Whistler entirely concurred. Both Whistler and Morris loathed the typically overdone, labyrinthine Victorian decor of the day and rebelled against the prevalent attitude that empty spaces were there to be filled to the point of claustrophobic density. Whistler carried his desire to purify interior spaces to the extreme of eliminating comfort as well. Unquestionably he was influenced to design spaces nearly devoid of furniture through his study of Japanese interiors in illustrations, photographs, and prints. It is also important to note that neither Whistler nor Morris was deeply involved in furniture design, each being preoccupied, rather, with the design of flat surfaces.[110]

Unlike Morris, Whistler remained cosmopolitan and contemporary in his interior designs. His varied background, which included his years spent in Russia, America, and France, gave him an ability to escape the cul-de-sac of imagining that a return to a fabled Gothic past in design represented the path to the future. Although Whistler drew upon many cultures for his interior design concepts, his house decorations were as modern as his paintings. He ridiculed Morris's sham medieval rooms, like those in his Georgian house at Hammersmith, to which Whistler alluded in his "Ten O'Clock." He found Pre-Raphaelite vernacular furniture, stained glass windows, dark tapestries, and drab green wallpaper oppressive, if not simply absurd.

Living out of his time had no appeal for Whistler. His interest in progressive modernism precluded the pretense of decorating small houses in the midst of modern London to resemble medieval castles. Menpes stated, "He could not bear vulgarity and the foolish struggle to turn suburban villas into palaces. He abominated the pretentious dado, the converting of drawing-rooms into bric-a-brac shops, the crowding of knick-knacks, and the distribution of superfluous objects conspicuously because of their associations."[111]

As the interior-arts-obsessed nineteenth century progressed, psychological implications of interiors such as those Morris and Whistler contrived—which seemed to demand that a decorative woman remain trapped inside the schemes to complete them—began to be explored. A comparison of Morris's *La Belle Iseult* [pl. 7] and Whistler's *Princess from the Land of Porcelain* [pl. 8] illustrates this point—that both artists conceived of a beautiful woman as a necessary objet d'art for their interior-decorated worlds.[112] The remarkable similarity of these two portrait paintings also suggests Whistler paid close attention to Morris's exotic, medievalized interior design program and consciously departed from it in his embrace of *japonisme*.

The opposing aspects of Whistler's and Morris's styles of interior design may be summed up briefly as: pure color versus naturalistic pattern, *japonisme* versus medievalism, art for art's sake versus democratic and socialistic values, stark modernity versus vernacular nostalgia.

The House Goes on Perfecting Itself: No. 2 Lindsey Row, 1867–1878

During the period in which Morris, Marshall, Faulkner was building its reputation as a prestigious decorating company, Whistler was working to develop himself as an independent decorative artist. In late 1866 he returned from a mysterious sojourn to Valparaíso, Chile. He had brought along a little notebook with a dark green silk moiré cover in which he sketched a floor plan, as though he were dreaming of possibilities for his next home. In February 1867 he moved into a more elegant three-story house just a few doors down from his first home. No. 2, a remodeled part of the original palace, was at the east end of Lindsey Row (now 96 Cheyne Walk). It fronted on the river and, like his first home, is still standing. It may have reminded him of his childhood home in St. Petersburg, Russia, near the Neva River. It was similar

to No. 7—narrow, white, and with two large front windows. Like Rudolph, in Henri Murger's tale of bohemia, Whistler may have initially felt "that secret anxiety which almost always one experiences on entering a new apartment." But like his fictional counterpart, he soon held a congenial housewarming party. William Rossetti recorded a few impressions of the gathering in his diary on February 5, 1867. "Accompanied G[abriel] to Marks's, to look at the Chinese furniture he has bought there. . . . Went on to dine with Whistler, for his housewarming at his new house in Lindsey Row. There are some fine old fixtures, as doors, fireplaces, etc.; and W has got up the rooms with many delightful Japanesisms etc. Saw for the first time his pagoda cabinet."[113]

In the second house, Whistler continued his intense experiments with interior decoration, which evolved in the direction of greater simplicity. The impression one gets from various accounts is that while the interiors were still predominantly Japanese in style, they were also considerably more elegant and orderly. He had given up his most obvious phase of *japonisme*, probably partly because he saw that it led to pastiche when borrowed by people who thought it fashionable to decorate with cheap "Japanesisms." To his American friend Samuel P. Avery he wrote, "The house has gone on perfecting itself as you will see on your return."[114]

A series of 1877 letters written by the American artist Julian Alden Weir (whose father, Robert, had been Whistler's drawing instructor at West Point) dispel any notion that the "Japanese artist in Chelsea" had become down-to-earth. Weir's comments on the atmosphere of London also suggest reasons why Whistler might have felt a need to retreat into an artificial, decorated, Oriental world.

> London is gloomy, sad and dirty to me after leaving Paris . . . the sun that shines here is not bright and cheerful . . . the people are semibarbaric, the language sounds harsh on the

streets. . . . everything seems heavy, awkward and without taste. . . . We are talking of going down to Chelsea to call on Whistler. . . . I hear that he has brought a suit against Ruskin for some criticism that he wrote on some of his exhibition pictures.

> [He continued in another letter.] Yesterday we all went out to visit Turner's house in Chelsea. We afterward went and called on Whistler, who we found a snob of the first water, a first class specimen of an eccentric man. His house is decorated according to his own taste. The dining room is à la Japanese with fans stuck on the wall and ceiling, according to his own liking. He showed us some of his nocturnes . . . best seen in a demi obscure room with the light softened by passing through several thicknesses of curtains. He showed us afterwards his studio or, as he called it, his workshop. His palette was a mahogany table about 3′ in length, with the colors set there on. . . . His talk was affected and like that of a spoiled child, hair curled, white pantaloons, patent leather boots and a decided pair of blue socks, one eyed eye glass and in escorting us to the boat, he carried a cane about the size of a darning needle. Alas! this is the immortal Whistler who I had imagined a substantial man.[115]

Walter Greaves, Whistler's neighborhood assistant who rowed him around the Thames River at night looking for nocturnal compositions and occasionally helped him distemper a room, said the dining room at No. 2 was blue with a darker blue dado and doors. A flight of purple Japanese fans in silken tissues was fastened on the walls and ceiling. Like Manet, Degas, Gauguin, Toulouse-Lautrec, and Pissarro, Whistler painted decorative designs on fans [fig. 34; see also figs. 9, 20, 27, and pl. 8]. Fans soon became ubiquitous in British homes, as an early Du Maurier cartoon suggests [fig. 35].[116]

Occasionally a flower-strewn Japanese bowl could

FIG. 34. Decorated Fan, *late 1860s, watercolor, related to the Six Projects. From Pennell and Pennell,* Life of James McNeill Whistler, I, *opposite 144.*

be found in the center of Whistler's dining room table containing three goldfish swimming to and fro. And whereas Morris's rooms had wallpapers based on natural flora, Whistler's rooms had fresh flowers. There might be a jar containing nasturtiums, water lilies, azaleas, roses, or a single tall lily. Flowers, especially those redolent of the Far East, were an integral part of his interior designs. During the aesthetic period, flowers were considered important symbols of beauty and took on cult status. Once, a nearsighted woman mistook Whistler's Japanese bath with lilies as a divan and tried to sit in it.[117] Undoubtedly the Japanese artist in Chelsea arranged flowers with the same taste for delicacy and Oriental asymmetry as he displayed in the placement of flowers in his portraits [see figs. 20, 27, 28, 29, 37, pl. 11].

Whistler began to entertain formally in his cerulean blue dining room in the late 1860s. For his first dinner party, pots and pans were borrowed from an early supporter, Mme Emilie Venturi. Mrs. Leyland loaned her valet and with her sister put up muslin curtains at the last minute. Whistler preferred plain curtains that allowed the light to filter through and flow softly into the room, but he sometimes used flowered chintz. This was in direct opposition to the Victorian practice of inviting gloom and obstructing disagreeable conditions with stained glass, small windows, and heavily patterned draperies. As Alan Cole remarked, Whistler's "house was full of light."[118]

The fashionable world flocked to Whistler's softly lit, sparsely decorated "Japanese" house at 2 Lindsey Row. He was a cordial, sunny host and, above all,

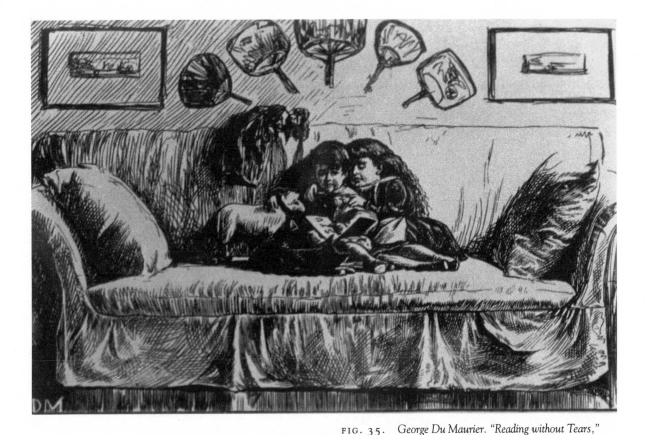

FIG. 35. *George Du Maurier. "Reading without Tears,"
cartoon in* Punch 56 *(February 27, 1869): 80. Whistlerian
decorative touches in the cartoon include Japanese fans arranged
on the wall, tiny pictures with wide mats and narrow frames,
and a sofa draped in soft, plain fabric.*

fashionable. His parties were chic and slightly bohe-
mian, and for his dinners and breakfasts Whistler took
infinite pains to arrange the table with fastidious care
so that everything he placed on it was beautiful. In
1873, he invented his famous "Sunday breakfasts."
His American-style breakfasts soon became a London
ritual. Through the years Whistler made buckwheat
pancakes with molasses for a roll call of the rich and
the famous. Artists, stars of the stage, writers, diplo-
mats, aristocrats—guests from all levels of society
were invited. The ladies wore a little yellow or blue to
match the colors of the dining room as if they were

characters in a drama. The women were indeed part
of the plan, part of his *coeur de femme*. A beauty like
the actress Lillie Langtry, whom he introduced at one
of his breakfasts, could be counted upon to lend style
to his dramatic gatherings.[119]

Whistler designed invitations for his frequent
dinners and breakfasts and devised menus, all signed
with his butterfly monogram "JW" [fig. 36]. More than
a hundred of these menus, handwritten in French, still
exist. He served mainly French and American foods.
He might offer simple fare such as Baltimore chicken
with hominy and bread sauce, or omelets with cheese,

FIG. 36. *Menu with Butterfly, January 7, 1875. Whistler designed this menu for one of his famous dinner parties. Whistler, W839, Birnie Philip Bequest, Glasgow University Library.*

smoked fish, curried lobster, saffron eggs, salmon, and hollandaise sauce, soup Nouvelle Orleans, polenta, pressed beef, tomato soup and oysters à l'Américaine, fish cakes, green corn, apple pie, and perhaps a Moselle wine that the Prince of Wales favored. Guests never knew what to expect. But for the ten or twenty invited, it would not be dull.

Sunday breakfast guests were wise not to arrive much before two; any earlier and they were likely to catch Whistler splashing in his bath behind a folding door. He was notoriously late even to his own parties.

But when he finally made his entrance, his panache and high spirits were infectious, and despite his painstaking planning, everything seemed spontaneous and informal. Whistler went around the table pouring some special burgundy wine and pacing his conversation for dramatic pause. He might sketch the guests and hang the drawings around the dining room or make a drypoint of someone. He was eager for gossip, which he loved, and he could be counted on to scintillate with wit, all the while preparing buckwheat pancakes at the fireplace in the corner.[120]

In 1877 Alan Cole received an invitation to report for breakfast. "But you must be here on Sunday morning at 12—hungry for half past 12 o'clock breakfast sharp *Buckwheat Cakes!* & molasses."[121] In his diary Cole recorded the conversations and artistry of a series of dinners in the seventies. He noted that on one occasion after dinner Whistler read to his sophisticated guests from Bret Harte's *Luck of Roaring Camp*, *The Outcasts of Poker Flat*, and *Tennessee's Partner*. Mark Twain's tall tales, Edgar Allan Poe's mysteries, and Rossetti's limericks were other after-dinner delights. Nor did Whistler neglect his obsession with the press. He loved to quote American newspapers like the *Danbury News* and the *Detroit Free Press*, and there were also "hot discussions" about Gustave Courbet and the Commune, Napoléon, Diego Velázquez, Honoré Balzac, Japanese art, the Comédie Française, Sarah Bernhardt, and spiritualism (in which Whistler believed). In and around the literary smorgasbord, laughter, and high jinks was the splendid aura of the aesthetic decor that helped Whistler to mesmerize his guests. He meticulously arranged his china, Japanese lacquers, silver, and linens embroidered with butterflies—the light and graceful things he had been collecting for years—to stunning effect. Cole recalls many of the beautiful items such as "Japanese birds" that the guests could visually savor while savoring the food and conversation, as well as a discussion of Whistler's "Japanese woman" and "a decorated room for

the [South Kensington] Museum." Finally, Whistler would bring out some recent works and show them one-by-one on an easel.[122]

The news of Whistler's talent for creating theatrically aesthetic dining experiences, widely known in London, eventually reached America and the Continent. In 1878 a writer for the *Saturday Review* credited Morris and his friends for beginning the revolution "in a mild and unassuming way. . . . They went to work to adorn the dining rooms of the many honest people who awoke and found themselves rich some fifteen years ago, in what they conceived to be the medieval style. . . .[Recently] the enterprising Mr. Whistler performed a sudden fantasia of colour and gilding." In the Peacock Room Whistler "set up a type of . . . festive decoration. Walls and roofs were converted into a meteor of flashing golden birds of paradise floating for ever through a heaven of blue."[123] Whistler's famous yellow decorative fantasias had especially been taken to heart, as an article in the *Leicester Post* reveals.

> Yellow is the fashionable colour for table decorations at present, and some charming effects have been lately produced by means of yellow satin and daffodils. Imagine a long strip of amber satin, placed upon the table, with a big bowl of daffodils in the center, and small vases of the same pretty flowers arranged on the mats at intervals. Then imagine a hanging lamp and candles with shades of yellow silk, and menus and namecards decorated with sketches of daffodils. Then put posies of daffodils here and there at the edge of the satin, tied up with long green tulip-leaves in lieu of ribbon, and say whether this would not be a harmony in yellow sufficiently pretty to delight the heart of Mr. Whistler himself.[124]

One can almost hear Whistler convulsed with laughter as he affixed this article to the page of one of his press clipping albums—where it can still be found today.

The impact of Whistler's coloristic concepts of aesthetic dining ranged from the sublime to the ridiculous, apparently. In an 1885 issue of *L'Art Moderne* it was reported: "Without a doubt there is some art in fricasseeing a chicken or in making an omelet. . . . include there the exquisite refinements of the painter Whistler who, when he invites his friends to lunch, has his guests served on Japanese plates whose shades he harmonizes with the color of the sauces and the tint of the food." Not all of Whistler's guests were charmed by Whistler's color symphonies in dyed-to-harmonize food. But he maintained that a dinner should aim "at a certain harmony throughout." He said, "Wasn't I the first to give white and yellow lunches, an idea copied everywhere afterward with great pretense of originality?" Menpes recalled that the artist was a purist "in cookery as in all things" but that the uninitiated "did not care for tinted rice pudding, and butter stained apple-green they looked upon with suspicion."[125] Whistler must have taken devilish delight in serving yellow sauce and green corn on blue-and-white plates to guests dressed in yellow and blue.

Whistler's light-hued drawing room at 2 Lindsey Row, which was carpeted with matting, had windows overlooking the Thames River. At night it was lit by a "beautiful Venetian lamp . . . Mme. [Venturi's] gift to the drawing room." It was a contrast in tone to his darker dining room and can be visualized from a *Baltimore Bulletin* article that Anna Whistler clipped and sent to her son at Speke Hall. The reporter commented on Whistler's well-known enthusiasm for Japanese and Chinese art and the Oriental influence in "the decoration of many rooms." He noted that the decor included "brilliant Japanese fans" and fifteen "large panels of Japanese pictures, each about five feet by two" of flowers and richly plumaged exotic birds, an ancient Chinese cabinet with a small pagoda on top, an old Japanese cabinet and several screens, "altogether making one of the most beautiful rooms

imaginable."[126] In 1870 Whistler's mother wrote that she had invited a child in to share coffee, toast, and a ripe pear. They went into the drawing room (Whistler referred to it as a "*withdrawing* room") to sit by the window, "but his attention was diverted by the Japanese novelties which decorate the drawing room and the studio opposite." In another letter Anna referred to her "Japanese bedroom," and Whistler is known to have slept in a huge black-lacquered Chinese bed with a great oval canopy and to have hung his painting of his mother in his bedroom.[127]

So it is apparent that Whistler did not retreat from his Oriental decorating style in his second home as has sometimes been assumed; rather, he refined it. An inspection of the backgrounds in the portraits Whistler painted at this house suggests a more fully assimilated, far more sophisticated *japonisme* than is revealed in his early, more obvious Japanese portraits. His stark paintings of his mother [pl. 1], Thomas Carlyle (*Arrangement in Grey and Black No. 2: Portrait of Thomas Carlyle* [1872–1873]), and Cicely Alexander [pl. 11] have serene, uncluttered abstract arrangement. In them, asymmetrical balance is used in the placement of striped matting, black dado, framed pictures, drapes, and battens. The neutral planes, blank spaces, and diagrammatic patterns correlate with Far Eastern values, and a sense of classical repose is also discernible. These traits also characterized his interior design style, which had begun to reveal his minimalist inclinations.

His painting of Frances Dawson Leyland [fig. 37], completed in the drawing room of No. 2 Lindsey Row, reveals the new subtlety. Like the dining room, this room was not finished until the day of Whistler's first dinner party, and there was a mad rush to complete it on time. Whistler drafted his neighborhood assistants, Walter and Henry Greaves, to lend him a hand, and they told him it would not be dry for the party. By the evening the walls were distempered with flesh color, pale yellow, and white, and the *kakemonos* were in

place. No doubt the clothes of the guests were also touched with this subtle color harmony that night.[128]

The beautiful, red-haired Mrs. Leyland's haute couture portrait reflects the feminine character and monochromatic scheme of this room. She is posed in front of a pale peach wall with white paneling in a matching flowing chiffon dress caught with scattered rosettes. Whistler designed the diaphanous, high-waisted, aesthetic gown specifically to harmonize with the setting. The whole ensemble demonstrates his extreme sensitivity to tender color and his desire to make his interiors delicate and unified. Even the checkered rush floor matting in gold and white was probably designed by Whistler specifically for the room.[129] This portrait, with its back view, resembles fashionable *ukiyo-e* prints of women by Utamaro and Kiyonaga [see fig. 30] and simultaneously evokes the pose, costume, and coloration of a Watteau painting, suggesting that the room itself may also have combined Eastern and eighteenth-century French rococo elegance—a combination that anticipates some art nouveau interiors of the 1890s.

As in his first home, Whistler painted his studio grey with black oak floor, doors, and paneled dado; it was a bare second-story back room. This "workshop" was in deliberate contrast to the typical Victorian artist's studio, which was self-consciously set up to look "artistic." Whistler had a lofty contempt for show studios. Like Marcel in Murger's tale, he limited his decor mainly to a great screen, which he covered with brown paper and painted with an abstract bridge that bisected the two panels [fig. 38]. To the screen he added a suggestion of Chelsea across the Thames and a moon (the reverse side is a bird-and-blossom design on Chinese silk) and entitled it *Blue and Silver: Screen with Old Battersea Bridge*. Such Oriental screens would become ubiquitous accessories in artists' studios and homes. Typically, Indian muslin curtains covered the windows of his studio to soften the light for a somewhat diffused effect.[130]

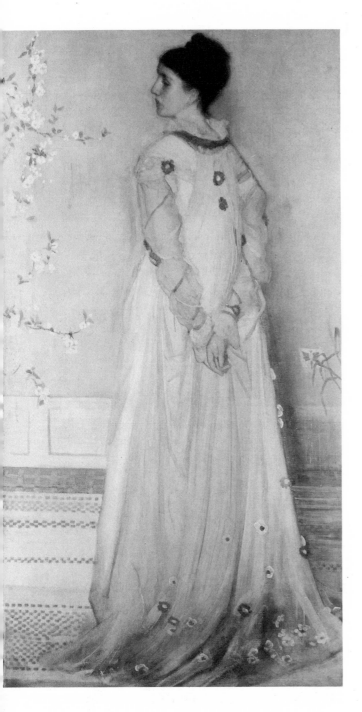

FIG. 37. Symphony in Flesh Color and Pink: Portrait of Mrs. Frances Leyland, *1871–74, oil on canvas, 77⅛ x 40¼ in. (195.9 x 102.2 cm). Mrs. Leyland stands in Whistler's delicately colored drawing room at No. 2 Lindsey Row, which has a paneled dado and checkered floor matting. The artist also designed her coordinating gown. Frick Collection, New York.*

Whistler had to "make do" with this studio, but he was not content. In July 1870 he tried to rent Merton Villa in Fulham for "less than £310." His mother wrote to her son's solicitor, "Jemie says all the Studios now being built when he had hoped to have one, are totally wrong, he must therefore have one as soon as possible, built according to his own views." Anna Mathilda was proud of her son's talent for decorating interiors, mentioning it from time to time in her correspondence. In one letter she remarked, "I wonder if I ever wrote you of all Jemie did to this house, No. 2? You would be delighted at its brightness in tinted walls and staircases."[131]

The staircase was the most elaborate aspect of this house [fig. 39]. It echoed the style and technique of the golden Oriental screens and Japanese lacquers in his collection. Gold was the true color of the imagination in the Orient, and Whistler had transformed a somewhat dark staircase by painting the upper walls a lemon tint and applying patches of Dutch metal and gold leaf on the dado below.[132] Reflective gilded surfaces would become a hallmark of his decorating style. Cicely Alexander [pl. 11] described Whistler's creation. "I was painted at the little house in Chelsea, and at the time he was decorating the staircase; it was to have a dado of gold and it was all done in gold leaf, and he laid it on by himself, I believe; he had numberless little books of gold leaf lying about, and any that weren't exactly the old gold shade he wanted he gave to me." The stairway was also flecked with chrysanthemum petals in pink and white and accented with

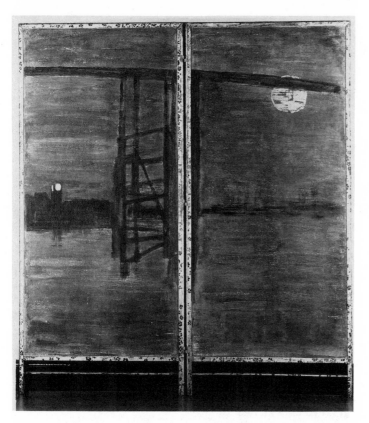

FIG. 38. Blue and Silver: Screen with Old Battersea Bridge, 1872, distemper and gold paint on brown paper, laid on canvas, each panel 67¾ x 33⅛ in. (172 x 84.1 cm). Whistler's attraction to the Momoyama period was revealed by his use of screens, as well as gold leaf and flowing silks, in interiors. Hunterian Art Gallery, Birnie Philip Bequest, Glasgow University.

butterflies.[133] Chrysanthemums and butterflies were favored in the iconography of Japanese artists, for whom plants and insects merited special attention. Whistler made such motifs his favorites as well.

Even more surprising than Whistler's golden staircase project was a spontaneous and fresh-looking mural in crisp blue and white of two sailing ships at sea with spreading sails seen through a colonnade, painted on panels at the end of the hall [figs. 39, 40].

Whistler's friend, the lithographer Thomas Way, remembered that when he visited Whistler in his studio with C. A. Howell "the passage from the door was panelled, and had, I think, a painting of ships on the wall." Later, Way found a rough sketch on brown paper among his father's things and recognized it as a drawing that probably related to this mural.[134]

Whistler was aware of the murals executed by Pre-Raphaelite artists at Oxford and at Morris's Red House, such as a painting of a great ship by Burne-Jones, and the frescoes by his friend Albert Moore and others. So it is understandable that he would eventually be seized by the desire to paint a mural. The Pennells tell the story of Whistler hurrying home on a Sunday morning after taking his mother to Chelsea Church, sending for the Greaves brothers, and setting to work painting the two panels in the hall with ships at sea and the Battersea Bridge in a blue-and-white harmony. When Anna returned, she was not pleased, since she wanted Jemie to put away his brushes on Sunday. But as F. R. Leyland would later discover, it was not easy to deter Whistler from painting walls once he had been seized by a desire to create mural-sized symphonies in color.[135]

Whistler's Homes as Model Sites

Obviously, Whistler designed his own homes as works of art, to exhibit like the canvases and prints that he showed to guests in his studio. They were not only private living spaces for himself and his companions (alternately, his puritanical mother and red-haired mistresses); they were prototypes or showplaces in which he demonstrated his talents as an interior decorator with an eye toward garnering commissions. No. 7 and No. 2 Lindsey Row are important harbingers of the English renaissance in domestic design, as much as Morris's Red House and Godwin's early homes. The difference was that Whistler's early houses were on constant show—and so was he.

At his Chelsea residence and later at his Paris flat, Whistler's open-door policy—it was literally open—was well known among reporters, collectors, artists, and friends.[136] His celebrated Sunday breakfasts and dinner parties, his reporters' interviews, and other events staged in these "private" homes indicate his efforts to make his home a magnet for artistic London. Fortunately, the distinguished assortment of people who streamed through his various rented houses and his other interiors often recorded their impressions of Whistler's decorating schemes in letters, diaries, newspaper articles, cartoons, poems, and novels. Creative figures such as Henry James, Oscar Wilde, Lillie Langtry, Alan and Henry Cole, Aubrey Beardsley, James Tissot, Albert Moore, E. W. Godwin, Louis Comfort Tiffany, George Du Maurier, Thomas Jeckyll, John Hollingshead, George Bernard Shaw, Sir Coutts Lindsay, F. R. and Frances Leyland, Julian Weir, the Reverend H. R. and Mary Haweis, Mortimer Menpes, Theodore Child, Henri Fantin-Latour, Alphonse Legros, Sheridan Ford, Lady Campbell, the Rossettis, Edgar Degas, Claude Monet, Henri Toulouse-Lautrec, Tom Taylor, Sidney Starr, and Elizabeth and Joseph Pennell, among others, visited Whistlerian interiors. The aesthete's fabled hospitality brought the artistic world to his doorstep, and he influenced many individuals to place greater importance on the design of interiors as a result of his elevation of this art.[137] Even before the artist left 2 Lindsey Row in 1878, he had become a force for promoting a new mode of domestic design.

As Whistler's interior designs became more widely known, some understanding of his ideas developed. In 1879, Frederick Wedmore, a frequent critic of Whistler's, paid the artist a dubious compliment when he conceded Whistler's nocturnes had certain decorative possibilities. "In them there is an effect of harmonious decoration, so that a dozen or so of them on the upper panels of a lofty chamber would afford even to the wall-papers of William Morris a welcome and justifiable alternative. . . . they say very little to

FIG. 39. *Staircase Design, "Petals on Gold Leaf"* (above), *and Mural Design, "Battersea Bridge and Ship"* (below), *late 1860s, pen and ink on white laid paper, 8⅞ x 7⅛ in. (22.5 x 18.1 cm). Whistler made sketches for a stairway and a wall decoration for No. 2 Lindsey Row, Chelsea. Hunterian Art Gallery, Birnie Philip Bequest, Glasgow University.*

the mind, but they are restful to the eye, in their agreeable simplicity and emptiness." He went on to discuss Whistler's Peacock Room, remarking, "As a decorative painter Mr. Whistler has few superiors. It is a department of Art in which his skill is wont to border upon genius."[138]

The Pennells were certainly convinced of Whistler's genius as a decorator.

FIG. 40. *Two Designs for Murals, "Battersea Bridge" and "Sailing Ships Viewed through Colonnades," late 1860s–mid 1870s, pen and ink, 8⅞ x 7⅛ in. (22.5 x 18.1 cm), on verso of fig. 39, annotated by Whistler. These are sketches for a wall decoration at No. 2 Lindsey Row, Chelsea. Hunterian Art Gallery, Birnie Philip Bequest, Glasgow University.*

Whistler had no factory, no shop, no staff of salesmen and workmen; he was not in the business as William Morris was. But as a decorative authority, Morris has grown old-fashioned, while Whistler has become a power. Little by little the beauty of the houses and studios he arranged for himself and his friends began to be seen, and because they were simple and beautiful, . . . they [were copied] until now his scheme of simplicity in decoration has spread all over the world. . . . everywhere [are] rooms with the walls washed or papered in a flat tint, only a few paintings or prints hanging upon them, with dark painted or stained floors, a few rugs or matting, with very little furniture and all of it simple.[139]

By the 1890s Whistlerian theories for interior design were so well-known that not only did they became commonplace in comments of critics like Wedmore, the pages of *Punch* magazine, and the musicals of Gilbert and Sullivan, they also provided the material for dialogue in novels. Harold Frederic, in his 1896 *Damnation of Theron Ware*, depicts a character, Celia Madden, who realizes that "beauty is the only thing in life that is worth while." As she plays Chopin, Celia informs her suitor that her beautiful red hair (the preferred aesthetic hair color) completes the room's color scheme: "We make up what Whistler would call a symphony." Charlotte Perkins Stetson Gilman's short story, "The Yellow Wall-Paper," published in *New England Magazine* in 1892, caught an undercurrent of feminine rage seething inside aesthetically decorated interiors. The onset of madness of a young wife, mother, and writer is projected into fantasies about the yellow wallpaper in the room that entraps her. The overbearing walls seem to be a grotesque fictional conflation of overly patterned Morrisian wallpaper and sinister Whistlerian yellow. Finally madness overtakes the woman, and she tears the sickly yellow wallpaper from the walls.[140]

The American wallpaper and textile designer, Candace Wheeler, who was one of the leaders of the aesthetic movement in America, was chief among those who championed Whistler's theme in declaring the centrality of color in beautifying interiors: "Color is the beneficent angel or the malicious devil of the house." She advocated the intelligent use of color, "the primary factor of beauty," as a harmonizing agent in the home. In their 1897 book *The Decoration of Houses*, American authors Edith Wharton and Ogden Codman, Jr., took up Whistlerian ideas such as the control of endless bric-a-brac. They also fulminated

against excessive pattern, promoted homogeneity, and considered walls chiefly as backgrounds for pictures, thereby dictating the use of uniform tints. Whistler would have approved.[141]

A number of painters who came into direct contact with Whistlerian interiors subsequently evolved into artists inspired to do interior design work. Louis Comfort Tiffany was such a figure. He was still a painter when he exhibited at the 1878 Paris Exposition, where, among other marvels of interior decoration, he saw the yellow dining room designed by Godwin and Whistler. (He was also aware of the Peacock Room.) Shortly afterward, in 1879, Tiffany joined with Edward Moore, Lockwood de Forest, and Candace Wheeler to form Associated Artists, which became a leading New York interior design firm that emulated the Morris company in its cooperative spirit. However, Tiffany's use of Oriental porcelains, peacock and butterfly motifs, iridescent colors, and Japanese details in aesthetic interiors all point to the influence of Whistler.[142]

Claude Monet also seems to have been inspired by Whistler's example as a decorative artist. He painted with Whistler and Courbet at Trouville and exhibited with Whistler a number of times. They corresponded, and Whistler invited Monet to show with the Society of British Artists in the late eighties. Monet probably saw the stunning yellow dining room at the 1878 Paris International Exhibition and knew of Whistler's 1883 white-and-yellow exhibition.[143] He visited Whistler at his home in London in the early 1890s and returned the hospitality by inviting him to Giverny. Aside from the Japanese garden, Whistler must have been startled by Monet's brilliant yellow dining room accented with cobalt blue and sparsely furnished with Japanese prints and porcelain vases. The rush-bottom chairs painted yellow, the blue table service on which Monet served Whistler pigeon stew, and the graduated monochromatic color schemes the Frenchman had painstakingly devised for the other rooms were all familiar Whistlerian touches.[144]

Of course, direct contact with Whistlerian interiors was not required in order to be significantly influenced by them. Vincent van Gogh was in England at the height of the British aesthetic movement during the period when the news coverage of *Harmony in Blue and Gold: The Peacock Room* was most intense and sunflower decorations were proliferating. Later, in an 1888 letter to his brother Theo, he shared his decorating dreams using Peacock Room nomenclature: "Now that I hope to live with Gauguin in a studio of our own, I want to make a decoration for the studio. Nothing but big sunflowers. . . . If I carry out this idea there will be a dozen panels. So the whole thing will be a symphony in blue and yellow." Marcel Proust, who kept a pair of Whistler's grey kid gloves as a souvenir, remarked that he based his "intentionally *bare*" rooms on the aesthete's example.[145]

Whistler's strikingly simple rooms had a liberating effect on several designers in England. His pared-down interiors with monochromatic harmonies, elegant proportions, and sense of organic design influenced later modernist designers like C. R. Ashbee, C. A. Voysey, and Charles Rennie Mackintosh.[146] Their domestic designs emulated the Japanese austerity, neatness, clean lines, and preference for stark white walls and unimpeded spaciousness favored by Whistler. His homes and studios became places of pilgrimage and the topic of conversation, and for a while at least, he was recognized as one of the leading decorators of the aesthetic movement. As James Laver remarked, "His taste for simplicity antedated that of the rest of England by more than a generation."[147] In a February 1903 *House Beautiful* article entitled "Mr. Whistler and the Art Crafts," the writer Gardner Teall reviewed Whistler's influence.

> Quite aside from the brilliant "ten o'clock" utterances which some persons could not and which Mr. Swinburne would not understand, other things from Mr. Whistler have exerted a tremendous influence on the artistic crafts which

produced the house beautiful. Unlike Mr. Ruskin, who preached much and did little, or William Morris, who preached and did, Mr. Whistler has affected to be encumbered by the multitudes, and therefore one expects the point of his influence to be disputed by the hurried; but let it be remembered that the cue of the multitude comes from . . . the frames of the Nocturnes, the little garden in Chelsea, the blue Nankin in Tite Street, the room at 49 Princes's Gate, Sarasate's music-room in Paris, and the gentle artist's gray studio arrangements have influenced the movement of the arts and crafts. Subtily [sic] it is true, but with a sureness and with refinement that

leave no room for a Morris chair . . . there is absolutely no question that Whistler ranks with those who have given out a potent influence in recovering art craftsmanship.[148]

Like other artists in Britain during the latter half of the nineteenth century, Whistler was comfortable creating interior designs, and he placed considerable value on his contributions in the field. As he remarked in a letter to the French art critic Théodore Duret, "You know that I attach just as much importance to my interior decorations as to my paintings."[149]

PL. 1. Arrangement in Grey and Black: Portrait of the Painter's Mother, 1871, oil on canvas, 56¾ x 64 in. (144.2 x 162.6 cm). Anna Mathilda Whistler is seated in her son's plain grey-distempered studio at No. 2 Lindsey Row, Chelsea. The room is sparsely decorated with a low, black-lacquered dado, embroidered drapes, and a print of Whistler's Black Lion Wharf in a narrow black frame with a wide mat. The etching is asymmetrically arranged on the wall at an exacting distance from the subject and from another picture just visible on the right. Musée d'Orsay. Musées Nationaux de France, Louvre, Paris.

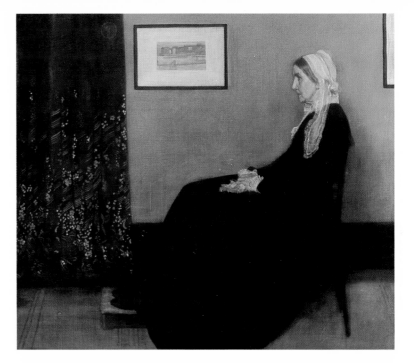

PL. 2. Nocturne in Blue and Gold: Old Battersea Bridge, 1872–77, oil on canvas, 26⅞ x 20⅛ (68.3 x 51.2). Whistler presented this painting at the Whistler v. Ruskin trial as an example of his designed-canvas theory. Tate Gallery, London, Great Britain/Art Resource, New York.

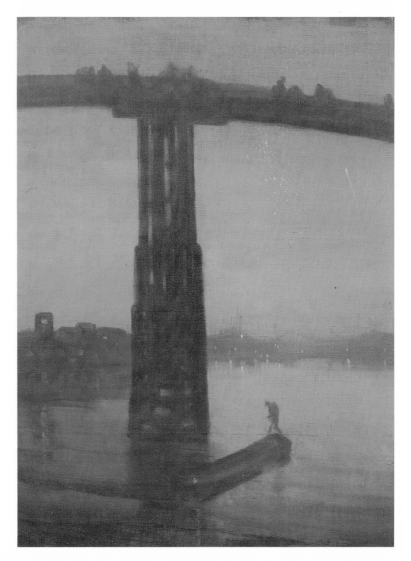

PL. 3. *Albert Moore. Beads, 1875, oil, 11¾ x 20¼ (29.8 x 51.4). Two slumbering women draped in filmy fabrics in the style of ancient Greek togas recline in an exquisitely designed setting decorated with soft-hued Oriental vases painted with scale patterns, striped floor matting, a Japanese fan, and silken textiles. National Gallery of Scotland, Edinburgh.*

PL. 4. *The Artist in His Studio, 1865–66, oil on paper mounted on mahogany panel, 24¾ x 18¾ in. (62.9 x 47.6 cm). The artist is attired in grey in his pale grey atelier at No. 7 Lindsey Row. His collection of glistening blue-and-white porcelain is on the left, a "white girl" sits next to a model wearing a flesh-colored kimono and holding a fan, and a tiny picture is placed asymmetrically to the right of a large mirror. The soft radiance of the rooms Whistler created is suggested by this luminous painting. 1912.141, © 1994, Art Institute of Chicago. All rights reserved.*

PL. 5. *Morris, Marshall, Faulkner and Company. Green Dining Room, 1866, opened in 1868. The room is decorated with embossed wallpaper, painted fruit-and-figure panels by Edward Burne-Jones and Fairfax Murray, a pictorial chest, a decorated piano, a frieze by Philip Webb, and stained glass windows. By courtesy of the Board of Trustees of the Victoria and Albert Museum, London.*

PL. 6. *William Holman Hunt. Awakening Conscience, 1853, oil, 34⅛ x 26 in. (76.2 x 55.9 cm). A compromised "white girl" is caught in a conventionally vulgar Victorian interior setting. Tate Gallery, London.*

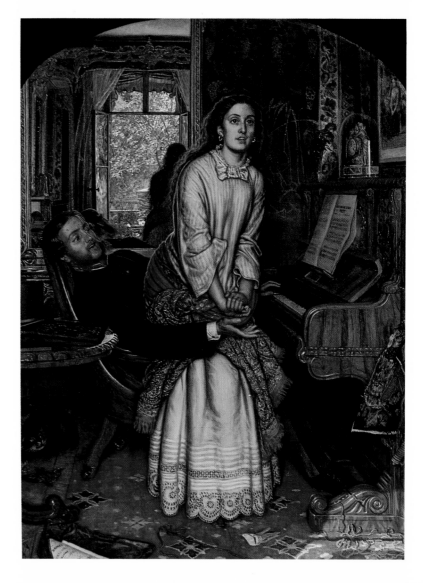

PL. 7. *William Morris. La Belle Iseult, 1858, oil on canvas, 28½ x 20 in. (72.4 x 50.8 cm). Jane Burden Morris is dressed in a brocaded costume and ensconced in a Morrisean medievalized interior setting. Tate Gallery, London.*

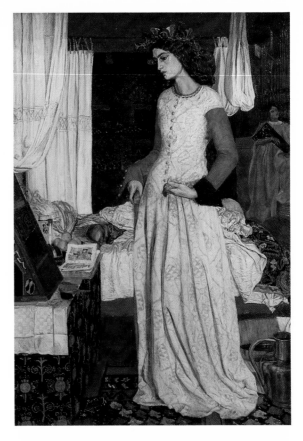

PL. 8. Rose and Silver: The Princess from the Land Porcelain, 1863–64, oil on canvas, 78¾ x 45¾ in. (200 x 116.2 cm). *Christine Spartali wears a salmon-and-silvery-grey silken kimono fastened with a red obi. She holds a fan decorated with irises and stands in the slightly inclined posture of a geisha in a Whistlerian environment replete with signs of early japonisme. Freer Gallery of Art, Smithsonian Institute, Washington, D.C.*

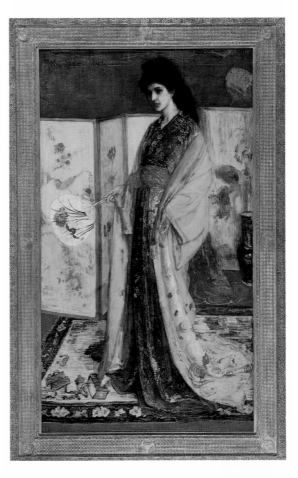

PL. 9. *Color Scheme for the Dining Room at Aubrey House,*
London, ca. 1873, gouache on brown paper, 7¼ x 5 in. (18.4
x 12.7 cm). The horizontally banded decorating scheme is remi-
niscent of Whistler's nocturne paintings. This decorative
progression of color fields using thin veils of color was a typical
Whistlerian wall treatment. Hunterian Art Gallery, Birnie
Philip Bequest, Glasgow University.

PL. 10. *Color Scheme for Aubrey House, London, ca.*
1873, gouache on brown paper, 5¾ x 9¾ in. (14.6 x 24.8
cm). The horizontal format of this scheme suggests Whistler
may have designed it for a hallway. The zoned wall treatment is
analogous to the articulated wall space in a traditional Japanese
room. Hunterian Art Gallery, Birnie Philip Bequest, Glasgow
University.

PL. 11. *Harmony in Grey and Green: Miss Cicely Alex-*
ander, 1872–74, oil on canvas, 74⅞ x 38½ in. (190.2 x 97.8
cm). Cicely wears a fine white muslin dress with accessories de-
signed by Whistler. She stands on checkered matting before a
grey-green distempered wall with black-lacquered dado and bat-
ten in the artist's No. 2 Lindsey Row studio. Tate Gallery,
London.

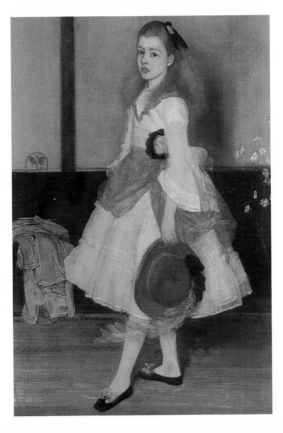

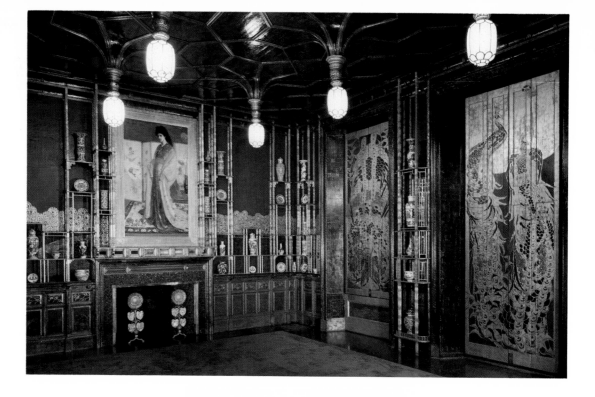

PL. 12. Harmony in Blue and Gold: The Peacock
Room, *1876–77, oil paint and metal leaf on leather and wood.
Thomas Jeckyll's designs for shelves and sunflower andirons,
and Whistler's color scheme in the* Princess *painting, peacock-
feather design, mottled wall surface treatment, and great pea-
cock shutter paintings, are shown. Freer Gallery of Art,
Smithsonian Institution, Washington, D.C.*

PL. 13. *"Whistler's Peacock Room: World's Greatest Mas-
terpiece of Decorative Art," Chicago Sunday Tribune,
September 4, 1894. This lavish, color newspaper layout helped
to acquaint Americans with Whistler's decorative masterpiece.
Charles Lang Freer Papers, Freer Gallery of Art/Arthur M.
Sackler Gallery Archives, Smithsonian Institution, Washington
D.C.*

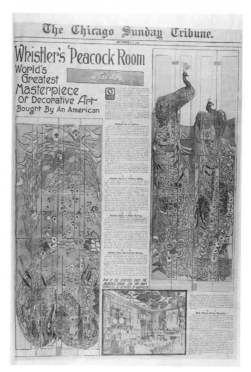

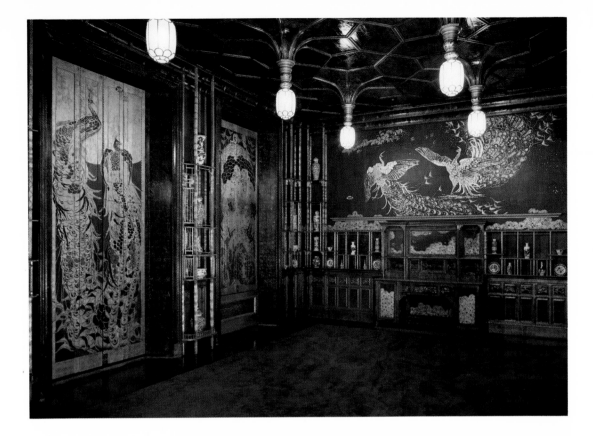

PL. 14. Fighting Peacocks Mural, 1876–77, oil paint, gold leaf, and platinum on leather. Included is Jeckyll's or Whistler's sideboard design painted by Whistler with a sea wave or feather motif to blend into the painted paneled woodwork. Freer Gallery of Art, Smithsonian Institution, Washington, D.C.

PL. 15. Pounced Cartoon for Fighting Peacocks Mural, 1876, black gouache, watercolor, white chalk, and pencils on brown paper, 72¼ x 153¼ in. (181 x 389.2 cm). Hunterian Art Gallery, Birnie Philip Bequest, Glasgow University.

PL. 16. *Max Beerbohm. Blue China cartoon. This imaginative re-creation of a Whistlerian installation shows Thomas Carlyle arriving at Whistler's first aesthetically decorated one-man exhibition in 1874. The artist stands by a mammoth blue porcelain pot. Tate Gallery, London.*

4

Passage to the Splendor of the Peacock

Transition to a World of Form and Color

Throughout the sixties Whistler experimented privately with interior design. His only other involvement in a decorative project for a domestic interior during this early period—which demonstrated his determination to become seriously engaged in such work—was an ambitious undertaking that the Pennells later named the "Six Projects" [fig. 41]. It is thought to be his first scheme of decoration for the discerning patron F. R. Leyland.[1] The Six Projects consisted of six decorative panels of similar dimensions depicting Grecian female figures draped in classical robes. The panels, like a series of Japanese *kakemonos*, may have been designed to fit into an integrated interior scheme. The attenuated Venus figures epitomized decorative beauty for the artist, and in his "Ten O'Clock," Whistler referred to art as "a whimsical goddess," the "glorious Greek" who "yielded up the secret of repeated line ... the

measured rhyme of lovely limb and draperies flowing in union." Whistler made many dozens of other Venus sketches and at least two large decorative paintings related to the tentative oil sketches that constituted the Six Projects. One of these was an unfinished painting, *The Three Girls*. Like the other Venus pictures, it was related to musical themes, and it had an original frame that Whistler designed and decorated with bars of music by Schubert.[2]

The correlation to music made this composition, designed to fit into one of Leyland's plans for an interior scheme (it later became a candidate for the south wall of the Peacock Room), highly appropriate for the businessman, who was passionately fond of music. Leyland practiced the piano every day, and he specifically commissioned pictures with musical references. It was Leyland who suggested the musical term "nocturne" for the artist's "moonlights."[3] Whistler

FIG. 41. Symphony in Blue and Pink, *ca. 1868, oil on millboard mounted on wood, 18⅜ x 24⅜ in. (46.7 x 61.9 cm). This oil sketch, one of the Six Projects, is from a series of Venus compositions. Freer Gallery of Art, Smithsonian Institution, Washington, D.C.*

would later extend the use of musical terminology to his interior schemes of decoration, calling his exhibitions and domestic interiors "harmonies" and "arrangements"—a fact that clarifies the equal status he afforded them. Whistler worked on Venus compositions from the mid-sixties through the late seventies and beyond. By 1867, the artist had received advance payment from Leyland in connection with this project.[4]

Whistler had cast aside Courbet's realism; now he was determined to create stylized, formally beautiful figure paintings. His aspiration toward such a form of art had grown out of his association with an even more unequivocally decorative artist than Rossetti, namely, Albert Moore. Like Whistler, Moore was attracted to a mix of classical and Japanese design elements, as his later painting *Beads* (1875) reveals [pl. 3]. Moore was keenly attuned to design, whether for his canvases or for interiors. He had worked as a decorator for the Morris company, designing wallpaper, tiles, and stained glass, and he had executed several large decorative fresco commissions. During the 1860s, Whistler, Moore, French artists such as Jean-Auguste-Dominique Ingres and Pierre-Cécile Puvis de Chavannes, and several English academicians were studying classical art. Recent archaeologic discoveries, including the Elgin Marbles from the Acropolis (they featured figures in classical drapery and were installed at the British Museum in 1865) and Hellenistic Tanagra figurines of the third and second centuries B.C. became sources of inspiration and prompted a collecting vogue. The Tanagra figurines were small terracotta figures of women draped in togas. They retained bits of soft pink and blue glazes on their surfaces that suggested new color harmonies to Whistler and Moore—harmonies that the artists proceeded to explore.[5] Whistler's decorative paintings featured a series of tall, supple women promenading on a beach, lounging around linear networks of piers and railings, examining flowers in a hothouse. His sense of fashion and high style, as well as his attraction to delicate,

transparent fabrics, was revealed in the figures' flowing gauze drapery blown by the wind, their Japanese fans and parasols, and their voguish, Kiyonaga-like poses [fig. 41; also see figs. 30, 34]. (Whistler not only decorated fans, he also designed a lily-pad parasol for Lady Archibald Campbell.) These nonnarrative wall panels also have the feeling of eighteenth-century rococo *fêtes galantes*, suggesting a graceful open-air party on the beach.

Whistler's fugitive-figure paintings began and ended as broad exercises in color and arrangement, even though he wiped out, scraped off, and generally reworked these compositions for years.[6] He was continually impatient with imperfections in his anatomical draftsmanship and inevitably his interest in subtle abstract arrangements on a flat surface plane took precedence. He was entranced by the allure of elegant swirls of freely brushed strokes in transparent oil paint applied as though finger painted in sweeping rhythmic lines. To Alan Cole he demonstrated his interest in an arrangement of beautiful lines by brushing in one liquid sweeping motion the back of a bowed figure.[7] The intoxicating harmonies he was creating with ivory, mauve, violet, flesh pink, yellow, salmon, sea green, apricot, aquamarine, powder blue, chalk white, and pungent red orange captured his growing sensitivity to color.

Whistler's series of Greco-Japanese-inspired panel paintings was his first serious bid to compete with the decorative art of Burne-Jones of Morris, Marshall, Faulkner and Company. Burne-Jones had himself done a set of six watercolor panels of solitary women—Leyland's preferred theme—for the collector's home at Queen's Gate.[8] Domestic decoration was a lucrative field; Whistler was competing to secure commissions from wealthy patrons to line the walls of their homes with panels of lithe, graceful figures. The panels were modeled after architectural decoration rather than easel paintings and, as with much eighteenth-century French rococo painting, were meant to fit into interior schemes.

His patron, Leyland, had a well-developed sense of design. The shipping magnate was a designer of new steamships for the Bibby Fleet. He was especially sensitive to interior design and carefully orchestrated the hanging of his pictures and the total look of the rooms in his homes. He employed leading decorators to transform his houses into palaces. Leyland, whose life was a rags-to-riches story, was a proud and reserved man, but he enjoyed excursions with Whistler and Rossetti to 2 Lindsey Row and Tudor House to mingle with the riffraff. From Rossetti and Whistler he developed a keen enthusiasm for the art of arranging collections within interiors. The Rossetti-Leyland letters (they were close friends) reveal that once Leyland had arrived at a preconceived total scheme for a picture arrangement within a room, it was necessary for the artist to fit his painting precisely into the plan.[9]

Whistler, who would begin to spend months at a time living with the Leylands at Speke Hall near Liverpool, was not an artist known to work well under such limitations, but nevertheless he must have admired, and learned from, Leyland's exacting method of master-planning picture rooms. Strictures imposed by Leyland may have contributed to the problem Whistler had in completing the Six Projects commission. In any case, his unfinished compositions of Hellenic-type women demonstrate graphically the struggle he went through to make the transition from paintings conceived primarily as slices of reality to paintings conceived primarily as design problems. These compositions became personal encounters for the artist in which he worked out deeply felt symphonies of color, line, and form. In this sense, this suite of paintings forecasts the character of the remainder of Whistler's career, in which he would consider himself foremost a sensitive instrument of decorative design. "Presently, and almost unconsciously," he acknowledged, "I began to criticize myself, and to feel the craving of the artist for form and colour."[10]

If he never managed to deliver Venuses to Leyland, he did use five of the Six Projects as a decorative installation in his own dining room at No. 21 Cheyne Walk. In 1884, the artist Jacques-Emile Blanche visited Whistler's No. 13 Tite Street studio. He found Whistler still engaged in creating compositions of women by the sea. "Another easel held the magic series of studies in which quaint creatures, geisha-girls, charming and affected, waving a fan or parasol against a sky of turquoise, walk beside the seashore; or nude, extend their pretty small bodies beside a slender flowering shrub."[11]

Whistler's long-term self-search through these works helped him to know himself as an artist and free his art from the confines of, as he said, "that damned Realism." As a result of this cathartic experience, he seems to have come to terms with his limitations and embraced his exceptional gifts as a colorist, arranger, composer, and evocative designer.[12]

E. W. Godwin: Avant-Garde Ally and Fellow Japoniste

Despite the direct formative influence of such figures as Moore, Swinburne, Rossetti, Morris, and even Leyland on Whistler's development as a designer, none of them had greater impact than Edward William Godwin. In the late 1850s Godwin was a successful neo-Gothic architect living in Bristol. In the early sixties he had attracted the attention of Ruskin, who proceeded to offer him unsolicited advice and criticism.[13]

Godwin made frequent trips to London, and in 1858 he sought out William Burges at 15 Buckingham Gate. At that point Burges was forming the first collection of Japanese art in England. They became close friends, sharing an interest in the theatre and a desire to bring back beauty in architecture and interiors. Godwin, who like Burges was extremely scholarly, subsequently undertook a prolonged study of Japanese art.[14] The result was that Godwin began to design wallpapers, furnishings, and interior ensembles in a style that, beginning in the mid–1870s, he called

"Anglo-Japanese." This style revealed an unprecedented depth of original assimilation of Japanese art.

Whistler and Godwin first met and became friendly in 1863, in the period when Whistler was creating his series of the first clearly Japanese-inspired paintings in England. The architect visited Whistler at his first studio and later became a frequent guest at Whistler's total-work-of-art breakfasts. They were in touch through mutual friends and acquaintances, such as Burges, who were involved in the design reform movement, and they were in the circle of avant-garde artists who met at the Arts Club founded by Whistler and others in 1863.

In the chronology of the design reform movement, the mutual catalytic influence of Whistler and Godwin would have begun to assert itself during the late 1860s and early 1870s. Whistler's ties with his Paris friends had weakened, and his intense daily involvement with the Pre-Raphaelite group lessened as Rossetti and Swinburne drifted into debilitating chloral and alcohol addictions in the early seventies. Rossetti's severe illness caused him to move out of London to Scotland and then to Kelmscott Manor in Oxfordshire from 1871 to 1874. When he returned to London, he saw very little of Whistler. Another factor affecting the closer association of Whistler and Godwin was that in 1865, after the death of his first wife, Godwin moved his growing architectural practice from Bristol and set up an office at 23 Baker Street, London.[15]

Certainly Godwin, whom Max Beerbohm called "the greatest aesthete of them all," became the single most potent force, aside from Japanese art itself, in Whistler's emergence as a modernist designer. Together the two aesthetes, employing a similar belligerent manner, promoted a number of related design concepts. Throughout the Godwin collection at the Victoria and Albert Museum and the Whistler collection at the University of Glasgow are sketches, notes, and letters that corroborate their close association in the seventies and eighties. Godwin had an endearing

habit of making sketches of Whistler and aspects of Whistler's interior designs and exhibitions in his series of sketchbooks and on the pages of catalogues and leaflets. As Elizabeth Aslin has pointed out, in a sense, their relationship continued even after Godwin's death, for Whistler married the architect's widow, Beatrix, herself a designer.[16] Whistler and Godwin were kindred spirits who reinforced each other's independence and fearless modernism. The intelligent cultivation of Japanese art was the key to their meeting of minds. Godwin is thought to have been among those who, along with Whistler, Rossetti, and Burges, may have purchased Japanese porcelains and prints directly from a public auction held for a large consignment of Japanese goods that arrived too late to be included in the 1862 London International Exhibition. They may also have made purchases from Farmer and Rogers Oriental Warehouse, which disposed of some of the exhibits.[17]

Whistler did not acquire a suitable home until about six months after these goods were put on sale. Godwin, however, had just moved into a large, elegant eighteenth-century stone-built house at No. 21 Portland Square in Bristol with his wife Sarah, and he therefore had a place in which to display his newly acquired treasures. According to his biographer, Dudley Harbron, Godwin's 1862 interior was already based on Japanese principles, which would make it the first of its kind in England. His spartan interior scheme consisted of laying Oriental rugs on the bare floor, using a few carefully selected eighteenth-century antiques, and arranging his colored Japanese woodcuts on walls painted in plain colors.[18]

In that same year the teenage Ellen Terry, an actress, attended an evening of Shakespeare reading at the architect's Bristol home. She was thrilled by Godwin's many beautiful objects and asked him about everything, including the Oriental carpets and the collection of blue china. The usually aloof Godwin answered all of Ellen's questions. He told her that he had friends among the skippers of sailing ships and

that they "brought him, from the Far East, many of the things in his house."[19]

It is surprising to learn that Godwin was already collecting porcelain in 1862. His direct access to Oriental goods—probably more of them Chinese than Japanese—from the ships coming into Bristol represented a unique advantage among the pioneer *japonistes* in England. He and Whistler, perhaps initially independent of one another, began to exhibit a taste for simplicity in their personal interiors based on Japanese art and their own iconoclastic revulsion toward the standard British decorating practices in the early 1860s. They were simultaneously in the forefront of simplifying interiors and starting a vogue for *japonisme* in interior design.[20]

As with Whistler, Godwin's decorative style may be seen evolving from his study of Japanese art. He became sensitive to geometric divisions of space, asymmetrical arrangements, lattice patterns, and the use of uninterrupted planes of pure color.[21] His diverse design activities included the interior and exterior of buildings, furniture, wallpaper, textiles, and stained glass. Godwin also initiated an aesthetic movement in the theatre, designing stage sets and costumes. He was, as well, a Shakespearean scholar, a member of the Royal Institute of British Architects, a play producer, an antiquarian, and a journalist. For twenty years, Godwin wrote weekly columns with an acerbic wit, sometimes in defense of Whistler, for *Architect, Building News,* and *British Architect,* which he initially edited, and also wrote for other magazines and newspapers.[22]

Certainly, this drive to put the printed media in the service of helping to revolutionize design was an important goal Whistler and Godwin shared. Godwin did not hesitate to go directly to the press to state his case for design reform. Neither artist could tolerate the preponderance of bad taste in their own era, and they both spoke out forcefully in print and in lectures. They may have plotted together to exploit the press through professional journals and daily newspapers.

During the aesthetic movement, enlightened designers like Godwin, who were making a protest against crude Victorian commercial production, called their new style of domestic design "art." Eastlake was probably the first to use "art furniture" as a generic term in his book *Hints on Household Taste in Furniture, Upholstery, and Other Details* (1868). A whole spate of popular books on artistic furniture and interior decoration appeared in this period, including *The Dining Room* by Mrs. W. J. Loftie, *The Bedroom and the Boudoir* by Mrs. Lady Baker, and *The Art of Beauty* and *Beautiful Houses* by Mrs. H. R. Haweis. In this period of interior design craze in Britain, Godwin, in 1867, started his short-lived Art Furniture Company; by 1870 he had aligned himself with furniture firms such as William Watt and Collinson and Lock, and wallpaper manufacturers such as Jeffrey and Company. In 1877 Watt issued an illustrated catalogue, with an introduction by Godwin, entitled *Art Furniture from Designs by E. W. Godwin, F.S.A, and Others,* which was a comprehensive survey of Godwin's modernistic furniture. Whether simple or elaborate, it was machine made, but the designs did not lose sight of aesthetic excellence.[23]

Whatever the derivation—Japanese, Chinese, Greek, Gothic, or Chippendale—Godwin's artistic furniture was characterized by studied elegance, light rectilinearity, economy, clean lines, and originality, as can be seen in his design for an Anglo-Japanese buffet [fig. 42]. As such, it represented a rejection of the Victorian philosophy of comfort expressed in heavy, earthbound, bulging furniture. Though the Morris company produced some lightweight furniture such as the popular black or green-stained rush-seated "Sussex chair" (1864), the emphasis in its simply constructed, stout furniture was generally on patterned upholstery or painted pictorial surfaces [pl. 5] rather than form.

Whistler and Godwin's approach to design required a new vision. Their approach was antithetical to Ruskinian-Morrisian design theory with its

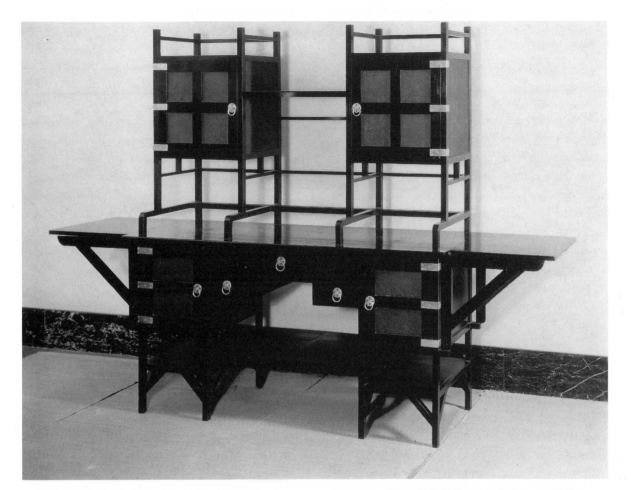

FIG. 42. *Edward W. Godwin. Anglo-Japanese Buffet, ca. 1876. The ebonized wood sideboard decorated with silver-plated fittings and embossed Japanese paper demonstrates the abstract arrangement of solids and voids with which the designer created visual interest. HD 1603 38-1953, Victoria and Albert Museum, London. By courtesy of the Board of Trustees.*

close focus on detailed patterns from nature, its nostalgic medievalism, and its dependence on the ornamentation of individual surfaces. Central to the Whistlerian-Godwinian theory of design was a focus on the long view, the total effect, the abstract configuration, the formal beauty of a piece. For a room, this meant seeing it as a unit rather than taking the myopic, piece-by-piece approach that often resulted in incongruous effects in conventional Victorian homes. They were striving for homogeneity and harmony, traits of the art nouveau interiors to follow. Also, instead of stressing rural charm or homely domesticity like the Morris company, Whistler and Godwin were interested in creating a chic theatrical aura

of suggestive mood and exotic drama in their interiors.

Godwin's career as a domestic interior designer—he had already executed grand public interior schemes—was sparked off in almost the identical way that the careers of Morris and Burne-Jones had begun. He was a recent widower in 1867 when he decided to decorate his London bachelor quarters in Taviton Street. He recorded this project in a blow-by-blow account in a series of articles entitled "My Chambers and What I Did to Them" in *Architect*. "When I came to the furniture," Godwin wrote, "I found that hardly anything could be bought ready made that was at all suitable to the requirements of the case. I therefore set to work and designed a lot of furniture and with a desire for economy directed it to be made of deal ebonized."[24]

It could have been Whistler himself speaking when Godwin lapsed into rhapsodies about his use of pure colors for his interior arrangements, especially yellow and white. These colors provided a brilliant background for his newly designed, starkly geometric, ebonized furniture and harmonized with his collections of Oriental art. But who was it that "invented" yellow distemper for walls? Whistler or Godwin? Whistler claimed it unequivocally, yet their close association may have made it difficult, even for them, to identify the origin of certain of their shared ideas, somewhat like Braque and Picasso at the height of cubism.

Another point of contact between Whistler and Godwin, which they had also learned from Japanese art, was their interest in producing beautiful effects economically, in terms both of expenditure and of deleting the unnecessary. In the articles describing his 1867 redecoration project, Godwin stressed function, cheapness, exceedingly plain effects, and utility—astonishingly modern characteristics to proclaim in the midst of an era of opulent visual confusion in interiors. Perhaps a contributing factor to their reductive, cleansing philosophy was that, while Morris enjoyed inherited wealth, these more daring designers often lived on the edge financially.

Godwin soon had an opportunity to decorate yet another Japanese-inspired house. On Saturday night, October 10, 1868, he ran off to live with the Shakespearean actress Ellen Terry, for whom he designed brilliant original sets and costumes. This liaison lasted six years and produced two children.[25]

Perhaps it was Whistler's wit that contributed to the name Godwin and Terry chose for their cottage at Gustard Wood Common: Red House. This Red House, however, bore no resemblance to Morris's miniature medieval palace. Rather, it was a model of early experimental British *japonisme*. Predictably, the walls were pale yellow, the woodwork was white, and the floors were waxed. The slender black furniture, which he designed, looked dramatic in this setting, which also included an innovative use of naturally colored and textured Indian matting on the floors and on the lower portion of the wall. Godwin also used Turkey and Van Eyck rugs. He purchased a wide range of Oriental accessories for this house from Whareham's, Hewitt's, and Farmer and Rogers Oriental Warehouse, furnishing the rooms with Japanese pots, lacquered trays, Chinese plates, Chinese screens, and other exotic objects. Ellen Terry recalled that Whistler contributed "the most lovely dinner-set of blue and white china that any woman ever possessed, and a set of Venetian glass, too good for a world where glass is broken. He sent my little girl a tiny Japanese Kimono when Liberty was hardly a name."[26]

Whistler and Godwin proceeded to use their interiors as ongoing experimental works of art, attempting to work out aesthetic problems by constantly rearranging and redecorating the rooms in their homes. In 1872, Godwin decided to refurnish his London apartment with graceful, light, eighteenth-century furniture with elegant silhouettes, such as Chippendale chairs. It was less expensive than new furniture and indicated his rejection of typical Victorian furniture stuffed with horsehair and trimmed

with tassels and fringe. Whistler shared this attraction to aristocratically reserved Regency decor, usually small in scale and based on Sheraton, Adam, and Chippendale designs. This attraction became increasingly evident in his later interiors. The Goncourt brothers were also reviving interest in eighteenth-century furniture in France. The revival of light, slender furniture was an antiphilistine reaction. Whistler and Godwin stressed restraint, economy, and decorum in their homes as a statement against the disorderly excesses of middle-class taste. Max Beerbohm stated that when the aesthetes decided they abhorred the overwrought furniture style favored by their parents, "they hurled their mahogany into the streets."[27]

Godwin wrote that he based the amber and pale grey green colors of his 1872 drawing room on the pineapple. In a critical reference to Morris, Godwin admitted that five years earlier he had used a "sad" dark green wallpaper for his dining room, a choice that revealed the influence of the Morris company's Green Dining Room. He viewed the resulting gloom as a health hazard, noting that an individual subjected to this depressing atmosphere "invariably suffers from it in some way." Whistler also began to consider the psychological impact of dour interior colors at this time, turning to whites, sunny yellows, pale flesh tones, greys, yellow greens—tertiary and secondary hues that suggested gaiety and fresh air. A major point Godwin made in the article was that he wished to avoid "an archipelago of large dumpy easy chairs, all frill and upholstery" that left only a channel to circumnavigate between the islands of knickknacks. Whistler had already dared to leave large spaces—indeed, whole rooms—entirely devoid of furniture, and Godwin's awareness that Japanese rooms had little or no furniture reinforced his courage to improve Victorian interiors through omission.[28]

In one intriguing article in the series Godwin cites a specific, unnamed room as a positive example in contrast to a particular (also unnamed), typically vulgar Victorian interior. He uses this room as a model

of design reform—one that would have a beneficial influence on those who entered it.

> There are two or three light chairs, one easy chair, one small sofa near the fireplace, a piano near one of the windows, a Chinese cabinet of light wood marvelously carved, and filled with choice china, a large Eastern vase as big as a font, a low Japanese screen, a few fans against the skirting and on the ceiling, and two small Japanese cabinets. . . . The floor is covered with Indian matting, the curtains are of whitish linen, embroidered with yellow silk and the walls above are panelled in long panels . . . each panel containing a Japanese embroidery on whitish silk. No description however, except perhaps that which may be conveyed in the form of music, can give any idea of the tenderness and if I may say so, the ultra-refinement of the delicate tones of colour which form the background to the few but unquestionable gems in this exquisitely sensitive room.[29]

Keeping in mind that Whistler and Godwin may have thought it professionally prudent not to highlight their close personal friendship repeatedly in the press, could not this "exquisitely sensitive room" be Whistler's drawing room at 2 Lindsey Row? The details mentioned all add up to Whistler's decor as described in several news reports and corroborated by lists of the artists' furnishings auctioned off in 1879.[30]

The exact extent of the Whistler-Godwin collaboration is difficult to establish, as Harbron notes. "[Whistler's] taste in decoration was curiously similar to that which Godwin had favoured so long for his own houses. . . . Indeed they . . . collaborated so frequently, so many times, in decorative schemes, that it is hardly possible to attribute with certainty their respective contributions to the whole. The idea was frequently Edward's when the execution was undoubtedly Whistler's. At every opportunity in public and private Godwin espoused the cause of his friend."[31]

Whistler and Godwin were joined in the "cause," creating model rooms of astonishing elegance, spaciousness, and simplicity.

Godwin, if anything more than Whistler, wanted total control—designing the house, choosing wallpapers, selecting paintings, mixing the paint. During this same period, he also contrived a total life-style for his young family in a new country home at Harpenden called Fallows Green. The building and furnishing of this large house set on twenty acres ultimately led to financial problems. The health-conscious Godwin was carrying on a psychological-aesthetic experiment in which he endeavored to create a rarefied environment for his young children. Terry wrote in her autobiography that her children were exceptional "and they had an exceptional bringing up."

> They were allowed no rubbishy picture-books, but from the first Japanese prints and fans lined their nursery walls, and Walter Crane [Toy Books were] their classic. If injudicious friends gave the wrong sort of present, it was promptly burned! A mechanical mouse in which Edy, my little daughter, showed keen interest and delight, was taken away as being "realistic and common." Only wooden toys were allowed. This severe training proved so effective that when a doll dressed in a violent pink silk dress was given to Edy, she said it was "vulgar"![32]

While Whistler held decided views on matters of taste, Godwin was even more dogmatic and extreme. He believed that the design of things affected the mind, particularly that of the young. Therefore he tried to make the lives of his children consistently perfect and without visual blight to corrupt their sensibilities. Colors too discordant or blatant, clothing too restrictive, and books with inferior illustrations were forbidden. To ensure that his children would grow up with impeccable taste, he designed their surroundings and their clothes. The design-conscious

life-style of Godwin and Terry, which did not include marriage, was conspicuous by contrast in every way to the lives of their middle-class neighbors and required courage to maintain. By November 1875 things had gone awry, and less than a year later, in 1876, Godwin married twenty-one-year-old Beatrix Philip, with whom he had a son within a year. Beatrix was a tall brunette of bohemian type, an amateur artist, and a decorative designer. She was the daughter of a well-known Scottish sculptor, John Birnie Philip, who was responsible for the frieze on the Albert Memorial.[33]

Whistler's attraction to Godwin's new wife, "Trixie," was immediate, and from this point forward, the alliance between Whistler and Godwin became notably closer. The mutual creative stimulus between the two artists would reach a dynamic new level within the next few years.

Commission for a Mosaic: A Chance for a Public Decorative Scheme, 1872

Whistler learned a great deal about interior design from his alliances, first with Rossetti and then with Godwin, throughout the 1860s and early 1870s. However, his status as a decorator remained semiprivate in nature. He was still struggling with *The Three Girls* for Leyland in the spring of 1873 when he invited Alan Cole to come round to see it. He was probably demonstrating to Cole his continuing efforts to create compositions suitable for use as architectural installations, for considerable time had passed since Alan's father had given him such a commission. As a frequent visitor to Whistler's home, Sir Henry Cole was evidently well aware of Whistler's aspirations to become a decorator. Even though Whistler's public career at that point was not yet distinguished by interior design projects, both Alan and Henry Cole had witnessed his decorating fantasies evolve in his private homes in the most remarkable way, and knew the artist had greater ambitions in this direction. The Pennells asserted that

"during all his life ... Whistler hoped to carry out some great decorative scheme." As director of the South Kensington Museum, Henry Cole had an interesting decorative scheme brewing. He was in the midst of planning the interior decoration of the building, and he had asked Richard Redgrave, Val Prinsep, John Tenniel, and others to contribute designs of figures for a large scheme of mosaic portraits of artists to be installed in the museum. This public project was a manifestation of the renewed interest in mosaic during the aesthetic period.[34]

On March 20, 1872, on behalf of the Committee of the Council of Education of the South Kensington Museum, Cole had commissioned Whistler to create designs for two figures, "a Japanese art worker" and "Neath, the Egyptian Goddess of the Spindle," for the Central Library for the sum of fifty guineas. By this date, the project had been underway for ten years. Whistler seems to have been among the last commissioned to submit a design, but he was undoubtedly delighted to be included at all. These designs would be transformed into mosaics and inserted into arcade niches that ran around the upper level of the South Court. (The mosaics remained in place until 1949.) Whistler told the Pennells, "You know Sir Henry Cole always liked me, and I told him he ought to provide me with a fine studio—it would be an honour to me—and to the Museum!" Tom Armstrong recalled that Whistler worked for some time in a studio in the iron building put up to temporarily house the collections acquired for the museum.[35]

Whistler prepared designs for one of the mosaic panels in the winter of 1873. He executed two different pastels on brown paper of a young woman with curled hair bound up, wearing a sumptuous kimono and carrying a Japanese parasol [fig. 43]. The first design is in a color scheme of blue, purple, and gold, and the second is colored in shades of red, orange, and yellow. Whistler spoke of his Japanese worker design as "The Gold Girl" or "Symphony in Gold," and he planned to have his studio assistants, Henry and

Walter Greaves, enlarge it and put it on a big canvas. He was well aware of the importance to his future career of being involved in this major public decoration project, and he wrote to Alan Cole:

> Your Gold Girl is all right—you have seen her well under way and in full swing. She is as safe as the bank and you shall have the large one colored and finished quite as soon as you are really ready for her—But do not "run me in" with her. ... Now you do not *need* the large finished work until the middle of April and my pictures *must* go to the Academy on the 1st so you are all safe. Say this to your father from me and say that I bind myself to the accomplishment of this thing. Moreover I have set my heart on having it in your halls in a state of perfection for exhibition. So that I take quite as much pride in it and am as anxious about it as you can be. Don't fancy that I am not alive to its importance to me or that I intend to shirk it for other matters.[36]

But Whistler had trouble delivering "The Gold Girl." Meanwhile, he wrote to Henry Cole apologizing for the delay because "my model broke down from over work. ... The work itself has become much more important as I have gone on with it." He discussed the use of photography to transfer the cartoon to another surface. "Tomorrow evening I believe that the traced cartoon will be ready for photography and enlarging upon the big canvas."[37]

The project, however, fell through, and Whistler seems to have never finished this cartoon for the mosaic. What went wrong? Why did Whistler's figures fail to appear among the designs of the other prestigious artists that were installed in the hall? The Pennells cite interruptions, delays, the pressure of other work to get out, and the possibility that Whistler's plan was judged out of keeping with the other designs submitted by the Royal Academy artists whose work was used.[38] In any case, the project remained an unrealized dream for Whistler.

FIG. 43. *"The Gold Girl" or "The Symphony in Gold," ca. 1873, 11 x 6⅞ in. (28 x 17.5 cm). This is one of two designs in pastel on brown paper that Whistler was commissioned to create for a proposed mosaic installation at the South Kensington Museum. From Pennell and Pennell,* Life of James McNeill Whistler, *vol. I, opposite p. 150.*

First Interior Design Commission: Aubrey House, 1873

Although he failed to deliver on a public decorative project, during this same period Whistler successfully decorated his first notable private interior. In 1872 he had been commissioned by William C. Alexander to paint portraits of his children. Whistler finished only one painting for the Alexanders—*Harmony in Grey and Green: Miss Cicely Alexander* [pl. 11]—considered by many to be his best work, and only partially finished May Alexander's portrait. On November 5, 1872, Whistler's mother mentioned in a letter, "We have formed a friendship with Mr. Alexander and his family since he bought that picture (a moonlight picture of this river, exhibited in the Dudley Gallery last Autumn). He is a banker of prominence."[39]

Florence Gladstone, a frequent visitor to the Alexander home, recalled that although the family belonged to the Church of England both William and Rachel had come from Quaker backgrounds. That fact may account in part for their appreciation of the austerity of Whistler's decorating style. In her monograph on the house, Gladstone describes Alexander as a man of wealth and intellect who, nevertheless, had an unusual degree of modesty, simplicity, and lack of pretension, as well as the good taste to commission Whistler.

It was due to this purity and directness of perception that he was able to save England from the disgrace of leaving Whistler unrecognized. . . . He was among the earliest collectors to realize the charm of Japanese and later, of Chinese art. . . . Both his houses gradually became filled with pictures, furniture, porcelain and embroideries. . . . As soon as he obtained possession of Aubrey House, Mr. Alexander asked Whistler to redecorate the reception rooms. Lady Mary's drawing-room became "The Red Room," a name it still bears, though it is no longer red. The panels of the White Room were painted by Whistler

in various carefully selected pale shades. This un-usual scheme was successful, but in 1913 . . . with regret, Mr. Alexander removed the panelling, as it interfered with his hanging of his collection of old Dutch masters. Whistler had also prepared a peacock design for the dining room. This was not accepted on account of the expense. It was after-wards adapted for Mr. Leyland's house in Prince's Gate.[40]

So, at least two of Whistler's color schemes for reception rooms, a Red Room and a White Room, were accepted by the Alexanders and perhaps others as well. Whistler was undoubtedly elated to finally have the chance to move outside the confines of the canvas on a professional basis, expanding his design-ing capabilities toward creating a unified environment in the Alexanders' art mansion in Campden Hill, Kensington (where it still stands), and incorporating the paintings he was then doing of family members. It was his first opportunity to move beyond the interiors of his own home, to attempt to create a total work of art at Aubrey House in the mode of historic interior designers such as the British decorator Thomas Hope in the early nineteenth century.

Although not all of Whistler's ideas were used, he apparently became involved in several facets of the interior design project. A number of his plans for the Alexanders have survived. The Fogg Art Museum at Harvard University has one of Whistler's interior color schemes executed in pastels, and at the Hunt-erian Art Gallery at Glasgow University are four plans for walls executed in very luminous hues of gouache and charcoal on brown paper. The British Museum Department of Prints and Drawings houses the Alex-ander Family Album, which contains, besides several letters from the artist to the Alexanders, five working drawings in pencil and black ink for interior arrange-ments.

Warming to the task of incorporating the Alex-anders' porcelain collection into interior settings,

Whistler began to sketch notations of pots arranged in an architectural niche—one solution he consid-ered for integrating blue and white into a room. Ac-quisition of objets d'art during the aesthetic period—porcelains and statuary as well as seashells, wax flow-ers, family photographs, ormolu clocks, ceramic dogs, elaborate glass items, and other types of bric-a-brac huge and tiny—was epidemic. Whistler had a typi-cally voracious Victorian appetite for collecting but a disdain for the cluttered rooms it tended to create. Thus the arranging of collections in his private resi-dences had long been a major concern of his. The same was true of Godwin, who, like Whistler, at-tempted to alleviate this problem by designing uni-fied, monochromatic color schemes and functional, built-in furniture for display. Such furniture would help organize and contain eclectic collections and give to homes the capacity of miniature museums. He devised various shelving systems such as elaborate overmantels, hanging racks, cupboards, cabinets, and buffets, all of which could hold collections of Tanagra figurines, fans, china, and other objects.

Three other notations for Aubrey House, drawn in black ink on F. R. Leyland's monogrammed statio-nery with wide black borders (Whistler was then stay-ing with the Leylands at Speke Hall), give an idea of what Whistler proposed for the dining room and drawing room. The first sketch of the dining room shows an asymmetrical arrangement that one could characterize as Japanese in feeling [fig. 44]. A tall doorway on the right is featured prominently and has been made taller by the addition of a shelf erected over the door to hold two vases and a large platter. This looming structure makes the extreme height of the plate railing on the left seem more acceptable, though obviously porcelain plates displayed at this height are out of comfortable viewing range. Balanc-ing this, below and to the left, are three straight, light-weight Windsor-style side chairs lined up against the dado. According to Menpes, Whistler felt that furni-ture should be "as simple as possible and be of straight

FIG. 44. *Design for Dining Room at Aubrey House, ca. 1873, black ink, 4½ x 6⅞ in. (11.4 x 17.5 cm). Whistler's sketch on F. R. Leyland's white monogrammed stationery shows a porcelain installation, zoned wall arrangement, and stick side chairs. Alexander Family Album, Trustees of the British Museum, London.*

lines." He was in favor neither of "comfortable chairs" nor of furniture that "suggested laziness." To wit, he remarked, "If you want to be comfortable, go to bed."[41]

The dining room sketch suggests a strictly "no-fuss" interior plan. Accordingly, there is no suggestion for coordinating patterned wallpapers and textiles such as Morris, and also Godwin, favored. Instead, the wall space has been left blank, presumably to receive paintings—paintings, perhaps, such as a series of friezelike panels of lithe women that Whistler was then producing with an eye toward providing

them as decorative interior installations for interested clients.

A second dining room sketch features a dado and above it a hanging cupboard to the left and a two-tiered rack for porcelains to the right [fig. 45, *top*]. Below it, Whistler designed a low, horizontal sideboard devoid of the elaboration typical of Victorian designs. Like the other furniture, it provides ample display capabilities while leaving a large space above free for a painting. In its rectilinear Oriental character, this piece bears some resemblance to Godwin's 1867 Anglo-Japanese ebonized buffet [see fig. 42].

Compared to Godwin's clever sideboard, with its arrangement of solids and voids and its complicated silhouette, however, Whistler's is simple in form, allowing easy incorporation into the unified design of the room. A streak of New England plainness seems to have surfaced alongside *japonisme* in Whistler's design.

A third sketch features a wall with three long, narrow windows [fig. 45, *bottom*]. Whistler proposed placing large vases on elevated perches above a dark dado between the windows. Long plain drapes fall straight to the floor in simple folds. This was the style that Whistler used in his own homes and that Godwin also preferred. Such simple curtaining was in direct opposition to the popular Victorian practice of achieving rich interior gloom through elaborate draping and looping of several layers of heavy curtains excessively embellished with fringes, tassels, cords, and braid.

These preparatory sketches catch Whistler in the act of thinking as a commissioned interior designer, perhaps for the first time. His quick notations suggest interiors based on the understated, flat grid system of a Japanese house, devoid of pattern or frill. The Pennells state that this initial work went no further, but a harmony in white for the drawing room was completed. However, the Alexanders may have found Whistler's refined austerity too stark, as it was later altered by the hanging of a series of Eastern tapestries in the room. In general, the use of white for either walls or ceilings was frowned upon during this period, and most writers warned readers against it. It was considered utilitarian at best, lowbrow at worst.[42] Whistler, of course, had created a long series of symphonies in white in his easel paintings, an idea that he proceeded to carry into his interior designs [see figs. 5, 20, 27; pl. 4].

The extant color plans for the walls at Aubrey House reveal floating veils of color such as he would have found in the Japanese prints he was collecting [fig. 46; pls. 9, 10]. He preferred soft, cheerful harmonies of lemon yellow and apple green, or Prussian blue

FIG. 45. *Two Views: Designs for Dining Room at Aubrey House, ca. 1873, black ink, each 4½ x 7 in. (11.4 x 17.5 cm). Whistler's sketches on F. R. Leyland's white, black-bordered monogrammed stationery feature plans for porcelain installations, a buffet, and vases on podiums between three draped windows. Alexander Family Album, Trustees of the British Museum, London.*

and gold, or peacock blue and terra-cotta red. He was using tertiary hues that recalled eighteenth-century rococo schemes and anticipated the colors favored by art nouveau decorators. Whistler's Arnoldian color schemes of sweetness and light for the Alexanders would have had the effect of bringing fresh air and sunlight into the house. In contrast to deep-toned,

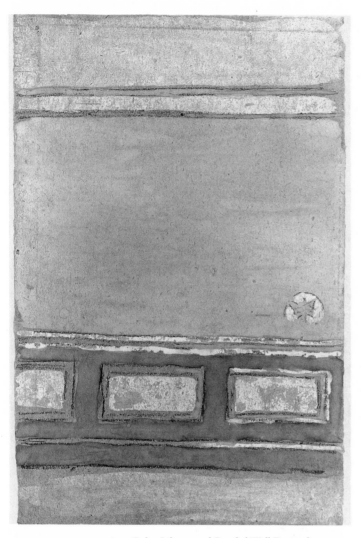

FIG. 46. *Color Scheme and Paneled Wall Design for Aubrey House, 1873, gouache on brown paper, 6 x 4 in. (15.2 x 10.1 cm). Hunterian Art Gallery, Birnie Philip Bequest, Glasgow University.*

medieval colors, he proposed to introduce fair Hellenic hues of sky blues and sunshine yellows for the dining room walls. Whistler may have been influenced by Eugène Viollet-le-Duc, a French designer and restorer of buildings, who used similar color schemes. He had also gained some idea of Greek and Roman color schemes through his study of Tanagra figurines.[43]

His light schemes of flat, rhythmically layered colors representing the divisions of frieze, main wall, and dado were the antithesis of the ponderous wall treatments favored in the period, though the clear division of the space into registers was typical. Vibrant bands of blues and yellows for wall colors would have made a beautiful and suitable backdrop for Alexander's glistening Oriental china, which Whistler featured so prominently in his various notations for the dining room. In some horizontally divided wall elevations, the brown paper he used showed through the thin pigment, indicating the underpainting and giving a good idea of the effect of tonal-based Whistlerian walls. The subtle gradations of hues in one of these schemes include a yellowish frieze, a sky blue railing for porcelain display, a powdery blue main wall, a sky blue chair rail, and yellow-gold paneled dado with a pale blue skirting [see fig. 46].

That these horizontal compositions for walls resemble the flat horizontal bands in Whistler's nocturne paintings was noted by the writer of a witty newspaper article. The writer pointed out that "a fine Whistler, in the artist's best manner—that is to say, a dull green piece of canvas, with a white streak across the middle called "The Thames at Midnight" looked "much more like a dining-room wall [marred] with some of the paint chipped off the back of the chair.[44]

Another color scheme for the Alexanders labeled "Dining Room Aubrey House" in Whistler's hand is signed with a butterfly in a circle in the manner of Japanese seals on prints (Whistler was just then consciously designing his signature) [pl. 9]. The lower portion of the main wall of this scheme features a

sprinkling of yellow chrysanthemum petals and but-
terflies that apparently would have run all around the
room just above the dado, a typically light Whis-
tlerian effect reminiscent of his treatment of the stair-
case wall in his current home at 2 Lindsey Row. The
blue-and-yellow scheme was Whistler's favored
harmony for a dining room designed to display pots.
Whether any of the blue, green, and yellow color har-
monies he prepared for the Alexanders were carried
out is open to question.

Whistler's predominantly blue schemes have a
classical feeling, a sense of serenity and repose. His ob-
jective of ethereal serenity for interior spaces may
have emanated partly from his familiarity with Zen
Buddhist ideas, such as the soul working its way to
peace and perfection by being in perfect harmony
with the universe. As Whistler's nocturnes captured
this spiritual aura of man blending into the cosmos,
his nocturnelike walls provided peaceful, contempla-
tive settings promoting a sense of ease and retreat into
other states and other worlds. Whistler's striving for
perfect harmony in his interiors and his orchestrating
of colors within spaces was consistent with his affinity
for Oriental ideals.[45] He may have learned to create
light, serene, simplified interiors by studying the man-
ifestations of Oriental philosophies as expressed in
colored Japanese prints. Decorating entire three-
dimensional spaces allowed the artist to expand color
auras, immerse people in color, and intensify feelings
of mood and perfect wholeness beyond what he could
achieve on a canvas of modest dimensions.

Whistler's distinctly banded wall divisions, em-
phasizing the dado, a key feature of aesthetic fashion,
foreshadowed the English preoccupation with dados
and wall treatments in general during the 1870s and
1880s. For aesthetic interest, Japanese houses de-
pended primarily on paneled and geometric wall divi-
sions constructed of wooden frames across which
white paper was stretched. These divisions occurred
in the form of exterior sliding grid walls, known as
shoji, and lighter interior walls, or *fusuma*, and were

undoubtedly a major source for Whistler in his experi-
ments with zoned wall treatments [see figs. 30, 61].[46]

Whistler's classical schemes of blue and yellow
and cream for Aubrey House have also been identi-
fied as beach scenes.[47] As such, these walls, lightly
sprinkled with petals, would have made marvelous
backgrounds indeed for Whistler's ongoing series of
paintings depicting windblown women strolling on
the beach and trailing flowers. Perhaps Whistler
hoped to sell the Alexanders a series of these decora-
tive panels and thus devised schemes calculated to
create a perfect setting for them. In any case, the re-
strained pure-color approach was certainly unusual in
the Victorian period. Even a modernist like Godwin
was inclined to fill the horizontal sections of the aes-
thetic divided wall with pattern or a prominent tex-
ture, despite his professed love of delicate color tones
for walls.

The typical Victorian decorator and client had an
immense tolerance for pattern; a surfeit of surface or-
nament was the rule and included the embellishment
of ceilings, which were decoratively painted, coffered,
or beamed [see fig. 32]. Whereas present-day walls are
usually covered in a single paper or color, decorators
at the time often combined as many as four patterns
with complicated flower and fruit designs in a single
room. Or they combined a single pattern, such as
Morris's *Pomegranates*, in three different tones of color
arranged in rigid, compartmentalized borders, hori-
zontal bands, and rectangular panels. Wallpaper de-
signs such as those by Morris, Bruce J. Talbert, and
Lewis F. Day were sold most successfully in drab shades
of green and khaki. In the 1870s and 1880s designers
also favored dividing the walls of homes into at least
three distinct sections: the uppermost frieze, the filler,
and the lower dado, or wainscoting, each covered
with a different wallpaper. With the addition of skirt-
ing below the dado and a cornice above the frieze, the
wall became even more complicated and gaudy. The
proportions of the divisions were shifted according to
taste and design. A painted wooden molding, or chair

rail, protected walls and divided the dado, usually some three feet high, from the filler, and a picture railing divided the filler from the frieze. This picture rail was often a narrow shelf that could be used to exhibit collections of porcelain and other bric-a-brac.[48]

Another more elaborate wall treatment plan for Aubrey House reflects an attraction to paneled geometry [pl. 10]. In this scheme, Whistler experimented further with distempered wall divisions and painted paneling. He may have designed the paneling, or more likely this was his plan for coordinated paint colors in a room with this existing architectural feature. In this design, like the others, Whistler set up a series of linear rhythms to emphasize the geometry of two rows of panels and the height of the chair rail and skirting. This scheme, an arrangement in tones of light green combined with cream and orange accents, is an early version of a favorite Whistlerian color harmony. The horizontal format of this wall elevation suggests it may have been designed for one of the grand hallways.

Such a scheme would have blended well with the recently completed portrait of Cicely Alexander [pl. 11]. Whistler had described his method of achieving a harmony in this work by explaining that "the colours which bind all this arrangement together, which play all through it, are green and gold . . . like . . . threads in a tapestry."[49] If Whistler was able to hang this silvery grey and green painting in the ambience of reflected tones of green that he had designed for an interior in Aubrey House, the unity he constantly sought in interiors would have been achieved—perhaps like the perfect interwoven harmony in a fine tapestry.

Whistlerian Decorative Influences at the Grosvenor Gallery

In 1877 Sir Coutts Lindsay, a wealthy banker and accomplished amateur artist, opened the Grosvenor Gallery in London. Though Sir Coutts denied he possessed the effete aesthetic propensities of Reginald Bunthorne, the "greenery-yallery Grosvenor Gallery foot-in-the-grave young man" parodied in Gilbert and Sullivan's *Patience, or Bunthorne's Bride*, he certainly shared Whistler and the other aesthetes' fascination with interior design, as the arrangement of the galleries revealed. In 1875 Sir Coutts had begun to contemplate the idea of setting up a new gallery together with his wife, C. E. Hallé, and J. Comyns Carr. He perceived a need in London for a picture gallery that would feature young contemporary artists as well as other artists to whom the Royal Academy failed to offer support, and he was interested in making the gallery itself a work of art.

Accordingly, Sir Coutts appointed the architect W. T. Sams to draw plans for an Italian Renaissance–style building with a Palladian doorway at No. 135–137 New Bond Street (now the Aeolian Hall). He decided on interiors lush with red silk walls, deep-green velvet hangings, and ubiquitous gilding. Alan Cole noted in his diary on March 19, 1876, that Whistler had dropped in to smoke with him and tell him about Sir Coutts's exciting new gallery for pictures. Sir Coutts's determination to show the best work in the finest manner possible was entirely in agreement with Whistler's concerns.[50]

The stir created by Ruskin's brutal "pot of paint" attack on Whistler's *Nocturne in Black and Gold: The Falling Rocket*, one of eight pictures he showed at the first Grosvenor exhibition, and the richness of the decor seem to have drawn attention from a contribution that Whistler very likely made to the gallery decoration—the design for the frieze. Although the interior no longer survives, the existence of this nocturnal frieze is one of the few decorating projects documented both by verbal descriptions and in published engravings [fig. 47]. While it is probable that Whistler designed the frieze, research at this point remains inconclusive.[51]

The Grosvenor Gallery became the headquarters for the amorphous aesthetic movement, which

needed a prestigious focal point to highlight the most worthy manifestations of the quest for renewal in the arts in England. The gallery helped to crystallize the British aesthetic movement as a serious force in painting. Sir Coutts's gallery was also one of the key ingredients in the advancing of Whistler's career. Whistler's press clipping albums have many pages covering his exhibitions at the Grosvenor. As one reporter wrote, "The Grosvenor Gallery exhibition would be incomplete, indeed, without some novelties by Mr. Whistler." Oscar Wilde's review of the opening exhibition, which appeared in the *Dublin University Magazine,* both ridiculed and complimented Whistler's work, of which he had little understanding at that point. (Wilde was so proud of his first published work in prose that he sent a copy to Walter Pater at Oxford, though they had not yet met.)[52]

Whistler exerted considerable influence on the advanced mode of exhibition at the gallery, and Sir Coutts placed an important space at his disposal. The display techniques that he had introduced three years earlier in his solo show at the Flemish Gallery in Pall Mall were much in evidence in the first Grosvenor installation. In contrast to Royal Academy hanging practices, works were well spaced, lighting was controlled with a velarium, pictures were hung with care, and each artist's contribution was treated with respect so that it appeared to the best advantage.[53] At one point in his exhibiting career at the new gallery, however, Whistler complained to his friend Waldo Story, a sculptor: "Waldino! The little figure lovely and light, is badly placed. . . . I am in bad odor with the Grosvenor—and have been egregiously insulted. . . . Hallé I have nothing to say to—and Sir Coutts has been too horrid—without meaning to affront me— which makes it worse. One's enemies one can deal with—one's friends are most dangerous." Despite his complaint, Whistler was generally treated with finesse by Sir Coutts, who, in 1888, gave him an opportunity to show his pastels in the gallery's first pastel exhibition.[54]

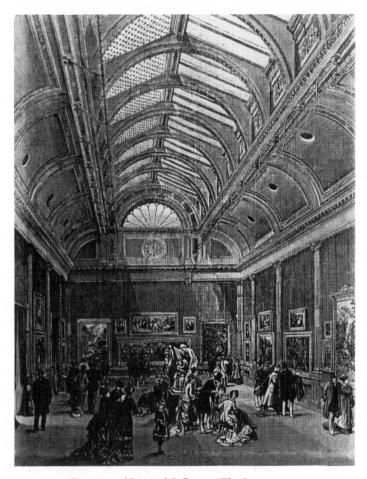

FIG. 47. *Engraving of Principal Gallery in "The Grosvenor Gallery of Fine Art, New Bond Street,"* Illustrated London News 70 (May 5, 1877): 420. *The frieze design of phases of the moon, which Walter Crane attributed to Whistler, is clearly depicted.*

There was an attempt to create a graceful palatial ambience in the gallery with antique furnishings and walls covered with red damask. Some visitors to the opening considered this aspect of the decor a failure. The reviewer for *Vanity Fair* reported, "Whistlers . . . look like mere blots of colour on the glowing walls." Complaints were heard from Henry James, Ruskin, and others about the gilded pilasters, the plush

furniture, the monumental fireplace, and the insistent sumptuousness of the "savage red" walls, which was "disastrous to the pictures." Apparently the complaints had some effect, as later, the walls acquired the "greenery yallery" tint that inspired the song from *Patience, or Bunthorne's Bride*. Despite all this, the Grosvenor was better than most English galleries, which offered bad lighting and crowded hanging conditions that fostered viewer fatigue.[55]

The writer for the *Illustrated London News* described the interior in detail, including the coved ceiling of the West Gallery, which was decorated with Whistlerian nocturnal effects.

> The principal gallery is 105 ft. long, 35 ft. wide and 36 ft. high having a coved ceiling painted blue, and sprinkled with gold stars, and a lantern above. The walls are divided into large panels by sixteen Ionic pilasters, fluted and gilt . . . supporting an elaborate frieze and cornice running around the gallery. The walls are entirely covered with rich deep-toned crimson silk damask, upon which the pictures are hung, with ample intervals of space between the frames. . . . the light is modified by a velarium worked from the exterior of the building.[56]

This new sensitivity to exhibition conditions was something Whistler had begun to promote in his 1874 one-man show. The Grosvenor, though it fell short of the Whistlerian ideal, helped to reinforce his ideas for exhibition design. As Walter Crane recalled, the artist "was a conspicuous figure at the Grosvenor Gallery private views in the early days, with his white lock, and his long wand." Crane also attributed the design of the frieze at the Grosvenor to Whistler.

> This gallery had a deep coved frieze immediately below the top lights, and this frieze was decorated from the designs of Mr. Whistler, and

consisted of the phases of the moon with stars on a subdued blue ground, the moon and stars being brought out in silver, the frieze being divided into panels by the supports of the glass room. The "phases" were sufficiently separated from each other. The walls were hung with crimson silk damask of an Italian eighteenth-century pattern divided by white and gold pilasters. I never thought this silk suited either the pictures or the cooler scheme of the cove.[57]

This design of moon and stars in silver and blue, which was cooler than the rest of the decor, painted on the deep curved frieze of the West Gallery, was reminiscent of Viollet-le-Duc's colorful and imaginative redecoration schemes for interiors. Ironically, the cool night-sky painting covered an ingenious early air-conditioning system that Sir Coutts had designed. The nocturnal motif, a theme favored in Oriental art, as well as the utter simplicity of the design, certainly was characteristic of the artist, who had an inclination to keep things simple just when everyone else was determined to be as elaborate as possible. Judging from the engraving, the design covered eight panels. It appears to be a simple foil for the grand decor below, even though the cool blue did not necessarily harmonize with the warm colors. The juxtaposition of a border of night sky next to the brilliant light of day streaming in through the glass roof probably was an amusing effect. While the Grosvenor was being decorated, Whistler was experimenting with evoking the beauty of the night in his most famous interior design, the Peacock Room; so it seems entirely possible that it *was* Whistler's idea to include panels of phases of the moon at the Grosvenor.[58]

Prelude to Peacocks: Leyland and Jeckyll

Despite Whistler's cultivation of a new mode of interior design in his homes and in a few partially realized

public and private commissions, one is unprepared for the artist's sudden realization of a masterpiece room for F. R. Leyland in his London mansion at 49 Prince's Gate. Although Leyland founded the Leyland Shipping Line and was widely known as an art collector, his historical fame, ironically, rests upon the extravagant Peacock Room that Whistler created in his home, against his wishes, in 1876 and 1877.

Following their introduction by Rossetti in the early sixties, Leyland began to buy Whistler's work. This was at a time when few were interested in it and the press was mostly abusive. He was the second purchaser of *The Princess from the Land of Porcelain.* Leyland consistently indulged Whistler, advancing him money during the years in which the artist seemed incapable of finishing projects. The artist painted and etched portraits of the entire Leyland family, although few of them were brought to completion.[59]

Whistler provided much-needed comic relief for the serious Leyland, and the businessman's family was charmed by the artist. Whistler's mother also became friendly with the Leylands; she nursed their children through a bout with scarlet fever. When Mrs. Leyland was in London, Whistler dined with her and took her to the opera. In the winter, when fruit was scarce, the Leylands sent oranges round to No. 2 Lindsey Row.[60] While living with the Leyland family at their country house, Speke Hall, Whistler had an opportunity to become acquainted with the early *japoniste* activity in nearby Liverpool. In 1868, Leyland bought a house at the fashionable address of 23 Queen's Gate with the intention of developing a complete artistic environment. According to Thomas Way, Leyland was a man of great taste and discernment—one of the most discriminating art patrons of the Victorian era in London. The Morris company had done three wallpapers for Speke Hall—*Pomegranates, Daisy,* and *Trellis*—and Leyland subsequently commissioned the company to refurbish Queen's Gate. Burne-Jones supervised the design of the wallpapers, and Albert Moore helped to decorate the house. Whistler assisted with the arrangement of pictures. He wrote to Leyland telling him he had supervised the hanging and photographing of his *Princess* painting in the Velázquez Room at Queen's Gate. He said he was still working on a large picture of three girls and thanked Leyland "for the name 'Nocturne' as the title for my Moonlights! You have no idea what an irritation it proves to the critics, and consequent pleasure to me; besides it is really so charming, and does so poetically say all I want to say and *no more* than I wish."[61]

Leyland consulted the artist about his art collecting, and Whistler advised him to buy Albert Moore's paintings. Leyland also asked Whistler's advice on whether he should purchase a Velázquez. Though Whistler was skeptical about the authenticity, Leyland bought the painting anyway. In 1873 he purchased twenty-three etchings by Whistler out of a group of twenty-nine sent to Speke Hall by Auguste Delâtre.[62]

Whistler and Leyland were both nonstop interior decorators and passionate collectors of blue-and-white porcelain during the many years in which they enjoyed each other's company. They also shared a passion for order in their surroundings.[63] Unlike Whistler, Leyland was intensely musical; he also spoke Italian to perfection, taught himself French, and enjoyed reading Balzac and Zola. Both men were sensitive to color and had exacting ideas about the incorporation of works of art into unified interior ensembles. They devised picture arrangements together at Speke Hall and Queen's Gate. The artist wrote to his mother about one of these experiments, sending her a sketch of a wall in Speke Hall that showed his famous painting of her between his portrait of Leyland and a painting by Velázquez. Mrs. Whistler enjoyed the idea of "the two on either side of mine covering the wall one whole side of the great dining room called the banqueting hall." (When Whistler sent his mother's portrait home to London on the train from Liverpool, the famous icon narrowly missed being burned in a fire. Mrs. Whistler told a friend, "The

flames had reached the case in which my portrait was ... the lid was burnt, a side of the frame was scorched.")[64]

On one occasion Whistler felt he could humorously chide the sometimes pompous Leyland about a gift of a piece of furniture.

> My very dear Leyland—Now what have I done to you that you should present me with this very questionable Japanese-Marks—Boulevard du Temple—bric a'brac stand!—It has just arrived, and the "Princess" has gone back in its stead. You were grand when you helped me buy the lacquer cabinet—but this is unkind. When the other morning the gift was made, my eyes were clouded with sympathy at what I took for your desire to testify appreciation of beautiful work done— "naif enfant"!—You lacked faith in my pink door and show your sense of my judgement by this wicked sarcasm!—Enfin mon cher. I accept the irony, as Georgie Chapman would say, but "pass" on the stand. Every yours—James W.[65]

In the spring of 1874 Leyland bought another commodious, but unostentatious, house, at 49 Prince's Gate. It was a stone's throw from the South Kensington Museum, where the Morris company's influential Green Dining Room and Poynter's Grill Room were on public view. It was a Queen Anne–style house, very like other respectable row homes in the Kensington district, which was the artistic center of London. The undistinguished exterior allowed Leyland a measure of anonymity, but he planned to transform the interior into an opulent London "art house." Rossetti had advised Leyland to either add a gallery at Queen's Gate or change residences so that he could hang his growing art collection properly. Leyland took his advice and engaged Rossetti and Morris and Company as decorators. He spent several months experimenting with the wallpapers Rossetti brought him, taking great

pains over the colors. He hired Richard Norman Shaw as the architect of reconstruction and engaged Whistler's friend, the designer and architect Thomas Jeckyll, to reconstruct the dining room to hold his collection of blue-and-white porcelain. Jeckyll had been recommended by the porcelain importer Murray Marks. Leyland relied on Marks, "a man of exquisite taste," to mastermind the entire project of converting the comparatively undistinguished town house into a place fit for living out the dream world of an old Venetian merchant in modern London, as Theodore Child remarked.[66]

Although Leyland may have "lacked faith" in Whistler's pink door, he was well aware of the artist's refined sense of chromatics. He included Whistler as a color consultant in the redesign of his Prince's Gate mansion. Apparently he also felt Whistler was capable of handling large-scale schemes, since he commissioned him to devise a decorative effect for the impressive wood-paneled staircase in the main entrance hall.[67]

A pencil drawing in the British Museum made by Whistler on the spot records his consideration of the main architectural elements in the foyer, including a prominent door, carved newel post, dado panels, and elaborate stair rail. Undoubtedly he took his decorating cue for devising the panels from the huge, much publicized late-eighteenth-century marble staircase with a floral balustrade of gilded bronze. The staircase had been removed from the recently demolished Northumberland House at Charing Cross and had been installed in Leyland's house.[68] The grand railing and the equally grand paintings that would be hung above the dado running from the lower hall up the sweeping open staircase dominated his design for the vast entrance hall. Leyland probably suggested that Whistler give the panels of the dado a treatment similar to that of Whistler's golden, petal-strewn staircase at 2 Lindsey Row, since it would form a suitably subtle gilded

backdrop for the bronze balustrade without distracting too much from his paintings [see fig. 39].

The remaining fragments of seventeen staircase panels at the Freer Gallery of Art permit an accurate reconstruction of Whistler's ingenious technical approach. He began by preparing the wood panels of the dado with sizing; over this he laid overlapping, tissue-thin, five-inch-square sheets of gold-toned Dutch metal foil made from an alloy of copper and zinc. He then covered the metallic base with semiopaque glazing and painted it with delicate pale rose and white sprigs of morning glories on a faint bamboo trellis. Thus Whistler obtained a spontaneous-looking, yet richly sensuous and subtly luxurious, effect similar to Japanese lacquerwork and screen paintings. Alan Cole noted that he had "seen Whistler's colouring of the Hall—very delicate cocoa colour and gold—successful." Later, Leyland and Whistler learned that the Dutch metal might tarnish over time, and the following summer Whistler supplemented the inexpensive foil with gold leaf.[69]

The original source of Whistler's morning glory-and-trellis design was Japanese print albums. He had already been inspired to feature morning glories intertwined in railings in some of his pastel Venus studies. The idea of flowers on trellises was currently popular both in English decorative arts and in real English gardens. Early arts and crafts practitioners such as William Morris and Philip Webb had designed trellis wallpaper by 1862, and other designers such as Lewis Day and the ceramist William De Morgan used the appealing theme of rhythmic stylized flowers combined with a grid—it seemed simultaneously English and Japanese.[70]

Whistler's grasp of the Oriental process of layering reflective metallic patches under murky layers of glaze demonstrates, as David Park Curry has pointed out, the artist's study of a similar technique in Japanese screens of the Momoyama and Edo periods. These types of screens were being sold in London and

Paris antique shops during this period. The dark-green-framed dado panels had a muted but glowing effect, and the wood panels of the wall above were painted in shades of willow. The resulting tonality of the hall and staircase was green from the foot to the top of the house. This green-toned color harmony was commonly identified with the aesthetes. The floral mosaic floor was partly covered with Oriental rugs, and other exotic furnishings such as gigantic cloisonné enamel vases, a circular divan, gilt seventeenth-century Venetian side chairs, an Italian cassone, and metal Japanese cranes were arranged in this entry. A large six-paneled Oriental screen beneath the staircase concealed an obtrusive door. With Whistler's subtle "Japanese screen" dado glimmering with patches of gold leaf opposite the gilded bronze balustrade, it was an altogether elegant entrance. Arranged up the staircase walls, Leyland's superb collection of modern Pre-Raphaelite paintings, including work by Rossetti, Sandys, Legros, Burne-Jones, and William Lindsay Windus, completed this setting.[71]

While Whistler layered on patches of gold and painted morning glories up the staircase, in the adjoining dining room Thomas Jeckyll contended with formidable practical decorating problems. First, he was attempting to create a dignified porcelain cabinet to exhibit Leyland's enormous collection of treasured Nankin pottery. Second, he had to incorporate a large amount of eighteenth-century embossed leather decorated with a busy stamped floral pattern in red, blue, and greenish gold, which Leyland had acquired for the walls.[72] Third, his ideas were significantly affected by the architect Richard Norman Shaw's installation of eight protruding, pendant gaslight fixtures. And, fourth, he had to deal with Whistler's subtly colored *Princess* painting, which was to be hung above the mantel.[73]

Jeckyll hoped a color scheme would help him harmonize the incongruous elements in the room. He

wrote Leyland to this effect, but the businessman's keen sense of color caused him to question Jeckyll's suggestion. On April 26, 1876, when the room was nearly completed, he wrote to Whistler [fig. 48]: "Jekell [*sic*] writes to know what colour to do the doors and windows in [the] dining room. He speaks of two yellows and white—Would it not be better to do it like the dado in the hall—i.e. using dutch metal in larger masses. It ought to go well with the leather. I wrote to him suggesting this but I wish you would give him your ideas."[74]

Leyland had unwittingly given Whistler the chance to get his foot in the door of the dining room, and neither he nor Jeckyll could have guessed at the course of events that would follow from this mild suggestion. Although Whistler's involvement in the room began innocently enough, in the coming months he would virtually obliterate Jeckyll's work, building on the wreck of it his Peacock Room. Of course, he was completely dependent on the architectural structure of panels and shelves already in the room. Whistler hated the ceiling with its pendant gaslights and talked about cutting them off, but he had to content himself with painting over the existing architectural elements, which, as Godwin pointed out, were far from beautiful. As a result, historical considerations of Whistler as a decorator, drawn from this single remaining interior, have been permanently colored by un-Whistlerian features such as the ceiling pattern, spindle shelving, and obtrusive lighting fixtures. Whistler had to adapt his design to these elements and, as an artist with an acute sense of organic ensemble, to the rest of the richly decorated rooms in the mansion. The result is an interior that to modern eyes appears more Victorian than avant-garde.[75]

While the room has the unity of design for which Whistler was noted, it is atypical when compared to his usual stark, modern, clearly Japanese-inspired designs. Also, it has several features of which Whistler did not approve. Since no other interiors that he decorated survive, his reputation as an interior designer

FIG. 48. *F. R. Leyland to Whistler, April 26, 1876, ink on white paper. This letter marks the beginning of the scandalous Peacock Room affair. Whistler L103, Birnie Philip Bequest, Glasgow University.*

has rested exclusively on this room. Art historians have been thrown off the track of Whistler's true legacy as a modernist interior designer because of the eclectic nature of the interior, which is redolent not only of *japonisme* but also of *chinoiserie*, rococo revivalism, and Dutch and Jacobean English antecedents. Thus, to some degree, Jeckyll has had his revenge.[76]

Who was the mysterious Thomas Jeckyll? Was he an individual fit for a tale of damaged psyche and split personality in the mode of *Dr. Jekyll and Mr. Hyde*? Perhaps he was. He certainly is one of the least understood and most tragic figures of the decorative reform movement in England. An examination of his truncated career indicates he was a natural designer, a pioneer *japoniste*, and potentially a major player in the course of events that led to the modern movement in design. Yet little is known of Jeckyll, who is described as "a pale little man with a bald head and a dark beard" who wore "knee breeches and buckle-shoes and was looked upon as peculiar."[77]

Judging from Du Maurier's letters, Whistler probably met Jeckyll in 1861. Du Maurier had been acquainted with Jeckyll before he went off to Paris to study. When members of the English group returned to London, Jeckyll became a member of the Paris Gang. From 1860 to 1863 Du Maurier recorded the gang's activities in his letters, and Jeckyll's name consistently pops up. Du Maurier complained, "The little man *clings* to me, it would seem," and on another occasion remarked, "What a little lying snob he is! as soon as I can pay him I shall see much less of him." Still, Du Maurier wrote of many amusing nights spent with Whistler, Tom Armstrong, and Tom Jeckyll "long ago and even lately." He noted Jeckyll's showing of his cast-iron *Norwich Gates* at the 1862 London International Exhibition and recognized that they were "one of the finest things" on display. But he again commented on his "colossal lies" and unpopularity. No one equivocated about the beauty of Jeckyll's inspired iron gates, however. His spontaneous design was neither Gothic nor classical but was composed of lacy tendrils of vines and leaves and flowers. Cast iron was a popular material during the Victorian era, but usually it was used without thought of fine design. Jeckyll's finesse in this medium marked him as a design reformer, and he became "Jeckyll of the Gates."[78]

During the mid-sixties, Jeckyll was part of the "London dining set," which included Swinburne and Whistler. He may have been somewhat on the fringe of the set, a close-knit, avant-garde fellowship of artists who supported each other's efforts, but he kept regular company with Whistler. In 1868 he wrote to Whistler's lawyer, Anderson Rose, mentioning that Whistler had paid for his dues in the Arundel Club, or "I should have been kicked out." At about this same time Whistler directed a mutual friend to "go get Tommy Jeckyll to go with you, for I want him to see my pet Nocturne." Also, in a letter written in 1870, Anna Whistler mentioned Jeckyll as a friend of Whistler's.[79] Whistler could see that Jeckyll was no fool when it came to matters of aesthetic taste, and he genuinely admired Jeckyll's delicate touch and sense of moderation as a designer.

Jeckyll followed the triumph of his gates with refined designs for cast-iron grates, or fireplace surrounds [see figs. 55, 57]. The grates, manufactured by Barnard, Bishop and Barnards of Norwich, were sometimes installed with William De Morgan tiles in stunning glazed designs. One major source for Jeckyll's ideas for decorative grates was Poynter's great cast-iron grill for the Grill Room at the South Kensington Museum in 1866. Jeckyll's fireplace surrounds have reeded backgrounds and a few casually spaced roundels with borders of Japanese fish-scale designs—a motif he also used on the door of the Peacock Room. The surrounds were not overly ornamented and proved to be very popular, selling by the thousands. Examples may be found today at the Victoria and Albert Museum and the Musée d'Orsay in Paris.[80]

Jeckyll had, like Godwin, begun his professional life as an architect of churches in the neo-Gothic style, a predictable style for mid-nineteenth-century British architects. He restored a number of churches and designed several undistinguished Gothic churches. In Cambridge he created a five-story house with advanced design aspects, which has since been razed.[81]

Jeckyll's exposure to the 1867 Paris International Exhibition, with its emphasis on Japanese art, led to his conversion to *japonisme*, and he would produce his best work as a designer in this mode. In 1870, when Alexander Ionides asked him to help decorate Holland House, his mansion at No. 1 Holland Park, Jeckyll complied with designs in the Anglo-Japanese manner. For the billiard room he constructed an oak framework and in it inserted Japanese red lacquer trays, woodblock prints of the Hokusai school, and large paintings on silk [fig. 49]. It was a clear predecessor of the Peacock Room.[82]

In 1873 Jeckyll won a prize medal at the Vienna International Exhibition for another set of gates, and then in 1876, for the Philadelphia Centennial

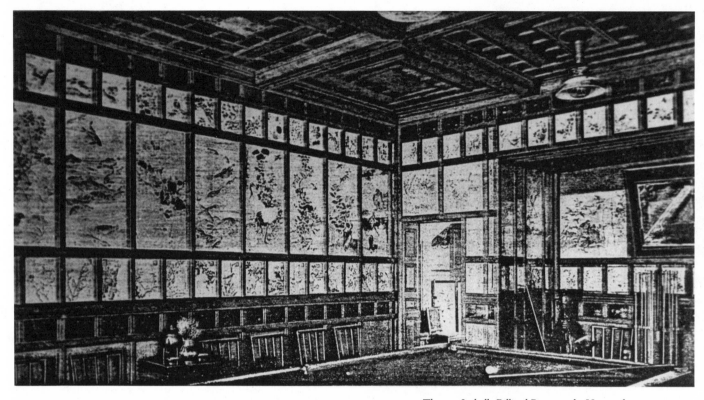

FIG. 49. *Thomas Jeckyll. Billiard Room at the Home of Alexander Ionides, No. 1 Holland Park, London, 1870–71. From Day, "A Kensington Interior," 142.*

Exposition, he outdid himself. He created a fanciful two-story metal pavilion that accurately imitated a Buddhist temple with curved eaves and intricate brackets. It was made of wrought iron and cast iron and was a *tour de force* of Japanese motifs in bas-relief. Most successful, though, was a 4½-foot-high iron railing of sunflowers with wilting leaves which surrounded the pavilion. It may have been due to Jeckyll's marvelous railing that the sunflower, another Japanese motif, became the ubiquitous emblem for the aesthetic movement. The pavilion was re-erected at the Paris International Exhibition of 1878.[83]

Jeckyll's last commission was for Leyland at Prince's Gate; presumably it followed from his success at Holland Park. The original plan for the twenty-by-thirty-two-foot dining room was probably to create an atmosphere of Oriental splendor along the lines of the paneled billiard room, though more lavish. The Japanese-inspired *Princess* painting by Whistler and the large amount of Nankin pottery tended to set the scene for *japonisme* [pl. 12]. One might think that Jeckyll would have attempted to simplify the setting. But the expensive leather purchased from a Norwich country house, which he had mounted on a wood frame to form the walls, had a highly patterned and embossed design of cross-hatching, colorful twisted ribbons, open pomegranates, and leaves gilded in silver leaf and coated with amber shellac. In his review,

Godwin referred to the leather's "sprawling rococo patterns," and on a leaflet he sketched the paneling, carved in an Elizabethan eight-pointed-star pattern, that covered the ceiling [fig. 50]. On three walls, reaching from dado to ceiling, Jeckyll had a delicate network of spindle shelving erected in dark walnut, carved with geometric designs of Chinese and Persian derivation (selected from Owen Jones's *Grammar of Ornament*) [fig. 51]. The shelves were Jeckyll's answer to the requirement of displaying Leyland's large collection of precious pots. The strong verticality of the thin spindle uprights added an impression of Gothic height and delicacy, though the incised designs were Oriental. This strange Oriental and Gothic duality ran through the whole aesthetic movement.[84]

Jeckyll's dado design featured paneling, a typically Jacobean element, but the rectilinear outline of the paneling, with its latticelike division of space, also resembled the geometrically designed sliding wall panels and screens in Japanese interiors [see pl. 14]. The only furniture was a simple sideboard, a dining table and chairs, and a buffet designed by Morris and Company according to Jeckyll's specifications. The buffet had paper panels covered with patterns of Persian lions, foliage, and sun motifs, and shelf panels with putti and flowers. The pendant gaslight lanterns in the room were used throughout the house and, according to a reporter from the *Observer*, were "similar to those which drop from the roof in Tudor architecture such as Kings College Chapel at Cambridge." To this mix Jeckyll added his designs for the fireplace: a wrought-iron fender and two large sunflower andirons with drooping leaves, a motif borrowed from his 1876 pavilion [fig. 51; pl. 12].[85] Jeckyll had constructed an elaborate room with patterned embossed leather walls, patterned blue-and-white porcelain, patterned shelves and ceiling, and a patterned carpet with a red border.

There is considerable disagreement about just how bad or good Jeckyll's design was. He relied heavily on eclectic historical antecedents commonly used by conservative Victorian architects. Thomas Sutherland, a business friend of Leyland's, thought that when blue and white was arranged on the dark shelves, the leather looked "dull and dingy." But Murray Marks maintained the room never looked so well as when the porcelains had been set upon Jeckyll's walnut shelves against the sumptuous leather backdrop. After Whistler completed his work, Marks was "bitterly disappointed" by the loss of the look of expensive antique leather, which he considered far better for the display of blue and white than turquoise blue, green, and gold paint. Marks and Leyland removed a large portion of the porcelain, but both men gradually came to the opinion the room was a masterpiece of decoration.[86]

As to Jeckyll's design, what did he have in mind for this room? Godwin, who was by this time a practiced interior decorator, reviewed Whistler's work in the room for *Architect*. "Let us examine the conditions and see what room it was . . . [Whistler] had to deal with. It was not the very commonplace South Kensington sort of room; neither was it *altogether* of any fashionable modern style, Jacobean, Queen Anne or Japanese. To speak most tenderly, it was at the best a trifle mixed."[87] In sum, the diverse assemblage of "givens" seemed irreconcilable.

After Jeckyll's showing of his sunflower pavilion at the Paris International Exhibition of 1878, nothing was heard of him again until his death in 1881. Obituaries failed to mention his ties with the famous dining room. He became the phantom architect of the Peacock Room. As the legend goes, Jeckyll visited the room after Whistler had transformed it with turquoise and gold paint and it had become the talk of the town. The shock broke him. He staggered home and was found a few hours later muttering to himself and trying to cover the floor of his room with gold. He died in a madhouse. Although this story seems apocryphal, Jeckyll was clearly disturbed by the problems with the room. Jeckyll's insanity had begun to surface after Whistler began to redecorate the room. In November

"HARMONY IN BLUE AND GOLD.
THE PEACOCK ROOM."

The Peacock is taken as a means of carrying out this arrangement.

A pattern, invented from the Eye of the Peacock, is seen in the ceiling spreading from the lamps. Between them is a pattern devised from the breast-feathers.

These two patterns are repeated throughout the room.

In the cove, the Eye will be seen running along beneath the small breast-work or throat-feathers.

On the lowest shelf the Eye is again seen, and on the shelf above—these patterns are combined: the Eye, the Breast-feathers, and the Throat.

Beginning again from the blue floor, on the dado is the breast-work, BLUE ON GOLD, *while above, on the Blue wall, the pattern is reversed,* GOLD ON BLUE.

Above the breast-work on the dado the Eye is again found, also reversed, that is GOLD ON BLUE, *as hitherto* BLUE ON GOLD.

The arrangement is completed by the Blue Peacocks on the Gold shutters, and finally the Gold Peacocks on the Blue wall.

FIG. 50. *Edward W. Godwin. Sketches of the Peacock Room Made on Whistler's Leaflet* Harmony in Blue and Gold: The Peacock Room, *February 1877, printed by Thomas Way. Whistler G100, Whistler Collections, Glasgow University Library.*

1876, he wrote to Whistler telling him that God was guiding his plans for the room, that God had written the letter. Did the humiliation of having a major commission usurped by Whistler push him over the edge? The answers are unclear.[88]

Although stories of the detrimental effect of the room's redecoration on Jeckyll's mental state and on Whistler's financial status are often told, art historian M. Susan Duval has pointed out that there has been a tendency to overlook devastating effects on Leyland. After 1877, Leyland never again commissioned a painting from anyone. Also, while there is earlier evidence of incompatibility between Leyland and his wife, her close friendship with Whistler seems to have

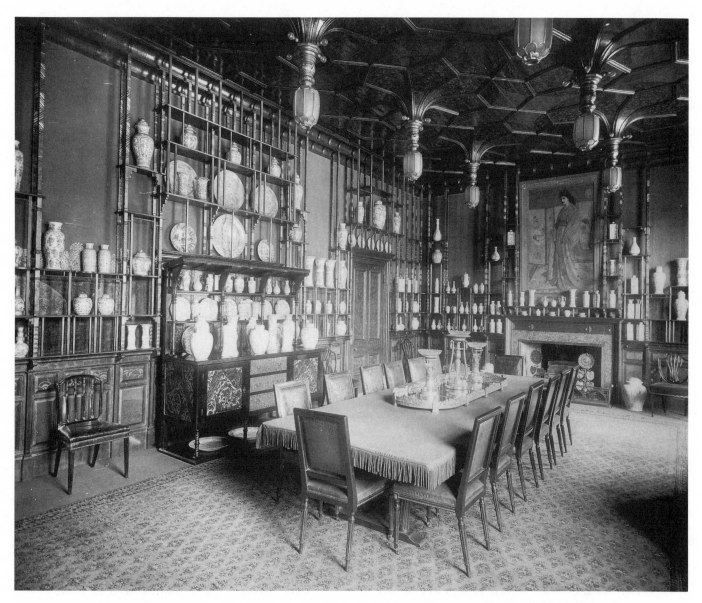

FIG. 51. Harmony in Blue and Gold: The Peacock
Room, *1876–77, London, 167⅝ x 398 ft. (425.8 x 1010.9
cm). Blue-and-white Nankin porcelain was loaned by A. T.
Hollingsworth and arranged on Thomas Jeckyll's shelves. A
Morris and Company buffet, Jeckyll's sunflower andirons, and
Whistler's* Princess from the Land of Porcelain *above the
mantel were part of the original decor. The room is located
today at the Freer Gallery of Art, Washington, D.C. Photo-
graph by Bedford Lemere, 1892, National Monuments Record
Center. RCHME Crown copyright.*

driven the final wedge between them. They were divorced in 1879. Murray Marks also claimed that the antagonism generated by the Peacock Room scandal "had a great deal to do with [Leyland's] premature decease [in 1892]."[89]

How the Peacock Grew: Publicity and Ecstasy

Whistler was forty-two when he took over the Peacock Room commission in the summer of 1876—without fully advising Leyland of the extent of his plans. As the only extant Whistler interior, it is of profound importance in understanding the artist's contribution to interior design reform during the late nineteenth century in Britain. The interior [pls. 12, 14] is possibly the most famous English room of the period and the most extraordinary single surviving monument of the British aesthetic movement. That it has recently been restored to its former radiance seems a testament to the artist's indefatigable elevation of the decorative arts. Whistler's professed desire to create a harmonious environment becomes manifestly clear when one stands in the Peacock Room completely enveloped in its atmosphere. An intense sensation of organic wholeness is felt—a wholeness all the more remarkable when one recalls that Whistler did not design the framework of the room but only painted on the decoration. Although it is far from a typical Whistlerian understated room, it reveals his ability to achieve opulence with simple means when deemed appropriate. To the Pennells he claimed that the whole thing had evolved without real forethought. "Well, you know, I just painted as I went on, without design or sketch—it grew as I painted. And towards the end I reached such a point of perfection putting in every touch with such freedom—that when I came round to the corner where I started, why, I had to paint part of it over again, or the difference would have been too marked. And the harmony in

blue and gold developing, you know, I forgot everything in my joy in it!"[90]

There was considerable truth in this statement. Whistler certainly was carried away by his drive to achieve a coherent, indeed perfect, aesthetic unity with this project. But, though Whistler may have been reluctant to admit it—given the reputation for spontaneity that he cultivated—some deliberate planning seems quite likely. For example, several sets of sketches for the peacock shutters and the feather motif as well as the cartoon for the peacock mural survive [pl. 15]. Though the sketches may have been executed after the fact, they nonetheless suggest that these ideas long excited the artist's imagination. And Whistler may have already had some plans, since he had earlier prepared designs for a peacock room in Aubrey House that had been rejected.

Whistler had practical reasons for wanting to create a major decorative work. He wished to make his mark in the lucrative field of interior design, as nearly all of his colleagues had already managed to do. He had not been able to earn much of a living from his pictorial work. As Peter Ferriday has stated, "It would be surprising if Whistler earned more than £3,000 in his profession between 1859 and 1876."[91] This is why he had been obliged to attach himself to a wealthy and generous patron like Leyland in the first place, just as Rossetti had done.

Furthermore, Whistler had not been receiving much public attention. He had stopped showing at the Royal Academy in 1872 after the grudging admittance of the painting of his mother. In 1876, despite great advances in his art and some worldly success, Whistler had a rather low profile for someone who thrived on publicity. The comments of a reporter from the *Observer* suggest Whistler's problem. "The few and insignificant works of Mr. Whistler which the world has seen of late years have not been such as to commend themselves to the majority. Since the exhibition of his works, held some five or six years ago,

they have been treated to nothing more than an annual 'Nocturne' or 'Symphony' at the Dudley Gallery and these have been passed over by the many." Did Whistler feel he was being passed over as an artist who merely turned out an occasional obscure canvas while his colleagues were involved in a wide range of large public and private decorative projects? This was an era in England when artists felt ready to take on designing anything imaginable—clothing, furniture, interiors, murals, books—thereby making these objects "artistic," raising them to the level of serious art. Certainly, Whistler, too, had adopted this attitude by 1876. The *Observer* reporter conceded, however, that now Whistler was engaged in a major project of decoration in a "truly original manner. . . . the sight of this profusion of gold transports one into the realms of Aladdin."[92]

Before Whistler took over, Jeckyll had been working on the room for six months, planning for Leyland's return in the fall. The Pennells stated, "Some say the original scheme was that Morris and Burne-Jones should decorate and furnish the dining-room, though when Whistler stepped in, they vanished."[93]

The trouble began when Whistler took a long, hard look at the decoration and determined that it had an adverse effect on his *Princess* painting, hanging above the fireplace [pls. 8, 12]. It was the painting that tripped the redecoration of the interior. Whistler's holistic approach caused him to key colors throughout the dining room to the delicate tones of his composition in order to make the room a sympathetic and harmonious frame for his painting. Whistler's attitude about the need to harmonize interior decorations with art collections was a typical point of view during the British aesthetic movement.

Whistler was living at the Prince's Gate mansion when he wrote to Leyland and complained that the delicate color harmony of the *Princess* was being ruined by the bright red border on the Oriental rug and the red flowers on the leather walls. Leyland

sensed that adjustments were needed, and he allowed Whistler to work on the room. Jeckyll's work in the room had been three-dimensional and architectural; Whistler's approach was painterly and two-dimensional. He therefore gilded the small red flowers on the leather walls with yellow and gold, and the offensive red border on the rug was ruthlessly cut off. The results were still unsatisfactory and Leyland agreed that Whistler could paint a design on the ceiling cove.[94]

In early August 1876 Leyland dropped in to see this work and wrote to Whistler to tell him he was sorry that he had missed him when he was in town. He said, "I liked very much the ornament in the cove; and altogether the room will be a great success." Leyland said Whistler should let him know how much more he owed him and mentioned that he would not be in town again for some time and therefore would likely miss Whistler's departure for Venice. (Whistler had planned, and postponed, a trip to Venice.) Leyland was involved in a new shipping venture and was living at Speke Hall during this period. Marks was also absent, being abroad at the time. Apparently, Leyland took no offense at Whistler's peacock-feather effects on the double-coved cornice—and may not even have initially recognized them as such. Whistler simply referred to the design as a wave pattern. Japanese schematic wave motifs had a notable impact on many artists' imaginations at this time, and Leyland, who was attuned to decorating trends, evidently liked the pattern.[95]

In the following weeks, in Leyland's absence, Whistler was extremely busy working on the room with the assistance of the Greaves brothers. To his friend Lord Redesdale, vacationing in Scotland, he wrote:

Anything more absurd than your floundering
around in Scotch sleet! . . . Why of course you
should be here. . . . This dining room is the devil,

and I will not move until it is quite complete, . . . and really in the way of decoration [I have] done something gorgeous! You must immediately upon your return go round to Prince's Gate 49, and say that I wish you to look over the dining room. The family are all away. . . . I suppose I really complete the thing this week, and then still have some lovely Peacocks to do on the shutters.[96]

According to the first review of the room in the September 2, 1876, issue of *Academy*, "Mr. Whistler, who is about to start for Venice, has lately been employed in decorating the dining-room of Mr. Leland's [*sic*] house at Prince's Gate." By this time Whistler had painted not only the cove but also the ceiling. He had applied blue and gold half-circles in a Japanese sea crest, or *seigaiha*, motif radiating out from the light fixtures. The motif represented the "large eye of the bird's fan" and the "softer plumage of the bird's breast" combined with intersecting curved lines. He repeated this pattern of plumage on the walnut panels of the dado. The reporter judged the execution as "ordered but by no means mechanical." Whistler had not yet painted over the leather walls above the dado with turquoise and blue; so far he had only modified the bold design by painting the flowers a gold and "fair primrose tint." In fact, Whistler had written to Leyland at about this time specifically to notify him that the walls were finished and ready to receive shellac so that the pots could soon be placed on the shelves. He added, "The blue which I tried as an experiment was quite injurious to the tone of that leather—and so I have carefully erased all trace of it." He assured Leyland he would only paint above and below the area in which the pots would be displayed "without interfering with the pots or the leather."[97]

There is no mention of a peacock mural in this early *Academy* review, but the presence of three "full-sized representations" of peacocks on the shutters of the room was already a reality [pl. 12]. The article concluded, "It will be seen that in this scheme of decoration Mr. Whistler has trodden upon new ground, and has essayed a very interesting experiment in a branch where tradition is too apt to exercise extravagant authority."[98]

Whistler was elated over the press review. Indeed, this sort of attention may have encouraged him to an even more radical alteration of the room. He sent the *Academy* review to Leyland and wrote him that he was thoroughly carrying out the plan of decoration that he had formed and was creating a perfect ensemble, but that he must not come until the last touch was on. Appealing to Leyland's musical sense, he wrote that it was no more possible to get a true understanding of the ensemble while it was only partially finished "than you could have of a complete opera judging from a third finger exercise!—Voila. . . . I have nearly worked myself to death. . . . There is no room in London like it Mon cher." He ended, "What did you think of the article in the Academy? There will be a little letter of mine in next week that Tommy [Jeckyll] may have his full share of the praise as is right." And in a September 9, 1876, letter to *Academy*, he acknowledged the architect's contribution.

[I] crave your permission to make clear one fact, important in this matter. The design of the elegant and beautiful framework in Mr. Leyland's dining-room is by Mr. Jeckyll, the distinguished architect, to whose exquisite sense of beauty and great knowledge we owe the well-remembered "Norwich Gates," and whose delicate subtlety of feeling we see in perfection in the fairy-like railings of Holland Park. If there be any quality whatever in my decoration, it is doubtless due to the inspiration I may have received from the graceful proportions and lovely lines of Mr. Jeckyll's work about me.[99]

Although Whistler made an initial effort to correct the news coverage of the room, this letter may well have been his method of salving his conscience

for obliterating his colleague's work. Jeckyll's failure to receive fair historical credit for his design would seem in good part due to Whistler, who soon began to omit mentioning Jeckyll's contribution.[100]

By the time Whistler's friend Lord Redesdale returned from Scotland in late October, he found Whistler "quite mad with excitement" over his project. He had gone beyond painting the cove, ceiling, dado, and shutters—he was painting over the expensive leather walls. Redesdale discovered Whistler at Prince's Gate on top of a ladder, looking like "a little evil imp, a gnome." He asked what he was doing and Whistler informed him, "I am doing the loveliest thing you ever saw!" Redesdale remonstrated, "But what of the beautiful old Spanish [sic] leather? And Leyland? Have you consulted him?" Whistler replied, "Why should I? I am doing the most beautiful thing that has ever been done, you know—the most beautiful room!"[101]

Whistler was apparently in ecstasy as he created this atmospheric chamber. He was now thinking of the room in terms of a single work of art. He was intent on giving the interior the quality of a harmonic ensemble in the mode of an eighteenth-century French rococo room. It would no longer be a series of discrete jarring entities typical of Victorian interiors and of Jeckyll's former design. Before Christmas, Whistler wrote to Leyland, who had been kept out of his house for a long time, telling him he would finish the work that week. "It is something quite wonderful, and I am extremely proud of it. As a decoration it is thoroughly new and most gorgeous, though refined."[102]

In reality Whistler would monopolize Leyland's dining room for more than two months longer. He was putting in twelve-hour days and was still in a delirium of decoration. And he was not listening to anyone, Leyland included. Whistler was working on the premise that the artist is outside the constraints of an essentially philistine society and owes duty to nothing beyond himself and his art. He had been seized by the inspiration to turn the room into a unified work of art,

thereby making a "demonstration" against haphazard bourgeois taste. The presence of the news writers further fueled his determination to transform the room.

Whistler's fellow *japoniste*, the Frenchman Edmond de Goncourt would have understood Whistler's passion. De Goncourt took years to arrive at the "assembled nuances" of an "artistic harmony" for a single wall in the entryway of his home. In 1884 he wrote in his journal, "One will never know the pleasure gained by an impassioned decorator as he composes panel walls of an apartment, on which materials and colors harmonize or contrast. It is like creating a great painting when he combines bronze, porcelain, lacquer, jade, and embroidery. This can satisfy one completely." De Goncourt meant this literally, because for him interior decoration had a sexual aspect, and as a confirmed misogynist, the rococo, ornamental "interior feminine world" arranged with beautiful objets d'art became a substitute for a real feminine presence.[103]

Whistler had no inclination to eliminate beautiful women from his life in favor of beautifully formed pots or to sublimate his libido in the joys of interior decorating. But in the true spirit of a modern artist, he was indeed striving to please only himself. It was an art for art's sake room. He was impervious to his patron's potential discomfiture and to cautionary suggestions from friends. Arthur Lasenby Liberty recognized this when he remarked: "Whistler always pretended that he valued my critical judgement, and certainly we had a feeling of sympathy on the Japanese impressionist side of things. I remember spending many hours with him when he was engaged on the famous peacock room, and it was a pleasant pose of his to suggest that I assisted him with advice. But no man, I suppose, was ever more independent of advice or less patient with it."[104]

At Liberty's (and elsewhere) Whistler put, in a prominent place, a bowlful of cards admitting visitors to the work-in-progress in Leyland's dining room. He also issued his own publication, a small 5-by-7½-inch

broadside entitled *Harmony in Blue and Gold: The Peacock Room*. The most intriguing extant specimen of this rare leaflet is Godwin's copy [see fig. 50]. He seems to have realized the historic importance of the room, marking it with the exact time and date of his visit: "6 o'clock 16 Feb. 1877." In preparation for his later review, Godwin covered the pages with comments and sketches of every aspect of the room.[105]

Whistler distributed his handout to invited reporters at an evening press view that he called on February 9, 1877, in order to explain his decorative intent. He also served tea and continually entertained daily while he worked. Perhaps hundreds of people came to see the show—all entering the mansion in Leyland's absence. Whistler seemed determined to get the same sort of attention for a private room that Morris and Poynter received for their exemplary public rooms at the South Kensington Museum. A parade of celebrities dropped by to be dazzled by the laying on of the blue and gold. Among them were Sir Henry Cole, Alan Cole, Princess Louise (Queen Victoria's daughter), the marquis of Westminster, the Alma-Tademas, Louise Jopling (who added a few gold touches), Sir Thomas Sutherland, George Boughton, the Rudolph Lehmanns, Maria Spartali Stillman, and Edward Poynter. The succession of informal receptions and press views held in Leyland's home, the loss of his beautiful old leather beneath gold and turquoise paint, Whistler's courting of his wife, and the artist's demand for additional money for uncommissioned work—all finally enraged the patient Leyland.[106]

Meanwhile, Whistler was euphoric. He had found his métier in the designing of a luxurious room—a project that gave his flair for *au courant* style and his superb sense of decorative design free reign. The laudatory press coverage he succeeded in attracting was beyond anything he had experienced in his preceding twenty years as an artist. The newspaper notices fill many pages in his press clipping albums; every move he made was reported. Whistler dressed for the part and reveled in holding the spotlight.

An article entitled "How Whistler Painted a Ceiling: London Letter to the Providence Press" has preserved an amusing image of the kind of publicity stunt Whistler liked to stage.

> Probably you have heard of Whistler's extravaganza in houses. . . . One day a friend asked me to go over and see one of the rooms that was nearly completed. . . . This is what we saw on entering: A very slim, spare figure extending on a mattress in the middle of the floor; beside him an enormous palette, paints, a half dozen long bamboo fish-poles, and a very large pair of binocular glasses. Mr. Whistler, dressed wholly in black velvet, with knickerbockers pantaloons stopping just below the knees, black silk stockings and low pointed shoes, with silk ties more than six inches wide and diamond buckles, was flat on his back, fishing-rod in hand and an enormous eye-glass in one eye, diligently putting some finishing touches on the ceiling, his brush being on the other end of the fishing pole. . . . "Now wouldn't I be a fool," said he, "to risk myself on scaffolding. . . ." And this was the celebrated "peacock room" about which all London went wild.[107]

The *Academy* review that resulted from Whistler's press conference brought the readers up to date on the artist's progress. The reporter stated that Whistler has been working for four or five months on a "decorative invention" in Leyland's dining room. "He has worked with immense zeal and spirit, and has produced a salient triumph of artistic novelty—too uniformly gorgeous." Whistler's mother was, of course, interested in her son's new venture, and his siblings, Willie and Deborah, kept her apprised of the progress. Whistler sent her a clipping from *Academy* and wrote: "I must not wait any longer that I may tell what I have lingered to do—the completion of this famous dining room. . . . I am content. It is a *noble* work, tho, Mother, and one we may be proud of, so very beautiful! and so entirely new and original as you can well

fancy it would be. For at least *that* quality is recognized in your son."[108] Anna Whistler laboriously copied the article in longhand and wrote to various friends about her son's project.

> [M]y dear Artist son's summer has been spent dec-orating a spacious dining room, the design quite original, but such a great undertaking painting walls and ceilings as he would do a picture in oils, that by the desire of Mr. Leyland he slept there and made it his home, to begin work at 9 in the morning ladders and scaffolding—no won-der he looks thin, tho he is elastic in spirit and thankful for strength according to his need. His Sister . . . went to the room and saw him at work. She wrote me it was beautiful beyond her lan-guage to describe. Tho when dear Jamie came to me . . . he with his pencil enabled me to fancy it.

To another friend she wrote: "I hear how beautiful is the effect produced by the Whistler genius. But a gentleman's private residence is not an exhibition! And I much regret Jamie's works are not this year seen in our native land."[109] What Mrs. Whistler did not quite realize was that her son's latest work *was* an ex-hibition—the most spectacular exhibition of his career.

Before the situation began to deteriorate, and Leyland threatened to "publicly horsewhip" him if he was seen with his wife again, Whistler's ecstatic work on the room continued until early March 1877, at which time Frances Leyland ordered him out of the house.[110] Earlier he had written to Mrs. Leyland: "The dining room has proved a Herculean task and I am bound to finish it—tho nearly ill with work—for were I to drop it,—doubtless I should never take it up again! . . . I wouldn't do it again for any one alive. . . . I am quite broken down with fatigue—and . . . won-der whether you will appreciate it? . . . I am nearly blind with sleep and blue peacock's feathers."[111]

Whistler's one grand demonstration of interior design reform continued to capture the imagination of the press. With the Peacock Room alone, he fo-cused more public attention on new interior design practices than other artists had generated through years of work—with the exception of Morris. The ground-breaking character of this "paradise of pea-cocks," this "blending of Occidental audacity and Ori-ental taste," was acknowledged by the writer for *Lon-don*, who praised the spectacle of color. However, he observed, "to stay in it long would be to earn a gor-geous headache, an imperial weariness of the vi-sion. . . . It seems unlikely that china can be displayed to advantage in so much glitter, but china may be seen anywhere." The critic recognized Whistler's interior design as a protest against the grim grey-green walls and grand style of upholstery of the day. "No pro-test could be more flamboyant than that of Mr. Whistler's."[112]

Whistler was breaking away from Pre-Raphaelite grey greens and morbid medievalism as well as more egregious aspects of Victorian conventionality. His ef-forts were correctly perceived as avant-garde by vari-ous reporters. The critic for the *Examiner* looked upon Whistler as a rebel, a reformer leading a protest against conventional British interior design practices. He noted that society had been "bullied by persons of taste and then imposed upon by upholsterers of no taste" until "a spirit of rebellion has arisen. . . . We can well imagine that his splendid decoration in blue and gold may seem to those who have carefully mas-tered all the little manuals on 'art in the house,' a rather startling and discomfiting performance. The text-books on the subject have not prepared their readers for the kind of beauty that is here expressed." The visitors to this room could therefore experience "the kind of added delight that belongs to a forbidden pleasure." The writer seemed to imply that so much color, so much glitter, so much gaiety, such alarming loveliness, was a bit sinful.[113]

Morris and Ruskin would certainly not have ap-proved. There was no apparent evidence of moral

purpose in this exercise in pure beauty. The Reverend Hugh Reginald Haweis, an author and society preacher par excellence (and a neighbor to Whistler), cited the room in his sermon, seeking to soothe the consciences of his parishioners who had happened to stop by the room to indulge themselves in the festive beauty. He assured them that it *did* have a spiritual dimension and that he had to visit the room again and again before its sacred quality finally dawned on him. Then he felt "something akin to a religious awe" before this "Peacock's plume," this "great iridescent work of God," and concluded that "there is a whole sermon, and a good one too in that room, the text of which was a peacock's feather." The room was a perfect expression of the height of the British aesthetic movement, during which artists in England and America emerged from their ivory towers to take charge of the whole setting of life. The pursuit of beauty in domestic design became paramount. In *Das Englische Haus*, Hermann Muthesius declared: "People in general suddenly began to feel that they were living in a hideous environment.... People looked about them for help. The call for art was heard."[114] Whistler responded positively to this call for improved standards in home decoration, but he reacted negatively against the platoons of amateurs who suddenly became instant experts in the field.

Not every reporter took a respectful attitude toward Whistler's triumphant achievement. *Punch* did a piece on the Peacock Room entitled "A Bird's-Eye View of the Future." The parody was a dialogue suggesting names for other bird rooms—Stormy Petrel Room, Bird of Paradise Room, Grouse Room, Owl Room, Golden Eagle Room, Swallow Room, Cormorant Room, Goose Room, and finally, a Common Barn-Door Fowl Room. In an even more ridiculous flight of fancy, *Punch* decided, in a later issue, that it was actually octopi instead of peacocks that had recently captured Whistler's decorative imagination. "Superb decorations. Japanese Octopi on a silver ground pervading the dining-room—the arms embracing cornice and the suckers studding ceiling."[115] Who would have believed the interior decoration of a dining room could elicit so much commentary, so much scandal, so much interest in exotic forms of art, so much jocularity.

Nor did the news coverage of Whistler's Peacock Room ever entirely abate. When the house was auctioned off at the time of Leyland's death in 1892 and, again, when the room was sold to Charles Lang Freer in 1904 for five thousand pounds and shipped to the United States for installation in his Detroit home (its erection on a wooden framework allowed it to be dismantled, relocated, and reassembled four times), the room received extravagant press coverage. The *Chicago Sunday Tribune* [pl. 13] and the *New York Examiner*, for example, ran lavish front page layouts in multiple colors. In 1904, *Studio* magazine, which championed designers and had often featured the work of Whistler, had this to say:

No scheme of decoration, in public or a private
place—in our own time at least—has ever
aroused the interest of the intelligent and the
curiosity of the unintelligent in such matters to
such an extent as the famous Peacock Room.
The fame of its unique scheme of design . . . the
extraordinary personality of the designer . . . the
legends about this room. . . . It is a witness to a
very determined effort on the part of one man
to escape from all the traditions that have controlled decoration in this country. Its originality
may be impaired by its tremendous debt to the
Japanese . . . but . . . its effect on contemporary
work, [is] chiefly in showing the absolute freedom
with which a man may work who is so much an
artist that unconsciously his production is controlled not by rules, but by the sense of form and
instinct for decoration within him. It is a pity
that a whole room conceived in the fancy of
an artist whose slightest sketches are treasured,
cannot remain in this county.[116]

Many other writers had expressed the hope that the Peacock Room would go to the Victoria and Albert Museum, where it would have provided an illuminating counterpoint to Poynter's Grill Room and Morris's Green Dining Room. Showcased in close proximity to those interiors, the room would have served as a compelling explication of Whistler's significant role in the British aesthetic movement. But Freer's purchase ended the speculation, and the room became an American treasure.

Whistler's panache and voguish high-society style were reflected in his choice of the haughty, iridescent peacock as the leitmotif for the room. When he conceived of the idea, he must have felt he had chosen the quintessential image for the period. Indeed, after Whistler's interior essay on the peacock, the bird would become a major symbol of elegant beauty during the British aesthetic movement in the 1870s and 1880s, would continue to be a favorite motif of the art nouveau movement, and would last well into the twentieth century.

The possible sources of inspiration for the peacock motif seem endless. Edward Poynter's 1866 Grill Room featured a cornice of white molded peacocks. In 1872 Albert Moore designed a large frieze featuring a repetitive design of posturing peacocks for Frederick Lehmann's house in Berkeley Square. And in 1873 Godwin designed peacock-patterned wallpaper based on a Japanese crest. Or, Whistler could have simply looked in Rossetti's backyard in Chelsea in the 1860s to see live, battling, strutting pet peacocks. The pioneer Liverpool *japonistes* George Ashdown Audsley and James Lord Bowes, whose collection Whistler no doubt knew, featured in their just-published book *Keramic Art of Japan* (1875) an illustration of a piece of Satsuma faience with paired peacocks that is extremely close to Whistler's peacock mural.[117]

The original source of the peacock motif in Japanese art and its easy identification with *haute couture* beauty no doubt convinced Whistler of its suitability as a decorative device. And despite all the precedents, Whistler's use of the motif in Leyland's dining room was so definitive and unique that in effect he laid claim to the peacock as his signature image. It was second only to his butterfly monogram, which he also included in the room four times in strategic locations—at the top of the right shutter, in the southwest corner of the ceiling, in the upper left panel of the sideboard, and at the end of the long panel over the sideboard.

Initially, Whistler decorated the cove with repeated, abstracted semicircular forms based on the tail feathers of the peacock. He then proceeded to paint the ceiling, dado, and paneling of the main wall with variations on the eye and breast feathers in blue greens and gold. A pen drawing in the Isabella Stewart Gardner Museum in Boston indicates that he also entertained the idea of painting fully opened peacock tails in the panels above the dado.[118]

The ancient motif that is variously known as wave, cloud, or fish-scale had already been used by Jeckyll in the leaded glass of the door, and Whistler followed this pattern in forming the feathers. Recent cleaning reveals that Whistler also repeated this half-circle pattern in enlarged form just above the dado. Luxurious peacock feathers were soon softly floating onto walls, paneled dados, shutters, and into every corner of the room.

Dazzling gold on blue, and blue on gold, with exaggerated tails in striking positive-negative patterns appeared glistening on the three large window shutters [pl. 12]. Whistler's use of gold leaf, the motif itself, the unusual viewpoint from a very low position, and the fold of the shutters are all strongly redolent of the art of Japan. The total effect of a triptych formed by the shutters particularly resembles a Japanese screen.

The flat, stencil-like effect of these peacock paintings also suggests Whistler's knowledge of Japanese paper stencils, or *katagami*, used for dyed textile designs. Whistler could have learned about these striking stencil designs by studying the fabrics in kimonos and other Japanese textiles in his own

collection. In any case, his familiarity with Japanese silhouette designs from the Meiji period (1868–1912) was the source of inspiration for another method of abstracting the peacock into bold two-dimensional designs.[119]

Battle over Shillings for Whistler's Wizardry in Walls

According to Alan Cole's diary, he was with Whistler at the mansion, consoling the artist while he worked on his three peacock shutters till 2 A.M. on March 5, 1877.[120] Even then he had not completed them. He continued to work, although at that point he had virtually no hope of being paid for his dogged efforts. An epic quarrel between Whistler and Leyland terminated any possibility that his once generous patron would answer his demands for more money.

Leyland was not excited by Whistler's abstracted shutter designs. He had long ago refused to pay for Whistler's additional uncommissioned labor in the room, whether shutters or painted leather walls. Five months earlier Leyland stated unequivocally he would not consent to Whistler's request of two thousand pounds. He added, "I do not think you should have involved me in such a large expenditure without previously telling me. . . . before developing into an elaborate scheme of decoration what was intended to be a very slight affair and the work of comparatively a few days." Nor would he pay Whistler's charge of twelve hundred pounds for the shutters. "I certainly do not require them," Leyland wrote, "and I can only suggest that you take them away."[121] He had only agreed to pay Whistler five hundred guineas; this had subsequently been raised to one thousand and finally to two thousand. Whistler wrote back to Leyland offering to halve the fee, hoping the "shipbroker" would come round with at least some additional payment. When the artist received a check from Leyland for the balance of only six hundred pounds, he wrote back,

noting the additional insult that he had been paid in the pounds of a tradesman rather than the guineas traditionally paid to artists. "I have enfin received your cheque—for six hundred pounds—shorn of my shillings, I perceive!—another fifty pounds off . . . Bon Dieu! What does it matter!—The work, just created, *alone remains* the fact—and that it happened in the house of this one or that one is merely the anecdote—so that in some future dull Vassari [*sic*] you also may go down to posterity, like the man who paid Corregio [*sic*] in pennies!" [fig. 52][122]

Leyland responded angrily to Whistler's impertinent, all-too-true letter the next day, refusing for the third time to pay more than a thousand pounds.[123] Whistler used the back of this letter from Leyland as sketch paper to make notations of fighting peacocks. He was beginning to plot his revenge in the form of an allegorical mural.

Whistler carried the peacock decoration to a conclusive decorative and emotional apotheosis when he painted a wall mural of a pair of battling peacocks with sweeping gestures on the south wall of the room [pl. 14]. In so doing, he discarded the original plan to incorporate the never-to-be-finished, since-lost canvas, *The Three Girls*, into the south wall.[124] Thus large peacocks with dashing demeanors painted on blue in orange gold and greenish gold, with silver and platinum coins used as breast feathers and around the feet of the attacking bird, appeared on the wall instead. Whistler's shillings are the only silver-colored touches in an otherwise blue-and-gold room. Some critics objected to the use of birds rather than human figures for such a costly decoration. The full-scale pounced cartoon for the fighting peacocks mural in charcoal, white chalk, watercolor, and gouache on brown paper is today the elegant jewel at the center of the Birnie Philip Bequest at the Hunterian Art Gallery at Glasgow University [pl. 15]. It is surely one of the most magnificent extant testimonies of the artist's genius for creating large decorative compositions of great verve and spontaneity. Whistler's friend Alan Cole

first noted the arrival of the peacock mural in the dining room in his diary on November 29, 1876 ("Golden Peacocks promise to be superb"), and referred to them again, implying completion, on December 4.[125]

With the mural, Whistler had every intention of creating a commentary on his antagonistic relations with Leyland over shillings, pounds, and guineas (Leyland had also forwarded the bills for materials). Whistler appears to have chosen this theme of battling peacocks when Leyland's letters conclusively convinced him that his patron would not pay him the fee he requested for his work. Whistler called the mural *L'Art et l'Argent* (Art and money), and he promoted the legend of the penurious millionaire patron pitted against the benign angelic artist. Although Whistler had long lived beyond his meager means, he blamed Leyland for his financial downfall, which led to bankruptcy in 1879. The final aesthetic impact of the peacock mural is close to that of Japanese lacquerware—an effect that fits in with the painted, gilded, varnished walls and ceilings.[126] To his credit, Leyland did not alter this insulting painting; as a true connoisseur he evidently recognized its value. Whistler also created *The Gold Scab: Eruption in Filthy Lucre* (oil, 1879), a harshly satirical, independent pictorial rendition of Leyland, as well as a couple of other caricatures depicting a ridiculous, fuming Mephistopheles in a frilled shirt.

Although the peacock was the leitmotif of the room, Whistler's title, *Harmony in Blue and Gold: The Peacock Room*, reflects his foremost concern—the harmony of color. The opening sentence of his explanatory broadside is "The Peacock is taken as a means of carrying out this arrangement." The abstract arrangement of form and color was the artist's prime consideration and the method by which he planned to bring unity to the room and correlate it with the green-toned Dutch-metal and gold-leaf effects he had already created in the entrance hall. To achieve this, he used a warm orange gold and a cooler greenish gold

FIG. 52. *Whistler to F. R. Leyland, October 31, 1876. The letter concerns his battle for shillings in payment for his work in the Peacock Room. Whistler L111, Birnie Philip Bequest, Glasgow University.*

with a ubiquitous dark turquoise blue—an oil-paint mixture of Prussian (Antwerp) blue and white. Walter Greaves said he found the verdigris blue at Freeman's; it was the same paint Whistler used for his Battersea Bridge screen. The green throughout the room is a copper resinate glaze. An emerald green appears around shutters and doors. Whistler followed Leyland's suggestion of extending into the dining room the Dutch-metal effect he had used up the staircase. He laid on squares of this foil as well as squares of gold.

Godwin said he also used "various varnishes."[127] Menpes related that Whistler used "great pails of Antwerp blue and books upon books of gold leaf. Whistler put blue paint on the walls—and into the paint he crammed gold, afterward more blue, and so on, until in the end the room was one glorious shimmer of gold and blue intermingled, a very beautiful whole." Later, while sketching illustrations to demonstrate his ingenious design to Otto Bacher, Whistler would tell Bacher about his scheme of alternating blue on gold and gold on blue.[128]

Whistler painted the expensive antique leather walls hesitantly at first and eventually with abandon. As his mother noted, he covered the walls as if they were his canvases. By painting seductive shades of color and adding blocks of gold leaf and varnishes, he gave the walls a look analogous to Japanese screens and lacquerwork, in which the emphasis is upon the beauty of the surface plane. Recent research reveals that Whistler's claim of blithe spontaneity in creating this effect was far from true; his complicated technique required a calculated approach. In some areas of the room he applied at least eleven layers of paint and gilt to the walls. His devotion to scrupulous craftsmanship, so evident in his etchings, and so typical of the design reformers in Britain, expressed itself also in the manipulation of color and materials in the Peacock Room.[129]

One hundred fifteen years of discoloration, grime, and varnish, and "restorations" between 1947 and 1950, altered the room's color harmony. While the Prussian blues mixed with white retained their original opaque hue, the translucent green copper resinate browned. Though the real gold still sparkled, the Dutch metal, as Leyland feared, tarnished; thus some of the iridescence was lost. Despite his meticulous approach, Whistler disregarded Leyland's concerns and Walter Greaves's warning that his materials would not hold up. Restoration work to remove darkened varnish and shellac films has revealed deep greenish-yellow surfaces on the wainscot moldings that outline the panels. The grid of these prominent moldings affects the appearance of a Japanese lattice or sliding wall-panel, and because of the cleaning, the grids now vie with the painted panels themselves for attention. They are in much closer harmony with the total monochromatic color scheme than was the discolored, brownish tone. The unity of the design has become evident once again. The typical nineteenth-century "greenery-yallery" aesthetic movement color scheme has been revealed.[130] The dado with outlined panels also creates flat planes of color analogous to the horizontal and vertical planar division of *ukiyo-e* prints. Originally, the iridescent peacock blue–green, green, yellow-green, orange-gold harmony that shimmered from floor to ceiling created an exciting, glittering jewel-box effect. As the cleaning proceeded and the authentic tertiary scheme was uncovered, it became progressively more evident why Whistler's stunning room dazzled people.

In fashioning evocative, reflective surfaces of tremendous complexity with "almost mathematical" alternations of opacity and transparency, Whistler employed a technical wizardry that recalled his approach to oil painting. His fascination with making the walls a complex design component in the room was typical of interior decoration in the period. Whistler applied diaphanous veils of paint and repeatedly scraped it off, abraded it, and distressed it, allowing colors to break through one another. Conservator Joyce Hill Stoner calls this "a push-pull pattern sequence."[131] These distressed surfaces with overlapping patches of gold leaf and Dutch metal foil resulted in an effect both animated and subtle. The flicker and vibration of the mottled surfaces that resulted are continuations of the Oriental screen technique Whistler had used in the entry dado. Such metallic, gilded effects were an important aspect of the aesthetic interiors of the era.[132] Like his paintings, which threaten to dissolve into layers of shadowy pentimenti, the walls of the room have undergone chemical changes that have created darkening and fading of fugitive effects. The

permanent changes in the Peacock Room leave one wondering what it looked like originally. Painstaking restoration, however, has returned the room to a close approximation of its former dazzle.

The horizontal sideboard, which merges into the end wall under the peacock mural for a built-in look, is another touch of *japonisme* in the room [pl. 14]. The Pennells state unequivocally, "Whistler designed the side-board." The straightforward quality of this piece makes this assertion feasible, especially since it bears some similarity to the rectilinear style of the sideboard Whistler sketched for the Aubrey House [see fig. 45]. If the sideboard is Whistler's design, it is his one three-dimensional contribution to the room. He may only have designed the sideboard's flat painted surfaces, however, continuing his abstracted peacock-feather design. The piece has the Oriental brackets Jeckyll used in the room, and the grooved, striated banding trim is characteristic of Jeckyll's and Whistler's furniture. When in 1892 Whistler wrote to D. Croal Thomson directing that "Kodak photographs" be taken of the room, he specifically asked for "separate ones of the sideboard."[133]

Whistler blended the structure of Jeckyll's shelving system into the harmonious whole and made it appear more Oriental in inspiration by gilding the shelves, so that they became more enveloped into the general shimmer of the room. The gilding also brought out the carved designs, making them resemble gilded bamboo, and rendered the structure reflective, like the small mirrors in the room. The slender, attenuated trellis of shelves repeats the geometry of the dado. Whistler also gilded Jeckyll's sunflower andirons and had the tiles around the fireplace changed to turquoise blue mosaic. A custom-made turquoise rug replaced the offending one, and the dining room table received a blue tablecloth.

Walter Crane recalled a dinner Leyland gave in the room. Nearly all the guests were Whistler's current or former friends, including Boughton, Poynter, Armstrong, Prinsep, Comyns Carr, Spencer Stanhope, and Burne-Jones. Crane expressed his appreciation of the room's artistic qualities to Burne-Jones. Understandably, the Pre-Raphaelite decorator was not inclined to expand on Whistler's merits as a decorator, since he was anticipating testifying against him shortly in the *Whistler v. Ruskin* trial. Murray Marks's biographer remarked that no one who had ever dined in the room could say a word against the almost miraculous beauty of the decoration.[134]

A Symbolist's Nocturnal Chamber: Art Nouveau Foreshadowed

The headiest aspect of the Peacock Room for Whistler may have been that he had created an interior that was a "dream of the night." It was not meant for the harsh light of day; it was designed, rather, to evoke the glamour and gaiety of evening. Once the turquoise carpet had been laid on the floor, it offered, in effect, total immersion in a six-sided nocturne.

For Whistler it was his *chef d'oeuvre*—exactly right for an artist who reveled in nocturnal atmosphere. Whistler's nocturnes were scoffed at to begin with, but eventually they became such a trademark that a Londoner caught in the blue twilight or pale starlight might exclaim, "How like a Whistler!"[135] The artist was in the midst of his most famous series of nocturnes at the time the commission for the Peacock Room evolved, and apparently he wished to create a similar aura of poetic enchantment in this room. His two pupils, the Greaves brothers, left off rowing him along the Thames River at night in search of ideas for nocturnes, and turned to climbing up scaffolding to help him apply the square patches of gold leaf to turquoise-painted leather walls. The three sometimes went home with gold on their faces and in their hair. Several reviews of the room clarified that it "was principally for use at night"; undoubtedly Whistler had stated as much during his February 9 private view for the press.[136]

In keeping with the mysterious symbolist ambience he had created in the room, Whistler held the press's view in the evening.[137] Since he painted late into the night on the room, he was well aware of the effect he was creating. As he worked, Whistler bathed himself in a three-dimensional blue-green aura softly lit by Japaneselike gaslight lanterns. When he danced Lady Ritchie across the floor during her visit to see the work in progress, Whistler must have had the illusion he was floating in the exotic, feathery world of an *ukiyo-e* print. His knowledge of Hiroshige's color prints of night scenes is the major documented Japanese source that inspired Whistler's passion for moonlight, water, and night.[138] Even without a moon, it is clear the Peacock Room is a night chamber meant to be experienced with the shutters closed, in artificial light. Only with the shutters extended are the peacocks revealed and the blue-and-gold harmony completed. At night the gaslight would illuminate the panels and dado and flicker across the surface of the porcelain, the glittering grid of the shelving, the splendid gold peacocks and feathers on the walls, and the gilt table service set on a blue cloth.[139]

In the Peacock Room, Whistler lived out his escapist, symbolist dreams. It was a "withdrawing room" and, as he said in a letter to his mother, a "palace of art." William Morris's version of such a palace was medieval, but the alchemy that Whistler wrought in the Peacock Room was devoted to the creation of a claustrophobic Oriental atmosphere. As such, this interior suggests Whistler's continuing desire for withdrawal into exoticism; one can almost catch a slight scent of opium in the air. His creation of an inner-sanctum type of environment that offered retreat from the vulgarities of ordinary life was in the tradition of such dandies as Gautier, Baudelaire, the Goncourt brothers, the popular fictional character Des Esseintes, and Comte Robert de Montesquiou.

Without traveling to Tahiti or the Orient, Whistler had created an earthly paradise that offered escape into a gilded fantasy. The critic for the *Times* recognized the paradisiacal quality in this "singular experiment in decoration," this "profusely gilt" and "beautiful iridescent" room. He commented that "the whole interior is so fanciful and fantastic, and at the same time so ingenious and original in motive as to be completely Japanesque." Whistler's friend E. W. Godwin took sharp exception to the *Times* review. He wondered how something could be both original and completely *japonesque*. "I may say at once that the decoration is not completely 'Japanesque.' I will go further, and venture to say that it is not Japanesque at all."[140]

This was a startling statement indeed from one confirmed *japoniste* about the work of another. Whistler was just then putting the finishing touches on shutters and a mural that demonstrated the result of twenty years of profound assimilation of the lessons of Japanese art. Godwin stated that although decorative patterns such as the "interrupted or broken up" technique were "known to the Japanese," and the "gold on colour and colour on gold," as well as the mural, might be interpreted as Japanese, they were just as likely to be of medieval, Greek, Egyptian, Elizabethan, or Jacobean derivation. Why, one wonders, was Godwin taking such pains to discount the *japonisme* in the Peacock Room? Godwin was a much more eclectic designer than Whistler, inclined to draw from the many sources he cited as possibilities for the Peacock Room. But at this point a good deal of bogus and inferior Japanese art was entering England. In an 1876 issue of *Architect*, Godwin reported that he had visited Liberty's Oriental Warehouse, which was crammed with goods, but that he was saddened by the "coarseness," "cheapening," "inferior work," and general "decline of Japanese art."[141] So it is conceivable that in Godwin's eyes, Oriental art had lost much of its initial allure and status, and he was thus disinclined to label the room "Japanesque." Godwin also found that the light from the pendant lamps "utterly ruin the ceiling

colour," and he had many complaints about the architecture of the room. He probably wished to have been the collaborating architect himself.

Godwin had various other criticisms, the most ironic being that he objected to *The Princess from the Land of Porcelain*—the painting for which Whistler had ostensibly redecorated the entire room—as a "defect" in the scheme. It was an "interruption," and amid all the glitter its color "looked somewhat sad, not to say, dirty."[142] What, one wonders, did Whistler make of his friend's acerbic review?

The celebrated Peacock Room's importance in the history of design rests not only on its status as a centerpiece of the British aesthetic movement but also on its role as a precursor of the international art nouveau movement of the 1890s and early 1900s. In the Peacock Room a new form of interior design crystallized in a dramatic fashion that captured an appealing gaiety in the air and caught the imagination of designers to follow. Ironically, Whistler denied the very existence of art nouveau and was definitely not inclined to discern the connection between that interior design movement and his own work in the field. His refusal to accept art nouveau as a serious style was entirely typical of the English response. Walter Crane called it "that strange, decorative disease." Whistler echoed Crane and other British designers when he stated, "There is—there can be—no *Art Nouveau*—there is only Art!"[143]

Undoubtedly the excesses of full-blown, flamboyant art nouveau were repugnant to Whistler, whose taste for Oriental reticence and nuance and for the exquisite precluded such seemingly aggressive vulgarity. And he was not amenable to the art nouveau idea of a break with a complex and rich past in favor of stylized naturalism. Nonetheless, the Peacock Room, featured in such art periodicals as *Academy*, *Art Journal*, *Magazine of Art*, *Saturday Review*, *Gazette des Beaux Arts*, and *Studio*, as well as in numerous daily papers, served as an important primer for art nouveau interior design artists.

The room demonstrated what would become a basic principle of art nouveau decoration—the mind's eye view of a room, or conceiving of it as a single entity. The intense interiority and privacy of the room, suggestive of psychological inner states, also foreshadowed art nouveau preoccupations. Likewise, its walls rich with ornament and murals, its stylized, abstracted forms, its faceted gilded panels, and its decorated surfaces anticipated the frankly luxurious character of French and Belgian modernist interiors in the 1890s. The stylized naturalism of Morris's floral designs were also emulated by art nouveau artists, but the grassroots sentiments and morality of his theory evolved into the arts and crafts movement. It was Whistler's theory of purely aesthetic, organic beauty, unencumbered by social consciousness—as epitomized by the Peacock Room—that most logically culminated in the art nouveau movement of 1893–1902.

The selection of the peacock itself, the most naturally beautiful of creatures, for a peacock extravaganza that even included peacocks with jeweled eyes—one with a "cape diamond" the other a "paste emerald," according to Godwin—gave to the art nouveau movement a recurring motif.[144] The splendid bird, as an interior design motif, was symbolic of the growing desire for elegant and glamorous interiors. The Japanese derivation of this motif and other aspects of the room also became a major source of inspiration for art nouveau decorative artists. The peacocks on Whistler's shutters, with their magnificent tail plumes sweeping downward in graceful curves, and the battling birds in the mural, however, surpassed the more reticent Japanese models. The exaggeration and the energy of the depictions are Whistlerian. The whiplash lines, especially evident in the sketches and cartoon [pls. 14, 15], predict the dynamic flowing line of art nouveau.

Aubrey Beardsley is an example of an art nouveau

artist who ardently admired the Peacock Room. He drew directly on the room and its underlying *japonisme*, as an extensively illustrated letter, which records his visit to the room in 1892, documents.[145] Beardsley's sensual peacock imagery; the *katagami* technique; the patterned, scalelike plumage that he used in several designs, such as his illustration *Peacock Skirt* (1894), created for Oscar Wilde's book *Salome*— all are based on Whistler's room. The monochromatic color scheme, the interest in creating an elegant rococolike setting, the symbolist, cloistered character, the demonstration the room represented against eclecticism in favor of a unified whole, predicted art nouveau interiors.

With this one splendid room, Whistler elevated the artistry of interior design and the level of interest in it. Certainly, he was convinced that in the Peacock Room he had created the most beautiful interior. On Christmas Day, 1879, in Venice, he went to high mass at St. Mark's and wrote to his sister-in-law Nellie about how splendid the golden domes were and how "very swell it all was—but do you know I couldn't help feeling that the Peacock Room is more beautiful in its effect." Whistler's high art approach to interior decoration and his personal flamboyance combined to make the decoration of beautiful living environments seem exciting—a pursuit worthy of the finest artists of the age. With his dramatization of the Peacock Room through receptions and press conferences, with the steady flow of articles his work generated, and with the glamour, exoticism, and scandal he created, Whistler set the scene for a surge of interest in opulent interior design.[146]

5

From Tite Street to the Rue du Bac

The White House on Tite Street

Whistler was a hot news item by 1877. The attention he had captured in newspapers and magazines as a result of his stunning transformation of the Leyland dining room at 49 Prince's Gate, combined with the controversy engendered by Ruskin's "pot of paint" review, gave him a new level of notoriety. Once the *Whistler v. Ruskin* trial had taken place, his public profile would become even higher, as a letter from Whistler to his solicitor Anderson Rose reveals. "Do get me out of this mess. . . . I was run after in Bond Street this morning by the commissionaire of the Grosvenor Gallery who told me that he has now lots of people calling . . . to ask where Mr. Whistler's pictures can be seen! I told him to send them to me here. As you say look what an advertisement the whole affair has been— but my dear Rose the Philistines are upon me!"[1]

Unfortunately, Whistler's financial situation did not improve as he became more controversial. His bitter quarrel with Leyland over payment for the Peacock Room had permanently alienated his most generous patron. Nevertheless, by 1878, Rossetti had faded off into his addictions, and Whistler had become the leading light in Chelsea. He decided it was time to move out of his Lindsey Row house. He had also begun to consider ways to ease his perpetual financial problems, and Godwin convinced him he was "working under studio disadvantages." Whistler decided to hire the architect to design a house with a large studio. In order to capitalize on his new celebrity status, he would create an *académie* such as those he had known in Paris and attract a following of students.[2] A writer from the *World* marked the moment in time when Whistler left Lindsey Row to move to a new Chelsea address.

[E]nclosed by his cerulean walls, he dispenses his hospitality from beneath a whole covey of hovering fire-screens and stuffed cock-robins, which are nailed with studied irregularity upon his ceiling. . . . Mr. Whistler has taken a new house, and his old one with its artistic memories, is shortly to be abandoned; and it was probably the knowledge of this fact that on Sunday flavoured my Baltimore chicken with bitterness, and my buckwheat with melancholy, and that made me gulp down my last remaining ground-nut with something very nearly approaching to a sob. "Who will inhabit this old house after the great master?" I wondered . . . some budding enthusiast . . . will dash off . . . upon the walls and ceilings, wild harmonies in blue and silver, or sprawling peacocks' tails, or weird odd-shaped Japanese ladies watering strange flower-pots.[3]

Whistler had created his own world at 2 Lindsey Row: Japanese art, walls of pure color, fans nailed to the ceiling, endless blue and white, the unfinished Venuses in the studio, a chic bohemian crowd, the unlikely combination of English fare, down-home American southern cooking, and French cuisine. After a visit to No. 2, Henry James wrote home that Whistler was "a queer little Londonized Southerner and paints abominably. But his breakfasts are easy and pleasant, and he has tomatoes and buckwheat cakes. I found there Sir Coutts and Lady Lindsay (the Grosvenor Gallery people)—who are very sociable (and Sir Coutts the handsomest man in England)."[4]

Whistler was reluctant to let go of his artistic house facing the Thames River, which he had decorated over a period of eleven years, but the lease was up on June 25, 1878. His new house was not ready for occupancy, however, even though it had already cost him the two thousand pounds that he had stipulated as the maximum. The next tenant in No. 2 was a Mr. Sydney Morse, who was soon to be married. The future Mrs. Morse must have been surprised when Whistler insisted upon discussing "gold size" (wall

primer), arranging their color schemes, and having his man Cossens do the distempering. He was afraid they would do it wrong, so he mixed the colors himself and directed the operation. However, he forgot to stir the paint at the right moment and spoiled the wash for the dining room. (He often applied the colors himself for his personal rooms.) The Morses appreciated Whistler's fine panels depicting "two ships with sails set at sea" as well as the golden petal-strewn staircase. Mrs. Morse remarked, "The house was colored as a 'sunset.'"[5] It was only after the artist had finally moved out that they ventured to wallpaper the drawing room and studio. By then Whistler's decorating talents were turned to his new home, the White House.

The financial fiasco over the Peacock Room had happened less than a year previously, and the expenses of the Ruskin trial loomed in the near future, when Whistler signed a lease, on October 23, 1877, with the Metropolitan Board of Works. The plan was to build a studio house on a double plot in Tite Street, at the newly fashionable east end of Chelsea. The street, named after Sir William Tite, was not particularly attractive; it was an access road that led to the prime front lots along the river. Whistler's house, No. 35, was situated on the north side of Tite Street at the corner of Dilke, not far from the river and overlooking the rear of the grounds of the Royal Chelsea Hospital.[6] The property had recently been made available in connection with the building of the Chelsea embankment. This was a massive engineering operation directed by the Board of Works, which had bought up the land in order to lease it for residential purposes.[7]

Certainly Whistler could not afford to build a house, but he was caught up in the excitement of new construction in Chelsea, and this, together with his optimism about his career and the outcome of the upcoming trial, deluded him. Most of the homes going up were red brick Queen Anne houses and flats. But Godwin, who was by this time Whistler's best friend,

had bolder ideas. Godwin had recently tested some of his original ideas in Jonathan T. Carr's Bedford Park project, an "artistic" middle-class garden suburb, before being dropped as the architect.[8]

On Tite Street, starting in 1877 with Whistler's unorthodox house, Godwin had a chance to design a series of unapologetically modern professional "studio houses." The studio house, which was an artist's tastefully appointed residence dominated by a large studio, became popular in London in the late nineteenth century, attracting public attention and press coverage. Artists began to entertain in their elaborate studios, carefully set up as showplaces. Whistler enjoyed combining his Sunday breakfasts with private views in his studio.[9] Not only could he exhibit his paintings and etchings in a proper setting, but he could also show off his interior designing capabilities. Potential buyers who came to see his pictures would usually get a tour of the residence as well.

Godwin's daring architectural design for Whistler stimulated other artists to hire him; he was ultimately responsible for several structures built on Tite Street. The commission helped to make him the key architect of the aesthetic movement.[10] Earlier, in 1877, he had built three typical Queen Anne flats in Chelsea, but his new designs for studio houses were avantgarde. They relied on subtle proportions and austere geometry and were based on his thorough knowledge of Japanese construction methods and concepts. In an article entitled "Japanese Wood Construction," Godwin focused on several aspects of Japanese architecture. He discussed two characteristics that would become important aspects of the White House—geometric trelliswork and daring, steeply pitched roofs.[11]

Clearly, Godwin was attempting a dramatic breakaway from heavy reliance on past Western styles. "The artist," he observed, "is the most extraordinary client that you can deal with—every individual painter has his individual idea as to what a studio should be."[12] Godwin's extraordinary clients, led by

Whistler, caused him to create his most original work. The house he designed for Frank Miles and Tower House (one of Whistler's homes) still stand on Tite Street. Oscar Wilde's flat, for which Godwin and Whistler designed interiors, survives as well. Sadly, Whistler's White House, an important aesthetic monument of the period, was demolished in the 1960s.[13] Nonetheless, Tite Street remains a prime site for viewing remnants of aesthetic dream houses created at the peak of the English design reform movement, which was driven with such aplomb by Whistler and Godwin.

The famous collaboration between the two aesthetes began on August 14, 1877 (about six months after Whistler had put the final touches on the Peacock Room), when they first came together to plan a house. In his diary Godwin wrote, "To Whistler's—dined together and W. came on home with me—ordered plans for a studio etc. (50 x 50 or thereabouts)." Godwin completed the preliminary plans in only six days, and Whistler and Godwin celebrated with a drink. They continued to work out the plans from August through September 1877. Godwin repeatedly made such notations in his diary as: "called on W. with wife," "to W's with wife to breakfast," "W. came at 8:30 to dine." And on September 15, 1877, he recorded, "Dined at W's[;] he approved of the last plans." Judging by these repeated meetings between the two men, Whistler would seem to have been vitally involved in the design process. The Pennells stated, "Godwin was the architect, but there is no doubt that Whistler was the designer."[14] Finally, after years of developing their ideas together on several projects, the two artists had a chance to conspire in the creation of a revolutionary house from the ground up.

The fact that Whistler was determined to build a studio house large enough to live and work in and to accommodate students is an indicator of his growing sense of status and his hopefulness for the future. In the 1860s and 1870s a number of artists, including

G. F. Watts, Lawrence Alma-Tadema, Val Prinsep, Edward Burne-Jones, and Frederic Leighton—all favorably associated with the Royal Academy—had set themselves up in tasteful art houses.[15] Together with his iconoclastic architect, designer, and friend, Godwin, Whistler now proposed to construct a Japanese-inspired studio house unlike any other in London.

It was while the White House was being built that *Art Journal* reported the exhibition of a Japanese room originally "constructed for Dr. Dresser when residing in Japan."[16] Unlike Christopher Dresser and, later, Menpes, neither Whistler nor Godwin had traveled to Japan. They had learned about Far Eastern interior design practices from photographs, Japanese prints, books, and artifacts and from Japanese and Chinese displays at international exhibitions.[17] Although no record of their visit to Dresser's room has emerged, it seems quite likely that Whistler and Godwin availed themselves of this singular opportunity to stand inside an authentic Japanese interior.

When, shortly after having completed Whistler's house, Godwin lectured to a large audience of members of the British Architect and Northern Engineer Association about some buildings he had designed, he did not allude to his inspiration from Japanese art. Instead, he charged his fellow architects to design buildings "developed out of the wants of the age" and encouraged an architecture of simplicity "appropriate to the times." Referring to the White House, which "everybody knew," he said it was built "entirely of hard white brick." Though he did not know how the white would last, when the house was first completed it had a lovely effect with the green Eureka slate roof. Godwin stressed that his pride in the house was that—unlike his prestigious neo-Gothic Northampton Town Hall and Dromore Castle commissions, which followed upon his early study of Ruskin and the Gothic—the entire effect of the White House was "original and pleasing." He had achieved a design as fresh in conception as any building he had ever created. Architectural circles were excited by the White

House as "one of the surprises of next season," but the Board of Works was far less impressed.[18]

Much to Whistler's extreme frustration, the first and second sets of Godwin's restrained, highly original designs for the exterior of his compact, three-story, blocky house were rejected by the Metropolitan Board of Works. The board could not fathom the Japanese inscrutability of the flat facade, which failed to divulge its interior secrets and failed to fit into the conventional notion of residential style in Victorian London [fig. 53, *top*]. The unadorned facade of the White House, featuring a vast studio roof pierced by a single window, engendered a long, violent, and tedious battle with the board, which had the authority to control the designs of houses on its leased property. The board may have interpreted the clean lines and startling simplicity of the White House design as too revolutionary or as an architectural protest against the dominant, fashionably quaint red brick Queen Anne style in Chelsea. In short, "The only objection which the Board have is that the elevation is of an ugly and unsightly character."[19]

One reporter who found the White House "peculiar outside and in" declared that "the whole structure is a twist sinister. The front of the house is a mere dead wall rising sheer from the street, pierced prominently with square holes filled with small glass panes. There is no railing, no porch, scarcely a patch of jutting masonry to relieve the bald sterility of the pale brick." According to Godwin, the board "said it was like a dead house." This was because it was devoid of all ornament and trimmings, and the worshipful Ruskinian attitude toward ornamentation was deeply etched. The board objected to the fact that the house was "all roof," though Godwin explained that the house would not give that impression from the street and that the roof's contour was dictated by function and economy.[20]

The radical house that aroused such xenophobic reactions had evolved in stages, and Whistler and

FIG. 53. *Edward W. Godwin. Original and Revised Front Elevations of the White House.* Top, *original design,* British Architect, *December 6, 1878, Whistler G115, Whistler Collections, Glasgow University Library; bottom, revised design, Z.1333 E.491-1963, Victoria and Albert Museum, London. By courtesy of the Board of Trustees.*

Godwin were in constant contact as the final drawings evolved. The original front elevation shows a facade consisting of a combination of pale brick and plain white wall punctuated by a paneled main door placed asymmetrically to the right with varied rectangles of small-paned windows arranged playfully, but sensitively, on the surface [fig. 53, *top*]. The aesthetic

purism and austere rectilinear asymmetry of the design anticipated the late art nouveau style of Scottish architect Charles Rennie Mackintosh, as, for example, in his Hill House (1903), and of German and Austrian architects, as in Josef Hoffmann's Palais Stoclet (1905–1911).[21]

It was a house built from the inside out, so the

windows were functionally placed and reflected the rooms within, as opposed to the regularity of the windows in other Chelsea houses. The upright verticals of the doors and windows were balanced by long horizontal moldings. These moldings and the Greek-style entablature above the door, topped by windows and an arch, were the only decoration. The facade design resembled Whistler's increasingly formalist canvases of the 1870s, which depended on a painterly arrangement of lines, forms, and colors. Like his nocturnes, the White House facade had the lyrical brevity of a *haiku* poem. The frames of windows and two doors were painted light grey-blue to harmonize with the green roof, but Whistler later decided the front door should be peacock blue.[22]

The revised plan, published in *British Architect* in 1878 [fig. 53, bottom], showed the results of the board's demands. The words "The White House" were placed diagonally above the door with Whistler's butterfly monogram on the right—this was the first recorded mention of the name—and the entire facade was now rendered in white brick. This was a less radical, more ornamented version of the original purist design. Godwin added sculptured panels, a statue in an alcove between two windows, decorative stone moldings around the windows to link them together, and front door details. The ornamental work was to be executed by Joseph Boehm, Leighton, or Watts, according to Whistler's letter to the board. Neither Whistler nor Godwin wanted bas-relief ornaments, but they were finally coerced into adding them—at some expense. Though the board granted a lease subject to the installation of decorative work within a year, Whistler failed to have the sculpture inserted into its niche. Not only could he not afford it, it was his intention to remove such ornaments once the board had time to forget.[23]

During this harried period, while the Metropolitan Board of Works raised repeated objections, the two schemers kept in constant touch with each other via short memorandums and blithely continued to build. On January 30, 1878, Whistler wrote to Godwin:

> Come down to me if you can possibly manage it tomorrow morning early—I want to tell you all about the Board—If they send for you—*dont* go—mind—I tell you straight—be out—and come here instead. . . . I have excellent advice about it from Wickham Flower who knows. He says *get on* "get on!—get on the roof as fast as you can"—and they can't make you pull it down—Keep away from the Board—until all is finished—When the roof "is on it is too late for them to put in an injunction." And by George old chap they *are* getting on! The whole scaffolding of the roof is already up! I saw it this evening. Looked lovely!—Let the builder know how pleased I am with his work and urge him to hasten—but . . . above all dont breathe a word of difficulty of any kind to Nightingale [Benjamin Ebenezer Nightingale was the contractor] or any one—All the yarn about Ruskin [the plans for the trial were beginning to heat up] is false.[24]

Shades of Peacock Room intrigue! Whistler was, as usual, determined to subvert authority in order to see his dream become a reality. And half the fun was in the game. The following letters are along the same lines:

> [G]et down here tomorrow at 9:30—and we will breakfast and bolt over to the house together and arrange so that I can get back to the printing [he was printing etchings for sale to defray costs]—for things are!!!—You have got I don't know what notion in your head about your line with [George] Vulliamy [the board's architect]. Of course nothing whatever must be done until the ▲ is up. . . . had not you better write a line [to William Webb, Whistler's current solicitor] and

say that quiet and silence are necessary until the alterations [we are] now making are complete.[25]

In a letter received by Godwin on March 22, 1878, Whistler was triumphant.

The most important thing is to have Vulliamy's last letter to you safe again in our hands—meanwhile stick to the drawing which he signed and the game is really ours. . . . *Thomas Carlyle* has been down to the house with me this morning!!! and is delighted—and highly enchanted with the story of the Board!

In the same letter he included a practical memorandum about design details.

I suppose you are not well enough to get down there on Monday or Tuesday and see West [one of the builders] about the Jeckyll stoves for the rooms. Some of them have come and he doesn't know where they are to go—Also what about the tiles to go round them—I want those plain simple yellow ones that Watt has from Doulton's—I cannot [stand] any of the other abominations—I have given West the plan for garden and corridor to it—and he is going on at once![26]

From this note one learns that although Whistler had erased Jeckyll's work in the Peacock Room, he proceeded to install his Japanese-inspired metal grates in the White House, since he recognized they were the finest aesthetic designs for fireplaces available. Also, instead of using popular pictorial tiles created by artist-designers like De Morgan, Crane, and Burne-Jones, Whistler considered only plain tiles tolerable. And either he or Godwin, or perhaps the two of them, had devised a plan for the garden, a key element in this house. Whistler continued to keep tabs on the smallest details of the house design: "Don't want the yellow tiles round fireplaces *all over the house*—In the dining room yes—in drawing room studio they might be red brick tiles—very simple and doubtless cheaper coin. . . . also do away with big key hole in the front door—Also should want the flag staff at once—and white bunting."[27]

A flagstaff and bunting! This memorandum reveals a design detail of the stark facade of Whistler's White House overlooked in the literature. Nevertheless, an inspection of the plans for the facade reveals the presence of a flagpole, above the front door to the left, in early and late versions of the plans [fig. 53]. The White House flagstaff, one supposes, would have sported a delicate white banner with a yellow butterfly fluttering in the breeze. Whistler was probably inspired by the banners and exotic kites of Japan, which Hokusai and Hiroshige occasionally featured in woodblock prints, as well as by his own sensitivity to the flowing rhythms of fabric. So the facade of the White House would not have been "dead," after all, but, rather, delightfully animated like the resident dandy himself.

As construction continued, he appealed to Lady Hogg, who thought the house charming, and to Princess Louise, whom he met at the Mitfords' home. He had a long talk with the princess about the house, telling her how unkindly the Board of Works was behaving. "She greatly sympathized—and I made a grand stroke! I said that if her Royal Highness would only drive past and say how beautiful she thought the house that of course this would put an end to the whole trouble. She laughed saying that she didn't believe her influence was as strong as that! but afterwards said in a reflective way that 'Lorne knows Sir James I think. . . .' So I fancy we will astonish old Vulliamy yet!"[28]

Godwin was fed up with the state of things and the attention being lavished on Whistler. In April he wrote to *British Architect* to refute certain lines in the

Examiner, especially the notion that the design was Whistler's.

> Mr. Whistler's house is *not* "eccentric", neither is it "fantastic", and it certainly is *not* Mr. Whistler's design. . . . That it was not *Gothic*, nor *Queen Anne*, nor *Palladian*, was probably its crime before the Board of Works. It is unhappily of white brick and is covered with green slates— two heresies in the last modern faith, that believes only in red brick and red tile. . . . Mr. Whistler as owner and Mr. Godwin as author of the work must be prepared to be misunderstood in days devoid alike of simplicity and originality.[29]

Richard Norman Shaw's Queen Anne houses in Chelsea received warm compliments from William Morris—he called them "elegantly fantastic"—but the cool, cubic White House was against everything Morris and Ruskin stood for. Clearly, Whistler and Godwin were swimming against the tide. All the more reason to rush the job. On May 9, Whistler urged that the workers get on with it. "Please direct the large studio floor to be stained the brown that I pointed out to Mr. West long ago—and once waxed—not varnished. Kindly have this hurried on that I may send my things in by Saturday."[30]

The surprising thing was that Whistler ever managed to live in his new house at all [fig. 54]. The board withheld the lease when the sculpture did not appear in its place. Whistler wrote furious letters saying the Lindsey Row tenants were pressing to move in. "The consequence will be that I shall be turned into the street." The board relented on this point but continued to create obstacles to the house's completion, and Whistler's funds were depleted as delays accumulated. It took longer to erect the house than projected, and Whistler altered the plans during construction, so it cost more than estimated. On September 12, Whistler wrote Godwin that he was on the warpath against

that "d——d thief Nightingale! . . . the ridiculous robbery he attempts to perpetrate! *Over nine hundred pounds for additions!* . . . However I'll have his scalp! Mine is the brightest little lawyer in London. . . . They tell me that in court it will be monstrously funny! I have set the whole machinery going."[31]

Whistler was looking for scapegoats for his acute financial problems. Leyland was an obvious target. And any one of the tradesmen or contractors who had worked on his house would do. Godwin did not escape blame. His itemized bill, dated September 9, 1878, listed £920.5 in "additions." He had estimated the White House at £910. In the letter accompanying his final account, he tried to persuade the artist he could sell his home for a good price.

> The above is the final statement of account with the delivery of which my professional duties cease. . . . It distressed me to find that the Contract should have been so much exceeded but then of course you have greater accommodation and more fitting than we have contemplated— When you have completed your internal painting and have put one or two of those final touches that used to be such eye openers to Watt I have little doubt—that you would be able to sell the house for £3000. Not perhaps as house property . . . but as a house plus a work of art— of the original Whistler. . . . You no doubt have seen that a princess possesses our mantelpiece of the Paris Exhibition.[32]

The mantelpiece to which Godwin referred was the central element in another collaboration between the two designers, a model room for the 1878 Paris International Exposition. The display was a sensation, but it did not bring Whistler design commissions. He had to pawn, sell, or mortgage anything he could lay his hands on to meet expenses. To his friend Charles Augustus Howell (sometimes a shady dealer) he sold

FIG. 54. *Edward W. Godwin. White House, 1878. Of a minimalistic design, the house was white brick with a green slate roof. Now demolished, it was located at 35 Tite Street, Chelsea. The photograph by W. E. Gray was taken after Harry Quilter added a bay window and headers on the windows. From Pennell and Pennell,* Life of James McNeill Whistler, *I, opposite 224.*

his portrait of actor Henry Irving for ten pounds and his sealskin coat. He persuaded the publisher Henry Graves to make engravings for sale of his portrait of Carlyle and several other works. And he put in "fiendish slavery" at the printing press. All the while, bills were rolling in, not only from contractors and from Liberty—who tried to soften the blow by enclosing sympathetic notes—but from the butcher, the greengrocer, the baker.[33]

It was October before the house was at last sufficiently finished for occupancy. Alan Cole commented in his diary, "Poor J. turned up depressed—very hard up and fearful of getting old [he was 44]." Apparently his depression lifted enough to stage a housewarming at which he held a private view in his new studio. He was in the midst of decorating the White House when, at the end of November, the Ruskin libel case came to trial.[34]

What Whistler's guests discovered behind the blank (or *blanc*) facade of the house at No. 35 Tite Street was an interior that was a complete contrast to the exterior. Beyond the abbreviated, yellow-distempered, blue-carpeted entrance hall, the house opened up to surprisingly spacious rooms with walls of pure color and glass. Only a couple of the rooms were actually in order, however. According to an anonymous writer, "Everywhere you encountered great packing-cases full of pretty things, and saw preparations for paper and carpeting, but somehow or other nothing ever got any forwarder. What was done was perfect in its way. The white wainscotting, the rich draperies, the rare Oriental china, the pictures and their frames, the old silver—all had a charm and a history of their own."[35] While one assumes that money was a factor, the incompleteness was true of all Whistler's residences from this point forward. Guests frequently had to walk around packing cases and trunks to get to the beauty.

One of Godwin's architectural drawings of the house includes the elegant artist ushering the architect through the front door with a sweeping gesture.

Another front door elevation, with one of the double doors flung open, reveals a section of the interior stair railing cutting horizontally across the field of vision at eye level [fig. 55]. Inevitably, the eyes of a visitor entering the house were drawn straight to this slender geometric stair railing. This same design motif was used a few steps up to the left in front of the dining room door. The design of this balustrade was based on Japanese examples. Whistler had used variations on such railings for years in the backgrounds of his Venus paintings and pastels [see fig. 29]. (His fascination with abstract structures was also evident in his bridge paintings.) The center post of this balustrade was to be inlaid with bands of ivory in the manner of Japanese and Chinese cabinet decoration.[36]

One visitor recalled, "Immediately inside the door (there is no hall worth mentioning) a flight of steps on the left leads to the studio; on the same side, a yard further on, half a dozen steps, guarded by a slim wooden railing, lead up to the dining room, while in front reached by an easy descent in blue Brussels carpet is the drawing room" [figs. 56, 57]. The artist Jacques-Emile Blanche recalled an impromptu trip with the artist Paul-César Helleu to visit Whistler in his new house.

> Never in my life had I been so astonished. Helleu was wild with enthusiasm: "Blanche, let's go and knock at the door of the White House, since Whistler knows you!" We jumped into a hansom. How excited we were when we were admitted. We went through a series of unfinished rooms distempered with yellow. Japanese matting lay on the floors; in the dining room there was blue and white Chinese porcelain; old English silver decorated the table permanently spread with a white cloth on which stood a blue and white bowl of goldfish.[37]

The art dealer Walter Dowdeswell, who visited the White House in order to learn how to frame

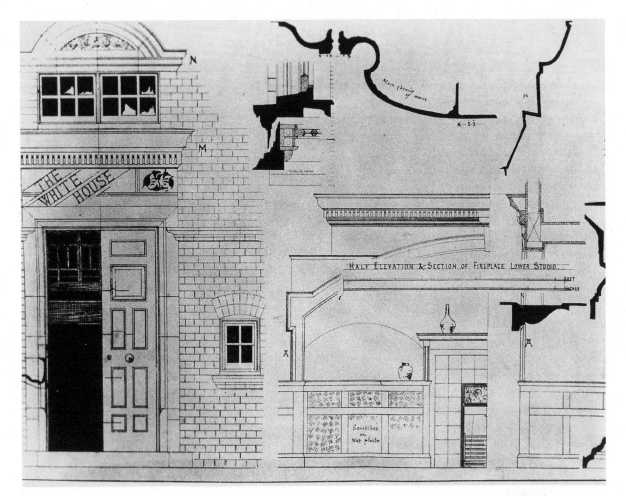

FIG. 55. *Edward W. Godwin. White House Designs for Double-Paneled Door and a Lintel with Diagonal Lettering, Butterfly, and Classical Dentil Detailing. Interior views include a design for a stair railing, a geometric dado labeled "scratches in wet plaster," and a tiled fireplace with a grate by Thomas Jeckyll. From British Architect, December 6, 1878, Whistler G117, Whistler Collections, Glasgow University Library.*

etchings correctly, gave a picturesque description of the "spacious and lofty" studio-drawing room.

> The house was a very strange one. His [earlier] house there [in Chelsea] had a peacock blue door, the only one in London for some years—

he took this colour with him to his door at the White House. The front door opened on to the pavement, and upon entering one found oneself at once midway upon a flight of stairs—I was directed to descend, and found myself in a large terra cotta coloured room with white

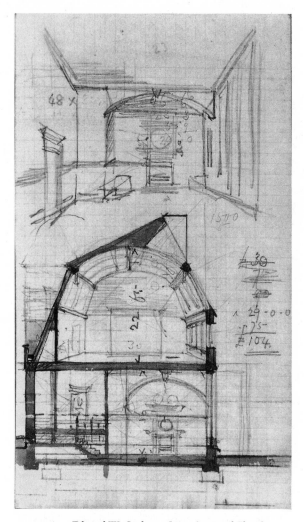

FIG. 56. *Edward W. Godwin. Cross-Sectional Plan for White House, 1877, 6¾ x 3½ in. (17.1 x 8.9 cm). The working plan shows the foyer, steps descending to the studio drawing room, and the large studio on the second floor. Hunterian Art Gallery, Birnie Philip Bequest, Glasgow University.*

woodwork—very plainly furnished and very unusual. There were two long windows about sixteen feet high on one side of the room, looking upon a little bit of garden. They had small square panes of about a foot square. The furniture consisted of a table and some large low chairs and a couch, covered to the ground in terra cotta serge. I had expected to find the furniture very severe in design, but to my surprise found no design at all save what was necessary for comfort. Upon the couch was an etching framed in black.[38]

Whistler's dire financial state may well have contributed to the near absence of furnishings. Yet he had always had ambivalent feelings about furniture per se. Japanese rooms that he had studied were devoid of freestanding pieces and were furnished instead with built-ins, *tatami* (thick rice-straw floor covering), and cushions. Whistler was interested in omission. He was determined to make his interior spaces resonant with color rather than stuffed with furniture. He was aware of the power of the void, of uninterrupted spaciousness. This was why his furniture appeared to have "no design at all"; it played a subordinate role in his schemes. It was simple in form because he did not want it to detract from the transcendent color harmony or the space.[39]

Whistler's Western adaptation of the Far Eastern ideal included the use of furniture that was low slung, painted, slipcovered, or draped with soft fabrics in the same tints as the walls so as to make it seem to disappear [see fig. 20, pl. 4]. At times Whistler casually draped lustrous silken throws over screens and sofas or playfully tossed them on the floor. Aside from curtains, these slipcovers and furniture throws were among some of Whistler's uses for the exquisite textiles from Liberty's that had such allure for him. His attraction to the sumptuous, decorative Momoyama period was manifested in his use of flowing silks, folding screens, and gilded surfaces.[40] The veiled and silken effect Whistler achieved on his canvases and

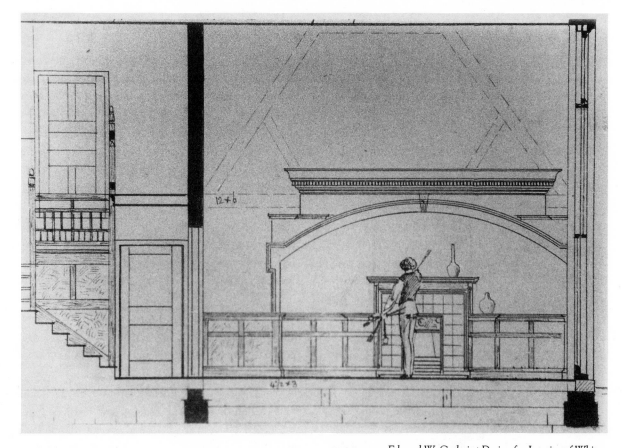

FIG. 57. *Edward W. Godwin: Design for Interior of White House, 1877–78. The detail shows the foyer, railing, and dado designs, tiled fireplace, dentiled cornice, rainbow arch, and a back view of Whistler executing a mural around the mantel. From British Architect, December 6, 1878, Whistler G 116, Whistler Collections, Glasgow University Library.*

on his walls is reminiscent of fine fabric and was certainly part of the delicate and mysterious ambience of the White House.

Another description of Whistler's terra-cotta studio-drawing room, which was 29½-by-17½-by-18-feet high, helps to complete the visual image of this room. "The drawing room, laid with Indian matting, [opened] on a small lawn enclosed with walls 10 feet high. All over the house there is a remarkable absence

of effect, both from the artist's and the auctioneer's point of view. Of paintings, the only one visible is a huge arrangement—'The Gold Scab'—Of more wordly effect the best—and there were few—were set out in the drawing room. A couple of couches, an easy chair, a carpet, two or three Japanese armchairs, . . . a davenport."[41]

In this studio-drawing room, so radically different from any other in Victorian London, the dado was

sectioned by battens into an arrangement of slim rectangles and squares of woodwork painted white. Godwin labeled his drawing of this dado with the words "scratches in wet plaster," which described a technique to give the lower wall a crosshatched texture somewhat like the dados of matting Godwin had installed in his various homes [see figs. 55, 57].[42] This wall treatment may have been inspired by Japanese fences reproduced in the *Manga*, which looked like *tatami*. These fences were made of reeds, straws, brushwood, bark, or plaited bamboo and may have suggested an alternative wall treatment less obtrusive than wallpaper but offering patterned, textural interest.[43] The delicate, varied tints and keen interest in textures, typical of the aesthetic period, were much in evidence in Whistler's home. The ledge above this white plaster dado was wide enough to display pots. Godwin's drawing of this room suggests Whistler planned to exhibit a few medium-sized porcelains—probably orange-colored Kaga vases—placing them asymmetrically.

A strong grid pattern pervaded the room. The rectilinear batten strips of the dado, the crisscross bars of the windows, and the square yellow tiles around the fireplace provided a subtly satisfying scheme of repetitive geometry. The example of subdivided Japanese interior and exterior walls provided the idea of a grid on which to build a well-ordered interior and thus eschew the chaotic excesses of conventional Victorian decor.

Two pieces of furniture still in existence were probably destined for this room. The famous *Harmony in Yellow and Gold: The Butterfly Cabinet*, which is a mantelpiece designed by Godwin and decorated by Whistler, was first incorporated into a model room for the 1878 Paris International Exhibition [fig. 58]. The bright mahogany of this mantelpiece would have blended with the terra-cotta color harmony of the room. The abstract, painterly *japonisme* of Whistler's painted design of petals and butterflies in gilt and

yellow on the back panels of the cabinet is a characteristic motif he had incorporated into several interiors and very likely planned to include in the White House. A second Godwin-designed piece, the *Four Seasons Cabinet*, now in the Victoria and Albert Museum, may also have been designed for Whistler's house [fig. 59]. It would have coordinated with the *Butterfly Cabinet*, and its satinwood and mahogany would have harmonized with the rust-red wall color. This cabinet has brass-framed lattice openings on the lower doors, taken from volume 5 of the *Manga*, a copy of which Godwin owned. The four gilt panels, based on the seasons, were probably painted by Beatrix Godwin, increasing the likelihood that it was designed for Whistler.[44]

There was also a "deep chimney corner" in this room (an inglenook, perhaps), a five-fold Japanese screen painted with flowers on silk with a gilt wood frame, a couple of small screens, an ebonized and gilded drawing room suite, Chinese clogs, two butterfly cages, and several Japanese lacquered trays.[45] Although there was a good deal of white in the painted woodwork, black in the ebonized, japanned, and lacquered furnishings, straw color in the matting and cages, and touches of gilt everywhere, the color scheme was essentially a harmony in terra-cotta and yellow—a lively sunlit harmony Morris would not have condoned.

The singular feature of this studio-drawing room was the grand floor-to-ceiling windows [fig. 60]. Whistler liked his windows big, whereas Victorians were generally inclined to regret large windows. Mrs. Orrinsmith, the author of decorating manuals, warned that light was healthy only in "discrete doses" and advised on ways of blocking out part of the glass with quarry panes. Morris, in his lecture "Making the Best of It" (1879), declared that "windows are much too big in most houses." Stained-glass windows by the Morris company invited mysterious interior gloom and also solved the problem of hiding views spoiled

by the factories and smokestacks of insistent British industrialization (which had formed an incongruous backdrop for *Variations in Flesh Color and Green: The Balcony* [fig. 29]). In the White House, however, the drawing room contained two large sixteen-foot-high paned windows that, essentially, formed a dramatic wall of glass.[46] The blank facade of the house did not seem to promise interior spaciousness or a vista. The surprising window wall, geometrically divided into squares, resembled Japanese *shoji* [fig. 61]. These windows permitted the outdoors to penetrate the indoors visually, creating a counterpoise between Whistler's austere interior and the natural garden and lawn, which was probably also Whistler's design. This was another typically Japanese touch, evident, for example, in Kiyonaga's *Gentlemen and Ladies at a Window Overlooking a Snowy Landscape* (see fig. 30), which anticipated one of the prime architectural objectives of Frank Lloyd Wright, the blending of house and site. Wright often designed houses with mysterious facades that gave way to interior spaciousness, light, and view. Whistler's knowledge of the design of gardens was probably drawn directly from Japanese gardens displayed at world fairs.[47]

Whistler's refined *japonisme* was also expressed by his choice of a Jeckyll fire grate, decorated with *mon* (a circular crest design), for the studio-drawing room [figs. 55, 57]. The broad rainbow arch over this modest little fireplace provided contrast to the rectilinear patterns and formed a kind of *tokonoma*, or picture recess, in which Whistler planned to paint a mural. (Godwin and Whistler's elaborate butterfly fireplace surround may have been designed to fit around Jeckyll's grate.) The low, flat arch, similar to those used in Japanese architecture for separating rooms or alcoves, also had the effect of making an otherwise ordinary wall seem very grand, and it focused attention on the hearth, which was typical in the aesthetic period.[48] The woven matting laid on the floor, which Whistler had designed to harmonize with the setting, resembled *tatami*

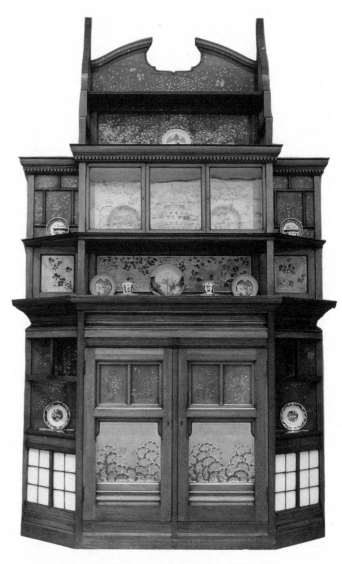

FIG. 58. *Edward W. Godwin and James Abbott McNeill Whistler.* Harmony in Yellow and Gold: The Butterfly Cabinet, *1877–78, 119¼ x 75 in. (303 x 190 cm). The gold-and-yellow mahogany fireplace overmantel (later converted to a cabinet) was decorated by Whistler for the Primrose Room in the 1878 Paris International Exhibition. Hunterian Art Gallery, Birnie Philip Bequest, Glasgow University.*

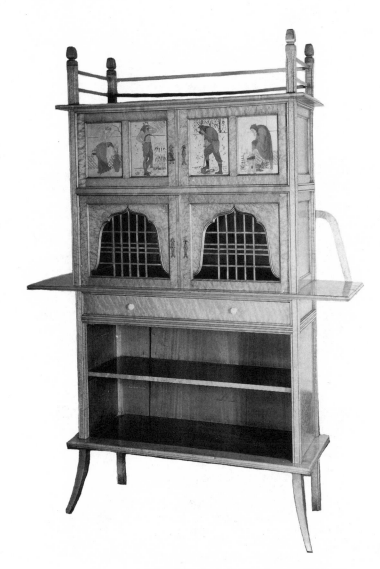

FIG. 59. *Edward W. Godwin. Four Seasons Cabinet, 1877, satinwood with brass mounts, mahogany case. The gilded figurative paintings were probably executed by Beatrix Godwin (later Beatrix Whistler). The lower brass-lattice door was designed after illustrations in Hokusai's Manga, vol. 5, 1816. GC 253 W. 15 1972, Victoria and Albert Museum, London. By courtesy of the Board of Trustees.*

[fig. 62] and coordinated with the textured dado. A single painting and an etching or two in black frames were hung on the terra-cotta walls.

Not every aspect of the studio-drawing room was of Far Eastern derivation. The restrained character of the setting, the prevalent use of white, and particularly the choice of "Pompeiian villa" terra-cotta red for the wall color reflected Whistler's affinity for classical art and his efforts to blend Japanese and Greco-Roman art. A plaster statue of the Venus de Milo was part of the decor (Godwin also had one), as well as a terra-cotta bust of Whistler by Boehm. A limited application of classical motifs could be found in the moldings, windows, and mantels. A dominant Greek cornice with dentils appeared above both the large arch over the fireplace and above the front door [see figs. 53, 55, 57]. Photographs from 1915, which appeared in *Vogue* magazine, show classical columns in the interior as well as a pediment and a colonnade in the garden, which may or may not have been original.

In one of his architectural renderings, Godwin depicted Whistler standing in his new studio-drawing room in front of the fireplace, painting a floral motif on the wall [fig. 57]. The "internal painting" and "final touches" to which Godwin had referred in one of his letters no doubt included Whistler's colorfully distempered walls and his murals with scatterings of painted petals, Japanese cloud and scale designs, butterflies, and touches of gold leaf. Whistler's other favored themes of Venuses, peacocks, parasols, fans, porcelains, trellises, checkerboards, and grids were all destined to become ubiquitous motifs during the aesthetic period. There was ingenuity of another sort in the White House. The writer for *Vogue* noted that a mechanical contrivance in the room above the studio-drawing room "enabled [Whistler] to run the paintings from his studio beneath" to an upper drawing room "to delight the eyes of his guests."[49]

The other rooms in the White House included a kitchen with a charcoal stove and an American stove,

a breakfast room, a dining room, a boudoir, five bedrooms, a scullery, a housekeeper's room, a wine cellar, and a school for pupils, which was the large studio. Distributed in these rooms were such items as a velvet pile carpet with a crimson background, a bordered Persian carpet, a mahogany-framed couch, a large brown earthenware cistern, Japanese bronze candlesticks, a stork with enameled wings, a japanned shower bath, Chinese trays, a few occasional tables, and some wicker furniture.[50]

Visitors who were invited to Sunday breakfast or an evening party in Whistler's new fifteen-by-twenty-foot dining room, which was a few steps up to the left as one entered the house, found themselves ensconced in a harmony in blue and yellow. This was the scheme Whistler typically used for the setting in which he displayed his large collection of blue-and-white porcelain as well as his sterling-silver and silver-plated pieces. The floor was covered with Indian matting in a soft golden color, and the room contained Japanese screens. There was a walnut occasional table and a mahogany dining table. The centerpiece was often a single fresh daffodil or lily in the elegant Eastern style. Whistler also owned a "handsome silver centerpiece in the form of a palm tree with leaves." Godwin made several sketches for built-in cabinets for this room, including an ornamental wooden fireplace mantel with mirrored panels and china recesses, a hanging cupboard in a straight-lined Anglo-Japanese style, and a corner china shelf with mirrored panels—a characteristic of Regency furniture. A Japanese camphorwood china cabinet, a dilapidated pianoforte, and a few cane-bottomed chairs, painted yellow, were also in this room.[51]

When Walter Dowdeswell dropped by to learn about framing, he was ushered into the terra-cotta studio-drawing room. He recalled: "After a minute, Whistler came in, and after a few remarks about the frame, said, 'Well, I suppose you'd like to see the studio now you're here?' I said I should whereupon he

FIG. 60. *Edward W. Godwin. Studio-Drawing Room, Window Wall, White House, 1878. From "The White House," 40.*

invited me to follow him up a very narrow staircase (just past the front door again) and after his cooly telling me that 'he wouldn't keep me long'—and not to 'break my neck up the stairs' (a not altogether needless warning) we came to the studio."[52]

The staircase leading up to the thirty-by-fifty-foot studio [fig. 56] was spiral, and the stairway walls may have been covered in felt, since, for the later design of Frank Miles's house, Godwin wrote that he would use felt for the staircase walls, like "Whistler's stuff." Dowdeswell noted: "[The studio] appeared to run the whole length of the house and was on the top floor. A large canvas of several light draped figures was on the easel. . . . he led me to one end of the studio, which was simply covered with beautiful studies in coloured chalk on brown paper, pinned upon the wall."[53]

The huge slanted skylight roof of the studio opened north to the small walled-garden side of the house. It was this room that caused the White House to have such a prominent gambrel roof, to which the

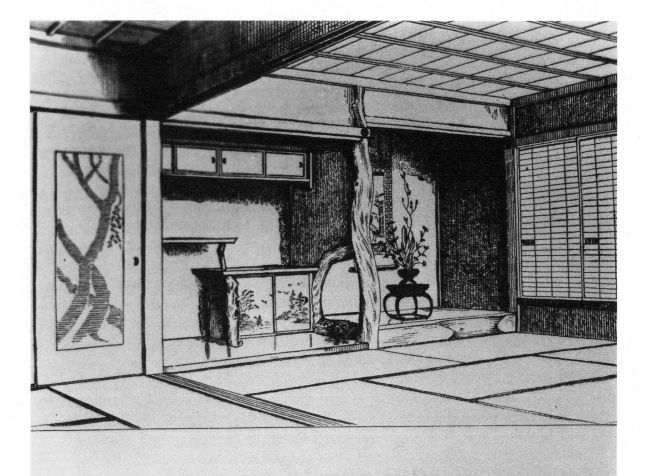

FIG. 61. *"Guest-Room in Hachi-Ishi." This photograph illustrates the geometric division of space and the paneling system characteristic of Japanese interiors. From Morse,* Japanese Homes and Their Surroundings, *1886.*

board objected. Thomas Way, who taught Whistler lithography and helped market his lithographs, recalled: "The studio was surprisingly different from the room he previously used in Lindsay [sic] Row, and entirely unlike the studios usually occupied by other artists. I remember a long, not very lofty room, very light, with windows along one side."[54]

Unlike other artists, who let all the glaring sunlight they could into their studios, Whistler controlled the light with curtains and shades, just as he did in his exhibitions. In his earlier studios there never was a skylight. As a master of atmosphere and tonal symphony, Whistler attempted to achieve a translucent atmosphere and tranquil effect by

FIG. 62. *Design for Matting, with Checkerboard and Flowers, ca. 1875, chalk on brown paper. Whistler designed similar floor coverings for various homes and exhibitions. From Pennell and Pennell,* Whistler Journal, *following 302.*

"scientifically" manipulating the light with white blinds that would not tint the studio with distracting coloration. This was an emulation of the soft effect achieved with paper-covered *shoji*. Whistler had discovered that filtering the light gave a suffused penumbra to the room, tempering the blankness of the walls and creating a feeling of quiet serenity.[55]

The studio also contained a "nearly new" 5½-by-4½-foot Turkey carpet, a Japanese carved wood bird cage with painted panels, an old carved oak nest of four drawers, a Japanese carved wood armchair with a cane seat, two similar chairs, two cane-seated chairs, a three-foot mahogany chest and a three-foot japanned chest, a mahogany occasional table with a pillar base, and a printing press.[56] Whistler had also transported his large Battersea Bridge screen to his spacious new studio.

In this room and all the rest, there was little free-standing furniture, which made his studio an anomaly, to say the least, among Victorian studios. Harper Pennington recalled that the furniture in the White House was limited to the barest necessities and frequently too few of those. There was a standing joke about Whistler's dearth of seats. Glancing around the studio with eyes protruding in search of something to sit on, an actor friend concluded there was "standing room only." After Sunday luncheon, when the guests repaired to the top-floor studio, they could find at best four or five small yellow-painted cane-seated chairs that had been requisitioned from the dining room and "the most uncomfortable bamboo sofa ever made. Nobody except some luckless model sat upon it twice." Whistler, like Godwin, was among the first to use bamboo furniture, which in the 1880s and 1890s became increasingly popular as part of the Japanese craze. By 1890 twenty-five English firms were producing bamboo furniture. Godwin designed cane furniture, and it is likely that Whistler owned some. Probably not much.[57]

Pennington noticed that there was never anything extra in Whistler's rooms, no instruments of music, no bibelots set out for show, nothing that would not be in constant use, nothing superfluous. "You cannot bring in an extra *book* without overcrowding them! . . . All his cares were centered on the wall and woodwork, painted in graduated monochromes of which he held the secret." When the next resident of the White House moved in, he converted Whistler's long, skylighted studio into a theatre with seating for two hundred people.[58]

Whistler had not even been in his home for a year when the creditors closed in and bailiffs knocked at his peacock blue door and took possession of the house. Auction bills were posted on the pristine façade of the White House. Whistler's occupancy ended in May 1879, when he was declared bankrupt. Leyland was his chief creditor. His liabilities amounted to £4,641, and his assets were estimated at £1,924. All the furniture had been numbered for sale when he decided to hold a farewell dinner. Whistler had a sense of occasion, not only for the beginning of things but for the end. William Rossetti and his wife found that Whistler had put some of the bailiffs to work as "liveried attendants" serving drinks and had seated others at a table in the Japanese garden, drinking beer. Some of them fell asleep, their heads falling to the table even as the guests circulated nearby.[59]

At the last reception, the artist climbed a tall stepladder and wrote in ink on the flagstone lintel above the door: "Except the Lord build the house, they labour in vain that build it. E. W. Godwin F.S.A. built this one."[60] Whistler was mocking the Victorian determination to sanctify homes and was taking a crack at the Ruskin-Morris morality that demanded evidence of God at work to justify a creative venture. Neither the *Whistler v. Ruskin* trial nor Whistler's original house had convinced the authorities of the validity of his art for art's sake point of view.

Posters announcing the May 7, 1879, auction at the White House reveal that most of Whistler's household accessories were Japanese or Chinese. These collections, which would have offered later researchers important clues to Whistler's *japonisme*, were about to be dispersed. The catalogue lists hundreds of objects of Oriental origin. There was Indian matting from the dining, drawing, and breakfast rooms, japanned chests, bronzes, lacquerware and glassware, a japanned hip bath, screens, ebonized furniture, his collection of eighty pieces of Chinese and Japanese porcelain. The finest items were reserved for the larger, later sale at Messrs. Sotheby,

Wilkinson and Hodge, held on Thursday, February 12, 1880. Sotheby's *Catalogue of Porcelain and Other Works of Art* is one of the major sources for divining the details of the White House decor. Maud Franklin, Whistler's young, slim, red-haired mistress, who had been associated with the artist for several years, wrote to Whistler's friend George Lucas in Paris on May 5, 1879, about the upcoming sheriff's sale. "I write because the show is so frightfully afire, Whistler can't. The place is full of men in possession. . . . You had better come over and buy."[61]

Whistler's friends and dealers showed up for the final liquidation sale at Sotheby's. Oscar Wilde bought the statue of Venus and a sketch thought to be of Sarah Bernhardt, who later signed it, though Whistler said it was not of her (Bernhardt was one of the "Venuses" in the artist's life, along with Lillie Langtry, Ellen Terry, and others). The bust of Whistler by Boehm went to Thomas Way for six guineas. The Fine Art Society, Walter Dowdeswell, Algernon B. Mitford (later Lord Redesdale), Charles Deschamps, Wickham Flower, and Charles Augustus Howell were the principal purchasers of the porcelain, glass, and bronzes. Marcus Huish purchased some china, eighteen Japanese picture books, and canceled copper etching plates. Howell bought the screen used in the *Princess* painting, James Jackson Jarves the Japanese bath, and Dowdeswell the disturbing caricature of Leyland. Whistler lost his aesthetic house and virtually everything in it—his Oriental prints and screens, his painter's studies—his entire fortune. He watched it all knocked down and secretly seethed.[62] Whistler's attitude toward his adopted country became increasingly bitter, and he assumed a disdainful attitude.

The venomous caricature, *The Gold Scab*, depicting Leyland as a demonic, peacocklike creature sitting on the roof of the White House and playing the piano sold for twelve guineas. Whistler displayed it prominently in the White House. It was the last work he completed before his bankruptcy. The painting presaged the poisonous, satanic current in the

later, symbolist art movement, represented by the works of Whistler, Pater, Joris-Karl Huysmans, Beardsley, Wilde, Mallarmé, and others. Some of Whistler's later interior designs for exhibitions would also betray a subtly sinister intent.

Whistler needed to leave London. When Ernest Brown, managing director of the Fine Art Society, had gone to the White House before everything blew up in Whistler's face, Whistler told him that he feared he was going to lose his house. Brown discussed the matter with the directors of the society in New Bond Street, and by September 7, 1879, Whistler was arranging a trip to Venice to produce a series of twelve etchings commissioned by the society.[63]

On September 18, in Whistler's absence, the White House was bought at auction by Harry Quilter, a collector and art critic for the *Spectator,* for twenty-seven hundred pounds. Whistler was furious and on one occasion said, "To think of 'Arry living in the temple I erected. He has no use for it—doesn't know what to do with it. If he had any feeling for the symmetry of things he would come to me and say, 'Here's your house Whistler; take it; you know its meaning, I don't. Take it and live in it.' But no; he hasn't sense enough to see that." Whistler never doubted the meaning of the White House. In 1881 he lived on Tite Street again, "next door to myself"—that is, next to the White House—and stood by as Quilter dared to defile the place by ruining the color schemes, adding a ridiculous bay window on the side, and sticking majolica decorations on the facade [see fig. 54]. After that, he never wanted to look at it again. He wrote a letter to the *World* in 1883 referring to Morris's Society for the Protection of Ancient Buildings. "A cry from the McNeill: . . . What of the 'Society for the Preservation of Beautiful Buildings?' Where *is* Ruskin? and what do Morris and Sir William Drake? For, behold! beside the Thames, the work of desecration continues, and the 'White House' swarms with the mason of contract . . . and history is wiped from the

face of Chelsea. . . . Shall the birthplace of art become the tomb of its parasite in Tite Street?"[64]

Whistler believed in the seminal importance of his "temple" of art, even if no one else did. Three weeks later, Godwin also wrote to the *World* to protest the vandalism.

> Is an architect an artist? Is architecture an art?
> . . . If they are, why does Mr. Harry Quilter outrage everything I did in the way of a design for Mr. Whistler's studio and house. . . . the proportions of the street front, over which I had been as lovingly careful as if I had been painting a picture, [have] been wholly destroyed. The public is always crying out for a nineteenth-century architecture and for originality. We endeavor, sometimes to meet the demand, and lo, the encouragement which is prepared for us![65]

On August 1, 1881, Whistler again went to Godwin about his need for a house. In his diary Godwin wrote, "Whistler came to tell me of his house troubles and get me to design him a new house." The two went together to Chelsea and looked at a site on Tite Street, and Godwin worked on an idea for a second house for Whistler. To his friend, the artist Louise Jopling, Whistler wrote that the plans were "simply ravishing." But the idea seems to have evaporated, and instead Godwin built Tower House, a multiple-studio apartment building. He had Whistler in mind when he designed it. The original plan was that Godwin would have the ground-floor studio and Whistler the first floor.[66]

Whistler never had the chance to build another house. The White House remained the most complete expression of his personal interior design theory. The interiors were based on his long-term understanding of spare, serene Japanese interiors, but more than that, they were distinctively personal.[67] The physiognomy of the White House was expressive of Whistler's purism. That is to say, the house—as much as can be

discerned from remaining evidence—exemplified the individuality of modernism. The personally expressive quality, clean lines, spacious rooms, large areas of glass, desire to blend house with site, high value placed on empty spaces, and rage for order predicted the future in modern interior design. There were few distractions from the mesmerizing color arrangements. Whistler's demand for economy of means, and his desire for repose, kept his interiors simple. In the midst of an era of gaudy and aggressively patterned wallpapers and massive, ornately carved, upholstered, bulging Victorian furniture, he decorated with plain walls, subtle textures, and a few lightweight pieces of mobile furniture. Instead of a clutter of bric-a-brac, he sought to introduce a subtle underlying geometry and to arrange collections in well-designed cabinets.

Together Whistler and Godwin had created a house with interiors that anticipated modern taste, that was far more revolutionary than anything the Morris company had produced. The stark *japonisme* of the White House made obsolete the neo-Gothic medievalism of Morris, Webb, Talbert, Eastlake, Burges, and others. Whistler and Godwin were design pioneers, and the finest of their collaborative efforts was the White House. It was the apogee of Whistler's campaign against the Victorian English design ethos. Yet a question lingers: Where did Godwin leave off and Whistler begin in terms of the daring introduction of startling modernistic interiors based on a Japanese model and original thought?

Another Historic Collaboration: The 1878 Butterfly Suite

Concurrent with the White House project, Godwin and Whistler worked together on a project for the Paris International Exhibition—*Harmony in Yellow and Gold: The Primrose Room,* or the "Butterfly Suite"—which received considerable attention. The

1878 Paris exhibition was important for its dissemination and reinforcement of the raging mania for Japanese art.[68]

The striking Anglo-Japanese setting that Godwin and Whistler jointly produced is additional proof of the early date at which they had assimilated Japanese aesthetic principles into interior design. At least for this project, the division of creative involvement is clear. Godwin designed the furniture—a couple of elegant lightweight chairs, occasional tables, a sofa, a case for music, and an elaborate fireplace and overmantel. Whistler painted the designs on the back panels of all of the shelves of the overmantel and part of the wall behind. It was a sensationally spare-looking aesthetic interior in shades of brilliant yellow. Since both Whistler and Godwin had been distempering walls in their own homes in tones of yellow for at least ten years, presumably they had no trouble agreeing on the yellow color scheme used throughout. When William Watt, who produced Godwin's Anglo-Japanese furniture, approached Godwin to do the exhibition project, the two designers were working in close harmony planning the White House. Godwin suggested that Whistler paint the dado, and Watt complied. Whistler, however, also executed a design for the mantelpiece using a motif that was similar to the one in the Peacock Room and that he was on the verge of using in the White House. He was paid fifty pounds for his efforts [see fig. 58].[69]

Whistler was undoubtedly keenly interested in the opportunity to paint a fine piece of Godwin furniture. He had collected and lived with painted and japanned Oriental furniture for years and was well aware of the trend for painted art furniture, which went back to the Morris company's earliest roots in the late 1850s. The vogue was largely started by Pre-Raphaelites and involved embellishing furniture with painted representational figures, usually in the realistic style of the Middle Ages.[70] Whistler himself had been depicted on such a piece of painted neo-Gothic furniture [see fig. 19]. Whistler's approach to painting

the *Butterfly Cabinet* was, however, quite different, since it was abstract.

The brilliant yellow model room attracted mixed reviews. Whistler's American friend George W. Smalley, a London correspondent for the *New York Daily Tribune*, gave a careful description of the room and included extensive comments about Whistler's growing reputation as an avant-garde interior decorator.

> Not far off is a section of a room for the decoration of which Mr. Whistler is responsible. Ever since Mr. Whistler did the famous Peacock Room for Mr. Leyland in Prince's Gate, he has had a reputation as unique in upholstery as in higher walks of art. He is building a house for himself in London; like no other house, of course; meant, perhaps, as a protest against the sudden popularity of Queen Anne fronts in red brick, with their balconies and draw-bridges. . . . He calls this room a Harmony in Yellow and Gold. Against a yellow wall is built up a chimney-piece and cabinet in one; of which the wood, like all the wood in the room is a curiously light yellow mahogany. . . . The fireplace is flush with the front of the cabinet, the front panelled in gilt bars below the shelf and cornice, inclosing tiles of pale sulphur; above the shelf a cupboard, with clear glass, and triangular open niches at either side, holding bits of Kaga porcelain, chosen for the yellowishness of the red.

The room was interpreted as an example of Whistler's imaginative approach to domestic design.

> Yellow on yellow, gold on gold, everywhere. The peacock reappears, the eyes and the breast feathers of him, but whereas in Prince's Gate it was always blue on gold, or gold on blue, here the feather is all gold, boldly and softly laid on a gold-tinted wall. The feet to the table-legs are tipped with brass, and rest on a yellowish-brown velvet rug. Chairs and sofas are covered with yellow, pure rich yellow velvet, darker in shade than the yellow of the wall and edged with yellow fringe. The framework of the sofa has a hint of the Japanese influence, which faintly, but only faintly, suggests itself all through the room.[71]

The critic for the *Magazine of Art* was not convinced of the success of the scheme. Referring to the room as a "Symphony in Yellow," he recognized the furniture as the "Japanese type affected by Mr. Godwin" and noted that "Mr. Whistler has painted a kind of scale ornament, intended possibly for clouds on the wall and the mantelpiece." He concluded, "For its startling mode of attracting the attention of the visitor, the work of Mr. Watt is unrivalled. We cannot say that we should care to be surrounded in our homes by the 'agony' in yellow."[72]

The mantelpiece from the room is today on display at the Hunterian Art Gallery.[73] (It was later converted to a cabinet, which detracts from one's image of its original appearance.) Despite its large size, there is a fine delicacy about the bright mahogany mantelpiece and Whistler's spritely painting scheme. It is an astounding exhibition piece and gives a good hint of the startling impression the entire display in tones of sulphur yellow and gold must have made on spectators. Whistler's painting of scattered petals and butterflies is principally metallic on a primrose yellow ground and is signed with his butterfly monogram. To his displeasure, workmen at Watt's damaged his design and he had to repair it. The design is based on Japanese screen painting, the petal detail is similar to that on his golden staircase at No. 2 Lindsey Row, and the cloud (or wave) pattern is essentially the same as that found in the Peacock Room. The cabinet was intended as a mantel museum, a favorite piece of furniture at the time. The geometric divisions in the upper and lower panels are derived from Japanese models, whereas the broken pediment at the top and the cornice with dentils are classical details, though the distinctive curves at the top seem Oriental.[74]

It is quite likely that the entire ensemble was created with the White House in mind. One can easily imagine this mantel museum installed around Jeckyll's fire grate and surrounded by other gilded and painted effects and terra-cotta walls. If this was the plan, Whistler's financial straits probably precluded the final installation. As Godwin mentioned to Whistler, the mantelpiece was purchased by a princess.[75] One thing is certain: the model yellow room was influential beyond its modest size. Louis Comfort Tiffany and Claude Monet were among the many who found the interior memorable and subsequently created related coloristic interiors. Also, Collinson and Lock's 1878 Paris International Exhibition interior featured yellowish pink walls, pale blue woodwork, Indian matting, De Morgan red lustre tiles, and yellow muslin curtains—a clear rejection of Victorian stodginess in favor of Whistlerian-Godwinian decor. Soon afterward, W. H. Batley began to design bright mahogany art furniture for James Schoolbred and Company.[76]

Return to Tite Street

After his bankruptcy, Whistler spent more than fourteen months in Venice creating etchings and pastels. He left London in early September 1879 and returned in the second week of November 1880. Initially, he took a place in Langham Street. On January 31, 1881, Whistler's mother, Anna Mathilda, suddenly passed away, and he was deeply distressed. Shortly afterward, he changed his lodging to 76 Alderney Street near Victoria Station. By March 1881 he had leased a studio flat at No. 13 Tite Street and begun to entertain delusions of grandeur. Alan Cole noted that Whistler intended "to paint all the fashionables—views of crowds competing for sittings—carriages along the streets."[77] This did not happen. Only a few daring people came to sit for portraits; the "fashionable people" were put off by Whistler's notoriety. He began to adopt an ever more exaggerated manner of dressing

and behaving. Whistler's barbed letters to the editor grew more numerous; his strutting and cackling increased; he seemed on the verge of becoming a parody of himself.

However, in the realm of interior decoration, he took up where he had left off and improved on his restrained, austere ideas. He furnished the flat, which was designed by Robert W. Edis, the moment that he had the wherewithal. (His successful Venice pastels exhibition was probably a source of revenue.) Many visitors recorded their impression of it as being even more beautiful than his past interiors. The New York art dealer, Frederick Keppel, who along with Samuel Avery was one of the first to make Whistler's etchings known in America, wrote *A Day with Whistler*, recalling a day and evening spent with Whistler at No. 13. He was admitted by a servant and shown "into a reception room in which the prevailing scheme was a pale and delicate yellow. The room at first looked bare and empty, yet its general effect was both novel and pleasing."[78]

A young American woman, Louisine Elder, who later, as Mrs. Henry Osborne Havemeyer, amassed a great art collection with her husband's fortune, was also shown into this room on a visit one May afternoon in 1881. There she met Oscar Wilde and purchased five Venice pastels for thirty pounds. In her memoirs she wrote:

> Although we sat down, I do not recall any furniture in the room, not even chairs; I was so impressed with the lovely yellow light that seemed to envelop us and which began right at the floor and mounted to the ceiling in the most harmonious gradations until you felt you were sitting in the soft flow of a June sunset. . . . Two objects arrested the eye: near the window stood a blue and white hawthorn jar which held one or two sprays of long reedy grass, and in the center of the room there was a huge Japanese bronze vase; it loomed up in that mellow light with the solemnity of an altar.

When Whistler entered, she was struck by his image, with "piercing black eyes" and dressed all in black "against the yellow light." She remembered this room as far more impressive than the Peacock Room. Subsequently, Whistler sent her his 1878 pamphlet *Whistler v. Ruskin: Art & Art Critics* [see fig. 14], noting that he hoped the "inflammatory work reached [her] safely." Ten years later Louisine commissioned Louis Comfort Tiffany to design color-coordinated interiors for the Havemeyers' New York residence with mosaic peacock accents. The scheme was surely based in part on memories of Whistlerian decor.[79]

Apparently, much of No. 13 was decorated in yellow, causing Whistler's roguish friend Charles Augustus Howell to remark that "to go and see Whistler was like standing inside an egg." Some felt overwhelmed by the color; it had an etherizing effect. Victorians were more comfortable with complicated patterned surfaces than planes of pure color. Mrs. Julian Hawthorne wrote about the yellow rooms at No. 13 for *Harper's Bazar*. "We were allowed to inspect two or three [rooms]. Pictures they were indeed, and exquisitely delicate and effective ones. Shades of yellow were present in all of them; in one room there was no other color besides yellow. But it would be impossible to describe the subtle variations which had been played upon it; how the mouldings, the ceiling, the mantel-piece, the curtains, and the matting on the floor enhanced and beautified the general harmony."[80]

The dark peacock blue dining room of No. 13, hung with yellow muslin curtains, was a vivid contrast to the pale, modulated yellow tonalities elsewhere in the house. Whistler's friend Thomas Way recalled:

> His decoration of the interior of this house was, as usual, very original. The whole place was sacrificed to the big studio in its arrangement, so that when one had been admitted by his manservant John, who, with his wife, kept the place for Whistler, one was shown into a small dining-room,

with a low pitched ceiling, walls distempered in a rather dark green blue, with simple straight yellow curtains by the windows, and very plain cane-seated chairs painted a bright yellow. A white cloth was on the table, with some few pieces of blue and white upon it; and on the bare wall opposite the window one small square hanging pot, I think Japanese, so perfectly placed as to fill its wall, so that one did not feel the want of anything else—though it was a curious lesson to teach visitors, that "pictures" were quite unnecessary in decoration, from a man whose work in life was to produce pictures to be hung upon their walls![81]

Visitors to Whistler's home looked upon Whistler's inexplicably modern interiors as exemplars from which to learn. The reporter from *Harper's Bazar* described his dining room.

> [T]he mass of color was a strangely vigorous blue-green, the precise counterpart of which we do not remember to have met with. This was picked out with yellow in the mouldings, cornice etc., with a result extremely satisfactory and charming. All the decoration was entirely free from anything in the way of pattern or diaper; the color was laid smoothly and broadly on the hard-finished plaster, and the effect depended solely upon the contrast and disposition of the tints. Such a method would fail in ninety-nine cases out of a hundred, for the least mistake in the selection or placing of a color would spoil all; but Mr. Whistler has done his work for himself, and it is faultlessly done.[82]

One cannot help thinking that Whistler's traumatizing bankruptcy, in which he lost his precious collections, was not without its benefits. His taste became further clarified and purified—distilled down to the essentials—thereby achieving a still greater modernity and simplicity. His subtle, daring color

harmonies and stark arrangements came dramatically to the fore. He was, by the early 1880s, creating highly conceptualized interior spaces.

Whistler's future biographer, Joseph Pennell, first met the artist on July 13, 1884, in his second Tite Street home. He found Whistler dressed in a white duck suit with a black string tie; his hair was, as usual, a mass of thick black curls, and he was all nerves and action. He invited the young artist for lunch and introduced him to his mode of daily living, which was "filled, as a matter of course, with the elements of beauty." Pennell stayed for "a wonderful curry, in a bright dining-room—the yellow and blue room." Frederick Keppel also dined with Whistler and Maud Franklin in this room. "I remember that the table was decorated with yellow flowers and that the dishes were hollow, the hollow space being filled with boiling water for the purpose of keeping the eatables hot."[83]

Whistler did a watercolor of Maud reading in the bedroom at No. 13—*Pink Note: The Novelette* (ca. 1884)—and captured the casual chic of the room, including grey-toned walls, darker grey-green fireplace, touches of pink and mauve, fans propped about, a delicate table, a striking striped bedcovering, and natural rattan floor matting. As in all of his homes, the floor covering throughout was matting [see fig. 62]. Whistler designed mattings in colors keyed to the harmony of the room colors and had them made to order. A surviving sketch for a matting design (ca. 1875) shows a horizontal arrangement in pale blue, brown, and beige (not unlike one of his walls or nocturnes in composition). His matting compositions were flat, decorative designs, subtle in color, distinctive in texture.[84] Glimpses of Whistler-designed mattings can be caught in some of his portraits [fig. 37; pl. 11].

The informal atelier at No. 13 was outstanding because of the brilliant company that regularly assembled there. His closest friends—the Godwins, Waldo and Julian Story, Frank Miles, Lady Archibald Campbell, Mortimer Menpes, and Harper Pennington—were often in attendance. Walter Sickert

was a frequent visitor and in June 1882 became a studio assistant and a part of Whistler's growing entourage. The poet Rennell Rodd was a favorite companion who joined in the fun of composing letters to the editor and creating exhibition catalogues containing reviewers' dubious quotes from the past (meant to impale the critics with their own words). There were always several women around.[85]

Wilde, who lived in the neighborhood with Frank Miles, was, by August 1881, a ubiquitous studio presence. Whistler was his hero, the embodiment of his Oxford undergraduate ideal of living a beautiful life surrounded by exquisite blue and white. Wilde was always welcome in Whistler's studio, willing as he was to pay homage and write beautiful verses about Whistler's Thames nocturne paintings. He sat there for hours, exchanging barbs, absorbing the aesthetics of pure beauty, admiring Whistler's color schemes, profiting from the artist's conversations about his theories of interior decoration, and preparing himself to become a showman and prophet for an elegant new way of living.[86]

The almost "mystical tone" in the Tite Street studio, described in Mrs. Hawthorne's review, demonstrated Whistler's intriguing method of distempering walls. A pale peach had been laid over a coat of grey in order to neutralize—almost negate—the walls. A visiting reporter noted, "The walls of the studio were colored a sort of gray flesh-tint—a singularly cold and unsympathetic hue, but according to Mr. Whistler's idea, all the better adapted on that account for a studio, which, as he remarked, should not be itself a picture but a place to make and exhibit pictures in." And, as Whistler interjected, "Now my other rooms, they are pictures in themselves." The journalist was certainly convinced. "We venture to say that the exhibition of this house of his in some generally accessible centre of civilization would do more to refine the public conception of decoration than all the examples, lectures, and books of which the modern decorative clique is just now so prolific."[87]

In 1881, when Whistler first moved into No. 13 Tite Street, he decided to take on a studio assistant, the Australian Mortimer Menpes. The young artist dropped out of Poynter's classes at the South Kensington Museum, threw himself at the feet of "the master," and "simply fagged for Whistler and gloried in the task."[88] Menpes would later prove to be one of the main historical conduits for Whistler's decorative theories—in which he took a strong interest—through his book, *Whistler as I Knew Him*. He discussed Whistler's design theories, particularly in regard to dress, exhibitions, and house decoration.

Whistler helped to devise the color schemes for Menpes's home inside and out, and the younger artist closely emulated Whistler's decorating practices. When the newspapers took note and Menpes claimed credit, Whistler was furious. This did not deter Menpes from following Whistler's model; he also adopted the Japanese style in his distinctive later home, designed by Arthur Mackmurdo. Menpes's trip to Japan in 1887 reinforced his interest in a new approach to interior design. His interiors were far more obviously derivative of Oriental art than anything Whistler would have done, however, though Menpes commented, "[Whistler] liked anything that was genuinely Japanese. In nearly all his rooms one saw cheap Japanese jars in beautiful colour." He also noted that Whistler was immensely interested in silver. "The colour delighted him. He collected silver with great judgement, not because it was rare, but because it was beautiful from the artistic standpoint" [see fig. 70]. According to Menpes, Whistler considered Sheffield plate the most beautiful and enjoyed the idea that he could find all these beautiful things in Wardour Street "under the noses of the Britons who had not been taught to see them."[89]

The strong example Whistler provided for high fashion in dress and house decoration in late-nineteenth-century England may be witnessed in microcosm in the responses of those gathered around him at this time. Menpes, as a leader of Whistler's circle of followers—which included such artists as Walter Sickert, Harper Pennington, Otto Bacher, Frank Miles, Julian and Waldo Story, Rennell Rodd, Sidney Starr, Albert Ludovici, Theodore Roussel, and William Stott—promoted the formation of a club. In the early 1880s seven of these young artists met at Menpes's house in Fulham and decided to rent a room on Baker Street for six shillings. This gave them the opportunity of "putting into practice ideas on the subject of house decoration, which we felt to be of the utmost importance,—in fact, a principal part of the mission."[90]

Accordingly, they distempered the walls of their club room, since distempering was "cheap" and "broad" and "simple." They realized that, in the Whistlerian mode, "the highest decorative art is not necessarily expensive." They were determined to imitate the master's method of interior decorating and based the strength of their scheme on color. They decided their club room colors should match tones from nature: "Roughly speaking our harmony should be that of the sea and sky." With this in mind they painted the woodwork the tone of the Dover cliffs and distempered the walls blue and the ceiling green. The upside-down character of this scheme did not at first occur to them. Menpes stated, "We were convinced that the prevailing system of house decoration was against the laws of art, and we were determined that our school should feel its way to a scheme that would revolutionise the system."[91]

Whistler's use of black as a "universal harmonizer"—a major aspect of his interior design theory—was a concept Menpes clarified in his book. And his explanation of Whistler's method of tonal painting on canvas offers insight into his elusive tones for walls, which had a misted effect.

[T]he Master began on a canvas previously prepared with flake white and ivory black, forming a neutral grey . . . the grey-toned panel . . . shone

through the pigment. . . . in company with the other Followers, I acquired the "grey-panel" craze. . . . I produced, stained grey panels in Whistlerian frames. . . . We Followers saw things from Whistler's standpoint. . . . Whistler's method of procuring a fine quality of distemper was almost exactly the same as that he used when painting his pictures. Before putting it upon the walls he prepared a groundwork of black and white, forming a neutral gray which broke through and gave to the colour a pearly quality. . . . He loved . . . silvery greys.[92]

Whistler's interest in a pearly quality, in silvery greys—that is, in tonal painting—whether for canvases or walls, originated with his admiration for Velázquez. The refined greyed tones in the canvases of the Spanish painter made a great impact on several painters between 1850 and 1870. Edouard Manet, C. E. A. Carolus-Duran, and John Singer Sargent were other artists who followed Velázquez's precedent for the use of low tonalities and neutral backgrounds. For Whistler this sensitivity to modulated tones was strengthened by his first teacher in Paris, Charles-Gabriel Gleyre, whose atelier he joined in 1856. Gleyre maintained that "ivory black was the basis for tonal painting." Whistler held to this belief for life.[93]

The neutral color tones and subtle gradations in Japanese prints were another source for Whistler's tonal schemes. The scholar of Japanese art Ernest Fenollosa stated, "[Whistler] is the first occidental to express firmly and in almost flat planes, pearly films of gray so subtly differentiated that without blending, each seems to vibrate and deliquesce into its neighbors. He, first of occidentals, has explored the infinite ranges of tones that lie wrapped about the central core of grays." Fenollosa found Whistler's use of undertones of opaque darks was "the secret chord" that pulled his paintings into their harmonic scheme, facilitating his

use of unusual colors of grey, yellow, olive, brick red, and stone brown.[94] By using grey as an undertone throughout the rooms of his houses, Whistler was able to create a subtle interrelationship that linked one room with the next. His palette for his pictures and for his walls was controlled by the extremes of white and black, both of which he often used for woodwork.[95]

In the Peacock Room, Whistler had set up iridescent vibrations in wall treatments by overlapping gold leaf, Dutch metal, and paint, and by distressing surfaces. In less palatial homes, one of his methods for enlivening a flat painted surface was to create a pearlized effect by allowing the grey or black underpainting to show through a semitransparent final coat of distemper. Some idea of the modulated quality of Whistler's interiors may be seen in Whistler's nocturnes or portraits, the surfaces of which echo the nuanced effect of his walls. Whistler's interest in such effects was typical during the aesthetic movement, when the treatment of surfaces in interiors was of paramount concern.[96]

Two highly specific letters from the 1880s document the artist's tonal approach to wall coloring. In the first letter, Whistler acts as a consultant for Dr. and Mrs. William Whistler. (Earlier, Whistler's mother had helped Willie decorate his bachelor quarters at 28 Wimpole Street, an indication that she, too, may have had skill as a decorator.) Willie and his wife Nellie needed help in correcting a gaudy wall color. Whistler advised:

My dear Nellie—It all comes of not doing *exactly* as I understood it should be. If the first coat had been as *I directed* grey brown—this too crude and glaring condition of the yellow would not have occurred—It is just because of the horrid white ground—Also why on earth should the workmen think for themselves that after all *two* coats of the yellow upon *white* would do just as well as *one*

coat of yellow on grey!—This was so ordered by me because in my experience the result would have been fair and at the same time soft and sweet. However it is not for the purpose of boring you my dear Nellie that I write all this, Now listen—See that the man gets a tube of "Ivory black" from any colorman's and a tube of "raw Sienna". Let him put first about a salt spoon full of the Ivory black into his pot of yellow paint, "mix well—and stir"—this will lower the moral tone of that yellow!—but you must not be alarmed if to your over anxious eyes it even looks a little green—all the better. Then mix and stir in say half of the tube of Raw Sienna—and I should think you would bring things to their natural harmony . . . "mix to taste."

He cautioned his sister-in-law not to be shocked if "the first little daub" of this mixture looked dirty on the bright yellow wall. "Of course it will—but remember that brightness is what you wish to be rid of." Tonal underpainting was Whistler's recipe for arriving at a subdued mustard hue in order to avoid what writer Lucy Crane called "Philistine coloring."[97]

A second letter, written in 1885 or 1886, adds further to our knowledge of Whistler's formula for distempering tonal-based walls. He wrote exacting directions to Ernest Brown of the London Fine Art Society for the painting of a bedroom and bath. His detailed notes for the coloring of the walls begin, "Here is what I promised."

Here is a list of colors:
Distemper. *First* one coat of light *grey* (made of simple whitewash and a little *Ivory* black—*not* the *vegetable black* of the trade—with a very little yellow ochre) *over ceiling and walls — strongly sized.*
Walls and Ceiling:
Now the apple green—*Distemper.* Light *Lemon Chrome. Antwerp blue*

Toned slightly with *Yellow Ochre,* & *Raw Sienna.*
Skirting and all Woodwork:
Oil Lemon Chrome—Middle Chrome light Yellow ochre Raw Sienna.[98]

To make the color plan perfectly clear, these directions were accompanied by a watercolor wall elevation signed with a butterfly.

In the second letter Whistler recommended two of his favorite hues: apple green and lemon chrome. But both colors were to be "toned slightly" by the addition of natural earth tones of raw sienna and yellow ochre. The visual result suggested is one of muted vibration and depth. A subtly mottled color resonance was produced by such floating layers of color upon color. It is significant that in addition to underpainting with grey or ivory black Whistler suggests a grey-brown undercoat. One observer noted the artist's use of "a brown, a grayish brown, a soft and singular shade of brown . . . delightful to *feel* in its sober and retiring neutrality . . . the best tone against which to hang Whistler's paintings."[99] Certainly, Whistler's widely recognized mastery in interior decoration was based chiefly on his ability to devise such "soft and sweet" tonal color schemes, the success of which was the secret layer of black, grey, or café au lait underneath.

Not that everyone agreed. A reporter for the *Leeds Express* acknowledged that Whistler's method of distempering was innovative, but the verdict on the effect gives one pause. "A new effect in colouring wall decoration has been devised by Mr. Whistler. . . . The walls were first painted a pure black and were then afterwards overpainted with a coat of semi-transparent yellow. The effect was the apparent annihilation of the walls and gave the effect of the impression of living in a petrified nocturne."[100] As Whistler's Peacock Room seemed to produce the illusion of being engulfed in one of his blue-green Battersea Bridge nocturnes, so his pearlized rooms turned the walls into

something insubstantial, hazy—a dreamlike, dissolving effect comparable to his foggy, grey-toned nocturnes. He was carrying the atmospheric effects depicted in his canvases into his interiors.

Henry James remarked that Whistler was a "votary of tone" whose manner of painting was "to breathe upon the canvas."[101] Whistler also used this ethereal effect in rooms to open up the claustrophobic Victorian interior and create three-dimensional, symbolist color-dream spaces with veil-like walls comparable to the thin, translucent sliding screens in Japanese homes. News of Whistler's unorthodox experiments reached the Continent, specifically Joris-Karl Huysmans, whose 1884 novel, *A Rebours*, features a symbolist, interior, painted world of intense, mysterious artifice.

Residential Commissions of the 1880s: Sarasate, Sickert, and D'Oyly Carte

Whistler's dedication to reforming domestic design had begun in 1863, and more than twenty years later he was still vitally involved in designing improved house interiors. His status as a decorator was well known. This was due to the spectacular examples of his two Lindsey Row houses, the Peacock Room, the White House, and No. 13 Tite Street, which were widely covered by newspaper reports. But there were other commissions of which only the slightest record survive—for example, several unidentified plans for color schemes and wall and textile designs. Whistler's ideas were far from conventional, and so his clients were those who enjoyed being in the vanguard of fashion. The Pennells list a number of distinguished clients for whom he created harmoniously colored walls, including the William Alexanders, Ellen Cobden and Walter Sickert, William Heinemann, the D'Oyly Cartes, the William Whistlers, Mortimer Menpes, and Pablo de Sarasate. He also created interiors for Anderson Rose, Ernest Brown, Oscar Wilde, and Lady

Archibald Campbell, to whom he explained his "scientific" theory of decorative "colour grouping," leading her to decorate a room based on the colors of the shell.[102] Undoubtedly there were others for which documents may still be found.

In the houses he decorated for friends, family, and clients, he was as restrained as in his own homes. Original furniture design was not his forte, though he made a few sketches for fragile, attenuated plant stands and severe, rectilinear porcelain cabinets. His function in this regard was mainly to help the party select, delete, and arrange. He once advised a client to begin the decoration of his house thus: "Well, first burn all your furniture." Whistler's attention was focused on color. Because of his extraordinary sensitivity to tonal schemes, people sought him out as a color consultant, just as Leyland had in the mid-1870s. Since he was ever mistrustful of British workmen, he prepared the wall colors to his own specifications. Whereas his chalky distemper colors were similar to eighteenth-century rococo distempers, his tonal method added an unorthodox dimension, a mysterious aura unlike anything before or since.[103]

Pablo de Sarasate, the virtuoso violinist, was one of the friends for whom Whistler devised a delicate color harmony. When in 1887 Walter Dowdeswell wrote an article on Whistler in *Art Journal*, it was the first appreciative article in an important English magazine. In it, Dowdeswell singled out two of Whistler's outstanding interior design commissions. "He produced in 1877 that triumph of decorative art, the 'Peacock Room.' . . . Several other houses in London demonstrate the beauty of his conceptions of harmonious colour in decoration. In Paris, too, the music-room of his friend Sarasate is one of the most recent results of his efforts in this direction. It is an arrangement of white and delicate pink and yellow, and all the furniture was designed with due regard to the purpose of the room." Albert Ludovici, writing in *Art Journal* in 1906, recalled that Whistler had also designed four brass sconces in the form of a violin for

Sarasate. Prior to their installation in the famous violinist's apartment, Whistler temporarily hung them in his own dining room at No. 13 Tite Street. Beyond these clues, little is known of the actual character of this decorative scheme, though Whistler was more involved in the design of the furniture than usual. Thomas Way also mentions Whistler's interior design for Sarasate's music room, "which we may hope will be preserved."[104]

Sarasate happened to strongly resemble Whistler, who had also painted a portrait of him. The violinist was born in 1844 in Pamplona. His Spanish heritage, and the colors Whistler associated with that, as well as his status as a virtuoso, appealed to Whistler. Sarasate had a long, glorious international career before he returned to Paris, where in 1884 he signed a long-term lease for an expensive apartment on the Boulevard Malesherbes and engaged Whistler to decorate the luxurious flat. It had large windows, typical of the new buildings at that time, which allowed much light in. His friends told him he was foolish to spend money on decorating an apartment that he occupied only a few months each year. Sarasate simply laughed and replied that Whistler's "harmonious color scheme would no doubt cost him many a *pizzicato*."[105] Whistler's delicate pink-and-yellow harmony for the flat seems to have been particularly complete in regard to the color arrangement, the furnishings, and even the violin motifs woven throughout the scheme.

Walter Sickert, Whistler's only other genuine pupil besides Menpes, also became an interior design client. Sickert's wife, Ellen Cobden, became a good friend of Whistler's and a constant visitor to his home. Two 1885 letters from Whistler to Cobden confirm his involvement in devising the color schemes for the Sickerts' house, though without specifying the colors.[106] More intriguing, however, is a piece of furniture he designed for them. Whistler did not think of himself as a furniture designer any more than William Morris did; however, on the occasion of Sickert's wedding in 1885, he had a large wardrobe fabricated [fig. 63]. Inside one of the wardrobe doors is the unattributed statement: "This cupboard was designed by Whistler as a wedding gift for Walter Sickert's marriage to his first wife who was a Miss Cobden, Connie Cobden-Sanderson's sister. I bought it from Sheila Cobden-Sanderson in its original condition. I find it most useful as a linen cupboard and to hold suitcases."[107]

Since the sideboard in the Peacock Room may only have been painted by the artist, this wardrobe, and possibly one of two remaining trunks, may be the only pieces of furniture designed by Whistler still in existence. These are logical furnishings for the *japoniste* artist to have designed, since storage chests, trunks, and cabinets, or *tansu*, are among the few favored items of furniture in Japanese homes [see fig. 66].[108] Whistler's wardrobe is devoid of applied ornamentation, and the design's basis in *shoji* screens is apparent [see figs. 30, 61].

The handsome wardrobe has a simple rectilinear form with reeded lines in the framework and the door handles. This is a motif that Thomas Jeckyll utilized in furniture and that Whistler employed in his picture frames. Whistler himself painted the framework blackish green and the panels off-white. The stark modernity of the wardrobe, which is made of yellow pine, would make it as appropriate in a modern home today as it was in the Sickerts' freshly distempered Whistlerian house. The design captures the spirit of Japanese art to a greater degree than Godwin's more complex furniture.

In the late eighties Whistler also acted as a color consultant for the home of the Richard D'Oyly Cartes. They were the producers of *Patience, or Bunthorne's Bride*, and Mrs. D'Oyly Carte had arranged and staged the artist's "Ten O'Clock" lecture. In an 1888 letter D'Oyly Carte asked Whistler to consider "the superintendence of the decorations of the Savoy Hotel" and "on what terms you could take it." It is not known why Whistler did not take on the Savoy Hotel commission; however, a note in the April 1888

FIG. 63. *Wardrobe Design, 1885. The pine wardrobe was designed and painted by Whistler with white panels and dark green reeded trim in a shoji-like pattern as a wedding present for Ellen and Walter Sickert. Hunterian Art Gallery, Glasgow University.*

edition of *Artist* announced that he was decorating one of the ceilings of the Adelphi Terrace house of the D'Oyly Cartes.[109] Mrs. D'Oyly Carte explained the nature of his decorative work.

It would not be quite correct to say that Mr. Whistler designed the decorations of my house, because it is one of the old Adam houses in Adelphi Terrace, and it contained the original Adam ceiling in the drawing-room and a number of the

old Adam mantelpieces, which Mr. Whistler much admired, as he did also some of the cornices, doors and other things. What he did do was to design a sort of colour-scheme for the house, and he mixed the colours for distempering the walls himself in each case, leaving only the painters to *apply* them. In this way he got the exact shade he wanted, which made all the difference, as I think the difficulty in getting any painting satisfactorily done is that painters simply have their stock shades which they show you to

choose from, and none of them seem like the kind of shades that Mr. Whistler managed to achieve by the mixing of his ingredients. He distempered the whole of the staircase walls a very light pink colour; the dining-room a different and deeper shade; the library he made one of those yellows he had in his own drawing-room at the Vale, a sort of primrose which seemed as if the sun was shining, however dark the day, and he painted the woodwork with it green, but not like the ordinary painter's green at all. He followed the same scheme in other rooms. His idea was to make the house "gay" and delicate in colour.[110]

The typical Whistlerian greens, pinks, and yellows were a far cry from stock Victorian colors and appropriate for an Adam house with neoclassical cornices, doors, and mantelpieces—which, of course, Whistler found to his taste.

Oscar Wilde's House Beautiful, 1884–1885

A collaborative decorative venture in the mid-eighties brought together the three great aesthetes of the age, namely, Whistler, Wilde, and Godwin. After his return from the American lecture tour in which he preached "the principles of true artistic decoration" à la Whistler and the Pre-Raphaelites (while Whistler wrote insulting letters to the press), Wilde spent some time on the Continent in 1883. Then in 1884, in anticipation of his marriage, Wilde leased No. 16 Tite Street (now 34), an unremarkable four-story Queen Anne house in plain red brick with a bay window passing through three floors. The challenge for Wilde was to uphold his reputation as a connoisseur of current advanced taste in interior design through the decoration of a house in the aesthetic mode. Wilde's remarks in his essay "The Artist as Critic" expressed his conviction about the import of decorative art. "The art that is frankly decorative is the art to live

with. It is, of all the visible arts, the one art that creates in us both mood and temperament. Mere colour, unspoiled by meaning, and unallied with definite form, can speak to the soul in a thousand different ways. The harmony that resides in the delicate proportions of lines and masses becomes mirrored in the mind. The repetitions of pattern give us rest. The marvels of design stir the imagination." Despite Whistler's evident annoyance with Wilde's takeover of his theories and his sensational success in his lecture series, Wilde asked his friend to superintend the decoration of his house. "No, Oscar," Whistler replied, "you have been lecturing to us about House Beautiful; now is your chance to show us one."[111]

Wilde then turned to Godwin, whom he had met and befriended in 1879, prior to the time he became friendly with Whistler, to help him devise a scheme of decoration. Wilde and Godwin ignored the ordinary exterior of No. 16 and concentrated on bringing an aura of exoticism and pure color to the interior. They were determined to make a prototype of modernity with high-gloss enamel woodwork and delicate distempered walls, as different from medieval revivalism as they could make it (though Wilde had often quoted Morris in his American lectures). Whistler soon became involved in the project, advising on color schemes, decorative details, and picture arrangements.[112] In keeping with Whistler and Godwin's interior design theory as expressed in their residences over a period of twenty years, Wilde's house was to be harmonious in form and color and individually expressive of its tenant. After several months, Wilde wrote to Godwin, "The house must be a success, do just add the bloom of colour to it in curtains and cushions." The Wildes moved in at the beginning of the New Year, 1885.[113]

Wilde's front door was white with frosted glass and a brass knocker and letter box. The other doors between rooms had been removed and replaced with curtains. The front, first-floor drawing room of Wilde's house had an elaborate overmantel, typical of

Godwin's designs, with a bronze bas-relief by John Donaghue, a Chicago sculptor, based on a Wilde poem, "Requiescat"; furniture was upholstered in faded antique brocades.[114] Godwin's surviving drawings show that the plan for this room was to have a deep frieze made up of framed pictures against a dull gold background running along two walls. The frieze would include Venetian etchings in white frames by Whistler and drawings by Burne-Jones in emulation of Ruskin's manner of displaying his Turners at Oxford. The cornice was gilded a flat lemon color, and a gold-patterned Japanese "leather" paper, which was available at Liberty's, was used around the top of the wall. The walls were distempered white tinted with flesh pink, Whistler's preferred scheme. One of Godwin's notes to himself about Wilde's house in one of his tiny sketchbooks says: "1 light chair, 2 easy chairs, table for tea . . . all in white . . . thick silk for curtains and covers."[115]

Wilde's library to the right of the entrance hall was decorated in a style described as either North African, Turkish, or Moorish. Some of these furnishings probably came from Liberty's, which was known for starting the fashion in Moorish decor. The lower walls were distempered dark blue, the ceiling and upper walls were pale gold, and the woodwork was rust red. An inscription from Shelley ran over a heavy beam and architrave in gilt, red, and blue. A cast of Hermes by Praxiteles stood in a corner, and pictures included a drawing by Simeon Solomon, a drawing by Adolphe Monticelli, and a Japanese print of gamboling children. Eastern inlaid tables, lanterns, low divans, ottomans, hangings, and curios gave the room a rich look. By contrast, the entrance hall had grey wainscoting, white walls, and the surprising touch of a yellow ceiling. The staircase continued the five-and-one-half-foot grey dado with yellow walls and ceiling and white woodwork; the stair steps were covered with gold-yellow matting. Engravings of Apollo and Diana decorated the entrance walls; the figures were meant to allude to Oscar and his wife, Constance.[116]

Wilde was especially fond of the dining room. It was, overall, a faintly opalescent white with woodwork enameled white and set against lime-white walls slightly tinted with black. A green-blue Morris carpet with a white pattern was on the floor.[117] Whistler loved arrangements in white, and the freshness of this scheme points to his influence; some sources credit him with the plan. However, Godwin's penchant for monochromatic color harmonies, and his great concern with introducing interior designs that suggested a hygienic, healthful dimension, make it equally likely that the architect created this scheme. And even though in his lectures Wilde had criticized the Americans for having too many white walls, he himself favored them. In this room, which had a few tints of blue and old ivory curtains embroidered with yellow silk, tea was served from a sideboard only about nine inches wide.[118]

For this neutral ensemble Godwin designed white furniture, such as the narrow sideboard, over which he took great pains. The room also included a dining table and Grecian-style enameled chairs copied from Greek vases. Wilde called the chairs "sonnets in ivory" and the table "a masterpiece in pearl." In April 1885, when "Godwino" was on vacation, resting and trying to regain his health, Wilde wrote to the sick man (who was suffering from acute inflammation of the bladder), saying, "Of course we miss you, but the white furniture reminds us of you daily, and we find that a rose leaf can be laid on the ivory table without scratching it . . . at least a white one can."[119]

Whistler had a Sheraton-style living room suite at this time that had been restyled and painted white [see fig. 68]. Which came first, Godwin's "sonnets in ivory" for Wilde or Whistler's harmonic white living room suite? All three aesthetes had a fondness for pristine Hellenic rooms, which would later become fashionable. Whistler's all-white sofa and chairs are on exhibition at the Hunterian Art Gallery at Glasgow University [see fig. 20 for an early Whistlerian ivory

sofa]. Charles Rennie Mackintosh's total neutralization of walls and furnishings in his own Far East-influenced living room, with furniture painted white to blend with walls, was presaged years earlier by the white-on-white scheme of Whistler, Godwin, and Wilde for No. 16 Tite Street. One guest, at a reception in Wilde's pearly dining room, was charmed by the image of women in summer costumes and men in black frock coats sipping tea out of dainty yellow cups "that might have been modeled for a lotus flower"—all silhouetted against this light backdrop.[120]

It was in the crowded back drawing room at a party that this same guest, Anna, comtesse de Brémont, an American friend of Wilde's mother, had an opportunity to see Whistler's exotic decorative contribution to Wilde's house. In the smoking lounge, she chanced upon Wilde enjoying a cigarette. Wilde led the comtesse into the adjoining drawing room to meet his new wife, Constance Lloyd, who was dressed in an exquisite Greek costume of cowslip yellow and apple-leaf green with her thick brown hair bound with yellow ribbon and caught in a knot at the back of her neck. The room had walls distempered dark green and the fireplace and woodwork were painted a brown pink. The *pièce de résistance* of the room was the decorated ceiling. "I was attracted by the exceeding beauty of the ceiling, which was all I could perceive of the decorations, as everyone was standing. Oscar spoke of it with much pride as being a masterpiece of design by Whistler."[121]

The pale green ceiling had two gold dragons at opposite corners, which blended into real, multicolored feathers that Whistler had incorporated into the plaster.[122] Even the fighting peacock mural must have paled in comparison. This certainly was an instance when Whistler took into account not only his own creative impulses but the flamboyant taste of his friend and client.

In general, it was a lively, rainbow-hued house expressive of the scintillating, witty, and warm personality of Oscar and the youth and bloom of Constance.

Godwin had returned to the Anglo-Japanese style to suit Wilde's decorating taste, though the Greek theme, as well as other exotic strains, was evident. It was an entirely eclectic home, modern but without the austerity that characterized interiors that Godwin, and especially Whistler, preferred. Even the opalescent, ivory-and-white dining room seems to have been cheerful rather than stark.

For ten years Wilde lived at No. 16 Tite Street, but the surrounding interior beauty did not create a beautiful life after all. He was as amusing and outrageous as ever, even as his life began to take on a sinister edge and finally unraveled. Whistler became the enemy, and the rainbow-colored house with the gold dragon ceiling became a farce. When Wilde's career and his spirit were broken by his trial and imprisonment in 1895 for soliciting sex from boys, the contents of the "house beautiful" were put up for sale, but nobody profited.

Fulham Road, the Pink Palace, the Vale, Tower House, and Cheyne Walk, 1885–1892

Whistler decided to move out of 13 Tite Street just as his rival, Wilde, was moving back into the neighborhood. To a friend he wrote, "I am no longer in Tite Street—Tite Street has consequently ceased to exist. Behold the address of my new studio, 454 A Fulham Road." The studio he leased on October 11, 1884, was reached by a rickety gate that led to an unkempt lane with a group of studios. Whistler had one of these, which, if nothing else, was spacious, a quality he greatly valued. And by early 1885 he was living nearby with Maud Franklin in a shabby house he called the "Pink Palace." The move was probably precipitated by economics; he was not selling much and remained miserably poor. Whistler himself painted the exterior of the house in the pink of a Venetian palazzo, and the Greaves brothers helped him to fix it up.[123]

In an 1885 issue of *Judy*, an ink drawing by Maurice Greiffenhagen labeled "The man is intended for Whistler" appears to catch Whistler with Maud during this period [fig. 64]. "Maud" is dressed in one of her stylish striped dresses (there is a photograph in which she wears a similar outfit), and Whistler, wearing striped socks, is seated on a Godwin-style rattan chair. A couple of fans decorate the wall. There was talk of violent scenes at the Pink Palace, and the *Judy* cartoon probably alludes to gossip about this. Maud is playing "For Ever" on the piano, and Whistler is saying, "Well, when you say 'For Ever' my dear, really a little variety might be preferable. (But she couldn't see it.)" The "variety" was Beatrix Godwin, an accomplished designer and fond pupil, who was frequently seen at Whistler's studio by this time.[124]

Whistler considered No. 2 in the Vale, Chelsea, where he and Maud soon moved, "an amazing place" [fig. 65]. It had a wild, overgrown garden containing larkspur and was situated in a cul-de-sac right off King's Road. "And yet," he said, "you might be in the heart of the country." His neighbors were the poet laureate Alfred Austin, and the superb arts and crafts potter William De Morgan, who collaborated with Morris. It was a comfortable late-Georgian house with an iron verandah.[125] Visitors noted the simplicity of the rooms. Whistler had eliminated heavy curtains, thick wallpaper, dusty rugs. Nothing was ostentatious, and everything introduced by Whistler could be easily redone, shaken out, or cleaned. Stale odors, dark colors, and heavy fabrics were banished.

Charles Ricketts and Charles H. Shannon, whose magazine, *Dial* (1889–1897), showed the influence of Whistlerian design ideals, established the Vale Press as the next tenant in Whistler's quaint cottage. They took it though it was in need of repairs. (Whistler had his son ask them "if they would mind" taking care of the cats.)[126] When Oscar Wilde took Will Rothenstein there in the 1890s, a fan-shaped watercolor by Whistler [see fig. 34] remained on the wall, as well as lithographs by Shannon and drawings by Hokusai.

They had kept the house simple and fresh looking in Whistlerian primrose with apple-green skirting and shelves. It really was a vale at that time, with wild grounds and houses engulfed by trees. The decor at No. 2 in the Vale seemed to indicate that Whistler's puritanical propensities were growing. When a rich man took him over to his new house and dwelt with pride and enthusiasm on this feature and that, Whistler constantly exclaimed, "Amazing, amazing!" When they had reached the end of their tour of the rooms and halls, Whistler at last said, "Amazing,—and there's no excuse for it!"[127]

The ever peripatetic Whistler would, from the mid-1880s on, become even more so. This made his frugal style of interior decoration entirely logical. Like Marcel in Murger's tale, Whistler could pick up his screen and move at a moment's notice. Quickly the walls were distempered in meltingly lovely tones, the checkerboard, striped, and flowered matting was rolled out on the floors, and what little there was of furniture was distributed. A Whistlerian domestic interior had all the permanency of the theatrical staging for one of his one-man shows. He seemed to be extending Pater's theory of living in the moment to his style of domestic decor. At the same time, these interiors were reflective of typical Japanese rooms, where everything provided the impression of mobility, of appearing subject to change. In other respects, his interiors of the mid-eighties were less apparently Japanese. The loss of his Oriental collections was undoubtedly a factor, and it was impossible for him to restore these objects.

His austere Fulham Road studio, with its whitewashed walls and wooden rafters used to store canvases, had a bare-bones look; times were not prosperous, and creditors often knocked at his door. Nevertheless, visitors were impressed by the vast, unencumbered space, which gave the impression of a workplace where only serious art would be tolerated. The studio was white throughout with just a touch of yellow in the rugs and mattings. There were none of

the artistic properties so frequently found in nine-teenth-century studios of the majority of painters.[128] Whistler's American friend, the painter William Merritt Chase, for example, made his famous 10th Street studio in New York aesthetically alluring with reproductions of old master paintings, his own paintings, casts of sculptures, musical instruments, brasses, Japanese fans, porcelains, an eclectic mix of carved furniture, luxurious textiles on the walls and draped on furniture, and a busily patterned Oriental rug.[129]

What Whistler had in his no-nonsense studio was a table covered with old Nankin china, a pale saffron-colored chair or two, the table that he used as a palette, and a couple of couches. Whistler's dealer, Walter Dowdeswell, noted this rare state of affairs, so spartan for the period. He recalled canvases all stacked at one end of the room and the exquisite drawings of semidraped figures from life, done in pastels on brown paper and pinned on the wall. Whistler could often be found working far into the night in his huge white studio.[130]

Booth Pearsall also described the unique ambience of this studio, to which he managed to gain entrance by referring to himself as "an impatient Irishman."

> I followed and entered a large room with a high light in the roof. A lady was sitting for her portrait. . . . He was as courteous and agreeable as a man could be, made me be seated on a huge Sheraton painted sofa, and asked me about his Irish friends. There was a group of men in the studio, to whom I was also introduced—Mortimer Menpes, Theodore Roussel, Walter Sickert, William Stott of Oldham. . . . I had about an hour and a half with the "Master," and I have never forgotten this interview . . . the bare studio in the twilight, the well-worn Sheraton settee, the receipted bills on the wall, the Chippendale table used as a palette . . . the alertness and decorum of all his movements.

FIG. 64. *Maurice Greiffenhagen. Cartoon Ink Sketch for Judy, 1885, 8 x 4 in. (20 x 10 cm). The drawing is labeled "The man is intended for Whistler." Whistler is depicted in striped socks, seated on a rattan chair; Maud is dressed in stripes against a fan-bedecked wall. E. 737-1948 (I. 120), Victoria and Albert Museum, London. By courtesy of the Board of Trustees.*

FIG. 65. *Whistler's house in the Vale, Chelsea, 1885–88. Photograph by W. E. Gray. From Pennell and Pennell, Whistler Journal, opposite 166.*

Whistler often dressed in a cool white linen duck suit in his white studio; he seemed to take a sensual delight in whiteness. Sometimes he took off his jacket, displaying spotless cambric sleeves. His palette and preternaturally long brushes were as pristine as his dress and the rooms of his house and studio.[131]

William Merritt Chase, who seemed to be the New York counterpart to Whistler as an aesthetically debonair artist, went to London in 1886 and established a fast friendship with Whistler. At one point, Whistler surprised Chase by refusing to deliver a painting to a woman who had bought it. Whistler explained, "You know, Chase, the people don't really want anything beautiful. They fill a room by chance with beautiful things, and some little trumpery, something over the mantelpiece gives the whole damned show away." Together the two toured the city's galleries, including Whistler's current show, and they painted portraits of each other in the stark Fulham Road studio. Whistler was not pleased with Chase's supercilious caricature portrait of him, which catches him at the height of his foppishness, and quarrels ensued, placing a lasting strain on their friendship.[132]

The years 1885 and 1886 marked a number of important occurrences in Whistler's life. He delivered his manifesto in May 1886, he mounted a second one-man exhibition at Dowdeswell's, and by June 1 he had been elected president of the Society of British Artists. On October 6, his dearest friend, Godwin, died. Whistler was at his side at the end, and he loyally ensured that suitable obituaries appeared in London papers. Then, following Godwin's wishes, he, Lady Archibald Campbell, and the young Mrs. Godwin accompanied the coffin in an open cart to a corner of a country field for burial, but not before covering the coffin to have a macabre picnic. Beatrix Godwin now became a studio fixture.[133]

On June 18, 1888, Whistler abandoned his primrose cottage in the Vale and his barnlike Fulham Road studio for a new studio flat in the recently built Tower House at No. 28 Tite Street, which was one of the last buildings Godwin designed before his death. To the left, on the facade, was a tower consisting of four studios, one piled on top of another, with huge multipaned windows. To the right of the tower were eight small-paned windows and, under them, the asymmetrically placed door. This building, a highly original solution for multiple studio houses, had a Queen Anne flavor, in contrast to the White House across the street. It was a big red-brick building with white trim and aesthetic sunflowers carved into the

arches above the windows.[134] Whistler's studio flat was two flights up, being the third from the ground.

This is where Whistler brought his first wife. He had somehow cast aside Maud, who had lived with him for fifteen years, called herself Mrs. Whistler, endured bankruptcy with him, and borne him two daughters. On August 11, 1888, at fifty-four years of age, he married Beatrix Godwin. The *Pall Mall Gazette* commented, "The Butterfly chained at last!" After the wedding ceremony at St. Mary's Abbott's, Kensington, the small wedding party adjourned to Tower House and the packing cases in the dining room. Usually at least one room in Whistler's house was in perfect order, but there had been no time to do this. The bride's sister had thought to order a wedding cake from Buszard's, and Whistler had a wedding breakfast sent from the Café Royal. The banquet was on the table when they arrived, but there were no chairs—a familiar state of affairs. So they sat on the packing cases and enjoyed the elegant wedding feast in an atmosphere resembling a stage set already struck.[135]

On their honeymoon, Whistler purchased a fine collection of English silver in Paris to begin the decoration of their new home and to replace the precious old silver lost in the bankruptcy sale. The Whistlers' flat comprised a spacious studio, dining room, and servants' rooms above. Sheridan Ford, in an article entitled "Mr. Whistler at Home," reported, "The whole interior is flooded with a wealth of golden color, two tints of pale yellow hangings create the effect of summer sunshine . . . one feels what a marvelous master of color planned the whole." A journalist from the *New York Sunday Spy* admired the vivid distempered rooms, especially the dining room laid with matting in blue-and-yellow squares, its yellow hearthstone with lemon yellow tiles, and its "yellow curtains elaborately embroidered [which] fall unconfined from the top of the windows to the floor."[136]

During this time, various reporters spied the Butterfly flitting about. A writer for *Harper's Bazar* wrote, "Here is a picture which a Paris correspondent to London gives of the artist Whistler: 'Whistler has been seen at Tortoni's wearing chrysanthemum-yellow gloves that harmonized perfectly with the opalescent green of the diluted absinthe he was imbibing.'" And on the day of his wedding, the *Brooklyn Times* ran an account of how the decor at Tower House was shaping up.

> The household decorative mania has considerably subsided, and people now talk quite rationally on the subject of domestic ornamentation. If, as we recently remarked, the Japanese have had a profound influence upon our pictorial art, they had a much more profound influence upon our decorative ideas. . . . Whistler is a type of Japanese maniac. . . . Whistler forgives all the absurdities of the Japanese painters in his feverish enthusiasm for their decorative skill. Whistler's admiration for the Japanese, an admiration which has led him to paint some very singular pictures, finds vent also in the decoration of his own house. From an article in *Home* we catch the glimpse of the eccentric American's British home. "One of the most daring bits of coloring on record in the way of household furnishing is the dining room of the artist Whistler. It may be said to be a symphony in yellow, or in blue and yellow. All of the walls are painted blue, the blue being a decidedly greenish blue. The cornice is painted in stripes of dark green, blue and yellow; the ceiling being pale yellow. The surbase is the color of a ripe lemon, as are all the doors and all the wood around the windows . . . the mantel . . . the hearthstone . . . the tiles. . . . two sets of shelves . . . the cane-seated chairs [with] the seat blue. The floor is covered with blue and yellow Chinese matting cubic pattern."[137]

Such reports helped attract critics and collectors to Whistler's door.

In March 1890 Whistler's future great collector, Charles Lang Freer, appeared at Tower House and was

ushered into the apartment. Freer noted a large room "finished in yellows," delightful color schemes that were "plain and unassuming" but "wholly harmonious," and the etching studio, which was "attractive, homey and restful, at the same time being a perfect dream of harmony in its appointments."[138] Whistler's Tower House decor was a complicated symphony in pure color tones, and, as always, it was economical. Yet there was richness.

> This is all very cheap sort of furnishing but here the cheapness ends. The curtains of rare needlework, of various shades of yellow upon fine white linen . . . the [yellow] shelves hold bits of rare blue china; on the mantel are Japanese curios, blue, sea green and yellow. A half-opened fan is in one corner. There are no mirrors and no pictures. Opposite the fireplace hang midway between floor and ceiling two Japanese flower pots, each holding a yellow primrose. The table service is of old blue. Who but an artist would undertake such a scheme of color, and who but an artist would succeed?[139]

Japan had arrived back on Tite Street. The combinations of yellow and blue were wilder. He was beginning to eliminate pictures from his decor. And it was news. New Yorkers could read all about it.

The artist W. Graham Robertson, who became Whistler's friend at this time, remembered that he "was perpetually changing houses and each house was to serve as a subject for new and charming schemes of decoration." Even without commissions, Whistler had, by constantly moving, found a way to exercise his desire to decorate attention-getting interiors. In March 1890 the Whistlers moved to a beautiful old four-story Queen Anne house at 21 Cheyne Walk, farther down the embankment from Lindsey Row and close to the Rossettis' Tudor House. In front of the residence was a modest little garden with trees and shrubs, but once inside, visitors found that the house seemed very large. This may have been because most of the rooms were left totally unfurnished. The house had six bedrooms and was paneled from top to bottom. The splendid view of the Thames River was the main attraction.[140]

Whistler was in the midst of fighting Sheridan Ford over Ford's publication of *The Gentle Art of Making Enemies*, a battle that Whistler won as a result of testifying in a lawsuit in Belgium. One day, Theodore Roussel found the Whistlers in their Cheyne Walk drawing room, buried by boxes of newspaper clippings, trying to select the best for a compilation for a book of the same title, which Whistler published that summer.[141]

Boxes of clippings, unpacked crates, and uncarpeted stairs did not stop the Whistlers from entertaining. All through the summer of 1890 Whistler held Sunday afternoon receptions with guests seated around tea tables in the large "Old World" garden at the back of the house. There was a mulberry tree, flower beds, and a summer house; it was ambrosial. To a favored guest, Isabella Stewart Gardner, one of the American rich who collected his work, he wrote: "Dear Mrs. Gardner, Do come and see us. We have a delightful old house in Cheyne Walk, Chelsea no. 21. facing the river and the most charming garden in London. Do come tomorrow. . . . in the morning. Don't forget."[142]

The dining room at Cheyne Walk was on the left as one entered; it had a cool scheme of white paneling with blue accents. The table always appeared to be set with blue-and-white china, and on any given day, one could find Whistler there breakfasting on an egg, as Joseph Pennell found him one day when he visited. (Whistler had been accused more than once of basing color schemes on the egg.) His interiors were becoming progressively simpler with perhaps nothing more than one painting above the mantel and the flowers of the season in little white glasses. The table and cane chairs were, as usual, painted in harmony with

the color scheme. For a while, five panels from the Six Projects hung on the wall between the windows. Robertson recalled the dining room as "a dream. . . . A little peat fire always burned on the blue-tiled hearth, the Projects sparkled on the walls, the room seemed full of warm spring sunshine."[143]

Whistler considered the dining room in this house one of the best he had created. After he left No. 21, he wrote to Sickert, who was helping him find someone to lease it: "My dear Walter—I hear from my sister in law that you know of some one who would like to take 21 Cheyne Walk. . . . Of course I should always regret that we had built that beautiful dining room for an Englishman to sit and eat his beef in—However he will never know how beautiful it is—so that's all right! . . . Manage the letting of the Cheyne Walk nicely for me Walter—right off—like a good fellow." Whistler also asked about an article in *Academy*, which he (incorrectly) believed Sickert had written, and added: "How really ineffably imbecile is Punch . . . I just picked up this last number with that ass Oscar [caricatured in it]. . . . Funny about Oscar though isn't it. That it should be his fate—in *everything* to be *after* me!" (Wilde would precede Whistler in death, however, dying syphilitic in a Paris hotel in 1900 after the horrors of imprisonment, his body exploding with fluids. He claimed till the end that the bad wallpaper in the room was fighting a duel to the death with him.)[144]

The second-floor drawing room at Cheyne Walk had been converted into a studio, and the Whistlers' bedroom on the top floor had been enhanced with a great deal of white and "beautiful butterflies here and there on everything." The rest of the rooms were left empty and bare; trunks were about.[145] One Japanese-inspired trunk with Whistler's nameplate appears to have been fabricated according to his design, demonstrating his desire to design all [fig. 66].

The house downstairs looked as if the Whistlers had just moved in or were about to move out. Increasingly, visitors noted the curious lack of pictures.

Whistler was beginning to find it superfluous to put one of his pictures in a room that, if done right, was already a complete aesthetic statement in itself. Why settle for a spot of color on the wall if you could have an entire room that constituted a three-dimensional color field? The unfurnished rooms were not only a sign of Whistler's congenital inability to finish work. There were philosophical reasons for them. M. Gerard Harry recalled:

> Whistler was certainly a delightful man. . . . It always seemed to me that his lavish wit begat wit all around him. To hear him was to drink sparkling champagne. . . . I remember a striking remark of his, at a garden-party in his Chelsea house. As he caught me observing some incompletely furnished rooms and questioning within myself whether he occupied the house more than a fortnight or so: "You see," he said, with his short laugh, "I do not care for definitely settling down anywhere. Where there is no more space for improvement, or dreaming about improvement, where mystery is in perfect shape, it is *finis*—the end—death. There is no hope, nor outlook left."[146]

The nature of Whistler's pictorial and interior design work, and his refusal to settle for anything less than perfection, may also relate to his identification with Zen Buddhist beliefs. The reposeful, exotic settings he created, the dissolving, pearlized walls, made his rooms places in which to dream and experience an "illusory existence." The incomplete, suggestive, transitory quality of Whistler's interiors, and his desire to achieve maximum effect with minimum means, constituted his original translation of Eastern values into Western interior design.[147]

One of Whistler's Cheyne Walk neighbors, the American, Arthur Warren, London correspondent for the *Boston Herald*, was treated to an impromptu lesson in the artist's ideas for ethereal interiors. One

FIG. 66. *Trunk with Metal Label, "J. McNeill Whistler."*
The trunk is probably an original Whistler design based on
Japanese models. Hunterian Art Gallery, Birnie Philip
Bequest, Glasgow University.

afternoon Whistler dropped by and asked Warren, "Didn't you tell me, the other day, that you intended redecorating this place?" Whistler walked about the flat, dramatically pointing here and there to the walls and ceilings with his bamboo wand and repeating again and again that what was called for was white. "White . . . all white. And a white you can wash! Londoners forget that they must live in their houses in winter. All their colours are dismal, and there's no sun. . . . Such-and-such a colour here, and such a line here. My dear boy, this is the whole secret,—tone and line." It cost no more to do it right than to do it wrong, Whistler emphasized. Warren "did up" his place, following Whistler's detailed directions, and "the result was," he declared, "I had one of the most delightful flats in London."[148]

110 Rue du Bac: A Garden Pavilion, 1892–1901

Since Whistler, ever the expatriate in search of a home, never settled down, he always had another interior to decorate and a new place to show. And he continued to invite many of the creative lights of the late nineteenth century to his homes and studios, wherever they were. By the beginning of the 1890s, though, he was growing more and more incensed over his treatment in Britain. Despite the public recognition he had received, he was galled by his experiences with the Royal Academy and the Royal Society of British Artists. He felt insulted that he had not been more suitably honored, understood, and appreciated. Meanwhile, he was developing important friends and allies among the symbolists in France and rebuilding his reputation there; his improved finances from sales of important work gave him greater freedom.[149]

In 1892, the Whistlers moved from No. 21 Cheyne Walk to Paris. They found an apartment at

110 rue du Bac and decorated it together. With the prospect of a new life in Paris with Beatrix, Whistler had a particularly keen interest in creating an original interior. This was the happiest period of his life. He was deeply in love with Beatrix, who was good natured and plump and towered over him. She, in turn, championed his art and treasured her difficult husband.

One attraction Whistler felt to Paris was the kinship he shared with avant-garde French artists working in a symbolist form of decorative art. French Nabis artists such as Edouard Vuillard and Pierre Bonnard, in the mode of Whistler, embraced the decorative arts, preferring panels, folding screens, and walls to the confines of the canvas. The Nabis-like, evocative, *intimiste* lithographs that Whistler began to do at this time, depicting Beatrix and her sisters playing the piano, lost in reverie, or having tête-à-têtes in the garden at 110 rue du Bac, capture the serenity, warmth, and grace that pervaded their Paris home, and manifest his alignment with French symbolist artists [see fig. 72]. The theme of decorative figures immersed in decorative environments took on amplified importance in the work of these artists.

Whistler and his wife not only shared the pleasure of withdrawal to a secluded Parisian retreat; they also shared their joy in honors that began to come to him. In 1889 he received the Cross of St. Michael and the ribbon of a chevalier of the French Legion of Honor, was made an honorary member of the Bavarian Royal Academy, and was awarded a first-class medal at Munich, a gold medal at the Amsterdam International Exhibition, and a first-class medal at the Paris Universal Exhibition. In March 1891 the city corporation of Glasgow bought Whistler's portrait of Thomas Carlyle for one thousand guineas, and in November 1891, under pressure from such figures as Mallarmé, Montesquiou, Duret, and Georges Clemenceau, the French government bought the portrait of his mother for four thousand francs, or six hundred

twenty dollars. Finally, Whistler organized an important retrospective of his work and brought off a triumph at the Goupil Gallery in London in March 1892. To his friend Sidney Starr he wrote:

> I must say I am delighted with the place, the dreariness and dullness of London was at last too depressing for anything and after the exhibition there was really nothing to stay for. Indeed the exhibition itself sized up this situation beautifully. It was, as you remember, a complete triumph—crowning all my past victories. No further fighting necessary—I could at last come away to this land of light and joy where honors are heaped upon me, and peace threatens to take up her abode in the garden of our pretty pavilion. However, I do not promise that I shall not, from time to time run over to London, in order that too great a sense of security may not come upon the people![150]

The move to Paris was complicated and required numerous return trips to London. During the period, their new house was undergoing alterations, and they oversaw the work from rooms at the Hotel Foyot at 33 rue Tournon (Whistler moved after an anarchist exploded a bomb in the kitchen window) and then the Hotel du Bon Lafontaine at 16 rue de Grenelle. He wrote to Sickert, assuring him that they were "greatly occupied with constructing new Palaces in this fascinating city."[151]

Joseph Pennell found Whistler "not too comfortably established, in one or two small rooms" and full of the wonders of the new apartment in the rue du Bac. Whistler took Pennell to see the redecoration project, but there was actually nothing to see but packing boxes and workmen. To his sister-in-law Nellie Whistler wrote that the place would have the charm of a blue-and-white china plate. He regaled his friend the publisher William Heinemann, saying: "The Palace is completing itself. The Studio as I have

told you is amazing! and the palatial residence. When you see it you will think that [it is] the very centre of all Fairy stories. . . . We are not yet off to the sea—because of the architect and workmen." Beatrix wrote to the Glasgow *japoniste* and collector Alexander Reid asking for a favor. She needed help in locating some "green stuff for covering the walls used by Madame Manet and Madame Morisot" that she had seen at Mallarmé's and that she hoped he could find. "It is a sort of sateen and very cheap."[152]

Stéphane Mallarmé, the symbolist poet, was Whistler's best friend in Paris; he had helped Whistler obtain recognition. Mallarmé was intrigued by Whistler's redecoration project at what he called the "Rue antique du Bac cent-dix." In their forays together to shops, they hunted for "old things," blue china, and silver. In June 1891 Whistler visited Mallarmé at Valvins, and they enjoyed an outing to Fontainebleau, searching for Empire furniture and relishing French architecture. Their treasure-hunting expedition apparently was successful, because subsequently Whistler wrote to Mallarmé to inform him Beatrix was delighted with the blue chairs, which would go very well with a background of azure sea—"a real harmony!" Later Mallarmé dropped a note to Whistler to tell him he had found some beautiful First Empire fabric. On Sunday, August 7, 1892, Mallarmé wrote to Whistler:

> Honfleur is a marvelous place . . . [but] Whistler is not here, he's bathing his eyes in the lawn of the rue du Bac at this very hour, on the Sunday when I write to him. . . . If the terrible architect Madame hasn't leveled the entire little house with her finger, to rebuild it in a style even more strictly Empire, I expect to see some pretty improvements when I return through Paris. . . . Your hand dear friend, I miss you after a week. Madame Whistler, there are such wonderfully perfumed roses at the Honfleur market, that I regret your absence; and everywhere there are blue China plates.[153]

Shortly before the Whistlers moved into their newly decorated apartment, Beatrix sent a note to Mlle Mallarmé in the winter of 1892 to thank her for some "pretty ribbons! They are charming. I hope that you will, when we are in the Rue du Bac, come and have tea with us, and let us show you how smart it all looks now with the new paint." Mallarmé continued his correspondence with the Whistlers, and in one letter he fondly recalled a visit to their garden and porcelain room. Meanwhile, Maud Franklin had not conveniently effaced herself but, rather, had taken up residence in the neighborhood. She was alone and poor and still retained the name "Mrs. Whistler" on her cards.[154]

The secluded apartment at No. 110 rue du Bac was on the right-hand side of the street, which ran perpendicular to the river Seine, near the Bon Marché department store. It was a ten-minute walk from the Louvre, though withdrawn from tourists and the cosmopolitan rue de Rivoli crowd. The rue du Bac had a stately yet domestic air, with Old World distinction. The entrance to 110 was via an archway between shops, which occupied the lower story of every house. No hint of what lay beyond could be anticipated from the street. Guests entered under the big arch, passed by the concierge, walked down a long, dark, covered tunnel and then between high walls until they came to a little bright courtyard paved with brick. There was an old bronze fountain in the plaza in front of a seventeenth-century house that had several doors. Using purple ink, Beatrix made a sketch of the facade of the series of flats, which featured rectangular beveled panels below sizable windows with small panes, a classical frieze above, and inset relief sculptures. One guest noted that there was "a flavour of classical art in the air." Whistler's door was across the courtyard and easy to spot. It was painted blue green and had a brass knocker; it was quite unlike any other door in Paris.[155]

Whistler was almost an institution by this time, and among the first to arrive at his door from London were R. A. Stevenson, Aubrey Beardsley, Henry Harland, D. S. McColl, Charles W. Furse, Alexander and Robert Ross, and the Pennells. Beardsley at first struck Whistler as a freak, though Whistler later told him, "I have made a very great mistake—you are a very great artist."[156] Realizing Whistler's initial revulsion, Beardsley did a couple of masterfully snide and witty caricatures depicting Whistler seated in one of his trellis-box chairs in the rue du Bac garden, pointing at a butterfly, and another of Whistler as a faun perched on a Sheraton settee next to a W. A. S. Benson-type lamp [fig. 67].

Americans, too, stopped by, including Samuel P. Avery, E. G. Kennedy, William Dean Howells, Henry James, Jonathan Sturges, John Singer Sargent, Isabella Stewart Gardner, Frederick MacMonnies, Edwin Austin Abbey, Charles Lang Freer, and in 1895 John La Farge, an artist and decorator who was, like Whistler, a pioneer in the discovery of Japanese art. Young American art students were attracted by Whistler's personal magnetism, and Walter Sickert and William Rothenstein were always on standby. His French friends tended to be from the circle of literary symbolists, including Mallarmé, François Viele-Griffin, Paul Verlaine, and Octave Mirabeau, and other figures such as Robert de Montesquiou, Antonio de la Gandara, Arsène Alexandre, Théodore Duret, George Rodenbach, Paul-César Helleu, Auguste Rodin, Alfred Stevens, Edmond-François Aman-Jean, Giovanni Boldini, and Pierre Puvis de Chavannes. Fantin-Latour's studio was nearby in the rue des Beaux-Arts. Whistler and the French composer Claude Debussy enjoyed each other's company, and Debussy began to write "nocturnes," taking the term from Whistler's work. Youthful members of the Glasgow Boys, who were caught up in Whistlerian questions of decorative design, made pilgrimages to Whistler's peacock blue door, especially John Lavery and James Guthrie.[157]

The finest description of the rue du Bac comes from Whistler's fellow American expatriate, Henry James. James, who had shown his failure to understand Whistler's work in his early critiques, based key

The
Dancing
Faun

by

Florence
Farr

London
John Lane
———
Roberts Brothers
Boston
1896

FIG. 67. *Aubrey Beardsley. "Whistler as a Faun on a Shera-*
ton Settee," 1894, 9½ x 2¾ in. (23.2 x 6.9 cm). The
caricature was designed for a title page of The Dancing Faun
by Florence Farr. JC 684 E. 1132-1965, Victoria and Albert
Museum, London. By courtesy of the Board of Trustees.

scenes of his 1903 novel, *The Ambassadors*, on the ethereal atmosphere of Whistler's home and garden in Paris. In a letter James described it as "a queer little garden-house off the rue du Bac where the only furniture is the paint on the walls and the smile on the lady's [Beatrix's] broad face."[158] In his novel, however, his description is more lyrical. James's character, Lambert Strether, represents the stunted American, unhappy over his own unlived life; the sculptor Gloriani is based on Whistler. In a major scene in the novel, Strether is deeply impressed by the artist's house and garden when he is taken by his friend Chad on a visit

> to see the great Gloriani, who was at home on Sunday afternoons and at whose house, for the most part, fewer bores were to be met than elsewhere; . . . Chad had made the point that the celebrated sculptor had a queer old garden. The place itself was a great impression—a small pavilion, clear-faced and sequestered, and an effect of polished *parquet*, of fine white panel and spare, sallow gilt, of decoration delicate and rare, in the heart of the Faubourg Saint-Germain and on the edge of a cluster of gardens attached to old noble houses. Far back from streets and unsuspected by crowds, reached by a long passage and a quiet court, it was as striking to the unprepared mind, he immediately saw, as treasure dug up.[159]

This surprise effect of "treasure dug up" was a matter of great pleasure to Whistler, just as he had delighted in hiding behind the blank facade of the White House a spacious studio-drawing room with a wall of glass that opened to a garden view. In the novel, Strether and Chad enter the elegant garden. They find birds twittering in the trees and a little party. It is a soft day, and everybody has spilled out of the house into the garden. Behind the garden wall the priests from a monastery are chanting and the chapel bells are tolling. James suggests that they are "priests

of the cultured life," a phrase equally descriptive of Whistler. Strether is enraptured by the haunting beauty of the setting Gloriani has created and stunned by the "aesthetic effect" of the women. Above all, he is struck by the artist's penetrating physiognomy.

> [H]e had the sense of names in the air, of ghosts at the windows, of signs and tokens. . . . Was it the most special flare, unequalled supreme of the aesthetic torch, lighting that wondrous world forever—the deceptive human expertness in Gloriani's charming smile—oh, the terrible life behind it!—was flashed upon him as a test of his stuff–almost formidable: Gloriani showed him, in such perfect confidence . . . a fine, worn, handsome face. . . . With his genius in his eyes, his manners on his lips, his long career behind him and his honors and rewards all round, the great artist, in the course of a single sustained look . . . affected our friend as a dazzling prodigy of type. Strether had seen in a museum—in the Luxembourg [Whistler's painting of his mother] as well as, more reverently, in other days, in the New York of the billionaires [such as Isabella Stewart Gardner]—the work of his hand.[160]

Henry James's description of the hard, gemlike flame that burned in the artist's eyes, and the delicate and rare decor with which he had surrounded himself, makes one think Whistler had at last achieved a perfect Paterian synaesthetic concert of aesthetic fulfillment. Whistler's thirst for celebrity also became a characteristic of Gloriani. As James wrote, "He had migrated in mid-career to Paris, where, with a personal lustre almost violent, he shone in a constellation: all of which was more than enough to crown him, for his quest, with the light, with the romance of glory."[161]

The young artist William Rothenstein, from the Slade School in London, had gone to Paris to study at the

Académie Julian and often dropped by to visit Whistler. (Whistler called the severe, mannered Rothenstein "the parson.") The young man was "always somewhat excited when visiting Whistler."[162] He remembered Whistler's front door as "painted a beautiful green and white," though other visitors reported variously that the artist's door was blue, green, blue and white, or blue green and white. The enchanting apartment was slightly below ground level, and Whistler's somber English servant (whose repeated infractions finally caused his dismissal) ushered guests down three or four steps into an empty vestibule. Although there was the usual absence of furniture, there was at least an Empire settee, which was always covered with coats and hats belonging to Whistler's guests, and, of course, trunks. The color harmony in this entrance room was white and blue; the scheme was carried into the paneled drawing room, which was entered via a big door opposite the entrance.[163]

A reporter from *Studio* described the drawing room as "obviously decorated to the order of a master of the craft. . . . [You] discover that the dainty simplicity is the result of a charming scheme of colour, at once splendidly reticent, yet not arrogantly nonobtrusive. The panelled walls betray the colourist."[164] Whistler's house was, like all his residences, a demonstration of his tonal, minimalist theories of interior design.

Arthur J. Eddy, a Chicago lawyer and collector, who, like Mortimer Menpes and Sheridan Ford, was a shrewd observer of Whistlerian decor, found the rue du Bac drawing room, or reception room, a revelation of the personality of the artist in its simplicity, dignity, and harmony. It was restful, with its paneled walls distempered pure white and blue and its ceiling a light shade of blue. The flat blue tones harmonized with white doors, windows, dado, woodwork, and floor, which was covered with a coarse dark blue matting. The sparse furnishings gave the room a spacious quality. What was there harmonized with the tone of the

walls and was "graceful almost to fragility." An unusual Japanese lantern in the form of a net full of seaweed and shells hung in the center of the room. Eddy noticed that "there were but two pictures in the room, one at each end, both sketches by Whistler of 'harmonies' or 'arrangements.' The 'key' being blue, the pictures blended with the walls, as all pictures should, as if part of the original scheme of decoration." For a while visitors noticed that either a Venus statue or one of the Six Projects was casually displayed.[165] The fragile furniture in this room consisted of grand piano, a few French Empire chairs, and a nineteenth-century English Regency living-room suite, which was a reproduction of a late-eighteenth-century Sheraton design [fig. 68]. This living room suite, which today is painted white and upholstered in off-white, has a somewhat Oriental look and was probably the same furniture mentioned as part of the Fulham Road decor.

Evidently, like Morris and Godwin, Whistler did not always find ready-made furniture to his taste. An examination of his beech wood, ivory-colored Sheraton sofa reveals tack holes along the back rail, suggesting that it was previously upholstered. Whistler probably had the piece reworked to match the design of his white-painted mahogany chairs.[166] Beatrix was also sketching different possibilities for "reformed" sofa designs. One of these is in a delightfully exaggerated Empire style [fig. 69].

The furniture Whistler collected for his late residences was Western rather than Eastern in origin, though many of his accessories were Japanese. There are no lacquered cabinets or series of golden screens of Japanese or Chinese origin at the Hunterian Art Gallery, which exhibits the extant furniture. Only the artist's Oriental-inspired screen painting of Battersea Bridge, which survived multiple moves, is on display [see fig. 38]. Whereas Whistler's Paris home retained the exquisitely restrained aura of a Japanese house, the Whistlers had developed a preference for classi-

cally inspired English Regency and French Empire furniture of the eighteenth and nineteenth centuries. Several remaining pieces are similar to American Federal style furniture (ca. 1790–1810). Menpes wrote of Whistler's early taste for Adam and Chippendale period pieces. By the 1890s his choices were unobtrusively elegant, as different from Morrisian "medieval" vernacular furniture as possible, and equally different from the elaborate, curvilinear rococo furniture then having a rampant revival in Paris.

An example is a French eighteenth-century bergère made by Jean-Baptiste Claude Sené, a cabinetmaker in the court of Louis XVI in 1769. It is of modest size in off-white-painted mahogany with leather upholstery and brass studs. Another armchair is an English spindle design (ca. 1800), which appears in a charcoal drawing, *Rosalind Birnie Philip Seated* (ca. 1897). It is stained mahogany and has rose silk cushions and brass feet. A large, round nineteenth-century English walnut-and-mahogany table with striated legs and ormolu paw feet could also be found at the rue du Bac, perpetually littered with newspapers, as was the matting-covered floor.[167] (Obviously, Whistler's obsession with collecting newspaper cuttings about himself had continued.) The Whistlers also incorporated a late-nineteenth-century stained mahogany chair upholstered in bright cherry silk into the decor.

The French Empire furniture that the Whistlers collected for this residence, such as straight-back chairs characterized by Napoleonic architectonic formality, appears in several of the artist's sketches, lithographs, and photographs from this period. Unfortunately, none of this furniture seems to have survived. The square geometry of the white-and-gold Empire furniture (another style enjoying a revival in the 1890s) coordinated well with the white paneled walls and hangings. The pieces they collected were severely rectilinear and classical with a subdued majestic quality. Whistler was probably familiar with Charles Percier and Pierre-François-Léonard Fontaine's

FIG. 68. *Sheraton-Style Settee, 1880s, 34 x 32⁷/₁₀ x 30 in. (86.5 x 83 x 76 cm). The spare sofa, designed by Whistler, is a reworked piece in beech wood, painted white and upholstered in off-white. The slender forms, refined elegance, straight lines, and white color give it a classical quality. Hunterian Art Gallery, Birnie Philip Bequest, Glasgow University.*

famous work on interior decoration, *Recueil de Décorations intérieures* (1801). This book, written during the reign of Napoléon I, is considered the "Bible" of Empire furniture. The English Sheraton pieces the Whistlers selected are also characterized by restrained classicism and delicacy. The couple may well have consulted Thomas Sheraton's most influential book, *The Cabinet-Maker and Upholsterer's Drawing Book* (1791), which featured the furniture of slender forms and straight lines that Whistler and his friends Godwin and Rossetti, preferred.[168]

If most of Whistler's decorating was now of Hellenic inspiration, the decorative accents in his drawing room revealed his continuing *japonisme*. A large late-nineteenth-century brown-glazed Oriental stoneware vase with a bold turquoise design depicting a Hiroshige-like hawk fighting a dragon survives in the Hunterian Art Gallery collection. And visitors noticed here and there "a sparkling note of low-toned pottery and china" as well as cool hangings of Japanese print chintz. Whistler also designed doorplates with Japanese cloud and lattice designs and several wall sconces that appear to evolve into butterflies. These were probably fabricated for the decoration of the rue du Bac. His desire to design every element of the interior down to the doorknobs would be characteristic of art nouveau designers to follow.[169]

One British reporter noted that Whistler's rue du

FIG. 69. *Beatrix Whistler. Design for Sofa or Window Seat,
1890s, 3⅕ x 4⁷⁄₁₀ in. (8.1 x 12 cm). Beatrix's design, of clas-
sical Empire derivation, was intended for 110 rue du Bac,
Paris. Hunterian Art Gallery, Birnie Philip Bequest,
Glasgow University.*

Bac pavilion certainly bore no resemblance to homes
in Bedford Park (the British suburban garden commu-
nity decorated with Morrisian medieval quaintness).
As in the White House, the real focal point of the
drawing room was the garden, which, in the Japanese
manner, was closely linked to the interior. The garden
could be seen through big open windows and a large
door. The reporter remarked, "As the sunshine at the
open window attracts your glance to the garden, you
realize the scheme of the room was designed to accord
with its delicious outlook. There, patches of daintiest
green . . . with masses of pink flowers supply the pat-
tern absent from the room." It was reminiscent of "a
panel by Watteau."[170]

Josef Engelhart, an Austrian representative of the
Vienna secessionist group, met Whistler in Paris in
1897 and encouraged him to join the group. To En-
gelhart, Whistler at sixty-three looked "doll-like," a
"dainty little fellow who moved in a nervous, jerky

fashion," dressed in grey coat and trousers and a grey
bowler, his grey curls and pointed mustache arranged
with care. He carried an extremely thin cane and wore
low-cut evening pumps and black silk stockings. He
painted his cheeks and eyebrows and wore a monocle,
the whole creating a slightly sinister effect. Only a
peacock feather in his hair seemed to be missing. By
this date the formerly accessible artist had become
inaccessible. But Engelhart wrangled an invitation
and had an opportunity to experience both the draw-
ing room and Whistler in a winter mode.

> I visited him in his little one-story garden house.
> He received me in a distinctive and tastefully fur-
> nished drawing-room where grayish-yellow colors
> predominated. Sketches and paintings . . . hung
> upon the gray walls in wide frames of dull gold.
> High glass doors led into a tiny garden over a
> small stone terrace and the tender gray light of a
> winter morning streamed through the tall arched
> windows. The leafless plane trees outside moved
> their boughs tremblingly as if suffering from cold
> and they seemed to enhance the melancholy,
> misty atmosphere of the room. Whistler stood be-
> fore me, unreal as any ghost. He wore his mono-
> cle tightly clasped in his eye and the scarlet
> patches of his painted cheeks provided the only
> spots of color in the room. As usual he was
> dressed in clothes of gray, which blended so har-
> moniously with his setting that I felt as if I were
> looking at one of those gray symphonies that he
> himself had so often painted.[171]

Either Whistler had redecorated his white-and-blue
drawing room in tones of yellow over grey by this date
or this was simply another room at the rue du Bac.
Perhaps Whistler's now-grey hair had induced him to
distemper the walls to match his personal color har-
mony as well as his mood.

Whistler's collection of silver was featured promi-

nently at his Paris residence—few failed to mention it [fig. 70]. Gleaming silver objects and gilded effects were significant aspects of the alchemy of the glamorous aesthetic house, and Whistler was one of the tastemakers who set the fashion for such displays. His silver was mainly English Georgian, French, Dutch, and Irish from the late eighteenth century with some pieces from the early nineteenth century. He had begun this second collection in 1888 at the time of his marriage. Each piece that Whistler found, he had engraved with a butterfly, just as he had his white linens embroidered with his butterfly monogram. In the mode of Marcel Duchamp, Whistler seems to have believed that by choosing certain objects for display or utilization, he conferred upon them the status of a work of art and that he, by proxy, became the artist.

When Whistler sold the portrait of Carlyle in 1891 and shortly thereafter the portrait of his mother, he quickly reinvested a large part of his new wealth in old silver. He selected unadorned antique silver of timeless design with gently curved surfaces—pieces that looked modern and unassuming. Several of the pieces, due to their globular and ovoid forms and Puritan simplicity, are reminiscent of C. R. Ashbee designs for silver.[172] The focus of Whistler's taste in silver was on the form and the allure of the metal itself. There are plain oval entree dishes, columnar classical candlesticks, various openwork baskets. Several softly rounded pitchers, coffeepots, and dishes have narrow beaded bandings or foliated edges. The designs are quietly beautiful, simpler and less decorated than advanced reformed designs for metalware being produced at the time.

Most of this silver was displayed in the dining room, which was distempered entirely in shades of blue. The room contained a large dining table surrounded by Empire chairs. In the center of the table was a blue-and-white porcelain stand that always held tongue-shaped dishes and blue-and-white bowls of trailing flowers arranged with a Far Eastern sense of balance and beauty. The Whistlers took great interest in the Oriental art of *ikebana*. What appeared to be a Japanese bird cage hung over the table.[173] The sideboard that stood in this room is a graceful, reserved Sheraton design with tapered, reeded legs, decorated with a slight linear tracing around each drawer. In its rue du Bac days one can be sure it was used by Whistler to display his silver.

Whistler's famous collection of blue-and-white porcelain filled the blue dining room of his Paris apartment [fig. 71]. Whistler told Engelhart of "his predilection for Chinese and Japanese art, in which the subject is nothing and the harmony of colors everything."[174] After his marriage to Beatrix, Whistler began again to amass a collection of porcelain, which eventually amounted to more than three hundred items dating from the late seventeenth century through the nineteenth century. Some of these pieces are pictorial, with landscapes, figures, and animals, and others are floral or abstract. The first collection of blue and white, which Whistler collected from the early 1860s through the late 1870s, was undoubtedly of higher quality than what he could find in the 1880s and 1890s.[175]

Nonetheless, Whistler's second collection had some prize pieces, such as an eighteenth-century plant holder—this was the porcelain stand always filled with flowers at the rue du Bac—a large seventeenth-century dragon bowl, and an early nineteenth-century low tea table. A more personal item—a porcelain inkstand—probably remained on Whistler's handsome mahogany Sheraton bureau writing desk, which is decorated with strips of marquetry outlining the drawers. Whistler made a series of sketchy designs (now in the Hunterian Art Gallery archive) for plain, light, rectilinear hanging cupboards, as did Beatrix, to be constructed for displaying his porcelain and silver collections. One of these was to be hung above the piano in the drawing room; no doubt other locations were

FIG. 70. *Selections from Whistler's Collection of Sterling-Plated and Sterling Silver Pieces, late 18th century–19th century. Hunterian Art Gallery, Birnie Philip Bequest, Glasgow University.*

found in the home for discreet display of treasures.

The famous Sunday breakfasts, which Whistler began in London in 1873, continued in Paris in the 1890s. Beatrix presided, a white-capped French maid served, and the table was exquisitely arranged with harmonies of porcelain and old silver. Flowers were always on the table and everywhere in the house. Guests enjoyed fine wine and delicacies such as Argenteuil asparagus and strawberries in little individual silver baskets.[176] Whistler's breakfasts and parties were like living theatre at its finest.

The garden was the central element of the Paris home, and the Whistlers enthusiastically designed its layout and furniture. A few slight sketches, lithographs, and photographs afford glimpses of this outdoor living room. It was a sizable garden with dense undergrowth and several large trees—a Watteau idyll, fit for a *fête galante* in the middle of urban Paris.[177]

Beatrix designed a trellis over the back entrance of the house, which led to the garden, and other lattice arrangements for this outdoor space [fig. 72]. About 1881 Whistler had designed elaborate trelliswork to decorate the facade of Coombe Hill Farm, the large country house of his close friend Lady Archibald Campbell. In his yellow-and-orange watercolor plan, Whistler directed that it was to be painted a pale primrose to harmonize with the house's orange roofs and doors. Green-leafed yellow and gold flowers were to be entwined about the trellis to create an animated surface design such as he effected by various methods for interior walls. The Whistlers brought a similar concept to their garden pavilion. This lattice pattern, reduced in scale, was also used for boxy garden chairs and settees [fig. 73]. These trellis-cube chairs forecasted later furniture designed by Mackintosh and the Austrian secessionists as well as more recent examples by Richard Meier. The Anglo-Japanese derivation of this trelliswork furniture made it suitable for the character of their garden, which was a blend of Japanese, French, and English concepts. Whistler's garden also contained painted Sheraton chairs in ivory with a delicate linear design of swags on the chair backs and saber legs. He also designed a series of extremely fragile attenuated flower stands for the garden, which are based on Japanese models and predict art nouveau exaggeration [fig. 74].[178]

Visitors found masses of pink flowers, winding graveled walks, lacy foliage, half-hidden rickety seats,

and bushes—all surrounded by a high wall beyond which bells, vesper prayers, and hymns could be faintly heard from a nearby seminary.[179] It was a symbolist garden. Perhaps it also had the aura of an impressionist canvas or a Japanese paradise à la Claude Monet, who more than likely visited it. To E. G. Kennedy, who promoted his prints (and also followed Whistler's instructions for the designs of exhibitions of his work in New York), Whistler wrote in July 1893: "We feel quite sorry that you are going away. The monks are at this moment singing a farewell to one of them who is going—not to the Chicago Exhibition but to China where he will probably be eaten up—or cooked in oil or something equally unpleasant. We have both got the blues—for they are making the most doleful sounds!"[180]

In fact, Whistler and his guests loved the chanting and felt the beauty and mystery of it. When the priests from the Séminaire des Missions Etrangères gathered under the great trees in the twilight of summer evenings and began to sing, everyone in Whistler's garden became silent.[181]

The Whistlers' garden also had exotic birds, including a parrot, and Beatrix made numerous ink drawings of cages and birds. Whistler sketched members of his family in the garden, did lithographs, and etched some plates there.[182] He often enjoyed coffee and a cigarette with guests outdoors, seated in an American-style rocking chair. It was probably similar to the Windsor chair in stained pine in the Hunterian Art Gallery collection [fig. 75], which he may have purchased at Liberty's, where such chairs, produced by Benjamin Worth at High Wycombe, were sold. The straight back and unfettered grace of the Windsor chair were in line with Whistler's taste for pure form and clean lines. As his sketches for attenuated flower stands and his earlier Aubrey House notations reveal, he was inclined toward a Shaker-type severity in his furniture. The garden was a mecca for visiting artists and dealers from America and England. One could

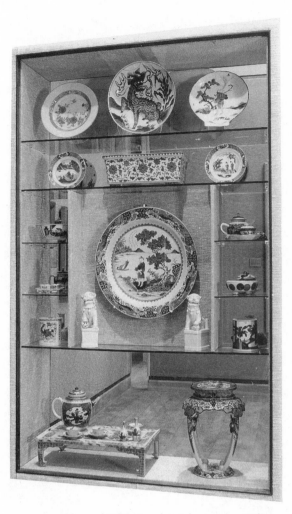

FIG. 71. *Blue-and-White Porcelain Selections from Whistler's Collection. Hunterian Art Gallery, Birnie Philip Bequest, Glasgow University.*

happen in on unexpected scenes, such as Whistler's English solicitor, Mr. William Webb, a little man who sniffed and wore big spectacles, watering the artist's plants with a hose.[183]

Although virtually nothing is known about the other rooms in Whistler's garden pavilion, one of the bedrooms probably contained a French canopied bed found in a sketch by Beatrix. In 1892, shortly before

FIG. 72. The Garden at 110 Rue du Bac, 1890s, approx. 11 x 9 in. (27.9 x 25 cm). *The lithograph shows Beatrix's design for an arched trellis and Whistler's design for a plant holder. Hunterian Art Gallery, Birnie Philip Bequest, Glasgow University.*

the Whistlers moved to No. 110, Robert de Montesquiou, who was a symbolist poet and symbolist interior decorator of the most extreme sort and whose portrait Whistler had recently painted, presented the Whistlers with an Empire bed now in the Victoria and Albert Museum [fig. 76]. It was probably given in par-

tial payment for the portrait. Both Whistlers were thrilled with the graceful boat-style bed, and each of them wrote to thank Montesquiou. Beatrix said: "I cannot tell you how pleased I am with the wonderful bed! and how difficult it is for me to thank you enough for it. It is so beautiful that the room in which it is going to be placed will really . . . have to be begun all over again to make it at all worthy of it."[184]

Whistler's Paris studio, which he called "stupendous," was several blocks away from No. 110. Though it was predictably bare, the decor included Regency and Empire Revival furniture, simple in form. Whistler had rented a top-floor studio six flights up in one of the highest buildings on the street at 86 rue Notre-Dame-des-Champs [fig. 77]. His large attic studio with a huge skylight was the biggest one he had ever had. Whistler had long been bothered with heart trouble, however, and the six-story climb up the polished oak stairs was probably too strenuous. He had to rest on a settee halfway up. The concierge directed visitors, "You can't go any further than M. Vistlaire!"[185]

The reward for the hike was a grand view overlooking the Pantheon and Luxembourg Gardens. Whistler wrote to Thomas Way telling him that he had to come to Paris. "My studio you will be delighted with—I have myself never seen one to compare with it!" The *Westminster Budget* published a watercolor illustration of Whistler's Paris studio and took its readers on a tour [fig. 78]. "Whistler . . . led me right across the immense room and opened doors, and drew aside draperies and brought me out on a broad terrace, with trellis work [designed by Beatrix] and venetian blinds, from which the whole of Paris was to be seen and there was a hothouse around to the left where Whistler intended to 'grow flowers, and grapes, perhaps, and charming things.'"[186] Even in his atelier Whistler had contrived a garden as an extension of the room.

The studio was distempered in a neutral tone of greyish brownish rose. Arthur Eddy reported that it

was painted by Whistler and that it had a "silvery quality." The Empire Revival furniture was white; there was a white cabinet for drawings, prints, and pastels; and most of the woodwork was also white. The floors were a rich, dark oak. One of the Empire sofas was a Grecian squab (a chaise lounge in scroll form such as is pictured in pl. 50 of Sheraton's *Cabinet Dictionary*). There were two or three empty easels and rows and rows of canvases.

Eddy carefully observed the unorthodox exhibition technique that Whistler followed in his studio. "[He] would first turn every picture to the wall and arrange the few pieces of furniture so that nothing should attract the vagrant eye, then he would place the one picture he wished seen on the easel in the best of light, without, however, letting it be seen until the frame and glass were carefully wiped, then stepping back on a line with his visitor, he, too, would enjoy his work as if he saw it for the first time." If there was sufficient time, he might bring forth two or even three pictures, but each by itself.[187] Whistler followed the Japanese method of exhibiting and individually appreciating artworks.

The stairway gallery in the studio ran up to a room or two; underneath was a model's dressing room and Whistler's print shop with the printing press screened off. The two plain circular tables in the room were of the type produced by Wright and Mansfield of London. Near the door was a French coal stove designed for efficiency; the trick was to keep it going, and Whistler, who required ample warmth, had no mechanical ability for it. A guest insisted upon opening the damper against Whistler's advice and a blazing fire resulted.[188]

If rows of canvases were unavailable for viewing, the studio was filled with "notes," "jottings," and "schemes in color and composition." The sylphlike models that Whistler sketched in pastels in his studio could be found seated on one of his Empire or Sheraton sofas swathed in transparent Liberty silks. A Jacomb-Hood photograph in the Pennell collection

FIG. 73. *In the Garden at the Rue du Bac, ca. 1894. The photograph shows a trelliswork bench designed by one of the Whistlers for their garden in Paris. Whistler is at the left. PH 1:67, Birnie Philip Bequest, Glasgow University Library.*

shows that at one point Whistler had his ivory Sheraton sofa in this studio. A Japanese parasol, a popular aesthetic-era decorating accessory, was one of the few effects in the room. Whistler kept a collection of photographs of Tanagra statuettes and of works by artists such as Hans Memling, Frans Hals, Peter Janssen, Vermeer, Tintoretto, Velázquez, Stevens, Moore, and

FIG. 75. *Whistler's Windsor-style Chair. Hunterian Art Gallery, Birnie Philip Bequest, Glasgow University.*

FIG. 74. *Designs for Furniture, 1890s. Whistler designed attenuated flower stands for his garden at 110 rue du Bac. Hunterian Art Gallery, Birnie Philip Bequest, Glasgow University.*

Degas in his studio. Some of these were probably tacked up from time to time.[189] Whistler was photographed in his Paris studio seated in a chair and also on one of his Empire Revival sofas before his Battersea Bridge screen [fig. 38]. The two-panel screen was one of the first objects with which Whistler announced his decorative and abstract aesthetic program—a pro-

gram he never strayed from. Intended for Leyland, the screen was still with the artist in his Paris studio more than twenty years later.[190]

Whistler's contribution to design reform through the example of his sophisticated Parisian interiors in the early 1890s was significant. His presence in Paris just as the Continental art nouveau movement was launched to some degree paralleled his arrival in London at the moment the British aesthetic movement began. In both cases he was a leading figure in these decorative-arts movements and his model rooms were

FIG. 76. *Whistler's Empire Bed. The boat-shaped bed was a gift to the Whistlers from Robert de Montesquiou in the 1890s for their Empire-style interior at 110 rue du Bac. 69676 W. 27-1933, Victoria and Albert Museum, London. By courtesy of the Board of Trustees.*

well-known exemplars of the vanguard in interior design. His Paris home and studio, like his previous homes in London, were gathering places for influential people. Journalists, collectors, dealers, writers, artists and students made it a point to stop and visit Whistler when they were in Paris. Like Henry James, they could not fail to be impressed by the minimalist chic of his interiors.

When his wife became ill late in 1894, Whistler locked the door at 110 rue due Bac and closed his studio at 86 rue Notre-Dame-des-Champs. He refused to accept his brother William's diagnosis of cancer and returned to England for further medical advice. (He

retained both properties, not selling them until October 1901.)[191] He was devastated by Beatrix's death on May 10, 1896, at St. Jude's Cottage on Hampstead Heath. He gave up on the idea of decorating another beautiful home for himself; he was too grief stricken to consider the details of beautiful living. On April 1, 1897, he wrote to Charles Freer (a few years later Freer purchased the Peacock Room, thereby preserving a single Whistlerian interior for posterity), who had become a friend. In the letter he referred to his "wanderings." He was on the move and more lost than ever without Beatrix. He told Freer, "I have kept her house—in its goodness and rare beauty—as she had

FIG. 77. *Studio at 86 Rue Notre-Dame-des-Champs, Paris. Whistler's studio was at the top. From Milner, The Studios of Paris, fig. 273, Yale University Press.*

made it—and from time to time I go to miss her in it."[192]

The Boston Public Library Mural Fiasco and the Company of the Butterfly, 1892–1898

While living in Paris, Whistler had sent several works to the Chicago Columbian Exposition of 1893 and received a gold medal, the first official honor given to him in America. In late 1892 another sign of American appreciation was extended to Whistler in recognition of his status as a gifted decorator. The new Boston Public Library, which was planned as a total work of art unparalleled in nineteenth-century American architecture, was being designed by McKim, Mead and White. They contracted with prestigious artists, including John Singer Sargent, Edwin Austin Abbey, Pierre Puvis de Chavannes, Augustus Saint-Gaudens, and Daniel Chester French, to decorate the interior. On March 2, 1891, a Boston patron of McKim's, E. W. Hooper, wrote to Whistler about painting a mural. Isabella Stewart Gardner, Abbey, Howells, and Saint-Gaudens urged Whistler to submit a plan. Sargent wrote to Whistler in December 1892 saying he wished to press him into doing the work "if you will be coerced. They are very anxious indeed to bring it about; and during the past year they have wrought upon the minds of the people from whom the money must come and are very hopeful of getting a sum. They feel that the room for you to do is the very holy of holies."[193]

Sam Abbott, Sargent, and Charles McKim stopped in Paris at the end of 1892, hoping to persuade Whistler to paint the mural on a large panel in a conspicuous spot in the library. The group went to a charming dinner Sargent had arranged at Foyot's, and Whistler in his excitement drew what was to be a ten-foot-high peacock on the tablecloth. His companions marveled, the cloth went into the wash, and the peacock seems to have disappeared. Nevertheless, an informal agreement was reached that Whistler would paint the mural. In July 1894, Abbott, as president of the board, was given the authority to execute a contract with Whistler to decorate the wall at the northeast Boylston Street end of Bates Hall for fifteen thousand dollars. Negotiations with Whistler went badly, however. By the spring of 1895 the offer of the contract was withdrawn, much to Whistler's dismay. McKim had gone to great lengths to secure a prominent Bates Hall location for Whistler's peacock decoration.[194]

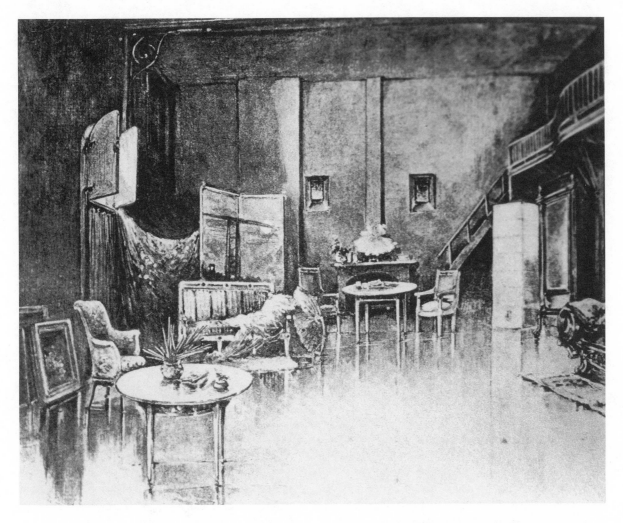

FIG. 78. *Studio Interior at 86 Rue Notre-Dame-des-Champs, Paris. From "Mr. Whistler in Paris, with a Sketch of His New Studio,"* Westminster Budget, *March 3, 1893, 12.*

In 1893 the New York *Art Journal* had reported that the "commission [had been] given to America's most illustrious son: to Mr. Whistler to decorate a wall in the great reading room." Some of Whistler's friends, however, were surprised by the commission. Jacques-Emile Blanche considered large murals beyond Whistler's powers. Before it reached the final stage, something went wrong. Whistler may have been difficult, or slow to submit plans. On May 7, 1895, he wrote to

the board trying to save the commission. "Gentlemen, It has long been my intention to write and state officially my acceptance of the proposal to paint the panel offered to me in the Boston Library. Verbally this was quite understood by Mr. McKim and Mr. Abbott. It was thoroughly settled that I should have carte blanche both as to time and subject."[195] Whistler said any remuneration the board had at its disposal would be appropriate and stated that the letter officially

renewed the agreement as settled earlier with McKim and Abbott.

Whistler urged Stanford White, architect for the library and himself a master designer of total interiors, to visit the Peacock Room to help save it and also to prove to White his powers as a muralist and decorator. On September 20, 1895, White wrote to Whistler telling him he had gone with Sargent to see the Peacock Room.

> [I]t is needless to say how delighted I was with it. The house is now in the hands of the Philistines, and is being gutted and torn down preparatory to furbishing it up in the latest modern style. It was as much as our lives were worth to get into the Peacock Room. . . . Sargent is to let me know what conditions surround its sale, and then I will pitch in. . . . Before it was covered by your own splendid work, it seems to me that the room must have been one of the most damnably ugly and hideous rooms ever concocted. . . . McKim is ready for war to the knife on the Public Library business, but is lying low at present until certain matters get straightened out. I beg you not to desert us, and promise that, as soon as the rumpus commences, there will be a song and dance around the Philistines on the Board of Trustees, which will make them sorry they ever tried any such "funny business." . . . The pleasantest recollection I carried back with me of my trip is the evening you spent with us in Paris.[196]

Like Whistler, Stanford White had an uncanny knack for intrigue.

Nothing came of Whistler's first opportunity since the Peacock Room to execute a mural. Years later he was still dreaming about plans for a mural in the Boston Public Library. The idea of a great peacock had dissipated, but he made sketches for three decorative panels: "Landing of Columbus," "Queen Isabella of Spain," and "Queen Elizabeth of England." The sketches were painted in blue-and-grey watercolor and gouache, but since the base was unsized wooden panels, the color soaked in. (Rosalind Birnie Philip gave a sketch that Whistler had prepared in connection with this project to the Boston Public Library in 1950.) To this day, the slightly curved thirteen-by-thirty-two-foot wall originally reserved for Whistler remains empty.[197]

By 1898 Whistler's spirits had revived sufficiently for him to become an active international figure. He was made president of an exhibition society, the International Society of Sculptors, Painters and Gravers, and he became involved in starting an art school in Paris, the Académie Carmen. He had been thinking about having an art school since building the White House. And in 1896 he had begun talking about becoming his own dealer, certain that he would succeed financially. He decided to start a business for the sale of his own work.

In 1898, advertisements for the Company of the Butterfly were run in *Athenaeum*. The company consisted only of Whistler. He leased two rooms on the first floor at No. 2 Hinde Street, Manchester Square, in London. He negotiated the rental of this property on April 2, 1897, and operated it unsuccessfully from 1898 until 1901. The company was probably based to some degree on the example of Morris and Company, in that Whistler was marketing his own wares directly to the public. He hoped having showrooms would be a way to ease the burden of the crowds of the curious who went to his studio; he could no longer admit everyone who knocked at his door. But his advertising backfired—he had no time to work. In 1899 Whistler wrote to his patron Freer to alert him to his new sales arrangement, and remarked, "Tell me how you like my company, if you think it is worthy of West Point."[198]

A reporter commented on what he called "The Whistler Art Syndicate," noting that Whistler's

"company has found some charming rooms in which to conduct its business, and we venture to say that the hand of the master is no less evident in the artistic decorations and arrangement of the rooms than in the many beautiful works hanging around the walls." A drawing by Whistler of the shop's exterior suggests that it had a large, wide window with small panes (like the White House), interrupted only by a front door placed off center to the right. Above the window a sign stated "The Blue Butterfly" and, below that, "Mr. Whistler's Works." To the far right above was a large butterfly with a sting.[199]

Descriptions of the company's interior evoke a modern gallery; it is a forerunner of the sparsely hung galleries typical of today. Whistler's interest in exhibition design was paramount, and he had introduced his favorite elements: floors covered with matting, white muslin curtains, and delicate tints on the walls. Just a few prints were hung about the gallery, and two small pictures were placed on easels. Given Whistler's central philosophy that easel pictures must be integrated into a total interior harmony, it made perfect sense that he demonstrated it by showing his work in the context of personally decorated rooms. He probably thought of his gallery as a means for staging a perpetual one-man show. Unfortunately, Whistler had no talent for running a business. The company soon closed, and William Heinemann took it over and at Whistler's recommendation began showing William Nicholson's prints, which included a color woodcut of Whistler as the quintessential dandy. The shop proved to be a continuing nuisance till Whistler's last days; his landlord pursued him to Corsica for payment of bills.[200]

The art of the room was a central concern of Whistler's career. At the height of the gaudy Victorian era he sought to renew the Western interior by infusing the design of domestic spaces with serenity, spaciousness, and geometric structure—ideas he derived primarily from the Far East. He promoted the ideal of a home as a unified design against the Victorian taste for miscellaneous collections and eclecticism. As James Laver remarked in 1930, "Whistler was a superb decorator, and his influence on decoration continues. If we no longer load our rooms with knick-knacks, if we prefer our walls plainly distempered, if we hang few pictures instead of many, and prefer Chinese matting to rose-embroidered carpets, it is at least as much his doing as anyone else's."[201] The seeds of modernism found in Whistler's interiors reach all the way back to his first aesthetic house in Lindsey Row in 1863. By his expression of profound interest in interior design and his splendid ability to arrange exemplary rooms that were beautiful, exotic, and inspiring, he was instrumental in improving taste in England and fomenting a movement to reform decorating practices. Whistler's stunning example helped to revitalize the Victorian interior. He elevated the status of interior design, making it into a form of art worthy of serious study by the finest creative minds of the latter half of the nineteenth century—his own included.

6

Whistler as Exhibitioner

The Making of an Avant-Garde Exhibition Designer

Whistler's seminal contribution to exhibition reform, which developed during an age of huge international art exhibitions, has received modest attention. His realization that drastic changes were needed in exhibition practices, and his discovery of the possibilities for creating controversy and achieving fame through exhibitions, came at the beginning of his career. Whistler arrived in Paris on November 3, 1855, in time to see the Exposition Universelle, which included a large international art exhibition, representing twenty-eight nations, displayed in the Central Hall of the Palais des Beaux-Arts. It was the first massive art exhibition held in connection with a world fair and was devised especially to demonstrate the superiority of the arts of the newly formed French Second Empire.[1]

Whistler was twenty-one and fresh from America. He had not seen impressive exhibitions of art since he was fourteen years old and living in St. Petersburg, Russia, and then, for a time shortly after that (from 1848 to 1849), in London. He must have been truly overwhelmed when he visited the Paris art exposition in the company of Seymour Haden. The display contained more than five thousand paintings hung in several stacked rows, frame-to-frame, leaving no room for the spectator to breathe, let alone contemplate the pictures individually.[2] Even as a complete tyro on the European art scene, Whistler must have been struck by the futility of such a mode of exhibition. This customary method of hanging pictures floor to ceiling in nineteenth-century salons was something he would correct.

For Whistler's future development of the one-man show, however, it was Gustave Courbet who furnished the prime example. Courbet had just issued his

realist manifesto in connection with his first, historic one-man show. He had constructed the Pavillon du Realisme not far from the official fair building for the exhibition of fifty of his paintings that had been rejected for the main exposition. The catalogue accompanying Courbet's show, in which he proclaimed his objectives, may also have been a model for Whistler. No specific record of Whistler's visit to Courbet's pavilion has emerged, but generally, Courbet's daring, certainly including his aggressive self-promotion in the face of a hostile press and his assertive method of exhibiting his work, bolstered Whistler's rebellious spirit.[3]

At the 1867 Paris International Exhibition, Courbet repeated his gesture of holding an independent show, and Manet also mounted a protest exhibition. Whistler was in Paris for the fair and was himself an exhibitor in the American section, though unhappily so. To his friend George Lucas he wrote, "I shall have had all the expense of sending my pictures to a corridor where they have been more or less damned by everybody and now will have to pay for getting them back again." At an early date, then, Whistler saw potent examples of courageous colleagues who rebelled against such treatment and independently exhibited their work in defiance of the system.[4]

While a student in Paris, Whistler became involved in one of the earliest demonstrations of artistic independence. In 1859, he submitted two etchings and the painting *At the Piano* [see fig. 21] to the Paris Salon. The etchings were accepted, but his painting was rejected. Whistler's colleagues Henri Fantin-Latour, Théodule Ribot, and Alphonse Legros suffered a similar fate. As Fantin-Latour recalled, "Bonvin, whom I knew, interested himself in our rejected pictures, and exhibited them in his studio and invited his friends, of whom Courbet was one, to see them. I recall very well [how] Courbet was struck with Whistler's picture." Whistler was a willing dissident against the bureaucracy in this early protest exhibition at François Bonvin's Atelier Flamand in the rue St.

Jacques. In the Salon their work might have been lost in the big display, but at Bonvin's, spectators crowded in to see the victims' paintings, which became the talk of the town. Whistler was delighted. He was beginning to realize that independent exhibitions could be used as a means to present political and aesthetic positions, as well as to merchandise work.[5]

After Whistler's exposure to the fatiguing crush of densely hung canvases at the 1855 exposition, the Louvre was his next major contact with official gallery installation practices [fig. 79]. As a student, Whistler spent a good deal of time in the Louvre studying and copying the masters. What he learned about exhibition techniques from his hours spent in the crowded galleries was how not to arrange pictures. He also acquired an unyielding standard of high quality for exhibited work. Whistler repeatedly told his biographers, "My standard is the Louvre. What is not worthy to go in the Louvre has nothing to do with art."[6]

When Whistler's painting of his mother [pl. 1] was purchased for the Luxembourg Museum collection in 1891, it was the realization of a lifelong dream. Consequently, he was deeply stung when a critic (unnamed) questioned the purchase of his masterpiece by the French government. Whistler wrote to George W. Smalley, "The Louvre . . . has come to me, and yet this malignant prig says 'its presence in the Luxembourg is only to be accounted for by the supposition that the tone of the French National Gallery has been lowered until it should meet the degraded level of Mr. Whistler's work.'" This attack, Whistler wrote, "leaves the simple minded Ruskin, a mere blundering Briton, far behind."[7] Such cruel critical commentary, which Whistler suffered throughout most of his career, is evidence of the difficulty he had in achieving official acceptance. This situation forced him to mount a series of one-man exhibitions in order to place his work continually before the public.

Whistler's English friend in Paris, Tom Armstrong, recalled that the Art Treasures Exhibition held in Manchester in 1857 was a memorable show that

also had "no little influence" on Whistler.[8] The exhibition included the finest paintings owned in Britain. More important, in terms of Whistler's eventual decorative approach to exhibition installation, the display contained Japanese and Chinese blue-and-white porcelains, Japanese prints, and other works of decorative and applied arts from the famous Soulages collection. The mixture of decorative objects with pictures was a practice Whistler would later follow in his own exhibition designs.[9]

The South Kensington Museum, which had been built during 1856 and 1857, just prior to Whistler's arrival in London in 1859, was among the first in the field of innovative gallery design. Aspects of its gallery decor and its state-of-the-art exhibiting techniques may have been carefully noted by the young Whistler, who at an early date became a friend of the museum's director, Henry Cole. It was Cole's intention to make the museum itself a work of art. Some interior walls were colored sage green and other walls and dados were painted in three shades of grey.[10] Cole had original ideas for skillful display, the most exciting being the use of gas illumination. The special attraction of the South Kensington Museum, which was a national museum of design, was its growing collection of decorative arts. Oscar Wilde also regularly visited the museum and spoke about it during his American lectures on the decorative arts. It was developing into an immensely popular gallery in London just as Whistler was beginning his career there.[11]

Whistler was a constant museum-goer. Several of his students and associates were treated to the bracing experience of being led through the Royal Academy, the Louvre, or the National Gallery by the artist. Théodore Duret and the Pennells "tramped the floors" of the galleries with Whistler many times [fig. 80]. Harper Pennington told of being taken by Whistler to "picture shows" at the Royal Academy, "a wilderness of Hardy Annual Horrors" from which they rushed to the National Gallery "just to get the taste out of our mouths," as Whistler remarked. In the 1880s Whistler

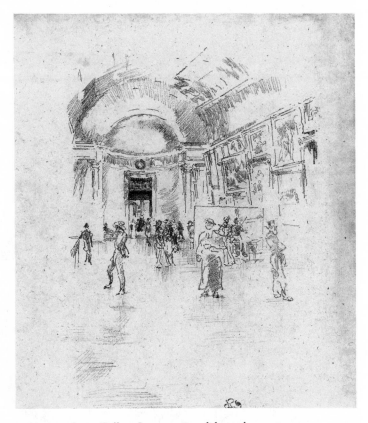

FIG. 79. Long Gallery, Louvre, *1894, lithograph on wove paper, 10 x 8¼ in. (29.8 x 21 cm). On the right can be seen an artist copying paintings as Whistler did when a student in Paris. Hunterian Art Gallery, Glasgow University.*

began a project to compose a gallery guide that was to be entitled *In the National Gallery with Whistler*, based on talks he had there with Malcolm Salaman. Unfortunately, Salaman could never pin Whistler down, and the project went no further than some commentary on Tintoretto and Veronese.[12]

Undoubtedly, the huge universal exhibitions being staged in London, Paris, and elsewhere reinforced Whistler's fascination with the art of display. Beginning with the 1862 London International Exhibition, the Japanese contribution was of crucial interest. Whistler's immersion in Japanese art not

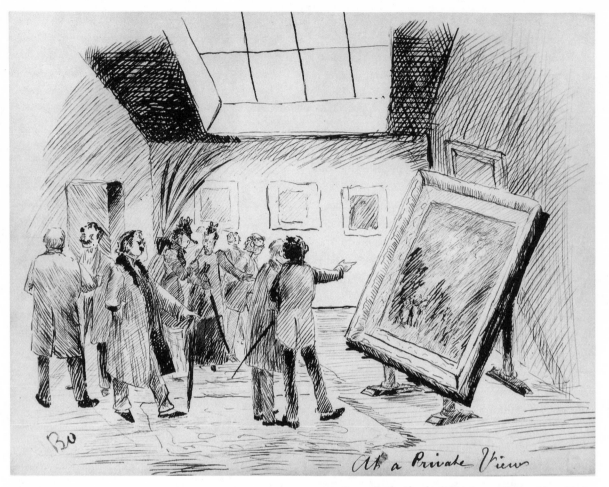

FIG. 80. *B. O. Sketch of Whistler at a Private View, black ink on white paper, 10 x 7¾ in. (29.8 x 20 cm). Hunterian Art Gallery, Glasgow University.*

only furnished the fundamental basis for his pictorial work and his domestic interiors, it also supplied the dominant model for the spare, restrained manner of exhibition that he introduced to London in his one-man shows. His interest in scrimlike devices to filter light was quite likely based on the *shoji* he saw at world fairs, at numerous Oriental shops, and in Japanese prints. Similarly, Japanese *tatami* offered an inspiration for the matting he used on the floors of galleries.

The geometric grid on which he based his arrangement for the gallery walls—apparent in the battens, the paneled dados, the balanced color plans, and the careful disposition of pictures—echoed the walls of Japanese rooms. And the limited color range, clear geometry, and empty spaces he found in the interior designs from the Far East suggested a way out of the haphazard character of Victorian exhibition salons. The ephemeral nature of Japanese rooms also helped

Whistler appreciate the allure of a temporary exhibition as a stage for a beautiful moment.[13]

Whistler's myopia figured into his desire for plain surfaces and clear-cut structure in exhibition installations. His monocle, a conspicuous component of his costume, was not merely for effect; it was a necessary correction for his poor eyesight. His optical blur helped facilitate an inclination to think in terms of large color spaces and carefully balanced settings, as opposed to confusing, highly patterned Victorian interiors.[14]

Perhaps the most notorious single incident to affect the course of Whistler's exhibiting practices occurred in 1863 when he decided to enter his *Symphony in White No. 1: The White Girl* [see fig. 5] in the Paris Salon. It had already been rejected by the London Royal Academy and was subsequently shown at Matthew Morgan's Gallery at 14 Berners Street. The catalogue listing for the painting was marked "Rejected at the Academy," an early indicator of his plans to use catalogues as retaliatory weapons. Although his "Brittany sea-piece" and "Thames Ice Sketch" were both accepted at the Royal Academy, Whistler noted that they were "stuck in as bad a place as possible."[15] In March, Whistler wrote his friend in Paris: "Lucas mon cher ami! . . . I want you to help me about the 'Salon' in Paris. I am going to send the 'White Girl' to the exhibition and see if better luck awaits it and whether it may not be by chance accepted by the jury. . . . I have set my heart upon this succeeding as it would be a criticism of the Royal Academy here, if what they refused were received at the Salon in Paris." No such luck awaited Whistler. The judges were particularly severe in 1863 and rejected many fine pictures. Whistler was in Amsterdam when he learned that on April 22, Napoléon III had instituted the Salon des Refusés, which meant his painting would be exhibited in Paris after all. He wrote to Fantin-Latour, "My dear Fantin! It is enchanting for us, this exposition of the rejects!"[16] It was just like old times at Bonvin's studio.

His *White Girl*, featured prominently in the display, roused no end of public derision, even more than Manet's titillating *Le Déjeuner sur l'herbe*. Years later Emile Zola would make of the ruckus and laughter Whistler's picture caused a central scene in his 1886 novel, *L'Oeuvre*. Although the populace jeered at this painting, the Paris elite praised it. Fantin-Latour wrote to Whistler: "Now you are famous. Your picture is well hung. You have won a great success."[17] Whistler secured a place in French modernism as a result of his exhibition of a controversial painting in a show of rejected work. In so doing, he discovered the immense publicity value of unorthodox exhibitions.

Nonetheless, Whistler's aim from the start was to win success at the Salon and at the Royal Academy; he yearned for official acceptance. The exhibitions staged at the Royal Academy had no rivals and attracted crowds.[18] One visitor recalled: "There is no public event which creates . . . so much interest throughout all classes . . . as the opening of the Royal Academy Exhibition. . . . From ten o'clock till six the rooms are thronged with an interested eager crowd enduring dust, heat and fatigue." The Royal Academy tyrannized the financial and historical fate of artists. The rewards for the artists on the inside, like Daniel Maclise, George Watts, Edwin Landseer, Frederic Leighton, Lawrence Alma-Tadema, and William Frith, were lucrative; but for those on the outside, there were few opportunities to build a reputation, attract patronage, or sell work.[19]

Walter Sickert recalled a story Whistler told, complete with Scottish accent, of Sir Francis Grant, president of the Royal Academy, summoning him to say, "There is this nonsense of Pre-Raphaelitism coming up, and we want some young men who can paint in the Academy. And ye can paint. And if ye behave yerself, we'll just make ye an Academeecian." This was too much for the *enfant terrible* Whistler. At the next private view at the Royal Academy, "Whistler

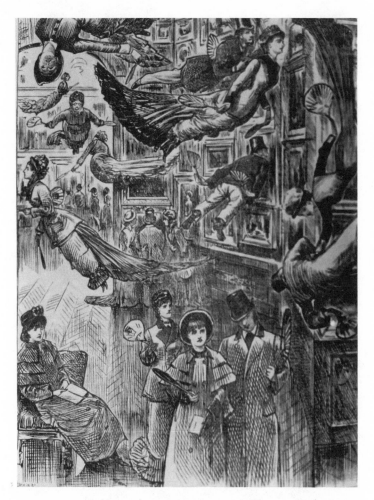

FIG. 81. *George Du Maurier. "Exhibition at the Royal Academy," cartoon in* Punch Almanack *for 1879 76 (December 9, 1878). The illustration (described as "Edison's Anti-Gravitation Under-Clothing") suggests the fallacy of the nineteenth-century custom of hanging pictures crammed together from floor to ceiling.*

danced around the rooms, shrieking like a peacock" and pointing at the paintings on the walls. "Just look at the damned things! That, and that, and that!"[20] Many artists regularly rejected at the Royal Academy tried harder next time to fall in line with the large-scale, highly finished, literary subject paintings the British establishment favored. By contrast, rejection

sent Whistler caroming off the walls, more determined than ever to produce small, low-definition, misty, abstract works. He took it upon himself to retaliate in the most direct manner, which naturally precluded his acceptance by the august body.[21]

Nonetheless, Whistler had two of his "Etchings from Nature" accepted by the Royal Academy as early as 1859. Usually, when the academy accepted his work, it was not hung "on the line." Pictures at Royal Academy exhibitions were crammed as closely together as those at the Paris Salon, the object being to show—and sell—as many paintings as possible [fig. 81]. Whistler usually experienced the humiliation of having his delicate paintings mercilessly hung either near the ceiling or near the floor. On one occasion he commented, "My pictures are pretty well hung at the Academy, only on a crowded day cannot be seen because of the crinolines."[22]

To add to the injury, critics reported on the unfavorable placement of works. A reporter described *Old Battersea Bridge* as the "most remarkable landscape in the room" and added it was "rather high up on the wall." Another way to abuse delicately executed work like Whistler's was with bad lighting. As F. G. Stephens wrote in *Athenaeum* in May 1863, "In the dismal Octagon Room are placed some of the exquisite dry-point productions of Mr. Whistler, whose fame the R. A. ignores by placing the marvelous plates that measure five inches by eight or so, at the top of the room, one hangs where the sun comes [in] to ruin its delicacy." Also in May 1863, Du Maurier noted Whistler's *Last of Old Westminster* was "down on the ground. . . . Jimmy, who had two refused, swears he's going to take a penknife & cut his pictures out of the frame." Such repeated indignities made Whistler a fighter for a "great federation of the arts" in which artists, not politicians, would be judges.[23]

Walter Crane commented that it was unfortunate the Royal Academy made no attempt to be a leader in the arrangement and hanging of exhibitions. "With the fine rooms at their disposal it would be possible

to make their great annual show of pictures far more striking and attractive." Whistler was a vociferous critic of its dismal display techniques. He not only abhorred the academy's clumsy mode of helter-skelter exhibition; he resented his repeated rejections and felt indignant about other rejectees. When a Henry Holiday painting was rejected, he attacked Richard Redgrave, a Royal Academician since 1851. Redgrave responded, "You know they can't hang everything that comes in higgledy-piggedly." Whistler replied vehemently, "Why, what do you call your present exhibition: isn't that higgledy—and particularly—*piggledy?*"[24]

When *The White Girl* was refused at the academy in 1862, Whistler wrote to Lucas: "Nothing daunted I am now exhibiting *The White Child* at another exposition, where she shows herself proudly to all London—that is all London who goes to see her. She looks grandly in her frame and creates an excitement in the artistic world here which the Academy did not prevent or foresee—after turning it out, I mean." Whistler also told Lucas of the "Rejected at the Academy" designation in the catalogue. "What do you say to that? Isn't that the way to fight 'em? Besides which it is affiched all over the town as 'Whistler's Extraordinary picture The Woman in White.' That is done of course by the directors but certainly it is waging an open war with the Academy. Eh?" Whistler's battle for the imprimatur of the Royal Academy ended when, in 1872, he entered his portrait of his mother, and it was begrudgingly hung only after Sir William Boxall threatened to resign. Whistler lost heart. It was the last time he ever showed a picture at the academy. He needed new venues and began to show at the Dudley Gallery, Ernest Gambart's French Gallery in Pall Mall, Paul Durand-Ruel's Society of French Artists at the Old German Gallery in 168 New Bond Street, and the Grosvenor Gallery. His fear of being badly hung and his hatred of rejection drove him from Royal Academy exhibitions to smaller galleries.[25]

After he stopped showing at the academy, he wrote to his friend Waldo Story, a sculptor in Rome, saying, "I am tired and disgusted—also really indignant.... I have been with Harper [Pennington] through the Academy—There is no word in the languages I am more or less in the habit of speaking that can at all convey an idea of the doddering senility and drivelling incapacity that have covered the walls of the Bazaar!"[26]

As he grew older, he refused even to let any of his work be shown at the academy. And he declared that once artists were made Academicians, "they never do anything after that; they are sucked down the great Art Drain in Piccadilly, and leave only their smell behind!" When a show of his works was proposed at the Royal Academy at the time of his death, his friends Heinemann and Pennell protested in a letter to the *London Times.* Royal Academician George D. Leslie, however, denied that the academy had ever "despised, derided, rejected or trampled upon Mr. Whistler and his art." He stated, "Nothing would give me a greater pleasure ... than to see as many as possible of Whistler's beautiful pictures in the forthcoming Winter Exhibition at Burlington House." Alluding to Whistler's reputation for decorating galleries, he added, "But the Royal Academy need be at no concern to decorate the rooms with sackcloth and ashes."[27]

Since Whistler could not work within the established exhibition routine, it was necessary for him to devise independent shows in order to merchandise his work. By exploiting the press and gaining the support of some London dealers, particularly Ernest Brown and Marcus Huish of the London Fine Art Society, and Walter Dowdeswell of Dowdeswell's Gallery, Whistler built his reputation in London.[28]

He called his one-man exhibitions "demonstrations," to emphasize their role as object lessons in interior design and methods of display.[29] Whistler's demonstrations not only provided working models for exhibition installations; they also showed that abstract works could be lived with if placed in appropriately elegant settings. The muted character of his

work necessitated the creation of exhibition settings of subtlety and organic harmony. His progressively smaller, simple works (about five-by-eight and six-by-twelve inches), often pastels, watercolors, or etchings, could not compete in the cacophony of the usual Victorian exhibition hall, which was dominated by large, realistic, violently colored oil paintings filled with exaggerated action. His solution was to become an exhibition designer and mount displays in sharp contrast to the chaotic galleries of the Royal Academy and other halls of exhibition in late-nineteenth-century England. Whistler declared that a picture "should be shown beautifully, therefore it must be hung so it can be seen with plenty of wall-space around it, and in a room made beautiful by color, by sculpture judiciously placed, by flowers, by furniture and hangings and decorations in harmony."[30]

The Whistlerian formula for the elegant packaging of an exhibition was the prototype for modern gallery installations that we now take for granted. Whistler took the role of master designer, coordinating the catalogues, invitations, and posters, as well as the draperies, wall and floor coverings, and, above all, unique schemes of color. He arranged the pictures on the wall, engineered the lighting, and alerted the press. The exhibition was opened at a gala private view, after which admission was charged. The guest list of high bourgeois, artistic, and aristocratic people, together with the decor, attracted news coverage. Whistler tried to make each show a *cause célèbre*, a perfect moment of high drama, conflict, intrigue, and beauty.

Whistler's earliest opportunity to exhibit his etchings and drypoints in London was arranged in 1861 by Serjeant E. Thomas, a lawyer. The show was held at Thomas's premises at 39 Old Bond Street, where he had set up his son Edmund as an art dealer. According to a couple of Du Maurier letters at this time, Thomas arranged for Delâtre to print the etchings that Whistler was then doing of the Thames River and had done earlier in his "French Set." He also agreed to display

them and cover the cost of advertising. The contract gave Whistler half the profits.[31]

Little documentation exists to suggest the aesthetic form this exhibition took—Whistler had not yet put the newspapers in his service. However, there is some evidence Whistler entered into the planning process. A printing press was set up in a room at Thomas's, and Whistler would arrive late at night to etch the plates and pull a few trial proofs. Thomas plied Whistler with excellent port wine to keep the press rolling. A charming touch was Whistler's design for an announcement adorned with an etched work. His first attempt, entitled *Milbank*, featured an extremely asymmetrical composition of the Thames River and boats, and revealed his early debt to Japanese *ukiyo-e* prints. His second try, *The Pool*, had a similarly striking composition and included the figures of Serjeant Thomas and Whistler surveying the boat-clogged Thames. Very likely it was this second, more successful try, with the depiction of his elderly patron, that was used. Inevitably, Whistler quarreled with Thomas, but his initial financial success with this display made him eager to have other shows. In October 1863, he tried to arrange a joint exhibition for himself, his French friends Fantin-Latour and Legros (the three called themselves the Société des Trois), and his new friend Rossetti. Despite his efforts to mount a modern exhibition, more than a dozen years would slip by before he managed a self-generated private show in which he controlled the terms of exhibition.[32]

The First Designed One-Man Show, 1874, and a Catalogue of Porcelains, 1878

In 1874, Edgar Degas wrote an urgent letter to Whistler, inviting him to join the Société Anonyme—a group of artists who later became known as impressionists—for an avant-garde exhibition opening April 15 at Nadar's photography studio on the Boulevard des Capucines in Paris. This exhibition has since

been pinpointed as pivotal in the history of modernism. Whistler did not reply to Degas's letter. He had been disappointed when he received little attention and no buyers for recent work exhibited at Durand-Ruel's Paris gallery in the rue Lafitte in January 1873, for which he had used coordinated frames and generally taken great care with presentation.[33]

Degas had stopped by to visit Whistler in Chelsea on his way to New Orleans in 1872. Their conversation may well have touched on the problem of circumventing official channels of exhibition in order to bring their modern pictures directly to the public. Unlike Whistler, however, who prided himself on being an artist and designer, the impressionists were chiefly painters. Their bright, sunlit, extroverted art did not suggest inner psychological states or seem to require a subtly nuanced interior setting. The emphasis of their inaugural exhibition was on the work itself rather than on the conditions of exhibition or the harmonic beauty of the installation.

By contrast, "gallery-trotters" who visited Whistler's first one-man exhibition were in for a total aesthetic experience. If the impressionist show had a spontaneous air, Whistler's exhibition was methodically designed. His preparations for the private view at the Flemish Gallery at 48 Pall Mall in June 1874 (a few weeks after the impressionist exhibition) was long-term and painstaking. It was with his 1874 show that Whistler first revealed his decorative style of exhibiting. He was moving out of the frame and into the room, redefining what an art exhibition should look like, inviting visitors to experience not only individual works but the entire room as a setting for aesthetic contemplation.[34]

A number of journalists arrived to review Whistler's unique exhibition. A reporter for the *London Tribune* recognized the show as a statement of dissent against the Royal Academy. "Mr. Whistler has thrown down a sort of challenge to the R. A. He declined, I hear, to send any pictures this year to the Academy, from disgust with what he thought the unfair way in

which his last contribution had been hung." Another writer remarked that the atmosphere at Whistler's exhibition was the opposite of the more familiar "crowded copal atmosphere" of official shows, comparable to "a great pot of boiling varnish."[35]

The revolutionary exhibition, scheduled to coincide with the Royal Academy show, shocked London. The private view, held from 10 A.M. to 6 P.M. on June 4, 5, and 6, was announced by invitation cards designed by Whistler. His mother and the Greaves family helped him to address the cards, decorate them with butterflies, and deliver them throughout Chelsea. He also designed his first exhibition catalogue with a coarse brown paper cover (he initially obtained such paper from the printer Delâtre). Henry and Walter Greaves had lent a hand in painting mackerelback patterns on some of the frames.[36]

Whistler's first one-man show was an early retrospective containing thirteen paintings, fifty etchings, thirty-six drawings, and his Battersea Bridge screen. Noted at the private view were "celebrities of the artistic community," including the actress Isabel Batemen and her sister; E. G. Gregory; E. F. Brewtnall; Thomas Carlyle [pl. 16]; Mary Aitken; and Charles Deschamps, manager of Durand-Ruel's Society of French Artists. Deschamps was director of the Old German Gallery, where the society held its exhibitions. Whistler may have had a hand in the design of the interiors of the gallery during 1872 and 1873. The Old German Gallery exhibitions were characterized by a sober appearance, sparse hangings, and a "homogeneous effect." One of the rooms was called the Whistler Gallery, and indeed the artist referred to it as "my gallery." Even the exhibition catalogues of the Society of French Artists strongly resembled later Whistlerian catalogues.[37]

Whereas Whistler no longer showed his work at the Royal Academy, Rossetti refused to exhibit his work altogether and was dependent on private patrons. When he learned about Whistler taking the problem of exhibition into his own hands, he became

worried about the possible loss of Frederick Leyland's patronage to Whistler's Svengali-like charms. To Leyland he wrote, "I heard of Whistler's Exhibition and wished him luck," but to his friend Ford Madox Brown, he expressed his suspicions and anxiety. "He must have finished the Leyland portraits, and persuaded L. that they were sure to be hung badly if sent to the R.A.—whereupon L., rather than see himself hoisted, paid bang out for an independent show of them. I have no doubt at this juncture it will send Whistler sky-high, and Leyland will probably buy no one else any more!"[38] It is likely it *was* Leyland's financial contribution, whether through purchases of his work or directly, that made possible Whistler's ability to lease the Flemish Gallery from E. Clifton Griffith. He paid a rent of £315 (a huge sum for Whistler) for an entire year in preparation for the independent one-man show.

The specifics of the setting of the exhibition can be reconstructed largely because of a lawsuit brought by Griffith over Whistler's failure to return the gallery to its original state. The affidavit from the case provides documentation of the particulars. It had taken a workman, Frederick Fox, two months to carry out Whistler's interior design plan, which included extensive cleaning and repair work. The artist judged the distemper Fox applied as too light, and it had to be redone. The final harmony consisted of a brown ceiling, pink-grey distempered walls, and white-painted wainscoting with the lower division formed into twenty panels painted grey white with grey moldings. A skylighted back room was painted primrose yellow. Even the lobby was washed and painted white.[39]

Whistler showed a wide variety of pictures—his finest portraits, three sketches for Leyland's Six Projects, several nocturnes. He mixed the vastly different-sized pictures, causing viewers to approach the wall repeatedly to inspect the small linear etchings and then stand back to view the broadly painted, large, full-length portraits. Whistler hung his work in two tiers, with a lower tier of color sketches and an upper tier of etchings, and interspersed this arrangement with several large oils. This push-pull hanging technique was one he would continue to use in later exhibitions. Whistler's stringent attention to the interrelationship between works and to meticulous wall composition and color always assured a refreshing viewing experience.[40]

In his biography of Godwin, Dudley Harbron referred to the "house-like appearance" of Whistler's 1874 exhibition and stated that "the two men had together made the arrangement." Since the gallery's renovation was particularly extensive, Whistler may well have consulted Godwin about its design. In 1884 Godwin created an interior design for McLean's Fine Art Galleries. Years earlier, in the 1870s, after visiting an exhibition of works by Thomas Armstrong and Val Prinsep, he came away making notes of his suggestions, such as "Pictures should be arranged at eye level in a panelled wall which should be painted in the prevailing tones of the pictures." He also suggested that frames be gilded, then painted and wiped off so the "flecks of gold should show amidst the paint."[41] These were ideas that Whistler shared, and proceeded to carry out in his one-man exhibitions.

The gallery decor for Whistler's 1874 one-man show so captivated reviewers that it generally received greater attention than the individual works. The ensemble was judged to be a "triumph of art" that included the "glaring yellow matting striped in two shades," the "finely formed couches and chairs covered with light maroon cloth," and the pictures in "plain wood frames." Steps and ledges held bronzes, palms, and "cool blue and white" porcelains that contained yellow calceolaria flowers, and the delicately tinted grey walls were softly enlivened by the subdued mellow light that passed through thin white blinds.[42] It was an arrangement of considerable elegance; several news reports specifically mentioned the aristocratic effect. A critic for the *Illustrated Review* called Whistler's exhibition "the most important event in the Art world during the last few weeks. . . . It is worth

going only to see the room, so different from the ordinary art gallery."[43]

Henry Blackburn, who reviewed the exhibition for *Pictorial World*, deemed the gallery "a symphony in colour" carried out in every detail, "above all, in the juxtaposition of the pictures." He recognized Whistler's sensitivity to color and harmony as "born of the Japanese," and he contrasted the serene gallery to the "conglomeration of a thousand pictures at the Royal Academy." Regrettably, Blackburn did not follow through on his stated plan to furnish readers with "a sketch of the little gallery" in the next issue.[44]

If Rossetti's speculation that Leyland provided the financial backing for the exhibition was correct, then Whistler may have been particularly eager to please his patron, who was himself an exacting arranger of his own picture galleries. The design of Whistler's 1874 exhibition installation emulated not only his own and Godwin's spare, elegant domestic interiors but also the reposeful and aristocratic atmosphere in the homes of wealthy clients such as Ionides, Alexander, and Leyland.

Before Whistler took down the show in August, Rossetti wrote to Ford Madox Brown, "Whistler called yesterday and carried me off to his exhibition which is now closed but not yet dismantled."[45] Since Rossetti had been an influential early model for him as a painter and interior designer, Whistler must have felt his friend would be interested in his original reform efforts in the realm of exhibition design.

When Gilbert and Sullivan created the opera *Patience, or Bunthorne's Bride*, they surely had Whistler in mind when they wrote the line, "Japanese young man, blue and white young man." His enthusiasm for Oriental china was intense, and the British public caught the fever. To be "intense" was almost by definition to collect blue and white. Oriental porcelains were more than decorative objects; they evoked faraway exotic places and brought a sense of high culture and mysticism into domestic settings. The question

Du Maurier posed with false gravity in his Wilde-Whistler cartoon, "The Six-Mark Tea-pot," was "Can we live up to it?" It became an aesthetic joke. "Chinamania" was one of Whistler's prime contributions to the aesthetic movement [figs. 8, 9, 24, 51, 71].

When in 1878 Murray Marks gave Whistler the chance to illustrate a catalogue for an exhibition of porcelain, Whistler was enthusiastic. He was keenly interested in designing catalogues in general, and this project had the added appeal of allowing him to imagine himself as a designer of blue-and-white porcelain. As someone passionate about porcelain, Whistler most likely knew of Félix Bracquemond's designs for *Le Service japonais* (1867), a famous dinner service commissioned by Eugène Rousseau and considered one of the first known examples of *japonisme* in the decorative arts. No doubt he was also aware of reforms in ceramic design—based on Japanese, Greek, and other exotic sources—by Christopher Dresser and William De Morgan.[46] Illustrating a porcelain catalogue gave him a chance to become more actively involved in the surge of creativity in ceramics taking place during the aesthetic period.

The china to be exhibited belonged to Sir Henry Thompson, a surgeon and watercolorist who exhibited regularly at the Royal Academy. Whistler prepared a sample page of six drawings, and Thompson agreed that he should proceed. The two artist-collectors together produced the drawings for an impressive exhibition catalogue entitled *Catalogue of Blue and White Nankin Porcelain Forming the Collection of Sir Henry Thompson*. Thompson did six plates of thirteen specimens, and Whistler prepared twenty plates of thirty-eight. As early as October 4, 1876, Julian Alden Weir, who was the son of Whistler's art teacher at West Point and was studying in Spain, wrote to his mother and father about Whistler's project.

I must now tell you a very amusing and interesting incident. While walking in the Alhambra . . .

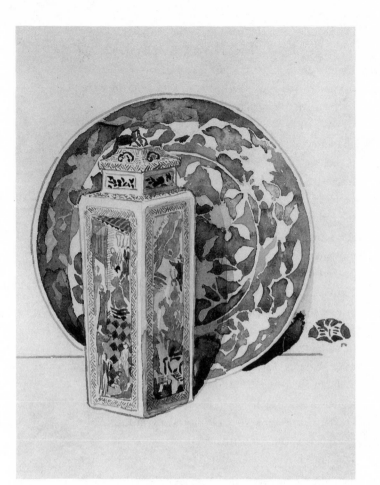

FIG. 82. *Drawing of Blue-and-White Porcelain, 1877–78, pen and ink with wash on paper, 8¾ x 7 in. (22.2 x 17.8 cm). Whistler prepared this preliminary sketch of a square canister and saucer-shaped dish for* Catalogue of Blue and White Nankin Porcelain Forming the Collection of Sir Henry Thompson, *plate 17, nos. 134, 202. Freer Gallery of Art, Smithsonian Institution, Washington, D.C./Royal Commission on the Historical Monuments of England.*

I noticed a retiring looking gentleman. . . . he was going to make studies of the palace . . . and who should he be but Sir Henry Thompson the famous surgeon who operated on the Emperor Napoleon [III]. . . . He said that he gives artists dinners each week and Alma Tadema is always there. He promises if I come to London he will bring together the most distinguished artists and Boughton and Whistler. I asked him about the latter and he said that at present he was working from some old china which he had lent him.[47]

Most of Thompson's collection had passed through Whistler's hands; that is, he had probably owned some of it, and he had also advised Thompson on purchases.

In his drawings of the K'ang-hsi pots, Whistler transformed the highly patterned, stylized porcelains into pen, ink, and watercolor wash drawings of considerable appeal [fig. 82]. He was proud of his illustrations, and on Friday, December 29, 1876, he dropped Marks a note saying, "Come down here tomorrow morning at about 11 or 12—and take your drawings—they are charming. Bring a lot more pots and take away the old ones."[48]

The resulting catalogue, with autotype reproductions, was beautiful. It was issued in May 1878 by Ellis and White of 29 New Bond Street in an ordinary edition measuring 10½ by 7⅞ inches, and in a deluxe version of 9 by 11½ inches—a total of 220 copies. The deluxe catalogue had a distinctive gilded cover with a greenish-gold, abstracted hawthorne blossom-and-stem design. Marks wrote a brief preface to the book, which was the first to catalogue a collection of blue and white, commenting on the renewed interest in collecting porcelain. He respectfully referred to Whistler's collection and catalogued the 339 pieces belonging to Thompson. He exhibited Whistler's original drawings and the catalogue together with the porcelains at his shop.[49]

Marks's exquisitely appointed shop featured one of the first artistic storefronts, designed by Richard

Norman Shaw in a Queen Anne style in 1874 at 395 Oxford Street. The large front window had been divided into small square panes, and the elegantly reserved interior was painted one color—cream. Marks also hired Shaw to design frames to display the pots, and he had them erected at the end of the room. Nothing like this exhibition decor had been done before. Whistler must have found Marks's tasteful gallery installation highly instructive. Although the private view was quite celebratory, the rare catalogue with Whistler's watercolors did not even pay for itself.[50] Nevertheless, as a catalogue illustrator, he not only helped to promote a finer appreciation of Japanese and Chinese decorative ceramics, he also honed his already keen interest in making catalogues a significant adjunct to an exhibition.

Three Shows at the Fine Art Society: 1880, 1881, and 1883

After the *Whistler v. Ruskin* trial in November 1878, the Fine Art Society organized a subscription to pay for Ruskin's court costs. Ironically, the society was also helping Whistler to recover from his financial ruin. Ernest Brown, representing the society, instigated the commissioning of Whistler to produce twelve etchings of Venice (a city closely identified with Ruskin), to be published and exhibited in the society gallery. He was to be paid twelve hundred pounds and was given three months to deliver the plates, that is, by December 20, 1879. Whistler, however, stalled in Venice for fourteen months. Brown recalled that Whistler said "he would lay the eggs, but I must supply the incubator." Brown was willing to go along with this plan. The catch was, Whistler "seemed anxious not to give up the eggs!"[51]

The society had alerted buyers, prepared for publication, advertised, and now could not pry Whistler

out of Venice. On January 14, 1880, Huish wrote angrily to the artist. Whistler replied, advising Huish to "double your bets all round," because he was going to bring back incomparable etchings to exhibit at society. Huish's anger dissolved, and he sent Whistler money for more etching supplies. He noted that an upcoming show of the greatest living etchers would be incomplete without his work. That did it; Whistler made plans to return.[52]

Whistler and Maud Franklin (whose health had been damaged by their harsh living conditions in Venice) arrived back in London homeless and penniless the second week in November 1880 and hid out. Whistler remarked, "I don't want anybody to know until I'm in full blaze." He set up a secret workshop to carry out the formidable task of printing one hundred sets of twelve prints each. As always, he chose his etching papers with great care. They ranged in color from the translucent yellow of *japon mince* to various greys, blues, and browns. And he used creamy "old Dutch" paper, Japanese papers made from the bark of mulberry trees, thicker vellumlike papers, and *chine colle*, which tended to turn orange or gold. The color of the paper became a key harmonic element in the total color arrangement of his exhibitions.[53]

By the end of the month, Whistler had his etchings ready for exhibition. It then occurred to the Fine Art Society members that they could appear ridiculous. The directors had issued a catalogue and sent out invitations to hundreds of people to attend a private view of only *twelve* etchings. Thus they arranged to have Frederick Goulding, the famous printer, give practical demonstrations of printing etchings in the same room where Whistler's work was to be displayed. They wrote a "nice little letter" to inform Whistler. Thomas Way recalled the artist's reaction. "It is impossible to describe its effect. He threw down the [etching] plate on which he was working at the time, and cussed and swore at large, and in particular! Very slowly, but at last, I got him to consent to reply to the

letter, but only in the form of an ultimatum." Whistler wrote:

> Look here, my dear Huish, I have not taken all
> this trouble for you in order that the people
> should "be amused" by either any printing tricks
> or spun glass or meerschaum pipe making in the
> place—I have supposed that the Private View
> was meant seriously and if it is to be a fiasco it
> will certainly become one. . . . If in short you in-
> tend to have Goulding fidgeting about the place
> tomorrow—I will give up the whole thing—I
> will not have the matter ruined like this—Fancy
> at this moment telling me that he is *engaged,* he
> must come! You had better *lose no time* in getting
> the *two presses out of the way* in order that there
> may be room for the people.

Goulding's printing presses were removed, and the artist arranged his exhibition of the "First Venice Set" on November 28 or 29. Whistler was on guard against anything that encouraged the dissolution of an art exhibition into third-rate entertainment. He remarked that he "wasn't running an aquarium or a music hall."[54]

The preparations for the show were rather hurried, but he hung the prints by themselves on the line, without any detractions, in the middle room of the Fine Art Society galleries. A sketch by Whistler shows the layout for the wall, which is arranged in the manner of a modern exhibition [fig. 83]. Whistler's interest in two-dimensional surface pattern extended to entire walls in his exhibitions. Indeed, the manipulation of forms and colors on a flat surface never failed to interest him. He hung the modest show of twelve etchings on a wall covered with fabric—a practice he would continue to follow. Like the dull wall surface achieved with distemper, fabric-covered walls assured a matte finish and also suggested a richer tone and provided a less easily marred surface.

The show, "Mr. Whistler's Etchings of Venice," was not a popular success, and reviews were mostly churlish. The *British Architect* reviewer complained that the show was "of twelve impressions arranged on a maroon-coloured cloth, with rough chalk numbers underneath, and not in sequence, possibly a quaint conceit on the part of the etcher, but not conducive to the visitor's convenience. The numbers go thus, 1, 12, 9, 7, 11, 5, 4, 3, 2, 10, 6, 8." Though Whistler showed some of his largest, most elaborate prints, the critic for *Truth* wrote off the show as "another crop of Mr. Whistler's little jokes." The *World* reporter declared, "They rather resemble vague first intentions or memoranda for future use" or work "half done." Whistler protested to the *World* editor, Edmund Yates, in a letter misquoting the reviewer's words for controversy's sake by referring to the etchings as "slight in execution and unimportant in size." Calling the critic "the private assassin you keep," he added, "I could cut my own throat better."[55] Whistler clipped the insulting newspaper articles and put them in a press clipping album for future reference. When he constructed his scathing catalogues for later shows, excerpts from these reviews would become prime material.

Ernest Brown brought Whistler's "First Venice Set" to Philadelphia, where Joseph Pennell saw it in 1881 in a little white-and-gold gallery at the Pennsylvania Academy of Fine Arts. The etchings were also shown in New York. While the reception in the United States was somewhat more favorable than in England, only eight sets sold. Whistler's reentrance into the London art scene had been something less than triumphant. Even his friend Godwin expressed his disapproval of Whistler's exhibition. He was ill at the time of the private view, but he recovered sufficiently to go to see the etchings. Godwin found the show to be just another example of Whistler's irritating gestures, and self-defeating in view of the fact that he was trying to rebuild his reputation.[56]

Godwin's critical response to Whistler's somewhat casual display of Venice etchings may have influenced

FIG. 83. *Layout Design for 1880 Exhibition, "Mr. Whistler's Etchings of Venice," pencil, 4½ x 7 in. (11.3 x 17.5 cm). Whistler's sketch records the plan for arranging a wall of an exhibition. Davison Art Center, Wesleyan University, Middletown, Conn.*

the artist's determined effort to completely redecorate a room for a second exhibition—this time, a show called "Venice Pastels"—at the Fine Art Society a couple of months later. Godwin, too, was working with the society in 1881, redesigning the front entrance of its building to make it more eye-catching [fig. 84].[57]

Whistler had no doubt his show of Venice pastels would be amazing. Alan Cole wrote, "Jimmy called—as self-reliant and sure as ever, full of confidence in the superlative merit of his pastels, which we are to go to see." Thomas Way made a series of thumbnail sketches of the fifty-three pastels in the show, which Whistler had selected from the ninety he brought back from Venice [fig. 85].[58] These charming drawings give some idea of the appealing nature of the exhibition.

The various ingredients of a Whistlerian total design package for an exhibition came together with particular finesse for this show. He designed a complicated color scheme, incorporated flowers and porcelains, used standardized, reeded wooden frames gilded in green gold and rich yellow gold keyed to the palette of individual compositions [see frame in fig. 20], and

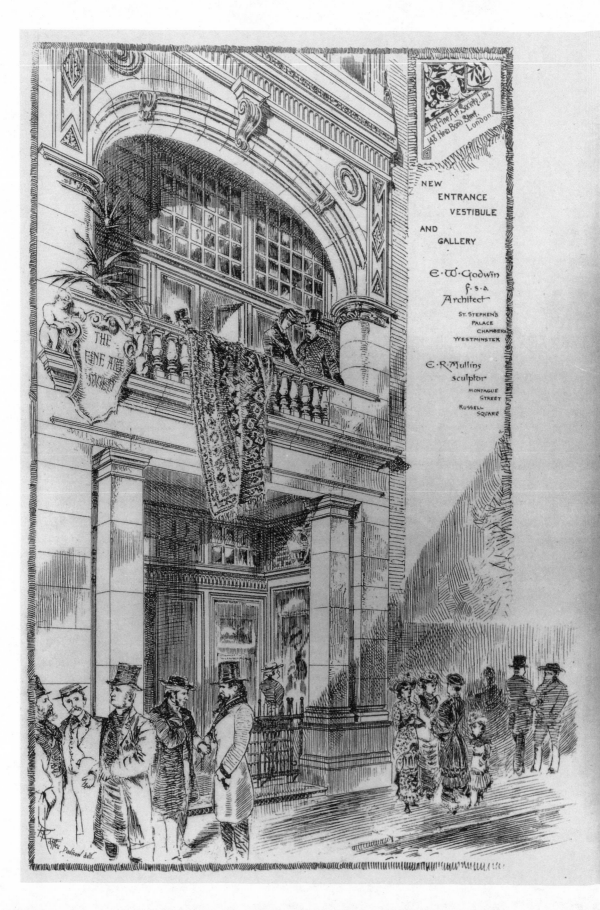

THE FINE ART SOCIETY
148 New Bond Street
London

NEW
ENTRANCE
VESTIBULE
AND
GALLERY

E·W·Godwin
f·s·a·
Architect

ST. STEPHEN'S
PALACE
CHAMBERS
WESTMINSTER

E·R·Mullins
sculptor
MONTAGUE
STREET
RUSSELL
SQUARE

THE
FINE ART
SOCIETY

arranged the pictures with ample spacing. He also put together a delicate four-page brown paper catalogue printed by Thomas Way, and sketched plans for an invitation and a poster, which he sent to his illegitimate son, Charles James Whistler Hanson, directing him to handle the details of printing.[59]

Godwin attended the evening press view on January 28, 1881, to do a review for *British Architect*. As he had previously done (on the handout for the press view of the Peacock Room), Godwin annotated and made sketches on the pages of his copy of the brown paper catalogue [fig. 86]. His little drawing of a wall from skirting to frieze shows Whistler's layout. The darker outlines around several pictures probably indicate the placement of green-gold frames. In his review Godwin wrote:

> [T]he arrangement of the drawings in the room, and the colours of the room, the mounts and frames, are all due to Mr. Whistler. First a low skirting of yellow gold, then a high dado of dull yellow green cloth, then a moulding of green gold, and then a frieze and ceiling of pale reddish brown. The frames are arranged "on the line," but here and there one is placed over another. Most of the frames and mounts are of rich yellow gold, but a dozen out of the fifty-three are in green gold, dotted about with a view to decoration, and eminently successful in attaining it.[60]

It was probably also Godwin who, three weeks later in *British Architect*, made a comparison between Whistler's sensitively designed installation and the

FIG. 84. *T. Raffles Davison. Facade of the Fine Art Society, London, 1881. The drawing shows Whistler and Ruskin improbably chatting congenially in front of the new entrance designed by Edward W. Godwin. Photograph from the Fine Art Society, London.*

FIG. 85. *Thomas Way. "Thumbnail Sketch of Whistler's Pastels," 1881. Shows some pastels that Whistler included in his "Venice Pastels" exhibition at the Fine Art Society, London. Way made a total of fifty-three sketches. Reproduced in color on brown paper in Way, Memories of J. McNeill Whistler, the Artist.*

dubious decor in the next room, contrived for an exhibition by John Everett Millais.

> The gallery itself, though well lighted, is most unfortunately decorated. In the adjoining room hung Whistler's pastels against walls that have been subjected to the artist's treatment. In the

FIG. 86. *Edward W. Godwin. Annotations and Sketch Made in the "Venice Pastels" Exhibition Catalogue, 1881. The drawing details an entire wall of Whistler's exhibition, identifying on-line arrangement, skirting, dado, frieze, ceiling, and, probably, green-gold frames. Whistler EC 1881.1, Birnie Philip Bequest, Glasgow University Library.*

Millais room the shrine of the paintings has been left to Messrs. Trollope, and to them we hear we are indebted for this crude arrangement: First a high skirting of black, capped by a bright bead of gold, then a wall to some feet above the tallest picture is covered with a crimsonish flock paper, not bad in pattern but destructive of much of the colour in the pictures. This is surmounted by a black moulded string, above which is a deep frieze of yellow flock paper; the yellow is repeated as a flat wash in the ceiling and between them a large moulded and dentilled cornice sticks fiery

off in startling terra cotta red! . . . Surely Mr. Millais might spare a moment to do for his work what Mr. Whistler has done for his. If he thinks it beneath his notice he is vastly mistaken.[61]

From this description we discover how abrasive Victorian exhibition design could be. Whistler was fighting against an ingrained preference for bold pattern and blatant color when he introduced plain walls and subtly harmonized color arrangements for gallery installations. His chic exhibition designs presaged a new smartness and cosmopolitanism emerging in a society in transition between Victorian and Edwardian England and demonstrated a revolutionary mode of showing work.

Few commentators failed to grasp the point that Whistler was not only unveiling his fifty-three pastels but was also making a public demonstration of new exhibition techniques. Critics were dazzled by the exquisite color scheme with moldings and frames in citron gold, guinea gold, and ruby gold, and walls covered with golden-olive-colored baize cloth topped by an upper wall and ceiling in pale red brown. However, the *World* reviewer considered Whistler's aesthetic decor an aberration that had the "effect of detaching attention from the work." There was, he noted, "a danger sometimes of the picture being forgotten because of the eccentric glories of its environment." But the *Daily Telegraph* critic observed that "the arrangement of the room will be a lesson to aesthetic visitors, in the now favorite amusement of domestic decoration."[62]

Whistler's opalescent pastels arranged in their uniquely contrived setting did indeed attract crowds to the private view the next day. The Pennells wrote that the opening was "a crush, Bond Street blocked with carriages, the sidewalk crowded with people struggling to get in. Nothing like [this] excitement was ever known at The Fine Art Society's." In the fashionable crowd who came to see the show was

Millais, who said loudly to Whistler, "Magnificent, fine—very cheeky—but fine!" The exhibitions by Whistler and Millais, amazingly, attracted 42,830 visitors, who paid £2,141 in admission fees, according to the Fine Art Society minutes for July 6, 1881.[63]

Whistler appeared to be unhinged by his phenomenal success. It was his best art exhibition to date. Visitors to the show noted that he seemed beside himself; his behavior was more exaggerated than ever, his voice shriller, his sharp "ha ha!" more piercing. Most observers did not know what to think or say about it; they wondered if such a fuss about a show of pastels might not be a put-on. Whistler recalled later: "I went there one day and met Sir George and Lady Beaumont face to face at the door as they were coming out. Both looked very much bored, but they couldn't escape me. So—well—the old man grasped my hand and chuckled—We have been looking at your things, and have been so much amused! He had an idea that the drawings on the walls were drolleries of some sort."[64]

Punch took the occasion to compare Whistler's pastels to the chalk drawings made by sidewalk artists on the pavement. And in another full-page article, entitled—with reference to Du Maurier's cartoon character Postelthwaite—"Whistler's Wenice; or, Pastels by Pastelthwaite," *Punch* suggested Whistler was using brown paper "off the family jam pots." Whistler remarked, "The pastel show was a source of constant consternation on their part, and amusement on mine." His pastels seemed to be just one more of his attempts to make art frivolous and decorative rather than serious and didactic.[65]

And yet, despite the jokes and ridicule, Whistler's pastels, which had the character of brief notations of pungent color on brown paper, *sold*. His success certainly related to his skillful installation, which demonstrated how effective such ephemeral images could be if properly framed and hung in a sympathetic setting. Beatrix Godwin was the first to praise the scheme. Maud, who long ago had tired of the poverty in which she lived with Whistler, wrote to Otto Bacher:

> As to the pastels, well—they are the fashion. There has never been such a success known. Whistler has decorated a room for them,—an arrangement in brown, gold and Venetian red— which is very lovely, and in it they look perfect gems. All the London world was at the private view—princesses, painters, beauties, actors, everybody. In fact, at one moment of the day it was impossible to move, for the room was crammed. Even Whistler's enemies were obliged to acknowledge their loveliness. The critics were one and all high in their praise. . . . I am going to send you a little book of all the cuttings of the newspapers, so that you can see for yourself. The best of it is, all the pastels are selling. Four hundred pounds worth went the first day; now over a thousand pounds' worth are sold. The prices range from 20 to 60 guineas, and nobody grumbles at paying for them.[66]

Before the show ended, Whistler determined he needed a cash advance on the eighteen hundred pounds for which his pastels had sold. When the Fine Art Society failed to give it to him, he decided to stage a protest. He marched into the crowded gallery and shouted, "Well, the Show's over." Huish and Brown rushed over and tried to quiet Whistler down, but he shouted, "Ha! ha! they will not give me any money and the Show's over." Whistler recalled, "I came just when the crowd was thickest, and everything was going beautifully." Huish promised a check on Monday. Whistler upped his demand from two hundred pounds to three hundred and said, "All right, the Show can go on."[67]

The coup de grâce of all of Whistler's exhibitions, when his nerve, panache, and daring artistry in exhibition design was at its absolute peak, was the third of

his shows, "Arrangement in White and Yellow," staged at the Fine Art Society in February 1883. It is a testament to the tolerance and intelligence of Huish and Brown that they went forward with yet another exhibition with Whistler. They certainly hoped for profit, and they were true patrons of his art, but they knew from past shows what an aggravating experience it was going to be. Whistler did not disappoint them. A poet from *Punch* felt moved to write "A Gavotte in Gamboge" after he had seen the startling show.

> Go to The Fine Art Society,
> Truly a marvellous show,
> See, in a wondrous variety,
> Etchings and dry points a-row. . . .
> Strangely adorned is the Gallery,
> Done up in gamboge and white.
> Even the flunkey is "yallery,"
> Made a most exquisite fright. . . .
> It looks consumedly bilious,
> This new "arrangement in gold."
> Then there's the Catalogue critical, . . .
> Full of American gall;
> WHISTLER is such a high stepper, he
> Prances at will o'er them all. . . .[68]

Whistler's symbolistic exhibition, in its aim to create a strangely perverse setting, paralleled Joris-Karl Huysmans' fictional manifesto of symbolism, *A Rebours*, published the following year. (James Laver called Huysmans a "hermit of aesthetic mysticism.") The difference was that Whistler's experimental alternative world, though temporary, was all too real. He wished to test synaesthetic possibilities and the power of color to induce nervous reactions and stimulate sensibilities in the public arena with an overwhelming, coloristic interior design.[69] He was the driving demon at the center of his yellow symbolistic exhibition, which, while beautiful, had an edge of perversity that many found unsettling and menacing.

Whistler's choice of an aggressively yellow scheme also had a comic quality that derived from the example of Japanese art. *Ukiyo-e* prints revealed to him the potency of a pure yellow background, which, taken together with the prints' often antic comic content, showed him a precedent for validating his artist-jester pose. His penchant for creating exotic Oriental environments with wit and style dovetailed with his trickster desire to amaze and disturb. Both he and Godwin had long used yellow and white schemes, and Whistler was well aware of the electrifying effect. Generating moods and atmospheric effects with color was a key characteristic of his aesthetic, and he was at his diabolical height when he put together the 1883 show. In a letter to his American friend Waldo Story about the upcoming show, he wrote with anticipatory glee:

> Now listen to me! . . . my dear Old Waldino. . . . Really I do believe "I am a devil" like Barnaby Rudge's raven!—Oscar too always says Jimmie you are a devil!—Any how I have had inspiration after inspiration and I am free to acknowledge that they partake greatly of the dainty cruelty and wild wickedness of our friend the original "Amazer"! Waldino it is simply superb the game! . . . You must just pack your bag and turn up in Tite Street [No. 13] on Wednesday. . . . Besides are you not my most intimate chum . . . and the only one who besides myself who really *knows!* . . . And, with this all I have not told you what it is about—well great Shebang on Saturday Feb. 17th. Opening of Show and Private View—"Arrangement in White and Yellow." I do the gallery in Bond Street. . . . All the world there . . . and the Butterfly rampant and all over the place![70]

Color orchestration being the dominant feature of a Whistler exhibition, he described for Story the brilliant yellow color harmony he had devised for his "great Shebang," adding "I can't tell you how

perfect—though you would instinctively know that there isn't a detail forgotten." He told Story the installation was sparkling and sharp with white walls of different whites, moldings painted yellow instead of gilded, and large white and yellow butterflies "rampant" on walls and curtains. He described the gallery design in staccato phrases: "yellow velvet curtains—pale yellow matting—yellow sofas and little chairs—lovely little table yellow—own design—with yellow pot and *Tiger* lily! Forty odd *superb* etchings round the white walls in their exquisite white frames—with their little butterflies—large white butterfly on yellow curtains and yellow butterfly on white wall in their exquisite white frame—and finally servant in yellow livery(!)"[71] Whistler launched into a description of his comic brown paper catalogue, entitled *Etchings & Drypoints: Venice, Second Series* [fig. 87]. In it he skewered his critics by excerpting their most hostile and insulting criticisms of his past work. He inserted these ten pages of quotes—occasionally misquotes—under the titles of each of his fifty-one etchings. The introductory phrase was "Out of their own mouths shall ye judge them."

The theatricality of the event would be heralded by the outfit worn by the attendant at the opening. He was to be a grave "yellow man" dressed in a cream-colored costume with gold buttons, yellow frogs, collar, tie, vest, epaulettes, and yellow stripes running down the pantaloons. This attendant would hand out the catalogue, which, Whistler said, was the "same size as [the] Ruskin Pamphlet!!!" Later, he recalled that the Prince of Wales had "roared over the catalog." The princess carried away a copy, telling Whistler he was "very malicious." To Story he wrote:

And *such* a catalogue! The last inspiration! Sublime simply: never such a thing thought of—I take my dear Waldo, all that I have collected of the silly drivel of the wise fools who write, and I pepper and salt it about the catalogue under the different etchings I exhibit—in short I put their

FIG. 87. *Cover of* Etchings & Drypoints: Venice, *1883, 7½ x 6 in. (18 x 15 cm). The controversial catalogue for the "Arrangement in White and Yellow" exhibition at the Fine Art Society, London. Joseph and Elizabeth Pennell Papers, Library of Congress.*

nose to the grindstone and turn the wheel with a whirl! I just let it spin! . . . I give 'em Hell! . . . The whole thing is a joy—and indeed a masterpiece of mischief.

Whistler implored Story to "rouse up . . . rush over here at once," so they could celebrate his private view together. He added, "And this is the final thing, I am having a lot of lovely little butterflies made in yellow satin and velvet [fig. 88] with their little sting in silver wire which will be worn as badges by the women Amazers!!!" Whistler relished his "box of wonderful Butterflies," which he gave "only to the select few, and

naturally everyone was eager to be decorated!"[72] He wished to make temporary art exhibitions magical, breathtaking theatrical events to rouse the populace and the press.

Early art nouveau architect and designer Arthur Mackmurdo was a youthful friend of Whistler's at this time, and he is thought to have helped Whistler set up some of his dramatic exhibitions. He was particularly attracted to "Whistlerian yellow," and subsequently he distempered his stand for the Liverpool Exhibition of 1886 a bright lemon and also painted his home, Brooklyn, at Enfield, yellow.[73] Whistler claimed chrome yellow as "his" color as much for reasons of publicity as for aesthetics. It was expressive of his early *japonisme*, and eventually his flamboyant use of yellow would furnish the keynote for the "Yellow Nineties." It became the color of the hour, inspiring Henry Harland and Aubrey Beardsley to create the periodical *Yellow Book* (1894–1895). Yellow became a symbol of all that was bizarre and outrageously modern in art and life.[74] Whistler's decorative use of color helped foster the sharp color sense of the period, and his yellow exhibition made his monopoly on the color definitive.

Whistler-designed invitations decorated with yellow butterflies had been dispatched to very important people. The writer for *Lady's Pictorial* reported that the Prince and Princess of Wales attended and that "Whistler basked in royal favour.... When royalty departed, the crowd pushed its way in.... Lady Archibald Campbell bravely sported the colours of the artist who has lately decorated her beautiful house. A yellow butterfly was in her hat of Canadian fur, another was pinned in her fur coat."[75] Assistants wore yellow neckties, and amid the blaze of yellow, Whistler wore black, with just a touch of yellow in his socks showing now and then above his low shoes.

A reporter noted, "Mr. Whistler signified on his cards of invitation that the colouring of the room would be yellow and white, and he took the trouble to suggest to those female friends who were unlikely

FIG. 88. *Silk and Plush Butterfly Badge Design, 1883. Created for the "Arrangement in White and Yellow" exhibition at the Fine Art Society, London. James McNeill Whistler Papers, Rare Books and Manuscripts Division, Astor, Lenox and Tilden Foundation, The New York Public Library.*

to dress in harmony, that black or white gowns would best fit in to his scheme of colour." The high-society guests at Whistler's private view who had dressed in the proper hues must have felt they were completing the artist's color harmony. It was living theatre orchestrated in the Oriental hues of Kabuki. Yellow prevailed—in flowers, ribbons, kerchiefs, men's ties, breast bouquets, and boutonnieres. The attendant dressed in the yellow plush livery added the right final decorative touch; he was dubbed the "animated poached egg."[76]

One critic remarked that he had no idea so much of the fashionable world could be crammed into one

small gallery. The crush was so great that a friend of his was advised to come back in a half hour. He found the opening rather like "a theatre on benefit night— only the costumes were a trifle different." The black-costumed figures against reflective yellow-and-white walls evoked the floating theatrical world of *ukiyo-e* prints or the silhouette theatre of *Le Chat Noir* (which Whistler thoroughly enjoyed). The floor covering was yellow-tinged Indian matting. And there were flowers. Rows of little yellow Japanese pots, each containing a single yellow flower—daffodils, marguerites, and narcissi—were arranged on yellow tables.[77]

Guests entered the exhibition room through an entrance adorned with a yellow velvet portiere over which hung a pale yellow silk valance. Drapery and textiles were important ingredients of a Whistlerian installation. The gallery was festooned with thin golden-yellow velvet and gauzy lemon-yellow muslin. Though we do not know precisely how Whistler draped these textiles, several portraits and his studies of little nude Venuses wrapped in silks offer some clue about the light, transparent drapings he preferred [see figs. 20, 37, 41]. Settees were made up with a yellow serge fabric, and the fireplace mantel had a lambrequin of thin, soft yellow plush. Walls were covered to a height of ten feet with white felt described variously as white flannel, white baize, and a material with a "Witney blanket character."[78]

On this fabric background, Whistler hung his "Second Venice Set," interspersed with occasional plates made in London. The white wall acted as a foil for the etchings, printed on old, yellowish paper. Whistler designed narrow white frames striped with two light-brown lines, and he gave the pictures ample spacing. His insistence upon blank wall space between pictures meant fewer items were displayed in his exhibitions than was usual for Victorian galleries. The blatant numbers commonly affixed to the corner of pictures were omitted, and discreet labels were attached to the wall, prefiguring the museum labeling used today.[79] Whistler hung his etchings rather high on the

wall. "When I was hanging my etchings, the consternation was great. On the ladder, I could hear whispers below me—no one would be able to see the etchings. Of course, I said, that's all right. In an exhibition of etchings, the etchings are the last things people come to see." He realized, as Théodore Duret noted, that the public is not generally drawn to etchings, considering them the province of artists and connoisseurs. Whistler proposed to offer "certain incentives to the curiosity which attracts the crowd." *Le Figaro* reported, "All London is talking about Mr. Whistler's latest arrangement—a symphony . . . in yellow."[80]

The symphony started with the white felt walls, which had been decorated with stenciled yellow lines and scattered butterflies. These abstracted stenciled effects were probably based on Japanese *katagami* techniques such as he had employed in the peacock shutters in the Peacock Room. A large lead butterfly stencil [fig. 89] in the Glasgow University collection may be what Whistler used to imprint the walls. Although, since the circular, *mon*-like stencil is quite crude, he may have used it instead to mark crates containing work sent to exhibitions. The white stenciled wall was set off by a vivid chrome yellow dado and topped by a yellow frieze.[81]

Although Whistler's installations were hardly characterized by typical Victorian comfort, he did provide sofas and chairs for weary spectators. A yellow sofa was installed in the center of the room, and there was a group of "perilous little cane-bottomed chairs painted canary-colour." One observer concluded that Whistler's talent was for interior decoration as much as for etching. "And now for the attraction itself. The true bent of Mr. Whistler's talent appears to be artistic furniture decoration, for his gallery is certainly effective and is in exceedingly good taste. It is not particularly original, for many of us have seen the same kind of idea carried out in houses of the nobility, but it is something quite new for a public art gallery."[82] Whistler's gallery design, though, did more than merely exemplify good taste and copy the homes of nobility. Just

FIG. 89. *Butterfly Stencil Design, 6¼ x 6½ in. (15.9 x 16.8 cm). A pierced lead cutout with pinhole in center. Hunterian Art Gallery, Birnie Philip Bequest, Glasgow University.*

the same, he had learned much about creating environments for pictures from his long-term association with wealthy clients.

Whistler's fantastic yellow scheme was not necessarily an unequivocally effective one for his reticent etchings, however. A spoof in *Funny Folks* suggests the problem. *"Whistlerian Enthusiast.—And how did you like the Whistler Exhibition? Fair Critic.—Oh, I was charmed. The Walls, the Programmes, the Furniture—everything was quite too lovely. All in yellow and white, you know. Whistlerian Enthusiast.—But the Etchings? Fair Critic.—The Etchings? I—I don't remember seeing them!"*[83]

Whistler's yellow exhibition was widely thought of as "an elaborate joke," a "screaming farce," a "manifesto of impudence." The glare of yellow "stung the optic nerve as if with mustard" and fatigued the gallery-goers, making them feel "jaundiced." The lighting, which was from the top, was found to intensify the blinding situation. "When you get into the room your breath is taken away. . . . On one side, like a great yellow splash, is the singular symbol which Mr. Whistler has adopted as a signature, and which is grotesquely suggestive of his own speaking countenance." Even Whistler's famous signature enlarged on the wall was perceived as slightly grotesque—a "demon butterfly."[84]

While some visitors considered the "decorations decidedly exhilarating to those who are tired of the shadows of a London winter," others sensed a sinister edge to Whistler's "excruciating" exhibition. Comic it might be, yet the room in Bond Street seemed "inoculated . . . with yellow fever . . . one feels ill directly."[85] Whistler's experiment in the psychological and physical effects of walls of pure, potent color on a room's inhabitants had been carried to extreme. Guests found themselves, according to the reviewer John Forbes-Robertson, in "a perfect bog of chromatic bewilderment. Hitherto the danger has been of a metaphorical kind; but in this, his latest exhibition, he absolutely perils not only the eyesight, but the general health of those who put their trust in him. . . . We left the room once or twice under the conviction that an attack of yellow jaundice was imminent, or that we were suffering from the sore affliction called by the learned Hemeralopia." And Forbes-Robertson went on:

The effect of all this white and yellow in a well-lit room is, as our readers may imagine, of the most bewildering kind, and the etchings with their broad white margins and glazed frames are seen dimly, as if a mist had risen up between them and the spectator. The strong yellow suffuses the white paper and dilutes to some degree the black lines of the etching. The ink thereof being slightly glossy, especially when looked at

sideways, absorbs the yellow, as it were, and haze, uncertainty, and presently alarm are the results.[86]

The possible damaging psychological effects of being enclosed too long in an atmosphere of super-abundant Whistlerian yellowness was seriously considered. One could imagine Huysmans' spiritually anguished character, Des Esseintes, perfectly ensconced in this room, which encouraged exotic, aesthetic withdrawal. As Des Esseintes withdrew from the crass ugliness of the world into his private, decorated room, the disturbed aesthete became progressively more psychologically ill. His interiors were transformed into a subjectivist dream world, a sick projection of self.[87] Occasionally Whistler's hermetic environments, like the Peacock Room, seem to have achieved the symbolist intensity of his nocturnes, evoking an enveloping, suspended world. Reviews of his yellow exhibition suggest that sensitive guests felt threatened by the haze-suffused atmosphere, as though they might be overwhelmed by the ether rising in the room—possibly the psychological essence of Whistler himself.

The artist must have been in one of his manic phases during the period his yellow exhibition was running in London. Afterward he wrote to Story with macabre glee: "The Critics simply slaughtered and lying around in masses! The people divided into opposite bodies, for and against—but all violent!—and the Gallery full!—and above all the catalogue selling like mad! . . . In short it is amazing." A remaining fragment of a letter he wrote to his brother about this same time reveals his exaggerated egotism.

> I must *not* be explained Willie—even to the Irish people! . . . The show itself was simply, [my dear] Willie, the most amazing game ever played in London. Success is quite too feeble a word to express the concentration of envy, hatred, malice, joy and surprise that pervaded the place on that famous afternoon. And you should have

seen the faces when the Princess appeared with my yellow butterfly on her shoulder!! No mon cher there are no expressions left in the language that were at all worth using on that occasion. I wish by the way I had one of those [satin] butterflies . . . made of white and yellow satin—most exquisite, wonderful little bodies of plush—with [the crisp] satin wings and the silver [hooked] sting that were worn by all that was lovely and distinguished in England! [Fig. 88 is the drawing from this letter.] My dear Willie as I said to [O'Leary?] mere Political movements were [mean] besides this demonstration! Fancy inventing the thing anyhow! This is really [Genius]—for when once a beautiful woman pins on your colors and wears your badge she is ready to die for you—and I had all the women—I mean—the beauties for me.[88]

Whistler's chorus of femmes fatales circling him at his yellow exhibition fed his Svengali-like fantasies. And certainly his desire to create a kind of disturbing psychic theatre was not merely imagined by the people who visited his exhibition. His objectives were not simply pure design; Whistler was stretching the exhibition experience into realms of psychology, spiritualism, symbolism, and theatre. He was recasting the exhibition arena as an experimental playground for extraordinary creative happenings.

News of Whistler's controversial show reached the Continent. Camille Pissarro wrote to his son Lucien: "How I regret not to have seen the Whistler show; I would have liked to have been there as much for the fine dry points as for the setting; which for Whistler has so much importance; he is even a bit too *pretentious* for me, aside from this I should say that for the room white and yellow is a charming combination." Pissarro went on to claim that it was he and his fellow French impressionist friends who had "made the first experiments with colors." For the impressionist exhibition in 1880 Pissarro had exhibited paintings in white frames and etchings on yellow

paper in purple frames. In 1882 Durand-Ruel refused to go along with this practice again. Referring to the 1880 exhibition, Pissarro continued: "The room in which I showed was lilac, bordered with canary yellow. But we poor little rejected painters lack the means to carry out our concepts of decoration. As for urging Durand-Ruel to hold an exhibition in a hall decorated by us, it would, I think, be wasted breath. You saw how I fought with him for white frames, and finally I had to abandon the idea. No! I do not think that Durand can be won over."[89]

Critical reviews pointing out the bizarre overtones of the yellow exhibition must have made Fine Art Society officials nervous. The society received considerable criticism for allowing Whistler to disseminate his "cruel," "scurvy" catalogue, which was thought to be in extremely bad taste. To add to the headaches, a financial dispute arose between Whistler and Huish over the charge for the gallery, the fee for advertising, the cost of the decorations, and the payment for the costumed attendant. Whistler wrote to Huish, accusing him of "official flights in to crime" and adding, "You *know* that the yellow man's wages do not come out of my pocket—You agreed to his engagement livery and all—or he never would have been there at all—he was one of the elements of the Exhibition—like the hangings and various arrangements in Canary—and I shall neither pay for the man—nor his socks, nor his hose, nor anything that is his." In a second letter he also disputed Huish's complaints about the expenses incurred for the redecoration of the gallery. "You point to the costs of the decorations, you seem to think that I am blind to the fact that in this way I *present* you, once for all, with the only perfect little Gallery in London. . . . You cannot suppose me to ignore the worth of this, both as enhancing the character of your future exhibitions —and also as an advertisement to the Fine Arts Society."[90]

The strange allure of Whistler's "Arrangement in White and Yellow" exhibition led to its restaging

several times. Later in the year, on October 10, 1883, Hermann Wunderlich and Company, located at 868 Broadway in New York, presented the same show with the addition of Whistler's controversial painting *Nocturne in Black and Gold: The Falling Rocket*. The show was probably coordinated through the Fine Art Society. Evidently Whistler sent instructions to E. G. Kennedy, later Wunderlich's partner, for the design and coloring of the invitations, the gallery decorations, the hanging of the artworks, and the costume for the page who sold the catalogues for thirty-five cents. Some of the original decorations were imported from London, and the same catalogue was used. Critics were devastated that the artist did not attend the sensational opening. Nevertheless, it was a landmark exhibition—Whistler's first major one-man show in America. London no longer had a monopoly on Whistler's "entertainments."[91]

Wunderlich hung Whistler's fifty-one Venice etchings in two rows at eye level on white wool stenciled with "cabalistic" gold butterflies. This sparse arrangement was as much a departure for an American nineteenth-century salon as for a European one. Since the customary practice was to cover entire walls with pictures, guests at the New York showing found the exhibition startlingly blank. And the critic for the *New York World* remarked, "When the first visitors passed through the yellow portieres into a well-lighted room there was a universal call for quinine, for the effect was positively malarial." The show traveled to Baltimore, Boston, Chicago, Detroit, and other American cities. Also in the same year, the Minneapolis Society of Fine Arts decorated one of its galleries using Whistler's yellow-and-white scheme during its first loan exhibition.[92]

After his well-publicized exhibition at the London Fine Art Society, Whistler may have felt it was an auspicious moment to return to showing his work in Paris, where he had not exhibited since 1873. In May 1883, he entered the portrait of his mother in the Salon and was awarded a third-class medal. He

also exhibited paintings at the Galerie Georges Petit. He continued to show at the Grosvenor Gallery, and on December 1, 1884, an exhibition of twenty-six paintings, most of them watercolors, opened at the Dublin Sketching Club. Whistler was pleased that he sold work and that the exhibition caused a commotion.[93]

Whistler Joins Forces with Les XX, 1884, 1886, 1888

Word of Whistler's controversial mode of exhibition for his 1883 one-man show circulated widely on the Continent. The elaborate presentation of his work served to further clarify Whistler's depth of interest in the decorative arts and focused attention on his defiant campaign to reform established exhibition practices. At this time, a similar dissatisfaction with exhibition control and a desire to stress the unity of the arts and recognize all forms of artistic innovation led a group of rebel artists to split off from official exhibitions. They formed an independent association called Salon des Vingt, or Les XX, to present shows of modern art just at the point that Brussels was evolving into a major center of the symbolist movement. Each year, Les XX invited twenty of the most radical artists to exhibit with them. In the course of their ten-year history, the exhibitors amounted to "a glorious aristocracy" of modern artists.[94]

Les XX exhibitions were the most adventuresome on the Continent. They featured paintings, sculptures, and applied arts displayed together in domestic-type settings in the mode that Whistler had introduced ten years earlier. Also, musical concerts and lectures accompanied their shows.[95] Octave Maus, musical impresario, secretary for the group, and art critic for the Brussels journal *L'Art Moderne* contacted Whistler at the moment the group was forming. In 1904, Maus recalled:

When, early in 1884, a group of Belgian artists, bent on emancipating themselves and defying routine, founded the "Society of the XX," the first foreign painter to be invited to join their ranks in the club's opening exhibition was James McNeill Whistler. And among the ardent spirits who were united by a common ideal of freedom, what man could more emphatically than Whistler personify the love of independence, the combativeness, the scorn of conventionality? . . . Would this man consent to place his conquering sword at the service of the young combatants now preparing to give battle?

Maus wrote to Whistler explaining the motives that had led to "the declaration of war—namely the hostility of official artists and public authorities toward the innovators, the systematic rejections of which they were the victims, and the ironical criticism of the ignorant crowds." He stated that Les XX heralded "an era of conflict" and that the intent was to "start a real revolution in aesthetics." Maus recalled that Whistler replied immediately, stating in effect, "I am with you and your friends, heart and soul. I like and admire your rebellious spirit; without it progress is impossible. We will fight together for the victory of our ideal."[96]

Whistler forwarded explicit instructions to Maus for the hanging of a selection of his Venice etchings and four paintings. Maus recalled that they were hung "on the line in the first exhibition of the 'XX.'" His work aroused considerable comment from the press.[97]

In 1886, Whistler loaned Les XX his portrait of Sarasate prior to sending it to the French Salon. Willy Finch, who was a Belgian of British descent, a neo-impressionist painter, and later a ceramist, had visited Whistler in London in 1884 and personally invited him to exhibit. In 1886 and again in 1888, Finch tried unsuccessfully to have Whistler elected to membership in Les XX, when even James Ensor, who was against admission of foreigners, voted for him.[98]

Whistler accepted a third invitation to exhibit in 1888, sending his portrait of Lady Archibald Campbell, a nocturne, and six pastels of the East End of London. He again sent Maus precise instructions, and a sketch, to describe exactly how his pictures were to be arranged. Great care in presentation characterized Les XX shows, and Whistler's demand for perfectionism in this regard was undoubtedly an influential factor in encouraging high standards of display.[99]

In 1885 Maus visited the artist in his "well-lighted studio in Chelsea" for several days and wrote two insightful articles about Whistler's work for *L'Art Moderne*. Maus stated that Whistler had "efficiently contributed" to the "triumphant way, though the battle was still fierce." He acknowledged that Whistler's influence could be found not only in the pictorial arts but also in interior decoration and dress.[100] Les XX exhibitions, which showcased applied arts and featured artist-designers like Whistler, foreshadowed the art for design's sake art nouveau movement, which originated in Belgium in the early 1890s. The group's exhibition in Brussels, as *La Reform* reported in 1896, helped to change exhibition practices. Madame Maus recalled that Whistler's influence on some members of the young, radical Les XX artists—many of whom were future symbolists and art nouveau artists—was so great that like a wizard he cast a spell on them.[101]

Whistler Exhibitions at Dowdeswell's, 1884 and 1886

Following the high interest generated by his bizarre yellow-and-white exhibition, Whistler naturally had a desire to keep his followers intrigued. When news of his next exhibition surfaced, critics began to speculate about what Whistler might do.[102] Whistler doubtless realized that he could not, and probably did not care to, concoct a more sizzling scheme of color than he had for his 1883 yellow exhibition. He settled on a fashionably chic—one commentator said "vacuous chic"—Edwardian scheme called "Arrangement in Flesh Color and Grey" for his 1884 exhibition of sixty-seven notes, harmonies, and nocturnes. Reviewers suggested Whistler had taken a hint from the fashion of the moment.[103]

For Whistler, walls painted in greyed tones were more than mere fashion, however. Starting in his first home at 7 Lindsey Row in 1863, he had painted his studios grey as if to reflect the grey of the Thames River just a few yards away. His first one-man exhibition ten years earlier had pink-grey walls. Pearlized films of greys and muted pinks recalled the delicate hues in woodblock prints by Kiyonaga and other Japanese artists that he collected. Ernest Fenollosa pointed out that Whistler interpreted the East to the West, that his exploration of the infinite range of tones of grey revealed his understanding of Oriental art, and that such greys "pulsate with imprisoned color." As for the flesh color, Whistler remarked that subdued pink reminded him of a Venetian palazzo.[104] Various reporters searched for the right words to describe the exquisite harmony Whistler created for his 1884 show, referring to it variously as shell pink and smoke, salmon and stone color, dull pink and fog, rose and silver, crushed strawberry and verdigris.

For this exhibition he changed locations, moving a few doors down from both the Fine Art Society and the Grosvenor Gallery to Messrs. Dowdeswell's Gallery. Whistler had been unable to agree upon the terms of a contract with the Fine Art Society. Walter Dowdeswell, who had previously been with the society, continued where Huish and Brown left off as champion of Whistler in his independent exhibitions. Whistler picked up his "theatrical props"—Liberty fabrics, pots of paint, and matting—and carried them down the block to stage his next show at 133 New Bond Street.

In addition to introducing a highly refined color scheme and moving to a different gallery, Whistler

presented his mastery over a new medium, water-color—new to Whistler, that is, who had at first found it difficult. Several of the watercolors were sea scenes that he had painted outdoors at St. Ives, Cornwall, where he worked in the company of Menpes and Sickert from January to March 1884. He combined the "little things" from Cornwall with studies made in Holland and other watercolors and oil sketches made in his wanderings in the byways of London. The latter works depicted streets shrouded in atmosphere, rows of old houses by the river, and abstracted storefronts in Chelsea. Whistler attempted to elevate etching, pastel, and watercolor, to make these more informal, sketchy, and decorative media—usually associated with amateur artists—acceptable.[105]

Londoners had every opportunity to read about the smallest details of Whistler's latest pink-and-grey exhibition design if they chose not to stop in New Bond Street to experience it firsthand. Typically, Whistler had alerted the newspapers and magazines, so press coverage was thorough and brought a rush of people to see the gallery. He had designed the catalogue, the posters, the invitations with rose-colored butterflies, and the entire decor. At the Saturday afternoon private view, Whistler was in his element. His fellow wit, Oscar Wilde, helped him preside over the multitudes who arrived to become part of the show, which was calculated to "puzzle and amuse." One reporter noted, "Hot as the day was, and crowded the room . . . the pale pink walls, white dado, crisp matting on the floor, frail white chairs and fresh flowers gave the show a cool effect."[106]

Well-known beauties who were ladies of fashion came dressed in harmony with the exhibition in "grey dresses with silver trimmings" or "flesh-coloured lace" with large, matching feathers, hats, or small bonnets. The distinguished founder of the feast himself, cane in hand, radiant and lively as usual, was present in the somewhat circumscribed space. He "talked to everyone at the same moment"—"a perfect host."[107]

If Whistler's white-and-yellow exhibition was a little garish or piercing, his flesh color-and-grey show was the epitome of subtlety, causing no fatigue or fright. Eyes were soothed by the subdued color. Still, the ambience was not without possible psychological or mystical effects. One writer noted that the gallery "produces on the eye a soft misty effect of delicate colour which seems to pervade the air of the apartment, and not merely to lie flat on the walls." The lighting Whistler had arranged for this exhibition had a great deal to do with the lyrical sense of mist and soft color that pervaded the air and affected the viewers' perceptions of the watercolors. As with his white-and-yellow harmony, the hues seemed to emanate from the walls and envelop the guests in a color field. The soft-edged watercolors and oil sketches of water and sand, sky and fog, clouds and nocturnal atmosphere, also suggested indeterminate worlds of dream and poetic imagination. Whistler had carried this mood into the total harmony in the gallery, creating a sequestered world of refined, perfect beauty, a nirvana detached from the tensions of ordinary reality.[108]

The exhibition was not without its expected comic touches. There was, for example, the white-faced attendant, whom some judged to be the most striking feature of the show. Menpes recalled that Whistler insisted the color scheme overflow "into Bond Street oozing out *via* the 'chucker out'" dressed in uniform. One critic quipped that "the poached egg is here but in a new liver-and-bacon suit of livery." Another described his attire as a "grey coat with flesh-coloured collar and cuffs, grey trousers, grey stockings and fashionably cut leather pumps." This was a bit of high-society foppery in which Whistler liked to indulge. He was fond of uniforms, and the costumes he designed for his gallery attendants may have reminded him of the grey West Point cadet uniform he had so proudly worn.[109]

While the catalogue did not attempt to "pull anyone's leg," Whistler did propound his artistic credo in

a series of "Propositions." The preface was entitled "L'Envoie." (This was either a misspelling or a non-word; pressed to explain, Whistler said it meant some sort of snake.) In it, Whistler declared that a work of art should be like a bud in bloom with no mission to fulfill. "A picture is finished when all trace of the means used to produce it have disappeared."[110]

Whistler's blossomlike watercolors, harmoniously related to one another, were spaciously arranged, and labels consisting of very pale numbers on tiny gold tickets were affixed to the walls. He had covered the upper walls in delicate flesh-color serge and painted the low dado a creamy white. He also painted mold-ings and chairs delicate tones of cream white, rose, and grey, and had grey matting placed on the floor. (*Queen* urged ladies "to study his system and his com-bination of colors." Whistler's mesmerizing, color-coded exhibition installations certainly intensified the enormous surge of interest in artistic interior dec-oration in late-nineteenth-century England.) The gallery was draped with wispy pink-and-grey fabric, which may have given the room a classical or rococo air. Whistler frequently used gossamer textiles to alter the character of the existing space; he may have been inspired by the use of drapery in the Salon in Paris, as well as the commercial practices of that era. The tex-tiles he chose, however, were the antithesis of the stiff taffetas and weighty, hard-glazed cottons common at the time. Liberty fabrics were a mainstay of Whistler's gallery designs; at the Society of British Artists, for instance, he used Liberty chintzes. For his pink-and-grey show, the mantel was covered with a grey velvet valance edged with flesh-colored cord and embroidered with a silver-and-flesh-color Japanese butterfly. Together with the grey draperies, it formed "a dove-like vision." The soft hues coordinated with the various gold tones of the frames. The "brilliant notes and scribbles" of the "artist who paints with fog" were enclosed in "massive frames" of "strange metal-lic lustres."[111]

Pale azaleas in rose-flushed vases, and a white marguerite daisy plant in a large salmon-colored earthenware jar decorated the space. Flowers and plants redolent of the Far East were ubiquitous in Whistler's schemes, and they changed with the sea-sons and the gallery's color harmony. There are no re-ports of aesthetic sunflowers or of the painted green carnations identified with Oscar Wilde, but Whistler was known to use yellow daffodils, irises, azaleas, tiger lilies, water lilies, daisies, and calceolaria to set the proper aesthetic mood.[112]

The planning of this seemingly simple installa-tion was more painstaking than guests might have imagined. It was important to Whistler that his inte-rior designs look as spontaneously executed as one of his watercolors. A surviving series of Whistler's mem-orandums to Dowdeswell reveal his exhausting efforts to get the job done right.

Thanks for the telegram—and all your trouble. I am so tired! . . . Enclosed is the velvet pattern. I should have thought they had something light. If not take the fairer one. Too absolutely ill. Now that I look again—this is really almost too brown. You must try something else. Really I [illegible] asleep!

The catalogue? am I not to have the proof tomor-row?—I thought to have had it to correct and re-vise tonight. . . . They are shockingly behind. . . . Also the matting. I ought to have the [sample?] for me to look at. I really am woefully sleepy and must go to bed.

Herewith meanwhile slight plan of walls of our Arrangement in Flesh and Grey! Take great care of it and let me have it back to complete other details—etc.

Enclosed is the pattern for the hangings. . . . My notion is that you had better see Buckley at once

about the butterfly to be embroidered. Let them do it as before.[113]

Menpes recalled: "I had never imagined that one human being could be so completely a master in minute details. He missed nothing, absolutely nothing and dominated to an extraordinary extent." The process for arranging the show began with choosing the pictures and having them framed. This was a time of "frantic excitement." Once this was done, the pictures were sent to the gallery. Whistler then began working the wall, sketching possible layouts and arranging pictures on the gallery floor to achieve decorative placing. "And thus they would be hung. Whistler, himself, always superintended the smallest detail in his exhibitions. The colouring of the room was arranged in accordance with the pictures; so also were the hangings, which were festooned in beautiful lines around the gallery."[114]

Menpes told a story of pricing the pictures. He, Whistler, Dowdeswell, and another companion gathered at the Arts Club. They had dinner and sparkling wine. As they imbibed the wine, the prices they imagined Whistler's pictures would fetch climbed higher. The following day, however,

the east wind was blowing, and we were away from the wine. It was Press Day. I arrived on the scenes very early—at half-past nine, when the gallery was scarcely open. Dowdeswell joined me, and together we paced before the pictures on the wall. We looked at each other, and at the exhibition, critically, but in dead silence. Neither of us uttered a word . . . but there was no doubt about it—in the cold daylight we were thoughtful and depressed. Brilliant and sparkling, the Master entered, and, with a few words, picked us up again. He knew the value of his own work and he soon impressed us with his views,—dealers and all. He hypnotised the dealers, as he did everyone else;

and they worked for him loyally. . . . It mattered little to them whether they sold the Master's work or not. They felt that it was sufficient privilege merely to exhibit them. Whistler literally bubbled over with joy.

As a final touch Whistler climbed a ladder and painted his signature boldly on the fabric wall "almost on the ceiling." Menpes concluded, "It was obvious to everyone that the Whistler's butterfly had pulled the exhibition together."[115]

Few contemporaries paused to consider the loss when Whistler's exhibition installations were dismantled, with nothing but verbal descriptions left to help reconstruct what they were like. Godwin was one of the rare individuals who wistfully realized that Whistler's efforts to create exhibitions represented landmark happenings.

When . . . Mr. Whistler's [pictures] have departed to their several purchasers, there will remain to Messrs Dowdeswell a gallery specially prepared for this collection in grey, white and flesh colour, which might be in itself an exhibition if the people could enjoy color. On a July afternoon, when the blind is drawn across the skylight, there is no place known of more graceful, more satisfying to the eye. The restlessness of modern fashion, for ever changing, that cannot allow the best of things to lay beyond a season, will perchance sweep away this decoration, and it will be counted with the other delightful harmonies Mr Whistler has produced in Piccadilly and Bond-street, and, indeed whenever his works have been exhibited. That these exquisitely lovely arrangements of colour should live as memories only, gives to the very nomenclature our painter has adopted a touch of pathos. The room in Piccadilly [the Whistler Gallery at the Society of French Artists] and the rooms at the Fine Arts Society have gone, as Whistlerian compositions,

quite as effectually as the vibrations of the last quartet.

Thomas Way also fondly recalled Whistler's gallery decorations. "It is much to be regretted that these decorations were so soon obliterated and lost."[116]

Despite widespread appreciation of the exhibition decor that Whistler contrived, it did add expense. To Whistler's chagrin, Dowdeswell informed him the exhibition had been a financial failure. Whistler wrote to him, "I am grieved to hear that you say the exhibition was an absolute loss to you and that you could have done better with the work of someone else. I had flattered myself that I managed to produce effective shows, as far as the decoration of the gallery goes, at a minimum expenditure—therefore I was not prepared for this statement of loss." Whistler assured him he had not meant to be "the Jonah on the ship!" and suggested Dowdeswell stop over. They would figure it out and make of it, after all, a "SUCCESS!!"[117]

Apparently, Whistler convinced Dowdeswell that his 1884 show was a success artistically if not financially. In the following year—the year of his flamboyant "Ten O'Clock"—Whistler was already diligently preparing for a second exhibition of seventy-five works, entitled "Notes, Harmonies, and Nocturnes," to open at Dowdeswell's on April 29, 1886. This occasioned a series of memorandums to the dealer. Among other things, Whistler explained why he happened to be working in Dieppe. "I slave as usual for our combined success. . . . Well I thought that in the 'Arrangement in Gold'—it would be well to see sparkling here and there a little bit of the blue sea, and so I rushed over here—and shall bring back, I think, what is wanted."[118] He was producing a series of paintings with blues to set off the golds and ochres planned for the room.

As the opening date of the show approached, he sent Dowdeswell a wall elevation for the gallery. This rare, vibrant sketch in watercolor and ink may be the only such gallery scheme extant [fig. 90] (though one hopes others may be discovered). The upper part of the drawing is the color of the light tan paper and is marked "*top*." Below this, the chair rail is indicated with two lines in black ink; it is washed in yellow. The dado is a very light ochre wash and the skirting is in alternating stripes of bright yellow and brownish yellow, ending with a grayish yellow curved toe molding. As the time grew short, the notes increased and became more urgent. "I am perfectly wild with work," Whistler wrote, "so don't venture to come near me."[119] One of Whistler's invitations went to Godwin, who was too ill to review the show or attend. He died a few months later [fig. 91].

The harmony for Whistler's "Arrangement in Brown and Gold" exhibition was complex. The modulated color orchestration started with the ceiling, which was gilded in a pale tone of brown gold. This metallic effect was echoed in the wide picture frames, which shaded away from silver through variations of yellow gold, red gold, real copper tones, and brown-orange gold. The shimmering golden opulence was complemented by brown and yellow hangings and a gilded dado. The gilded surfaces probably had a broken, scintillating effect. The golden luster of this exhibition may have rivaled the layered surfaces of the Peacock Room.[120]

The common brown paper that Whistler used to cover the walls was the cheapest, most improbable material to combine with the lustrous, gilded ceiling, wainscoting, and frames. A critic remarked that "the affair might be called the apotheosis of brown paper, hitherto identified chiefly with parcels and associated with string." Equally in contrast to the brown paper walls was the velvet, in an "indescribable tone of brownish, yellowish greenish-gold," and the amber Indian silk that covered the mantelpiece. "Flimsy yellow curtains" and "seventy-five sketches of the slightest sort" added up to "the most harmonious and piquant little gallery ever put together."[121]

In this exhibition, Whistler introduced "artistic

FIG. 90. *Color Scheme for "Arrangement in Brown and Gold" Exhibition at Dowdeswell's Gallery, London, 1886, 3¾ x 7⅜ in. (9.4 x 18.4 cm). Whistler's plan is in pencil, black ink, and shades of yellow, ochre, and brown watercolor on lined tan notepaper. Lessing J. Rosenwald Collection, Rare Book and Special Collection Division, Library of Congress.*

engineering," a velarium designed to create diffused lighting. Charles deKay from *Art Review* found that floating above his head was a cloud of yellow forming a series of exquisite curves [fig. 92]. He considered the velarium the most distinctive aspect of the room. "Pay your shilling, and penetrating to a small square gallery furnished in light yellow, seat yourself on a circular yellow sofa under a swinging umbrella of pale yellow silk, which bears the Japanese butterfly, bat or nondescript that Mr. Whistler had chosen for his trademark and badge." Another critic observed: "The canopy above the center of the room" made the light "perfectly fair. . . . Of course, in the midst of such an arrangement of colour[,] marked violet or blue have wonderful force."[122]

Whistler's plans for pictures with pungent sea blues among the golds had proved effective, and his unorthodox lighting control enhanced the effect. The velarium, suspended by brass hooks and hung by cords two or three feet below the gallery skylight had the effect of a yellow silk scarf. It was arranged so that the light fell on the pictures alone, while the spectators (dressed in brown and gold) were completely in the shadow. Whistler said, "Picture galleries lighted at the top are very good for the pictures but not for the spectators; for the falling light is reflected up from the floor on to the pictures so that they cannot be properly seen."[123]

When Whistler's 1886 exhibition closed, his gilded, brown paper interior was left intact. The *World*

FIG. 91. *Invitation Card, Engraved with a Butterfly, 1886.*
Whistler sent this card to Godwin for his "Arrangement in
Brown and Gold" exhibition at Dowdeswell's Gallery, London.
G119, Birnie Philip Bequest, Glasgow University Library.

reported that Dowdeswell's was arranging a series of sketches of Scottish scenery by James Orrock "at their Whistleresque room."[124]

A statement in *Art Age* suggests that during the 1880s Whistler had built a strong reputation as an original designer of exhibitions and domestic interiors of rare beauty. His private views were highly publicized artistic events, and his type of decor was well-recognized.

> While the Academy has fallen below its usual level . . . and the Grosvenor is degenerating into a gallery for an overflow of Academicians. . . . Mr. Whistler challenges the critics with an

exhibition of his own, in which he is as original, if not as good, as ever, and makes no signs of succumbing to conventional standards. If his method of exhibiting his new collection of Notes, Harmonies and Nocturnes be affected, it is pleasant as well. The little room on Bond Street, with its cool brown walls, and light graceful golden draperies, is a refreshing retreat after the glaring walls and warm galleries of the Academy. The sunlight streaming in through the glass roof . . . is pleasantly tempered in its fall upon the pictures by a golden canopy of silk. Mr. Whistler's emblem is appliqued in velvet in one corner. To dress his attendant in the brown and gold livery may be an affectation. . . . It is assuredly

not one of his lesser merits that he understands so perfectly the true secret of making a room beautiful. This he can do without the introduction of his famous peacock feathers or eccentric decoration, but with the simplest means. I have lately seen a drawing-room furnished according to his designs, in which simplicity was the greatest charm. It was one of the most successful harmonies in white and gold. The walls were pale golden, a rug of a darker shade lay on the floor, white and gold cretonne covered the furniture and hung at the windows. The only ornaments were a few small drawings and sketches on the walls and small white glass jars full of pale spring flowers on the mantel. Cool and light and yet filled with a rich, golden glow, it was as much a contrast to the over-crowded dark drawing-rooms of the day, as is the little room on Bond Street to the galleries of the Royal Academy. There are harmonies in blue and pearl, in pink and grey, in grey and silver, in opal and green; notes in grey and gold, caprices in blue and silver.[125]

Whistler and the Royal Society of British Artists, 1884–1888

Throughout the 1880s Whistler masterfully controlled the terms of his own career in London by designing carefully conceived settings for his one-man shows. He thus bypassed the Royal Academy, attracted a public following and a few patrons, and received ample press coverage. Meanwhile, he had not lost all contact with French modernist artists. He frequently crossed the Channel, corresponded with several impressionists, and occasionally showed his work with theirs, though his theoretical viewpoint differed. He was determined, however, to expand his sphere of influence and achieve still greater prominence.[126] His return to the Paris Salon in 1883 and his interest in showing with the avant-garde Belgian Les XX exhibition society in 1884 are indicators of this intent. Of

FIG. 92. *Design for a Velarium, 1886, pencil and watercolor, 9⅞ x 6⅞ in. (25.1 x 17.5 cm). Created for the "Arrangement in Brown and Gold" exhibition at Dowdeswell's Gallery, the velarium was like a giant Japanese parasol shielding the pictures from the harsh light coming in from the skylight. Hunterian Art Gallery, Glasgow University.*

course, his 1885 "Ten O'Clock" was the central ele-
ment in his campaign to promote himself and his aes-
thetic concepts.

Even before his "Ten O'Clock," Whistler had be-
gun to consider another angle—membership in the
Society of British Artists. He sent Sickert round to
talk to Albert Ludovici, an artist who did impression-
ist studies much influenced by Whistler. Ludovici
could not believe Sickert's message—that if the soci-
ety chose to invite Whistler, he would be willing to
join. The society, founded in 1823, was a staid, all-
British organization currently losing fashionable pa-
tronage and being shunted aside by the advent of new
galleries that were more commodious and better
lighted. It was also, however, one of the first groups to
realize the need to break the monopoly of the Royal
Academy; this factor acted as a powerful attraction
to Whistler.[127]

Ludovici delivered Whistler's message to his fa-
ther, who was treasurer of the society, the president
John Burr, and other officers. They all laughed, think-
ing it was just another of Whistler's pranks. Only Burr
was pleased. Frederic Leighton, colonel for the club,
was frightened about electing "an Art Buffoon into
the nursery of the Royal Academy." Certain members
were bitterly hostile. Ludovici, however, convinced
the officers "what a splendid advertisement it would
be" for their winter show.[128]

A special meeting was called within the week,
and Whistler was elected to membership on Novem-
ber 21, 1884. A traditional British society, in a reck-
less moment, had admitted a renegade into its ranks.
Whistler was fifty; it was his first taste of membership
in a society. His desire to join such a conservative or-
ganization was considered inexplicable, but there was
no time for members to wonder. The winter exhibi-
tion at the Suffolk Street gallery was set to open, and
Whistler was informed that if he wished to be in it, he
must submit work immediately. Newspapers promptly
reported that Whistler had been "Suffolkated."
The society members assumed he would remain

uninvolved, but this naive supposition proved en-
tirely wrong. Whistler took an immense interest in
the society during the four years he belonged to it, at-
tending meetings from the beginning to the end and
especially concerning himself with exhibition poli-
cies. Ludovici observed:

> Young artists of the present day have much to
> thank Whistler for. They would be surprised to
> learn what a struggle it was to bring about any
> reform, or change, in the way of hanging a wall
> of works of art. Even a catalogue in those days
> looked more like a tradesman's book of advertise-
> ments than an artistic compilation of pictures.
> Whistler was an artist of great taste and refine-
> ment, which were shown in his work and interior
> decorations. He was the first to introduce white
> rooms and to do away with elaborately patterned
> wall-papers so popular in those days, in favour of
> plain walls of different schemes of colour; this,
> with just sufficient furniture to make a room com-
> fortable, was a great improvement to private
> houses, overcrowded, as was the fashion then,
> with unnecessary knick-knacks.[129]

Whistler was eager to demonstrate the art of pic-
ture hanging on the larger, somewhat more prominent
stage of a London art society. Claude Phillip remarked
in the *Gazette des Beaux-Arts* that Whistler had "gone
to a neglected little gallery, the British Artists, which
he will probably bring into fashion."[130] This certainly
was Whistler's intent. As soon as he could manage, he
began instituting exhibition reforms at the society. He
instigated the redecorating of the galleries, which
caught the attention of the critics, who were soon
suitably agog. The reports of Whistler's adventures at
the society would eventually amount to a flood of
newsprint. "It seems to have suddenly dawned upon
the Council of the Society of British Artists that the
Suffolk Street Galleries were getting a little dingy and
behind the times in point of decorations. All this
has now been altered greatly by the aid of paint and

artistic wall coverings." A private view at the society was referred to as the "surprise party" of the artistic world; it was "The Butterfly's Ball." A writer for the *St. James Gazette* reported: "The change that has come over the affairs at the gallery in Suffolk-street bids fair in time to make it really attractive. This time last year it was like a more than usually dusty and dismal auction-room. Now it shines with gold and crimson and oak parquet."[131]

Whistler had not accomplished the transformation of a dusty salesroom into a cheerful, shining gold-and-crimson gallery without some difficulty. A letter from Whistler to the "Hanging Committee of the British Artists" reveals rumblings.

> Gentlemen—My plan for the decoration as you all know was finally to embrace the gilded dado in *all* the rooms—meanwhile you are now suffering uselessly in the matter of the color on the dado in the 4 small rooms—for you might know that if I am satisfied it is because I have thoroughly completed the color scheme that should not reveal to the public the poverty of purse that made the Society halt in their exposition—This much faith gentlemen you might have had in me. However, I am well pleased that you should do at *once* what would have been done next year.[132]

It was not only decoration that Whistler set out to change; he also took an interest in the economics of the organization. He suggested that when receptions for critics were held in the gallery, instead of a large lunch, light Sunday breakfast should be served to members and their guests, who could pay for the refreshments. These "Sunday tea parties" were served by charming girls dressed in frocks color-keyed to the decorations. (For an evening opening at Dowdeswell's, Whistler had designed a bright red dress for "Oriental-Tea girls ... which looked extremely effective against the dark green background.") The

traditional practice had been to provide a feast for the critics at press views. Given the society's depleted funds, Whistler suggested that a prudent economic measure would be to drop this custom, but members strenuously objected. He was successful, however, with his idea to have photographs taken of members' work and put up for sale in the lobby. And since he found the society emblem objectionable, he took it upon himself to design a new symbol, a small red lion, which was subsequently used on ballots, stationery, catalogues, and a signboard. Whistler himself painted the sign, which hung outside the gallery, with a lion and a butterfly in gold and red. He also objected to the society's overly commercialized catalogues littered with advertisements. He relegated ads and prices to the back and designed an asymmetrical cover with light Whistlerian typography in italics.[133]

To the astonishment of many, on June 1, 1886, Whistler was elected president of the society. There was great excitement at the election meeting, but Whistler remained calm. Now he could begin to implement even more-sweeping changes to resuscitate the moribund organization and give it prestige, vitality, and scope. It was Whistler's intention to carry out the original purpose of the Grosvenor Gallery.[134] To do so, he attempted to break down the society's insular exhibition habits by encouraging the acceptance of controversial modern work and inviting foreigners to join its exhibitions. For example, he brought in Monet's work, which was hardly known in England, and invited Monet to the opening. Art circles in Paris began to pay keen attention to what Whistler was engineering at Suffolk Street. The *Spectator* critic commented, "There is now no gallery in London, probably none in the world, where can be so clearly seen as in this exhibition in Suffolk Street, the most conventional and commonplace of old-fashioned work, side by side with the most eccentric and daring examples of modern impressionism."[135]

Whistler also introduced his retinue of young

"pupils," imitators, and colleagues as exhibitors. This included two of the women currently in his life, Beatrix and Maud. Sidney Starr, Henri Fantin-Latour, Charles Keene, Alfred Stevens, Theodore Roussel, Mortimer Menpes, and Walter Sickert, as well as Glasgow artists like John Lavery and James Guthrie, all exhibited with the society during Whistler's tenure, and Oscar Wilde appeared at openings. Top billing, however, inevitably went to Whistler, though Ludovici claimed Whistler sometimes did not hang his own work until after the press view. Sickert's mother remarked at the time that since Whistler had become president of the society, there was "much more glory among the faithful pupils and adherents."[136]

Whistler inaugurated evening gaslit previews, a welcome departure. Not only could the stylish guests avoid the heat of the day, they could "promenade the gallery" in evening dress. Gaslighting, while not particularly subtle, was a further development toward the artificial control of illumination in galleries. The idea, which had been introduced in Paris, caught on in London through Whistler's example.[137]

Menpes wrote that Whistler "set to work to cleanse the Society with the hot water and soft soap of his own good taste." Part of the cleansing was to ruthlessly eliminate large numbers of members' paintings, reducing by half the number of works shown in the galleries. "Out damned spot! Out! Out!" was Whistler's oft-expressed phrase. No matter who had sent it, he refused to show mediocre work. To Menpes he said, "You need never be afraid of rejecting a masterpiece. We want clean spaces round our pictures. We want them to be seen. The British Artists' must cease to be a shop." He proposed a size limit on the pictures allowed in the exhibitions as well as a limitation on quantity. The few remaining pictures "were hung in a decorative pattern." Whistler pawned his large gold medal from Paris to loan five hundred pounds for gallery decorations, and he presented the society with four yellow velvet curtains for the doors to the large room.[138]

When Whistler had been successful in working a number of radical changes in the way that exhibitions were installed in the society's galleries, he paused to make a pen-and-pencil drawing of the interior of the main room during an exhibition [fig. 93]. In the sketch, the velvet curtains that Whistler donated may be seen to the left. Visitors to the gallery are consulting their catalogues as they study a series of cabinet-sized pictures with wide mats. By today's standards the pictures appear to be hung rather closely to one another; however, they are arranged in a comfortable, two-row, eye-level line around the walls. The tentlike velarium floats overhead to temper the light coming from the skylight. The frieze area is a darker shade, whereas the walls, railing, dado, and skirting are all very light; the fireplace is draped in fabric.

For the winter exhibition of 1886–1887, Whistler was determined to achieve an artistic success. His friendship with Wilde was on again, so the poet could help him to receive guests at the private view. Since the budget was modest, he decided on a simple scheme of greenish yellow walls, neutral brown felt carpet, and just a hint of gold here and there. He also designed ingeniously wispy yellow festoons of Liberty material, an Indian madras muslin. One day during the preparations, he entered the gallery to find that gold was being used too freely, ruining his design. The artist in charge saw no harm in the extra gold, but Whistler explained, "Suppose I'm making an omelette and you come along and drop in a seagull's egg?"[139]

Whistler hung a velarium in the central hall also, informing the skeptical hanging committee that the velarium "was his patent." Some visitors concluded that the velarium in the gallery resulted in "a depressing sense of gloom."[140] No overcrowding was allowed, and carefully selected pictures were faultlessly arranged. He had even worked a small section of graphics into the exhibition. There was not enough muslin, however, resulting in some bare space under the ceiling, and temporary battens remained in places. Whistler announced that if it were criticized, he

would say, "The battens are well placed, they make decorative lines." Reviews of the show were largely favorable. "By a touch of the famous wand [a] complete metamorphosis has been brought about," noted the *Saturday Review* reporter, commenting further that the public had been spared "the fatigue of glaring and overcrowded walls."[141] But a reporter from the *Times* did question the unfinished wall treatment. Whistler wrote to the paper's editor that since the writer was "qualified by ignorance" to remark with "bald assurance" upon the "engineering of the light in the galleries, and the decorations of the walls," he felt permitted to rectify the erroneous impression left. "Tell your readers that there is nothing 'tentative' in the 'arrangement' of colour, walls or drapery—that the battens should *not* 'be removed'—that they are meant to remain, not only for their use, but as bringing parallel lines into play that subdivide charmingly the lower portion of the walls and add to their light appearance—that the whole 'combination' is complete."[142] He took on his critics one by one.

When Whistler was not thinking of schemes to reform the society's antiquated methods of exhibition, he was thinking of ways in which to make it a powerful rival of the Royal Academy. In 1887 he began to investigate methods by which he could accomplish his plan of obtaining a royal charter for the society. He appealed to W. H. Hurlbert, first lord of the Treasury, "for advice on how to apply to the Queen for the title of 'Royal.'"[143]

Whistler also extended personally written invitations to royals to attend the society's private views. On April 4, he received the Prince of Wales at the moment of his arrival at 11:30 A.M. for the society's spring exhibition. The prince—who had never heard of the society—asked Whistler a number of questions. He inquired about the history of the organization, and Whistler replied, "Sir, it has none; its history begins to-day." In the same year, Whistler was invited, as president of a society, to attend Queen Victoria's jubilee celebration. The gift he designed for the

FIG. 93. *Sketch of Exhibition Installation at the Royal Society of British Artists' Gallery, Suffolk Street, Pall Mall, 1886, pen and ink, 7⅞ x 6¼ in. (20 x 15.9 cm). Whistler recorded his hanging scheme and the velarium he introduced at the Royal Society of British Artists' exhibition and at Dowdeswell's. The Visitors of the Ashmolean Museum, Oxford.*

occasion was a twelve-page illuminated address executed on old Dutch etching paper. The binding was in yellowish white morocco, the lining was a gold-colored silk, and on the back cover was a butterfly.[144] Whistler also did a series of etchings of the jubilee naval review at Spithead and submitted it to Her Majesty. He carried out these projects without prior consultation with the society. With the acknowledgment

of the gift came a command that the society should be called "Royal." Now, in addition to the Royal Academy in London, there was the Royal Society of British Artists.

Whistler's bold but secretive bid to outface the Royal Academy was not met with unalloyed enthusiasm by members of the society. They were becoming increasingly alarmed with Whistler's autocratic rule during the course of his presidency. The comic periodical *Fun* depicted him in a cartoon and a poem as a heron pecking away at the Suffolk Streeters [fig. 94]. Menpes related that he laughed till he cried at the society meetings led by Whistler. But he was drowned out by the complaints and angry shouts of the formerly dignified men around him. Members were not amused by Whistler's determination to make the society a battleground or by his juggernaut tactics. His unrelenting radical ideas and the "perpetual outlay upon peculiar decorations" were wearing thin. Late one night, the artist stayed at the Suffolk Street galleries and painted the doors and mantelpieces primrose yellow to match the yellow draperies from Liberty's. Some members registered complaints, and Whistler abruptly abandoned the gallery unfinished, leaving other members scrambling to tone down the yellow before the imminent arrival of the Prince of Wales.[145]

Whistler continued to insist upon blank wall space, which meant the reduction of members' works and fewer sales. The loss of exhibition space was calculated by members in square feet and pounds. He had abolished skying at the society and demanded that generously spaced pictures be hung only at eye level. Meanwhile, the critics continued to rave. "What a reform! What headaches saved!" Whatever the members' complaints, the press was complimentary. Whistler's series of new designs for the galleries revealed regard for the visitors. He also implemented many of the special oddities of his interior design style such as the use of brown paper wall covering, which caused George Bernard Shaw to describe the Suffolk Street

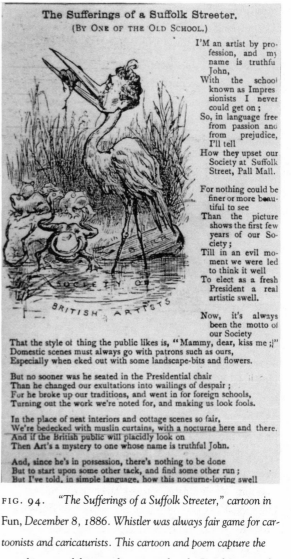

FIG. 94. *"The Sufferings of a Suffolk Streeter," cartoon in* Fun, *December 8, 1886. Whistler was always fair game for cartoonists and caricaturists. This cartoon and poem capture the upset his new exhibition policies caused at the Royal Society of British Artists.*

gallery as "a vinegar and brown paper bower." (Whistler presumably was the vinegar.) He was utterly determined to realize his concepts for exhibition installation in the larger sphere and bigger spaces of the society.[146]

However, Whistler's drive to transform a parochial British exhibition society into a cosmopolitan,

highly visible modern association was doomed. The society shared none of his international aspirations, and opposition to his drastic reforms and dictatorial methods did not subside. In June 1888, Whistler was asked to resign. He availed himself of his presidential right to convene a meeting of the society. Assuming a cheerfully magnanimous attitude, he fought his ousting by stating his case and by reading extracts from favorable press releases. Seeing himself defeated, Whistler invited the members of the society, in good fellowship, to join him in a parting glass of champagne.[147]

Every member had been brought in to approve his expulsion from the society—"the maimed, the halt, the lame, and the blind . . . everything but the corpses," according to Whistler. On July 2, 1888, Whistler's letter of resignation, written in his son Charles Hanson's hand, was submitted. He refused to hang any of his pictures in the current society show and withdrew his Liberty hangings and other fabrics. In an interview in the *Pall Mall Gazette* entitled, "The Rise and Fall of the Whistler Dynasty," Whistler remarked, "The 'Artists' have come out, and the 'British' remain." More than twenty of his artist friends had ceremoniously walked out of the society with him to protest his forced resignation.[148]

Afterward, many wistful reports appeared in newspapers remarking on the dull, "De-Whistlerized" exhibitions at the Royal Society of British Artists' "Sleepy Hollow." The society remained a somnolent place that Thackeray satirized as "a safe and secluded spot to make an assignation with a mistress or to secure absolute freedom from interruption if solitude was desirable."[149]

New Alliances, Salons, and One-Man Shows, 1889–1898

Whistler had to turn to other conquests and other markets. In the late 1880s he exhibited widely in Paris, Brussels, Munich, Amsterdam, and New York. On March 6, 1889, New York connoisseurs, critics, and the public, had a second chance to view a Whistlerian exhibition installation at Wunderlich's. Whistler had repeatedly promised a visit to America, but he never returned. His pictures and reconstructions of his exhibition designs, however, did reach his homeland.

The large exhibition at Wunderlich's—"Notes, Harmonies, and Nocturnes," an arrangement in pale pink—included sixty-two oils, watercolors, pastels, and drawings. A brown paper catalogue was issued, and pictures in plain frames were arranged on walls hung with faint pink silk. Tables, chairs, and woodwork were painted in a light peach-pink tint, a velarium of a similar hue was suspended overhead, and matting covered the floor. Two pink tables in far corners each held Chinese "deep liver red jars." The entire room harmony and artistic arrangement of pictures was identified as "'a Whistleresque concept' as was the yellow and white exhibition." The critic for the *New York Tribune* stated, "Fortunately Mr. Whistler has a fine decorative instinct—perhaps he might be called first of all a decorator." Another reviewer pointed out that the harmonized arrangement took the "spottiness" out of an exhibition. "Instead of each picture obtruding itself, they all become as so many notes in a soft chord of color. Whistler's decorative plans are the best part of his work."[150]

The effect of the subdued pink ambience on one reviewer was such that he instinctively hushed his voice and tiptoed through the "holy-of-holies of a cult. This is the temple of esoteric worship, and Mr. Whistler is the apostle of high art." He continued:

> You go through Mr. Wunderlich's shop, lift a portiere and you find yourself in a little square peach-blow-colored room, over the walls of which are scattered, in little flat gold frames, all alike, a quantity of little "Notes" and "Harmonies." There is a little peach blow vase in one

corner and a little light stand with catalogues in another, and that is all. The whole effect is extravagantly simple, and the diffused light and the strange color give one the impression that one is enclosed in the heart of some great pink lotus flower in the bottom of a lake.[151]

Who had created this evocative Whistlerian room? The writer for *Critic* solved the mystery. "You will stop to admire the room—everybody does,—and to think it so very Whistler-like, though it is the charming creation of Mr. Kennedy." E. G. Kennedy, the head of Wunderlich's, certainly was in consultation with Whistler about the controlled environment he devised for this second one-man Whistlerian installation in New York. The effect on visitors paralleled the reactions to the artist's earlier American show. At the rear of Wunderlich's, Kennedy had contrived a "restricted Fairyland" that people entered through a "rose-colored mist" to find themselves in "some eight-by-ten elysium."[152]

Kennedy's translation of a Whistlerian installation resulted in a modest success in sales. Twelve American collectors seized the opportunity to buy Whistler's pictures. Henry Havemeyer was a notable collector who stopped by the exhibition. He would most likely have been one of the appreciators of Whistler's demand for homogeneous interior arrangements for picture shows. His interest in avant-garde interior design was demonstrated by his hiring of Tiffany to decorate his home. Recalling his wife's fondness for the artist's Venice pastels, which she purchased eight years earlier, he selected three watercolors and a pastel for their collection. To Kennedy's chagrin, however, most of the works had to be returned to Whistler unsold.[153]

Whistler was allied with a group of young artists who had formed the New English Art Club in 1886 and mounted their first exhibition at the Marlborough Galleries. Following the decline of the Grosvenor Gallery, the club was considered the most progressive new exhibiting body in England. These artists shared with Whistler a critical attitude toward the Royal Academy and, like him, they were mostly Paris-trained. Members of the Glasgow school and Newlyn school were the first sympathizers with the New English Art Club. But by 1889, an impressionist clique led by Walter Sickert and including Fred Brown, Paul Maitland, Philip Wilson Steer, Sidney Starr, and Theodore Roussel, all of whom were stalwart supporters of Whistler, constituted the leadership. Whistler was keenly interested in the group; he sat on the jury and sent an early oil and a new etching of Brussels to their third exhibition in June 1888 and participated in their May 1889 exhibition. Later, he fell out with the group over his battle with Sickert during the Eden affair in 1894. When Whistler was made president of another exhibiting body four years later, it was his express aim to supersede the New English Art Club, which he found, Laver declared, "wholly ridiculous." Yet, in 1902, a few months before his death, he was advising Richard Canfield he "had better go and see the 'New English Art Club' exhibition."[154]

Despite differences, Whistler was certainly the leading spirit of the New English Art Club. He had fought against British insularity, brought down the authority of Ruskin's prejudices, and set himself up as a symbol of independent thought. A description of the group's 1889 exhibition has a familiar ring. "The New English Art Club have a very striking exhibition at the Dudley Gallery. . . . pictures are well hung and are neither "floored" nor "skied" and a pretty *valerium* [*sic*] prevents the light coming down too strongly on them." The *New York Herald* reporter observed, "The Hanging Committee of this year of the New English Art Club seems very properly, to be of the opinion that the arrangement of the pictures for public inspection may in itself be made a subject of careful consideration, and may call for the exercise of the same nice sense of balance and harmony, as each painter would wish to bestow on that portion of the exhibition

which is contained within the frame of his own picture."[155] Whistler had bequeathed to a leading group of England's most avant-garde artists his legacy of high standards for the art of exhibition. It is conceivable that he may have had a direct hand in the design of some of their installations as well.

Ironically, at the moment that Whistler was booted out of the Royal Society of British Artists, his influence and fame had begun to build and a number of awards started to come his way. To celebrate the awards, a banquet was held for him on April 28, 1889, in Paris, and following that, on May 1, two hundred of the chief artists in the English art world came together for dinner at the Criterion in Piccadilly Circus. Sir Coutts Lindsay spoke, and Whistler was very touched. In the same month, he showed in the British section of the Paris International Exposition, and in the autumn, he had three paintings in the international exhibition in Amsterdam. Also in May, his right-hand man, Walter Sickert, honored him by organizing a major show, a remarkable retrospective exhibition of more than fifty works. And many of his most important pictures were shown at the invitation of Miss Gould, principal at the College for Working Men and Women at 28 Queen Square, beginning on May 2.[156]

At the college, Lord Halsbury opened the exhibition, an arrangement in blue and white, to a large crowd; but no catalogue was issued, and the press response was comparatively indifferent. The show was the antithesis of a Whistlerian exhibition in several respects. Inefficiently organized and rather casually decorated, it seems to have been a languid affair, devoid of the usual Whistlerian dynamics. Whistler was irked by the tepid response, but Ellen Cobden Sickert found it "the most perfect thing in London . . . the rooms are exquisite—the pictures hung in these wonderful old rooms show to wonderful advantage."[157]

A representative selection of Whistler's work was displayed, including his portraits of his mother, Carlyle, Rosa Corder, and Sir Henry Irving, along with many pastels, watercolors, and etchings. Whistler injected a note of spice by attempting to walk off with one of the pastels on loan by its owner. The lender had warned of just such a happening if the work was left unprotected. Miss Gould pursued Whistler and recovered the work from the artist, who objected to the frame. Whistler was incensed when his simple pieces were incorrectly reframed and forever impatient with the "dull and impertinent people happening to possess my work."[158]

Thomas Way recalled that, after the opening, few bothered to visit the exhibition. Apparently, Whistler's meticulous and flamboyant method of presenting his one-man exhibitions was necessary if he expected his work to be seen and purchased. George Thomson of the *Pall Mall Gazette* described his visit to the exhibition at the eighteenth-century Queen Anne house in Bloomsbury, which had an "air of old-world quiet." Whistler's work hung in the second-floor drawing room, which was up a half-dozen steps to the back. Thomson found that the bay windows at one side let sunlight into the room for a pleasant combination of light and shade. The scanty furnishings included a grand piano and a few frail, black, cane-seated chairs; couches had been draped with blue-and-white coverings, and flowers were arranged in blue porcelain pots on tables.[159]

Sheridan Ford questioned whether Whistler's arrangement in blue and white exhibition at a college for middle-class working men and women, to aid the funds of the college, meant he had "turned from the joy of the purposeless painting to tread the path of the reformer." A year later, when editing his version of *The Gentle Art of Making Enemies*, Ford summarized Whistler's contribution to exhibition design.

> Every year saw some assertion of his leadership in all decorative matters. His initial exhibition in Pall Mall, in 1874, where for the first time walls were brought into harmony with the pictures . . .

and his many brilliant successes in Bond Street—at The Fine Art Society and at Messrs. Dowdeswell's—are accepted facts in the art history of London. Each of these especially embodied the demonstration of a problem of a colour scheme in decoration, and was heralded by the title of the room's "Arrangement." . . . His transformation of the Suffolk-Street Gallery is not likely to be forgotten. Oblivious to the interests of the working-man, whom he neither asks to make wall papers, cretonnes, nor carpets, he is—notwithstanding—perhaps the greatest socialist of them all, through having inaugurated in his exquisiteness of colour and ordered harmony, a simplicity—with the use of distemper, matting and muslin—that suggests an art democracy in which he himself professes no belief.[160]

In 1889 and 1890, a split within the Paris Salon caught Whistler's attention as had the earlier splinter group Les XX. The breakup was caused by disagreements about exhibition systems and an interest in unifying the arts. It resulted, in 1890, in the creation of two factions: the Société des Artistes Français and the dissident wing, the Société Nationale des Beaux-Arts. This latter group held their salon in the Palace of the Beaux Arts on the Champ-de-Mars, abolished the system of medals and rewards, and for the first time treated applied arts with equal respect. Among those who joined this group were Auguste Rodin, Eugène Carrière, Pierre Puvis de Chavannes, Jules Dalou, and Edouard Dubufe—all individuals devoted to the decorative arts—and symbolists and art nouveau artists. Duret wrote that Whistler "rallied to the new society and chose it as his exhibition ground for the principal works he wished to make known in France."[161]

The reasons for Whistler's interest in the society are clear. The first salon of the Société Nationale des Beaux-Arts, held in May 1890, was modeled on Les XX exhibitions, with decorative arts receiving the same recognition as sculptures and paintings. And the French aim to aristocratize the decorative arts, rather than democratize them in the English mode, was in line with Whistler's thinking. Another objective of the new salon was to give artists greater control, something for which Whistler had long fought.

Whistler was staging a comeback in France. He had sent two pictures to the 1885 Paris Salon and, at the invitation of the impressionist group, exhibited fifty of his small oils, watercolors, and pastels in the International Exhibition at the Georges Petit Gallery in 1887. In 1888 he participated in Durand-Ruel exhibitions, and in 1889 Félix Fénéon noted the "action de M Whistler" when he wrote his Paris Salon review. Symbolism was becoming increasingly important, and Whistler was perceived as a progenitor. The reformed salon of the Société Nationale des Beaux-Arts became one of the major venues in which Whistler attempted to reestablish himself as an important exhibitor. *Nation* reported in 1890 that "the arrangements for exhibiting this unusually fine collection are usually good. They prove how much the general effect of a picture depends upon artistic thought and care in hanging. There is no senseless piling of frames upon frames, often there is but one painting on the line."[162]

In 1891, Whistler, as a *sociétaire*, showed two paintings at the Société Nationale des Beaux-Arts: *Arrangement in Black and Brown: Miss Rosa Corder* and *Nocturne in Blue and Gold: Valparaíso Bay*. Whistler again joined the society for its exhibitions in 1892, 1894, 1897, and 1902. In 1892 he served on the jury and sent his portrait *Valerie Meux: Harmony in Grey and Rose* and several nocturnes. When Pissarro visited the group's exhibition in April 1894, he found, "as in other years, nothing extraordinary at the Champ-de-Mars, that is, besides Whistlers and Puvis de Chavannes. Whistler's Portrait of *Montesquiou* is very beautiful, in gesture and rakish elegance."[163] By this time Whistler had left London and was living in Paris. His parting gesture had been a stunning one-man show at Goupil's.

None of the works in Whistler's March 21, 1892, retrospective at Goupil's Gallery were for sale; all forty-three entries had been obtained from collectors. This fact greatly influenced how Whistler set up the show. Unlike previous installations, it was not designed as a demonstration. Whistler could afford to let the work stand alone. Little did he realize, however, that the resounding success of the Goupil exhibition would precipitate a sharp rise in the prices for his work. This led a number of English collectors to sell their Whistlers for huge personal profits, which infuriated him.[164]

Despite the fact that this exhibition, "43 Nocturnes, Marines and Chevalet Pieces," was not calculated to promote sales, it is still difficult to explain Whistler's sudden indifference to color orchestration for the installation. His exhibition designs for shows at the Fine Art Society, Dowdeswell's, Wunderlich's, and the Royal Society of British Artists added up to more than a dozen. All of them were characterized by meticulously worked-out schemes of color—to a point that bordered on fanaticism. These coloristic interiors that seemed to emulate eighteenth-century rococo ensembles were the epitome of haute couture 1880s aestheticism, reflected exotic *japonisme*, predicted symbolism, and foreshadowed art nouveau interiors at the end of the century. In other words, Whistler's exhibition installations were richly evocative interior spaces that drew upon tradition, caught the moment, and anticipated future developments.

Why did Whistler drop his phenomenally successful color-fantasia style of exhibition design? Why not the usual decorated ambience that his fans had come to expect? Several possible factors might have come into play. By 1892, Whistler's prestige was high. His work had been purchased for national collections, and he had a number of wealthy patrons.[165] His status as a connoisseur was recognized by the Liverpool Art Society in August 1891 when it asked him to be on the hanging committee for its autumn exhibition. Perhaps Whistler had taken the concept of

painstaking color arrangements for exhibitions as far as he wished. His other shows had generally featured smaller works, whereas for the Goupil exhibition Whistler had carefully selected choice oil paintings from the previous thirty years.

Whatever his reasons, Whistler set aside his harmonic color approach at the very moment that art nouveau designers were poised to invent even more opulent, organic, color-rich interiors. For this exhibition Whistler pulled back from his overwhelming focus on color and refined elegance in favor of something far less contrived. His move toward a more neutral interior space in this exhibition, less nuanced and less like a living room, may have represented another stage in the development of his concept of exhibition design.

Perhaps Whistler was a minimalist at heart. His unapologetic serving up of art in an undecorated environment would not have been considered acceptable earlier, when only wall-to-wall pictures had seemed to justify inviting a crowd. To compensate for the threat of bare wall spaces in his exhibitions, Whistler offered unique, artful decoration. However, by 1892, his confidence in his own work was such that he could present it in a well-arranged but unadorned gallery setting. Thus the design of his Goupil show was not only more Japanese in its restraint and understatement, it also closely approached the character of exhibitions as we know them today.

Whistler's move to Paris in 1892 necessitated a flurry of long letters to the critic and Goupil Gallery art dealer and manager, David Croal Thomson, in London, who was carrying out his commands for the arrangements for the show. Their correspondence documents Whistler's extreme thoroughness in planning this exhibition.[166]

Above all, Whistler wanted his Goupil show to have the character of a triumphant surprise moment that would happen suddenly and disappear quickly. He was adamant that the timing be exact. He wrote

Thomson, "I have a feeling that after all you have not chosen the very best moment for this business." Introducing the idea of fleeting time was a reflection of Whistler's Paterian sense of the exhibition as a heightened moment of living theatre—beautiful and ephemeral like a butterfly, and gone with a poof in the wind. He told Thomson, "Now let me assure you that the very *shortness* of duration is one of the best elements of success—giving it a character of smartness and crispness and above all of preciousness and rarity. . . . The people must feel that it is not the usual long dragging call for shillings, but a rapid occasion, over in a moment." Even the posters, which were to be very simple, would state, "for 3 *weeks* only." He added, "I mean everything to be *very simple*—with very little demonstration—if any."[167] Whistler's stark installation for this exhibition and his increasingly restrained designs for private interiors prefigure the international style in twentieth-century architecture.

The pared-down approach carried through to the catalogue, which was intended to rival his controversial 1883 production. Again, it was his intention to take revenge on critics, and particularly on Ruskinian forces. On March 1, he sent Thomson a letter containing various sketches. There were three designs— front, back, and title page—for the catalogue, which would have a "brown cover as usual . . . some rough paper for inside as usual." All type was to be italic. Thomson sent Whistler four volumes of Ruskin's *Modern Painters* for perusal to find extracts to include in the catalogue. Later, Whistler sent Thomson a quote he had selected from the Ruskin trial for the first page: "I do not know when so much amusement has been afforded to the British Public as by Mr. Whistler's pictures. Speech of the Attorney General of England, Westminster, November 16, 1878." The quotes were designed to expose inanity in the writings of figures such as Frederick Wedmore, a critic who had regularly downgraded his work. Later, Whistler wrote Thomson that absolutely nothing would be left to chance in the design of the catalogue. "I want the

whole page—I must judge . . . the effect of the thing in its *entirety* and *completeness*. I want to see *exactly* how the type and the margin go together—what the relative proportions of black and white shall be. . . . I want to regulate and fix once and for all the *exact* placing of every letter."[168] Whistler was a designer to the core.

He also sent Thomson a poster design, stating, "If you have this enlarged in exactly these proportions, you will thus produce the most distinguished thing in Posters I have yet seen. The *white* appearance of the whole will be its characteristic." Thomson sent back the resultant sample, but it was not satisfactory. Whistler again made a sketch. "You understand the correction. Would like the whole thing to look whiter— that is more brought together or rather larger margins."[169] Despite his efforts, a rather ordinary poster resulted. Even though it was less black with print than the usual posters of the day, the style of his design was not scrupulously duplicated. His *japoniste* love of the void and his inclination toward simple modernity remained evident. Indeed, the theme of the show was the void, space, clarity—Whistlerian purism at its height.

While peppering Thomson with lists of directives, the artist himself was busy working day and night. He "applied to the owners, corresponded with them and cajoled the unwilling into letting him have their treasures." Thomson was struck by Whistler's "intense application" and felt he had "received a great lesson in the art of arranging a collection."[170]

Whistler had written Thomson, "I mean everything to be a success and shall run over myself two or three days beforehand." This was the point at which a reporter caught him [fig. 95]. "I made my way to Goupil's the other evening, feeling sure that if I knew anything of Mr. Whistler, he would be on the spot supervising the hanging of the pictures which were to be shown to the critics on the morrow." Persuasive talk was needed to distract Whistler from the task of hanging the show. "[However], in a minute or two the

heavy, mysterious-looking draperies that covered the entrance to the Whistler galleries were drawn aside and the famous painter himself darted towards me with a greeting of characteristic cordiality." The interviewer, naturally enough, asked, "Well, Mr. Whistler, have you any surprises for us this time? Any dainty delights in drapery?" Whistler responded that the catalogue, with its parody of the critics, would provide amusement and broke into his piercing Ha, ha, ha! The reporter inquired, "A Whistler exhibition without any decorations will seem strange to the private viewer, won't it?" Apparently there was no answer, for "Whistler was fidgeting to get back to his congenial task of picture-hanging." The critic said he would catch him on another day, but Whistler replied, "You won't find me. I only ran over to see the show through. I leave for Paris at once."[171]

Whistler's exhibition at Goupil's may have lacked elaborate decorations; however, the frames of the forty-three pictures alone provided considerable decorative interest. His concern about frames, which dated back as early as 1862, was undiminished. He sent Thomson directions for cleaning and varnishing the paintings and putting them in new frames of his own design to achieve uniformity. He also implored his collectors, such as the Alexanders, to have new frames made according to his design.[172] The fusion of the frame with the work clarified its status as a decorative art object. The obsession with borders, evident in the wallpapers, carpets, and drapes of the aesthetic period, was expressed by Whistler in his focus on frames.

Whistler's earliest personally designed frame may have been in 1864, for his painting *Purple and Rose: The Lange Leizen of the Six Marks* [see fig. 9]. This work, which he exhibited at the Goupil show, has a flat, gilded oak frame covered with five rows of carved spirals and six circular designs containing Chinese characters; its outer edge has carved Chinese motifs. His first Japanese pictures all received similar simple, but

FIG. 95. *"Mr. Whistler in Bond Street," Goupil Gallery exhibition review, in* Pictorial World, *February 27, 1892. Whistler's highly successful retrospective show before his departure for Paris puzzled viewers because it lacked the special Whistlerian decor.*

luxurious, frames decorated with Oriental motifs. He painted each frame individually to enhance the painting, though the frames related to each other as well. Seventeenth-century Dutch frames also influenced him, as well as the tradition of coordinated frames established by the Pre-Raphaelites. He patterned frames after Rossetti's designs, but the final results were original. In the early 1870s, he introduced his checkerboard motif. Jeckyll's use of striated moldings in his furniture and interiors suggested a prototype for the elegant style of framing that Rossetti used and that Whistler adopted from 1875 on; it became known as the "Whistler frame" [see fig. 20].[173]

These wide simple frames were incised with parallel, reeded lines and were gilded or bronzed. Whistler first painted them red, green, or blue and then scumbled over the colors with gilding. They framed oils, watercolors, and pastels and were keyed to the

palette of the painting. Greenish gold frames were often used for nocturnes in which blue and green were dominant. Reddish gold was used for paintings emphasizing flesh tones. Godwin had advocated the technique, and Whistler in turn used it for creating burnished and abraded effects on dados, panels, and ceilings.[174]

Often, Whistler painted his butterfly signature on his frames. It appeared strategically placed to balance and complete the total effect of the composition. Sometimes on flat sections of the frames, between the reeding, he applied motifs such as sea waves, clouds, parallel lines, whorls, checkerboards, fish scales, petals, basket weave, herringbone, bamboo, and in one case a musical passage. Whether incised, cast, carved, painted, wide, or flat, the frames were always restrained and delicate in effect. Whistler copied motifs he found in Owen Jones's *Grammar of Ornament*, pattern books, Japanese porcelains, and woodblock prints.[175]

Whistler's early frames were made by his assistants, the Greaves brothers, and some of his last were done by Edward "Teddie" Godwin, his stepson, who was a sculptor. They constituted a radical departure from heavy, ornate Victorian frames. In 1891, when Dowdeswell's exhibited an unfinished Whistler canvas depicting women in a conservatory—*Three Figures: Pink and Grey*—in a non-Whistlerian frame, Whistler wrote to the *Pall Mall Gazette* protesting, "I am in no way responsible for the taste of the frame with its astonishments of plus and varied gildings!"[176]

Walter Sickert would eventually become critical of Whistler's framing style and of his exhibition decor, accusing him of being "hampered by an excessive dose of taste." But when he reviewed the Goupil Gallery show, he was transfixed by "the great tall, dark canvases." He found that "in the large gallery you are conscious at once that the works give to four bare walls an atmosphere of repose and grandeur, suggesting in no way a shop or an exhibition."[177] Later, after his falling out with Whistler and his alliance with Degas,

Sickert's opinion of Whistler's theatrically chic exhibition installations changed radically.

> The Whistlerian *mise en scène!* Hangings and overpowering frames, frames, frames, out of all proportion to the matter enclosed in them. . . . More and more do I find myself confirmed in the opinion that Whistler's too tasteful, too feminine and too impatient talent had need for its development to remain in the severe and informed surroundings of Paris, the robust soil where his art had its birth. A wholesome fear of the tongue of Degas, if nothing else, would perhaps have nipped in the bud his growing reliance on the *snobismes* of *réclame* and of *mise en scène*. The effect of the exhibition is rather that of a hat-shop with a stock that is not quite up to date than of, shall we say, the lawn at Ascot.[178]

If Whistler learned of Sickert's hat shop dig, it struck a nerve, certainly. The fact is, with the Goupil installation, Whistler had already begun to make a change to a starker form of exhibition. Mindful of reviews stating that his elegant decor distracted from the work, he sensed that his once avant-garde approach to exhibition installation had dated.

His standardized frames, however, still seem modern. One of these frames was "thin black—narrow—with a thin flat strip of gold," as he described it to a patron, Alfred Chapman, telling him also that a large white margin would be needed for his etchings, which should be mounted rather high within the frame.[179] Eventually, Whistler confined his work to definite sizes so that he had ready-made frames to fit his pictures. Also the uniform frame sizes contributed to the look of continuity he wished to achieve in his exhibitions.

For his 1883 etching exhibition he had designed narrow white frames with wide mats to hang on the white baize walls. Degas, Pissarro, Gauguin, and many of the impressionists also used white frames in an attempt to neutralize the setting and let the painting

come forward. In 1858 Degas had sketched simple, flat frames in his notebooks; Whistler was influenced by these ideas at the beginning of his career. He sometimes added blue, grey, brown, black, or purple lines, bars, or patterns on his white frames. When he used these frames for etchings and lithographs, the total effect of picture and frame was frescolike on the white walls. It was the antithesis of typical ornate Victorian frames on ruby red damask walls. Pissarro, writing from Paris to his son Lucien, who was in London, on April 24, 1883, said, "I find it curious that Durand should have used white frames for my pictures [in London], when here he won't permit it under any circumstance." He had not seen the London show that Lucien described to him, and commented, "What you report about the way the pictures were crowded together is terrible. We are not guilty of such lapses here. It is true if the tapestries are that frightful official red, there is no remedy. Yes, Whistler is right, here is another convention which must be demolished." Later he commented, "You see how much importance Whistler attaches to the mode of presentation and he is right to do so."[180]

Even without the lure of an interior designed to be an extravaganza of color, the Goupil galleries were crowded. Hundreds of invitations went out, and guests went to meet Whistler as much as to see the canvases. The artist, however, did not greet and charm them; he and Beatrix arrived at about five o'clock and remained in a curtained-off section of the gallery. Thomson recalled, "Crowds thronged the galleries all day, and it is impossible to describe the excitement. . . . I do not think I am exaggerating when I say that this collection marked a revolution in the public feeling towards Whistler."[181]

The critic for *Saturday Review* went so far as to commend Whistler on the *lack* of decorations. "Nor can we fail to commend the reserve which the painter has himself shown in the arrangement of the gallery." He noted there was no daffodil-colored attendant, no "butterflies dancing about the place on wires" and no "pale green and gold hangings" to distract attention from the pictures. However, Elizabeth Pennell, in *Nation*, expressed her ambivalence about the missing Whistlerian touches.

> To those who look only for eccentricity from Mr. Whistler the show must be a disappointment. There are none of the yellow canopies and yellow walls, none of the fluttering butterflies and original schemes of decoration which his name suggests. The pictures, many in old tarnished frames, hang on Messrs. Boussod and Valadon's red walls . . . and the visitor looks at them from the upholstered sofa of commonplace commerce. The one old Whistler touch is in the catalogue, in which he has collected, as of yore, choice criticisms by men of note.[182]

The original scheme of decoration was absent, but Whistler was exultant, especially with the "fury of the press!" After the show had been open for eight days, he wrote gleefully to Thomson, "The post has brought me an enormous sheaf of '*cuttings*'—as it does every day—Really there is no doubt that this is what is called a 'howling success'—it cannot be disguised." Later he wondered whether Ruskin had been sent a card of invitation. "You certainly ought to post him a season ticket at once!" Whistler decided to admit artists free in the morning up to eleven o'clock. Bernard Partridge did a *Punch* cartoon based on this announcement, which provides a tantalizing glimpse of the entrance to the Goupil exhibition [fig. 96]. By April 6, Whistler was considering whether the exhibition should be kept open another week.

> You see what a stupendous "event in Bond Street" it has been—I think [of] the visits of the Dowdeswells! Excellent!—Well of course it must finish in this way—One *blaze* to the end—and then absolutely vanish. Wherefore it would never do to attempt the extra week if you thought that there were the faintest chance of

FIG. 96. *Bernard Partridge. "A Brother Pastellist," cartoon in* Punch *102 (April 9, 1892): 171. The illustration shows the draped entrance to Whistler's London retrospective at the Goupil Gallery.*

the fever heat subsiding, of the people's interest diminishing—and of its all fizzling, or flickering out in smoke in the last added days—If it could be done—at the same splendid tension of excitement, well it would be a magnificent coup.[183]

Whistler wanted to leave London in a blaze of glory. With his Goupil exhibition, he quite accomplished it. To Thomson he wrote, "How thoroughly pleased and satisfied I am with the manner of your management of this Exhibition. . . . [It] has been such a perfect episode in the general crusade against the Philistine!" Whistler had more than regained the recognition of the English public that he lost at the time

of the Ruskin attack. He later referred to his Goupil exhibition as "my heroic kick in Bond Street."[184]

Whistler's final one-man show in London, several years later, was an exhibition of lithographs at the Fine Art Society held from December 1895 through January 1896. By then Whistler was sixty years old; he and Beatrix had settled in Paris two years earlier. They had imagined it to be their final home, but by December 1894, Beatrix had become ill and they returned to London.

Whistler had planned a publication of lithographs to be printed by Belfont and published by William Heinemann in London. Its title, *Songs on Stone,* was Mallarmé's phrase for lithographs. Unfortunately, Belfont closed his shop in 1894, and Whistler's lithographic stones disappeared. However, with Beatrix's encouragement, lithography became Whistler's new passion. His finesse in the medium had been recognized in 1893 by André Marty, the French editor and publisher, when he asked Whistler to submit prints for a portfolio of lithographs entitled *L'Estampe Originale.*[185]

The seventy-five lithographs that Whistler was preparing for his show at the Fine Art Society in 1895 were a mixture of Parisian and London scenes, Venuses, Chelsea shops, *intimiste* scenes of domestic life in Paris, subjects done in Lyme Regis, and a portrait of Stéphane Mallarmé [see figs. 72, 79]. Whistler was working in conjunction with the lithographer Thomas Way. He sent Way seven pen sketches of some of the lithographs he was executing in Lyme Regis, where Beatrix continued to convalesce. From Dorset, Whistler wrote Way, "I shall have another half dozen ready [for printing] directly."[186] The Fine Art Society show had developed when Whistler was approached by Huish, who had not been through the rigors of a Whistlerian exhibition for more than twelve years. The artist decided he would take the opportunity Huish offered and exhibit his lithographs, even though, since he was preoccupied with his wife's

illness, it was not the right moment. He told Way the show would be his contribution to the centenary of the invention of lithography. For the first time he asked someone—Joseph Pennell—to write a preface for the catalogue.[187]

Whistler took some interest in plans for the exhibition. He suggested a young man "who has done the Butterfly scores of times on all my silver" be hired to do the butterfly on the engraved plate for the invitation, for "it may as well be perfect." A correspondence ensued between Huish and Whistler on the matter of designing a banner to hang outside the society entrance to advertise the exhibition. Huish noted the society had used one for its previous show and that it "brought the people in splendidly." He asked Whistler whether he would object to having one, and Whistler agreed to the idea. He tried various square designs and then drew a long, narrow, elegant triangular flag in black, brown, and yellow, nothing like Huish's suggestions for square or blunt triangular banners [fig. 97]. Whistler annotated his drawing, "*Flag pale yellow*— cool in tone. *Square* properly fit in pale *Brown*. Like the covers of my old catalogues. *Butterfly. Black*. The *tail* a small dot. The pale yellow of the flag again." He added, "Pretty isn't it?"[188]

Inevitably, Whistler became involved in the preparations for the exhibition. "Now what do you think," he wrote Huish, "of all the pretty things I have been doing for *your show?* You see I *knew* it would be so. You thought I was to have no trouble! And now I am up to the neck in the whole business. I can't help it. But I *do* know how to do these things delightfully don't you think! There is nothing mean or modest about *that* is there?" Despite the gloom of his private life, Whistler was apparently in his element. In "Mr. Whistler's Lithographs," Way's review for the December issue of *Studio*, he declared that the London exhibition "goes far to put us on an equal footing with Paris."[189]

The exhibition, however, was not well covered by the press and did not stop traffic on Bond Street. The Pennells said the exhibition "was far from a financial success, and no one save a few artists paid the least attention to it." The lithographs could be bought for two or three guineas, but few bothered. (Years later, in 1919, at the Anderson Gallery in New York, several of these same prints sold for a total of forty thousand dollars.)[190] Whistler suffered a terrible disappointment at the lack of interest in his explorations in lithography. Within a few months Beatrix died, and he never did another lithograph.

Exhibition Arrangements for a World Stage

One might think Whistler's enthusiasm for staging unorthodox, independent exhibitions would have faded after the disappointing response to his show of lithographs. Certainly, his experience at the Royal Society of British Artists, where his experimental ideas for group shows met with alarm and anxiety, should have permanently discouraged him from entertaining any further visions of major exhibition reform or combating insular attitudes toward modern art in England. This, however, was not the case. Yet, without the instigation of a small group of young artists who called upon him to lead them in the grand venture of staging international art expositions, it is doubtful he would have found a venue for his avant-garde exhibition concepts. Whistler's role in English art in this regard has seldom been reviewed. Curiously, while the Grosvenor Gallery and the New English Art Club have received critical attention for their roles in the development of late-nineteenth-century English art, the exhibiting organization led by Whistler, which introduced modern foreign art in England, has received scant notice.[191]

The idea for organizing an international exhibition took root on December 23, 1897, when a few artists in an association called the Company of the International Exhibition met at the unlikely venue of Prince's Skating Rink in London. Artists in

FIG. 97. *Design for a Banner or Flag, 1895, 3½ x 4½ in. (8.8 x 12.3 cm). Whistler designed a banner to hang in front of the Fine Art Society in London to advertise his exhibition of lithographs. The sketch was enclosed in a letter to the society's director, Marcus Huish. Whistler LB 3:37, Birnie Philip Bequest, Glasgow University Library.*

attendance at the first meeting included John Lavery as acting chair, E. A. Walton, George Sauter, and Francis Howard. Whistler, Alfred Gilbert, and others sent telegrams and letters. Apparently, considerable discussion had preceded the initial meeting, since the council was prepared to deal with the business of extending "formal invitations of Honorary Membership to a list of distinguished artists from abroad"[192]

Whistler's cosmopolitan outlook, fighting nature, and outsider status had long ago caused him to consider the idea of staging independent international exhibitions of advanced art. His experience with the Royal Society of British Artists, however, had taught him that one man alone could not break down the barriers of parochialism in Britain. Whistler and E. A. Walton, a Glasgow Boy, had looked into leasing the Grosvenor Gallery, which had closed in 1890, for the purpose of holding a modern art exposition. When this failed, they considered the Grafton Gallery. Whistler was searching for a gallery in which he could show advanced European art and place his own work in the context of the exhibition in order to make a cogent demonstration of his influential role in the course of the evolution of modern art.[193]

It was not until 1897, however, that Francis Howard, a young American painter and journalist, promoted the idea of forming a company to hold a comprehensive modern exhibition at Prince's Skating Rink in Knightsbridge. Whistler was eager to cooperate with Howard, Lavery, Walton, and Sauter, but he at first opposed staging the exhibition at a skating rink, though it was centrally located and the most fashionable meeting place of the day. He was eventually persuaded, however, when he learned that Admiral Frederick A. Maxse, owner of the rink, was willing to invest four hundred pounds to transform the interior into an art gallery to be known as the International Gallery. Maxse charged the artists no rent, relying on a percentage of the gate money for his return. When Whistler realized the artists would be in

control and would incur no expense, he offered his full support.[194]

A row broke out at the second meeting of the Company of the International Exhibition, held on February 7, 1898, and chaired by Alfred Gilbert, a sculptor, over a "most unfortunate" list of names that Howard had suggested as exhibitors. Approved members were Gilbert, Lavery, Walton, Sauter, Howard, Arthur Melville, Charles H. Shannon, Maurice Greiffenhagen, William Rothenstein, Joseph Farquharson, Frederick Sandys, Charles W. Furse, Charles Ricketts, James Guthrie, and Whistler. It was noted that about four hundred works were needed to fill the gallery. By the third meeting Gilbert had retired from the executive council; he was fearful of jeopardizing his association with the Royal Academy. He had been successful, however, in insisting that the prospectus state that the Company of the International Exhibition would not be in opposition to existing institutions.[195]

A more dynamic, oppositional approach, however, was exactly what Whistler had in mind. Although initially he appeared to go along with Gilbert's bid to lower the temperature of the Company of the International Exhibition, he soon expressed his firm objection to dual membership. This effectively eliminated outside memberships in the Royal Academy and the New English Art Club. The latter he described as "only a raft!" whereas the Company of the International Exhibition was a "fighting ship." And certainly from Whistler's point of view, the International (as it was called) represented organized revolt, particularly against the Royal Academy.[196] Neither Sickert nor Menpes, both of whom he had quarreled with, exhibited at the International, though Menpes had been admitted to membership against Whistler's objections. Whistler's insistence that his protégé Albert Ludovici be accepted led to a violent disagreement and resignations. But he held to it because Ludovici, who moved easily between London and Paris, could act as a contact man for him. He dispatched

Ludovici as a diplomatic envoy to persuade a number of French artists to join the International. He also insisted on the presence of Joseph Pennell in the membership.[197]

Stormy meetings inevitably resulted from Whistler's biases and dictatorial tactics, but at the fourth council meeting, held February 16, 1898, "Mr. Whistler was unanimously elected Chairman of the Executive Council." Also, the "disposition of the rooms (two large and two small) was agreed upon . . . and the Chairman was empowered to procure designs and estimates of the work proposed." As acting chair, it was Lavery (a Glasgow Boy) who acted as pressure valve for the conflicting forces within the International while carrying out Whistler's steady stream of commands. Whistler, who was glorying in his unquestioned power in directing the project, at one point remarked that "Napoleon and I do these things." Inevitably, Lavery's enthusiasm for Whistler cooled somewhat as the commands continued. A long list of artists had been sent invitations to exhibit. Whistler strongly objected to invitations going out to "amateurs" and wrote to Howard on April 10, 1898, "I might possibly had I known in time, have prevented the folly of certain amiabilities toward such typical mediocrities as say Mr. East and Mr. Maclure and dear me who else, *Little groups of lunchers at the Arts Club.*"[198]

Nevertheless, though time was running short for organizing such a large show, a strong attempt was made to make the exhibition genuinely international. Artists from America, Austria, Germany, Switzerland, Italy, Norway, Holland, Sweden, France, and Belgium were invited to exhibit. Americans included William Merritt Chase, Waldo Story, Frederick MacMonnies, and Augustus Saint-Gaudens. There were twenty Germans, and France was represented by forty-two artists, including Edouard Vuillard, Pierre Bonnard, Camille Pissarro, Alfred Sisley, Paul Cézanne, Pierre Puvis de Chavannes, Théophile-Alexandre Steinlen,

Auguste Rodin, Claude Monet, and Edouard Manet. Ludovici had convinced Whistler that Cézanne should be invited, even though Whistler particularly disliked his work; someone else highly recommended Pascal-Adolph-Jean Dagnan-Bouveret. Some of the most controversial symbolists, like Félicien Rops, Giovanni Segantini, Gustav Klimt, Fernand Khnopff, and Odilon Redon were included. Whistler remarked that he was "doing away with the 'parochial' side" and that there was "now an immense interest firmly established" for the upcoming exhibition. "What a show the Frenchmen will make!"[199] Durand-Ruel's compliance with Whistler's requests for French modernist works was one of the keys to this representation.

The English contingent of 104 exhibitors was the largest and was led by Aubrey Beardsley, Charles Conder, Walter Crane, George Sauter, and T. Stirling Lee. Of the forty-one Scottish artists, the core group was the Glasgow Boys, all of whom took part. (Margaret MacDonald and C. R. Mackintosh did not exhibit with the International until 1899.) While the English presence was large, it was the Scots who formed the backbone of the International. Many were fervent followers of Whistler and considered his "Ten O'Clock" the gospel. They were a cosmopolitan lot of artists, most of whom had studied in Paris, Munich, or Glasgow. A grand total of 256 painters, sculptors, and printmakers consented to exhibit in the first International. They were hung together and not divided into nationalities or schools, one of the aims being "the non-recognition of nationality in art."[200]

The original planners were set to stage a brilliant blockbuster exhibition that would showcase, in the insular environment of England, the richly diverse work of major modernist artists throughout Europe and America. It was the closest thing in Britain to a secessionist exhibition. Indeed, Whistler was so busy organizing the International that he had to turn down a request from Gustav Klimt, president of the Society of Austrian Artists, to exhibit with the Vienna

secessionists. Klimt had made a point of emphasizing to Whistler that the Vienna group's show would be highly select and not the "ordinary gigantic 'art-warehouse' so refractory to good taste and art." Evidently Klimt was well acquainted with Whistler's demanding standards for well-hung exhibitions. In the last years of the century, Whistler exhibited with several European secessionist groups springing up on the continent and won medals and honors at those shows.[201]

Whistler officially accepted the position of chair of the International when the group convened on February 24, and at the April 23 meeting the group unanimously elected him president. The group also changed its name to International Society of Sculptors, Painters and Gravers (ISSPG). This somewhat cumbersome name—which may not have helped the group to be remembered in history—was the title under which the group would continue to sponsor international exhibitions through 1925. The final meeting of the ISSPG occurred on December 16, 1927. The ISSPG began to lose firm direction during the period of Whistler's increasingly ill health and under the benign presidency of Rodin, who remained in office until 1917. Sharp discernment disappeared and infighting increased, causing the ISSPG to decline rapidly and ultimately to relinquish its avant-garde status to the New English Art Club. Blanche recalled that Rodin "would raise no objections" to hanging various exhibitors, whereas Whistler "had shown uncompromising severity which made allowances for no one's feelings."[202]

When Whistler took over the helm of the society, he was living in Paris at the rue du Bac and was not able to travel because of illness. Still, there was no question that Whistler was in control, though he did not attend meetings during the first year. He recovered sufficiently to come over from Paris for the opening of the first exhibition on May 16, 1898, in order to inspect the hanging of his own pictures and to

approve the rest of the installation. Whistler's first actual appearance at a meeting of the ISSPG was not until July 18, 1899. The second exhibition at Knightsbridge was in progress at the time. He arrived at the meeting late and took the chair, the vice-president John Lavery vacating it. According to the minutes of the meeting, "The President expressed his regret that he had been unable to attend previous meetings and spoke of the pleasure it gave him to occupy the chair. The position of affairs was then briefly explained to the President."[203]

Whistler believed, as he corresponded from Paris with Lavery, Howard, Pennell, and Ludovici about ISSPG business, that they were withholding information from him, especially about finances. He insisted on knowing everything done by the association. He repeatedly lodged complaints, and the executive council repeatedly bowed to his wishes. Whistler ultimately attended almost a dozen meetings during his tenure as president; he also appeared at informal ISSPG luncheons at the Café Royal. He devised menus for the annual ISSPG dinners, which were meant to eclipse Royal Academy banquets. When he could not attend meetings, he always received a written copy of the minutes with explanations.[204]

The executive council sent detailed plans for the galleries in an effort to give Whistler a very clear idea of the layout. Whistler in return sent back drawings with designs for hanging arrangements, color harmonies, and even suggestions for the placement of tables and chairs. "No detail was too small, no scheme too large that could add to 'the finish and intimacy and mystery and general richness and concentration of the exhibition.'"[205]

The reality was that the ISSPG needed Whistler's energy and influence to make it a success, and Whistler needed a place to exhibit his work in a sympathetic context that he designed and controlled. His prestige was no longer in question, and he did not need to countenance opposition. He wanted to create

an "Art Congress for artists of the world," which he felt would make a "really formidable force" that "nothing can stand against." For the first exhibition, in 1898, Whistler contributed nine oil paintings, which were hung in the central hall. Six works by Degas were placed on the opposite wall. Degas was furious because he had not given his permission (like Whistler he was extremely sensitive to the conditions in which his works were shown). In fact, he had ignored the invitation—the same response Whistler had given to Degas's request to show with the impressionists twenty years earlier.[206]

Manet's *Execution of the Emperor Maximilian*, hung in the north gallery, was, after Whistler's work, thought to be the most important work in the show, whereas Henri de Toulouse-Lautrec's works were considered some of the most controversial. Mixed in with the modern masters was a preponderance of work by little-known British and Scottish artists who had closely modeled their work on Whistler's. Bonnard and Vuillard, puzzled, asked, "Why do all these people want to paint old Masters?" Joseph Crawhall's work, for example, epitomized Whistlerian traits—muted tonality, poeticism, delicate drawing, and a concern with decorative design.[207]

As Phil Athill has pointed out, Whistler's reconstruction of modernism in the International Gallery had a subliminal message: "'Advanced' art should be seen to spring from Manet, Degas and himself." Impressionism was downplayed in the exhibition and nearly absent in its English form, though a few paintings of New English Art Club artists were shown.[208]

Whistler's entries, starting from the left as arranged on the wall, were *Thames in Ice, or 25th December 1860 on the Thames*; *The Little Blue Bonnet*; *At the Piano*; *Arrangement in Black and Brown: Miss Rosa Corder*; *Self-Portrait: Gold and Brown*; *Rose and Silver: The Princess from the Land of Porcelain*; and three etchings in white frames designed by Beatrix: *Rose and Brown: Philosopher*, *Nocturne: Valparaíso*, and *Petite*

Souris. The arrangement was based on the last of the three plans Whistler had sent Ludovici [fig. 98]. A photograph from this exhibition confirms that Whistler's plan for the arrangement of his work was scrupulously followed [fig. 99].

In 1899, Whistler sent the ISSPG several of his 1881 Venice pastels, six oils, including *Rose and Gold: The Little Lady Sophie of Soho*, and a roomful of etchings of Paris and Amsterdam. (In this show, the American painter Arthur B. Davies, future organizer of the 1913 Armory Show, exhibited alongside Whistler.) His etchings, together with his "Naval Review" series, were hung in a special "White Room" that had been decorated especially for his prints. The all-white scheme is not surprising in view of Whistler's increasing purism. The prominence given to prints points to one of the aims of the ISSPG—to raise the public's level of awareness of the graphic arts. A fundamental aim of the ISSPG was the equal treatment of a variety of media. No international exhibition was held in 1900 because of the Paris International Exhibition. In 1901, Whistler showed four figure studies, one pastel, and two seascapes, and in 1902 two pastels. Whistler's cosmopolitan approach to art exhibition was realized when the ISSPG circulated shows far afield to Budapest, Munich, Dusseldorf, Detroit, Boston, Philadelphia, Pittsburgh, Chicago, and St. Louis.[209]

The enthusiastic press response to the first ISSPG International Art Exhibition must have been very gratifying. Shortly before the opening, the *Pall Mall Gazette* sent a reporter to find Whistler at his "charming little green and white pavilion" in the rue du Bac. Whistler agreed to the interview and expressed in clear terms the most serious artistic aims of the ISSPG. He stated that he had been approached

[T]o begin with, by a number of young men— the vanguard of English art—who expressed the desire to see a really international collection of pictures brought together in London. We wanted

FIG. 98. *Sketch of Hanging Arrangements for the 1898 Exhibition of the International Society of Sculptors, Painters and Gravers, 4 x 6 in. (10 x 15 cm). Whistler enclosed this sketch, made on a notecard, in a letter to Albert Ludovici. It is the plan for the placement of his own work on the gallery wall at the first international exhibition in London. Joseph and Elizabeth Pennell Papers, Library of Congress:*

FIG. 99. *The Whistler Wall, 1898. This photograph of the first exhibition of the International Society of Sculptors, Painters and Gravers, at the International Gallery, Knightsbridge, London, shows the low, lacquered dado, canvas walls, velarium, and center group of works arranged according to Whistler's hanging plan. Joseph and Elizabeth Pennell Papers, Library of Congress.*

to break through the wearisome routine of the annual shows—to mention only the Royal Academy, the New Art Gallery, the Grosvenor, and so forth. . . . The British public is kept completely in the dark as to the real nature of the Art movement throughout the world. It will be the task of the International Art Exhibition to enlighten that ignorance. Fortunately the position which I occupy here gives me the necessary authority to persuade the great continental painters to treat this scheme seriously.

He referred to the International exhibition as an "artistic congress" that would enable artists and public

"to study and comprehend the progress art is making. . . . We shall have brought together the most representative collection of international art that has ever been exhibited in London."[210]

Whistler's exhibition standards for the large ISSPG shows were very like the objectives of improved design that he had long advocated for smaller gallery installations. Letters arrived at the rue du Bac with queries concerning the details of the exhibition. "What colors shall the festoons and the walls be, and what do you think should cover the floor?" Lavery had sent Whistler a description of the basic dimensions together with a diagram of the floor plan of the galleries, which were immensely lofty, and said Ludovici would

be a great help to them in carrying out his plan [fig. 100]. "Nothing can be done for some days yet and if you will kindly consider the scheme, we shall follow out, I need hardly say, in as far as possible to us anything you may be good enough to command." Soon after, Howard wrote asking, "What about the colours in the decorations of the gallery?"[211]

An exquisite color scheme was decided upon, consisting of a black dado and subdued green walls—a distinguished arrangement in black and green. A year later Lavery wrote to Whistler saying that they were trying to accomplish finishing touches such as varnishing the dado, staining the floor, and adding a band of darker color to run around the galleries. He also mentioned that they were trying to persuade Admiral Maxse to agree to the "small added expense" of those touches. Textiles came into play. The galleries, which were lit from above by the glass roof, were screened with white muslin, a grey cloth velarium was hung, and walls were covered with cool green canvas. Howard wrote to say they were carrying out Whistler's demand for a perfect arrangement.

> The preparation of the galleries (assuring the employment of the right colours, textures, proportion etc.) the reception, unpacking and classification of home and foreign works, the insurance and general financial affairs and the arrangements (including the constant stimulation of the Press) [is being accomplished]. . . . Lavery's natural caution and my natural lack of it seems to have alarmed you. But I am sure unnecessarily! We are all conscious of the great issue, and none more so than Lavery and myself! But we especially are, so to speak, on our hands and knees arranging the very pebbles of the pathway.[212]

Whistler continued to bombard the council with questions and requests. "How do you all get on with the hanging? and the catalogue?" Whistler took it

FIG. 100. *John Lavery. Layout for the International Gallery, 1898. Lavery sent this sketch to Whistler in Paris. It records the proposed arrangement of the rooms for the first exhibition of the International Society of Sculptors, Painters and Gravers. Whistler 128, Birnie Philip Bequest, Glasgow University Library.*

upon himself to design the catalogue and a seal. Quite naturally, he had "some odd things" for the illustrated catalogue, which Heinemann published. He had relied on Ludovici to understand and implement many of his plans for this first international exhibition, including the exact hanging of his work on the line.

Ludovici responded to all Whistler's directives

and questions with a detailed letter stating that they had finished hanging his work [see fig. 99]. "What a magnificent wall it all makes. . . . I think you would be agreeably surprised, if you walked in and saw the rooms. They impress me very much, and I am sure, will make another epoch in the Whistlerian era, become historical, and start a revolution in picture shows."[213]

Whistler demanded dignity and aristocratic status for the international exhibition and was convinced that the presence of royalty would bring home this point. He wrote to the Prince of Wales asking him to officiate at the opening, but unfortunately, the Prince was not available to appear at the exhibition until later in the week. Whistler was outraged by weak attempts to amuse the public at the International Art Exhibition. When he heard about "string bands" and "greasy tea" and "other indecencies" pervading the galleries, he outlawed them. He was convinced that music distracted from the pictures in the gallery. Nevertheless, in the following year a costume ball, Sunday musical, and dance performances by children were held in the galleries. Despite his years of courting the press, Whistler was appalled when he discovered that press clippings were being handed out in the galleries. Ludovici assured him that the clippings were only lying out on some of the tea tables. (Whistler had framed a large press clipping for inclusion in his 1883 show.) Admiral Maxse wrote anxiously to Whistler; press coverage was crucial to the success of the ISSPG. It was strange to have to explain the power of the press to, of all people, Whistler. He also opposed money prizes and would not allow medals to be given. Even with the positive press response and attempts to lure the public with refreshments and music, the crowds were modest. On May 23, Ludovici wrote that since the opening there had been only about 160 visitors per day. It was an artistic rather than a commercial success.[214]

The reviews of the exhibition were consistent in drawing attention to its aesthetic qualities. Thomas Dartmouth, in *Art Journal,* noted the careful control of the lighting in the galleries and said, "All the modern theories of the exhibition of pictures are carried out." In *Studio* George Sauter, one of the original founders, exulted, "International! Almost incredible in London! . . . having at their head no less a President than James McNeill Whistler. . . . Some people . . . prophesied that it would be merely a Whistler and Glasgow show. How surprised they must have been to see [so] many different paths are recognized. . . . The three rooms . . . are all equally good, in shape, lighting and colour, and all the works are almost equally well hung. . . . [and] can be seen equally well."[215] Other reporters declared, "The severest blow the Royal Academy has yet received has been given it this spring. . . . Mr. Whistler's International Society of Sculptors, Painters and Gravers has fixed its momentary abode. . . . The ice-floor is boarded over, the vast hall is divided by partitions, the walls are hung with dull green, awnings shade the floor." And, "Against this evil [of badly hung, low-standard shows] the International Exhibition proves a triumphant protest." During his years with the ISSPG, Whistler encouraged reporters to make such invidious comparisons with other exhibiting bodies—for the greater glory of the ISSPG.[216]

When Whistler returned to Paris after his visit to the international exhibition, he wrote to the ISSPG committee to express his pride and pleasure in the design of the exhibition.

Gentlemen—It was greatly to my regret that I was forced to return before calling you all together to express, to you, my satisfaction at the splendid way in which you have worked, in unison, to bring about the harmonious result I intended, and you have achieved! I have barely had more than time to perceive the rare appreciation and sympathy with which the plan of the walls, has been carried out!—The managing of the lighting, the placing of the "velum" as it is

called here, about which I was so anxious, is most perfect. My compliments also to the hangers, whose labours must have been Herculean, and whose results show no trace of the terrible difficulties, overcome in such impossible time! In short, Gentlemen, your President is proud of his Committee and begs them to accept his warmest congratulations upon the triumphant results of their endeavors—together with his conviction that this year's brilliant beginning has brought with it the assurance of next year's absolute success, and of the irresistible future.

At the time of the second ISSPG exhibition in 1899, the photographer Peter Henry Emerson, whose approach to photography was influenced by Whistler, was among those who recognized the artist as a leading reformer of exhibition design. "Another great step in advance introduced by Mr. Whistler has been the reform in hanging pictures . . . he has managed his exhibitions much more artistically than any other in the country."[217]

Whistler's exhibitions were *causes célèbres* that drew substantial crowds, including the movers and shakers of late Victorian society, and attracted thorough press coverage. Walter Crane wrote, "In the artistic arrangement of its exhibitions [the ISSPG] has set an example to the older societies. They also influenced secessionist exhibitions, and did much to foster the acceptance of modern foreign art in England." The Pennells declared, "Whistler's influence has been as marked in picture galleries [as in home decoration]. It is not too much to say that every well-arranged exhibition in Europe today owes its inspiration to him." And they pointed out that during his tenure at the Royal Society of British Artists Whistler had arranged and hung well-designed exhibitions "years before there was any idea of artistic hanging in German Secessions."[218]

Whistler's innovations in exhibitions and his efforts to break the ice in Britain's art world were not forgotten. In 1910, when Roger Fry (founder of the Omega Workshops, devoted to bringing the talents of painters to the domestic interior) organized an important exhibition of postimpressionism at the Grafton Gallery, the press raised a violent cry of outrage. Fry remarked, "There has been nothing like this outbreak of militant Philistinism since Whistler's day!"[219]

Pervading all the shows that Whistler designed were certain operative principles. It is obvious as one looks at these exhibitions that he had formulated a unique and cogent aesthetic that was consistent with, and as important as, the individual works he was showing. First, Whistler believed and demonstrated that the exhibition itself was a work of art. Second, he perceived the necessity for a careful harmony between the individual works of art and the setting; each exhibition was to be designed individually for a specific group of pictures. Third, the orchestration of color was the most important factor in achieving his objective of harmony, of a total color field. Fourth, to implement the unity of mood and chromatic harmony, the exhibitor had to control all the details, somewhat like writing a musical score. Fifth, the exhibition would be an ephemeral theatrical drama, staged and acted out as a grand performance. Patrons were invited to be part of the performance—the perfect Zen moment or Paterian effervescent happening— and were asked to fulfill certain expectations, adding to the wit and comic dimension of the show. Sixth, accordingly, the press was called in to publicize the event and catch the highlights of the drama. Seventh, exhibitions had an underlying symbolist code; they were intended to evoke moods and suggest alternative states. Whistler was attuned to psychological values of colors and the synaesthesic implications of chromatic chords. Eighth, *japonisme* was predominant and became more so as time progressed. Whistler sought to devise a serene, minimalist space, to create an atmosphere quite different from that of an ordinary exhibition—not an atmosphere of sales but rather an

idealistic one of pure art. Ninth, Whistler took on the role of teacher with his exhibitions. He taught through example, staging "demonstrations" to the very end of his career.

A Last House

During the final years of Whistler's life, the number of his residences multiplied. He referred to them as his "collection of *châteaux* and *pieds-à-terre*," and he enjoyed maintaining a sense of clandestine mystery about his movements and whereabouts.[220]

While Beatrix was ill in 1896 and living her last days at Hampstead Heath, Whistler had purchased a studio at 8 Fitzroy Street. It was only one of the places he lived after her death, and he did not sell it until 1902. It was a "huge place at the back of [a] house, one flight up and reached by a ramshackle glass-roofed passage." Here he invited friends and patrons to tea. In this period, Whistler wandered about a great deal, and all the while his health was in steady decline. He was in and out of rooms at the Hotel Chatham and Garlant's Hotel. He lived for a long while with his publisher, William Heinemann, at No. 4 Whitehall Court, until his friend married. He was in Dieppe in 1896 and 1897, painting small oils and watercolors of the sea. His sisters-in-law stayed at the rue du Bac, and sometimes he returned, though the dampness of the garden pavilion, which had once been the site of warmth and beauty, proved to be detrimental to his health. He took a house six miles out of Dublin in 1900. In the winter of 1901 he was at Ajaccio, Corsica. And he went to Bath, Holland, seaside resorts in England, and even back to Tite Street in March 1902.[221]

Whistler had suffered a minor heart attack near the time, in April 1902, he leased 74 Cheyne Walk, a modern studio house built by arts and crafts leader C. R. Ashbee. Whistler had gone to Ashbee old and ill, curled and corseted, to see if he could rent his house, since Ashbee was moving to Chipping Campden. For a while Ashbee had affected Whistler's dandified style and followed aspects of his interior design style; he must have been thrilled with the idea of his new tenant. Whistler's mother-in-law, Mrs. Birnie Philip, and his sister-in-law, Rosalind, came to look after him and support him. In return, he made Rosalind his executrix. When the Pennells visited him on Sunday, April 20, 1903, he confided in them his opinion of the house he had taken, "the whole, you know, a successful example of the disastrous effect of art upon the British middle classes."[222]

Whistler's ideas had not changed since he had delivered his "Ten O'Clock" in 1885. He was convinced, as he had always been, that the arts and crafts mentality of art for the people by the people represented nothing more than a leveling of taste and downgrading of art. But, had he not been so ill, he probably would have been highly amused by the arts and crafts house he had leased. "When I look at the copper front door," he remarked, "and all the little odd decorative touches throughout the house, I ask myself what am I doing there, anyhow? But the studio is fine, I have decorated it for myself, gone back to the old scheme of grey."[223]

Despite Whistler's complaints, the house in which he was living, and the one going up next door, were both influenced by his concepts. Ashbee was in accord with Morrisian ideals of humanistic joy in work, but he eschewed rustic charm, mock historicism, and medievalism. Instead he followed Whistlerian austerity and puritanism in interior design. His houses were relaxed, humble, and stark, and his style emanated in no small part from his knowledge of Godwin and Whistler's White House on Tite Street, just a few blocks away. His interiors were a deliberate rebuke to late Victorian drawing rooms. He used plain papers, embossed leather, or often his houses had distempered walls. The peacocks and peacock blue color

in the dining room of the Magpie and Stump, one of his houses, were outright Whistlerian. The simplicity, rectilinearity, and unpretentiousness were all resonant of the style of the "Japanese artist in Chelsea." Ashbee's interiors, however, were loose and eclectic. His less-than-harmonious ensembles did not necessarily hold together. As Whistler noted, there were "little odd decorative touches throughout."[224] Had Whistler had the strength, he might have tried to correct Ashbee's interior, just as he had corrected Jeckyll's.

The circumstances of Whistler's final days provide a commentary on both his lifelong quest for publicity and his aesthetic theory. He was concerned as always with the press, dress, a good joke, fighting the powers that be, the latest exhibition, being the center of attention, and the color and design of his surroundings.

Whistler never stopped finding reasons to decorate interiors so long as he was able, but now he was ill. Also, Ashbee's house did not suit him; the windows with small panes opening on the Thames were high and little, so Whistler could hardly see his beloved river. The studio, on a lower level than the street, was reached by a two- or three-step descent from the entrance. Because the large studio dominated, the kitchen and bedroom were three flights up—impossible for Whistler. The arts and crafts decor and the beaten copper door provided the kind of dubious amateur touches that Whistler abhorred, and for a while, he entertained ideas of transforming the interior. He revived his mural idea and sketched a wall decoration in black chalk on brown paper of ships under an arcade, much like his 2 Lindsey Row ship mural of thirty years before [see figs. 39, 40]. But he was unable to execute the design.[225]

Whistler placed his beautiful blue-and-white porcelain in glass-enclosed cases lining the drawing room walls. A white tablecloth and exquisite white napkins embroidered with white butterflies were placed on the table. He sent more than one hundred of his most elegant silver pieces to the Fine Art Society for a December 1902 exhibition of old silver entitled "Knife, Fork, Spoon and Silver Table-Plate Service." The other cases were lined with red, but Whistler's silver, in a case by itself, was draped with his white butterfly-monogrammed napkins. After the Pennells saw the show on December 6, he questioned them on every detail. He wondered how the white of the beautiful napkins looked and asked how the accent of blue in the rare old Japanese plates appeared. "Didn't the other cases seem vulgar in comparison?—and didn't the simplicity of my silver, evidently for use, and cared for, make the rest look like Museum specimens?" He took inordinate pleasure in this showing, though he was too ill to attend and the society had misspelled his name in the catalogue.[226]

The ambience at 74 Cheyne Walk was rather bleak; Whistlerian atmosphere was lacking. A great pile of brown paper could be found on the settee, and everything had a forlorn, comfortless look, the antithesis of the gay and sunny schemes of all the past interiors. Meanwhile, the incessant pounding on the house going up next door, an Ashbee project, was making him progressively more nervous and agitated, although he was supposed to avoid excitement because of his heart. Because of it, he wanted to hound Ashbee out of the Art Workers Guild. (Ashbee founded the Guild of Handicrafts, and in 1890 published a book on it, which had covers of coarse brown paper, an asymmetrical title, and Japanese vellum paper—all based on Whistlerian design.) Ashbee called at the house, asking about his health, and made Whistler even angrier. Whistler overlooked the fact that he was not paying Ashbee rent and that Ashbee might have turned him out if he were not so ill. The daily, incessant noise was hastening his decline.[227]

Finally, Whistler was an invalid. His Empire bed was moved from the top of the house downstairs into a small room adjoining the studio. He remained in bed in a white silk nightshirt. His cat amused him, and he

still read newspapers, saving press clippings, plotting letters to the editor, and sharing old correspondence with friends who stopped by. An "imaginative" popular book about him, written by the American arts and crafts leader Elbert Hubbard and published by Roycroft Press in its Little Journey series, was one of his last amusements. He began to plan a new pamphlet ridiculing the critic Frederick Wedmore and to have litigious thoughts about Ashbee. He contacted his solicitor William Webb to see what could be done about "Ashbee's conduct." As he became more ill, loyal friends drifted in and out almost daily, for Whistler could not stand to be alone. He added to his invalid costume an old black fur-lined overcoat, shabby and like nothing the Whistler in healthier days of sartorial splendor would have dreamed of wearing.[228]

The studio in which Whistler did his last work was bare; the walls were distempered a neutral Whistlerian grey. Near the end, when he was able, he worked on some portraits of the New York gambler Richard Canfield, his friend Charles Lang Freer, and his sister-in-law, Rosalind Birnie Philip. He was also painting a young Irish model, the red-haired Dorothy Seton, and he was trying to bring a Venus to life on canvas. On Friday, July 17, 1903, Whistler, the most colorful of men, died of a heart attack in this colorless studio at the age of sixty-nine.[229] The reticent hue of his final interior may seem to be an irony, but to Whistler, grey pulsated with life. So had the career of this man who opposed so much of the Victorian aesthetic.

Ignoring Whistler's role as a designer of avant-garde interiors is far more serious than simply bypassing a facet of his oeuvre. His interior design work is the matrix of his aesthetic and a crucial ingredient in nineteenth-century art history. Indeed, what particularly distinguishes him as an artist is that he did not limit himself to the pictorial but rather achieved an integration of all the arts in order to realize the larger design of his modernist interiors. Whistler's unified view of the arts was predictive of the art nouveau movement at the turn of the century.

Whistler's early encounter with Japanese art provided the foundation not only for his decorative pictorial work but also for his simple, geometrically structured interior schemes. His chic and witty approach to interior design, combined with an application of Far Eastern concepts of order, restraint, unimpeded spaciousness, and nuanced coloration, was revolutionary in the midst of the stodgy Victorian period, when comfort, clutter, and pattern predominated. Not satisfied with promoting a taste for simplicity through the example of his private interiors and a series of residential commissions, Whistler also developed a determined campaign to foster higher standards in the aesthetics of exhibition. Along the way, he endured constant setbacks, general misunderstanding, unfair criticism in the press, and his ousting from the Royal Society of British Artists. Ultimately, as president of the International Society of Sculptors, Painters and Gravers, he had a chance to instigate and design the first secessionist-style international exhibitions of modern art in England.

Despite his disdain for reformers of public taste such as Ruskin, Morris, and Wilde, Whistler was himself a preacher and a tastemaker. And in terms of impact, originality, and daring modernity, the style of his interior designs and his mode of presenting them surpassed those of Morris and other designers of his era in England.

Thus a full estimation of Whistler's career, as well as an understanding of his alignment with the British design reform movement, demands an examination of his roles as provocateur and, more important, as modernist designer of interiors and exhibitions. He was a difficult person because he set terrible demands for himself, not in one endeavor but in several. It is the many dimensions of Whistler that make him remarkable in his own time and in ours.

Notes

Frequently cited archival sources and frequently used terms have been identified by the following abbreviations:

AAA	Archives of American Art, Washington, D.C.
BM PD	Print and Drawing Department, British Museum, London
Freer	Charles Lang Freer Papers, Freer Gallery of Art/Arthur M. Sackler Gallery Archives, Smithsonian Institution, Washington, D.C.
GUL	Special Collections, Glasgow University Library, Scotland
GUL BP	Whistler Papers, Birnie Philip Bequest, Special Collections, Glasgow University Library, Scotland
LC PP	Joseph and Elizabeth Pennell Papers, Library of Congress
LC RC	Lessing J. Rosenwald Collection, Rare Book and Special Collections Division, Library of Congress
NYPL	New York Public Library
pc	Press clipping
Tate	Tate Gallery Archives, London
VA PD	Department of Designs, Prints, and Drawings, Victoria and Albert Museum, London

Introduction

1. Elizabeth Robins Pennell and Joseph Pennell, *The Whistler Journal* (Philadelphia: J. B. Lippincott, 1921), 59.

2. Whistler to Lucas, January 18, 1873, in John Mahey, "The Letters of James McNeill Whistler to George A. Lucas," *Art Bulletin* 49 (September 1967): 252–53.

3. Ibid., 252–53. In 1872 a critic of Whistler's *Mother* stated, "An artist who could deal with large masses so grandly might have shown a little less severity, and thrown in a few details of interest without offense." Whistler's pupil Walter Sickert added a humorous note to this

unidentified press clipping in album 1:9, GUL BP: "A glass of sherry and the Bible Whistler once suggested to me."

4. Mahey, 253. David Park Curry, "Whistler and Decoration," *Magazine Antiques* 126 (November 1984): 1188.

5. Mortimer Menpes, *Whistler as I Knew Him* (London: Adam and Charles Black, 1904), 129.

6. W. Graham Robertson, "Of James McNeill Whistler," *Life Was Worth Living: The Reminiscences of W. Graham Robertson* (New York: Harper and Brothers, 1931), 188–89.

7. T. R. Way and G. R. Dennis, *The Art of James McNeill Whistler: An Appreciation* (London: George Bell and Sons, 1904), 99.

8. Whistler to Atlas [Edmund Yates], in Whistler, *The Gentle Art of Making Enemies* (1892; reprint, New York: Dover Publications, 1967), 124–25. The Peacock Room is at the Freer Gallery of Art, Smithsonian Institution, Washington, D.C.

9. Way and Dennis, 99.

10. Nancy Burch Wilkinson, "Edward William Godwin and Japonisme in England" (Ph.d. diss., University of California, Los Angeles, 1987), 342, notes a similar fate for Godwin's reputation as an interior designer.

11. Oliver Fairclough and Emmeline Leary, *Textiles by William Morris and Company, 1861–1940,* exh. cat.,

Birmingham Museums and Art Gallery (Westfield, N.J.: Eastview Editions, 1981), 15–16. See also Catherine Lynn, "Surface Ornament: Wallpapers, Carpets, Textiles, and Embroidery," in Doreen Bolger Burke et al., *In Pursuit of Beauty: Americans and the Aesthetic Movement*, exh. cat., Metropolitan Museum of Art (New York: Rizzoli, 1986), 74–75, and Elizabeth Wilhide, *William Morris Decor and Design* (New York: Harry N. Abrams, 1991), 8, 66, 126, 167–88. Liberty and Company supplies adaptations of several Morris fabric patterns. Sanderson (in London and New York) is the major producer, supplying Morris and Company wallpaper patterns in over one hundred colors.

12. Nikolaus Pevsner, *Pioneers of Modern Design, from William Morris to Walter Gropius* (1936; reprint, London: Penguin Books, 1975), 151.

13. Walter Crane, a decorative artist contemporary with Whistler, in *William Morris to Whistler: Papers and Addresses on Art and Craft and the Commonwealth* (London: G. Bell and Sons, 1911), 64, refers to Whistler as a decorator. In "Design and the Art of Mr. Whistler," *Art Journal* (May 1893): 134–35, Crane states, "For my part I am for the unity of the arts and the sooner design, painting, and decoration are drawn closer, the sooner artificial, social, and commercial distinctions are obliterated in their equal, and interdependent, co-operative brotherhood, the better."

1. Manipulating the Press

1. John Rewald, *The History of Impressionism*, 4th ed. (New York: Museum of Modern Art, 1987), 162; Katharine A. Lochnan, *Whistler and His Circle*, exh. cat. (Ontario: Art Gallery of Ontario, 1986), 13; Elizabeth Robins Pennell and Joseph Pennell, *The Life of James McNeill Whistler*, 2 vols. (Philadelphia: J. B. Lippincott, 1908), 1:81–82.

2. Denys Sutton, "Whistler: The Artist as Dandy," in Denys Sutton, ed., *James McNeill Whistler: Whistler Exhibition in Japan*, exh. cat. (Tokyo: Japan Association of Art Museums, 1987), 25.

3. See Leonardo Benevolo, *History of Modern Architecture*, vol. 1, *The Tradition of Modern Architecture* (Cambridge: MIT Press, 1984), 168, for exhibition organizer Henry Cole's reaction to the 1851 exhibition. For more on the beginnings of the design reform movement in England, see Alf Bøe, *From Gothic Revival to*

Functional Form: A Study in Victorian Theories of Design (New York: Da Capo, 1979).

4. On Whistler's decision to return to London, see Pennell and Pennell, *Life of . . . Whistler*, 2:171, 1:83. Also see Anna Mathilda Whistler to James Gamble, December 5, 1858, in "The Lady of the Portrait: Letters of Whistler's Mother," ed. K. E. Abbott, *Atlantic Monthly* 136 (September 1925): 323.

5. See Elizabeth Robins Pennell and Joseph Pennell, "Whistler as Decorator," *Century Magazine* 83 (February 1912): 500–13; and Gardner C. Teall, "Mr. Whistler and the Art Crafts," *House Beautiful* 13 (February 1903): 188–91, for evaluations of Whistler's impact as a designer.

6. For more on Pugin, Ruskin, and Cole, see Phoebe B. Stanton, *Pugin* (New York: Viking, 1971); Fiona MacCarthy, *A History of British Design, 1830–1970* (London: George Allen and Unwin, 1972), 11; and John

Physick, *The Victoria and Albert Museum* (Oxford: Phaidon, Christie's, 1982).

7. Benevolo, 176.

8. Stephan Tschudi Madsen, *Sources of Art Nouveau,* trans. Ragnar Christopherson (New York: Da Capo, 1975), 88, 89 n; Wilhide, 32; Pennell and Pennell, *Whistler Journal,* 300.

9. Cole preceded Morris in England in establishing a community of artists seeking to raise the level of the applied arts. He founded Summerly's Art Manufactures in 1847, and beginning in 1849 he published the *Journal of Design and Manufactures.* Madsen, 142. Cole was a professional reformer and the first great propagandist for design. He sought to improve public taste through an alliance between art and manufacture. Benevolo, 168; MacCarthy, 7–19.

10. Whistler maintained this pose until death. In a July 18, 1903, obituary, a *London Times* reporter characterized Whistler as "an extremely irritating controversialist." Pc, Tate.

11. Oscar Wilde, *The Picture of Dorian Gray* (1891; reprint, Cleveland: World, 1946), 21. Wilde denied a desire for advertisement.

12. Charles Lang Freer, "A Day with Whistler," *Detroit Free Press,* Sunday, March 30, 1890, Various Scrapbook I, 2, Freer. For background on Freer, see Thomas Lawton and Linda Merrill, *Freer: A Legacy of Art* (New York: Freer Gallery of Art, Smithsonian Institution, in association with Harry N. Abrams, 1993), 30–57, 177–201. A notation by Whistler on page 3 of his earliest extant press clipping album, which he dates "Nov. 1878!," suggests he may have begun his series of press clipping albums at that point. Some articles in the album are from the early 1860s, indicating that he tracked his public reception in the press from the beginning of his career.

13. Whistler to *Truth,* January 2, 1890, in Oscar Wilde, *The Letters of Oscar Wilde,* ed. Rupert Hart-Davis (New York: Rupert Hart-Davis, 1962), 253. Whistler publicly criticized the agency; Henry Romeike publicly objected, pointing out he had sent Whistler 807 cuttings. Whistler apologized profusely. Whistler, *Gentle Art,* 236, 280–83. See also Kate Donnelly and Nigel Thorp, *Whistlers and Further Family,* exh. cat. (Glasgow: Glasgow University Library, 1980), 19, for data on Whistler's illegitimate son, Charles James Whistler Hanson, who in the late 1880s and early 1890s performed secretarial duties such as collecting clippings. Whistler's wife, Beatrix, her sisters, and her mother helped collect clippings as well. Joy Newton and Margaret F. MacDonald, "Whistler: Search for a European Reputation," *Zeitschrift für Kunstgeschichte,* vol. 41, book 2 (Berlin, 1978), 151 n. 9, note that Whistler also tracked his critical reception in the Continental European press. Some evidence of this can be found in his albums. Whistler also gave his American friend Waldo Story, a sculptor, a red scrapbook of clippings, today at the Metropolitan Museum of Art, New York. Robert H. Getscher and Paul G. Marks, *James McNeill Whistler and John Singer Sargent: Two Annotated Bibliographies* (New York: Garland Publishing, 1986), 34.

14. *Manchester Examiner Times,* June 8, 1874, pc, 1:69, GUL BP.

15. *Yorkshire Post,* May 30, 1884, pc, 6:12, GUL BP.

16. Menpes, *Whistler,* 121–22.

17. Whistler to Walter Dowdeswell, n.d., case 1, 1997, 32, LC RC.

18. Whistler to Anna Mathilda Whistler, September 1876, Freer.

19. G. C. Williamson, *Murray Marks and His Friends: A Tribute of Regard* (New York: John Lane, 1919), 94.

20. Alan S. Cole, quoted in Pennell and Pennell, *Whistler Journal,* 108.

21. Whistler to Mrs. Lyulph Stanley, n.d., quoted in David Park Curry, *James McNeill Whistler at the Freer Gallery of Art,* exh. cat. (New York: W. W. Norton, 1984), 93 n. 17, clarifies that the artist was aware of the Leyland family's desire for privacy and tried to invite people when they would not be around.

22. Williamson, 93–94; Pennell and Pennell, *Life of . . . Whistler,* 1:207; Pennell and Pennell, *Whistler Journal,* 110. There is evidence that Jeckyll was unstable earlier, judging from Du Maurier's remarks in his letters in the 1860s. George Du Maurier, *The Young George Du Maurier: A Selection of His Letters, 1860–67,* ed. Daphne Du Maurier (London: Peter Davies, 1951), 8, 15, 33. Leyland to Whistler, July 17, 1877, L 117, 121, 128, GUL BP, documents Whistler's persona non grata status.

23. Whistler to Leyland, July 1877, L 125, GUL BP.

24. Leyland to Whistler (written on Whistler to Leyland, July 1877), postmarked July 22 or 23 [illegible], 1877, L 125, GUL BP.

25. Whistler to Leyland, telegram, L 127, GUL BP; Annulet Andrews, "Cousin Butterfly, Being Some Memories of Whistler," *Lippincott's Monthly Magazine* 73

(March 1904): 318; Pennell and Pennell, *Whistler Journal*, 58.

26. Leyland to Whistler from Woolten Hall, Liverpool, July 24, 1877, L 128, GUL BP; Arthur Jerome Eddy, *Recollections and Impressions of James A. McNeill Whistler* (Philadelphia: J. B. Lippincott, 1903), 92.

27. Menpes, *Whistler*, xxii–xxiii, 3.

28. Alfred Werner, introduction to Whistler's *Gentle Art*, vi–vii; Getscher and Marks, foreword; Pennell and Pennell, *Whistler Journal*, 11; Pennell and Pennell, *Life of . . . Whistler*, 2:100–102, 108–10.

29. Pennell and Pennell, *Life of . . . Whistler*, 1:97. The critic's [F. G. Stephens?] remarks on "White Girl" are in "Fine Art Gossip," *Athenaeum*, June 28, 1862, 859. Whistler's first letter to the editor was published July 5, 1862, in the *Athenaeum*'s "Our Weekly Gossip" column, p. 23, reprinted in Sheridan Ford, ed., *The Gentle Art of Making Enemies*, by James McNeill Whistler (New York: Frederick Stokes and Brother, 1890), 54. His last letter to an editor appeared on November 21, 1902. Getscher and Marks, 25, 71–72.

30. Pennell and Pennell, *Life of . . . Whistler*, 1:273; Otto H. Bacher, *With Whistler in Venice* (New York: Century, 1908), 47. As with newspaper clippings, Whistler carried his letters about. [Thomas Armstrong], *Thomas Armstrong, C.B.: A Memoir, 1832–1911*, ed., L. M. Lamont (London: Martin Secker, 1912), 203. Lord Redesdale recalled that Whistler would come to him and read his latest letters at breakfast or after dinner so that they could laugh together about the dullness of the correspondents. Pennell and Pennell, *Life of . . . Whistler*, 1:187.

31. Whistler, "To the Editor of the Hour: Mr. Whistler's Pictures," *Hour*, June 1874, case 199, LC PP; Whistler, *Gentle Art*, 47–48.

32. Harper Pennington, "The Field of Art," *Scribner's Magazine* 35 (May 1904): 640; Pennell and Pennell, *Life of . . . Whistler*, 2:24–25.

33. Menpes, *Whistler*, 123.

34. L. V. Fildes, ed., *Luke Fildes, R.A.: A Victorian Painter* (London: Michael Joseph, 1968), 57, 64–65.

35. Denys Sutton, *Walter Sickert: A Biography* (London: Michael Joseph, 1976), 34.

36. Ibid., 36; [Walter Sickert], *A Free House! or the Artist as Craftsman, Being the Writings of Walter Sickert*, ed. Osbert Sitwell (London: Macmillan, 1947), 8.

37. Walter Sickert, "Impressionism—True and False," *Pall Mall Gazette*, February 2, 1889, pc, 9:11, GUL BP.

38. Sutton, *Sickert*, 66, 82, 146–47.

39. Whistler, *Gentle Art*, 233–35.

40. Ford, ed., 205, 208; Getscher and Marks, 260–61; Menpes, *Whistler*, 44–45.

41. Ford, ed., 208–209, 210–11.

42. Whistler, *Gentle Art*, 235; Pennell and Pennell, *Life of . . . Whistler*, 2:112; Menpes, *Whistler*, xxiv, 42–45.

43. See Don Seitz, "James Abbott McNeill Whistler: Wit, Wasp, and Butterfly," *McClure's Magazine* 1 (August 1925): 497–500, for background on the dramatic story of Whistler's battle with Ford over the book. See also Pennell and Pennell, *Life of . . . Whistler*, 2:100–105; and Pennell and Pennell, *Whistler Journal*, 215–16, for their accounts.

44. See Getscher and Marks, 260–61; and Ford, ed., 204–206.

45. Whistler to the editor, *World*, December 26, 1888, in *Gentle Art*, 233–34.

46. "The Home of Taste," *Pall Mall Gazette*, December 1, 1888, reprinted in Whistler, *Gentle Art*, 230–32. See Getscher and Marks, 260–61.

47. Du Maurier to his mother, [June 1860], in Du Maurier, *Young George Du Maurier*, 6, 9. [Armstrong], iii, 148, 151, describes this apartment.

48. James Laver, *Whistler* (New York: Cosmopolitan Book, 1930), 166–67; Richard Kelly, *George Du Maurier* (Boston: Twayne, 1983), 11, 17, 34. Du Maurier worked for *Punch* for over thirty years, producing more than three thousand cartoons. In a couple of his earliest cartoons, he depicted Whistler as himself.

49. For more on Du Maurier's aesthetic cartoons, see Colleen Denney, "Exhibition Reforms and Systems: The Grosvenor Gallery, 1877–1890" (Ph.D. diss., University of Minnesota, 1990).

50. Walter Hamilton, *The Aesthetic Movement in England*, 3d ed. (London: Reeves and Turner, 1882), 75, 76, 79. Hamilton, who wrote the first history of the movement, noted Du Maurier's caricatures were not grossly exaggerated, "as he spends the greater part of his life in the study of such exalted personages in their own elegant saloons and boudoirs" and therefore "must needs be truthful and correct." See also Robin Spencer, *The Aesthetic Movement: Theory and Practice* (New York: Studio Vista, Dutton Pictureback, 1972), 131.

51. Du Maurier to his mother, [June 1860], in Du Maurier, *Young George Du Maurier*, 7, 9; Pennell and Pennell, *Life of . . . Whistler*, 1:78–79.

52. Du Maurier to his mother, [January 1861], and to Tom Armstrong, [December 1861 and 1862], in Du

Maurier, *Young George Du Maurier*, 29, 185; Pennell and Pennell, *Life of . . . Whistler*, 1:79; Whistler to [?], 1874, typescript, case 32, LC PP.

53. Frederick Wedmore, "Mr. Whistler's Arrangement in Flesh Colour and Gray," *Academy* 25 (May 24, 1884): 374.

54. Elizabeth Aslin, *The Aesthetic Movement: Prelude to Art Nouveau* (New York: Frederick A. Praeger, 1969), 112; Lloyd Lewis and Henry Justin Smith, *Oscar Wilde Discovers America* (1936; reprint, New York: Benjamin Blom, 1967), 5, 20. Du Maurier's Cimabue Brown family may have been based on E. W. Godwin and Ellen Terry, who carried on an experiment in aesthetic living with their children, Edith and Edward Craig, in the 1870s.

55. Leonée Ormond, *George Du Maurier* (Pittsburgh: University of Pittsburgh Press, 1969), 161; Fildes, 59.

56. Unidentified clipping, pc, 4:40; and Henry Furniss, "Whistler's Wenice; or, Pastels by Pastelthwaite," *Punch* 80 (February 12, 1881): 69, pc, 10:43, both in GUL BP. See also Robin Spencer, *Whistler: A Retrospective* (New York: Hugh Lauter Levin Associates, 1989), 177. *Punch* cartoons and jokes may be found throughout Whistler's press clipping albums along with those from other comic magazines. He did not collect Du Maurier's caricatures, however, which may have been a little too close to reality for comfort.

57. Hamilton, 18; T. R. Way, *Memories of James McNeill Whistler, the Artist* (London: John Lane, the Bodley Head, 1912), 21; Richard Ellmann, *Oscar Wilde* (New York: Vintage Books, 1988), 134; Hilary Taylor, *James McNeill Whistler* (New York: G. P. Putnam's Sons, 1978), 94–95, 183 n. 4. *The Grasshopper* was based on Meilhac and Ludovici Halevy's French comedy *La Cigale* (1877), in which impressionism was satirized.

58. John Hollingshead, "Mr. Whistler and the Grasshopper," *Daily News*, pc, 1:93, GUL BP; W. Macqueen-Pope, *Gaiety, Theatre of Enchantment* (London: W. H. Allen, 1949), 187.

59. Dialogue quoted in Ellmann, 134.

60. Du Maurier to Burnand, July 18, 1880, quoted in Ormond, 280. For more on Godwin, see Dudley Harbron, *The Conscious Stone: The Life of Edward William Godwin* (London: Latimer House, 1949), 152–53. For more on *The Colonel*, see Ellmann, 134; Hamilton, 78–80; and Aslin, *Aesthetic Movement*, 116.

61. Aslin, *Aesthetic Movement*, 116, 125; Hamilton, 38.

62. Ellmann, 135; Aslin, *Aesthetic Movement*,

125–27. See also Bernard Denvir, *The Late Victorians: Art, Design, and Society, 1852–1910* (New York: Longman, 1986), 18, 19; and Alison Adburgham, *Liberty's: A Biography of a Shop* (London: George Allen and Unwin, 1975), 31–32. *A Cabinet of Secrets* (1875), a skit on China collecting, directed by Joseph Comyns Carr, was yet another aesthetic play.

63. Pennell and Pennell, *Life of . . . Whistler*, 1:197. In 1876, Whistler joined Alan Cole in *Under the Umbrella* and was "elated" by the review of his performance in the *Daily News*. Sutton, *Sickert*, 29.

64. Ellmann, 33.

65. Hamilton, 89–90; Lewis and Smith, 10; Aslin, *Aesthetic Movement*, 98.

66. Anonymous acquaintance, quoted in Hamilton, 90.

67. In 1882 Wilde wrote to Whistler from America to tell him about an artist, Miss Richards, so good that "she is quite worthy of your blue and white china." Wilde, *Letters*, 119.

68. Hamilton, 89; Ellmann, 32–33; Pennell and Pennell, *Life of . . . Whistler*, 2: 13. At Oxford, Wilde followed Ruskin's ideology to the point of working at road making for him—eventually an abandoned project.

69. This quote is the final line from Pater's famous "Conclusion" of *Studies in the History of the Renaissance* (1873), in William E. Buckler, ed. "Walter Horatio Pater: The Renaissance," *Prose of the Victorian Period* (Boston: Houghton Mifflin, 1958), 553. On Wilde's relationship with Pater, see Ellmann, 83–85, 139. When Whistler's young friend, the artist William Rothenstein, visited Pater at Oxford, he said, "[I] asked about Whistler about whom he had no great admiration." William Rothenstein, *Men and Memories: Recollections of William Rothenstein* (New York: Coward-McCann, 1931), 1:139.

70. "Mr. Oscar Wilde at Home at Mr. Whistler's," *Bat*, November 30, 1887, pc, GUL BP.

71. Telegram exchange between Whistler and Wilde sent to Edmund Yates, editor of the *World*, November 14, 1883, in Whistler, *Gentle Art*, 66. Among other things, Whistler called Wilde "fat," and Wilde called Whistler "short."

72. Ellen Terry, *Memoirs*, ed. Edith Craig and Christopher St. John (1932; reprint, New York: Benjamin Blom, 1969), 231.

73. These salutations are gleaned from assorted published letter exchanges between Whistler and Wilde, catalogued in Whistler's press clipping albums, GUL BP.

74. Ford, 217. This peculiar remark about the press is from Pennell and Pennell, *Life of . . . Whistler*, 2:58.

75. Denys Sutton, *Nocturne: The Art of James McNeill* *Whistler* (Philadelphia: J. B. Lippincott, 1964), 13. As his career progressed, Whistler had many links to, and friends in, the press.

2. The Dandy Dresses for Battle

1. Lou Ann Farris Cully, "Artist's Lifestyles in Nineteenth-Century France and England: The Dandy, the Bohemian, and the Realist" (Ph.D. diss., Stanford University, 1975), 67. Cully provides a complete discussion of the evolution of Whistler's dandyism.

2. Menpes, *Whistler*, 6–7, 34–36; Cully, 67–68. "Ape" [Carlo Pellegrini], "Spy" [Leslie Ward], Walter Greaves, Menpes, and many others produced numerous caricatures of Whistler as a dandy. Pennell and Pennell, *Whistler Journal*, 6. William Merritt Chase, in "Whistler: His Art, His Ways, and His Silver Tuft," *New York Herald*, March 13, 1904, Scrapbook 1:29, Freer, recalled Whistler's "abnormal personal vanity," noting the hours it took him to primp before going out. He describes Whistler as five feet four inches tall, his "utmost weight 130 pounds."

3. Andrews, 318–19; Wilde, *Letters*, 121.

4. Ellmann, 310–11. In the original draft of the novel, Dorian Gray killed a painter who was clearly and libelously Whistler, thus providing a record of Wilde's "homicidal impulse" toward Whistler (278).

5. Ibid., 212, 133; Wilkinson, 54–56, 219–20.

6. Rothenstein, 102. See also Stanley Weintraub, *Whistler: A Biography* (New York: E. P. Dutton, 1988), 345. Several of Whistler's fashionable colleagues adopted this *japoniste* mode of dressing in kimonos. Like Whistler, Gustav Klimt collected kimonos and had them made for himself.

7. Pennell and Pennell, *Life of . . . Whistler*, 1:80; Cully, 80; Laver, 219–20.

8. Wilkinson, 122, 202–204, 220, 345, 376; Barbara Morris, *Liberty Design, 1874–1914* (London: Pyramid Books, an imprint of Octopus Publishing, 1989), 44; Aslin, *Aesthetic Movement*, 157; Ellen Terry, *The Story of My Life* (London: Hutchinson, 1908), 38, 50; Wilde, *Letters*, 159–60 n. See also Sir Johnston Forbes-Robertson, *A Player under Three Reigns* (New York: Benjamin Blom, 1971), 67; and Getscher and Marks, 34. Sheridan Ford called Godwin "the great authority on costume." Harbron, 168–69. For background on Liberty textiles, see Clay Lancaster, "Oriental Contributions to Art Nouveau," *Art Bulletin* 34 (December 1952): 301–302.

9. Adburgham, 14; John Walker, *James McNeill Whistler* (New York: Harry N. Abrams, 1987), 64; Pennell and Pennell, *Life of . . . Whistler*, 1:147–48.

10. James and Anna Mathilda Whistler to Mrs. William Alexander, August 26, 1872, Alexander Family Album, 20, BM PD.

11. Whistler to Mrs. William Alexander, Esquire, Aubrey House, Campden Hill, Kensington, n.d., on stationery embossed FRL for Frederick Richards Leyland, Alexander Family Album, 21, BM PD.

12. Pennell and Pennell, *Life of . . . Whistler*, 1:303. Every character's costume in the play is described in Whistlerian coloristic nomenclature. *Age*, February 15, 1885, pc, 5:31, GUL BP. The two-way nature of the influence is demonstrated by the example of Whistler having a theatrical costumier, Mrs. Alias, make a costly blue dress for a planned painting in 1882.

13. *"Wilde v. Whistler," Being an Acrimonious Correspondence on Art between Oscar Wilde and James McNeill Whistler* (London: privately printed [Chelsea], 1906), 20, in Prints Division, NYPL (microfilm, AAA). Lajos Kossuth was a Hungarian revolutionary, resident in England from 1851 to 1859, known to wear a Polish cap. Mr. Mantalini is a character in Charles Dickens's *Nicholas Nickleby*, husband to a milliner. He wore an elaborate morning gown. Nathan's was a London clothier. Ellmann, 154 n.

14. Sidney Starr, "Personal Recollections of Whistler," *Atlantic Monthly* 101 (April 1908): 529. For more on the Grosvenor Gallery, see Denney.

15. Alan Cole, diary extract, March 1876, LC PP, and quoted by Taylor, 95.

16. For a complete quote of the passage, see His Honour Judge Edward A. Parry, "Whistler v. Ruskin," *Cornhill Magazine* 50 (January 1921): 24–25. Parry used the brief of the trial for his article. At Oxford, Ruskin attacked Whistler in "Shield and Apron," a lecture on Tuscan art. Pennell and Pennell, *Life of . . . Whistler*, 2:4; Laver, 181.

17. From John Ruskin, *The Works of John Ruskin*, 39 vols., ed. E. T. Cook and Alexander Wedderburn (London: George Allen, 1903–12), 29:160.

18. G. H. Boughton, "A Few of the Various Whistlers

I Have Known," *Studio* 30 (December 1903): 212. For more on the Arts Club, see Wilkinson, 121–22.

19. Whistler to William Heinemann, 1892, autographed letter no. 70, Manuscript Division, NYPL (microfilm, AAA).

20. Pennell and Pennell, *Life of . . . Whistler*, 1:213; Williamson, 93. Menpes states, in *Whistler as I Knew Him*, 33, "As a man he was sadly misunderstood by the masses. His nature was combative, and his long and brilliant career was a continuous fight."

21. Ruskin, *Works*, 29:587. See also Linda Merrill, *A Pot of Paint: Aesthetics on Trial in "Whistler v. Ruskin"* (Washington, D.C.: Smithsonian Institution Press, in collaboration with the Freer Gallery of Art, 1992), 289–93.

22. Ruskin, *Works*, 29:585. See also Merrill, 292; Parry, 21–23.

23. John Ruskin, *Modern Painters*, 6th ed., 6 vols. (New York: John Wiley & Sons, 1886), 3:4, 21–23, 58–61, 82, 139, 141, 190, 280, 291. Despite Ruskin's professed democratic ideals in art, an elitist prejudice is revealed by certain statements he made. Ruskin wrote in his "Academy Notes" of 1875, "I have always said that no woman could paint" and "I thought that what the public made such a fuss about *must* be good for nothing." Ruskin, *Works*, 14:308.

24. Henry James, "The London Exhibitions—the Grosvenor Gallery," *Nation* 26 (May 23, 1878): 338–39.

25. Whistler, *Gentle Art*, 126. The interview "Celebrities at Home. No. XCII: Mr. James Whistler at Cheyne-Walk," *World*, May 22, 1878, 4–5, was revised and reprinted as "The Red Rag" (perhaps a reference to the Spanish bullfighter's cape) in Whistler's and Ford's editions of *Gentle Art*, 126–28 and 68–70, respectively.

26. Whistler, *Gentle Art*, 126, 318. *Nocturne in Grey and Gold: Chelsea Snow* (ca. 1876) is in the Fogg Museum, Cambridge, Mass.

27. Whistler, *Gentle Art*, 128. The reporter for *Orange Blossoms*, February 25, 1885, having listened to Whistler's "Ten O'Clock" lecture, remarked, "After much cogitation I have decided . . . ordinary people who want some 'story' in a picture are Goths, Vandals and Philistines." Pc, 5:39, GUL BP.

28. Mahey, 252–53.

29. Whistler, *Gentle Art*, 127–28. For a discussion of Whistler's abstract musical titles, see Ron Johnson, "Whistler's Musical Modes: Numinous Nocturnes," *Arts Magazine* 55 (April 1981): 169–76.

30. Whistler to Avery, March 1, 18[?], Samuel Putnam Avery Papers, Letters from American and European Artists, microfilm, AAA.

31. Eugene Matthew Becker, "Whistler and the Aesthetic Movement" (Ph.D. diss., Princeton University, 1959), 28. Also see Anthea Brooke, *Victorian Painting*, exh. cat. (London: Fine Art Society, 1977), for an overview of the categories of subjects and themes of Victorian narrative painting.

32. Pennell and Pennell, *Whistler Journal*, 206.

33. E. H. Gombrich, *The Sense of Order: A Study in the Psychology of Decorative Art* (Ithaca: Cornell University Press, 1979), 58, 62. Gombrich discusses the mutual influence of design and the pictorial arts and its ramification for modern styles (33–62).

34. Whistler, *Gentle Art*, 18; James Jackson Jarves, "Art of the Whistler Sort," *New York Times*, January 12, 1877, 10; "History of the Week," *John Bull* 30 (November 1878): 773.

35. Frank Whitford, *Japanese Prints and Western Painters* (New York: Macmillan, 1977), 139; Whistler, *Gentle Art*, 309.

36. John Gloag, *Victorian Comfort: A Societal History of Design from 1830 to 1900* (London: Adam and Charles Black, 1961), 40–42. See also Marilynn Johnson, "Art Furniture: Wedding the Beautiful to the Useful," in Burke et al., 143.

37. Pennell and Pennell, *Life of . . . Whistler*, 1:229–31; Wilkinson, 364.

38. In the 1870s, more serious concerns in art were particularly evident in the social realist works of a group of British artists including Frank Holl, Luke Fildes, Hubert von Herkomer, and others. Their work appeared in the news magazine *Graphic*, and their subjects included poverty, unemployment, alcoholism, and other social ills. Julian Treuherz, *Hard Times: Social Realism in Victorian Art*, exh. cat. (Mount Kisco, N.Y.: Moyer Bell, 1987), 9.

39. Pennell and Pennell, *Life of . . . Whistler*, 1:231–42. *Eden versus Whistler, the Baronet and the Butterfly: A Valentine with a Verdict* (Paris: Louis-Henry May, 1899) is a pamphlet cited in Getscher and Marks, 20–21, about a suit, argued in Paris, that Whistler brought against Sir William Eden. This 1894 case was a battle for the ultimate right of the artist to final ownership of his own work.

40. Whistler, *Gentle Art*, 3, 8.

41. Whistler to Anderson Rose, November 10, 1878, LC PP; Whistler, *Gentle Art*, 9.

42. Pennell and Pennell, *Life of . . . Whistler*, 1:165, 204, 234; Pennell and Pennell, *Whistler Journal*, 115–16.

43. Weintraub, 204; Whistler, *Gentle Art*, 8.

44. Burne-Jones to St. C. [Ruskin], [November 1878], in John Ruskin, *The Brantwood Diary of John Ruskin*, ed. Helen Gill Viljoen (New Haven: Yale University Press, 1971), 425. In the same letter, Burne-Jones talked of testifying against Whistler: "I did feel ill & miserable over it all & am sleepless . . . it was all so hideous. . . . Morris carried me metaphorically in his arms to the door of the Court."

45. Unattributed clipping, pc, 2:31, GUL BP.

46. Whistler to Nellie Whistler, n.d., Charles Freer Papers, letter no. 26, microfilm, AAA.

47. *World*, June 11, 1879, pc, GUL BP.

48. Whistler to Liberty, [November] 1878, L 147, GUL BP.

49. Whistler, *Gentle Art*, 21–34.

50. "Encore, Whistler v. Ruskin," *Chelsea News and Kensington Post*, January 11, 1879, pc, 2:31, GUL BP. See Pennell and Pennell, *Whistler Journal*, 30, 56, and Pennell and Pennell, *Life of . . . Whistler*, 2:183.

51. Susan Otis Thompson, "The Arts and Crafts Book," in Robert Judson Clark, ed., *The Arts and Crafts Movement in America, 1876–1916*, exh. cat., Princeton University and the Art Institute of Chicago (Princeton: Princeton University Press, 1972), 115–48. See also Pennell and Pennell, *Life of . . . Whistler*, 2:106–108; and Way, 31, 71–72. For descriptions of several pamphlets, books, and book cover designs by Whistler, see Getscher and Marks, 1–10, 80–81, 86.

52. Henry James, *The Painter's Eye: Notes and Essays on the Pictorial Arts*, ed. John L. Sweeney (Cambridge: Harvard University Press, 1956), 175.

53. Whistler, *Gentle Art*, 32.

54. Théophile Gautier, *The Complete Works of Théophile Gautier*, ed. S. C. DeSumichrast (London: Athenaeum Press, n.d.), 1:11, 16, 17, 34, 39, 40. For more on the importance of Gautier and Baudelaire to Whistler's aesthetic theory, see Johnson, "Whistler's Musical Modes: Numinous Nocturnes," 171–75, and "Whistler's Musical Modes: Symbolist Symphonies," 166–68, both in *Arts Magazine* 55 (April 1981). Also see Phylis Floyd, *Seeking the Floating World: The Japanese Spirit in Turn-of-the-Century French Art*, exh. cat., Rutgers University (Yokohama: Sogo Department Store, 1989), 126.

55. Charles Baudelaire, *Art in Paris, 1845–1862: Salons and Other Exhibitions*, trans. and ed. Jonathan Mayne (London: Phaidon, 1965), 220; Whistler to Fantin-Latour, 1863, microfilm, 850–52, LC PP; Pennell and Pennell, *Life of . . . Whistler*, 1:98.

56. Debora L. Silverman, *Art Nouveau in Fin-de-Siècle France: Politics, Psychology, and Style* (Berkeley and Los Angeles: University of California Press, 1989) 116; Charles Baudelaire, "The Dandy," *The Painter of Modern Life and Other Essays*, trans. and ed. Jonathan Mayne (New York: Da Capo Paperback, 1964), 27–29, 151; Pennell and Pennell, *Life of . . . Whistler*, 1:66. John Milner, *Symbolists and Decadents*, ed. David Herbert (New York: Studio Vista, 1971), 30, notes that Baudelaire had an elaborately equipped suite of rooms at the Hotel Lazun in Paris with red-and-black wallpaper and heavy damask.

57. Mark Girouard, *Sweetness and Light: The 'Queen Anne' Movement, 1860–1900* (New Haven: Yale University Press, 1977), 15.

58. Algernon Charles Swinburne, "Notes on Some Pictures of 1868," *Essays and Studies* (London: Chatto and Windus, 1875), 372–75; John Sandberg, "Whistler Studies," *Art Bulletin* 50 (March 1968): 59–64. Swinburne had taken a strong art for art's sake stand in his *William Blake: A Critical Essay* (1866). See also Alfred Lys Baldry, *Albert Moore: His Life and Works* (London: George Bell & Sons, 1894), 15, 31; and, on Moore's and Whistler's aesthetic preoccupations at this time, Katharine A. Lochnan, *The Etchings of James McNeill Whistler* (New Haven: Yale University Press), 152–55.

59. Allen Staley, *"Painter of the Beautiful": Lord Leighton, Whistler, Albert Moore, and Conder*, exh. cat. (New York: Durlacher Bros., 1964), unpaginated.

60. William H. Mallock, *The New Republic; or, Culture, Faith, and Philosophy in an English Country House*, ed. J. Max Patrick (1877; reprint, Gainesville: University of Florida Press, 1950), 21.

61. William Buckler, *Walter Pater: The Critic as Artist of Ideas* (New York: New York University Press, 1987), 58; Buckler, "Walter Horatio Pater," in Buckler, ed., 553.

62. Mallock, xxvi. Even the Mona Lisa is transformed into a sinister image by Pater. Eventually Pater backed away from this hedonistic philosophy with its satanic undercurrent. Buckler, "Walter Horatio Pater," 549–50.

63. Ellmann, 164, 210, 239, 262, 263, 268. See also Pennell and Pennell, *Life of . . . Whistler*, 2:16–18; Aslin, *Aesthetic Movement*, 99–100; and Wilde to Mrs. George Lewis, March 20, 1882, in Wilde, *Letters*, 105, 111. Wilde's lecture "The English Renaissance of Art" was first delivered at Chickering Hall, New York, January 9, 1882.

"Oscar Wilde's Lecture: The Young Apostle of Aestheticism Explains His Theories of the English Renaissance," pc, 10:95, GUL BP.

64. Ellmann, 193–94; Wilde, "House Decoration," *Miscellanies* (Boston: John W. Luce, 1908), 14:186–87.

65. For a selection of letters in which Whistler voiced his complaints against Wilde, see Whistler, *Gentle Art*, 236–43. Whistler claimed that he suggested to Wilde what he might say in his Royal Academy lecture and that Wilde never acknowledged the fact. Ellmann, 238. Elizabeth Pennell states that Wilde "had no more to say about anyone than Whistler." She heard Wilde lecture in Philadelphia. Pennell and Pennell, *Whistler Journal*, 3. Nevertheless, Whistler had good reason to fear that his ideas would be credited to Wilde and that he would be eclipsed by the younger man. An anonymous reporter wrote, "If he had not followed the example of Mr. Oscar Wilde, his name would be comparatively unknown." Cited in R. Spencer, *Whistler*, 211.

66. The "Ten O'Clock" developed out of a lecture he planned to deliver to the Dublin Sketching Club in connection with an exhibition. For background on the lecture, see Wilkinson, 348; Pennell and Pennell, *Life of . . . Whistler*, 2:16, 42; and Taylor, 117–18.

67. *World*, February 15, 1885, pc, vol. 3, GUL BP. A "Ten O'Clock" ticket/invitation is in the Arts Division, NYPL.

68. *Country Gentleman*, January 1, 1885, pc, 5:28, GUL BP.

69. Whistler to Alan Cole, n.d., LC PP.

70. Pennell and Pennell, *Life of . . . Whistler*, 2:37.

71. *World*, February 25, 1885, pc, 7:23; *Sheffield Independent*, February 14, 1885, pc, 5:29, both in GUL BP.

72. *Daily Telegraph*, February 21, 1885, pc, vol. 8, GUL BP; *Punch*, February 28, 1885; Pennell and Pennell, *Life of . . . Whistler*, 2:38.

73. Quotes from the lecture are in Whistler's *Gentle Art*, 135–59. Although Whistler seemed to assume the character of a preacher in jest, it was a natural role for him. See Pennell and Pennell, *Life of . . . Whistler*, 1:9, and Laver 16–17, for details of Whistler's Puritan background.

74. See Johnson, "Whistler's Musical Modes: Symbolist Symphonies," 174–75, for similar symbolist passages from Gautier and Baudelaire.

75. Menpes, *Whistler*, 120–21.

76. Hamilton, 94–95; Jerome Hamilton Buckley, *The Victorian Temper: A Study in Literary Culture* (London: Frank Cass, 1966), 223.

77. *London Times*, July 18, 1903, pc, p. 2, Tate. Whistler's ahistorical conflation of Greek and Japanese art—like the conflation of medieval art and Japanese art by Burges and others—was not uncommon in late-nineteenth-century England. Pennell and Pennell, *Life of . . . Whistler*, 2:61.

78. *Whitehall Review*, 1885, pc, 8:3, GUL BP; *World*, October 13, 1886. Gauguin probably accompanied Whistler to London subsequent to the "Ten O'Clock" lecture. Whitford, 172. Press clippings about Whistler's impending trip to America are in pc, 7:18, GUL BP.

79. Starr, 535; Sidney Starr, quoted in Pennell and Pennell, *Life of . . . Whistler*, 2:43. Whistler also gave the "Ten O'Clock" for his friend Otto Bacher. Bacher, 46. Lionel Lambourne, curator, Paintings Section of the Collection of Prints, Drawings, and Paintings at the Victoria and Albert Museum, in a conversation with the author, August 1990, mentioned the possibility that Whistler's "Ten O'Clock" had been recorded on wax.

80. "Mr. Whistler's Ten O'Clock," *Daily Telegraph*, February 21, 1885, pc, vol. 8, GUL BP; Carl Paul Barbier, "Whistler and Mallarmé," *The College Courant, Being the Journal of the Glasgow University Graduates Association* 25 (November 1960): 15–16.

81. For more on the collaboration between Whistler and Mallarmé, see R. Spencer, *Whistler*, 302–303.

82. *Mid-Surrey Times*, February 28, 1885, pc, 5:42, GUL BP.

83. Oscar Wilde, "Mr. Whistler's Ten O'Clock," *Pall Mall Gazette*, February 21, 1885, pc, vol. 8, GUL BP.

84. Algernon Charles Swinburne, in Whistler, *Gentle Art*, 250–58. The unstable Swinburne was living in retirement at Putney as a reformed alcoholic under the care of Theodore Watts. Roy McMullen, *Victorian Outsider: A Biography of J. A. M. Whistler* (New York: E. P. Dutton, 1973), 235; Pennell and Pennell, *Life of . . . Whistler*, 2:45–46.

85. Swinburne, in Whistler, *Gentle Art*, 256.

86. Wilde to Whistler, sent to Edmund Yates, editor, *World*, February 25, 1885, and Whistler's reply to Swinburne, both in Whistler, *Gentle Art*, 163, 259–62.

3. The "Japanese Decorator" in Chelsea

1. See Silverman, 12, for a discussion of the French art nouveau concept of aristocratizing the applied arts, which Whistler anticipated.

2. Marilynn Johnson, "The Artful Interior," in Burke et al., 111; Whistler, *Gentle Art,* 145. For more on the aesthetic movement and Whistler's place in it, see Joanna Banham, Sally MacDonald, and Julia Porter, *Victorian Interior Design* (London: Cassell and Studio Editions Ltd., 1991).

3. See Phylis Anne Floyd, "*Japonisme* in Context: Documentation, Criticism, Aesthetic Reactions" (Ph.D. diss., University of Michigan, 1983), 9–10; Wilkinson, 7–8; and Samuel Eliot Morison, "*Old Bruin,*" *Commodore Matthew Calbraith Perry* (Boston: Little Brown, 1967). Floyd points out that Dutch traders carried Japanese exports to the West before 1854, and the influx was at first gradual. Denys Sutton, quoted in Getscher and Marks, 242, suggests that Whistler may have known of the congressional report of the Perry expedition to Japan through his West Point connection.

4. For a detailed discussion of the timing and development of Whistler's encounter with the art of China and particularly Japan, see Toshio Watanabe, *High Victorian Japonisme* (New York: Peter Lang, 1991), 211–44. Watanabe suggests Whistler may have seen Far Eastern porcelain in Russia in the mid-forties and at the Art Treasures Exhibition in Manchester in 1857.

5. Goncourts' novel quoted by Floyd, "*Japonisme* in Context," 138–39. See also Robin Spencer, "Whistler and Japan: Work in Progress," *Japonisme in Art: An International Symposium,* ed. Society for the Study of Japonisme (Tokyo: Committee for the Year 2001 and Kodansha International, 1980), 74, for a specific example of the romantic allure of Japan for Whistler.

6. For more on this romantic aspect of *japonisme,* see Elisa Evett, *The Critical Reception of Japanese Art in Late-Nineteenth-Century Europe* (Ann Arbor: UMI, 1982).

7. Philippe Burty, "Fine Art *Japonisme,*" *Academy* 8 (August 7, 1875): 150. See Gabriel P. Weisberg, "The Early Years of Philippe Burty: Art Critic, Amateur, and Japoniste" (Ph.D. diss., Johns Hopkins University, 1967); and Weisberg, "Félix Bracquemond and Japonisme," *Art Quarterly* 32 (spring 1969): 57.

8. See John Ross Key, "Recollections of Whistler While in the Office of the United States Coast Survey," *Century Illustrated Magazine* 75 (April 1908): 931–32; Lochnan, *Etchings,* 4–9, 16; Pennell and Pennell, *Life of . . . Whistler,* 1:42–44; Gordon Fleming, *The Young Whistler, 1834–66* (London: George Allen and Unwin, 1978), chaps. 1–5; Adolphus Lindenkohl [a fellow craftsman at the Coast Survey], unidentified clipping, March 16, 1910, Scrapbook 1:58–59, Freer; Pennell and Pennell, *Whistler Journal,* 181; [Armstrong], 176.

9. Pennell and Pennell, *Life of . . . Whistler,* 1:68, 115–16. He also decorated a stair wall at the Coast Survey. Key, 928–29.

10. Bracquemond said he met Whistler at the Louvre, ca. 1856. Bracquemond letter to Pennells, LC PP. For debates about the discovery of the *Manga,* see Gabriel P. Weisberg, "Japonisme: Early Sources and the French Printmaker, 1854–1882," in Weisberg et al., *Japonisme: Japanese Influence on French Art, 1854–1910,* exh. cat., Cleveland Museum of Art (Cleveland: Robert G. Sawers, 1975), 3; Martin Eidelberg, "Bracquemond, Delâtre, and the Discovery of Japanese Prints," *Burlington Magazine* 123 (April 1981): 221–27; and Watanabe, *High Victorian Japonisme,* 85, 213–14.

11. R. Spencer, "Whistler and Japan," 59; Léonce Bénédite, "Artistes Contemporains: Whistler," *Gazette des Beaux-Arts,* 3d ser., 34, no. 578 (1905): 143. Spencer found reference to these figures as early *japonistes* in Whistler's letters to Fantin-Latour, 1859–67, LC PP.

12. For information on Oriental shops in Paris see Weisberg, "Japonisme: Early Sources," in Weisberg et al., 3–4, 16–17 nn. Bénédite, no. 578, mentions Whistler's letters to Fantin-Latour in 1864, charging him with a commission to buy Japanese goods at La Porte Chinoise (144).

13. For a valuable guide to *japonisme* in France, see Weisberg et al. For more on Whistler's *japonisme,* see Jacques Dufwa, *Winds from the East: A Study in the Art of Manet, Degas, Monet, and Whistler, 1856–1886* (Stockholm: Almquist and Wiksell International, 1981), 155–78; R. Spencer, "Whistler and Japan," 57–80; and Pennell and Pennell, *Life of . . . Whistler,* 1:116.

14. Mr. Rowley and Mr. Miles, quoted by Pennell and Pennell, *Life of . . . Whistler,* 1: 51–54; [Armstrong], 176.

15. Whistler started collecting by the late 1850s, according to Pennell and Pennell, *Life of . . . Whistler,* 1:51–54.

16. Henri Murger, *Latin Quarter: Scènes de la vie de bohème*, trans. Elizabeth Ward Hugus (1847–49; reprint, Westport, Conn.: Hyperion Press, 1978), 10–12.

17. Ibid., 157, 21, 43, 366, 267.

18. Laver, *Whistler*, 111; Williamson, 32; Dufwa, 158. For background on the aesthetic movement, see Aslin, *Aesthetic Movement*. For a comprehensive account of the movement in America, see Burke et al.

19. "Japanese Exhibition," *Illustrated London News* 24 (February 4, 1854): 97–98. See also Susan Weber, "Whistler as Collector, Interior Colorist, and Decorator (master's thesis, Parson's School of Design, through the Cooper-Hewitt Museum of the Smithsonian Institution, Washington, D. C., 1987), 10; and Wilkinson, 10–12, 35–36, 349–50. According to Peter Thornton, *Authentic Decor: The Domestic Interior, 1630–1920* (New York: Viking Penguin, 1984), 143, Chinese taste began to be fashionable in the 1780s and exhausted itself by 1820.

20. Bénédite, no. 578, 144; R. Spencer, "Whistler and Japan," 60–61; Gabriel Rossetti to his mother from Paris, November 12, 1864, in Dante Gabriel Rossetti, *Letters of Dante Gabriel Rossetti*, ed. Oswald Doughty and John Robert Wahl (Oxford: Clarendon, 1967), 526–27; Whitford, 99; Raymond Watkinson, *William Morris as Designer* (New York: New York Graphic Society, 1970), 10; Pennell and Pennell, *Life of . . . Whistler*, 1:116–17; Aslin, *Aesthetic Movement*, 82, 128.

21. Gabriel P. Weisberg and Yvonne M. L. Weisberg, *Japonisme: An Annotated Bibliography* (New York: Garland Publishing, 1990), 33, 164–67, 177. This is the finest bibliography on *japonisme* available.

22. See Gabriel P. Weisberg, "Japonisme: The Commercialization of an Opportunity," *Japonisme Comes to America: The Japanese Impact on the Graphic Arts, 1876–1925* (New York: Harry N. Abrams, 1990), 36–38; Wilkinson, 57–61; R. Spencer, *The Aesthetic Movement*, 70, 74, 87; R. Spencer, "Whistler and Japan," 71–72; John Sandberg, "The Discovery of Japanese Prints," *Gazette des Beaux-Arts* 71 (June 1968): 295–305; Whitford, 236. For a discussion of Dresser, see Stephen Jones, "England and Japan: Notes on Christopher Dresser: Japanese Visit, 1876–1877," in Sarah Macready and F. H. Thompson, eds., *Influences in Victorian Art and Architecture* (London: Thames and Hudson, 1985), 150–54; and Catherine Lynn, "Decorating Surfaces: Aesthetic Delight, Theoretical Dilemma," in Burke et al., 53–63.

23. Anna Mathilda Whistler to Mr. [James] Gamble, in A. Whistler, "Lady of the Portrait," 323.

24. Whistler to Samuel P. Avery from 2 Lindsey Houses, and later letter to Avery, n. d., both in Samuel Putnam Avery Papers, Letters from American and European Artists, roll NMM-27, microfilm, AAA.

25. Clive Wainwright, assistant keeper, Department of Furniture and Interior Design, Victoria and Albert Museum, discussion with the author, August 1990; N. Cromey-Hawke, "William Morris and Victorian Painted Furniture," *Connoisseur* 191 (January 1976): 41; Oswald Doughty, *A Victorian Romantic, Dante Gabriel Rossetti* (London: Oxford University Press, 1960), 332. See also Mordaunt Crook, *William Burges and the High Victorian Dream* (Chicago: University of Chicago Press, 1981); and Wilkinson, 66–71. For a description of Burges's house built in the 1870s, see Hermann Muthesius, *Das Englische Haus* (1904; reprint, New York: Rizzoli, 1979), 157. The Burges collection is in VA PD.

26. Edward W. Godwin, "The Home of an English Architect," *Art Journal* 48 (October 1886): 301–304. Oscar Wilde and Whistler were almost the last to visit Burges before his death in 1881. Crook, 87, 328.

27. William Burges, "The Japanese Court in the International Exhibition," *Gentlemen's Magazine and Historical Review* 213 (September 1862): 254; Wilkinson, 24, 40; Elizabeth Aslin, *Nineteenth-Century English Furniture* (New York: Thomas Yosef, 1962), 38–39; Watanabe, *High Victorian Japonisme*, 89–92; Pennell and Pennell, *Life of . . . Whistler*, 1:78; Elizabeth Robins Pennell, *Whistler the Friend* (Philadelphia: J. B. Lippincott, 1930), 72.

28. Thornton, 216–17. Wilhide, 151, quotes a writer for *Building News* (1862) who criticized Morris company designs as expensive, suitable for a barn, and self-consciously backward looking.

29. Clive Wainwright of the Victoria and Albert Museum alerted me to this sideboard portrait by Edward Poynter, which he felt could be of Whistler. He also made valuable comments on interiors and furnishings by the Morris company, Poynter, Burges, Morris, Godwin, Nesfield, and others. According to the abstract of Burges's memoirs, this sideboard is the first painted piece of furniture he executed, in 1858.

30. For more on this sideboard, known as the Yatman Cabinet, and another similar Burges cabinet at the Detroit Institute of Arts, see Sarah Towne Hufford, "The 'St.

Bacchus Sideboard': A New Piece of Furniture by William Burges," *Burlington Magazine* 128 (June 1986): 407–13. The Yatman Cabinet is VA acquisition 8042-1862.

31. Freer to Colonel Hecker, June 3, 1903, from the Carlton Hotel, Freer.

32. Wilkinson, 42, 48, 50.

33. Wainwright pointed out the likelihood that Whistler lunched at the Grill Room. He believes Poynter's room deserves greater attention in the story of *japonisme* in England.

34. Barbara Morris, *Inspiration for Design: The Influence of the Victoria and Albert Museum* (London: Victoria and Albert Museum, 1986), 36–38; Simon Jarvis, *High Victorian Design* (Suffolk: Boydell, 1983), 147; Wilkinson, 92; Watanabe, *High Victorian Japonisme*, 190 n. 45.

35. [Armstrong], 193–94; Janet Woodbury Adams, *Decorative Folding Screens: Four Hundred Years in the Western World* (New York: Viking, 1982), 116; Andrews, 326. Nesfield's screen, Poynter's room, and Burges's chest are all on display at the Victoria and Albert Museum.

36. Wilkinson, 14, 85, 167; Whitford, 101.

37. Whistler to Fantin-Latour, August 16, 1865, including a pen sketch of *Symphony in White No. 3*, case 1, LC PP; Way and Dennis, 21.

38. Whistler to Fantin-Latour, ca. August 31, 1867, typescript, Freer; "A 'Confession' by Whistler," *Art Journal* 47 (1906): 9.

39. Whistler was acquainted at an early date with the Ionides family, which collected Tanagra figurines. He personally owned an album of photographs of classical Tanagra figurines from the Ionides collection, now in the Birnie Philip Bequest, Hunterian Art Gallery Archive, Glasgow University, Scotland.

40. Peter Ferriday, "Peacock Room," *Architectural Review* 125 (June 1959): 409.

41. Bacher, 42, 45.

42. Gabriel P. Weisberg, *Art Nouveau Bing: Paris Style, 1900* (New York: Harry N. Abrams 1986), 14–20, 266; Wichmann, 281. Whistler sold a small oil to Bing at his L'Art Nouveau gallery in Paris, May 19, 1894, for two hundred pounds. The painting was *Green and Gold: The Sloop* (1887–1889). Andrew McLaren Young, Margaret F. MacDonald, and Robin Spencer, with the assistance of Hamish Miles, *The Paintings of James McNeill Whistler*, 2 vols. (New Haven: Yale University Press, 1980), 167. Maurice Denis's interior for Bing's first salon in his L'Art Nouveau gallery had Whistlerian yellowish grey walls.

Critics thoroughly disliked the room, finding it melancholy and oppressive, like a mortuary chamber. Weisberg, *Art Nouveau Bing*, 81.

43. Whistler to Isabella Stewart Gardner [1894], Isabella Stewart Gardner Museum, Boston (microfilm, AAA). The definitive study of Siegfried Bing is Weisberg, *Art Nouveau Bing*. On Bing's trip to America, see 32–35, 48–49. Also see Gabriel P. Weisberg, "Japonisme: The Commercialization of an Opportunity," in *Japonisme Comes to America: The Japanese Impact on the Graphic Arts, 1876–1925* (New York: Harry N. Abrams, 1990), 30–31; and Gabriel P. Weisberg and Laurinda Dixon, eds., with the assistance of Antje Bultmann Lemke, *The Documented Image: Visions in Art History* (Syracuse: Syracuse University Press, 1987), 51–68.

44. See Weisberg, *Art Nouveau Bing*, 52–56, 114–21, for a discussion of these exhibitions. Also see Colleen Denney, "English Book Designers and the Role of the Modern Book at L'Art Nouveau, Part II: Relations between England and the Continent," *Arts Magazine* 61.2 (summer 1987): 49.

45. Fantin-Latour to his parents in Grenoble, June 26, July 14 and 15, 1859, quoted in Lochnan, *Etchings*, 64–65, 70–72, 293 nn. 7, 8; E. R. Pennell, 64–68; Pennell and Pennell, *Life of . . . Whistler*, 1:76; Deborah Haden, quoted in Anna Whistler to Mr. Gamble, W 553, GUL BP.

46. See Graham Ovenden, *Clementina Lady Hawarden* (New York: St. Martin's, 1974), 5–7.

47. Pennell and Pennell, *Life of . . . Whistler*, 1:98–99, 103–14; Du Maurier, *Young George Du Maurier*, 139; Watanabe, *High Victorian Japonisme*, 199 n. 62. The Pennells' suggestion of Paradise Row as a location for Whistler's residence is probably incorrect unless it preceded 7A Queen's Road, Chelsea.

48. Becker, 24.

49. For the history of Whistler's first two Lindsey Row homes, see Peter Kroyer, *The Story of Lindsey House, Chelsea* (London: Country Life, 1956).

50. William Gaunt, *Chelsea* (London: B. T. Batsford, 1954), 113–19, 127. A Miss Greaves (related to Walter and Henry Greaves) said that No. 7 was not part of the palace but had been stables and that outhouses had stood there. Pennell and Pennell, *Whistler Journal*, 124. John Singer Sargent, Henry James, and T. S. Eliot number among the notable Americans who lived in Chelsea.

51. Pennell and Pennell, *Life of . . . Whistler*, 1:106.

52. Du Maurier, *Young George Du Maurier*, 216; Pennell and Pennell, *Life of . . . Whistler*, 1:138, 2:260. For

details on Whistler's lavish entertaining at No. 7 and No. 2 Lindsey Row, see Margaret F. MacDonald, ed. *Whistler's Mother's Cook Book* (New York: G. P. Putnam's Sons, 1979). The fashion for arranging blue-and-white china plates on bracketed shelves in aesthetic houses is credited to Whistler and Rossetti. This aspect of the aesthetic home can be seen today in the Linley Sambourne House, 18 Stafford Terrace, London. See Marion Sambourne, *A Victorian Household* (London: Alan Sutton Publishing, 1988), 24.

53. Pennell and Pennell, *Life of . . . Whistler*, 1:123; Watanabe, *High Victorian Japonisme*, 238–39; Dufwa, 176. According to Toshio Watanabe, in "Eishi Prints in Whistler's Studio? Eighteenth-Century Japanese Prints in the West before 1870," *Burlington Magazine* 128 (December 1986): 874–81, Whistler may have been one of the few collectors to collect not only works by Hiroshige and Hokusai but also older *bijinga* prints by Eishi.

54. Pennell and Pennell, *Life of . . . Whistler*, 1:123.

55. Ibid., 1:109, 116; Pennell and Pennell, *Whistler Journal*, 121; Aslin, *Aesthetic Movement*, 64; Mark Girouard, Introduction to *Victorians at Home*, by Susan Lasdun (New York: Viking, 1981), 19.

56. Pennell and Pennell, *Life of . . . Whistler*, 1:116–17.

57. R. Spencer, "Whistler and Japan," 61–62. See Bénédite, no. 578, 144, for a discussion of Whistler's purchases of Japanese art. In 1866 Whistler considered selling his valuable collection of Japanese costumes and using the funds to move to Paris.

58. *Japonaiserie* refers to "an interest in Japanese motifs because of their decorative, exotic, or fantastic qualities." *Japonisme* describes "the use of devices of composition, presentation, and structure derived from Japanese works." Taylor, 19.

59. Clifford Adams to E. R. Pennell, January 26, 1912, LC PP. A furniture restorer tells a story of selling Whistler Japanese dolls and later learning that Whistler had used them as models for his *Balcony* painting; he was dumbfounded. See also Young, MacDonald, and Spencer, 32.

60. Pennell and Pennell, *Life of . . . Whistler*, 1:109; Ralph Curtis, an American expatriate, quoted in Pennell and Pennell, *Life of . . . Whistler*, 1:274. See Basil Gray, "Japonisme and Whistler," *Burlington Magazine* 107 (June 1965): 324, for data on Japanese prints that belonged to Beatrix Whistler and were given to the British Museum.

61. Whistler to Fantin-Latour, August 16, 1866,

typescript, Freer; Pennell and Pennell, *Life of . . . Whistler*, 1:184.

62. Sutton, ed., 188.

63. Fantin-Latour letter [July 1864], quoted by McMullen, 122.

64. Anna Whistler to Mr. [James] Gamble, February 10, 1864, W 516, GUL BP. Within his family Whistler was called Jimmie, Jemie, Jamie, James, and Jim.

65. Whistler to Fantin-Latour [1863], cited by Gordon Fleming, *James Abbott McNeill Whistler: A Life* (New York: St. Martin's, 1991), 101. See also Donnelly and Thorp, 4; and Pennell and Pennell, *Whistler Journal*, 161.

66. MacDonald, ed., 31, 36; Margaret F. MacDonald, "Whistler: The Painting of the 'Mother,'" *Gazette des Beaux-Arts* 85 (February 1975): 73; Anna Whistler to her sister Kate Palmer, quoted in Weintraub, 90.

67. Du Maurier to Tom Armstrong, October 11, 1863, in Du Maurier, *Young George Du Maurier*, 216, 226–27; Pennell and Pennell, *Life of . . . Whistler*, 1:104–105.

68. Watanabe, *High Victorian Japonisme*, 199, 215, 239; Algernon Charles Swinburne, *The Swinburne Letters: Volume I, 1854–69*, ed. Cecil Y. Lang (New Haven: Yale University Press, 1974), 130. Dante Gabriel Rossetti, *Dante Gabriel Rossetti: His Family — Letters, Vol. 1*, ed. William Michael Rossetti (Boston: Roberts Brothers, 1895), 237, finds the first mention of Whistler in his brother's letter of August 21, 1862. Whistler liked to imitate Ruskin's voice.

69. Pennell and Pennell, *Life of . . . Whistler*, 1:118, 99, 109–15. See also D. G. Rossetti, *DGR: His Family — Letters*, 263; Laver, *Whistler*, 111.

70. N. John Hall, introduction to *Rossetti and His Circle*, by Max Beerbohm (New Haven: Yale University Press, 1987), 44, 31. See also Odette Bornand, *The Diary of William Michael Rossetti, 1870–1873* (Oxford: Clarendon, 1977), 19; Doughty, 350; Pennell and Pennell, *Life of . . . Whistler*, 1:110, 117, 119; and Pennell and Pennell, *Whistler Journal*, 157, 170–71, 273.

71. Sandberg, "Whistler Studies," 63; Laver, *Whistler*, 83; W. Crane, *Morris to Whistler*, 49; Cromey-Hawke, 33; D. G. Rossetti, *DGR: His Family — Letters*, 412.

72. Pevsner, *Pioneers*, 22–23. See also Charlotte Gere, *Morris and Company*, exh. cat. (London: Fine Art Society, 1971); and William Michael Rossetti, *Dante Gabriel Rossetti as Designer and Writer* (London: Cassell, 1889), 59.

73. Watkinson, 170, 193, 196; D. G. Rossetti, *Letters*, 531, 541. For more on DGR's connection with the Morris company, see W. M. Rossetti, *DGR as Designer and Writer*, 34, and D. G. Rossetti, *DGR: His Family — Letters*, 346–47.

74. Elizabeth Robins Pennell and Joseph Pennell, "Whistler as Decorator," *Century Magazine* 83 (February 1912): 501–502.

75. Pennell and Pennell, *Life of . . . Whistler*, 1:115–16; Watkinson, 195; D. G. Rossetti, *DGR: His Family — Letters*, 263.

76. Bornand, 42; Williamson, 32, 144–46; Pennell and Pennell, *Life of . . . Whistler*, 1:116–18; Wilkinson, 76, 195; Watanabe, *High Victorian Japonisme*, 205; William Gaunt, *The Aesthetic Adventure* (New York: Harcourt, Brace, 1945), 42–44; Adburgham, 14; D. G. Rossetti, *DGR: His Family — Letters*, 263.

77. Muthesius, 159, 162; Doughty, 314, 335; Watkinson, 170; Hamerton, quoted in Williamson, 99.

78. Lasdun, 107. Rossetti actually disliked the aesthetes, such as Oscar Wilde. Beerbohm, 42.

79. Watkinson, 7–17; Philip Henderson, *William Morris* (New York: McGraw-Hill, 1967), 15, 23–39.

80. Rossetti to William Allingham, December 18, 1856, quoted in Henderson, 39. Burne-Jones also wrote about their project in a letter to Miss Sampson. Cromey-Hawke, 35.

81. W. M. Rossetti, *DGR as Designer and Writer*, 34.

82. Henderson, 61–62. See "Art in the Dining Room," *Saturday Review*, January 12, 1878, 41–42. See also Watkinson, 162–72, for the early evolution of Rossetti, Morris, and Burne-Jones as designers. The Oxford mural was a technical disaster but still survives after multiple restorations.

83. Paul Thompson, *The Works of William Morris* (Oxford: Oxford University Press, 1993), 14–15.

84. Watkinson, 172; Gillian Naylor, *William Morris by Himself* (Boston: Little Brown, 1988), 16; Deed of Partnership, William Morris and Company, December 8, 1862, J. Anderson Rose [solicitor], 27 pp., LC PP; notice of partnership dissolved, *London Times*, April 7, 1875; MacCarthy, 23.

85. Lochnan, *Etchings*, 168. Also see Henderson, 22; Fleming, *The Young Whistler*, 39–43; and Pennell and Pennell, *Life of . . . Whistler*, 1:153.

86. Thornton, 311. See Wilhide for several photographs of Morris interiors. While Whistler was certainly aware of Red House, according to P. Thompson, 14, it received no publicity in the contemporary press at the time it was built.

87. Peter Stansky, *William Morris* (New York: Oxford University Press, 1983), 72; Henderson, 58–61. Pennell and Pennell, *Whistler Journal*, 251, relate a puzzling comment: "What William Morris, long Master of the Guild, thought of Whistler. J. learned at one of the [guild] meetings some years after Whistler's death. . . . In the course of the evening a story was told of William Morris who had objected when Whistler once was called an artist, saying that he wasn't. Somebody in the company could not agree, declaring that Whistler was a great painter. 'Any fool can see that Whistler was a great painter,' said Morris."

88. Charlotte Gere and Peyton Skipwith, "The Morris Movement," *Connoisseur* 201 (May 1979): 33–39; William Morris, "The Lesser Arts," *Hopes and Fears for Art* (1882; reprint, New York: Longmans, Green, 1901), 11, 14; Wilhide, 42–43.

89. Ford, ed., 211–15; Sheridan Ford, quoted by Sadakichi Hartmann [Sidney Allen], *The Whistler Book* (Boston: L. C. Page, 1910), 100.

90. W. Morris, 214. After a visit to Morris's Kelmscott House, Helena Sickert commented on the "exquisite cleanliness" and "deliciously homely" atmosphere. Wilhide, 52.

91. P. Thompson, 181. See also Wilhide, 87–113, 167–186, for splendid samples of Morris designs.

92. Lang, 280–81; "William Morris," *Once a Week*, August 17, 1872, 148.

93. Hamilton, 93–94; [Sickert], 15.

94. Wilhide, 94.

95. W. Morris, 139, 143. Queen Victoria's homes at Claremount and Osborn had yellow drawing rooms. Lasdun, 61.

96. See Whistler, *Gentle Art*, 230–31; and Aslin, *Aesthetic Movement*, 67, 176. Morris designs did not sell well initially; it took years before they caught on. P. Thompson, 108.

97. Watanabe, "Eishi Prints," 877–78, believes Whistler studied these less popularly known prints.

98. Muthesius, 169, 171, 52; Pennell and Pennell, *Whistler Journal*, 301; Pennell and Pennell, "Whistler as Decorator," 502, 504.

99. Henderson, 206–207. See also Aslin, *Aesthetic Movement*, 99. Benson was a principal organizer of the Arts and Crafts Exhibition Society and a modernist designer of copper and brass metalwork.

100. Mrs. H. R. [Mary E.] Haweis, *The Art of Decoration* (London: Chatto and Windus, 1889), 215, 228.

101. Nicholas Cooper, *The Opulent Eye* (New York: Watson-Guptill, 1976), 12; Wilkinson, 74; Pennell and Pennell, "Whistler as Decorator," 503, 504, 508; Pennell and Pennell, *Whistler Journal*, 301; Pennell and Pennell, *Life of . . . Whistler*, 1:221–22. Mass production of wallpaper began in 1841. By about 1860 there were some three hundred wallpaper factories in Paris alone. Papered walls were to be seen in virtually every house. Thornton, 223.

102. Menpes, *Whistler*, 127–28; Aslin, *Aesthetic Movement*, 63.

103. Morris himself considered wallpaper makeshift. He preferred tapestry, embroidery, and wall hangings. Wilhide, 93–94, 40.

104. W. Crane, *Morris to Whistler*, 271–72.

105. Aslin, *Aesthetic Movement*, 64; Lynn, "Decorating Surfaces," in Burke et al., 53–63.

106. Whistler to Goldschmidt [1890s] from 110 rue du Bac, Paris, case 1, LC PP.

107. Henderson, 203; Ford, ed., 214.

108. Peter Stansky, *Redesigning the World* (Princeton: Princeton University Press, 1985) 215; Watanabe, *High Victorian Japonisme*, 208. See also Helen Dore, *William Morris* (Secaucus, N.J.: Chartwell Books, 1990), 33.

109. Nevertheless, Sir Rutherford Alcock believed Morris had gotten the idea of painting walls and backgrounds in neutral colors from the Japanese. Weisberg and Weisberg, 177.

110. W. Morris, 160–61. However, Haweis, xxiii, lists Whistler as "designer of the 'Peacock Room' and furniture on Japanese principles."

111. Menpes, *Whistler*, 127; Pennell and Pennell, "Whistler as Decorator," 503.

112. Milner, *Symbolists and Decadents*, 22–23, draws a comparison between the exotic environments in *The Princess from the Land of Porcelain* and *La Belle Iseult*. See Silverman, 30, for a discussion of the eighteenth-century aristocratic woman as a central element in rococo interior decoration.

113. Pennell and Pennell, *Life of . . . Whistler*, 1:137; agreement between Whistler and Robert Booth, latter of Bromley Kent, for lease of 2 Lindsey Row, December 1866, LC PP; Dante Gabriel Rossetti, *Rossetti Papers, 1862 to 1870* (London: Sands, 1903), 222. The green moiré notebook is in Special Collections, GUL BP.

114. Pennell and Pennell, *Life of . . . Whistler*, 1:138;
Pennell and Pennell, "Whistler as Decorator," 508; Whistler to Avery from 2 Lindsey Houses, Samuel Putnam Avery Papers, Letters from American and European Artists, roll NMM-27, microfilm, AAA.

115. Julian Alden Weir to his parents, from 80 Newman St., London W., August 3, 12, 22, 1877, W. Julian Alden Weir (1852–1919) Papers, roll 71 941–2, case no. 17, microfilm, AAA; Pennell and Pennell, *Life of . . . Whistler*, 1:31.

116. Pennell and Pennell, *Life of . . . Whistler*, 1:116, 137. See Wichmann, "The Fan," *Japonisme*, 162–69, for further examples of fans by European artists.

117. "A Last Breakfast in Cheyne Walk," *World*, June 19, 1878, pc, 2:37, GUL BP; Pennell and Pennell, *Life of . . . Whistler*, 1:188, 191.

118. Pennell and Pennell, *Life of . . . Whistler*, 1:186–88; Thornton, 318–20; Pennell and Pennell, *Whistler Journal*, 102, 302. Morris shared Whistler's preference for plain white curtains.

119. MacDonald, ed., 38, 42, 43; Stanley Weintraub, *Whistler: A Biography* (New York: E. P. Dutton, 1988), 271.

120. Phoebe Garnaut Smalley, "Mr. Whistler," *Lamp* 27 (August 1903): 110; MacDonald, ed., 38–43; Forbes-Robertson, 108; Pennell and Pennell, *Life of . . . Whistler*, 1:192–95. See Weintraub, 271–72, for a description of a buffet lunch served by Whistler at 12 Tite Street in June 1882. Most of Whistler's remaining menus are preserved in the Whistler Collection, Glasgow University.

121. Whistler to Alan S. Cole [1877], two-page letter, case 1, LC PP.

122. Pennell and Pennell, *Life of . . . Whistler*, 1:189–91.

123. "Art in the Dining Room," 41–42.

124. *Leicester Post*, April 25, 1885, pc, 6:3, GUL BP.

125. *L'Art Moderne*, August 1885, pc, 6:30, GUL BP; Pennell and Pennell, *Whistler Journal*, 271; Menpes, *Whistler*, 52–53. Did Joris-Karl Huysmans know of Whistler's dyed-to-match dinners when, in 1884, in *A Rebours* he invented a dinner in black consisting of caviar, black pudding, and trifles served on a black tablecloth by naked black women carrying black-bordered plates? James Laver, *The First Decadent, Being the Strange Life of Joris-Karl Huysmans* (London, n.d.), 78.

126. Anna Whistler to sister Kate McNeill Palmer, May 21, in "Whistler's Mother," *Art Digest* 7 (January 1, 1933): 6; M. D. Conway, *Baltimore Bulletin* article reprinted from *Harper's Magazine*, Saturday, November 21 [n.d.], annotated at the top by Anna Whistler: "For the Artist at

Speke Hall," in loose clippings, case 199, LC PP; Anna Whistler to Mary [Rodewald?], Saturday, October 29, 1870, from 2 Lindsey House, LC PP. Weber cites a photo in LC PP with a note at the bottom saying Whistler purchased his prized Chinese pagoda cabinet at the 1855 Paris International Exhibition. If the annotation is correct, this is indeed an early example of his Oriental art collecting. Whistler later arranged through C. A. Howell to sell the cabinet to Sidney Morse. However, after Morse had paid for it but before the transaction was completed, Howell decided to pawn the cabinet, first removing the pagoda top. Morse somehow ended up with the cabinet, the pawnbroker with the top, and both felt cheated. An angry Whistler paid the pawnbroker, returned the top to Morse, and wrote a pamphlet on the fiasco called "The Paddon Papers, or, The Owl and the Cabinet." The cabinet is still extant and is located in the Music Room of the Frederic Leighton House, 12 Holland Park Road, London.

127. Anna Whistler to "dearest Sister" from 2 Lindsey House, Chelsea, Saturday, October 29, 1870, LC PP; Anna to Mr. [James] Gamble, April 10, 1872 [dated incorrectly 1866], in A. Whistler, "Lady of the Portrait," 324–25; Pennell and Pennell, *Life of . . . Whistler,* 1:138, 174; Pennell and Pennell, *Whistler Journal,* 241–42; Robertson, 189–90.

128. Pennell and Pennell, *Whistler Journal,* 101–102; 123–24; Pennell and Pennell, *Life of . . . Whistler,* 1:138. The Pennells mention this incident occurring at No. 7, but several details fit Whistler's decor at No. 2. The Greaveses were influenced by Whistler to create a "Whistler Room" in the Streatham Town Hall. Whistler's wife was not amused, but he was. Pennell and Pennell, *Whistler Journal,* 125, 141.

129. Pennell and Pennell, *Life of . . . Whistler,* 1:177–78.

130. Ibid., 1:138; Way, 28.

131. Anna Whistler to Anderson Rose, July 28, 1870, LC PP; Anna Whistler to Mr. [James] Gamble, September 30, 1874, Chelsea, London, in A. Whistler, "Lady of the Portrait," 327.

132. Pennell and Pennell, *Whistler Journal,* 198. See Wichmann, 157.

133. Pennell and Pennell, *Life of . . . Whistler,* 1:138, 174; M. D. Conway, *Baltimore Bulletin* article, case 199, LC PP.

134. Pennell and Pennell, *Whistler Journal,* 121–23; Way, 9–10. The Pennells' account of No. 2 Lindsey Row is based mainly on the Greaves brothers' recollections.

135. Pennell and Pennell, *Life of . . . Whistler,* 1:139.

136. Ibid., 1:107.

137. Ibid., 1:182–85.

138. Frederick Wedmore, "Mr. Whistler's Theories and Mr. Whistler's Art," *Nineteenth Century* 6 (August 1879): 338–39; Pennell and Pennell, *Life of . . . Whistler,* 1:250.

139. Pennell and Pennell, *Whistler Journal,* 303–304; Pennell and Pennell, "Whistler as Decorator," 503.

140. Roger B. Stein, "Artifact as Ideology: The Aesthetic Movement in American Culture," in Burke et al., 42–46. Stein cites the two fictional renderings of aesthetic interiors as indicators of the nightmare undercurrent in the aesthetic movement. He identifies the source of the philosophy in Frederic's novel as Matthew Arnold.

141. Ibid., 30, 37–39, 50 nn. 63, 73; Edith Wharton and Ogden Codman, Jr., *The Decoration of Houses* (1897; reprint, New York: W. W. Norton, 1978), 28, 29, 45. Stein, 39, credits Owen Jones and Christopher Dresser as the source of Wheeler's ideas on color.

142. Vivienne Couldrey, *The Art of Louis Comfort Tiffany* (London: Wellfleet, 1989), 18, 51; Catherine Hoover Voorsanger, "Dictionary of Architects, Artisans, Artists, and Manufacturers," 474, and Johnson, "The Artful Interior," both in Burke et al., 123–26. Aslin, *Aesthetic Movement,* 179, notes the work of the Morris company was similar to that of H. W. Batley, Lewis F. Day, and Thomas Jeckyll.

143. Robert Gordon and Andrew Forge, *Monet* (New York: Harry N. Abrams, 1985), 176, 196. See Wichmann, 19.

144. Weintraub, 346. See Claire Joyce, *Monet's Table: The Cooking Journals of Claude Monet* (New York: Simon and Schuster, 1989), 75, 76, 102, 103, especially Jean-Bernard Naudin's photographs of Monet's dining room; and Pennell and Pennell, *Whistler Journal,* 208. Monet and Whistler corresponded from 1887 to 1896.

145. Vincent van Gogh, *The Letters of Vincent van Gogh,* ed. Mark Roskill (New York: Atheneum, 1985), 284, 341; Marcel Proust to Marie Nordlinger, February 8 or 9, 1905, quoted in R. Spencer, *Whistler,* 364. As late as 1905 Marcel Proust mused, "The more I think of Ruskin's and Wisthler's [sic] theories, the more I feel they are not irreconcilable."

146. See Roger Billcliffe, *Charles Rennie Mackintosh: The Complete Furniture, Furniture Drawings, and Interior Designs* (New York: E. P. Dutton, 1986), 9, 10, 20, 21. Mackin-

tosh believed in designing all the components of the total environment—a harmonious orchestration—in the mode of Whistler.

147. Laver, *Whistler*, 133; Hartmann, 109.

4. *Passage to the Splendor of the Peacock*

1. "Six Projects" is an identifying title not used during Whistler's lifetime. For more on the Six Projects, see Curry, "Whistler and Decoration," 1188–90; and Curry, *James McNeill Whistler at the Freer*, 44–45, 107–11, 238–45, 270–78. Also see Margaret MacDonald, *Whistler Pastels and Related Works in the Hunterian Gallery*, exh. cat., Hunterian Art Gallery (Glasgow: University of Glasgow, 1984), 15–25.

2. Young, MacDonald, and Spencer, 50; R. Spencer, "Whistler and Japan," 66.

3. Val C. Prinsep and Lionel Robinson, "The Private Art Collections of London: The Late Mr. Frederick Leyland's in Prince's Gate," *Art Journal*, n.s., 54 (May 1892): 129–30; Val C. Prinsep, "A Collector's Correspondence," *Art Journal*, n.s., 54 (1892): 252; Pennell and Pennell, *Life of . . . Whistler*, 1:166.

4. Way, 35–36. Anna Whistler to James Gamble, August 27, 1867, in Young, MacDonald, and Spencer, 50, mentions Whistler's order from Leyland for two pictures.

5. Curry, *James McNeill Whistler at the Freer*, 108; MacDonald, *Whistler Pastels*, 18.

6. MacDonald, *Whistler Pastels*, 7. His figure drawings, however, became more precise and finished.

7. Pennell and Pennell, *Life of . . . Whistler*, 1:148–49. For more background on the Six Projects, see Curry, *James McNeill Whistler at the Freer*, 107–109.

8. R. Spencer, *Whistler*, 27–28; Curry, *James McNeill Whistler at the Freer*, 44, 107.

9. M. Susan Duval, "F. R. Leyland: A Maecenas from Liverpool," *Apollo* 124 (August 1986): 110; George C. Chandler, "The Leyland Line," *Liverpool Shipping: A Short History* (London: Phoenix House, 1960), 86–87, 126–27; Prinsep and Robinson, 129; Ferriday, 409, 408; M. Susan Duval, "A Reconstruction of F. R. Leyland's Collection: An Aspect of Northern Painting" (master's thesis, Courtauld Institute, 1982), 11, 21, 37; Francis L. Fennell, Jr., *The Rossetti-Leyland Letters* (Athens: Ohio University Press, 1978), 26. By 1873 the Bibby Fleet was Leyland and Company. Clement Jones, *Pioneer Shipowners* (Liverpool: Charles Birchall & Sons, 1934), 118, described Leyland as

follows: "Leyland, with his fine head and pointed beard, had the appearance of a Spanish Grandee adventurer; and he had the coolness and effrontery to match. His passage through life was mainly in the teeth of a storm."

10. Pennell and Pennell, *Life of . . . Whistler*, 2:84.

11. J.-E. Blanche, quoted in MacDonald, *Whistler Pastels*, 24.

12. Sandberg, "Whistler Studies," 64.

13. Harbron, 22–23; Catherine Hoover Voorsanger, "Dictionary of Architects, Artisans, Artists, and Manufacturers," in Burke et al., 431–33; Mark Girouard, "Chelsea's Bohemian Studio Houses: The Victorian Artist at Home—II," *Country Life* 152 (November 23, 1972): 1370–74; Edward W. Godwin, "On Some Buildings I Have Designed," *British Architect and Northern Engineer*, November 29, 1878, 210; Wilkinson, 104.

14. Wilkinson, 104. Godwin worked with Burges on the design of the London Law Courts and with R. W. Edis on the design of the House of Parliament in Berlin. Donnelly and Thorp, 16.

15. Elizabeth Aslin, "E. W. Godwin and the Japanese Taste," *Apollo* 76 (December 1962): 782; Elizabeth Aslin, *E. W. Godwin: Furniture and Interior Decoration* (London: John Murray, 1986), 13–14; Aslin, *Nineteenth-Century English Furniture*, 63. On Wednesday, June 5, 1872, Rossetti wrote, "This diary-work is becoming too painful now." Bornand, 206. Dante Gabriel Rossetti was suffering from paranoid schizophrenia accompanied by delusions and hallucinations. The death of his first wife, Lizzy Siddal, in 1862, was assumed to be a suicide. He later became involved with Morris's wife, Jane, and on June 8, 1872, he attempted suicide by taking an overdose of laudanum. Wilhide, 26.

16. Max Beerbohm, quoted in Harbron, xiii, 115; Aslin, "E. W. Godwin and the Japanese Taste," 782; Aslin, *E. W. Godwin: Furniture and Interior Decoration*, 13–14. Whistler also did some sketching in Godwin's sketchbooks.

17. Aslin, "E. W. Godwin and the Japanese Taste," 781; Wilkinson, 113–14. Watanabe, *High Victorian Japonisme*, 94, refers to it as speculation on Aslin's part

that these individuals took advantage of this public auction.

18. Harbron, 32–33. For aspects of Godwin's *japonisme*, see his notebooks and sketchbooks, VA PD. Whistler probably moved into 7A Queen's Road by May 1862. Almost nothing is known about this residence or how long he remained there. It is conceivable, however, that it was decorated in a Japanese style.

19. Edward Craig (Terry's grandson), quoted in Wilkinson, 111; Terry, *Story*, 38.

20. Wilkinson, 114, 224–26; Aslin, *E. W. Godwin: Furniture and Interior Decoration*, 9.

21. Wilkinson, 145–46; Edward W. Godwin, "Japanese Wood Construction: Woodwork V," *Building News* 28 (February 12, 1875): 173. The illustrations shows trellislike construction.

22. Aslin, *E. W. Godwin: Furniture and Interior Decoration*, 20; Elizabeth Aslin, "The Furniture Designs of E. W. Godwin," *Victoria and Albert Museum Bulletin* 3 (October 1967): 145, 147; Pennell and Pennell, *Life of . . . Whistler*, 2:75.

23. Aslin, *E. W. Godwin: Furniture and Interior Decoration*, 20; Aslin, "The Furniture Designs of E. W. Godwin," 145, 147; Aslin, *Aesthetic Movement*, 52; Harbron, 119; Wilkinson, 133, 234, 375; Edgar Kaufmann, Jr., "Makers of Tradition: 30. Edward Godwin and Christopher Dresser: The 'Esthetic' Designers, Pioneers of the 1870s," *Interiors*, October 1958, 162–65; Pennell and Pennell, "Whistler as Decorator," 509–10; Nikolaus Pevsner, "Art Furniture," *Architectural Review* 3 (January 1, 1952): 48.

24. Edward W. Godwin, "My Chambers and What I Did to Them," *Architect* 16 (July 1, 1876): 4–5.

25. Wilkinson, 148–54.

26. Ibid.; Terry, *Story*, 101.

27. Muthesius, 159, 161; Godwin, "My Chambers" (July 8, 1876): 19; Menpes, *Whistler*, 128–29; Max Beerbohm, quoted in Harbron, 151.

28. Godwin, "My Chambers" (July 8, 1876): 19, and (August 5, 1876): 73; Aslin, "E. W. Godwin and the Japanese Taste," 784; Lasdun, 108.

29. Godwin, "My Chambers" (August 5, 1876): 73. Aslin, *Aesthetic Movement*, 65–66, assumes Godwin is writing about his own interior here. Wilkinson follows this line (265). Godwin, however, does not seem to have reached this state of ultra-refinement, delicacy, and spareness as early as Whistler, judging from his descriptions of his own private chambers in these articles.

30. Godwin, "My Chambers" (August 5, 1876): 73; "Art Sales," *Academy*, February 21, 1880.

31. Harbron, 122–23.

32. Terry, *Story*, 80.

33. Harbron, 75, 82; Terry, *Story*, 80; Pennell and Pennell, *Life of . . . Whistler*, 2:75. Wilkinson, 27, states, "Apparently Godwin had nothing to do with his first family [after his marriage to Beatrix]. Edward Gordon Craig [his son] stated in his memoirs that he never saw his father after the age of three."

34. Whistler to Alan Cole, n.d., quoted in Young, MacDonald, and Spencer, 51; MacDonald, *Whistler Pastels*, 17.

35. Sutton, ed., 194; Pennell and Pennell, *Life of . . . Whistler*, 1:150–51, 189–91; [Armstrong], 204. For background on these mosaics, see Physick, 62–67. The mosaics are in storage.

36. Curry, *James McNeill Whistler at the Freer*, 244; Whistler to Alan S. Cole, 1873, Whistler Letters, 1897, 309, LC RC. See also Alice Lee Parker, "The Whistler Material in the Rosenwald Collection," *Library of Congress Quarterly Journal of Current Acquisitions* 3 (October 1945): 63.

37. Whistler to Henry Cole, Esq., C. B., Kensington, transcript, LC PP (microfilm, AAA).

38. Pennell and Pennell, *Life of . . . Whistler*, 1:151; Pennell and Pennell, "Whistler as Decorator," 506; [Sickert], 32.

39. Anna Whistler to James Gamble, November 5, 1872, in A. Whistler, "Lady of the Portrait," 327.

40. Florence M. Gladstone, *Aubrey House, Kensington, 1698–1920* (London: Arthur L. Humphreys, 1922), 53–54. In John Cornforth, *English Interiors, 1790–1848: The Quest for Comfort* (London: Barrie & Jenkins, 1978), figures 110, 111, 112, and 113 show interiors of Aubrey House.

41. Wilkinson, 119; Menpes, *Whistler*, 128; Pennell and Pennell, *Whistler Journal*, 302; Pennell and Pennell, "Whistler as Decorator," 505. Lasdun, 122, attributes an identical remark to Morris.

42. Pennell and Pennell, *Life of . . . Whistler*, 1:202–203; Aslin, *Aesthetic Movement*, 63.

43. Matthew Arnold, "Sweetness and Light" and "Hebraism and Hellenism," in Buckler, ed., 457–86; Nikolaus Pevsner, *Ruskin and Viollet-le-Duc* (London: Thames and Hudson, 1969).

44. Letter from "Brother Artist," *Piccadilly*, June 6, 1878, pc, 10:63, GUL BP.

45. M. E. Hayward, "Influence of the Classical Oriental Tradition on American Painting," *Winterthur Portfolio* 14 (summer 1979): 111–12.

46. Aslin, *Aesthetic Movement*, 48; Wichmann, 231, 237. By the 1890s the dado was rapidly going out of style. Cooper, 12.

47. MacDonald, *Whistler Pastels*, 47.

48. Aslin, *Aesthetic Movement*, 176. See also Catherine Lynn, "Decorating Surfaces" and "Surface Ornament: Wallpapers, Carpets, Textiles, and Embroidery," 64–109; and Marilynn Johnson, "The Artful Interior," 111–41, all in Burke et al.

49. Pennell and Pennell, *Life of . . . Whistler*, 1:147, 172–73; Whistler to Fantin-Latour, September 1868, transcript, 9, Freer.

50. Barrie Bullen, "The Palace of Arts: Sir Coutts Lindsay and the Grosvenor Gallery," *Apollo* 102 (November 1975): 352–54, 357 n. 20; Pennell and Pennell, *Life of . . . Whistler*, 1:210, 212.

51. Parry, 23, notes, "Whistler himself had designed a frieze for one of the [Grosvenor] galleries." See also Denney, "Exhibition Reforms and Systems"; and Donald M. Murray, "James and Whistler at the Grosvenor Gallery," *American Quarterly* 4 (spring 1952): 49.

52. Hamilton, 23; Bullen, 354–55; Oscar Wilde, "The Grosvenor Gallery, *Dublin University Magazine* 90 (July 1877): 118; Ellmann, 79, 83; Pennell and Pennell, *Life of . . . Whistler*, 1:210–13.

53. "Grosvenor Gallery," *L.S.D.*, June 12, 1877, pc, 10:113, GUL BP; Ellmann, 78; Eddy, 119.

54. Whistler to Waldo Story, n.d., case 2, LC PP; unidentified press clippings, with annotations in Whistler's hand, pc, 10:35, GUL BP. On the same page of this press clipping volume, Whistler saved a clipping in which his competitive brother-in-law Francis Seymour Haden wrote to the *Standard*, November 13, 1888, to say this was the *third* not the *first* show of pastels in London. See also Walter Dowdeswell, "Whistler," *Art Journal* 49 (April 1877): 97–98.

55. Megilp, "The Grosvenor Gallery and Royal Academy," *Vanity Fair*, May 5, 1877, 281; Pennell and Pennell, *Life of . . . Whistler*, 1:210–18; Harbron, 123.

56. "The Grosvenor Gallery of Fine Art, New Bond Street," *Illustrated London News* 70 (May 5, 1877): 419–20; Bullen, 357. The last exhibition at the gallery took place in 1890.

57. Walter Crane, *An Artist's Reminiscences* (London: Methuen, 1907), 175; Crane to E. Pennell, August 12, 1906, LC PP, 281.

58. Bullen, 352–57; "The Grosvenor Gallery," 419–20.

59. Duval, "A Reconstruction," 40–41; Duval, "F. R. Leyland," 110; Pennell and Pennell, *Life of . . . Whistler*, 1:116, 175–76.

60. Frances Leyland, quoted in Pennell and Pennell, *Whistler Journal*, 101; Pennell and Pennell, *Life of . . . Whistler*, 1:175–76; Anna Mathilda Whistler, "Whistler's Mother," *Art Digest* 7 (January 1933), 6.

61. Whistler to Leyland, n.d., LC PP (microfilm, AAA); Duval, "F. R. Leyland," 110–11.

62. Anna Mathilda Whistler and James McNeill Whistler to Leyland concerning his purchase of a "Velasquez," August [1870s], LC PP. Lochnan, *Etchings*, 156, notes Leyland collected Signorelli, Bellini, Giorgione, Botticelli, and Crivelli, "each one chosen with impeccable taste."

63. Ferriday, 408.

64. Anna Whistler to James Gamble, April 10, 1872 [incorrectly dated 1866], in A. Whistler, "Lady of the Portrait," 326; Ferriday, 408.

65. Whistler to Leyland, n.d., L 104, GUL BP.

66. Theodore Child, "A Pre-Raphaelite Mansion: F. R. Leyland at Prince's Gate," *Harper's New Monthly Magazine* 82 (December 1890): 81–99; Duval, "A Reconstruction," 34, 38, 41, 42; Duval, "F. R. Leyland," 112–13; Williamson, 84, 92; Pennell and Pennell, *Life of . . . Whistler*, 1:203. Child cites Leyland as the source of the details in his article.

67. Curry, "Whistler and Decoration," 1190–92; Duval, "A Reconstruction," 34, 38, 41, 42.

68. Duval, "F. R. Leyland," 113; Pennell and Pennell, "Whistler as Decorator," 506.

69. See Curry, *James McNeill Whistler at the Freer*, 160–63, for a detailed discussion of the staircase panels. Also see Pennell and Pennell, *Life of . . . Whistler*, 1:203.

70. Curry, *James McNeill Whistler at the Freer*, 160–63. Curry also compares the stairway panels to imitation marble wallpapers of the late seventeenth and early eighteenth centuries (162).

71. Child, 82; Curry, *James McNeill Whistler at the Freer*, 161–62; Prinsep and Robinson, 129–38. For background on Japanese screens, see Wichmann, 154–161. For more on Leyland's collection, see Duval, "A Reconstruction" and "F. R. Leyland." According to Duval there were ten paintings in the entrance hall.

72. Linda Merrill, associate curator of American art, Freer Gallery of Art, together with conservators, corrected the assumption that the leather was of sixteenth-century Spanish origin. See Kenneth Baker, "Polishing the Peacock Room: The Freer Gallery's Great Treasure Glitters Again," *Architectural Digest* 50 (March 1993): 32.

73. Williamson, 89–94; Duval, "A Reconstruction," 43. Thomas Jeckyll is often mistakenly referred to as "Henry" in the literature.

74. Leyland to Whistler, April 26, 1876, L 103, GUL BP; Child, 82. Mrs. Leyland also wrote Whistler to ask him to help Jeckyll with the color. Jeckyll's name is often misspelled. The spelling used herein is taken from his signature in his private letters.

75. Ferriday, 410; Young, MacDonald, and Spencer, 102; Lewis F. Day, "A Kensington Interior," *Art Journal* 55 (May 1893): 143–44.

76. Curry, *James McNeill Whistler at the Freer*, 58.

77. Ferriday, 410.

78. Du Maurier, *Young George Du Maurier*, 8, 15, 33, 39, 66, 69; Aslin, *Aesthetic Movement*, 143; Ferriday, 410.

79. Ferriday, 410; Jeckyll to Anderson Rose, June 19, 1868, from Queen's Gate, case 6B, LC PP; Anna Whistler to James Gamble, Saturday, October 29, 1870, LC PP.

80. Ferriday, 411. See Gabriel P. Weisberg, *Stile Floreale: The Cult of Nature in Italian Design* (Miami: Wolfsonian Foundation, 1988), fig. 86 (p. 96), for an example of a Jeckyll design for a fireplace grate. Examples of Jeckyll's furniture also may be seen at the Victoria and Albert Museum. The Jeckyll fire grate at the Musée d'Orsay is surrounded by blue-glazed De Morgan ceramic tiles.

81. Ferriday, 410–11.

82. Ibid.; R. Spencer, *The Aesthetic Movement*, 65, 68; Aslin, *Aesthetic Movement*, 93. Holland House was destroyed in World War II. Jeckyll's superb plans for the grounds and billiard room (ca. 1878) are in W 19 E 1797–1917, VA PD.

83. Ferriday, 411; Aslin, *Aesthetic Movement*, 93, 143.

84. Ferriday, 411; Duval, "A Reconstruction," 44; Luke Ionides, *Memories* (Paris: Herbert Clark, 1925), 48.

85. Duval, "A Reconstruction," 43; Ferriday, 410–11. For a condensed history of the Peacock Room, see Young, MacDonald, and Spencer, 102–104.

86. Pennell and Pennell, *Whistler Journal*, 107; Williamson, 94–95. Curry, *James McNeill Whistler at the Freer*, 61, debates the report by Williamson that Murray Marks deleted porcelains.

87. Edward W. Godwin, "Notes on Mr. Whistler's Peacock Room," *Architect* 16 (February 24, 1877): 118–19.

88. "Art at Home—Mr. Leland's [sic] at Princes Gate," *Observer*, January 28, 1877, case 199, LC PP; Child, 84; Menpes, *Whistler*, 32; Williamson, 96; Jeckyll to Whistler, November 11, 1876, in Curry, *James McNeill Whistler at the Freer*, 54; Laver, 161.

89. Duval, "F. R. Leyland," 114–15; Williamson, 76. Leyland died of a heart attack at age sixty-one on January 4, 1892, at Blackfriar's Railway Station. Frances Leyland told the Pennells she "regretted that [Whistler] could not have married her . . . it would have been much better for him, she thinks." Pennell and Pennell, *Whistler Journal*, 105.

90. Pennell and Pennell, *Life of . . . Whistler*, 1:204. In 1919 the room went to the Freer Gallery of Art, Washington, D.C.

91. Ferriday, 409; Pennell and Pennell, *Life of . . . Whistler*, 1:221–22.

92. "Art at Home," case 199, LC PP; Duval, "A Reconstruction," 40.

93. Pennell and Pennell, *Life of . . . Whistler*, 1:203.

94. Ibid., 1:204; C. J. H., "The Peacock Room," *Catalogue of Messrs. Obach's Galleries*, New Bond Street, London, June 1904.

95. Leyland to Whistler, August 7, 1876, Wh L 105, GUL BP. See Menpes, *Whistler*, 129–32, for his account of the Peacock Room.

96. Whistler to [Lord Redesdale], typescript, [fall 1876], unascribed, LC PP. An identical letter (transcript, Rosenwald Collection, 308, LC RC) is ascribed to Alan Cole as receiver. The letter was probably written to Redesdale, who was in Scotland at this time.

97. "Notes and News," *Academy*, 10 (September 2, 1876): 249; Whistler to Leyland, n. d., case 6B, LC PP.

98. "Notes and News," 249. A second review appeared in the *Morning Post*, November [?], 1876.

99. Whistler to Leyland, September 1876, LC PP (microfilm, AAA); Ferriday, 412–13; Pennell and Pennell, *Life of . . . Whistler*, 1:207; Whistler letter, in *Academy* 10 (September 9, 1876): 275, L 139, GUL BP. Whistler's press cutting album, vol. 2, e.g., has twenty different articles on the Peacock Room, in GUL BP.

100. Curry, *James McNeill Whistler at the Freer*, 54–55.

101. Alan Cole, extracts from diary, and Lord Redesdale, recollections of his October 29, 1876, visit, both in Pennell and Pennell, *Life of . . . Whistler*, 1:205–206; Pennell and Pennell, *Whistler Journal*, 108.

102. Whistler to Leyland, quoted in Sutton, *Nocturne*, 84.

103. Edmond de Goncourt, in 1884, quoted in Silverman, 34, 35–36. For a fascinating discussion of the Goncourts' house in Auteuil (1869), see Silverman, 17–39. Ellmann notes, 228–29, that Wilde visited the Goncourts in 1883. A two-volume photographic monograph, *La Maison d'un artiste*, commissioned by Edmond de Goncourt, was published in 1881.

104. Liberty, quoted in Adburgham, *Liberty*, 28; Robert Schmutzler, *Art Nouveau* (New York: Harry N. Abrams, 1978), 21.

105. Godwin's copy of *Harmony in Blue and Gold: The Peacock Room* (London: T. Way, 1877), G 100 GUL BP.

106. Pennell and Pennell, *Whistler Journal*, 98–113; Pennell and Pennell, *Life of . . . Whistler*, 1:208–209; Leyland to Whistler, July 1877, L 117, and July 17, 1877, L 121, GUL BP; Young, MacDonald, and Spencer, 102. "The housemaid tells me that the number of persons calling to see the dining room interferes with her greatly in getting the house ready. There is so little time left before we come up, that I must ask you to refuse any further applications to view the room." Leyland apparently knew about the visitors but believed it to be a more formal and controlled situation than was the case. Leyland to Whistler, n.d., [Friday], L 115, GUL BP.

107. "How Whistler Painted a Ceiling: London Letter to the Providence Press," pc, 10:73, in GUL BP.

108. "Peacock Room," *Academy*, February 17, 1877, 147, pc, 2:6, GUL BP; Whistler to Anna Mathilda Whistler, 1876, NYPL (roll N25, microfilm, AAA).

109. Anna Mathilda Whistler to Mr. James Gamble, September 8, 1876, GUL BP; Anna Mathilda Whistler to Miss Eastwick, Wednesday, July 19, 1876, LC PP.

110. Leyland to Whistler, July 17, 1877, letter no. 14, L 121, GUL BP. Leyland to Whistler, July 1877, letter no. 11, L 117 GUL BP: "I have strictly forbidden my servants to admit you again, and . . . I have also told my wife and children that I do not wish them to have any further intercourse with you." Leyland to Whistler, July 24, 1877, letter no. 19, L 128, GUL BP: "Five months ago your insolence was so intolerable that my wife ordered you out of the house." According to Thomas Way, one day Mrs. Leyland, who had been out of town, returned unexpectedly and let herself into the mansion with her own key. She overheard a conversation in the dining room in which Whistler remarked, "Well, you know what can you expect from a parvenu?" Until then, he had come and gone like one of the family, but this abuse signaled the beginning of the end. Pennell and Pennell, *Whistler Journal*, 106. Later Mrs. Leyland did let Whistler in; however, by 1879 she had divorced Leyland. Duval, "F. R. Leyland," 114. While Whistler himself could no longer get into the room, he relished getting his friends in, knowing that if Leyland knew it, "the place would be sealed up forever." Whistler to Theodore Child, case 1, p. 10, LC PP.

111. Whistler to Frances Leyland, [1877], case 2, LC PP.

112. "Mr. Whistler's Peacock," *London*, February 17, 1877, pc, 2:4, GUL BP.

113. "Ornamental Painting," *Examiner*, February 24, 1877, pc, 2:4, GUL BP.

114. The Reverend H. R. Haweis, "A Sermon Preached at St. James's Hall, 'Money and Morals,'" February 18, 1877, quoted in R. Spencer, *Whistler*, 123; Muthesius, 160.

115. *Punch*, March 3, 1877, pc, 7:47, and March 17, 1877, pc, 2:7, GUL BP. Whistler's elimination of human figures in favor of a bird as a theme for an opulent room was part of the basis for these parodies.

116. *Chicago Sunday Tribune*, September 4, 1904; and *New York Examiner*, July 17, 1904, both in Whistler Scrapbook, Freer; "Studio Talk," *Studio* 32 (August 1904): 241–46.

117. Pennell and Pennell, *Life of . . . Whistler*, 1:110, 202–203; R. Spencer, *The Aesthetic Movement*, 70, 74.

118. Young, MacDonald, and Spencer, 104.

119. See Wichmann, 196–204.

120. Alan Cole, diary extract quoted in Pennell and Pennell, *Life of . . . Whistler*, 1:207.

121. Leyland to Whistler, October 21, 1876, letter no. 1, Wh L 106, GUL BP; Pennell and Pennell, *Whistler Journal*, 110. Baker, 30, computed Whistler's "astronomical" fee for his work in the Peacock Room as nine to ten thousand dollars at today's rates.

122. Whistler to Leyland, October 24–30, 1876, quoted in R. Spencer, *Whistler*, 121; Pennell and Pennell, *Whistler Journal*, 112; Whistler to Leyland, October 31, 1876, letter no. 6, L 111, GUL BP.

123. Leyland to Whistler, November 1, 1876, letter no. 7, L 114, GUL BP.

124. Leyland to Whistler, July 27, 1877, letter no. 21, L 132, GUL BP; Way, 36; Way and Dennis, 100.

125. Curry, *James McNeill Whistler at the Freer*, 55.

126. See John Winter and Elisabeth West Fitzhugh, "Some Technical Notes on Whistler's 'Peacock Room,'"

Studies in Conservation 30 (November 1985): 149–54. See also Duval, *A Reconstruction*, 46.

127. Winter and Fitzhugh, 149, 153; Edward W. Godwin, "Notes on Mr. Whistler's Peacock Room," 118; Young, MacDonald, and Spencer, 102.

128. Menpes, *Whistler*, 130; Pennell and Pennell, *Life of . . . Whistler*, 1:204–205; Bacher, 32.

129. Quotes from Joyce Hill Stoner, "Art Historical and Technical Evaluation of Works by Three Nineteenth-Century Artists: Allston, Whistler, and Ryder," in *Appearance, Opinion, Change: Evaluating the Look of Paintings* (London: United Kingdom Institute for Conservation, 1990), 38–39.

130. Winter and Fitzhugh, 151; Stoner, 39; Benjamin Forgey, "Polishing the Peacocks at the Freer," *Washington Post*, March 31, 1990, sec. D, col. 1.

131. Joyce Hill Stoner, comments made to author during restoration work in the Peacock Room, May 1990.

132. "Description of the Salon Dore," gallery documentation, French interior (1768) of Count d'Orsay, Corcoran Gallery, Washington, D.C.; "The Peacock Room," *Athenaeum*, June 18, 1904: 793.

133. Pennell and Pennell, *Life of . . . Whistler*, 1:203; Whistler to D. Croal Thomson from 33 rue de Tournon, May or June 1892, case 33B LC PP. At the time of its sale in 1904, the room was exhibited at Obach's Gallery on Bond Street. C. J. H., "The Peacock Room," states that the sideboard "seems to have been designed by Whistler." Curry, *James McNeill Whistler at the Freer*, 61, 68, states that Jeckyll designed the sideboard; his source is not clear.

134. W. Crane, *An Artist's Reminiscences*, 199.

135. Pennell and Pennell, *Life of . . . Whistler*, 1:163; Williamson, 94–95.

136. Pennell and Pennell, *Life of . . . Whistler*, 1:204–205; "The Peacock Room," *The Bazaar, the Exchange and Mart*, June 18, 1904, 1737.

137. "Art in Decoration," *Standard*, February 22, 1877, pc, 1:42, GUL BP.

138. Pennell and Pennell, *Life of . . . Whistler*, 1:206–207.

139. *Standard*, February 22, 1877, GUL BP; Curry, *James McNeill Whistler at the Freer*, 68; Weber, 50–51; Whistler to Theodore Child, case 1, p. 11, LC PP.

140. "A Peacock Room," *London Times*, February 15, 1877, 4, col. d, case 199, LC PP; Godwin, "Notes on Mr. Whistler's Peacock Room," 118–19.

141. Godwin, "Notes on Mr. Whistler's Peacock Room," 10; E. W. Godwin, "Afternoon Strolls," *Architect*, December 23, 1876, 363.

142. Godwin, "Notes on Mr. Whistler's Peacock Room," 10.

143. "L'Art Nouveau: What Is Thought of It," *Magazine of Art*, 28 (1903): 211; W. Crane, *An Artist's Reminiscences*, 232; Pennell and Pennell, *Whistler Journal*, 73. This was Whistler's response to John Lavery's attempt to define art nouveau.

144. Godwin, "Notes on Mr. Whistler's Peacock Room," 11.

145. Aubrey Beardsley to G. F. Scotson Clark, ca. 1892, 4 pp., 11 sketches, Pennell Fund 38, 0717R, no. 24, LC PP; Pennell and Pennell, *Life of . . . Whistler*, 1:263. See also Dennis Farr, *English Art, 1870–1940*, vol. 14 of *The Oxford History of English Art* (Oxford: Clarendon, 1978), 67; and Catherine Slessor, *The Art of Aubrey Beardsley* (Secaucus, N.J.: Chartwell Books, 1989), 16. Beardsley based his signature on Whistler's butterfly monogram.

146. Whistler to his sister-in-law Nellie Whistler, December, 1879, W 52, GUL BP. See Weisberg, *Art Nouveau Bing*, 60–66, for more on this aesthetic viewpoint brought to fruition in the art nouveau movement.

5. From Tite Street to the Rue du Bac

1. Whistler to Anderson Rose from the White House, received December 6, 1878, case 4, LC PP.

2. Harbron, 136; Girouard, *Sweetness and Light*, 177; Pennell and Pennell, *Life of . . . Whistler*, 1:222.

3. "A Last Breakfast in Cheyne-Walk," *World*, June 19, 1878, pc, 2:37, GUL BP.

4. Henry James, *The Letters of Henry James: Volume II, 1875–1883*, ed. Leon Edel (Cambridge: Harvard University Press, Belknap Press, 1975), 167–68.

5. Whistler to Mr. Morse, letter no. 1238, vol. 7, LC PP; Pennell and Pennell, *Life of . . . Whistler*, 1:224; Pennell and Pennell, *Whistler Journal*, 34; Eddy, 131.

6. Gaunt, *Chelsea*, 144; Girouard, "Chelsea's Bohemian Studio Houses," 1370–71; Wilkinson, 315.

7. Girouard, "Chelsea's Bohemian Studio Houses," 1370–71; Wilkinson, 315. The ground rent was twenty-nine pounds a year.

8. See Wilkinson, 287–88. Queen Anne had become the preferred style even for William Morris, who had "lost confidence in the Gothic revival." P. Thompson, 66.

9. See John Milner, *The Studios of Paris* (New Haven: Yale University Press, 1988), 45–46; Wilkinson, 311–12; Harbron, 136. I have used the chronology in R. Spencer, *Whistler*, for several exact dates in this chapter.

10. See Aslin, "E. W. Godwin and the Japanese Taste," 779–84; Gaunt, *Chelsea*, 144–45; Girouard, *Sweetness and Light*, 177–81, 181–84, and "Chelsea's Bohemian Studio Houses," 1372.

11. Godwin, "Japanese Wood Construction," 173–75.

12. Gaunt, *Chelsea*, 145.

13. The destruction of the White House helped to precipitate the formation of the Victorian Society, which works to protect nineteenth-century monuments of this nature. Less-inspired houses by E. W. Edis, Frederick Beeston, and F. S. Waller remain on Tite Street. Girouard, *Sweetness and Light*, 184.

14. Godwin, diary entries quoted in Wilkinson, 311, 318; Harbron, 125; Pennell and Pennell, *Whistler Journal*, 303; Pennell and Pennell, "Whistler as Decorator," 507. Beatrix Godwin was included in these planning meetings to design the White House.

15. Wilkinson, 312.

16. "A Japanese Room," *Art Journal* 40 (July 1878): 158.

17. Watanabe, *High Victorian Japonisme*, 127–29, points out a new source for learning about Japan appeared in Western publications during the 1850s and 1860s, namely, illustrations based on photographs. Felice Beato produced the most famous photographs of Japan in the late 1860s. Whistler was keenly interested in photography. Photographs of Japanese interiors may have represented a key source for him.

18. Godwin, "On Some Buildings I Have Designed," 210–11; Harbron, 125–26; Girouard, *Sweetness and Light*, 180.

19. The board solicitor, February 25, 1878, quoted in Girouard, *Sweetness and Light*, 180; Wilkinson, 317; R. Spencer, *Aesthetic Movement*, 61; Pennell and Pennell, *Life of . . . Whistler*, 1:223.

20. Unidentified press clipping, September 19, 1879, 2:50, 1997, LC RC; Harbron, 136–37.

21. Harbron, 183; Dufwa, 172; Wilkinson, 315–18. Mackintosh's Hill House has the steep roof, stark simplicity, walled asymmetry, and grid patterns of the White House. Hoffmann's rectilinear white Palais Stoclet in Brussels seems to combine the severe style of the exterior of the White House with the opulent jeweled and gilded interior of the Peacock Room.

22. Wilkinson, 319; Girouard, "Chelsea's Bohemian Studio Houses," 1370.

23. Girouard, *Sweetness and Light*, 180–81, and "Chelsea's Bohemian Studio Houses," 1371; Pennell and Pennell, *Life of . . . Whistler*, 1:251. Several plans were submitted before Godwin won acceptance.

24. Whistler to Godwin, January 30, 1878, G 101, GUL BP. The Whistler-to-Godwin letters are, with a few exceptions, in Special Collections, University of Glasgow, Birnie Philip Bequest.

25. Whistler to Godwin, [1878], G 104, GUL BP.

26. Whistler to Godwin, received March 22, 1878, G 105, GUL BP.

27. Whistler to Godwin, 1878, G 107, GUL BP.

28. Whistler to Godwin, [1878], G 112, GUL BP.

29. Godwin, quoted in R. Spencer, *Whistler*, 125.

30. Morris, quoted in Girouard, *Sweetness and Light*, 99; Whistler to Godwin, May 9, 1878, G 108, GUL BP. See also P. Thompson, 63–64.

31. Girouard, *Sweetness and Light*, 181; Whistler to Godwin, September 11, 1878, from 28 Wimpole Street, case 4, LC PP. The following day, September 12, Godwin responded, "Do not be rash." NYPL (roll no. N25, microfilm, AAA).

32. Harbron, 129; Weintraub, 225; Godwin to Whistler, September 9, 1878, 8 Victoria Chamber S. W., NYPL (roll no. N25, microfilm, AAA).

33. Charles Augustus Howell, diary, October 1878, quoted in Pennell and Pennell, *Life of . . . Whistler*, 1:200, 225–27. Memorandum from A. Lasenby Liberty & Co., Japanese, Chinese and Indian Warehouse, September 14, 1878, LC PP: "Dear Whistler, We have now got three of your bills (all of them) returned. Can you let us have the balance or shall we draw fresh ones? Your Obedient Servant A. Liberty."

34. Alan Cole, diary extract, October 16, 1878, 281, LC PP; Pennell and Pennell, *Life of . . . Whistler*, 1:228; Girouard, *Sweetness and Light*, 178; Harbron, 129.

35. This anonymous description is not clearly designated to be of the White House; however, it is appropri-

ate commentary for any of Whistler's homes. "Whistler, Painter and Comedian," *McClure's Magazine* 7 (1896): 378. For a discussion of the development of the aesthetic interior in America, see Marilynn Johnson, "The Artful Interior," in Burke et al., 111–41.

36. Wilkinson, 309; Godwin, "Japanese Wood Construction," 173; Pennell and Pennell, "Whistler as Decorator," 506.

37. Unidentified press clipping, September 19, 1879, case 2, 1997, LC RC; Jacques-Emile Blanche, *Portraits of a Lifetime: The Late Victorian Era: The Edwardian Pageant, 1870–1914*, trans. and ed. Walter Clement (London: Coward-McCann, 1938), 73.

38. Walter Dowdeswell, n.d., pc, transcription, 2:26, 1997, ND237.W6A18, LC RC.

39. Wichmann, 377, 403. Whitford, 109, notes wealthy homeowners in Japan usually had a fireproof warehouse (*kura*) in which most family possessions were stored. Superfluous decoration was thus kept to a minimum.

40. Pennell and Pennell, *Whistler Journal*, 303. See Farr, 175; Wichmann, 205. The Momoyama (Peach hill) period (1573–1615) was an age of affluence, and the decorative style that developed was lavish with lustrous surfaces and gold leaf. Robert Jacobsen, *Japanese Art: Selections from the Mary and Jackson Burke Collection* (Minneapolis: Minneapolis Institute of Arts, 1977), n.p. For a photograph of the Katsura Palace interior, which typifies the Momoyama period, see Wichmann, 379.

41. Unidentified press clipping, September 19, 1879, case 2, 1997, LC RC.

42. Wilkinson, 320.

43. See Wichmann, 372–73, for numerous images of Japanese wall and fence treatments.

44. Clive Wainwright of the Victoria and Albert Museum, in a conversation with the author, June 23, 1990, pointed out this cabinet, referred to herein as the *Four Seasons Cabinet*, and noted that it was "possibly done for Whistler's White House in Tite Street." See Aslin, *E. W. Godwin: Furniture and Interior Decoration*, pls. 9, 10, p. 24.

45. These items are listed for the living room in auction posters and in the *Catalogue of Porcelain and Other Works of Art and Objects of Antiquity, the Property of J. A. M. Whistler*, Sotheby, Wilkinson and Hodge, London, February 12, 1880, sc 1880.1, GUL BP.

46. See Pevsner, "Art Furniture," 49; Pennell and Pennell, "Whistler as Decorator," 504; and Pennell and Pennell, *Whistler Journal*, 302. Also see "The White House," *Vogue* 46 (August 1, 1915): 40. This one-page

layout includes four photographs of the exterior, courtyard, studio-drawing room, and upper drawing room. At this date Miss Anabel Douglas lived in the house. The writer stated that Miss Douglas "uses Whistler's great painting room as a dining-room, the atmosphere is but little changed." There was fine oak paneling and a "well-designed fireplace" in this room in 1915. The great windows were still in place. A second-story room, serving as a drawing room for Miss Douglas, had classical columns and a fireplace with a frieze. More research is indicated to ascertain which original fixtures survived when these photographs were taken. Since the drawing room was also a studio, this, in part, accounts for the large windows. However, it does not explain why they were floor-to-ceiling or located directly in front of the walled garden. Whistler continued to design gardens as extensions of the interior, especially in his Paris home. He may have chosen the rust-red wall color to create a vivid complement to the grass-green exterior.

47. Pennell and Pennell, "Whistler as Decorator," 507; Wichmann, 251, 347, 359–67, 374. Zacharie Astruc, quoted in Weisberg and Weisberg, 143–44, notes that the garden surrounding the Japanese house at the 1867 Paris Exposition "made everyone who sees it dream."

48. Wilkinson, 319; Wichmann, 251, 362.

49. Godwin to Whistler, September 9, 1876, NYPL (roll no. N25, microfilm AAA); "The White House," 40.

50. These details of the accessories in the White House are gleaned from the *Catalogue of Porcelain and Other Works of Art*; "Particulars and Condition of Sale of an Excellent 'Brick Detached Residence . . . Known as 'the White House,' Tite Street, Chelsea," Baker & Sons, September 18, 1879; and "Art Sale: Messrs. Christies," *Academy*, pc, 6:32, all in GUL BP.

51. Godwin's drawings of the built-ins for Whistler's White House are in the Godwin Papers, VA PD; china cabinet, pianoforte, cane-bottomed chairs are listed in *Catalogue of Porcelain and Other Works of Art*.

52. [Dowdeswell], unidentified handwritten record, pc, 2:1997, ND 237.W6A18, 26, LC RC.

53. Wilkinson, 329; [Dowdeswell], unidentified handwritten record, pc, 2:1997, ND 237.W6A18, 26, LC RC.

54. Way, 24.

55. J. Hillier, "Japan," *World Furniture*, ed. Helena Hayward (Secaucus, N.J.: Chartwell Books, 1977), 280; Harbron, 137; Pennell and Pennell, "Whistler as Decorator," 504; Pennell and Pennell, *Life of . . . Whistler*, 1:138, 222–23.

56. *Catalogue of Porcelain and Other Works of Art.*

57. Pennington, quoted in Hartmann, 107, 111; Wilkinson, 194–95; Harbron, 137; Wichmann, 84–85.

58. Pennington, quoted in Hartmann, 113; Pennington, 640; "Performance at the White House, Chelsea," *Graphic*, May 28, 1881, full page engraving, LB 12, 68–69, GUL BP.

59. Pennell and Pennell, *Life of . . . Whistler*, 1:252–54; Bacher, 266.

60. Harbron, 133; Pennell and Pennell, *Whistler Journal*, 163–66. Bacher, 266: "It took a mason several days to erase every trace of that inscription."

61. *Catalogue of Porcelain and Other Works of Art*; Mahey, 253, 254. For details on Maud (born in 1857), see Donnelly and Thorp, 14–15; and Margaret F. MacDonald, "Maud Franklin," in Ruth E. Fine, ed. *James McNeill Whistler: A Reexamination*, vol. 19 of *Studies in the History of Art* (Hanover, N.H.: University Press of New England and National Gallery of Art, 1987), 17, 22, 23.

62. Pennell and Pennell, *Life of . . . Whistler*, 1:260; Pennell and Pennell, *Whistler Journal*, 65, 73.

63. Pennell and Pennell, *Life of . . . Whistler*, 1:257.

64. Harbron, 138; Ford, ed., 249; Pennell and Pennell, *Life of . . . Whistler*, 1:258; unidentified press clipping, annotated in Whistler's hand: "Upon the alterations of the White House by 'Arry,'" vol. 23, GUL BP. See also Whistler, *Gentle Art*, 124–25.

65. *World*, November 7, 1883, pc, 3:39, GUL BP.

66. Wilkinson, 338; Harbron, 137, 183–84.

67. Harbron, 125.

68. See Weisberg, *Art Nouveau Bing*, 16, on Japanese art at the 1878 Paris International Exhibition.

69. Aslin, *E. W. Godwin: Furniture and Interior Decoration*, 14–15; Kaufmann, 164; Wilkinson, 304–305.

70. R. Spencer, *The Aesthetic Movement*, 60.

71. G. W. S. [George W. Smalley], "Household Decoration . . . Whistler's 'Harmony in Yellow and Gold' . . . ," *New York Daily Tribune*, July 6, 1878, cols. c and d.

72. Quoted in Elizabeth Gilmore Holt, *The Expanding World of Art, 1874–1902*, vol. 1, *Universal Expositions and State-Sponsored Fine Arts Exhibitions* (New Haven: Yale University Press, 1988), 23.

73. A collector, Pickford Waller, found the *Butterfly Cabinet* in a secondhand furniture shop. In 1973 the University of Glasgow purchased it through Christie's for eighty-four hundred pounds. Waller also collected Whistler's catalogues. Farr, 141–42.

74. Gallery documentation on the Butterfly Suite, Hunterian Art Gallery, University of Glasgow; Wilkinson, 397 n; Farr, 141–42; Aslin, *Nineteenth-Century English Furniture*, 63–64; Godwin Daybook, E 233–1963, VA PD. A Godwin drawing annotated "Paris 22 September 1877," representing a combination fireplace and cabinet, appears in one of Godwin's miniature sketchbooks. Aslin, *E. W. Godwin: Furniture and Interior Decoration*, pls. 10, 24, 64.

75. Pennell and Pennell, *Life of . . . Whistler*, 1:219 n. 39. According to Godwin's letter, Watt sold it.

76. Aslin, *Aesthetic Movement*, 84; Frances Weitzenhoffer, *The Havemeyers: Impressionism Comes to America* (New York: Harry N. Abrams, 1986), 48, states Tiffany probably knew of the Peacock Room and had visited the Butterfly Suite before launching his decorating business in 1879.

77. Pennell and Pennell, *Life of . . . Whistler*, 1:300.

78. Ibid., 2:7; Frederick Keppel, *One Day with Whistler* (New York: Frederick Keppel, 1904), 4.

79. Louisine W. Havemeyer, *Sixteen to Sixty: Memoirs of a Collector* (New York: privately printed, 1961), 205–206; Weitzenhoffer, 22–23. See Alice Cooney Frelinghuysen, "A New Renaissance: Stained Glass in the Aesthetic Period," in Burke et al., 189–97, for photographs of Tiffany's interiors for the Havemeyers.

80. Williamson, 149; Mrs. Julian Hawthorne, "Mr. Whistler's New Portrait," *Harper's Bazar* 14 (October 15, 1881): 658–59.

81. Way, 62–63.

82. Hawthorne, 658–59.

83. Pennell and Pennell, *Life of . . . Whistler*, 2:5, 1, 2, 14; Pennell and Pennell, *Whistler Journal*, 4–5; Keppel, 6.

84. Sketches of matting are in no. PD 73-1959, Fitzwilliam Museum, and no. 1943.610, Fogg Museum, Boston. See Curry, "Total Control: Whistler at an Exhibition," in Fine, ed., 72.

85. Pennell and Pennell, *Life of . . . Whistler*, 1:304; 2:10, 12. For a photograph of several of Whistler's friends assembled in this studio, see 2:10.

86. Pennell and Pennell, *Life of . . . Whistler*, 1:304; Girouard, *Sweetness and Light*, 178; Aslin, *Aesthetic Movement*, 99.

87. Hawthorne, 659; Way, 63.

88. Menpes, *Whistler*, 89. See Andrew Dempsey, "Whistler and Sickert: A Friendship and Its End," *Apollo* 83 (January 1966): 30; and Mortimer Menpes, "Reminiscences of Whistler by Mortimer Menpes, Recorded by Dorothy Menpes," *Studio* 29 (September 1903): 245–57.

89. Menpes, *Whistler*, 42–44, 129; Pennell and Pennell, "Whistler as Decorator," 505–506; Rothenstein, 125–26. In the 1890s an assistant named Eugene pilfered some of Whistler's silver. He was caught and imprisoned, but he had melted down the silver.

90. Menpes, *Whistler*, 16–17, 42–44, 129.

91. Ibid., 16–17.

92. Ibid., 25, 69, 71, 127–28. These combined comments on Whistler's tonal painting are taken from three different sections of the book.

93. William Hauptman, "Charles Gleyre: Tradition and Innovation," in *Charles Gleyre, 1806–1874*, exh. cat. (New York: Grey Art Gallery and Study Center, New York University, 1980); Pennell and Pennell, *Life of . . . Whistler*, 1:50, 221; Sutton, *Nocturne*, 22. For a description of Gleyre's studio, see Rewald, 72–73.

94. Ernest F. Fenollosa, "The Collection of Mr. Charles Freer," *Pacific Era* 1 (November 1907): 61–63.

95. Pennell and Pennell, *Life of . . . Whistler*, 2:275.

96. David Park Curry, "Total Control: Whistler at an Exhibition," in Fine, ed., 80 n. 24, notes that the ground of *Miss May Alexander* "is misted with vaguely defined mauves that shimmer as one moves before the work. Whistler's walls, with color applied upon color, may have had a similar shimmering appearance." See Catherine Lynn, "Surface Ornament: Wallpaper, Carpets, Textiles, and Embroidery," in Burke, et al., 65–109.

97. Whistler to Nellie Whistler, December 16, 1881, W 689, GUL BP; Lucy Crane, *Art and the Formation of Taste* (Boston: Chautauqua, 1885). Godwin also mixed his own colors. Wilkinson, 329.

98. Whistler to Ernest Brown of the London Fine Art Society, 148 New Bond Street, LB 9, Am 1967 I/4, GUL BP.

99. Eddy, 131–32.

100. *Leeds Express*, January 17, 1891, cited in Weber, 148.

101. James, *The Painter's Eye*, 209.

102. Pennell and Pennell, *Life of . . . Whistler*, 1:220; Lady Campbell to the Pennells, December 1907, including a copy of *Rainbow Music: A Treatise on the Philosophy of Color Grouping* (London, 1886), vol. 280, nos. 371, 373, LC PP. The following reveal some examples of unidentified decorative work: a study for a portiere with a circle and chevron design; a design for the coloring of a room in Venetian red, white, yellow ochre, and raw sienna; and a design for a wall decoration featuring tall irises with an oval cartouche. Freer Gallery Archive.

103. Pennell and Pennell, "Whistler as Decorator," 507; Pennell and Pennell, *Life of . . . Whistler*, 1:221. The advice to a client to burn the furniture is also attributed to Rossetti. Lasdun, 121. See Curry, "Whistler and Decoration," 1189–90, for a discussion of the French rococo influence in Whistler's decorative work.

104. Dowdeswell, 98; Albert Ludovici, "Whistlerian Dynasty at Suffolk Street," *Art Journal* 47 (July and August 1906): 194; Way and Dennis, 103; Pennell and Pennell, *Life of . . . Whistler*, 2:3; Hartmann, 113.

105. Grange Woolley, "Pablo de Sarasate: His Historical Significance," *Music and Letters* 36 (July 1955): 237, 240–41.

106. Sutton, *Sickert*, 44–45; Whistler to E. Cobden, October 12, 1885, LC PP; Dempsey, 130.

107. Marjorie Lilly, *Sickert: The Painter and His Circle* (Park Ridge, N.J.: Noyes, 1973), 106.

108. Kazuko Koizumi, *Traditional Japanese Furniture*, trans. Alfred Birnbaum (Tokyo: Kodansha International, 1986), 26, 57, 76, 77.

109. D'Oyly Carte to Whistler, March 20, 1888, GUL BP; *Artist*, April 1888, pc, 9:77, GUL BP.

110. Pennell and Pennell, *Life of . . . Whistler*, 1:220–21.

111. Wilde, quoted in Gombrich, 58; Forbes-Robertson, 109–10.

112. Ellmann, 256.

113. H. Montgomery Hyde, "Oscar Wilde and His Architect," *Architectural Review* 109 (March 1951): 176.

114. Hyde, 175–76; Ellmann, 256–58.

115. E. W. Godwin, elevations and notes for plans for No. 16 Tite Street for Oscar Wilde, Sketchbook, Godwin Papers, VA PD; Hyde, 175.

116. Edward Joy, Introduction to *Pictorial Dictionary of British Nineteenth-Century Furniture Design* (Woodbridge, Suffolk: Antique Collectors' Research Project, 1977), xi; Ellmann, 256–57.

117. Hyde, 175; Ellmann, 257–58. Wilde had decorated the sitting room of his first place in London (1879), Thames House, 13 Salisbury Street, entirely in white paneling. Visitors were amazed. Ellmann, 109.

118. Ellmann, 256–57; Anna, comtesse de Brémont, *Oscar Wilde and His Mother* (London: Everett, 1911), 87.

119. Hyde, 176. Excerpts from three Wilde letters to Godwin, February or March 1885 and April 1885, in Wilde, *Letters*, 171–74.

120. Brémont, 88. See also William Buchanan, "Japanese Influences on the Glasgow Boys and Charles Rennie

Mackintosh," *Japonisme in Art: An International Symposium*, ed. Society for the Study of Japonisme (Tokyo: Committee for the Year 2001, 1980), 291–302.

121. Brémont, 88–89; Ellmann, 259.

122. Ellmann, 257–58.

123. Whistler to Locker, quoted in Fleming, *James Abbott McNeill Whistler*, 238; Pennell and Pennell, *Life of . . . Whistler*, 2:24; 165. Walter Greaves stated, "We attended to all the work of his studio, mixing his colours, stretching his canvases, preparing the grey distemper ground he worked on, [painting] the inside of his home." Pennell and Pennell, *Life of . . . Whistler*, 1:138–39.

124. Drawing for *Judy* (1885) by Maurice Greiffenhagen, R. A., E. 737–1948, VA PD; Pennell and Pennell, *Whistler Journal*, 119.

125. Pennell and Pennell, *Whistler Journal*, 165; Pennell and Pennell, *Life of . . . Whistler*, 2:24; Way, 63–64.

126. Whistler to his son, Charles James Whistler Hanson, ca. 1892, from Paris to Fulham Rd., RC LC. Whistler's fondness for cats, which were so frequently featured in Japanese art, was shared by such contemporaries as Théophile Alexander Steinlen and Edouard Manet.

127. Rothenstein, 167; Eddy, 55.

128. See Milner, *The Studios of Paris*, on "decorated" late-nineteenth-century Paris studios.

129. Stein, "Artifact as Ideology: The Aesthetic Movement in American Culture," 37, 39–40, and Doreen Bolger Burke, "Painters and Sculptors in a Decorative Age," both in Burke et al., 322.

130. Pennell and Pennell, *Life of . . . Whistler*, 2:25–27; Rothenstein, 167.

131. Pennell and Pennell, *Life of . . . Whistler*, 2:28–29 (Pearsall quote), 29, 32.

132. Keith L. Bryant, *William Merritt Chase: A Genteel Bohemian* (Columbia: University of Missouri Press, 1991), 94–95; William Merritt Chase, "The Two Whistlers: Recollections of a Summer with the Great Etcher," *Century Illustrated Monthly Magazine* 80 (June 1910): 219. Chase's portrait of Whistler is at the Metropolitan Museum of Art in New York.

133. Pennell and Pennell, *Whistler Journal*, 166; Wilkinson, 303; Harbron, 185.

134. Girouard, *Sweetness and Light*, 184.

135. Pennell and Pennell, *Life of . . . Whistler*, 2:76. My spelling of Beatrix's name—sometimes spelled "Beatrice" in other sources—is based on her signature in her letters. For background on Beatrix, see Donnelly and Thorp, 5–6.

136. *Hawk*, November 6, 1888, pc, 10:31; Sheridan Ford, "Mr. Whistler at Home," *Brooklyn Citizen*, December 2, 1888, pc, vol. 10; and *New York Sunday Spy*, July 29, 1888, pc, 10:17, all in GUL BP.

137. Reprint from *Harper's Bazar* in the *Advertiser*, July 3, 1888, pc, 10:20; *Brooklyn Times*, August 11, 1888, pc, 10:21, both in GUL BP.

138. Charles Lang Freer, "A Day with Whistler," *Detroit Free Press*, Sunday, March 30, 1890, Various Scrapbook I, 2, Freer. Within the month Whistler moved to 21 Cheyne Walk. Pennell and Pennell, *Whistler Journal*, 113, report Freer never went to London or Paris in the 1890s without stopping to see Whistler.

139. *Brooklyn Times*, August 11, 1888, pc, 10:21, GUL BP.

140. Robertson, 192; Pennell and Pennell, *Life of . . . Whistler*, 2:93–94; Fleming, *James Abbott McNeill Whistler*, 267.

141. Pennell and Pennell, *Whistler Journal*, 216.

142. Robertson, 192; Whistler to Isabella Stewart Gardner, 1890, Isabella Stewart Gardner Museum, Boston (microfilm, AAA).

143. Pennell and Pennell, *Life of . . . Whistler*, 2:93–95; Pennell and Pennell, *Whistler Journal*, 303; Wilhide, 97. One has to keep in mind Whistler's frequent redecoration, which may account for Robertson's description of this room as yellow. Whistler's repeated moves may also have caused occasional mixups in visitors' memories. Robertson, 192.

144. Whistler to Walter Sickert from Paris, [1892], case 32, LC PP. Wilde appears caricatured in *Punch*, March 5, 1892, 113. The illustration was based on his appearance when he addressed the audience following a performance of his first successful play, *Lady Windmere's Fan*. Ellmann, 581, 584.

145. Pennell and Pennell, *Life of . . . Whistler*, 2:94–95; Pennell and Pennell, *Whistler Journal*, 8.

146. Pennell and Pennell, *Life of . . . Whistler*, 2:94.

147. Dufwa, 155–78; Wichmann, 403–404.

148. Arthur Warren, *London Days: A Book of Reminiscences* (Boston: Little, Brown, 1920), 163–64.

149. See Lochnan, *Etchings*, 256.

150. Pennell and Pennell, *Whistler Journal*, 3; Pennell and Pennell, *Life of . . . Whistler*, 2:88–89, 115–16; Whistler to Sidney Starr, *Atlantic Monthly*, 101, no. 4 (1908): 536–37.

151. Whistler to Sickert, case 32, LC PP; Pennell and Pennell, *Life of . . . Whistler*, 2:134.

152. Pennell and Pennell, *Life of . . . Whistler*, 2:134; Whistler to Heinemann from Hotel du Bon Lafontaine, 1892, vol. 10, LC PP; Beatrix Whistler to Alexander Reid, ca. 1892, Freer.

153. Margaret MacDonald, *Whistler and Mallarmé*, exh. cat., Hunterian Art Gallery (Glasgow: University of Glasgow, 1973), pl. 37; letters of June 19, 1891, July 23, 1892, June 22, 1892, September 24, 1892[?], in Carl Paul Barbier, ed. *Correspondance Mallarmé-Whistler: Histoire de la grande amitié de leurs dernières années* (Paris: A. G. Nizet, 1964), 89, 170, 166, 172; Mallarmé to Whistler, August 7, 1892, in Barbier, ed. 171.

154. Beatrix to Mlle Mallarmé, winter 1892; and Mallarmé to Whistler, April, 1892, both in Barbier, ed., 205; Pennell and Pennell, *Life of . . . Whistler*, 1:261; Pennell and Pennell, *Whistler Journal*, 167, 253. Maud's fortunes improved when she married an American and lived comfortably. Later, as a widow, she refused to share her recollections of life with Whistler—a major loss for history.

155. "Afternoons in Studios: A Chat with Mr. Whistler," *Studio* 4 (January 1895): 116. See Pennell and Pennell, *Life of . . . Whistler*, 2:133, 137–41, 140, 153, for descriptions of the rue du Bac house.

156. Pennell and Pennell, *Life of . . . Whistler*, 2:133, 139–40.

157. Pennell and Pennell, *Life of . . . Whistler*, 2:150–51, 218; Pennell and Pennell, *Whistler Journal*, 155–56.

158. Professor Chester Anderson, University of Minnesota, on the connection between *The Ambassadors* and Whistler's Paris home, in a conversation with the author, April 1991; Alan W. Bellringer, *The Ambassadors*, Unwin Critical Library, ed. Edward Claude Rawson (London: George Allen & Unwin, 1984), 98. See also Louise Hale Tharp, *Mrs. Jack: A Biography of Isabella Stewart Gardner* (Boston: Little Brown, 1965), 167.

159. Henry James, *The Ambassadors* (New York: Harper and Row, 1948), 133–34.

160. Bellringer, 8–13; James, 134.

161. James, 134. See Pennell and Pennell, *Whistler Journal*, 12–13, for another recollection of the rue du Bac period. Whistler may also have had a hand in decorating the Paris flat of his sister-in-law Ethel Birnie Philip.

162. Rothenstein, 83, 101; Blanche, 128.

163. Eddy, 220–22; Pennell and Pennell, *Life of . . . Whistler*, 2:138; Laver, *Whistler*, 256–57.

164. "Afternoons in Studios," 116.

165. Eddy, 220–21; Pennell and Pennell, *Life of . . . Whistler*, 2:138–39; Laver, *Whistler*, 256–57.

166. All furniture and furnishings in photographs and sketches are, with rare exception, at the Hunterian Art Gallery, University of Glasgow, Birnie Philip Bequest.

167. Frances Collard, *Regency Furniture* (Suffolk: Antique Collectors' Club, 1985), chap. 5; Lochnan, *Whistler and His Circle*, 55; Clifford Musgrave, "England, 1800–1830," in Hayward, ed., 202–206, 234–35. See Sutton, ed., 196, 204, for commentary on these prints.

168. Eddy, 221–22. For more on Empire furniture, see Serge Grandjean, *Empire Furniture* (New York: Taplinger, 1966); and Louise Ade Boger and H. Batterson Boger, *The Dictionary of Antiques and the Decorative Arts* (New York: Charles Scribner's Sons, 1967). Also see Collard, 245–52.

169. Adams, 145–46. Five drawings for wall sconces by Whistler are in the Hunterian Art Gallery Archive, Glasgow University.

170. Pennell and Pennell, *Life of . . . Whistler*, 2:138–39; "Afternoons in Studios," 116.

171. Josef Engelhart, "Memories of Whistler," *Living Age* no. 338 (May 15, 1930): 369–74.

172. Pennell and Pennell, *Whistler Journal*, 269, 289; Pennell and Pennell, *Life of . . . Whistler*, 2:145; Percy Macquoid, "Knife, Fork, Spoon, and Silver Table-Plate Exhibition Catalogue," *Fine Art Society Exhibitions, 1901–03* (London: Fine Art Society, 1902), 44–45; "Afternoons in Studios," 116. See Alan Crawford, *C. R. Ashbee* (New Haven: Yale University Press, 1985), for examples of Ashbee silver pieces.

173. Rothenstein, 83; Pennell and Pennell, *Life of . . . Whistler*, 2:139. On metalware during the aesthetic period, see David A. Hanks and Jennifer Toher, "Metalwork: An Eclectic Aesthetic," in Burke et al., 253–93.

174. Engelhart, 374.

175. Gallery documentary information, Hunterian Art Gallery, University of Glasgow.

176. Pennell and Pennell, *Whistler Journal*, 13; Pennell and Pennell, *Life of . . . Whistler*, 2:153.

177. Pennell and Pennell, *Life of . . . Whistler*, 2:139. See Margaret Morgan Grasselli and Pierre Rosenberg, *Watteau*, exh. cat. (Washington, D.C.: National Gallery of Art, 1984), 396–401.

178. "Afternoons in Studios," 116; Royal Cortissoz, "Whistler," *Atlantic Monthly* 92 (December 1903): 836.

179. Eddy, 222.

180. Whistler to E. G. Kennedy, July 1, 1893, Manuscript Division, NYPL (microfilm, AAA).

181. Pennell and Pennell, *Whistler Journal*, 185–86; Pennell and Pennell, *Life of . . . Whistler*, 2:144.

182. Pennell and Pennell, *Life of . . . Whistler*, 2:143.

183. Nancy A. Goyne, "American Windsor Chairs: A Style Survey," *Antiques* 95 (April 1969): 538–49; Pennell and Pennell, *Life of . . . Whistler*, 2:144.

184. Edgar Munhall, "Whistler's Portrait of Robert de Montesquiou: The Documents," *Gazette des Beaux-Arts* 71 (1968): 238; Young, MacDonald, and Spencer, 178.

185. Pennell and Pennell, *Life of . . . Whistler*, 2:137, 163; Laver, *Whistler*, 256. See also Collard, 242, and Lochnan, *Etchings*, 260.

186. Whistler to Thomas R. Way, Jr., September 30, 1892, from 110 rue du Bac, letter no. 93, Freer; "Mr. Whistler in Paris, with a Sketch of His New Studio," *Westminster Budget*, March 3, 1893, 12–13; Pennell and Pennell, *Life of . . . Whistler*, 2:137–40.

187. Eddy, 131; Boger and Boger, 216.

188. Eddy, 230–31.

189. Bacher, 65. See Curry, *James McNeill Whistler at the Freer*, 200–201, 238–45, 268–78, for examples of Whistler's depictions of Venuses in filmy drapery and watercolors, and photographs of the interior of Whistler's Paris studio. See Nigel Thorp, "Studies in Black and White: Whistler's Photographs in Glasgow University Library," in Fine, ed., 90–91, for information on Whistler's collection of six hundred photographs. On Liberty silks, see Victor Arwas, *The Liberty Style* (New York: Rizzoli International Publications, 1979), 1.

190. Adams, 126, 145.

191. Milner, *The Studios of Paris*, 216; Pennell and Pennell, *Whistler Journal*, 14; Pennell and Pennell, *Life of . . . Whistler*, 2:162–63. Whistler fell out with his brother, a physician, over the diagnosis. William never recovered from the blow.

192. Whistler to Freer, April 2, 1897, case 38, Freer; Pennell and Pennell, *Life of . . . Whistler*, 2:166–67, 172–73.

193. Walter Muir Whitehill, "The Making of an Architectural Masterpiece—The Boston Public Library," *American Art Journal* 2 (fall 1970): 13–25; Pennell and Pennell, *Life of . . . Whistler*, 2:132; Young, MacDonald, and Spencer, 176; Stanley Olson, *John Singer Sargent: His Portrait* (New York: St. Martin's, 1986), 172–73.

194. Whitehill, 19, 22; Pennell and Pennell, *Life of . . . Whistler*, 1:150.

195. "The New Public Library at Boston, U.S.A.," *Art Journal* (New York) 55 (April 1893): 126–27; Blanche, 76; Whistler to Board of Trustees, Boston Public Library, May 7, 1895, B 127, GUL BP.

196. Stanford White to Whistler, September 20, 1895, M 58, GUL BP. See Johnson, "The Artful Interior," in Burke et al., 130, for examples of White's finest interiors.

197. Whitehill, 24–25; Young, MacDonald, and Spencer, 176, date the panels ca. 1891–1893.

198. Pennell and Pennell, *Life of . . . Whistler*, 2:199–200; Whistler to Freer, ca. 1899, Freer.

199. Unidentified typescript commenting on the Company of the Butterfly, case 32, LC PP; Williamson, 12–13; Pennell and Pennell, *Whistler Journal*, 1, 14, 77.

200. See Pennell and Pennell, *Life of . . . Whistler*, 2:199–201; Pennell and Pennell, *Whistler Journal*, 15.

201. Laver, *Whistler*, 302–303.

6. Whistler as Exhibitioner

1. Rewald, 13–14.

2. On Whistler in America, see John Sandberg, "Whistler's Early Work in America, 1834–1855," *Art Quarterly* 29, no. 1 (1966): 47. On Whistler's early years in Paris, see Laver, *Whistler*, 35–70; Weintraub, 11–58; Pennell and Pennell, *Life of . . . Whistler*, 1:48–75; and Fleming, *The Young Whistler*, 21–119. On the Exposition Universelle, see Rewald, 13–17.

3. Pennell and Pennell, *Life of . . . Whistler*, 1:49; Rewald, 16. See Petra ten-Doesschate Chu, *Letters of Gustave Courbet* (Chicago: University of Chicago Press, 1992), 269, 601, for letters that document the close friendship between Whistler and Courbet. Whistler met Courbet at the Brasserie Andler in 1858.

4. Mahey, 252; Rewald, 16.

5. Pennell and Pennell, *Life of . . . Whistler*, 1:75; E. R. Pennell, 53–55. See Gabriel P. Weisberg and Laurinda Dixon, Introduction, in Weisberg and Dixon, eds., xvii–xxii, for a summary of the role of exhibitions in the promotion of art and artists. See also Elizabeth

Gilmore Holt, *The Triumph of Art for the Public: The Emerging Role of Exhibitions and Critics* (Garden City, N.Y.: Anchor, 1979), 121, 137, and Holt, *Universal Expositions,* for discussions of early independent exhibitions.

6. Gleyre to Count de Nieuwerke, cited in Lochnan, *Etchings,* 290 n. 4; Pennell and Pennell, *Life of . . . Whistler,* 1:67. See Lochnan, *Whistler and His Circle,* 52–54.

7. Whistler to Smalley, 1891, letter no. 7, book 14, LC PP. See Fleming, *James Abbott McNeill Whistler,* 271–73, for an account of Mallarmé's role in the negotiations. The portrait of his mother subsequently went to the Louvre and today is in the Musée d'Orsay.

8. [Armstrong], 187.

9. Ibid., 188. It is not clear whether the paintings and porcelains were shown together. See Lochnan, *Etchings,* 294 n. 15.

10. Physick, 35.

11. Ibid., 35, 48, 50. The South Kensington Museum acquired 61 Whistler prints, and the British Museum collected 104 prints.

12. Pennell and Pennell, *Life of . . . Whistler,* 1:67, 2:21; Pennell and Pennell, *Whistler Journal,* 247–29; Menpes, *Whistler,* xix–xx.

13. Pennell and Pennell, *Life of . . . Whistler,* 1:141.

14. Lochnan, *Etchings,* 100, 295 nn. 20, 21.

15. Du Maurier, *Young George Du Maurier,* 137; Whistler to George Lucas, June 26, 1862, quoted in R. Spencer, *Whistler,* 63.

16. Whistler to George Lucas, March 10, 1863, MSS roll 3482, microfilm, AAA; Whistler to Fantin-Latour, quoted in Fleming, *The Young Whistler,* 187.

17. Fantin-Latour to Whistler, [May 15?], 1863, F 5, GUL BP.

18. Pennell and Pennell, *Whistler Journal,* 213. In Luke Fildes to M. H. Spielmann, 1903, Fildes states that Whistler sounded him out on the possibility of being elected to the prestigious body. Fildes, 168–69.

19. Margaret Oliphant, quoted in Fleming, *The Young Whistler,* 162–63; Ormond, 85. See Sandberg, "Whistler Studies," 62, for a discussion of the comparison between the Paris Salon and the Royal Academy in London.

20. [Sickert], 45.

21. Pennell and Pennell, *Life of . . . Whistler,* 2:53; 1:158–59.

22. Whistler to Luke Ionides from 2 Lindsey Row, n.d., LC PP.

23. *North American Review* 177 (September 1903): 382, pc, 1:15, GUL BP; Stephens, quoted in Fleming, *The Young Whistler,* 186; Du Maurier to Armstrong, May 1863, in Du Maurier, *Young George Du Maurier,* 204.

24. W. Crane, *Morris to Whistler,* 62; Henry Holiday, *Reminiscences of My Life* (London: Heinemann, 1914), 96.

25. Whistler to Lucas, June 26, 1862, quoted in R. Spencer, *Whistler,* 63–64; Pennell and Pennell, *Life of . . . Whistler,* 1:156–58, 199. Gambart's French Gallery closed in 1867. Robin Spencer, "Whistler's First One-Man Exhibition Reconstructed," in Weisberg and Dixon, eds., 29.

26. Whistler to Waldo Story, n.d., LC PP.

27. Whistler, quoted by M. H. Spielmann, in "James A. McNeill Whistler: 1834–1903," *Magazine of Art* 28 (November 1903): 14; Heinemann and Pennell to the editor of the *London Times,* August 15, 1903, pc, 2; and G. D. Leslie, *London Times,* August 11, 1903, pc, 1, both in Tate; G. W. Smalley, "Whistler: A Tribute from One of His Old Friends," *New York Tribune,* August 19, 1903, 10. See also Getscher and Marks, 262–63.

28. Pennell and Pennell, "Whistler as Decorator," 500; Menpes, *Whistler,* 124.

29. Eddy, 132.

30. David Park Curry, lecture, Minnesota Museum of Art, May 4, 1989; Whistler, quoted in Pennell and Pennell, "Whistler as Decorator," 510; Eddy, 127.

31. Du Maurier to Tom Armstrong, [November, 1860], in Du Maurier, *Young George Du Maurier,* 27, 282.

32. Pennell and Pennell, *Life of . . . Whistler,* 1:85–86; Lochnan, *Etchings,* 120, 125–27; Laver, *Whistler,* 73. See Lochnan, *Etchings,* 126, for images of these announcements.

33. Mahey, 252; Spencer, "Whistler's First One-Man Exhibition Reconstructed," in Weisberg and Dixon, eds., 28–29; Mary Cassatt to Joseph Pennell, Mesnil-Beaufresne, Mesnil (Oise), September 12, [1906?], LC PP. Even his good friend Fantin-Latour failed to understand Whistler's work at Durand-Ruel's, Paris. Fantin-Latour to Otto Scholderer, January 23, 1873, in R. Spencer, *Whistler,* 108.

34. "Mr. Whistler's Latest 'Arrangement,'" *Pall Mall Gazette,* February 19, 1883, pc, 8:10, GUL BP; Lawrence Weschler, "In a Desert of Pure Feeling," *New Yorker* 69 (June 16, 1993): 86.

35. "Notes from London," *London Tribune,* June 13, 1874, pc, 1:61; and "Exhibition of Mr. Whistler's Works," June 1874, pc, 1:67, both in GUL BP. The writer was quoting a statement made by John Constable's friend Dr. John Fisher.

36. Walter Greaves, quoted in Pennell and Pennell,

Life of . . . Whistler, 1:179–81; Pennell and Pennell, "Whistler as Decorator," 510; Spencer, "Whistler's First One-Man Exhibition Reconstructed," 37.

37. "Art Notes," *Illustrated Review,* June 1874, 319, case 199, LC PP; Spencer, "Whistler's First One-Man Exhibition Reconstructed," 37–38; Whistler to Deschamps from Speke Hall on Leyland's monogrammed stationery, [December] 1872, LC PP.

38. D. G. Rossetti, *Letters,* 105.

39. Whistler to Anderson Rose, February 7, 1875, LC PP (microfilm, AAA). See original draft of the affidavit of Fox, in James Anderson Rose's handwriting, 4 pp., 1875, LC PP, and quoted in Spencer, "Whistler's First One-Man Exhibition Reconstructed," 29–30. Also see Spencer, 41–44; and Pennell and Pennell, *Whistler Journal,* 304.

40. Spencer, "Whistler's First One-Man Exhibition Reconstructed," 32–33; Sidney Colvin, "Exhibition of Mr. Whistler's Pictures," *Academy* 5 (June 13, 1874): 673. See *Mr. Whistler's Exhibition,* exh. cat., EC 1874, GUL BP.

41. Harbron, 101–104, 114; Wilkinson, 342.

42. *Manchester Examiner Times,* June 8, 1874, case 199, LC PP.

43. "Mr. Whistler's Exhibition," loose clippings, case 199, LC PP; Pennell and Pennell, *Life of . . . Whistler,* 1:179; *Illustrated Review,* June 17, 1874, pc, 1:65, GUL BP. The entrance fee was one shilling. "Mr. Whistler's Exhibition," *Builder* 32 (July 5, 1874), pc, 1:73, GUL BP.

44. Henry Blackburn, "A Symphony in Pall Mall," *Pictorial World,* June 13, 1874, pc, 1:79, GUL BP.

45. Rossetti to Madox Brown, in Duval, "A Reconstruction," 22.

46. Margaret MacDonald, "Whistler's Designs for a Catalogue of Blue and White Nankin Porcelain," *Connoisseur* 198 (August 1978): 292; Gabriel P. Weisberg, "Félix Bracquemond and Japanese Influence in Ceramic Design," *Art Bulletin* 115 (September 1969): 277–80, and "Félix Bracquemond and Japonisme," 57–68; Weisberg et al., *Japonisme,* 157–61.

47. Deluxe catalogue from Whistler's library, GUL BP; Pennell and Pennell, *Life of . . . Whistler,* 1:216–27; Julian Alden Weir to Father and Mother from Alhambra, Grenada [*sic*], October 4, 1876, no. 160, 420, AAA. See also Williamson for more on the craze for blue and white. Ferriday, 409, notes that Thompson "fed his cobra on mice at the dinner table."

48. Williamson, letter facsimile, between 48 and 49; Gerald Reitlinger, "The Craze for Blue and White," *Connoisseur* 189 (July 1975): 217.

49. Williamson, 42. Of the 220 catalogues issued, 120 were for sale. Getscher and Marks, 75–76, 166.

50. Williamson, 12–13; 45–46; MacDonald, "Whistler's Designs for a Catalogue," 295.

51. Pennell and Pennell, *Whistler Journal,* 188.

52. Huish to Whistler, January 14, 1880, II 13-5; and Whistler to Huish, January, 1880, II C/8, both in GUL BP; Huish to Whistler, October 19, 1880, quoted in Lochnan, *Etchings,* 182–84. Margaret F. MacDonald, Introduction to *"Notes, Harmonies, and Nocturnes": Small Works by James McNeill Whistler,* exh. cat. (New York: Knoedler, 1984), 11, notes that "in Venice in 1880 he turned from large oil paintings to etchings and pastels."

53. Menpes, *Whistler,* 92–93, 153. See Lochnan, *Etchings,* 53–55, 58.

54. Way, 47–48; Whistler to Huish, November 27, 1880, case 2, LC PP; Pennell and Pennell, *Whistler Journal,* 122.

55. *British Architect,* December 10, 1880, pc, 6:15, GUL BP; Pennell and Pennell, *Life of . . . Whistler,* 1:291; Whistler to editor, *World,* December 8, 1880, and December 29, 1880, in Whistler, *Gentle Art,* 50, 51.

56. Pennell and Pennell, *Whistler Journal,* 2; Harbron, 144–45.

57. John O'Callaghan, "The Fine Art Society and E. W. Godwin," *Centenary: 1876–1976,* exh. cat. (London: Fine Art Society, 1976), 7.

58. Alan Cole, diary extracts, January 2, 1881, quoted in Pennell and Pennell, *Life of . . . Whistler,* 1:292; Way, 52–54.

59. Whistler to Charles James Whistler Hanson, with sketches for invitation and poster, case 1, LC PP; J. A. McNeill Whistler, *Venice Pastels,* exh. cat. (London: T. Way), EC 1881.1, GUL BP. While Whistler was working to set up his exhibition, he was called to Hastings, where his mother was dying. She died on January 31, 1881, at seventy-four.

60. E. W. Godwin, "Mr. Whistler's Venice Pastels," *British Architect* 4 (February 4, 1881), pc, 10:39, GUL BP.

61. [E. W. Godwin?], cited in O'Callaghan, 7.

62. *Country Gentleman,* February 5, 1881, pc, 10:47, and "Fine Arts: Mr. Whistler's 'Venice Pastels,'" *World,* February 2, 1881, pc, 10:49; and "Venice Pastels," *Daily Telegraph,* February 5, 1881, pc, 10:49, all in GUL BP.

63. Pennell and Pennell, *Life of . . . Whistler,* 1:293, 108; Millais to Whistler, July 17, 1881, quoted in Sutton, *Nocturne,* 98; minutes quoted in O'Callaghan, 6. It is not

clear whether visitors necessarily attended both shows. The popular Millais may have been the bigger draw.

64. Pennell and Pennell, *Life of . . . Whistler*, 1:293; Pennell and Pennell, *Whistler Journal*, 182.

65. "London Paved with Gold," *Punch* 80 (March 19, 1881); and Henry Furniss, "Whistler's Wenice; or, Pastels by Pastelthwaite," *Punch* 80 (February 12, 1881): 69, pc, 10:43, both in GUL BP.

66. Maud Franklin to Otto Bacher, in Bacher, 206–207.

67. Pennell and Pennell, *Whistler Journal*, 187. The entry for March 23, 1881, in the Fine Art Society minutes, verifies that a check for three hundred pounds was drawn for Whistler. Lochnan, *Etchings*, 218.

68. Poem fragment, *Punch*, March 1883, pc, 6:48, GUL BP.

69. Laver, *The First Decadent*, 1. See a copy of Joris-Karl Huysmans, *A Rebours* (1884) in Whistler's private collection, inscribed "AM. James Whistler, l'un de ses fervents, J. K. Huysmans," WH 63, GUL BP. Royal Cortissoz, "Whistler," *Atlantic Monthly* 92 (December 1903): 826–38, recognized the symbolist–Des Esseintes dimension of Whistler's interiors. See also Silverman, 77.

70. Whistler to Signor Waldo Story in Rome from 13 Tite Street, Chelsea, February 12, 1883, Whistler Letters II, Pierpont Morgan Library, New York (N68-12, microfilm, AAA). Dickens's *Barnaby Rudge* (1844) is the story of the half-witted Barnaby and his raven, a bird of ill omen. Edgar Allan Poe reviewed the book, then composed "The Raven," based on it. Poe and Dickens were favorites of Whistler's. Poe had attended West Point.

71. Ibid.

72. Ibid.; Pennell and Pennell, *Whistler Journal*, 187. Whistler sketches for a striped silk butterfly are in PD, British Museum. The actual design he used is in an 1883 illustrated letter to his brother William, in Whistler Papers, Manuscripts Division, microfilm roll 49 M 155, NYPL (microfilm, AAA). Wilde mentions the yellow exhibition in a letter to Waldo Story, January 1883, in Wilde, *Letters*, 135. For background on Story, see Young, MacDonald, and Spencer, 138. See also Pennell and Pennell, *Life of . . . Whistler*, 1:310–12, for their account of the yellow exhibition.

73. See Schmutzler, *Art Nouveau*, 39–41, for a brief background on Mackmurdo, who was also a pupil of Ruskin's and influenced by Morris.

74. Holbrook Jackson, *The Eighteen Nineties* (London: Jonathan Cape, 1913–1931), 46.

75. *Lady's Pictorial* writer, quoted in R. Spencer, *Whistler*, 199.

76. Unidentified press clipping, 1883, pc, 6:43; *Society*, 1883, pc, 6:49; and John Forbes-Robertson, "Mr. Whistler: His Arrangement in White and Yellow . . . ," *Pictorial World*, March 31, 1883, pc, vol. 8, all in GUL BP.

77. *British Times*, March 1, 1883, pc, 6:46, GUL BP; Whistler to Dowdeswell, [mid-1880s], case 1, 1997, LC RC.

78. "Mr. Whistler's Latest 'Arrangement,'" *Pall Mall Gazette*, February 19, 1883, pc, 8:10; and *St. James Gazette*, February 20, 1883, pc, 7:24, both in GUL BP.

79. Pennell and Pennell, "Whistler as Decorator," 510; unidentified press clipping, 1883, pc, 6:43, GUL BP.

80. Pennell and Pennell, *Whistler Journal*, 187; Théodore Duret, *History of James McNeill Whistler and His Work*, trans. Frank Rutter (Philadelphia: J. B. Lippincott, 1917), 61–62; *Le Figaro*, February 24, 1883, pc, 6:43, GUL BP.

81. *Building News*, February 23, 1883, pc, 6:42; and *People*, February 25, 1883, pc, 6:44, all in GUL BP. The butterfly stencil could also have been something Whistler used for his 1874 exhibition. Since its style does not match the increasingly freer style of later monograms, Brian McKerracher, chief technician and paper conservator at the Hunterian Art Gallery, suggested in June 1989 that it may be a stencil used to mark packing crates or boxes.

82. "Mr. Whistler's Latest 'Arrangement,'" pc, 8:10; and *British Times*, March 1, 1883, pc, 6:46, both in GUL BP.

83. *Funny Folks*, March 10, 1883, pc, 6:48, GUL BP.

84. *Coventry Standard*, February 23, 1883, pc, 6:42, GUL BP. These descriptive phrases are taken from a number of press clippings in GUL BP.

85. *Country Gentleman*, February 1883, pc, 6:43, GUL BP.

86. Forbes-Robertson, "Mr. Whistler: His Arrangement in White and Yellow . . . ," pc, vol. 8, GUL BP.

87. *Coventry Standard*, February 23, 1883, pc, 6:42, GUL BP; G. A. Cevasco, *J. K. Huysmans: A Reference Guide to English Translations . . . 1880–1978* (Boston: G. K. Hall, 1980), 126.

88. Whistler to Story, n.d. [1883], quoted in Lochnan, *Etchings*, 229; Whistler to Willie Whistler, [1883], incomplete letter illustrated with a butterfly, from 13 Tite Street, Whistler Papers, Manuscripts Division, microfilm roll 49 M 155, NYPL (microfilm, AAA). Whistler said that from eighty to one hundred butterflies were made. Whistler's cult of beautiful women went back to the 1860s

and the time of his friendship with Rossetti. At Oxford, Wilde held "beauty parties" for professional beauties.

89. Pissarro to Lucien Pissarro, February 28, 1883, in Camille Pissarro, *Camille Pissarro: Letters to His Son Lucien*, ed. John Rewald, with the assistance of Lucien Pissarro (London: Pantheon Books, 1943), 22–23. David Park Curry, "Total Control: Whistler at an Exhibition," in Fine, ed., 75, 81 n. 40, notes that according to the *Standard*, 1873, Durand-Ruel's Society of French Artists in London used pottery and porcelains to enhance its display. Whistler may have influenced this mode of exhibition or been influenced by it.

90. Whistler to Huish, 1883, II 13/47; and Whistler to Huish, 1883, II 13/50, both in GUL BP.

91. Gerold M. Wunderlich and Susan Sheehan, *1883 Arrangement in White and Yellow*, exh. cat., Wunderlich and Company (New York: 1983), WH EC 1983.3, GUL.

92. *New York World*, October 11, 1883, pc, 10:12, GUL BP; Harold Peterson, "Whistler's Chelsea," *Arts* 13 (April 1990): 9.

93. R. Spencer, *Whistler*, 14; Pennell and Pennell, *Life of . . . Whistler*, 2:35–36.

94. Octave Maus, "Whistler in Belgium" *Studio* 32 (June 1904): 7–8.

95. Silverman, 210; Troy, 15.

96. Maus, 7–8.

97. Ibid., 8; Whistler to Charles Deschamps [1884], from St. Ives, Cornwall, LC PP.

98. Sutton, *Sickert*, 48; Bruce Laughton, "The British and American Contribution to Les XX, 1884–93," *Apollo* 86 (November 1967): 374; Staley and Reff, eds., 77.

99. Laughton, 378, 374; Taylor, 108.

100. Octave Maus, "James McNeill Whistler," *L'Art Moderne*, September 13, 1885, 294–96, pc, 6:30–31; Madsen, 303 n. 3; Staley and Reff, eds., 125.

101. Staley and Reff, eds., 125.

102. *Yorkshire Post*, March 24, 1884, pc, 6:12, GUL BP.

103. "Flesh Colour and Grey," *Queen*, May 31, 1884, pc, 7:5, GUL BP.

104. Fenollosa, 61–63. Staley and Reff, eds., 21, note that at the turn of the century Whistler followers became influenced by his tonalities. Some writers have suggested Whistler's influence as a source for Picasso's Blue Period.

105. Pennell and Pennell, *Life of . . . Whistler*, 2:1.

106. Anonymous, pc, 2:32; and *Manchester Guardian*, May 20, 1884, pc, 6:6, both in GUL BP.

107. "Flesh Colour and Grey," *Queen*, May 31, 1884, pc, 7:5, GUL BP.

108. [Illegible], May 1884, pc, 6:57, GUL BP.

109. *Town* [illegible], May 24, 1884, pc, 6:55, GUL BP. See Pennell and Pennell, *Life of . . . Whistler*, 1:36. He described himself in his cadet uniform as "very dandy in grey." See also Menpes, *Whistler*, 117–24, for his comments on the "Flesh Colour and Grey" show.

110. "Whistler," pc, 6:55, GUL BP.

111. "Flesh Colour and Grey," *Queen*, May 31, 1884, pc, 7:5; *Globe*, May 1884, pc, 7:5; *Illustrated London News*, May 24, 1884, pc, 6:53; unidentified clipping, ca. 1885, pc, 3:116; "Whistler," *Topical Times*, May 1884, pc, 6:35; and [illegible] *Gazette*, May 24, 1884, pc, 9:4, all in GUL BP.

112. Oscar Wilde and other gay men at this time wore green and yellow carnations to recognize each other as G.A.Y.

113. Whistler to Walter Dowdeswell, 7, 41–62, case 1, 1997, 62, LC RC. The first note discussing the velvet pattern is dated May 9, 1884.

114. Menpes, *Whistler*, 115–16, 120.

115. Ibid., 120–21. The Pennells and Menpes occasionally conflated stories and mixed memories. Whistler's 1883 exhibition also featured a large butterfly on the wall. This incident could recall 1883, or Whistler may have repeated the idea in 1884.

116. E. W. Godwin, cited by R. Spencer, *Whistler*, 201; Way, 103; Whistler to Deschamps, [December] 1872, LC PP (Whistler refers to the Whistler Gallery in this letter).

117. Whistler to Dowdeswell, letter no. 50, case 1, 1997, LC RC.

118. Whistler, letters and telegrams to Dowdeswell concerning the 1884 show, letters no. 21–70, case 1, 1997, LC RC.

119. At one point Whistler wrote Dowdeswell, "The section of the moulding I will send tomorrow." Fig. 90 could be either a wall design or a sketch of a molding. Letter no. 40, case 1, 1997, LC RC. Pennell and Pennell, *Life of . . . Whistler*, 2:60, refer to a brown-and-gold Whistler sketch for this show that was owned by Walter Dowdeswell.

120. *Saturday Review*, May 22, 1886, pc, 8:12; and Charlotte Rolenson, article in *Queen*, April 13, 1889, pc, 10:95, both in GUL BP. Curry, lecture, May 4, 1889, considered whether Whistler used a sponging technique for a "broken, scintillating effect" on walls.

121. *Saturday Review*, May 22, 1886, pc, 8:12; and

Truth, May 6, 1886, pc, 8:13, both in GUL BP. Pennell and Pennell, "Whistler as Decorator," 510, state, "Mr. Walter Dowdeswell still preserves the mantel hangings for the brown-and-gold arrangement upon which the butterfly was embroidered as carefully as it was signed to a painting."

122. Charles deKay, "Whistler, the Head of the Impressionists, *Art Review* 1 (November 1886): 1; *Saturday Review*, May 22, 1884, pc, 8:12, GUL BP. See also *Sunday Times*, May 2, 1886, GUL BP.

123. Whistler, quoted in Pennell and Pennell, "Whistler as Decorator," 510. Critics gave mixed reviews of the show, but it was a financial success because a certain H. S. Theobald purchased all remaining pictures.

124. *World*, April 20, 1887, pc, vol. 14, GUL BP; Pennell and Pennell, *Life of . . . Whistler*, 2:55.

125. *Art Age*, June 1886, Whistler clippings, vol. 36, LC PP.

126. Taylor, 115.

127. See Albert Ludovici, "The R.B.A. and Whistler," *An Artist's Life in London and Paris, 1870–1925* (New York: Minton, Balch, 1926), 70–78; Pennell and Pennell, *Life of . . . Whistler*, 2:55. The Society of British Artists was considered an alternative to the Royal Academy.

128. Ludovici, " The R.B.A.," 76; Laver, *Whistler*, 228–32.

129. Thomas Roberts to Whistler, November 24, 1884, inviting Whistler to become a member from the Incorporated Society of British Artists, R 164, GUL BP; Pennell and Pennell, *Life of . . . Whistler*, 2:48–56, citing *Times*, December 3, 1884; Pennell and Pennell, *Life of . . . Whistler*, 2:47–48; Ludovici, "The R.B.A.," 77–78.

130. Phillip, quoted in Pennell and Pennell, *Life of . . . Whistler*, 2:55, 58.

131. "Topical Art," *Topical Times*, December 12, 1885, pc, 8:6; *Pall Mall Gazette*, November 27, 1888, pc, 10:38; and *St. James Gazette*, April 22, 1885, pc, 6:24, all in GUL BP.

132. Whistler to Horace [?], Honorable Secretary, British Artists, typescript, case 1, LC PP.

133. Pennell and Pennell, *Life of . . . Whistler*, 2:57–59, 64; Laver, *Whistler*, 230; *Sunday Times*, January 8, 1888, pc, 9:53, GUL BP; Menpes, *Whistler*, 108.

134. Pennell and Pennell, *Life of . . . Whistler*, 2:60.

135. *Spectator*, December 26, 1885, pc, vol. 8, GUL BP. Monet replied to Whistler's invitation, saying he was delighted to exhibit in London "and especially in your company." M 106, GUL BP.

136. Margaret F. MacDonald, "Maud Franklin," in

Fine, ed., 24; Ludovici, "The R.B.A.," 82; Sutton, *Sickert*, 38.

137. *Bristol Times*, January 17, 1888, pc, GUL BP; Dempsey, 31.

138. Menpes, *Whistler*, 105–106; Pennell and Pennell, *Life of . . . Whistler*, 2:64; Starr, 529.

139. Robertson, 198–99.

140. Ellmann, 274. Whistler patented his velarium in March or April 1888. Spencer, "Whistler's First One-Man Exhibition Reconstructed," 33.

141. *World*, March 30, 1887, pc, 7:71; *Saturday Review*, April 9, 1887, pc, 7:73, both in GUL BP.

142. Whistler, *Gentle Art*, 203; Whistler, *London Times*, December 1, 1886, p. 8, col. f., album 35, LC PP.

143. Whistler to William Henry Hurlbert from the Hogarth Club, [ca. 1887], H305, GUL BP. See Pennell and Pennell, *Whistler Journal*, 176–77.

144. *Bookbinder*, October 25, 1887, pc, 10:30, GUL BP.

145. *Pall Mall Gazette*, August 11, 1888, pc, vol. 2, GUL BP; Pennell and Pennell, *Life of . . . Whistler*, 2:64–65; Menpes, *Whistler*, 105.

146. *Artist*, January 1889, pc, 10:52, GUL BP; Pennell and Pennell, *Life of . . . Whistler*, 2:65; Pennell and Pennell, "Whistler as Decorator," 509.

147. *Leeds Mercury*, December 22, 1888, pc, 10:51–52, GUL BP; Pennell and Pennell, *Life of . . . Whistler*, 2:68–69; Pennell and Pennell, *Whistler Journal*, 177.

148. Whistler's letter of resignation, July 2, 1888, LB 7, 20; and *Glasgow Herald*, June 6, 1888, pc, 10:13, both in GUL BP. See also Pennell and Pennell, *Life of . . . Whistler*, 2:68–73; "The Rise and Fall of the Whistler Dynasty: An Interview with Ex-President Whistler," *Pall Mall Gazette*, June 11, 1888, pc, 9:58–59, GUL BP; and Ludovici, "Whistlerian Dynasty" (July 1906): 193–95 and (August 1906): 237–39.

149. *New York Times*, November 27, 1886, pc, 10:42; and *Brooklyn Citizen*, December 2, 1888, pc, 10:54, both in GUL BP.

150. *New York Tribune*, March 17, 1889; and *Brooklyn Daily Eagle*, March 1889, both pc, 10:85, GUL BP.

151. *New York Evening Post*, March 6, 1889, pc, 10:85, GUL BP.

152. *Critic*, March 16, 1889, pc, vol. 1889–91, GUL BP. E. G. Kennedy compiled a monumental catalogue of Whistler's etchings.

153. MacDonald, Introduction to *"Notes, Harmonies, and Nocturnes,"* 10; Weitzenhoffer, 54–55.

154. Laver, *Whistler*, 302; Whistler to Canfield, ca. 1902, from 74 Cheyne Walk, letters 189–195, microfilm roll Br-22, Brooklyn Museum Records, AAA. See also Rothenstein, 267; and Sutton, *Nocturne*, 53, 189. For background on the New English Art Club and the Newlyn school, see Gabriel P. Weisberg, *Beyond Impressionism: The Naturalist Impulse* (New York: Harry N. Abrams, 1992), 108, 113, 117, 127–34, 139, 152.

155. *Society*, April 20, 1889, pc, 10:83; and *New York Herald*, April 16, 1889, pc, 1889–1891, both in GUL BP.

156. On specific medals and honors awarded Whistler, see Pennell and Pennell, *Life of . . . Whistler*, 2:88. See also Sutton, *Sickert*, 16.

157. Pennell and Pennell, *Life of . . . Whistler*, 2:92–93; E. M. C. Sickert to Joseph Pennell, May 8, 1889, case 264, LC PP. See also Getscher and Marks, 291.

158. Whistler to Thomson, April 5, 1892, from 33 rue du Tournon, Paris, LC PP; Way, 83–84.

159. Way, 83–84; G. T. [George Thomson], "A Whistler Exhibition," *Pall Mall Gazette*, May 1889, pc, GUL BP. See also Sutton, *Sickert*, 61.

160. Ford to the *Bachelor Newspaper Syndicate*, May 14, 1889, excerpt in Ford, ed., 221, 213–15.

161. Duret, 115; Troy, 66; Silverman, 207–211.

162. *Nation*, June 26, 1890, album 36, LC PP; Sutton, *Nocturne*, 122; Silverman, 207–10.

163. Whistler to Salaman, May 10, 1892, case 2, LC PP; Pissarro to Lucien Pissarro, April 28, 1894, in Pissarro, 238. He also mentioned "several marines, hardly painted, a blue note scarcely drawn."

164. Pennell and Pennell, *Life of . . . Whistler*, 2:117–26. The dealer David Croal Thomson stated, "Within a year after the exhibition was closed, I had aided in the transfer of more than one-half of the pictures from their first owners." Whistler's resulting anger led him to try to get his best work out of England (122–23).

165. Pennell and Pennell, *Whistler Journal*, 10; D. S. MacColl, "The Whistler Exhibition," *Saturday Review*, February 25, 1905, pc, Tate.

166. E. R. Pennell, 18. Nigel Thorp, "Studies in Black and White: Whistler's Photographs in Glasgow University Library," in Fine, ed., 92, notes that Whistler had William Gray photograph the paintings in this exhibition and that he had his work photographed as a matter of course, using several different photographers. In an undated letter to Thomson, ca. February 1892, he stated, "But begin with the best photographer [for the catalogue]." LC PP. Whistler found that his work was very difficult to re-

produce in photographs. It may have made him hesitate to leave photographs of his various exhibition installations to posterity. The question remains, why did Whistler not have his exhibition installations photographed?

167. Whistler to Thomson, May 10, 1892; and Whistler to Thomson, received February 26, 1892, both in LC PP.

168. Whistler to Thomson, [March 2 or 4], 1892, LC PP; Taylor, 103.

169. Whistler to Thomson, March 1, 1892, and November 26, 1892, LC PP.

170. D. Croal Thomson, "Whistler and His London Exhibitions," *Art Journal* 67 (April 1905): 108; Pennell and Pennell, *Life of . . . Whistler*, 2:120.

171. An Indiscriminate Admirer, "A Gossip at Goupil's: Mr. Whistler on his Work," *Illustrated London News* 100 (March 26, 1892): 384.

172. Whistler, letters to Alexanders, [ca. 1892], Alexander Family Album, 11–14, BM PD; Mahey, 253.

173. See Ira M. Horowitz, "Whistler's Frames," *Art Journal* 39 (winter 1979–80): 124–31; Mahey, 253; Harbron, 114; Pennell and Pennell, *Whistler Journal*, 299; Doreen Bolger Burke, "Painters and Sculptors in a Decorative Age," in Burke et al., 320–21. The Musée d'Orsay, Paris, features a display with commentary on Whistler's designs for frames.

174. Horowitz, 124–31; Pennell and Pennell, *Life of . . . Whistler*, 1:126.

175. Horowitz, 126–27.

176. Pennell and Pennell, *Life of . . . Whistler*, 1:126; Pennell and Pennell, *Whistler Journal*, 116–17, 299; Whistler to *Pall Mall Gazette*, July 28, 1891, pc, vol. 1889–91, GUL BP.

177. Walter Sickert, "Whistler To-Day," *Fortnightly Review* 57 (April 1892): 546.

178. [Sickert], 34.

179. Whistler to Alfred Chapman, [c. 1892], case 1, LC PP. This letter includes two sketches showing the correct and incorrect methods of framing his pictures.

180. Horowitz, 130; Pissarro to Lucien Pissarro, April 24, 1883, and December 13, 1888, in Pissarro, 28, 132, and see also 32.

181. Pennell and Pennell, *Life of . . . Whistler*, 2:120–22; Weintraub, 370. Burne-Jones attended the exhibition. He paid to enter and stayed a long time. Typescript, March 23–26, 1892, LC PP, 17.

182. "Mr. Whistler's Pictures," *Saturday Review*, March 26, 1892, 357, Freer; N. N. [Elizabeth R. Pennell],

"Mr. Whistler's Triumph," *Nation* 54 (April 14, 1892): 280.

183. Whistler to Thomson, March 29 and April 5, 1892, LC PP; Pennell and Pennell, *Life of . . . Whistler*, 2:124–29; Whistler to Thomson, stamped April 6, 1892, LC PP.

184. Whistler to Thomson, stamped April 12, 1892, case 2, LC PP; Pennell and Pennell, *Life of . . . Whistler*, 2:133.

185. Whistler to Way, November 12, 1893, Freer. For more background on Whistler's lithographs, see Lochnan, *Whistler and His Circle*, 46–51. Whistler also published lithographs in *Studio*.

186. Mallarmé, *Divagations on Whistler* (1899), cited in R. Spencer, *Whistler*, 303; Pennell and Pennell, *Life of . . . Whistler*, 2:167; Whistler to Way [1895], Freer. At this time Whistler received news he had won twenty-five hundred francs at the Venice International Exhibition. Way, 120–22.

187. Whistler to Thomson, September 14, 1894, case 17, LC PP; Way, 116; Pennell and Pennell, *Whistler Journal*, 189. *Catalogue of a Collection of Lithographs by James McNeill Whistler*, with the preface by Joseph Pennell, is bound into a volume in the Fine Art Society Collection.

188. Whistler to Huish [1895], F 239, and [1895] with Sketch, LB 3/37, both in GUL BP. Huish tried to convince him the long narrow flag would wind around the pole.

189. Whistler to Huish [1895], LB 3/37, GUL BP; Way, "Mr. Whistler's Lithographs," quoted in R. Spencer, *Whistler*, 304–17. Earlier, Way and Rothenstein had written a two-part article on Whistler's lithographs for *Studio*, which appeared in April 1893. In 1896 Way published the first catalogue raisonné of Whistler's lithographs.

190. Weintraub, 382–83; Pennell and Pennell, *Whistler Journal*, 189.

191. Philip Athill, "The International Society of Sculptors, Painters and Gravers," *Burlington Magazine* 127 (January 1985): 21. This article is the most valuable contemporary source on the ISSPG. Also see Joy Newton and Margaret F. MacDonald, "Whistler, Rodin, and the 'International,'" *Gazette des Beaux-Arts* 103 (March 1984): 115–23. The Pennells devoted a chapter to the ISSPG in *Life of . . . Whistler*, 2:216–27.

192. Invitations were sent to Puvis de Chavannes, Rodin, Besnard, Boldini, Menzel, Stück, Helleu, Degas, Zorn, von Lenbach, Klinger, von Uhde, Böcklin, Liebermann, Blanche, Costa, Meunier, Aman-Jean, Carrière, Thaulow,

Alexander, Maris, Pradilla, Segantini, Mesdag, Fragiacomo, Dill, Moreau, Klimt, MacMonnies, and Fantin-Latour. Minutes to Council Meetings, Book I: International Society of Sculptors, Painters and Gravers, Thursday, December 23, 1897, Tate.

193. Pennell and Pennell, *Life of . . . Whistler*, 2:216; Athill, 22–24; Rothenstein, 336. Rothenstein credited the success of the Company of the International Exhibition especially to Howard.

194. Lavery to Whistler, concerning Admiral Maxse, n.d., no. 954, 72–45/302, Tate; Pennell and Pennell, *Life of . . . Whistler*, 2:216–17. Rothstein, 336, noted Maxse was the hero of Meredith's *Harry Richmond* and was closely associated with the skating rink. After Maxse died, Whistler still preferred to keep the exhibitions at the rink because that was where "the public now expects to find us!" A later suggestion to show at Earl's Court he would not hear of. "It would be a dishonor to art—to be shown with watercuts and switchbacks as part of the entertainment." Pennell and Pennell, *Whistler Journal*, 196. On the ISSPG, see John Lavery, *The Life of a Painter* (London: Cassel, 1940), chap. 10.

195. Rothenstein, 335; Athill, 23–24.

196. See Pennell and Pennell, *Whistler Journal*, 14, 145, 151, 196, 217, 272, 275, 281, 283, 305–307, for their report on the ISSPG. See also Taylor, 172–73.

197. Pennell and Pennell, *Whistler Journal*, 14, 145, 151, 196, 217, 272, 275, 281, 283, 305–397; Ludovici, "International Society of Sculptors, Painters, and Gravers," *An Artist's Life*, 116–55.

198. Minutes to Council Meeting, ISSPG, Friday, July 15, 1888, 738.1.15, Tate; Athill, 23–24; Whistler to Heinemann, n.d., case 2, LC PP; Whistler to Howard, April 10, 1898, cited by Newton and MacDonald, 115–16; Minutes to Council Meeting, ISSPG, February 7, 1898, Tate. See also Report I, 18, GUL. Blanche, recalled that when he was on the committee of the ISSPG in the 1900s "our meetings, held in the office of the gallery at which we exhibited, lasted for hours and hours" (111).

199. Ludovici, "International Society," 129; Newton and MacDonald, 115–16; Athill, 24; Laver, *Whistler*, 281–82; Whistler to Ludovici, 1898, LC PP.

200. Newton and MacDonald, 115–16; Laver, *Whistler*, 281–82; Athill, 24–25; R. Spencer, *Whistler*, 320.

201. Pennell and Pennell, "Whistler as Decorator," 511; Gustav Klimt and W. Scholerman to Whistler, December 13, 1897, cited by R. Spencer, *Whistler*, 31, 319, 16; Carl E. Schorske, *Fin-de-Siècle Vienna: Politics and Culture* (New York: Vintage Books, 1980), 214, 217, 254, 266–67.

Klimt was a leader in the secession in 1897. The House of the Secession, designed by Olbrich in 1898, was a temple of art with "walls white and gleaming, holy and chaste." The secessionists took up the tasks that concerned Whistler, the "development of interior space," of "aestheticized inwardness," of *gesamtkunstwerk* (a total work of art). The ablest secessionists turned to interior design. Led by Josef Hofmann, they exploited rectilinear geometric forms and gold leaf, both hallmarks of Whistlerian decor. The Viennese artists' concern with flat abstract pattern, fantasized interiors, psychological-symbolistic undercurrents, and neoclassicism, and their desire to reform exhibition practices as well as to "bring everything together in an ecstacy of *joie de vivre* and in the service of beauty," followed Whistlerian aims. Angelica Baumer, *Gustav Klimt Women* (New York: Rizzoli, 1987), 16, 24. Whistler exhibited with others in Vienna at the Society for Reproductive Art in 1895. He owned copies of the Austrian Secessionist journal *Ver Sacrum*.

202. Blanche, 113, 124; Athill, 29; Newton and MacDonald, 122; ISSPG Minutes, Tate.

203. Newton and MacDonald, 116–17; Minutes, First Agenda Book, 36th Council Meeting, ISSPG, July 18, 1899, 7381, 54, Tate.

204. Athill, 26; Lavery to Whistler, March 3, 1898, I 28, GUL BP. See Pennell and Pennell, *Whistler Journal*, 151–53, 281, 283, for a condensed account of the ISSPG. A count made from the records in the ISSPG minutes book yielded eleven meetings attended by Whistler. Tate.

205. Pennell and Pennell, *Whistler Journal*, 143, 151, 217.

206. Rothenstein, 336; Whistler to Ludovici, 1898, LC PP. The International obtained Degas's work from Durand-Ruel. Taylor, 172. The following year, Degas wrote, "I do not wish to exhibit and am taking the precaution of replying to your second invitation so that the *sans gêne* of last year is not repeated. I thought my silence would be enough and that by not accepting in writing I was quite simply refusing. . . . I should have thought that our president, my old friend Whistler, would have defended my rights and not have permitted such a lack of consideration towards me. Perhaps he did not think of it." Edgar Degas, *Letters*, ed. Marcel Gùerin; trans. Margaret Kay (Oxford: B. Cassiver, 1947), 99. When the Austrian Josef Engelhart went to visit Whistler at 110 rue du Bac to choose works for a Viennese exhibition, Whistler told him, "As far as painting is concerned, there is only Degas and myself."

Degas, however, thought exhibitions were "brothels." Theodore Reff, "The Butterfly and the Old Ox," *Art News* 70 (March 1971): 26–27; Athill, 22–25.

207. Newton and MacDonald, 120; Ludovici, "International Society," 135. See Athill, 25–26, for a list of the works.

208. Athill, 26.

209. "The International Society," *Studio* 24 (January 1902): 120–21; Newton and MacDonald, 117; Paul Kruty, "Arthur Jerome Eddy and His Collection: Prelude and Postscript to the Armory Show," *Arts Magazine* 61 (February 1987): 40–47. Critics did not fault Whistler at this point, though Rinder found the third ISSPG international exhibition less noteworthy than the one in 1898. Frank Rinder, "The International Society of Sculptors, Painters and Gravers . . . ," *Art Journal* 63 (December 1901): 378–81.

210. "The International Art Exhibition with Mr. Whistler," *Pall Mall Gazette*, April 26, 1898, album 36, LC PP.

211. Joseph Pennell and Francis Howard to Whistler, 1898, I 21; Lavery, illustrated letter to Whistler, March 3, 1898, I 28; and Howard to Whistler, 1898, I 29, all in GUL BP.

212. Lavery to Whistler, April 27, 1899, 75-45/311, 973, letter no. 53, Tate; Howard to Whistler, 1898, I 50, GUL BP.

213. Whistler, letters to Ludovici, [1898], 540016, case 2, LC PP; *Catalogue of the International Society of Sculptors, Painters and Gravers*, 1898, E 1898.6; and Ludovici to Whistler, May 14, 1898, I 51, both in GUL BP. See Pennell and Pennell, *Life of . . . Whistler*, 2:74.

214. Ludovici to Whistler, May 27, 1898, Tate; Whistler to Lavery, May 1898, I 52, GUL BP; Minutes to Council Meetings, ISSPG, May 25 and June 9, 1899, Tate; Pennell and Pennell, *Whistler Journal*, 52; Pennell and Pennell, *Life of . . . Whistler*, 2:225; Maxse to Whistler, May 26, 1898, cited by Athill, 23.

215. Thomas Dartmouth, "International Art at Knightsbridge," *Art Journal* 60 (August 1898): 249–50; George Sauter, "The International Society of Painters, Sculptors and Gravers," *Studio* 14 (July 1898): 109. See Pennell and Pennell, *Whistler Journal*, 150, for background on Sauter.

216. "International Society," *London Times*, May 16, 1898; "International Art Exhibition in London," unidentified newspaper, May 19, 1898–June 2, 1898; Stevenson, "An Interesting Exhibition," *Nation*, June, 1899, pc, album

36; and "An Art Exhibition in London," May 1899, pc, album 36, all in LC PP.

217. Whistler to the Committee, May 18, 1898, dictated to Rosalind Birnie-Philip (in her hand) and enclosed in a private letter to Lavery, 7245.262, Tate; Peter Henry Emerson, quoted in R. Spencer, *Whistler*, 323.

218. W. Crane, *An Artist's Reminiscences*, 488; Pennell and Pennell, *Whistler Journal*, 304; Pennell and Pennell, *Life of . . . Whistler*, 2:65. Burke, "Painters and Sculptors in a Decorative Age," in Burke et al., 322, notes that when the Ten American Painters mounted an exhibition in 1898, they actively protested against "the Society of American Artists' crowded and chaotic hanging practices" and followed Whistler's example.

219. Gaunt, *Aesthetic Adventure*, 24, 340–41; Pennell and Pennell, "Whistler as Decorator," 511. Several memorial exhibitions were held shortly after Whistler's death. These included a 1904 exhibition in Boston by the Copley Society, a 1905 exhibition of 750 works in London by the ISSPG, and a 1905 exhibition of 440 works in Paris at the Ecole des Beaux-Arts. In Boston and London, galleries followed Whistler's dictums for exhibitions. The ISSPG show attracted twenty-five thousand people, including King Edward VII and Queen Mary.

220. Pennell and Pennell, *Life of . . . Whistler*, 2:173, 179, 252, 258–59, 269, 276.

221. Edith Shaw, "Four Years with Whistler," *Apollo* 87 (March 1968): 198; Pennell and Pennell, *Life of . . . Whistler*, 2:170, 252–53.

222. Crawford, 70–71, 105, 297–311; Pennell and Pennell, *Life of . . . Whistler*, 2:277.

223. Pennell and Pennell, *Whistler Journal*, 234, 241; Pennell and Pennell, *Life of . . . Whistler*, 2:277.

224. Crawford, 237–41. For more on the Ashbee house, see Pennell and Pennell, *Whistler Journal*, 234, 237–38, 241–42, 245, 247, 250–51, 255–57.

225. MacDonald, *Whistler Pastels*, pl. 107, p. 47; Pennell and Pennell, *Life of . . . Whistler*, 2:277.

226. Whistler, quoted in Pennell and Pennell, *Whistler Journal*, 250, 269; Macquoid, 44–45; Whistler to Thomson, 1894, case 17, LC PP. McNeill was misspelled "McNeil" to his annoyance. Huish wrote Whistler a considerate letter about the exhibit, September 24, 1902, II 13/28, GUL BP.

227. Rothenstein, 51; Pennell and Pennell, *Whistler Journal*, 250, 257; Pennell and Pennell, *Life of . . . Whistler*, 2:276–79, 288; Crawford, 120, 372.

228. Pennell and Pennell, *Whistler Journal*, 235–36; Pennell and Pennell, *Life of . . . Whistler*, 2:296–97; Whistler to Mr. Webb, 1903, concerning "Ashbee's conduct," Freer. See Getscher and Marks, 122.

229. Pennell and Pennell, *Whistler Journal*, 270–71, 292; Pennell and Pennell, *Life of . . . Whistler*, 2:278–79, 296–97, 301.

Bibliography

Publications about and by Whistler

"Afternoons in Studios: A Chat with Mr. Whistler." *Studio* 4 (January 1895): 116–21.

Andrews, Annulet. "Cousin Butterfly, Being Some Memories of Whistler." *Lippincott's Monthly Magazine* 73 (March 1904): 318–27.

"Art Sales." *Academy* 17 (February 21, 1880): 148–49.

———. *"Wilde v. Whistler," Being an Acrimonious Correspondence on Art between Oscar Wilde and James McNeill Whistler.* London: privately printed [Chelsea], 1906.

Athill, Philip. "The International Society of Sculptors, Painters and Gravers." *Burlington Magazine* 127 (January 1985): 21–29, 33.

Bacher, Otto. *With Whistler in Venice.* New York: Century, 1908.

Baker, Kenneth. "Polishing the Peacock Room: The Freer Gallery's Great Treasure Glitters Again." *Architectural Digest* 50 (March 1993): 32.

Baldry, A. L. "James McNeill Whistler: His Art and His Influence." *Studio* 29 (September 1903): 237–57.

Barbier, Carl Paul. "Whistler and Mallarmé." *The College Courant, Being the Journal of the Glasgow University Graduates Association* 25 (November, 1960): 14–19.

———, ed. *Correspondance Mallarmé-Whistler: Histoire de la grande amitié de leur dernières années.* Paris: A. G. Nizet, 1964.

Bénédite, Léonce. "Artistes Contemporains: Whistler." *Gazette des Beaux-Arts*, 3d ser., vol. 33, no. 575 (1905): 403–10; no. 576: 496–511; no. 578: 142–58; no. 579: 231–46; vol. 34, no. 578: 142–58, 231–46.

Boughton, G. H. "A Few of the Various Whistlers I Have Known." *Studio* 30 (December 1903): 208–18.

Broun, Elizabeth. "Thoughts That Began with the Gods: The Content of Whistler's Art." *Arts Magazine* 62 (October 1987): 36–43.

Chase, William Merritt. "The Two Whistlers: Recollections of a Summer with the Great Etcher." *Century Illustrated Monthly Magazine* 80 (July 1910).

C. J. H. "The Peacock Room." *Catalogue of Messrs. Obach Galleries.* New Bond Street, London, June 1904.

Colvin, Sidney. "Exhibition of Mr. Whistler's Pictures." *Academy* 5 (June 13, 1874): 672–73.

"A 'Confession' by Whistler." *Art Journal* 47 (1906): 9.

Cortissoz, Royal. "Whistler." *Atlantic Monthly* 92 (December 1903): 826–38.

Crane, Walter. *William Morris to Whistler: Papers and Addresses on Art and Craft and the Commonwealth.* London: G. Bell and Sons, 1911.

———. "Design and the Art of Mr. Whistler." *Art Journal* (May 1893): 134–35.

Curry, David Park. *James McNeill Whistler at the Freer Gallery of Art.* Exhibition catalogue. New York: W. W. Norton, 1984.

———. "Total Control: Whistler at an Exhibition." In Fine, ed., 61–82.

———. "Whistler and Decoration." *Magazine Antiques* 126 (November 1984): 1186–99.

deKay, Charles. "Whistler, the Head of the Impressionists." *Art Review* 1 (November 1886): 1–3.

Dempsey, Andrew. "Whistler and Sickert: A Friendship and Its End." *Apollo* 83 (January 1966): 30–37.

Donnelly, Kate, and Nigel Thorp. *Whistlers and Further Family.* Exhibition catalogue, Hunterian Art Gallery. Glasgow: University of Glasgow, 1980.

Dowdeswell, Walter. "Whistler." *Art Journal* 49 (April 1887): 97–103.

Duret, Théodore. *History of James McNeill Whistler and His Work.* Trans. Frank Rutter. Philadelphia: J. B. Lippincott, 1917.

Eddy, Arthur Jerome. *Recollections and Impressions of James A. McNeill Whistler.* Philadelphia: J. B. Lippincott, 1903.

Engelhart, Josef. "Memories of Whistler." *Living Age,* no. 338 (May 15, 1930): 369–74.

"Exhibits for the Paris Fair." *Building News* 34 (March 22, 1878): 287–88.

Ferriday, Peter. "Peacock Room." *Architectural Review* 125 (June 1959): 407–14.

Fine, Ruth, ed., *James McNeill Whistler: A Reexamination.* Vol. 19 of *Studies in the History of Art.* Hanover, N.H.: University Press of New England and National Gallery of Art, 1987.

Fleming, Gordon. *James Abbott McNeill Whistler: A Life.* New York: St. Martin's, 1991.

———. *The Young Whistler, 1834–66.* London: George Allen and Unwin, 1978.

Ford, Sheridan, ed. *The Gentle Art of Making Enemies,* by James McNeill Whistler. Paris: Delabrosse, 1890; New York: Frederick Stokes and Brother, 1890.

Gallatin, A. E. "Notes on an Exhibition of Whistlerania." *American Magazine of Art* 108 (April 1919): 201–206.

Getscher, Robert H., and Paul G. Marks. *James McNeill Whistler and John Singer Sargent: Two Annotated Bibliographies.* New York: Garland Publishing, 1986.

Godwin, Edward W. "Notes on Mr. Whistler's Peacock Room," *Architect* 16 (February 24, 1877): 118–19.

———. "On Some Buildings I Have Designed." *British Architect and Northern Engineer* (November 29, 1878): 210–11.

Grieve, Alastair. "Whistler and the Pre-Raphaelites." *Art Quarterly* 34 (summer 1971): 219–28.

"A Harmony in Yellow and Gold." *American Architect and Building News* 4 (July 27, 1878): 38.

Hartman, Elwood. "Mallarmé and Whistler: An Aesthetic Alliance." *Kentucky Romance Quarterly* 22, no. 4 (1975): 543–60.

Hartmann, Sadakichi [Sidney Allen]. *The Whistler Book.* Boston: L. C. Page, 1910.

Hawthorne, Mrs. Julian. "Mr. Whistler's New Portraits." *Harper's Bazar* 14 (October 15, 1881): 658–59.

Horowitz, Ira M. "Whistler's Frames." *Art Journal* 39 (winter 1979–80): 124–31.

An Indiscriminate Admirer. "A Gossip at Goupil's: Mr. Whistler on His Works." *Illustrated London News* 100 (March 26, 1892): 384.

"James Abbott McNeill Whistler." *American Architect and Building News* 22 (November 26, 1887): 258–59.

James, Henry. *The Painter's Eye: Notes and Essays on the Pictorial Arts.* Ed. John L. Sweeney. Cambridge: Harvard University Press, 1956.

Johnson, Ron. "Whistler's Musical Modes: Symbolist Symphonies" and "Whistler's Musical Modes: Numinous Nocturnes." *Arts Magazine* 55 (April 1981): 164–68; 169–76.

Keppel, Frederick. *One Day with Whistler.* New York: Frederick Keppel, 1904.

Key, John Ross. "Recollections of Whistler While in the Office of the United States Coast Survey." *Century Illustrated Magazine* 75 (April 1908): 928–32.

Laver, James. *Whistler.* New York: Cosmopolitan Book, 1930.

"The Lay Figure: On Domestic Decoration." *Studio* 32 (July 1904): 182.

Lochnan, Katharine A. *The Etchings of James McNeill Whistler.* New Haven: Yale University Press, 1984.

———. *Whistler and His Circle.* Exhibition catalogue. Ontario: Art Gallery of Ontario, 1986.

Ludovici, Albert. "Whistlerian Dynasty at Suffolk Street." *Art Journal* 47 (July–August 1906): 193–95, 237–39.

MacDonald, Margaret F. *"Notes, Harmonies, Nocturnes": Small Works by James McNeill Whistler*. Exhibition catalogue. New York: Knoedler, 1984.

———. *Whistler and Mallarmé*. Exhibition catalogue, Hunterian Art Gallery. Glasgow: University of Glasgow, 1973.

———. *Whistler Pastels and Related Works in the Hunterian Gallery*. Exhibition catalogue, Hunterian Art Gallery. Glasgow: University of Glasgow, 1984.

———. "Whistler: The Painting of the Mother." *Gazette des Beaux-Arts* 85 (February 1975): 73–88.

———. "Whistler's Designs for a Catalogue of Blue and White Nankin Porcelain." *Connoisseur* 198 (August 1978): 290–95.

———. ed. *Whistler's Mother's Cook Book*. New York: G. P. Putnam's Sons, 1979.

MacDonald [MacInnes], Margaret F. "Whistler's Last Years: Spring 1901—Algiers and Corsica." *Gazette des Beaux-Arts* 73 (May–June 1969): 323–43.

MacDonald, Margaret, and Joy Newton, eds. "Letters from the Whistler Collection (University of Glasgow): Correspondence with French Painters." *Gazette des Beaux-Arts* 108 (December 1986): 201–14.

McMullen, Roy. *Victorian Outsider: A Biography of J. A. M. Whistler*. New York: E. P. Dutton, 1973.

Mahey, John. "The Letters of James McNeill Whistler to George A. Lucas." *Art Bulletin* 49 (September 1967): 247–57.

Mallarmé, Stéphane. *Selected Letters of Stéphane Mallarmé*. Ed. and trans. Rosemary Lloyd. Chicago: University of Chicago Press, 1988.

Maus, Octave. "Whistler in Belgium." *Studio* 32 (June 1904): 7–12.

Menpes, Mortimer. *Whistler as I Knew Him*. London: Adam and Charles Black, 1904.

———. "Reminiscences of Whistler by Mortimer Menpes, Recorded by Dorothy Menpes." *Studio* 29 (September 1903): 245–57.

Merrill, Linda. *A Pot of Paint: Aesthetics on Trial in "Whistler v. Ruskin."* Washington, D.C.: Smithsonian Institution Press, in collaboration with the Freer Gallery of Art, 1992.

Monkhouse, Cosmo. "Brown and Gold." *Academy* 29 (May 22, 1886): 369–70.

"Mr. Whistler's Arrangement in Flesh Colour and Gray." *Academy* 26 (May 24, 1884): 374.

"Mr. Whistler's Pictures." *Saturday Review*, March 26, 1892, 357.

Munhall, Edgar. "Whistler's Portrait of Robert de Montesquiou: The Documents." *Gazette des Beaux-Arts* 71 (1968): 231–41.

Murray, Donald M. "James and Whistler at the Grosvenor Gallery." *American Quarterly* 4 (spring 1952): 49–65.

"The New Public Library at Boston, U.S.A." *Art Journal* (New York) 55 (April 1893): 126–27.

Newton, Joy, and Margaret F. MacDonald. "Whistler, Rodin, and the 'International.'" *Gazette des Beaux-Arts* 103 (March 1984): 115–23.

———. "Whistler: Search for a European Reputation." *Zeitschrift für Kunstgeschichte* 41, no. 2 (1978): 148–59.

Noguchi, Yone. "A Japanese on Whistler." *Academy* 80 (June 17, 1911): 750.

"Notes and News." *Academy* 10 (September 2, 1876): 249.

Parker, Alice Lee. "The Whistler Material in the Rosenwald Collection." *Library of Congress Quarterly Journal of Current Acquisitions* 3 (October 1945): 63–66.

Parry, His Honor Judge Edward A. "Whistler v. Ruskin." *Cornhill Magazine*, n.s., 50 (January 1921): 21–33.

"The Peacock Room." *Athenaeum*, June 18, 1904, 793.

"The Peacock Room in the Freer Collection." *New York Times Magazine*, October 5, 1919, 12.

Pennell, Elizabeth Robins. "Mr. Whistler's Triumph." *Nation* 54 (April 14, 1892): 280.

———. *Whistler the Friend*. Philadelphia: J. B. Lippincott, 1930.

Pennell, Elizabeth Robins, and Joseph Pennell. *The Life of James McNeill Whistler*. 2 vols. Philadelphia: J. B. Lippincott, 1908.

———. "Whistler as Decorator." *Century Magazine* 83 (February 1912): 500–13.

———. *The Whistler Journal*. Philadelphia: J. B. Lippincott, 1921.

Pennell, Joseph. Prefatory note to *Catalogue of a Collection of Lithographs by James McNeill Whistler*. Exhibition catalogue. London: Fine Art Society, 1895.

Peterson, Harold. "Whistler's Chelsea." *Arts* 13 (April 1990): 7–9.

Prinsep, Val, R. A. "James A. McNeill Whistler, 1834–1903: 1. Personal Recollections." *Magazine of Art* 28 (October 1903): 577–79.

Reff, Theodore. "The Butterfly and the Old Ox." *Art News* 70 (March 1971): 26–27.

Robertson, W. Graham. "Of James McNeill Whistler."

Life Was Worth Living: The Reminiscences of W. Graham Robertson. New York: Harper and Brothers, 1931.

Rutter, Frank. *James McNeill Whistler: An Estimate and a Biography.* London: Grant Richards, 1911.

Sandberg, John. "'Japonisme' and Whistler." *Burlington Magazine* 106 (November 1964): 500–507.

———. "Whistler's Early Work in America, 1834–1855." *Art Quarterly* 29, no. 1 (1966): 46–59.

———. "Whistler Studies." *Art Bulletin* 50 (March 1968): 59–64.

Seitz, Don. "James Abbott McNeill Whistler: Wit, Wasp, and Butterfly." *McClure's Magazine* 1 (August 1925): 497–500.

Shaw, Edith. "Four Years with Whistler." *Apollo* 87 (March 1968): 198.

Sickert, Walter. "Whistler To-Day." *Fortnightly Review* 57 (April 1892): 543–47.

Smalley, Phoebe Garnaut. "Mr. Whistler." *Lamp* 27 (August 1903): 110–12.

Spencer, Robin. *Whistler: A Retrospective.* New York: Hugh Lauter Levin Associates, 1989.

———. "Whistler and Japan: Work in Progress." *Japonisme in Art: An International Symposium.* Ed. Society for the Study of Japonisme. Tokyo: Committee for the Year 2001 and Kodansha International, 1980, 57–80.

———. "Whistler's First One-Man Exhibition Reconstructed." In Weisberg and Dixon, eds., 27–49 (see below, p. 317).

Spielmann, M. H. "James A. McNeill Whistler, 1834–1903: 2. The Man and the Artist." *Magazine of Art* 28 (October 1903): 579–84; (November 1903): 8–17.

Staley, Allen. *"Painter of the Beautiful": Lord Leighton, Whistler, Albert Moore, and Conder.* Exhibition catalogue. New York: Durlacher Bros., 1964.

Staley, Allen, and Theodore Reff, eds. *From Realism to Symbolism: Whistler and His World.* Exhibition catalogue. New York: Columbia University, 1971.

Starr, Sidney. "Personal Recollections of Whistler." *Atlantic Monthly* 101 (April 1908): 528–37.

Stoner, Joyce Hill. "Art Historical and Technical Evaluation of Works by Three Nineteenth-Century Artists: Allston, Whistler, and Ryder." In *Appearances, Opinion, Change: Evaluating the Look of Paintings.* London: United Kingdom Institute for Conservation, 1990.

"Studio Talk." *Studio* 32 (August 1904): 241–46.

Sutton, Denys. Introduction to *An Exhibition of Etchings, Dry Points, and Lithographs by James McNeill Whistler.*

Exhibition catalog, P. & D. Colnaghi. Chatham: W. and J. Mackay, 1971.

———. *James McNeill Whistler: Paintings, Etchings, Pastels, and Watercolours.* London: Phaidon, 1966.

———. *Nocturne: The Art of James McNeill Whistler.* Philadelphia: J. B. Lippincott, 1964.

———, ed. *James McNeill Whistler: Whistler Exhibition in Japan.* Exhibition catalogue. Tokyo: Japan Association of Art Museums, 1987

Swinburne, Algernon Charles. "Mr. Whistler's Lecture on Art." *Fortnightly Review* 43 (June 5, 1888): 745–51.

Taylor, Hilary. *James McNeill Whistler.* New York: G. P. Putnam's Sons, 1978.

Teall, Gardner C. "Mr. Whistler and the Art Crafts." *House Beautiful* 13 (February 1903): 188–91.

Thomson, D. Croal. "Whistler and His London Exhibitions." *Art Journal* 67 (April 1905): 107–11.

Walker, John. *Whistler.* New York: Harry N. Abrams, 1987.

Watanabe, Toshio. "Eishi Prints in Whistler's Studio? Eighteenth-Century Japanese Prints in the West before 1870." *Burlington Magazine* 128 (December 1986): 874–81.

Way, T. R. *Memories of James McNeill Whistler, the Artist.* London: John Lane, the Bodley Head, 1912.

Way, T. R., and G. R. Dennis. *The Art of James McNeill Whistler: An Appreciation.* London: George Bell and Sons, 1904.

Wedmore, Frederick. "Mr. Whistler's Arrangement in Flesh Colour and Gray." *Academy* 25 (May 24, 1884): 374.

———. "Mr. Whistler's Exhibition." *Academy* 23 (February 24, 1883): 139–40.

———. "Fine Art: Mr. Whistler's Pastels." *Academy* 19 (February 19, 1881): 142.

———. "Mr. Whistler's Theories and Mr. Whistler's Art." *Nineteenth Century* (August 1879): 334–43.

Weintraub, Stanley. *Whistler: A Biography.* New York: E. P. Dutton, 1988.

Whistler, Anna Mathilda. "The Lady of the Portrait: Letters of Whistler's Mother." Ed. K. E. Abbott. *Atlantic Monthly* 136 (September 1925): 319–28.

———. "Whistler's Mother." *Art Digest* 7 (January 1, 1933): 6–30.

Whistler, James Abbott McNeill. *The Gentle Art of Making Enemies.* 1892. Reprint, New York: Dover Publications, 1967.

———. *Harmony in Blue and Gold.* London: Thomas R. Way, 1877.

———. "Notes and News." *Academy* 10 (September 9, 1876): 275.

———. *Whistler v. Ruskin: Art and Art Critics*. London: Chatto and Windus, Thomas R. Way, 1878.

"Whistler, Painter and Comedian." *McClure's Magazine* 7 (1896): 374–78.

"The White House." *Vogue* 46 (August 1, 1915): 40.

Winter, John, and Elisabeth West Fitzhugh. "Some Technical Notes on Whistler's 'Peacock Room.'" *Studies in Conservation* 30 (November 1985): 149–54.

"The Work of James McNeill Whistler." *Edinburgh Review* 201 (April 1905): 445–67.

Young, Andrew McLaren. *James McNeill Whistler: An Exhibition of Painting and Other Works*. Exhibition catalogue. London: Arts Council of Great Britain, 1960.

Young, Andrew McLaren, Margaret F. MacDonald, and Robin Spencer, with the assistance of Hamish Miles. *The Paintings of James McNeill Whistler*. 2 vols. New Haven: Yale University Press, 1980.

General Publications

Adams, Janet Woodbury. *Decorative Folding Screens: Four Hundred Years in the Western World*. New York: Viking, 1982.

Adburgham, Alison. *Liberty's: A Biography of a Shop*. London: George Allen and Unwin, 1975.

Alcock, Sir Rutherford. "Japanese Art." *Art Journal* 40 (January 1878): 1–3; (March 1878): 81–84; (June 1878): 137–40.

Anderson, William. "Japanese Homes and Their Surroundings." *Magazine of Art* 9 (1886): 295–99.

"An Experiment in the Application of Japanese Ornament to the Decoration of an English House: Mr. Mortimer Menpes' House." *Studio* 17 (1899): 170–78.

[Armstrong, Thomas]. *Thomas Armstrong, C.B.: A Memoir, 1832–1911*. Ed. L. M. Lamont. London: Martin Secker, 1912.

"Art in the Dining Room." *Saturday Review*, January 12, 1878, 41–42.

Arwas, Victor. *The Liberty Style*. New York: Rizzoli International Publications, 1979.

Aslin, Elizabeth. *The Aesthetic Movement: Prelude to Art Nouveau*. New York: Frederick A. Praeger, 1969.

———. "E. W. Godwin and the Japanese Taste." *Apollo* 76 (December 1962): 779–84.

———. *E. W. Godwin: Furniture and Interior Decoration*. London: John Murray, 1986.

———. *Nineteenth-Century English Furniture*. New York: Thomas Yosef, 1962.

———. "The Furniture Designs of E. W. Godwin." *Victoria and Albert Museum Bulletin* 3 (October 1967): 145–54.

Baldry, Alfred Lys. *Albert Moore: His Life and Works*. London: George Bell & Sons, 1894.

Banham, Joanna, Sally MacDonald, and Julia Porter. *Victorian Interior Design*. London: Cassell and Studio Editions Ltd., 1991.

Baudelaire, Charles. *Art in Paris, 1845–1862: Salons and Other Exhibitions*. Trans. and ed. Jonathan Mayne. London: Phaidon, 1965.

———. *Flowers of Evil (Les Fleurs du Mal)*. Trans. Enid Starkie. Intro. Geoffrey Wagner. Norfolk: New Classics, 1946.

———. *The Painter of Modern Life and Other Essays*. Trans. and ed. Jonathan Mayne. New York: Da Capo Paperback, 1964.

Baumer, Angelica. *Gustav Klimt Women*. New York: Rizzoli, 1987.

Beerbohm, Max. *Rossetti and His Circle*. Ed. N. John Hall. New Haven: Yale University Press, 1987.

Bellringer, Alan W. *The Ambassadors*. Unwin Critical Library, ed. Edward Claude Rawson. London: George Allen & Unwin, 1984.

Benevolo, Leonardo. *History of Modern Architecture*. Vol. 1, *The Tradition of Modern Architecture*. Cambridge: MIT Press, 1984.

Billcliffe, Roger. *Charles Rennie Mackintosh: The Complete Furniture, Furniture Drawings, and Interior Design*. New York: E. P. Dutton, 1986.

Blanche, Jacques-Emile. *Portraits of a Lifetime: The Late Victorian Era: The Edwardian Pageant, 1870–1914*. Trans. and ed. Walter Clement. New York: Coward-McCann, 1938.

Bøe, Alf. *From Gothic Revival to Functional Form: A Study in Victorian Theories of Design*. New York: Da Capo, 1979.

Boger, Louise Ade, and H. Batterson Boger. *The Dictionary*

of Antiques and the Decorative Arts. New York: Charles Scribner's Sons, 1967.

Bornand, Odette. *The Diary of William Michael Rossetti, 1870–73*. Oxford: Clarendon, 1977.

Brémont, Anna, comtesse de. *Oscar Wilde and His Mother*. London: Everett, 1911.

Brooke, Anthea. *Victorian Painting*. Exhibition catalogue. London: Fine Art Society, 1977.

Buchanan, William. "Japanese Influences on the Glasgow Boys and Charles Rennie Mackintosh." *Japonisme in Art: An International Symposium*. Ed. Society for the Study of Japonisme. Tokyo: Committee for the Year 2001, 1980.

Buckler, William E. *Walter Pater: The Critic as Artist of Ideas*. New York: New York University Press, 1987.

———, ed. *Prose of the Victorian Period*. Boston: Houghton Mifflin, 1958.

Buckley, Jerome Hamilton. *The Victorian Temper: A Study in Literary Culture*. London: Frank Cass, 1966.

Bullen, Barrie. "The Palace of Art: Sir Coutts Lindsay and the Grosvenor Gallery." *Apollo* 120 (November 1975): 352–57.

Burges, William. "The Japanese Court in the International Exhibition." *Gentlemen's Magazine and Historical Review* 213 (September 1862): 243–54.

Burke, Doreen Bolger, et al. *In Pursuit of Beauty: Americans and the Aesthetic Movement*. Exhibition catalogue. New York: Metropolitan Museum of Art, Rizzoli, 1986.

Burty, Philippe. "Fine Art *Japonisme*." *Academy* 8 (August 7, 1875): 150–51.

Cevasco, G. A. *J. K. Huysmans: A Reference Guide to English Translations . . . 1880–1978*. Boston: G. K. Hall, 1980.

Chandler, George C. "The Leyland Line." *Liverpool Shipping: A Short History*. London: Phoenix House, 1960.

Child, Theodore. "A Pre-Raphaelite Mansion: F. R. Leyland at Prince's Gate." *Harper's New Monthly Magazine* 82 (December 1890): 81–99.

Chu, Petra ten-Doesschate, ed. *Letters of Gustave Courbet*. Chicago: University of Chicago Press, 1992.

Clark, Robert Judson, ed. *The Arts and Crafts Movement in America, 1876–1916*. Exhibition catalogue, Princeton University and the Art Institute of Chicago. Princeton: Princeton University Press, 1972.

Collard, Frances. *Regency Furniture*. Suffolk: Antique Collectors' Club, 1985.

Cooper, Nicholas. *The Opulent Eye*. New York: Watson-Guptill, 1976.

Cornforth, John. *English Interiors, 1790–1848: The Quest for Comfort*. London: Barrie & Jenkins, 1978.

Couldrey, Vivienne. *The Art of Louis Comfort Tiffany*. London: Wellfleet, 1989.

Crane, Lucy. *Art and the Formation of Taste*. Boston: Chatauqua, 1885.

Crane, Walter. *An Artist's Reminiscences*. London: Methuen, 1907.

Crawford, Alan. *C. R. Ashbee*. New Haven: Yale University Press, 1985.

Cromey-Hawke, N. "William Morris and Victorian Painted Furniture." *Connoisseur* 191 (January 1976): 32–43.

Crook, Mordaunt. *William Burges and the High Victorian Dream*. Chicago: University of Chicago Press, 1981.

Dartmouth, Thomas. "International Art at Knightsbridge." *Art Journal* 60 (August 1898): 249–50.

Day, Lewis F. "A Kensington Interior." *Art Journal* 55 (May 1893): 139–44.

Degas, Edgar. *Letters*. Ed. Marcel Guerin. Trans. Margaret Kay. Oxford: B. Cassiver, 1947.

Denney, Colleen. "English Book Designers and the Role of the Modern Book at L'Art Nouveau, Part II: Relations between England and the Continent." *Arts Magazine* 61.2 (summer 1987): 49.

Denvir, Bernard. *The Late Victorians: Art, Design, and Society, 1852–1910*. New York: Longman, 1986.

Dore, Helen. *William Morris*. Secaucus, N.J.: Chartwell Books, 1990.

Doughty, Oswald. *A Victorian Romantic, Dante Gabriel Rossetti*. London: Oxford University Press, 1960.

Dufwa, Jacques. *Winds from the East: A Study of the Art of Manet, Degas, Monet, and Whistler, 1856–1886*. Stockholm: Almquist and Wiksell International, 1981.

Du Maurier, George. *Trilby*. New York: Harpers and Brothers, 1895.

———. *The Young George Du Maurier: A Selection of His Letters, 1860–67*. Ed. Daphne Du Maurier. London: Peter Davies, 1951.

Dutton, Ralph. *The Victorian Home*. London: B. T. Batsford, 1954.

Duval, M. Susan. "F. R. Leyland: A Maecenas from Liverpool." *Apollo* 124 (August 1986): 110–15.

Earle, Joe. "The Taxonomic Obsession: British Collectors and Japanese Objects, 1852–1986." *Burlington Magazine* 128 (December 1986): 864–73.

Eastlake, Charles Lock. *Hints on Household Taste in Furniture, Upholstery, and Other Details*. London: Longmans, Green, 1868.

Edis, Robert W. *Decoration and Furniture of Town Houses.* 1881. Reprint, New York: E. P. Dutton, 1972.

Eidelberg, Martin. "Bracquemond, Delâtre, and the Discovery of Japanese Prints." *Burlington Magazine* 123 (April 1981): 221–27.

Ellmann, Richard. *Oscar Wilde.* New York: Vintage Books, 1988.

Evett, Elisa. *The Critical Reception of Japanese Art in Late-Nineteenth-Century Europe.* Ann Arbor: UMI, 1982.

Fairclough, Oliver, and Emmeline Leary. *Textiles by William Morris and Company, 1861–1940.* Exhibition catalogue, Birmingham Museums and Art Gallery. Westfield, N.J.: Eastview Editions, 1981.

Farr, Dennis. *English Art, 1870–1940.* Vol. 14 of *The Oxford History of English Art.* Oxford: Clarendon, 1978.

Fennell, Francis L., Jr., ed. *The Rossetti-Leyland Letters.* Athens: Ohio University Press, 1978.

Fenollosa, Ernest F. "The Collection of Mr. Charles Freer." *Pacific Era* 1 (November 1907): 57–66.

Fildes, L. V., ed. *Luke Fildes, R.A.: A Victorian Painter.* London: Michael Joseph, 1968.

Floyd, Phylis. *Seeking the Floating World: The Japanese Spirit in Turn-of-the-Century French Art.* Exhibition catalogue, Rutgers University. Yokohama: Sogo Department Store, 1989.

Forbes-Robertson, Sir Johnston. *A Player under Three Reigns.* New York: Benjamin Blom, 1971.

Gaunt, William. *The Aesthetic Adventure.* New York: Harcourt, Brace, 1945.

————. *Chelsea.* London: B. T. Batsford, 1954.

Gautier, Théophile. *The Complete Works of Théophile Gautier.* 2 vols. Ed. S. C. DeSumichrast. London: Athenaeum, n.d.

Gere, Charlotte. *Morris and Company.* Exhibition catalogue. London: Fine Art Society, 1971.

Gere, Charlotte, and Peyton Skipwith. "The Morris Movement." *Connoisseur* 201 (May 1971): 33–39.

Girouard, Mark. "Chelsea's Bohemian Studio Houses: The Victorian Artist at Home—II." *Country Life* 152 (November 23, 1972): 1370–74.

————. *Sweetness and Light: The "Queen Anne" Movement, 1860–1900.* New Haven: Yale University Press, 1977.

Gladstone, Florence M. *Aubrey House, Kensington, 1698–1920.* London: Arthur L. Humphreys, 1922.

Gloag, John. *Victorian Comfort: A Social History of Design, 1830–1900.* London: Adam and Charles Black, 1961.

Godwin, Edward W. "Japanese Wood Construction: Woodwork V." *Building News and Engineering Journal* 28 (February 12, 1875): 173–75.

————. "My Chambers and What I Did to Them." *Architect* 16 (July 1, 1876): 4–5; (July 8, 1876): 18–19; (August 5, 1876): 72–73.

————. "The Home of an English Architect." *Art Journal* 48 (October 1886), 301–304.

Gombrich, E. H. *The Sense of Order: A Study in the Psychology of Decorative Art.* Ithaca: Cornell University Press, 1979.

Gordon, Robert, and Andrew Forge. *Monet.* New York: Harry N. Abrams, 1985.

Goyne, Nancy. "American Windsor Chairs: A Style Survey." *Antiques* 95 (April 1969): 538–49.

Grandjean, Serge. *Empire Furniture.* New York: Taplinger, 1966.

Grasselli, Margaret Morgan, and Pierre Rosenberg. *Watteau.* Exhibition catalogue. Washington, D.C.: National Gallery of Art, 1984.

"The Grosvenor Gallery of Fine Art, New Bond Street." *Illustrated London News* 70 (May 5, 1877): 419–20.

Hamilton, Walter. *The Aesthetic Movement in England.* 3d ed. London: Reeves and Turner, 1882.

Harbron, Dudley. *The Conscious Stone: The Life of Edward William Godwin.* London: Latimer House, 1949.

Haslam, Malcolm. "Ceramics." In *The Aesthetic Movement and the Cult of Japan.* Exhibition catalogue. London: Fine Art Society, 1972.

Hauptman, William. "Charles Gleyre: Tradition and Innovation." In *Charles Gleyre, 1806–1874.* Exhibition catalogue. New York: Grey Art Gallery and Study Center, New York University, 1980.

Havemeyer, Louisine W. *Sixteen to Sixty: Memoirs of a Collector.* New York: privately printed, 1961.

Haweis, Mrs. H. R. [Mary E.] *The Art of Decoration.* London: Chatto and Windus, 1889.

Hayward, Helena, ed. *World Furniture.* Secaucus, N.J.: Chartwell Books, 1977.

Hayward, M. E. "Influence of the Classical Oriental Tradition on American Painting." *Winterthur Portfolio* 14 (summer 1979): 111–12.

Henderson, Philip. *William Morris.* New York: McGraw-Hill, 1967.

"History of the Week." *John Bull* 30 (November 1878): 773.

Holiday, Henry. *Reminiscences of My Life.* London: Heinemann, 1914.

Holt, Elizabeth Gilmore. *The Expanding World of Art,*

1874–1902. Vol. I, *Universal Expositions and State-Sponsored Fine Arts Expositions.* New Haven: Yale University Press, 1988.

———. *The Triumph of Art for the Public: The Emerging Role of Exhibitions and Critics.* Garden City, N.Y.: Anchor, 1979.

Honour, Hugh. *Chinoiserie: The Vision of Cathay.* London: John Murray, 1961.

Hufford, Sarah Towne. "The 'St. Bacchus Sideboard': A New Piece of Furniture by William Burges." *Burlington Magazine* 128.2 (June 1986): 407–13.

Huysmans, Joris-Karl. *A Rebours.* Paris: G. Charpentier, 1884.

Hyde, H. Montgomery. "Oscar Wilde and His Architect." *Architectural Review* 109 (March 1951): 175–76.

"The International Society." *Studio* 24 (January 1902): 210–21.

Ionides, Luke. *Memories.* Paris: Herbert Clark, 1925.

Ives, Colta Feller. *The Great Wave: The Influence of Japanese Woodcuts on French Prints.* New York: Metropolitan Museum of Art, 1974.

Jackson, Holbrook. *The Eighteen Nineties.* (London: Jonathan Cape, 1913–31).

Jacobsen, Robert. *Japanese Art: Selections from the Mary and Jackson Burke Collection.* Minneapolis: Minneapolis Institute of Arts, 1977.

James, Henry. *The Ambassadors.* New York: Harper, 1948.

———. *The Letters of Henry James: Volume II, 1875–1883.* Ed. Leon Edel. Cambridge: Harvard University Press, Belknap Press, 1975.

———. "The London Exhibitions—the Grosvenor Gallery." *Nation* 26 (May 23, 1878): 338–39.

"A Japanese Room." *Art Journal* 40 (July 1878): 158.

"Japanese Exhibition." *Illustrated London News* 24 (February 4, 1854): 97–98.

Jarvis, Simon. *High Victorian Design.* Suffolk: Boydell, 1983.

———. *Victorian Furniture.* London: Ward Lock, n.d.

Jones, Clement. *Pioneer Shipowners.* Liverpool: Charles Birchall & Sons, 1934.

Joy, Edward. Introduction to *Pictorial Dictionary of British Nineteenth-Century Furniture Design.* Woodbridge, Suffolk: Antique Collectors' Research Project, 1977.

Joyce, Claire. *Monet's Table: The Cooking Journals of Claude Monet.* New York: Simon and Schuster, 1989.

Kaufmann, Edgar, Jr. "Makers of Tradition: 30. Edward Godwin and Christopher Dresser: The 'Esthetic' Designers, Pioneers of the 1870s." *Interiors,* October 1958, 162–65.

Kelly, Richard. *George Du Maurier.* Boston: Twayne, 1983.

Koizumi, Kazuko. *Traditional Japanese Furniture.* Trans. Alfred Birnbaum. Tokyo: Kodansha International, 1986.

Kroyer, Peter. *The Story of Lindsey House, Chelsea.* London: Country Life, 1956.

Kruty, Paul. "Arthur Jerome Eddy and His Collection: Prelude and Postscript to the Armory Show." *Arts Magazine* 61 (February 1987): 40–47.

Lancaster, Clay. *The Japanese Influence in America.* New York: Walton H. Rawls, 1963.

———. "Oriental Contributions to Art Nouveau." *Art Bulletin* 34, no. 4 (1952): 297–310.

Lang, Cecil Y. *The Pre-Raphaelites and Their Circle.* Chicago: University of Chicago Press, 1975.

"L'Art Nouveau: What Is Thought of It." *Magazine of Art* 28 (1903): 211.

Lasdun, Susan. *Victorians at Home.* New York: Viking, 1981.

Laughton, Bruce. "The British and American Contribution to Les XX, 1884–93." *Apollo* 86 (November 1967): 372–79.

Laver, James. *The First Decadent, Being the Strange Life of Joris-Karl Huysmans.* New York: Citadel, 1955.

———. *Victoriana.* London: Ward Lock, 1966.

Lavery, John. *The Life of a Painter.* London: Cassell, 1940.

Lawton, Thomas, and Linda Merrill, *Freer: A Legacy of Art.* New York: Freer Gallery of Art, Smithsonian Institution, in association with Harry N. Abrams, 1993.

Lewis, Lloyd, and Henry Justin Smith. *Oscar Wilde Discovers America.* 1936. Reprint, New York: Benjamin Blom, 1964.

Lilly, Marjorie. *Sickert: The Painter and His Circle.* Park Ridge, N.J.: Noyes, 1973.

Lucie-Smith, Edward. *Symbolist Art.* New York: Thames and Hudson, 1988.

Ludovici, Albert. *An Artist's Life in London and Paris, 1870–1925.* New York: Minton, Balch, 1926.

MacCarthy, Fiona. *A History of British Design, 1830–1970.* London: George Allen and Unwin, 1972.

Macready, Sarah, and F. H. Thompson, eds. *Influences in Victorian Art and Architecture.* London: Thames and Hudson, 1985.

Macqueen-Pope, W. *Gaiety, Theatre of Enchantment.* London: W. H. Allen, 1949.

Macquoid, Percy. "Knife, Fork, Spoon, and Silver Table-Plate Exhibition Catalogue." *Fine Art Society Exhibitions, 1901–03*. London: Fine Art Society, 1902.

Madsen, Stephan Tschudi. *Sources of Art Nouveau*. Trans. Ragnar Christopherson. New York: Da Capo, 1975.

Mallock, William H. *The New Republic; or, Culture, Faith, and Philosophy in an English Country House*. Ed. J. Max Patrick, 1877. Reprint, Gainesville: University of Florida Press, 1950.

Megilp. "The Grosvenor Gallery and the Royal Academy." *Vanity Fair*, May 5, 1877, 281.

Milner, John. *The Studios of Paris*. New Haven: Yale University Press, 1988.

———. *Symbolists and Decadents*. Ed. David Herbert. New York: Studio Vista, 1971.

Morison, Samuel Eliot. *"Old Bruin": Commodore Matthew Calbraith Perry*. Boston: Little Brown, 1967.

Morris, Barbara. *Inspiration for Design: The Influence of the Victoria and Albert Museum*, London: Victoria and Albert Museum, 1986.

———. *Liberty Design, 1874–1914*. London: Pyramid Books, an imprint of Octopus Publishing, 1989.

Morris, William. *Hopes and Fears for Art*. New York: Longmans, Green, 1901.

Morse, Edward S. *Japanese Homes and Their Surroundings*. 1886. Reprint, Rutland, Vt.: Charles E. Tuttle, 1977.

Murger, Henri. *Latin Quarter: Scènes de la vie de Bohème*. Trans. Elizabeth Ward Hugus. Intro. D. B. Wyndham Lewis. 1847–49. Reprint, Westport, Conn.: Hyperion Press, 1978.

Muthesius, Hermann. *Das Englische Haus*. 1904. Reprint, New York: Rizzoli, 1979.

Naylor, Gillian. *William Morris by Himself*. Boston: Little Brown, 1988.

Neve, Christopher. "The Cult of Japan." *Country Life* 152 (October 5, 1972): 804–805.

O'Callaghan, John. "The Fine Art Society and E. W. Godwin." *Centenary, 1876–1976*. Exhibition catalogue. London: Fine Art Society, 1976.

Olson, Stanley. *John Singer Sargent: His Portrait*. New York: St. Martin's, 1986.

Ormond, Leonée. *George Du Maurier*. Pittsburgh: University of Pittsburgh Press, 1969.

Ovenden, Graham. *Clementina Lady Hawarden*. New York: St. Martin's, 1974.

Pennington, Harper. "The Field of Art." *Scribner's Magazine* 35 (May 1904): 639–40.

Pevsner, Nikolaus. "Art Furniture." *Architectural Review* 3 (January 1, 1952): 43–50.

———. *Pioneers of Modern Design, from William Morris to Walter Gropius*. 1936. Reprint, London: Penguin Books, 1975.

———. *Ruskin and Viollet-le-Duc*. London: Thames and Hudson, 1969.

Physick, John. *The Victoria and Albert Museum*. Oxford: Phaidon, Christie's, 1982.

Pissarro, Camille. *Camille Pissarro: Letters to his Son Lucien*. Ed. John Rewald, with the assistance of Lucien Pissarro. London: Pantheon Books, 1943.

Poe, Edgar Allan. "The Philosophy of Furniture." In *Essays and Miscellanies*. Vol. 14 of *The Complete Works of Edgar Allan Poe*. Ed. James A. Harrison. New York: AMS Press, 1965.

Prinsep, Val C. "A Collector's Correspondence." *Art Journal*, n.s., 54 (1892): 249–52.

Prinsep, Val C., and Lionel Robinson. "The Private Art Collections of London: The Late Mr. Frederick Leyland's in Prince's Gate." *Art Journal*, n.s., 54 (May 1892): 129–38.

Reitlinger, Gerald. "The Craze for Blue and White." *Connoisseur* 189 (July 1975): 216–19.

Rewald, John. *The History of Impressionism*. 4th ed. New York: Museum of Modern Art, 1987.

Rinder, Frank. "The International Society of Sculptors, Painters and Gravers . . ." *Art Journal* 63 (December 1901): 378–81.

Robinson, Edward. *The H. O. Havemeyer Collection*. Exhibition catalogue. New York: Metropolitan Museum of Art, 1930.

Roe, Gordon. *Victorian Furniture*. London: Phoenix House, 1952.

Rossetti, Dante Gabriel. *Dante Gabriel Rossetti: His Family—Letters, Vol. 1*. Ed. William Michael Rossetti. Boston: Roberts Brothers, 1895.

———. *Letters of Dante Gabriel Rossetti*. Ed. Oswald Doughty and John Robert Wahl. Oxford: Clarendon, 1967.

———. *Rossetti Papers, 1862 to 1870*. London: Sands, 1903.

Rossetti, William Michael. *Dante Gabriel Rossetti as Designer and Writer*. London: Cassell, 1889.

———. *The Pre-Raphaelite Brotherhood Journal*. Ed.

William Fredeman. Oxford: Clarendon Press, 1975.

Rothenstein, William. *Men and Memories: Recollections of William Rothenstein, 1872–1900*. New York: Coward-McCann, 1931.

Ruskin, John. *The Brantwood Diary of John Ruskin*. Ed. Helen Gill Viljoen. New Haven: Yale University Press, 1971.

———. *Modern Painters*. 6th ed. 6 vols. 1843. Reprint, New York: John Wiley & Sons, 1891.

———. *The Seven Lamps of Architecture*. New York: E. P. Dutton, 1928.

———. *The Stones of Venice*. New York: Merrill and Baker, 1851.

———. *The Two Paths, Being Lectures on Art and Its Application to Decoration and Manufacture*. New York: John W. Lowell, 1859.

———. *The Works of John Ruskin*. 39 vols. Ed. E. T. Cook and Alexander Wedderburn. London: George Allen, 1903–12.

Saisselin, Rémy G. *The Bourgeois and the Bibelot*. New Brunswick, Rutgers University Press, 1984.

Sambourne, Marion. *A Victorian Household*. London: Alan Sutton Publishing, 1988.

Sandberg, John. "The Discovery of Japanese Prints in the Nineteenth Century before 1867." *Gazette des Beaux-Arts* 71 (May–June 1968): 295–302.

Sauter, George. "The International Society of Painters, Sculptors and Gravers." *Studio* 14 (July 1898): 109–19.

Schmutzler, Robert. *Art Nouveau*. New York: Harry N. Abrams, 1978.

———. "The English Origins of Art Nouveau." *Architectural Review* 117 (February 1955): 108–16.

Schorske, Carl E. *Fin-de-Siècle Vienna: Politics and Culture*. New York: Vintage, 1980.

[Sickert, Walter]. *A Free House! or the Artist as Craftsman, Being the Writings of Walter Richard Sickert*. Ed. Osbert Sitwell. London: Macmillan, 1947.

Silverman, Debora L. *Art Nouveau in Fin-de-Siècle France: Politics, Psychology, and Style*. Berkeley and Los Angeles: University of California Press, 1989.

Slessor, Catherine. *The Art of Aubrey Beardsley*. Secaucus, N.J.: Chartwell Books, 1989.

Spencer, Charles. *The Aesthetic Movement, 1869–1890*. Exhibition catalogue, Camden Art Center. New York: St. Martin's, 1973.

Spencer, Robin. *The Aesthetic Movement: Theory and Practice*. New York: Studio Vista, Dutton Pictureback, 1972.

———. Introduction and "Paintings." In *The Aesthetic Movement and the Cult of Japan*. Exhibition catalogue. London: Fine Art Society, 1972.

Stansky, Peter. *Redesigning the World*. Princeton: Princeton University Press, 1985.

———. *William Morris*. New York: Oxford University Press, 1983.

Stanton, Phoebe. *Pugin*. New York: Viking, 1971.

Sutton, Denys. *Walter Sickert: A Biography*. London: Michael Joseph, 1976.

Swinburne, Algernon Charles. "Notes on Some Pictures of 1868." *Essays and Studies*. London: Chatto and Windus, 1875.

———. *The Swinburne Letters: Volume I, 1854–69*. Ed. Cecil Y. Lang. New Haven: Yale University Press, 1974.

Symonds, R. W., and B. B. Whineray. *Victorian Furniture*. London: Country Life, n.d.

Terry, Ellen. *The Story of My Life*. London: Hutchinson, 1908.

Tharp, Louise Hale. *Mrs. Jack: A Biography of Isabella Stewart Gardner*. Boston: Little Brown, 1965.

Thompson, Paul. *The Works of William Morris*. Oxford: Oxford University Press, 1993.

Thornton, Peter. *Authentic Decor: The Domestic Interior, 1630–1920*. New York: Viking Penguin, 1984.

Treuherz, Julian. *Hard Times: Social Realism in Victorian Art*. Exhibition catalogue. Mount Kisco, N.Y.: Moyer Bell, 1987.

Troy, Nancy J. *Modernism and the Decorative Arts in France*. New Haven: Yale University Press, 1991.

van Gogh, Vincent. *The Letters of Vincent van Gogh*. Ed. Mark Roskill. New York: Atheneum, 1985.

Warren, Arthur. *London Days: A Book of Reminiscences*. Boston: Little Brown, 1920.

Watanabe, Toshio. *High Victorian Japonisme*. New York: Peter Lang, 1991.

Watkinson, Raymond. *William Morris as Designer*. New York: New York Graphic Society, 1970.

Weisberg, Gabriel P. *Art Nouveau Bing: Paris Style, 1900*. New York: Harry N. Abrams, 1986.

———. "The Arts and Crafts Traditions in America: An Examination of 'The Art That Is Life' Exhibition." *Arts Magazine* 61 (April 1987): 46–49.

———. *Beyond Impressionism: The Naturalist Impulse*. New York: Harry N. Abrams, 1992.

———. "Félix Braquemond and Japanese Influence in

Ceramic Design." *Art Bulletin* 115 (September 1969): 277–80.

———. "Félix Bracquemond and Japonisme." *Art Quarterly* 32 (spring 1969): 57–68.

———. "Japonisme: The Commercialization of an Opportunity." *Japonisme Comes to America: The Japanese Impact on the Graphic Arts, 1876–1925.* New York: Harry N. Abrams, 1990.

———. *Stile Floreale: The Cult of Nature in Italian Design.* Miami: Wolfsonian Foundation, 1988.

Weisberg, Gabriel P., et al. *Japonisme: Japanese Influence on French Art, 1854–1910.* Exhibition catalogue, Cleveland Museum of Art. Cleveland: Robert G. Sawers, 1975.

Weisberg, Gabriel P., and Laurinda Dixon, eds., with the assistance of Antje Bultmann Lemke. *The Documented Image: Visions in Art History.* Syracuse: Syracuse University Press, 1987.

Weisberg, Gabriel P., and Yvonne M. L. Weisberg. *Japonisme: An Annotated Bibliography.* New York: Garland Publishing, 1990.

Weitzenhoffer, Frances. *The Havemeyers: Impressionism Comes to America.* New York: Harry N. Abrams, 1986.

Weschler, Lawrence. "In a Desert of Pure Feeling." *New Yorker* 69 (June 16, 1993).

Wharton, Edith, and Ogden Codman, Jr. *The Decoration of Houses.* 1897. Reprint, New York: W. W. Norton, 1978.

Whitehill, Walter Muir. "The Making of an Architectural Masterpiece—The Boston Public Library." *American Art Journal* 2 (fall 1970): 13–35.

Whitford, Frank. *Japanese Prints and Western Painters.* New York: Macmillan, 1977.

Wichmann, Siegfried. *Japonisme: The Japanese Influence on Western Art in the Nineteenth and Twentieth Centuries.* New York: Harmony Books, 1981.

Wilde, Oscar. "The Grosvenor Gallery." *Dublin University Magazine* 90 (July 1877): 118–26.

———. *The Letters of Oscar Wilde.* Ed. Rupert Hart-Davis. London: Rupert Hart-Davis, 1962.

———. *Miscellanies.* Vol. 14 of *Complete Works.* Boston: John W. Luce, 1908.

———. *The Picture of Dorian Gray.* 1891. Reprint, Cleveland: World, 1946.

Wilhide, Elizabeth. *William Morris: Decor and Design.* New York: Harry N. Abrams, 1991.

"William Morris." *Once a Week,* August 17, 1872, 18.

Williamson, C. G. *Murray Marks and His Friends: A Tribute of Regard.* New York: John Lane, 1919.

Woolley, Grande. "Pablo de Sarasate: His Historical Significance." *Music and Letters* 36 (July 1955): 236–52.

Theses and Dissertations

Becker, Eugene Matthew. "Whistler and the Aesthetic Movement." Ph.D. diss., Princeton University, 1959.

Bendix, Deanna Marohn. "James McNeill Whistler as a Designer: Interiors and Exhibitions." Ph.D. diss., University of Minnesota, 1992.

Cully, Lou Ann Farris. "Artist's Lifestyles in Nineteenth-Century France and England: The Dandy, the Bohemian, and the Realist." Ph.D. diss., Stanford University, 1975.

Denney, Colleen. "Exhibition Reforms and Systems: The Grosvenor Gallery, 1877–1890." Ph.D. diss., University of Minnesota, 1990.

Duval, M. Susan "A Reconstruction of F. R. Leyland's Collection: An Aspect of Northern Painting." Master's thesis, Courtauld Institute, 1982.

Floyd, Phylis Anne. "*Japonisme* in Context: Documentation, Criticism, Aesthetic Reactions." Ph.D. diss., University of Michigan, 1983.

Weber, Susan. "Whistler as Collector, Interior Colorist, and Decorator." Master's thesis, Parson's School of Design, through the Cooper-Hewitt Museum of the Smithsonian Institution, 1987.

Weisberg, Gabriel P. "The Early Years of Philippe Burty: Art Critic, Amateur, and *Japoniste.*" Ph.D. diss., Johns Hopkins University, 1967.

Wilkinson, Nancy Burch. "Edward William Godwin and Japonisme in England." Ph.D. diss., University of California, Los Angeles, 1987.

Index

Page numbers of illustrations are in italics.

DATE DUE

DEMCO 38-297